THE DOCUMENTS OF 20TH-CENTURY ART

DIALOGUES WITH MARCEL DUCHAMP

by Pierre Cabanne. Translated from the French by Ron Padgett, with an editor's note by Robert Motherwell, a preface by Salvador Dali, and an appreciation by Jasper Johns. Bibliography and chronology by Bernard Karpel. Illustrated.

MY GALLERIES AND PAINTERS

by Daniel-Henry Kahnweiler with Francis Crémieux. Translated from the French by Helen Weaver. Introduction by John Russell. Chronology and selected bibliography by Bernard Karpel. Illustrated.

ARP ON ARP: Poems, Essays, Memories 1920–1965

by Jean Arp. Edited by Marcel Jean. Translated by Joachim Neugroschel.
Bibliographical survey by Bernard Karpel. Illustrated.

HENRY MOORE ON SCULPTURE

by Henry Moore. Edited by Philip James. Selected bibliography by Philip James and Bernard Karpel. Illustrated.

ROBERT MOTHERWELL, *General Editor*

BERNARD KARPEL, *Documentary Editor*

ARTHUR A. COHEN, *Managing Editor*

Apollinaire
on Art

NATIONAL GALLERY ASSOCIATION

Apollinaire on Art:
Essays and Reviews 1902-1918
by Guillaume Apollinaire

EDITED BY LEROY C. BREUNIG
TRANSLATED BY SUSAN SULEIMAN
NEW YORK THE VIKING PRESS

"Peintres" by Guillaume Apollinaire from *Il y a* reprinted by permission
of Éditions Messein.
Fragonard and the United States and "Exoticism and Ethnography" by
Guillaume Apollinaire by permission of the Administrator of the Estate of
Guillaume Apollinaire.

TRANSLATOR'S NOTE

I am grateful to Professor LeRoy C. Breunig for his unfailing cooperation
throughout the course of this long work, and for the many helpful sugges-
tions he made after reading the manuscript.

S. S.

Contents

CONTENTS

CONTENTS

CONTENTS

CONTENTS

CONTENTS

1914

CONTENTS

CONTENTS

List of Illustrations

Introduction

At the time of his death, in 1918, Apollinaire had published only one slim volume of art criticism, *Les Peintres cubistes.* His reputation in Paris as the champion of modern art was in fact based more on deeds than on published works. It was thanks to Apollinaire that Braque and Picasso had met in 1907. It was he who had helped organize the cubist Room 41 at the Salon des Indépendants of 1911; established liaison between the Montmartre and the Puteaux cubists; lectured at the important Section d'Or exhibit in 1912; selected Derain and Dufy as his illustrators; posed for portraits by Vlaminck, Rousseau, Metzinger, Picasso, De Chirico, Modigliani, Larionov, and Marie Laurencin; baptized orphism and become its champion at a Delaunay show in Berlin; launched and directed the *Soirées de Paris,* one of the principal organs of the avant-garde before the war; issued a manifesto for futurism; and coined the term surrealism apropos of the Cocteau-Satie-Picasso-Massine production of the ballet *Parade.* His magnetism, his all-embracing enthusiasms, his very ubiquity in prewar Paris made him beyond a doubt the main impresario of the avant-garde.

Between the two wars, Apollinaire was more read about than read. He became in fact a semilegendary figure whose very identity was wrapped in mystery. H. L. Mencken put his name in quotes in a 1924 article because of the conviction that he was merely a Greenwich Village hoax; and to Matthew Josephson's claim that this

INTRODUCTION

"Apollinaire" was born in Monte Carlo and baptized in Santa Maria Maggiore, the offspring of a Polish lady of a noble house and a high prelate of the Catholic Church, Mencken, not to be outdone, replied that, on the contrary, his father was "a respectable waiter at Appenrodt's, by name perhaps Max Spritzwasser: hence the *nom de plume.* His mother, I venture, was a Mlle. Kunigunda Schmidt." (Actually, Josephson was not so far from wrong: although born in Rome—in 1880—Apollinaire was educated in Monte Carlo; his mother, Angelica de Kostrowitzky, was the daughter of a Vatican official; and the identity of the father is still open to question, although in all probability it was an Italian army officer named Francesco Flugi d'Aspermont.)

In the thirties, Americans knew him largely through Gertrude Stein's highly colored portrait in *The Autobiography of Alice B. Toklas.* Guillaume was "very wonderful"; he was "extraordinary" and the real hero of the famous Montmartre banquet in honor of the Douanier Rousseau. But Gertrude Stein—like Apollinaire himself—often interspersed some shrewd observations among her fantastic portrayals, and the following comment on Apollinaire as a conversationalist is applicable to much of his writing as well:

> Guillaume was extraordinarily brilliant and no matter what subject was started, if he knew anything about it or not, he quickly saw the whole meaning of the thing and elaborated it by his wit and fancy carrying it further than anybody knowing anything about it could have done, and oddly enough generally correctly.

Naturally, Apollinaire had a coterie of readers between the wars. A translation of *Les Peintres cubistes* in *The Little Review* as early as 1922 elicited some appreciative letters to the editor, including one by William Carlos Williams. It was not, however, until after World War II, in France as well as abroad, that he gradually assumed his present rank as a major twentieth-century poet. From beneath the modernistic veneer of the unpunctuated free verse, the clever "calligrams," and the Eiffel Tower imagery, there emerged a more profoundly modern sensibility, which appealed to the new postwar generation; and the collection *Alcools* came to be recognized as a masterpiece. Shortly before his death, in 1961, Camus ranked it along with Rimbaud's *Illuminations* as the most important volume of French poetry of the preceding hundred years.

Apollinaire's newly won prestige also sparked a rebirth of interest in his art criticism, especially since the innovations he had championed were now taking their place as the great seminal movements of twentieth-century art. In the forties and fifties, *Les Peintres cubistes* was translated into English, Italian, Spanish, German, Polish, and Japanese. In Paris, fragments of other articles by Apollinaire, unearthed from this or that prewar magazine or catalogue, were reprinted as talismans to ensure the success of a new one-man or collective show. And when in 1952 Marcel Adéma published the first solid, factual biography of Apollinaire, in which he reproduced excerpts from the poet's writings on painters, it became apparent that the art criticism that had appeared in the periodicals of the time was much more voluminous than the eighty-odd pages of *Les Peintres cubistes*.

Of course, Apollinaire's contemporaries remembered that he had served for some time as the critic for the Paris daily, *L'Intransigeant*. Furthermore, his articles for *Les Soirées de Paris* had been published by his widow in 1925, in the posthumous collection *Il y a*. But the total extent of his writing remained a mystery. He had been most generous with his name, knowing that its prestige was just the fillip needed by some little magazine or the catalogue of some unknown painter. Where were these articles now? Meanwhile, the controversy over Apollinaire's competence as an art critic, which had already begun during his lifetime, continued to divide the public. By some he was exalted as the great "poet-critic" of the century, the new Baudelaire. Others claimed that he could not tell a Rubens from a Raphael. It seemed rather anomalous that such judgments were being uttered on the basis of a small fraction of the *œuvre*, and it was largely to fill this gap that we undertook to collect and annotate all the scattered writings on art from the first item in 1902 on the Pergamum Altar of Berlin, written by Apollinaire at twenty-one for the symbolist magazine *La Revue blanche*, down to the "Echos," which were appearing in *L'Europe nouvelle* at the time of his death, sixteen years later. Our volume was published by Gallimard in 1960 under the title *Chroniques d'art*.

In the present English-language edition, in the fine translation by Susan Suleiman, a few excisions have been made, chiefly to avoid repetition, and considerable new material has been added: the hither-

INTRODUCTION

to untranslated articles from *Il y a* and several addenda that have
come to light within the last decade, notably a 1912 essay on Negro
art; a 1914 pamphlet on Fragonard in the United States, originally
published in English; and three little items on art and the war
recently discovered by John H. Field. We have also revised a con-
siderable number of footnotes with the English-reading public in mind.

In neither edition have we attempted to reproduce every word
that Apollinaire wrote on the art of the day. If he was a poet and
critic, he was also a journalist, living by his pen. When he ran the
column "La Vie artistique" (here translated as "The Art World")
in *L'Intransigeant,* from 1910 to 1914, his articles appeared almost
daily. Inevitably, they included numerous brief items and commentaries
of purely ephemeral interest, which we have omitted. The reviews of
the annual Paris Salons have been rather extensively pruned—especially
those of the traditionalist Salon de la Société Nationale and Salon des
Artistes Français—but also, at times, because of the sheer plethora of
names, those of the more modernist Salon d'Automne and Salon des
Indépendants. (Excisions have been indicated by ellipses in square
brackets.) Apollinaire, like many of his colleagues, seems to have
recalled somewhat too readily the remark of Chardin: "Gentlemen,
gentlemen, be kind!" and some of his paragraphs read like the dean's
list at a small college.

Indeed, we may be criticized for not having made more extensive
abridgments; scores of forgotten painters have been resuscitated in
these pages. Our answer is simply that we have been guided not by
the rank of the artist but by the nature of the commentary. If it is
too brief or neutral, we have cut it out; otherwise we have preferred
to retain it not merely for the light it may shed on the tastes and
ideas of the author but because the bulk of such remarks throw into
sharper relief the originality of the modern masters for whom Apolli-
naire was the most ardent apologist. By putting Matisse, Picasso,
Braque, and company back in the matrix of the academic art of the
beginning of the century, we can appreciate more deeply and more
dramatically the revolution they led and the perspicacity of the poet
who defended them almost singlehanded.

It is, of course, a gross exaggeration to call Apollinaire the only
champion of the modernists at the time. When he says so himself,
we mustn't take him too literally; the readers of *Alcools* are familiar

enough with his messianic moods. It would be more to the point to go along with the opinion of one of his adversaries in the battle of cubism—Louis Vauxcelles. In an unexpected eulogy of "poet-critics" (*Gil Blas*, March 18, 1913), Vauxcelles admits that poets are often more perceptive than his own confreres, the professional art critics; and he names three writers who were both poets and defenders of the new painting: Apollinaire, André Salmon, and Roger Allard. Of these three, Apollinaire did not necessarily possess the greatest expertise, but he had, as Nicolas Beauduin has said, "a kind of natural authority"; he was endowed with the qualities of a true "chef d'école." In his writings, his strong personality is revealed in a style full of assurance and verve to which few readers can remain insensitive.

Apparently Apollinaire had little professional training for his job. We know that as a child he won first prize in design in the fifth form at the Collège Saint-Charles in Monaco, but he did not have a particularly pleasant recollection of this class to judge from an article in *L'Intransigeant* (July 19, 1911):

> When I recall the drawing class at school, I remember the awful lithographs they used to give us as models—works without artistry by unknown drawing teachers whose solemnity and lack of daring were equaled only by their unskillfulness.
>
> Their timid scribbles were enough to impart a distaste for art even to those students who would later come to adore it.

We must assume that in his knowledge of painting and sculpture Apollinaire was almost completely self-taught. In Paris in 1901, just before his departure for a year in the Rhineland as a tutor, he apparently attended lectures at the Collège d'Esthétique Moderne, a center of the reaction against the *fin de siècle* style of the symbolist movement; and presumably it was here that he developed an inclination, although still very intermittent, for the kind of modernism that a few months later was to cause him to evoke the monumental qualities of the Eiffel Tower in front of the Cathedral of Cologne.

In any case, his taste was already fairly developed when he began to send from Germany his first articles for *La Revue blanche* and *L'Européen*. The statues of the Prussian princes that had recently been set up in the Tiergarten of Berlin elicited a caustic condemnation,

and he could not conceal his disappointment before the big polychrome Beethoven of Max Klinger. His enthusiasm for the Pergamum Altar and the Virgin of Nuremberg is, of course, that of a sensitive tourist rather than an art historian, but it is clear that this young man already had a flair and a sense of the authentic.

We are not completely justified, then, in supposing, as has been customary, that the aesthetician in Apollinaire needed the contact with Derain, Vlaminck, and Picasso in order to awaken. These meetings, which date from around 1904, as well as those with Salmon and the poet-painter Max Jacob, were essential for the development of the new aesthetic, but it is obvious that if his discernment had not already evolved, he would have been incapable of appreciating the works of his new friends. Already in his Rhineland poems and especially in his masterpiece of lyric poetry, "La Chanson du mal-aimé" (1903), one senses the desire to work out an accommodation between a form of lyricism anchored in reality, whether urban or rural, and the symbolist notion inherited from Mallarmé of the poem as an enigma. And when he undertakes to write on Picasso in 1905, he stresses the mixture of similar qualities in the field of painting. In the first article, in April, he says of Picasso: "His naturalism, with its fondness for precision, is accompanied by that mysticism that in Spain inhabits the least religious souls."

In May, 1905, there appeared in *La Plume* a more extensive study on Picasso, a prose poem that seeks to transpose through words and images the haunting atmosphere of the blue period. Accompanied by reproductions of five paintings, including the masterpieces *Woman with a Crow*, *The Two Friends*, and *Two Saltimbanques with a Dog*, it was the first serious piece to appear on the Spanish painter, and for Apollinaire it was only the beginning of a series of eulogies of the artist whom he considered without question the greatest of his generation.

In 1906, Apollinaire visited the Salon des Indépendants. The pencil remarks he jotted down on his copy of the catalogue—which have only recently come to light, thanks to Michel Décaudin (*Gazette des Beaux-Arts*, February, 1970)—betray above all the young poet's craving to break into all the art circles of Paris, to learn the intricacies of their politics, and his hope of becoming a collector on his own. Here are some samples. Pierre Bonnard: "I have a lithograph signed by him."

Henri-Edmond Cross: "A friend of Fénéon. Prince of the pointillists."
Othon Friesz: "His mistress is the sister of Fernande Bellevallée, the
mistress of Picasso." Henri Matisse: "At the moment [Leo] Stein
swears only by two painters, Matisse and Picasso." Georges Rouault:
"Apparently he is a Catholic." Henri Rousseau: "A friend of Jarry."
Kees Van Dongen: "I must rent his apartment on the Rue Girardon."

A childhood friend, James Onimus, confirms Apollinaire's growing
interest in the avant-garde at this time and his awareness of the role
he felt he must play. "In 1905 or 1906 I saw him again in Paris. He
took one of my friends and me to the Louvre, to the gallery of
antiquities. He spoke with great verve against the *Antinoüs*; it wasn't
that he was trying to destroy classical sculpture but rather that in his
love for a new art, for the need to surpass all that was known in art,
he was attacking the foundations, impeccable in themselves, but the
consequences of which lead to the academic style."

Such a desire to shock is on the whole less evident in his writings
on art than one would expect from the author of *Le Poète assassiné*
and *Les Mamelles de Tirésias*. Only once did Apollinaire's taste for
scandal incite him to write some texts that would have been libelous,
were it not for their fantastic tone. These were his 1907 articles for a
little rag entitled *Je dis tout*. The longest, "The Salon d'Automne," is
a hodgepodge of gossip, weird anecdotes, and polemics in the manner
of Apollinaire's friend Alfred Jarry, the author of *Ubu*. Even here,
however, one senses the poet's discernment, especially in connection
with Cézanne, who was to become one of Apollinaire's idols and on
whom, according to a remark reported to Alain-Fournier in 1910, he
intended to write a complete work. Cézanne and Seurat, these were
the two unrecognized painters of the nineteenth century who were
to find in Apollinaire a constant champion.

In sharp contrast to the *Je dis tout* style, a most respectful essay
on Matisse appeared at the end of the year. Apollinaire writes as a
modest reporter, transcribing the words of the young master and
praising the simplicity and the perfect equilibrium of his compositions.
The article, which was published in the neosymbolist magazine *La
Phalange* along with reproductions of four recent paintings, remains
famous as one of the first truly sympathetic appreciations of Matisse.

In 1908, Apollinaire wrote his first "Salon des Indépendants," a
judicious review in both the choice of the painters and the perceptive-

ness of the evaluations, with which for the most part—Rousseau and Rouault do not fare too well—posterity would concur. A month later, there appeared the first of a long series of catalogue prefaces, an essay entitled "The Three Plastic Virtues," for an exhibit of fauve painters in Le Havre. In a very hermetic style, Apollinaire enunciates several aesthetic themes that are equally applicable to his poetry of the period: the independence of art from nature, the "divinity" of the artist as creator, the autonomy and purity of the work of art, and the concept of simultaneity. It is difficult to read the statement solely as a characterization of the fauve style, and when one recalls that it dates from roughly the same time as the *Demoiselles d'Avignon* and Apollinaire's own poem "Les Fiançailles," which is dedicated to Picasso, one is tempted to see it, in part at least, as an effort, under the symbolic image of the flame, to unite the painter and the poet in their heroic quest for new forms of expression. In November, Braque's historic one-man show at Kahnweiler's—the first cubist exhibit of any kind—gave Apollinaire the opportunity to launch a diatribe against impressionism in the name of "a more noble, more measured, more orderly, and more cultivated art."

By 1910, his reputation as a critic was solid enough to prompt André Salmon to recommend him for the column "La Vie artistique" in *L'Intransigeant*, and it was in this major Paris paper that he reported on the salons and the gallery shows during four of the most crucial years of modern art. For the years 1910 to 1914 were precisely those in which the new painting—whether in schools such as cubism, futurism, and orphism, or in the works of a vast number of individual artists, many of whom were exhibiting in Paris for the first time (Mondrian, Chagall, De Chirico, Kandinsky, etc.)—had to struggle against the jeers of a skeptical or openly hostile public.

It is true that Apollinaire's great hope during these years was to lead the battle of the entire avant-garde under a single flag, and his acrobatics with the terms cubism, orphism, dramatism, futurism, and New Spirit represent successive efforts, by extending the limits of each definition, to make it the new catchall. Yet those who know only *Les Peintres cubistes* and the essays in *Les Soirées de Paris* will be struck, as they read the articles from *L'Intransigeant*, by Apollinaire's independent spirit and the breadth of his taste. In the midst of the combat, he could take time to admire the sculptors of the past century,

Barye, Carpeaux; praise the gracious works of Albert Besnard; express his delight over the posters of Cappiello or the drawings of Willette; and even surrender to the charm of the romantic style of Henri de Groux, while admitting openly that no painter could be more *passé*. On the other hand he doesn't conceal his disappointment in front of a canvas by Metzinger or Le Fauconnier, and when he decides to write the word "cubism" for the first time, apropos of the Salon d'Automne of 1910, it is hardly a compliment:

> There has been some talk about a bizarre manifestation of cubism. Badly informed journalists have gone so far as to speak of "plastic metaphysics." But the cubism they had in mind is not even that; it is simply a listless and servile imitation of certain works that were not included in the Salon and that were painted by an artist who is endowed with a strong personality and who, furthermore, has revealed his secrets to no one. The name of this great artist is Pablo Picasso. The cubism at the Salon d'Automne, however, was a jay in peacock's feathers.

Of course, the demands of a newspaper column explain to a certain extent Apollinaire's eclecticism. It would have been exhausting to go on the warpath every day, especially since the editors of *L'Intransigeant* looked upon most modern art as a form of collective madness. In fact, the tone of his articles in the avant-garde magazines such as *Montjoie!, Der Sturm*, and especially *Les Soirées de Paris* is considerably more militant. Nevertheless, the image of Apollinaire as a hard-line activist is, without actually being wrong, perhaps less justified than that of an open-minded poet with an insatiable curiosity.

The contrast between these two images is particularly apparent in the double title of the volume published in 1913: *Les Peintres cubistes, méditations esthétiques.* Actually the second part was to have been the main title, but the publisher, presumably for commercial reasons, relegated it to the lower position. As a defense of cubism per se, much of the work seems irrelevant, despite the chapter headings in the last half of the book, which include the names of Picasso, Braque, Metzinger, Gleizes, Gris, Léger, Picabia, and Duchamp. However, the moment that one examines the work as a general collection of essays and articles, many of which had already appeared in various periodicals over the past decade, the title of "aesthetic meditations" takes

on a fuller meaning. In 1912, Apollinaire was collecting his best poems of the previous fifteen years for publication in the volume to be called *Alcools*, and it was natural for him to do much the same for his writings on art. The fact that he modified his intentions as a result of the vogue of cubism in the winter of 1912, after the big Section d'Or exhibit, does not really detract from the volume's interest as a more inclusive work, and we can more readily pardon the author for his pages on Marie Laurencin, the Douanier Rousseau, and others who can hardly be labeled cubists. In any case, we reprint in their appropriate chronological order the original versions of the essays and notes that Apollinaire revised for the 1913 edition. These include "The Three Plastic Virtues" (1908); "On the Subject in Modern Painting" and "The New Painting: Art Notes" (1912); two pieces on Picasso (1905); "Georges Braque" (1908); "Women Painters" (1912), and other fragments, which are indicated as such in the footnotes. Readers who may be interested in studying the variants are referred to the Documents of Modern Art edition of *The Cubist Painters* (1949) and the annotated edition of *Les Peintres cubistes* published by Hermann in Paris (1965).

Apollinaire's skepticism regarding "isms" becomes even more apparent in 1914, when he writes, "One must therefore not take literally the names of the various schools: cubists, orphists, futurists, simultaneists, etc. For some time, they have meant absolutely nothing." Yet it was because of one of these words that in March he lost his column in *L'Intransigeant*. His review of the Salon des Indépendants, in which he noted in passing the influence of the "futurist" Delauney on the work of Henri Ottmann, had provoked irate replies from Delauney, from Ottman, and from the futurists themselves. The editors of the paper felt obliged to publish these letters but, at the same time, announced that they accepted no responsibility whatsoever for the opinions of M. Guillaume Apollinaire. On being informed that he must tone down his remarks, Apollinaire preferred to resign. In little more than a month, however, he found a position with *Paris-Journal*, and from May 1 to August 1 he wrote for the column "Les Arts" some of his most lively articles on modern painting.

The war not only interrupted this column but was largely responsible for the abandonment of other more ambitious projects. After the success of his 1912 lecture on cubism at the Section d'Or exhibit, the

publisher Eugène Figuière had named Apollinaire general editor of a series to be called "Tous les Arts," and in fact *Les Peintres cubistes* was the first (and only) volume to appear in this collection. An announcement on the back cover of the first edition lists the other titles to appear: *Cézanne, Forain, Puvis de Chavannes, Rude, Manet, Seurat, Beethoven, Rimsky-Korsakov, Degas, Daumier, Renior, Rodin, The Orphic Painters, César Franck.* We know that Apollinaire was intending himself to write the volume on the orphists, a term that he had coined in 1912 to designate the new abstract style emerging from cubism. According to his friend Nicolas Beauduin, he was planning to study in particular Kupka, Kandinsky, and Delaunay. This project undoubtedly explains the otherwise puzzling omission in *Les Peintres cubistes* of any chapter on Delaunay, with whom Apollinaire was closely allied in 1912.

Presumably, he was to have written the volume on Cézanne, as we have seen, but with the possible exception of the Seurat, it seems unlikely that he intended to undertake any of the other works himself. On the other hand, a work on Picasso had been announced in 1911 (was it simply the essay in *Les Peintres cubistes*?), and one finds in the avant-garde journals before the war statements of other projects as well. Apollinaire's ambitions were not modest.

Serving first in the artillery, then at his own request in the infantry on the front of Champagne, he manages to keep in touch with his painter friends and writes a couple of articles in 1915 on their wartime activities. But it is only after convalescing from the wound he received on March 17, 1916, that he returns to art criticism, on the occasion of a Derain exhibit in Paris, for which he writes the catalogue preface. Wearing a bandage around his head, as in the famous Picasso sketch, he begins anew to frequent the Left Bank cafés and resume the struggle for the New Spirit. During the two remaining years of his life, he becomes as ubiquitous as ever, with his signature appearing not only in the pages of the *Mercure de France*, where he again takes up his column, "Anecdotiques," and in the "Echos" of *L'Europe nouvelle*, but also in the catalogue of an exhibit of French painting in Norway; in the introduction to a volume on Negro art by Paul Guillaume; in the pages of the new magazine *SIC*, as the author of a prose poem on Picasso; in the program notes for *Parade*; and in the catalogue of a joint Matisse-Picasso show. Once more he will throw

himself into ambitious projects. Apropos of a Léopold Survage-Irène Lagut exhibit, he announces that this is the first of a series he is organizing under the auspices of the newly resuscitated *Soirées de Paris*. (Unfortunately it is the only one, and the *Soirées* remain defunct.) For Paul Guillaume, he takes charge of a new magazine, *Les Arts à Paris*, where under various pseudonyms he writes almost all the copy himself. (He directs only two issues.) In 1918, he announces a plan to collect all his poems on painters and painting in a volume to be entitled "Le Marchand d'oiseaux." Such hopes and many others would undoubtedly have been fulfilled after the Armistice, but on November 9, Apollinaire died after a five-day illness, a victim of the world-wide influenza epidemic of 1918. Only a week before, he had written the following note about a young French poet:

> The Spanish flu, or Asiatic if you prefer, has carried off Justin-Frantz Simon in the space of four days from the side of his young wife, who was laid low by the same illness.
> He loved life, this modern life, and his young talent was full of promises that death has just snuffed out.

Until the end Apollinaire himself remained young, vigorous, and full of hope for the future of art. In a letter to André Breton during the war, he wrote: "I am convinced that art itself does not change and that what makes one believe in changes is the series of efforts that men make to maintain art at the height at which it could not help existing." This belief in what he often called the "sublime" quality of art never left him during the sixteen important years that he was following—or rather leading—its diverse expressions. His criticism was often subjective and impressionistic; he did not hesitate to say in complete candor: "I love that painting," or "I find that painting detestable." To rigorous intellectual analysis, he generally preferred the lyric statement. He varied his manner considerably, depending upon the circumstances and the audience, but he seems to have felt most at home when he could give free rein to a flamboyant style consisting of rich metaphors, hyperbolic judgments, ambiguous abstractions, and disconcerting juxtapositions. "His genius as a critic," writes André Salmon, "was inseparable from his poetic genius." And those who would suggest that he wrote this way in order to cover up his alleged incompetence in painting and sculpture should be reminded

that he often used the same baroque style in his literary criticism, a field in which his expertise can hardly be questioned.

Whatever the risks of such a style, Apollinaire possessed a gift that most professional critics will envy, and that was his flair. He knew how to recognize greatness. His innate taste and his faith in the "nobility" of art permitted him to choose from among the mass of unknown painters swarming in the salons and the galleries of the period those who were destined to survive. He knew his gifts and was undoubtedly thinking of himself when in 1914 he quoted the following statement by the writer Ernest Hello: "The man who can say to an unknown apprentice: 'My boy, you are a man of genius!' deserves the immortality he promises. 'To understand is to equal,' Raphael said. . . . The critic must be as accurate as posterity; he must speak in the present the words of the future."

Except for the texts from *Il y a*, we have omitted Apollinaire's writings on art published in other volumes. The reader will find these titles in Bernard Karpel's Bibliography. They include the definitive text of *Les Peintres cubistes*, the scattered pages on artists in *Anecdotiques*, and the poems on such painters as Delaunay, Chagall, Rousseau, Picabia, Survage, and Lagut in the Pléiade edition of the *Oeuvres poétiques*. The excisions we have made in Apollinaire's periodical articles are listed in the original French edition of the *Chroniques d'art*.

The footnotes have been added in order to indicate the source of the articles and the circumstances surrounding their composition; to clarify the numerous references to events and personages of the period; and to identify as accurately as possible the works that the author comments upon without naming. The Index of names we consider quite frankly one of the most valuable sections of the book, since we hope that many readers—not only art historians—will use this volume as a reference work. The factual information alone, not to mention Apollinaire's opinions, makes this book a most valuable document for the study of modern art.

In addition to our acknowledgments in the original French edition, we wish to thank M. Gilbert Boudar, the nephew of Mme. Jacqueline Apollinaire, for permission to reprint the newly discovered documents; and we are particularly grateful to Messrs. Minard and Décaudin, for it is through their joint efforts as publisher and editor that the

annual volume *Guillaume Apollinaire* has served as the principal center of scholarly research for the last eight years. We also wish to add the names of those scholars and critics whose contributions on Apollinaire and modern art during the last decade have been particularly helpful to us: Scott Bates, Noëmi Blumenkranz-Onimus, Jean-Claude Chevalier, Douglas Cooper, John H. Field, Edward Fry, John Golding, S. I. Lockerbie, Pascal Pia, Michel Ragon, John Russell, Francis Steegmuller, Simon Watson Taylor. For Ersi L. Breunig, our most affectionate εὐχαριστῶ for her tolerance and cooperation.

—LeRoy C. Breunig

June, 1970

Apollinaire
on Art

1902

The Pergamum Altar in Berlin

Berlin is a hideous, practical city. All the things that give it the appearance of a world capital are in execrable taste. Just about any other city in the Empire is more interesting than this churchless town. If it weren't for the castles in the area, plus a few paintings in the old museum and the recently opened Pergamon Museum, a trip to Berlin would be entirely useless. The building known as the Pergamon, located behind the old museum, contains the treasures brought back from the excavations at Pergamum. Above all, it contains the gigantomachy that graced the altar of Jupiter. The altar is now restored, after twenty-three years of work by Berlin scholars.

And how beautiful it is! What a magnificent poem in stone! The Olympian gods—earth gods, sea gods, gods of the underworld—furiously intermingle their sometimes mutilated limbs with those of animals, giants, monsters; the torsos of goddesses rear up against the arms of heroes; faces are tense, mouths ready to bite. This work, which artisans carved in a very rough-textured stone, exudes such an aura of divinity that the traveler, forgetful of the crowd of mustachioed visitors and ugly women, stands entranced, hoping to hear the roar of the bulls from the hecatombs.

The gigantomachy dates from the third Hellenic period, which extended from 331 B.C. to 63 B.C.

Perhaps by contemplating the stone cutters of Pergamum, some men may yet become sculptors in Germany. I certainly hope so, because the Germans have really absolutely no idea of what sculpture is. The scarecrows of the Siegesallee, the works of Begas or more recently of Max Klinger (with all due respect to M. Georg Brandes) contain nothing that would contradict this opinion.[1]

(*La Revue blanche*, M A Y 15)

The Düsseldorf Exhibition

The considerable effort expended by the two provinces that collaborated in organizing the Westphalia and Rhineland Exhibition[2] in Düsseldorf must not blind the visitor to the crisis of German commerce and industry. One of the most interesting parts of the exhibition is the Kunstpalast, which houses the first large fine-art exhibit in Düsseldorf. The exhibit contains works by artists from all over Germany.

The Düsseldorf school seemed to be on the decline. Of the artists who once made it glorious, only one of the Aschenbachs[3] is left, wealthy, a bit crazy, and quite out of date. Yet compared to the very questionable works from Berlin and the bizarre offerings from Dresden and Vienna, the paintings of the younger members of the Düsseldorf school, Gebhart, Jansem, and Bockmann,[4] produce a restful impression of health that is reassuring for the future of this pretty and prosperous city. All in all, too many important painters are absent from this exhibit to justify its claim of being a kind of decennial.

It is true that several painters who for one reason or another were not exhibited at the Kunstpalast are well represented in galleries in town. For example, there is Professor Braun (from Munich), a battle painter and a student of Vernet. M. Braun is showing some very personal landscapes of the Bavarian Alps.

In the section devoted to the industrial arts, the contributions from Vienna are remarkable.

The major work in the section devoted to sculpture is Max Klinger's *Beethoven*. I had already seen this would-be Jupiter in colored marble last winter in Vienna. At first, it seems, it was intended to be no more

than a studio exercise, but it was subsequently mistaken for a master-piece. The arguments it has aroused over the past year have not made it any better, as far as I am concerned. Prussia, Saxony, and Austria all laid claim to it. Saxony is the winner; the *Beethoven* will go to Leipzig.

All in all, the Düsseldorf exhibition is very important. I hope that one of its consequences will be to breathe new life into this center of the arts where money is no problem.

It seems to me above all that the artists of Düsseldorf, having established themselves as painters of life and light, should continue in that direction. They can only benefit by opposing their sincerity to the lies of the secessionists from Munich (represented by the too-famous and pernicious Professor Stuck) and those of Berlin, whom it is best not to talk about.

(*L'Européen*, O C T O B E R 11)[5]

The Germanic Museum of Nuremberg

After touring Nuremberg twenty times, paying to enter all the churches, and standing in admiration before the Schöne Brunnen and all the other fountains of the city, stopping for a while on every bridge of the Pegnitz, visiting the ancient Kaiserburg and Dürer's house, and meditating on his tombstone in the cemetery of St. John; after drinking some Nuremberg beer (which many prefer to the beer of Munich) in the Bratwurst-Glöcklein, a little inn still full of mementoes of the Dürers, the Krafts, and the Vischers, who all frequented it in their time, and where one can see some more modern mementoes, such as the delightful drawing that Walter Crane left there in 1900 (the drawing represents a crane holding up a pewter jug and saluting with a *"Prosit"* a painting showing Albrecht Dürer looking the way he painted himself in his portrait of Christ at the Pinakothek of Munich but in profile); in a word, after seeing everything there is to see in Nuremberg, one should visit the Germanic National Museum— Germanisches Nationalmuseum. Although it stands on the territory of the Kingdom of Bavaria, this museum belongs to the German

5

Empire. Founded by Baron Hans von Aufsess, it has been enlarged since then and was solemnly opened in 1892 by Kaiser Wilhelm II in the presence of the Regent of Bavaria.

The purpose of the museum is to proclaim to the universe the artistic genius of the Germanic peoples. I say Germanic, because the museum contains originals or reproductions, not only of all the works of art produced on imperial soil, but also of works produced in every country of German race or language, such as Austria and part of Switzerland. The idea seems to me an excellent one, and I mention it because it seems to me desirable that an authorized person should undertake to create a similar museum devoted to the incontestably superior productions of the Latin genius. One would not have to choose as a site for this museum a world capital like Paris. Just as the Germans chose Nuremberg because that city is the model and ideal of their medieval towns, we could choose a city that would sum up the ideal of Latinity. I would propose Nîmes, Rome, or even (why not?) Trèves on the Moselle as possible sites for a museum to which the following would contribute: France, Belgium, the Rhineland and the Moselle region, Italy, the Iberian Peninsula, Rumania, North Africa, and Latin America.

Getting back to the Nuremberg museum: it contains both artistic and historical exhibits, as well as collections of coins, medals, and prints. It also has some important archives and a library containing 200,000 volumes.

To house the museum, Baron von Aufsess was granted the Carthusian monastery built by Marquard Mendel in 1380 and belonging to the city since the Reformation, together with the Tiergärtnersthorturm and the so-called houses of Pilate and Topler. The museum was organized under the direction of the late privy councilor, Dr. A. von Essenwein. After several collections relating to prehistoric times and to the Germanic periods, I note in Gallery 7 the electroplated reproduction of the Golden Treasure of Athanaric, King of the Visigoths, the original of which is in the Bucharest museum. Galleries 10–13 contain a collection of tile stoves that is certainly one of the loveliest of its kind. Farther on, we find a reproduction of the colossal Roland of Bremen. In Gallery 28, there is the famous Virgin of Nuremberg, a masterpiece of German medieval sculpture of which there is a reproduction in the Museum of Comparative Sculpture at

the Trocadéro. Gallery 33 contains a collection of woodcarvings belonging to the city of Nuremberg. Among them are the works of Veit Stoss and the original model of the *Little Goose Man* (*Gänsemänchen*) by Labenwolf, which decorates the famous fountain that several German cities such as Stuttgart and Bonn have recently copied.

On the second floor is a very interesting collection having to do with the history of housing in Germany, the Tirol, and Switzerland. Gallery 56 contains a collection of bindings, a collection on printing, some writings of Hans Sachs, etc. After that, if one goes through the rooms devoted to pharmacy, astrology, alchemy, and toys from Nuremberg, one reaches the painting gallery that belongs in part to the city. This gallery contains a *Madonna with the Pea Blossom* in the manner of the one by Master Wilhelm in the Cologne museum.[6] A crucifixion by Stephan Lochner, and *Moses Bringing Forth Water from the Rock*, by Lucas van Leyden. Two madonnas by Holbein the Elder, five paintings by Dürer: *Hercules and the Birds of Stymphalis*, a sober, powerful, and mysterious canvas, together with a *Pietà* and the three truly imperial and superb portraits of the Emperors Charlemagne, Sigismund, and Maximilian. Some Cranachs, a self-portrait by Rembrandt. A Ruysdael, and finally a solid portrait by Lenbach of Bismarck, who is definitely unavoidable in any German museum. In Gallery 82, I note Lenau's guitar and one of Marie-Antoinette's harps.

I will not speak of the immense collection of German pottery, glassware, and costumes, or of the reproductions of the most famous works of German art, such as the bronze doors, the chandeliers with the lion, and the baptismal fonts of the Cathedral of Hildesheim.

This museum appeared to me to be the triumphant realization of an undertaking that the Latin races ought to imitate. With the exception of the portrait of Bismarck, the Nuremberg museum contains only medieval and Renaissance works. How inestimable would be the value of a museum where one could trace Latin culture from antiquity through the Middle Ages and up to modern times!

To conclude, I want to record a grievance that was not formulated, as one might imagine, by a Bavarian prone to denigrate anything done by the Prussians, but rather by a Brandenburger born and living in Berlin.

It seems that the administrators of the Berlin museums are casting jealous glances at certain treasures of the Nuremberg museum. Indeed,

1903

On Fakes

It will be quite common from now on in all the museums to see people standing before the most respectable works of art repeating the old saw, "One would almost say it was a fake." The tiara of Saïtapharnes[1] will, I hope, give the public a good dose of scorn for the past. Scorn is a liberating sentiment. It exalts an honorable soul and incites it to undertake great things.

Only one kind of scorn deserves to be deplored, and that is the scorn for beauty. Now the tiara of Saïtapharnes is a beautiful thing. That was my feeling when I saw it, and I have since read in the newspapers that goldsmiths are of the same opinion. The reasons that scholars are now horrified by it are of a purely archaeological order, which means that they are of no importance whatsoever. Anyway, according to the original judgment of those same scholars, at least the scholars of the Louvre, the tiara is a work of admirable craftsmanship. I would add, without fear of using an outmoded phrase, that the work is as beautiful as an antique. The tiara of Saïtapharnes, then, is not to be scorned. The Ministry of Fine Arts was surely lacking in imagination in this instance: a beautiful work of art, so worthy of being exhibited in a national museum, should not have been allowed to leave it.

1 9 0 3

At best, since it is probable that the artist who made it is still alive, the tiara could have been transferred to the Luxembourg and exhibited with the following label, which would have restored to the work all its authenticity: "Unknown Russian master, late nineteenth century." After ten years, the tiara would have been returned to the Louvre, where it would have been exhibited as a masterpiece of nineteenth-century goldsmithing. The scholars whose business it is to augment the national collections should, in fact, have considered it their duty to acquire as many works as possible by this great and now unrecognized artist. He could have been designated as the "Master of the Tiara of Saïtapharnes," as we already have in painting the Master of the Death of Mary, the Master of St. Severin, the Master of the Heisterbach Altar, and the Master of St. Bartholomew of the Boisserée (pronounced *Bozré*) family.

The Germans, who in this instance were so quick to offer us their idiotic commiseration and to plague us with their useless pedantry, do precisely this on occasion. Suppose that a work in one of their museums is recognized as a fake. Instead of lamenting the fact and transporting the work to the attic, the German curators simply place the little word "*nach*" ("in the manner of") before the artist's name. Let's take, for example, the Dresden museum. One of the justly celebrated ornaments of that gallery used to be *The Madonna of Burgomaster Meyer of Basel*, by Hans Holbein the Younger. In 1871, it was discovered that the original Holbein was in fact in Darmstadt, in the palace of the Grand Duke of Hesse. In Dresden, the word "*nach*" was added to the label and the painting has remained in the place of honor it has always occupied. The same story can be cited in the case of Jan Brueghel the Elder. *The Adoration of the Magi* is in Vienna, and *Christ Preaching at the Lake of Galilee* is I don't know where. Dresden, which featured them as originals, has placed "*nach*" before the name of Jan Brueghel. The taste for fakes is so much a part of the German character that a scarf shown in a store window with the label "silk" will certainly be mostly cotton. Genuine silk will be designated by the label "pure silk." In their museums, the Germans exhibit a copy with the pride one would take in showing an original. Germans wear false jewelry as contentedly as if it were real.

The French are sorry that the tiara is a fake. One would think this was the first time a fake was discovered in France. The French are

wrong, and all the more so since, even if the tiara were ugly as well as false, it is still made of gold and could have been put to very respectable use by being offered to the President of the Republic. It would have looked very good on his handsome bearded head.

In any case, fakes should no longer bother anyone. Every city has a few fakes of almost official status. In the Santa Sophia of Constantinople, English and other tourists are shown the handprint of the conqueror and the mark left by his saber on one of the walls. At the Frauenkirche in Munich, the feet of the devil have left two black marks on the stone pavement. In Bonn, a large tavern where the Kaiser and after him his son, the Kronprinz, used to go on their drinking sprees when they were students has kept the tankards that these two princes drank from. They are exhibited on small shelves and are objects of admiration for all who visit that tavern in the city of the Muses. If one day a clumsy waiter should break one, there is a good chance that it will be replaced by one exactly like it from the large stock of the establishment.

Literature, too, is full of fakes. The poets who sang the praises of Angelica, Queen of Cathay, or of Helen, more dazzling than her stellar brothers and as white as her father, the enamored swan who will never sing at all, thought that they were honoring with their songs an embodiment of beauty and youth. In fact, we know through Lucian that at the time of her flight with the Phrygian shepherd, Helen was reaching her tenth lustrum, and a poem by Brusantini, *Angelica innamorata*, assures us that the lady in question was forty years old when she loved Medoro.

> *Ella era gionta al quadragesimo anno*
> *Et era quasi alhor più che mai, bella.*

(She had attained her fortieth year
And was then almost more than ever beautiful.)

The poets were misled by Homer and Ariosto.

The Gospels are later than those to whom they are attributed; and is there not some sanctuary that exhibits a picture of the Virgin painted by St. Luke? I mention simply as a matter of information the false relics to be found everywhere and the innumerable horses racing under false pedigrees made in Belgium.

There is at least one person who must be indifferent to fakes: it is

1 9 0 3

M. Domenech, who recently baptized M. Gaston Pollonnais.[2] In 1860, M. Domenech published under Gide's imprint a volume entitled: *Manuscrit pictographique américain précédé d'une notice sur l'idéographie des Peaux-Rouges.* The manuscript in question is at the Bibliothèque de l'Arsenal. It is entitled *Le Livre des Sauvages* and is the work of a German. It is a collection of pencil drawings, most of them obscene. Many common German words scattered throughout the volume and written in German script were mistaken by M. Domenech for Iroquois terms.

I once saw a counterfeiter at work in Honnef, on the Rhine. He was a very strange old man, living in seclusion and seeing only foreigners who came to buy his false antiques. This man's specialty was the fabrication of fake Siegburg pottery. He had taken a liking to me, and I once saw him kneeling in his little garden, smudging some pieces of brand-new pottery with moist earth. A few months later, he sold those pieces to a Protestant minister who was a collector of Rhenish antiques. That old counterfeiter was completely happy only on the days he had disguised some forgery. He would then admire his work with a smile and say, "I have created a god, a false god, a real, pretty, false god." Then he would take his guitar, and screwing up his toothless mouth, he would sing some old German lieder celebrating Kätchen of Heilbrönn or Schinderhannes.

(*La Revue blanche,* A P R I L 1)

1905

Picasso, Painter and Draftsman

Serrurier Gallery[1]

It has been said of Picasso that his work bears witness to a precocious disenchantment.

I believe the opposite is true.

Everything enchants him, and his incontestable talent seems to me to be at the service of a fantasy that justly blends the delightful with the horrible, the abject the refined.

His naturalism, with its fondness for precision, is accompanied by the mysticism that in Spain inhabits the least religious souls. It is well known that Castelar used to carry a rosary in his pocket; and if Picasso is not very religious (which I think to be the case), he must nevertheless have retained a refined veneration for St. Teresa or St. Isidor.

In Rome, at Carnival time, there are certain maskers (Harlequin, Columbine, or the *Cuoca Francese*) who in the morning, after a night of revelry that sometimes ends in murder, go to St. Peter's to kiss the worn toe of the statue of the Prince of the Apostles.

They are the kind of creatures who would enchant Picasso.

Beneath the tawdry finery of his slender clowns, one feels the presence of real young men of the people—versatile, shrewd, clever, poor, and deceitful.

His mothers' hands are taut, and fine as are often the hands of young working-class mothers; his nudes are blazoned with the fleece that traditional painters disdain and which is the shield of Occidental modesty.

(*La Revue immoraliste*, A P R I L)

Young Artists: Picasso the Painter

If we knew, all the gods would awaken. Born of the profound knowledge that humanity had of itself, the adored pantheisms that resembled it have gone to sleep. But despite eternal slumbers, there are eyes that reflect humanities resembling divine and joyous phantoms.

Those eyes are attentive like flowers that wish ever to contemplate the sun. O fecund joy, there are men who see with those eyes!

Picasso has looked at human images that floated in the azure of our memories and that partake of the divine to the damnation of metaphysicians. How pious are his skies stirred by the movement of wings, his lights heavy and low like the lights of grottoes.

There are children who have wandered without learning the catechism. They stop and the rain dries up. "Look! There are people who live in these hovels, and they are poorly dressed." These children whom no one caresses understand so much. Mommy, love me a lot! They know how to jump and the feats they accomplish are mental evolutions.

These women who are no longer loved remember. They are tired of ironing their brittle ideas today. They do not pray; their devotion is to their memories. They huddle in the twilight like an ancient church. These women are giving up, and their fingers are eager to weave crowns of straw. At daybreak, they disappear, they have consoled themselves in silence. They have passed through many doors: mothers protected the cradles so that the newborn babes would not be ill favored; when they leaned over, the little children smiled to know them so kind.

They have often given thanks, and their forearms trembled like their eyelids.

Enveloped in icy mists, the old men wait without pondering, for children alone ponder. Stirred by faraway lands, by the quarrels of animals, and by hardened tresses, these old men can beg without humility.

Other beggars have been worn out by life. They are the cripples, the disabled, and the knaves. They are astonished at having reached the goal that has remained blue yet is no longer the horizon. Growing old, they have become mad like kings with too many herds of elephants carrying miniature citadels. There are travelers who confuse flowers with stars.

Grown old the way oxen die at twenty-five, young men have carried infants suckled by the moon.

In pure sunlight, women remain silent, their bodies are angelic and their glances tremble.

In the face of danger, their smiles become internal. They await fear to confess innocent sins.

For the space of one year, Picasso lived this painting, wet and blue like the humid depths of the abyss, and pitiful.

Pity made Picasso more harsh. The public squares held up a hanged man stretching himself against the houses above oblique passers-by. These tortured men were waiting for a redeemer. The cord swung away, miraculously; on the mansard roofs, the windowpanes blazed with the flowers of the windows.

In bedrooms, poor painters drew fleecy nudes by lamplight. The women's shoes abandoned near the bed suggested tender haste.

Calm descended after this frenzy.

The harlequins live beneath their ragged finery while the painting gathers, heats up, or whitens its colors in order to tell of the strength and the duration of passions, while the lines outlining the costume curve, soar up, or are cut short.

Paternity transfigures the harlequin in a square room while his wife bathes herself with cold water and admires herself, as slender and frail as her husband, the puppet. A neighboring fireplace sends some warmth into the caravan. Lovely songs mingle in the air and soldiers pass elsewhere, cursing the day.

Love is good when it is adorned, and the habit of living in one's own home redoubles the paternal sentiment. The child brings together the father and the wife, whom Picasso sees as glorious and immaculate.

1905

The expectant mothers were no longer expecting the child, perhaps because of certain chattering crows and evil omens. Noël! They gave birth to future acrobats amid the familiar monkeys, the white horses, and the bearlike dogs.

The adolescent sisters, treading and balancing themselves on the great balls of the saltimbanques, impart to those spheres the radiant movement of the planets. These girlish adolescents, children still, have the anxieties of innocence; animals teach them the religious mysteries. Some harlequins accompany the aura of the women and resemble them, neither male nor female.

Color has the flat quality of frescoes, and the lines are firm. But placed at the outer limits of life, the animals are human and the sexes indistinct.

Hybrid beasts have the consciousness of the demigods of Egypt; the cheeks and brows of taciturn clowns are withered by morbid sensibilities.

One cannot confuse these saltimbanques with mere actors on a stage. The spectator who watches them must be pious, for they celebrate wordless rites with painstaking agility. This is what distinguishes this painter from the Greek potters, whom his drawing sometimes calls to mind. On the painted vases, bearded, verbose priests sacrificed resigned animals bound to no destiny. In these paintings virility is beardless, but it manifests itself in the muscles of the skinny arms and flat cheekbones, and the animals are mysterious.

Picasso's penchant for the fleeting trait transforms and penetrates and produces almost unique examples of linear drypoints, in which the general aspect of the world is not altered by the light that modifies forms by altering colors.

More than all the poets, sculptors, and other painters, this Spaniard stings us like a sudden chill. His meditations are laid bare in silence. He comes from far away, from the richness of composition and brutal decoration of the Spaniards of the seventeenth century.

Those who have known him remember fiery outbursts that were already more than mere experiments.

His perseverance in the pursuit of beauty has led him on his way. He has seen himself ethically more of a Latin, rhythmically more of an Arab.

(*La Plume*, MAY 15)[2]

1907

Bernheim-Wagram

"Bernheim-Wagram" does not designate a new bus route. What is involved here is an affair that has, with reason, stirred up the art world.

A young gentleman of letters, a Wagram, who is, incidentally, related to the Rothschilds, had taken it into his head that he wanted to become an art dealer. He allied himself for this purpose with the Bernheims, expert and established dealers who dealt impartially in the most varied kinds of merchandise: Roybet, Cézanne; Jean Béraud, Bonnard; Madeleine Lemaire, Van Gogh; Bonnat, Matisse, etc. People are eclectic in high society.

We are told that in order to test the loyalty of his associates, the young gentleman of letters arranged on his own, and without their knowledge, to have some paintings sold to them.

The Bernheims, after some heavy bargaining, would buy a painting for 10,000 francs, for example, and would then tell their young associate that they had bought a masterpiece for 50,000 francs, which was really nothing, hardly the price of the frame.

Our young gentleman considered this an abuse of his incompetence, so outdealing the dealers, he has brought a claim against them. One wonders what the art experts appointed by the judge have to do with this affair. Rather than art experts, it's handwriting experts that are needed.

It is clear that the affair is a purely commercial one and that the value of the Cézannes, Van Goghs, Seurats, and Gauguins is not in question. The people who stupidly proclaimed the bankruptcy of modern painting—of painting without form!—made a gross error. Critics without taste, ignorant dilettantes, their lack of culture should bar them from getting mixed up with things they do not understand. They would like to reduce art to their level. Let them swallow it and may it choke them!

After this, let us say that we will gladly publish any explanations that Messrs. Bernheim might wish to address to us.

(*Je dis tout*, J U L Y 25)[1]

The Salon d'Automne

[O C T O B E R 12]

> *Mets ta jupe en cretonne*
> *Et ton bonnet, mignonne!*
> *Nous allons rire un brin*
> *De l'art contemporain*
> *Et du Salon d'Automne.*

> (Wear your best skirt, pretty one,
> And put your bonnet on!
> We're off to have a lark
> With contemporary art
> At the Autumn Salon.)

For it seems to me a must to visit the Salon d'Automne. Fathers will do well to take their sons there, both from a pedagogical and a humanitarian point of view.

It is good that a child should learn while he is still a child the names of men who will be famous.

Monsieur Jourdain

Monsieur Jourdain, whom Baignières[2] familiarly calls "Frantz First" or "The Foot That Moves" or "The President of Façades" or "The

Good Samaritan," combines the function of architect of the Salon d'Automne with that of honorary president of the Samaritaine, which solicited him one evening at a corner of the quays.[3]

It's because he is well preserved, for his age! He looks like an apostolic and anarchistic Mormon, a fact that earned him the rosette of the Légion d'Honneur, together with this little song sung to a well-known tune:

> *Monsieur Jourdain*
> *A le goût fin*
> *Depuis l'âge le plus tendre.*
> *Pour tout savoir*
> *Il n'a qu'à voir*
> *Et pas besoin d'entendre.*
> *Comme architec,*
> *On dit: "Quel mec!*
> *Il a du poil au ventre!"*
> *Et l'on assur'*
> *Qu'en fait d'peintur'*
> *C'est un gai dilettantre*
> *Qui port 'fièrement*
> *Son bout d'ruban.*
>
> *Il en a un p'tit bout*
> *Qui fait fort bien son affaire, etc.*

> (Monsieur Jourdain
> Has been a great man
> Since the age of three.
> His taste is great—
> No need to hear him,
> Anyone can see.
> In architecture
> He's a master.
> People say so,
> They must know.
> It's also known
> That he is prone
> To judging paintings
> Like a pro.
> That's why he was given
> His little bit of ribbon.

> He only has a little bit,
> That's all he needs, etc.)

This year he was admirable. His journey from the basement of the Grand-Palais to the Bernheim Gallery,[4] in the Rue Richepanse, was a glorious episode in the life of our great manager of the fine arts. He is a person who will go down in history.

He was surrounded and pressed from every side. One member of the jury held his candy box, another his spittoon, a third his noble handkerchief. During the whole trip, the Good Samaritan cried, "Look at me! I am charging ahead like a bull!"

Upon arriving at Bernheim's, he charged at an admirable painting by Cézanne, a red painting, needless to say: the portrait of Mme. Cézanne. Fénéon stopped him by stolidly declaiming an astonishing piece of news in three lines.

M. Jourdain then turned on a landscape. He charged, running like a madman, but that painting of Cézanne's was not a canvas, it *was* a landscape. Frantz Jourdain dived into it and disappeared on the horizon, because of the fact that the earth is round. A young employee of Bernheim's who is a sports enthusiast exclaimed, "He's going to go around the world!"

Luckily, that did not happen. Those assembled saw Frantz Jourdain emerge, all red and out of breath. At first, he looked very small against the landscape, but he grew bigger as he approached.

He arrived, a bit embarrassed, and wiped his brow. "What a devil, that Cézanne!" he murmured. "What a devil!"

He stopped before two paintings, one of which was a still life with apples and the other the portrait of an old man.

"Gentlemen," he said, "I defy anyone to say that this is not admirable."

"I will say it, monsieur," replied Rouault. "That hand is a stump."

And Frantz Jourdain had to remain silent, for there in fact is the chink in his armor. For him, painting is reduced to this question: Is a hand a stump or is it not? Whatever he may say or do, he cannot avoid that stump. But when a man has spent twenty years proclaiming his admiration for Cézanne, he cannot be expected to admit that he does not know why he admires him.

Among the dozen Cézannes at Bernheim's, there was a fruit bowl,

all lopsided, twisted, and askew. M. Frantz Jourdain had some reservations. Fruit bowls generally look better than that, they stand more upright. M. Bernheim then took the trouble to defend the poor fruit bowl, mustering all the graciousness of a man who frequents the most noble salons of the empire:

"Cézanne was probably standing to the left of the fruit bowl. He was seeing it at an angle. Move a little to the left of the painting, M. Frantz Jourdain. . . . Like this . . . Now close one eye. Is it not true that this way the painting makes sense? . . . So you see, there was no error on Cézanne's part."

On the way back to the basement of the Grand-Palais, M. Frantz Jourdain was deep in thought; his wrinkled brows attested to the seriousness of his preoccupation. Finally, having thought over the battles he had fought, he pronounced the following words with a sincerity that brought tender tears to the eyes of every member of the jury:

"The dozen Cézannes at Bernheim's are extremely dangerous!" He thought a bit more, then added:

"As for me, I stop at Vuillard."

Then he looked at the setting sun, and he seemed to see from afar the shining gold of the domes of the Samaritaine. He was heard to murmur from time to time: "The dozen Cézannes! . . . the dozen Cézannes!" And M. Frantz Jourdain, who is a cultivated man, thought of Suetonius.

REFRAIN
(By the Chorus of the Guards of the Grand-Palais)

Il en a un p'tit bout
Qui fait fort bien son affaire, etc.

(He only has a little bit
That's all he needs, etc.)

Down in the basement, M. Frantz Jourdain had not yet finished with Cézanne.

Passing his arms familiarly around Desvallières's neck,

Neck that no human arm has e'er entwined!

he explained:

1907

"You understand, I am for freedom in art and color. That portrait of Mme. Cézanne, for example, I think is extraordinary. Really, that lady was beautiful. But that mouth, that mouth . . . Do you think it is real? I keep asking myself that, and I cannot bring myself to believe it. . . . What the devil can one do with such a mouth!"

And the parade of paintings before the eyes of the jury recommenced. . . .

There appeared a painting of the kind used for advertising purposes by some of the department stores—a wax head, on a body draped in real fabrics.

Rouault said loudly:

"Do the dress shops wish to exhibit at the Salon d'Automne this year?"

At this remark, Frantz Jourdain turned around purple with anger, and spluttering in Rouault's face, he pronounced these memorable words:

"Certainly they are exhibiting, monsieur! I am for progress, for progress always! When there are hats for 25 sous, there will no longer be any for 25 francs, and we will all be artists."

At this, M. Desvallières, who is a rich and respectable man, showed signs of amazement:

"Really! They already make hats for 25 francs? That's very cheap! I didn't think one could buy a hat for less than 25 louis."

Upon which, M. Frantz Jourdain had the painting brought back, and it was then accepted by the jury.

And so the work of the jury went on amidst the gnashing of teeth. Frantz Jourdain made some witty digs at the opposition:

"Piot is screaming," he said, "but Rouault is getting pale; he is raging like a fanatic."

We were speaking earlier of Molière.* It is simply that M. Frantz Jourdain has just had his name engraved on all the pillars of the Samaritaine, to which he is constantly adding new buildings. Like his namesake, the Bourgeois Gentilhomme, Frantz Jourdain has a penchant for ceremonies. Didn't he, after all, in order to ennoble and consecrate the liaison between one of his relatives and the daughter of the

* The reference is to M. Paul Adam.[5]

anarchist Vaillant, the one who was guillotined although he hadn't killed anyone, organize a feast of redemption and purification complete with banquet and intricate ritual?*

Nevertheless, when he had heard the news, he had been shocked out of his wits. The bourgeois in him was outraged:

"Fie! The daughter of a guillotined man! What a scandal!"

But the anarchist in him soon came to life:

"I am pleased, after all. It was a plucky thing to do, what X did, and not at all bourgeois."

So the ceremony was held.

His eyes full of tears, his voice trembling, and his arms upraised, he blessed his dear X in the name of anarchist principles, after having feasted like a bourgeois.

Cézanne

There is no need for us to speak about the art of Cézanne.† Let it be known, however, that M. Frantz Jourdain, under the pretext of not wishing to tarnish the glory of that great man and of not displeasing the clientele of his backer, Jansen, deliberately underrepresented him at the Salon d'Automne.

Cézanne's affability is now almost legendary. When Vollard went to Aix to buy some paintings from him, he found to his astonishment that almost all the paintings with houses in them had a square hole pierced just above the chimney. He asked the reason for this:

"Pooh!"‡ replied the master. "It's my children, having some fun. They thought that if the chimneys didn't have holes, the smoke could not get out."[6]

Cézanne was rich. He used to go painting in the countryside in a provincial landau,‡ a fact that strikes us as a rather nice sign of the times.

The master from Aix was modest. He would willingly discuss art

* It was at Carnival time.
† It is spoken of most learnedly in the works of M. Georges Lecomte.
‡ The reference is to M. Paul Adam.

with the high-school drawing teacher, and would not be too proud to ask him for advice:

"Do not be afraid to correct me," he would say. "You know much more about it than I do."

He liked to tell stories about his painting. One day, on the occasion of a first communion, he gave a painting to the heroine of the little celebration.*

Her parents said nothing, and barely even thanked him. They thought the painting was horrible. Cézanne was extremely amused at their discomfiture.

A few days later, he went back to see the same people. The whole family surrounded him, thanked him, and spoke of his genius.

Since they had last seen him, those fine people had done a bit of investigating and had found that the painting was worth money.

People have sometimes spoken about Cézanne's religious sentiments. On that subject, we might cite one of his own statements:† "The Jesuits have got hold of me; my sister goes to Mass, and so do I."

Vollard

He was Cézanne's first dealer, and he is one of the best in Paris. He was born on the island of Réunion, like Leconte de Lisle, M. de Mahy, and Marius-Ary Leblond. His shop is one of the most exclusive in town. The best people gather there every evening.‡

For some unknown reason, he regrets having sold the paintings he has sold. He was the one who used to say to Guérin, speaking of Lefebvre, Henner, and others: "How sorry I am not to have sold the paintings of those gentlemen!"

And he would add, to the tune of the ditty "You Smell of Mint":

> *Je march' pour tout c'qu'on me propose*
> *Laprade, Marquet, Manzana,*
> *Leurs toil's n'sont pas couleur de rose;*
> *J'eusse préféré vendr' des Bonnat.*

* The reference is to M. Paul Adam.
† M. Jean de Mitty contests the authenticity of this anecdote.
‡ There are, among others, Messrs. X, Y, and Z. A sense of discretion that cannot fail to be appreciated prevents us from naming the ladies.

Mais j'march', qu'voulez-vous, j'suis marchand,
La fortune vient en marchant.

REFRAIN À SA BONNE

Rangez toutes ces toil' charmantes
Toutes ces toiles charmantes,
Tout ce charme rentoilé,
Empilez-les, empilez-les,
Aux ca, aux ca, aux cabinets.

(I deal in what the world proposes,
Laprade, Marquet, Manzana,
Their canvases don't smell like roses;
I'd much rather sell Bonnat.
But I deal; after all, I'm a dealer,
Fortunes are made by dealers like me.

REFRAIN SUNG TO HIS MAID

Take all these charming canvases,
These canvases so full of charm,
Take this canvased charm
And pile it, pile it . . .
In the toilet.)

Desvallières

He has been with the young painters for forty years now, and
thanks to his very praiseworthy good will, he always suits his manner
to the taste of the moment. He succeeded, without too much maneuver-
ing, in becoming Vice-President of the Salon d'Automne.

He is Legouvé's grandson, and he follows to the letter the dodeca-
syllabic advice of his honored ancestor:

Do worship the sex to which you owe your mother.

Speaking of No. 4 Rue Saint-Marc, where Legouvé lived and where
M. Desvallières lives, Léon Bloy has said:

"There are some microbes left in that house. They are all coming
down on the head of our friend Desvallières."

This year, the lovable Vice-President conceived a subtle idea,* to

* The reference is to M. Paul Adam.

wit, having the Salon d'Automne lauded in *La Grande Revue* by M. Cormon, a member of the Institute.*

"You understand," he explained to one of our collaborators,* "Cormon will criticize with civility. We will be able to reply to him in the same terms.

"It is time to make the members of the Institute understand current trends.

"The members of the Institute are the most authorized representatives of the upper bourgeoisie, and the bourgeoisie must march at the head of the intellectual movement. It must direct that movement if it does not wish to perish."

M. Cormon declined the offer in an extremely subtle letter with approximately the following conclusion: "I do not like *hoi polloi*. I am with Jesus against Barrabas, and *hoi polloi* will always be with Barrabas against Jesus."

M. Desvallières has a brother who is rather well known for having written *Champignol malgré lui*. This gay author is also a painter, and he exhibits at the Salon d'Automne under various pseudonyms. One would think he would be content with being a popular vaudeville artist. But no, he must have his little whims; painting is his hobby, and the laurels of his brother interfere with his sleep.

Some time ago, he wrote him a letter, the gist of which was the following: "Monsieur, when you are still a member of the Institute, *I* will be a man of genius."

M. Desvallières was very flattered, for he dreams of becoming a member of the Institute; and as he is a very likable and proper gentleman, he will become a member of the Institute.

Abel-Truchet

To get to the Cézanne retrospective, one must pass in front of the paintings of M. Abel-Truchet.

This fact reveals his whole character.

* The reference is not to M. Paul Adam.

In other years, his name was always first in the catalogue. To arrive at this result, M. Truchet had discovered a clever device: the hyphen.

This year, however, his cleverness was not enough, for a certain Aaron[7] submitted canvases that were accepted by the jury.

In the catalogue, M. Abel-Truchet is now only in second place.

Abel-Truchet has a remarkable head for business. If he organizes an exhibition, he is there every day to watch over sales, and he makes sure to have some small canvases at modest prices, 50 to 60 francs, destined for collectors without fortunes.

At the Salon d'Automne, you will see him not far from his paintings, distributing prospectuses and calling cards with his address.

His greatest merit, as he is the first to admit, is his frankness.

"Frantz Jourdain," he says, "treats me like a rotten fish, because I do not like Cézanne. I do not like him, that is true, but Frantz Jourdain does not like him any more than I do. I am frank about it, at least. He says he likes him. I do not."

Matisse

The fauve of fauves.[8] They do not dare to refuse his canvases. The jury had decreed. The paintings were accepted. The vote had been taken. At that point, M. Frantz Jourdain remembered the mission entrusted to him by M. Jansen, the well-known upholsterer, who is a financial backer of the Salon d'Automne.

M. Jansen likes neither Cézanne nor Matisse, nor any painting more daring than M. Abel-Truchet's.

It was to defend his upholsterer's taste that M. Jansen delegated M. Frantz Jourdain, who fulfilled his mission very nicely.

The paintings of M. Henri Matisse, then, had been accepted. M. Frantz Jourdain suddenly got up and recalled *The Dressing Table*, which was the biggest of the paintings sent by Matisse.[9]

"Gentlemen," said Frantz Jourdain, "I ask, both in the interest of the Salon d'Automne and in the interest of Matisse himself, that this painting be refused."

Desvallières, man of the world that he is, protested:

"We look upon the painting of our friend Matisse not as judges but as companions. It is true that it may appear a bit preposterous

to an unpracticed eye. Nevertheless, the vote has been taken, and we ought to observe the rules."

Rouault also protests, less gracefully. He too invokes the famous rules. He becomes violent and starts gesticulating in front of the President, who seizes him by the neck with an iron fist and shakes him like a pear tree.

"I stand by the rules," cries Frantz Jourdain, while Rouault begins to turn purple beneath his grip. "I stand by them, do you hear me? I know very well that I will be devoured for this by the fauves, but I do not give a damn."

And he did not desist. While the unlucky Rouault dropped down on a chair and caught his breath, a new vote was taken, and Matisse's *The Dressing Table* was refused.

Piet

Some of his friends call him the Soleilland[10] of the Salon d'Automne, but it's a nickname he does not really deserve. He is called that, it seems, because his language is not sufficiently temperate. In telling you, for example, that he cannot sleep in his apartment on the Rue Rochechouart because the plumbers make too much noise, Piet will pronounce twenty blasphemies and forty obscenities.

Is it any wonder, after this, that he is taken for a satyr?

Othon Friesz

The head of the School of Le Havre. He has a mistress who in her fits of anger likes to slash his paintings, and who speaks Japanese perfectly. Friesz's paintings would have been refused if M. Desvallières hadn't gotten up and said:

"I beg your indulgence for the canvases of our friend Friesz, who is an admirable man not only as an artist, but above all as a man. He has a mistress who in her fits of anger likes to slash his paintings, and who speaks Javanese perfectly."

In this way, the paintings were accepted.

Vallotton

He is exhibiting six paintings, among which is a portrait of *Mlle. Stein,* that American lady who with her brother and a group of her relatives constitutes the most unexpected patronage of the arts in our time.

> *Leurs pieds nus sont chaussés de sandales delphiques,*
> *Ils lèvent vers le ciel des fronts scientifiques.*

(Their bare feet shod in sandals Delphic,
They raise toward heaven their brows scientific.)

Those sandals have sometimes done them harm. Caterers and soft-drink vendors are especially averse to them.

Often when these millionaires want to relax on the terrace of a café on one of the boulevards, the waiters refuse to serve them and politely inform them that the drinks at that café are too expensive for people in sandals.

But they could not care less about the ways of waiters and calmly pursue their aesthetic experiments.

Much to our regret, M. Vallotton is not exhibiting the portrait of a wealthy Protestant lady from Switzerland who insisted on taking out her denture during her sittings:

"It would not be honest to paint my teeth," she said. "In fact, I have none. The ones that are in my mouth are false, and I think that a painter should paint only what is real."

Gropeano

Truchet says to him: "There you are, you great big Pleyel!"
He is the Foreign Delegate to the Salon d'Automne.
Incidentally, we were unable to obtain any information either about his functions or about the way he is fulfilling them.
Once he starts to talk about Gropeano, Truchet cannot be stopped.
"Rumanians," he says, "are born either with a bag of *écus* or with a *violon,* but they always have the last part of the former and the first part of the latter."[11]

1 9 0 7

This year, M. Gropeano is exhibiting a *Portrait of Her Majesty Carmen Sylva Examining a Typewriter for Blind Children Manufactured at the Royal Palace of Bucharest.*

It is all in blue, and it is frightening. The queen has white hair, and she looks blind herself.

[OCTOBER 19]

A large number of typographical errors illustrated and enlivened our preceding article. Typesetters, praise God, have made remarkable progress in the subtle art of typographical errors. Erdome[12] had already carried the art to a point of perfection. He wanted typos to be licentious and blasphemous, but in our opinion it is enough if they are merely picturesque. After all, we have not yet left the Salon d'Automne.

The Douanier Rousseau

This good man had sent a few paintings.

The jury accepted them. But M. Frantz Jourdain, who must have somehow missed the voting, had the paintings hung in the section of the Salon devoted to the decorative arts; after which, pulling out of his pockets the remnants of cotton he always carries instead of a handkerchief, he whipped together a curtain to cover and completely hide the works of the Douanier.

This curious act had a mystery behind it, which Rousseau discovered purely by chance.

On the day of the opening, the old gentleman was practically in tears.

"Someone has a grudge against me," he said, "although I have done no harm to anyone. If they didn't want my paintings, why didn't they refuse them? The gentlemen of the jury were free to do so, after all."

At that moment, M. Frantz Jourdain passed by, surrounded by a crowd of admirers from Belgium. The aged Rousseau was stunned. He suddenly staggered and had to be held up. When he came to himself, he cried: "It's him! It's that gentleman!"

"Whom are you talking about?" he was asked. "The man you just saw is your President, M. Frantz Jourdain."

"Is it possible?" murmured the former customs official. Then he told us this touching story:

> *"Trente ans debout à la frontière,*
> *J'arrêtai le contrebandier.*
> *Je palpai la contrebandière;*
> *Puis, quand je devins brigadier,*
>
> *"Un soir, dans le train de dix heures,*
> *D'un homme correctement mis*
> *Voyageant avec un permis*
> *Je tâtai les gibbosités postérieures.*
>
> *"O temps lointains! lointaines gares*
> *Que le gaz éclairait bien mal!*
> *Le monsieur transportrait quatre mille cigares.*
> *Je lui dressai procès-verbal.*
> *Ce temps passa. Des noms: Gauguin, Cézanne*
> *Me hantaient. Pour leur art, je laissai la douane.*
>
> *"Et gardant ce surnom: le douanier,*
> *Je ne suis pas, des peintres, le dernier.*
> *Or, dans mon souvenir, une fenêtre*
> *S'est ouverte. Je viens de reconnaître*
> *L'ancien voyageur fier de s'être vengé*
> *Parce que par ma faute il a mal voyagé."*

("For thirty years at the frontier
 I stopped the smugglers,
 I felt the lady smugglers.
 Then I became a brigadier.

"One night in the midnight train
 I saw a well-dressed gentleman
 With proper papers and a ticket
 And a curiously bulging pocket.

"O bygone days, like distant stars!
 The gentleman had four thousand cigars.
 Naturally, I made out a report.
 Time passed. As I grew old,
 Art became my passion and my life.
 Gauguin, Cézanne were my masters—
 I gave up the customs for their art.

1907

> "Although I am still known as the Douanier,
> I am not exactly unknown as a painter.
> Now imagine my surprise
> When today I recognize
> The gentleman with four thousand cigars.
> He is proud that he has scored
> Against the brigadier's report.
> O bygone days! O distant stars!"[13]

We stood for a long time commiserating with the unfortunate Rousseau, while we spoke about the profound differences that exist between the customs and the plastic arts. Then we were off to see the *Zola* of M.

José de Charmoy

This sculptor took the trouble to engrave on the monumental brow of the thinker whose features he has immortalized a staff on which M. Bruneau intends to inscribe a few bars of music. Our friend André Salmon was originally commissioned to write the words that would be sung to this melody.

He wrote a rondeau whose opening lines are:

> *De Charmoy n'a qu'un défaut*
> *C'est d'aimer trop la sculpture.*

> (De Charmoy has only one fault
> He's too much in love with sculpture.)

But, apart from the fact that the couplet contains an incorrect use of the nobiliary particle, M. Bruneau preferred to write his music to simple prose. It is true that M. de Tirames had proposed a slight correction:

> *Ce Charmoy n'a qu'un défaut*
> *C'est d'aimer trop la sculpture.*

> (That Charmoy has only one fault
> He's too much in love with sculpture.)

But M. Bruneau insisted on prose. The new text has remained a secret.

M. de Charmoy's work, incidentally, was not accepted without difficulty. The jury was ready to refuse the model. It was M. Frantz Jourdain who, uttering a few moving words, put an end to all hesitation:

"It is appropriate," he said, "that we should accept this gigantic bust, not because of the personality of its sculptor but as an homage to Zola. The exhibition of this monument is not an aesthetic question but a social one."

De Vlaminck

We were informed that M. de Vlaminck was M. Frantz Jourdain's favorite.

We were not at all surprised.

The fact that this painter boasts a particle that has nothing to do with nobility will make people smile. In effect the "de" here is only an article, and the name De Vlaminck means simply "the Fleming."

Because of the personal sympathy he bears us and, let us say it right out, because it is in his interest, M. de Vlaminck has undertaken the dangerous task of assassinating us.

Dressed in a rubber suit and armed with a necktie, he follows us everywhere, watching for the moment when he can treacherously give us a mortal blow with his Croatian instrument.

Less famous than M. Le Bargy's neckties, M. de Vlaminck's are more interesting. Made entirely of wood and varnished in loud colors, they have a variety of uses.

If M. de Vlaminck wants to call the waiter in a restaurant, he detaches his necktie from the nail by which it is attached to his shirt collar and raps with it sharply on the table top.

If, when he is in company, it happens that he wants to organize a little dance, he simply takes off his necktie. With a few catguts stretched across its back, the tie makes a nice little violin of the kind that dancing masters used to like in the old days.

To tell the truth, he has no bow and uses his tie more like a mandolin, mandola, or guitar.

The tie also serves as a defensive weapon, which on occasion can become offensive.

1907

Georges Braque

Almost everything he sent was refused. He has only a single painting here.[14] But he is finding solace after these exhibitionist frustrations in the South of France. The attic of the house where he is staying contains a large number of books, and at present, Georges Braque is reading the good works of the sixteenth-century polygraphs.

This humanistic painter has ruined his health by excessive spitting while he smokes his pipe. Being delicate and weakly, he should not neglect to take his daily dose of cod-liver oil. We recommend a few liters a day, taken one glass at a time, from early November until the beginning of spring.

[OCTOBER 26]

The Maurice de Vlaminck Case

The Salon d'Automne is over. We would gladly have turned to other matters. But the gentlemen of the committee are furnishing us with such proofs of their intellectual poverty that we consider it essential to call them once more to the attention of the public.

Their ignorance is equaled only by their discourtesy.

They devoted one of their secret sessions to the selection of new members.

M. Maurice de Vlaminck was among the happy few to be selected. The following letter informed him of his appointment:

SOCIÉTÉ DU SALON D'AUTOMNE
Grand-Palais des Champs-Elysées

PARIS, October 18, 1907

To: M. Maurice de Vlaminck

DEAR SIR:

I have the honor of informing you that at their meeting of October 16, 1907, the Founding Members appointed you to membership.

Please be good enough to inform us, at the earliest date possible, whether you accept membership in the Society.

I remain, dear sir,

> Very sincerely yours,
> PAUL CORNU
> *Secretary General*

Approved:
FRANTZ JOURDAIN
President

Press releases were sent out at the same time as the letter. *Le Figaro* and other newspapers announced the appointment.

M. Maurice de Vlaminck wrote to the President of the Salon d'Automne informing him that he accepted the appointment. Thereupon, he received another unexpected letter. It read as follows:

SOCIÉTÉ DU SALON D'AUTOMNE
Grand-Palais des Champs-Elysées
Secrétariat général
11 Boulevard Clichy
Paris IXᵉ

> October 21, 1907

DEAR SIR:

You must have received a letter relative to the appointment of new members. That letter was addressed to you by mistake. Please be so kind as to disregard it.

We remain, dear sir,

> Sincerely yours,
> PAUL CORNU
> *Secretary General*

FRANTZ JOURDAIN
President

What could have happened between October 18 and 21? M. de Vlaminck was puzzled, and he addressed the following letter to the President of the Salon d'Automne:

> Rueil, October 23, 1907

DEAR MR. PRESIDENT:

On October 18, I received a letter informing me that I had been appointed a member of the Société du Salon d'Automne. I replied,

1 9 0 7

signifying my acceptance. On October 21, I received a second letter canceling the first, without offering any explanation. Is this a proper way to behave?

I am extremely surprised, Mr. President, that you and the other members of the committee should tolerate and support such an absolute lack of good manners.

What would you have said, Mr. President, if after having been offered the presidency, you had been informed that a mistake had been made at your expense?

In view of the extreme indifference with which I have been treated, I ask you, Mr. President, to tell me why I was appointed a member of the Société, and why I was subsequently considered to be unworthy of my appointment.

You will find enclosed a certificate testifying to my good conduct and morals.

MAURICE DE VLAMINCK

20 Avenue Victor-Hugo
Rueil (S.-et-O.)

It is quite clear that no error had been committed. Two other artists, Messrs. Camoin and Manzana, have received similar letters. M. de Vlaminck's case is not an isolated one.

And yet, the committee is not composed exclusively of hooligans. There are a few gentlemen among its members. How can Messrs. Desvallières and Dethomas tolerate such incorrect behavior on the part of a committee to which they belong?

(*Je dis tout*)[15]

Henri Matisse

Here is a timid essay on an artist who, I believe, combines in himself France's most appealing qualities: the power of her simplicity and the sweetness of her clarity.

There is no simple relationship between painting and literature,

and I have made every effort to avoid confusion on that subject. Yet Matisse aims for plastic expression the way a poet aims for lyrical expression.

When I came toward you, Matisse, the crowd was looking at you and laughing, but you were smiling back.

People saw a monster where, in fact, there stood a miracle.

I questioned you, and your replies conveyed the reasons for the balance of your sensible art.

"I have striven," you told me, "to enrich my brain by finding answers to the various questions that beset my mind, by endeavoring to familiarize myself with the varied thoughts of the masters of the plastic arts, both past and present. And this was also physical work, for I tried at the same time to understand their techniques."

Then, after filling my glass with the old *rancio* you brought back from Collioure, you undertook to retrace for me the vicissitudes of your perilous voyage in search of a personality. The voyage begins in knowledge and ends in awareness, that is, in total forgetfulness of everything that was not already in yourself. And what an arduous road! Discretion and taste are the only gendarmes here to protect one from the things one must not meet on the way. Instinct is no guide; it has lost the way; it is what one is seeking.

"After that," you said, "I created my self by scrutinizing first of all my earliest works. They rarely lead one astray. I found in them a recurring element, which I first took to be a repetition that made my paintings monotonous. In fact, it was the manifestation of my personality, remaining the same regardless of the varied states of mind that I experienced."

You had rediscovered your instinct. At last, you subordinated your human consciousness to nature's unconsciousness. But this process came about in its own good time.

What an image for an artist: the gods, omniscient and omnipotent, but subordinated to Fate!

You said to me: "I made an effort to develop this personality by relying above all on my instinct and by often returning to first principles. Whenever I was blocked by difficulties, I would say to myself: 'I have colors and a canvas, and I must express myself with purity, even if it means doing so sketchily—by putting down four or five

spots of color, for example, or by tracing four or five lines that have a plastic expression.' "

People have often criticized you for this sketchiness, my dear Matisse, without stopping to think that you have thereby accomplished one of the most difficult of tasks: you have endowed your paintings with a plastic existence without having recourse to objects except to stimulate sensations.

The eloquence of your work arises primarily from the combination of colors and lines. That is what constitutes the art of the painter—and not the simple reproduction of objects, as certain superficial minds persist in believing.

Henri Matisse builds up his conceptions. He constructs his paintings by means of colors and lines until he succeeds in giving life to his combinations, until they become logical and form a closed composition from which one could remove neither a single color nor a single line without reducing the whole to a mere chance encounter of lines and colors.

To make order out of chaos—that is creation. And if the aim of the artist is to create, he must have an order of which his instinct is the measure.

To an artist who works this way, the influence of other personalities can do no harm. His certitudes are internal. They derive from his sincerity, and the doubts that assail him will become stimulants for his curiosity.

"I have never shunned the influence of others," Matisse told me. "I would have considered it cowardly and lacking in sincerity toward myself. I believe that an artist's personality develops and affirms itself through the struggles it has to endure against other personalities. If the struggle proves fatal to it, if it succumbs, that means it was fated to do so."

Consequently, every kind of plastic script—the hieratic Egyptians, the refined Greeks, the voluptuous Cambodians, the productions of the ancient Peruvians, the African Negro statuettes proportioned in accord with the passions that inspired them—can interest an artist and help him to develop his personality. It is by constantly comparing his art with other artistic conceptions, and by not closing his mind to the arts that are close to the plastic arts, that Henri Matisse—

whose personality was already so rich and could have developed in isolation—attained the grandeur and the confident pride that distinguish him.

But although he is eager to know the artistic countenance of all the human races, Henri Matisse remains devoted above all to the beauty of Europe.

We Europeans have a patrimony that extends from the gardens bathed by the Mediterranean to the solid seas of the far north. There we find the nourishment we love, and the aromatic produce of the rest of the world can at most be spices for us. Thus it is that Henri Matisse has studied particularly Giotto, Piero della Francesca, the Sienese primitives, Duccio, who are less powerful in volume but more so in spirit. After that, Matisse pondered Rembrandt. Then, having placed himself at that crossroads of painting, he looked at himself in order to discover the road to be followed by his triumphant instinct.

We are not here in the presence of an extravagant or extremist undertaking; Matisse's art is eminently reasonable. Whether his reason be by turns passionate or tender, it expresses itself with enough purity to be heard. This painter's consciousness is the result of his knowledge of other kinds of artistic consciousness. He owes his plastic freshness to his instinct, his knowledge of himself.

When we speak of nature, we must not forget that we are a part of it and that we must consider ourselves with the same curiosity and sincerity with which we study a tree, a sky, or an idea. For there is a relationship between us and the rest of the universe; we can discover it and then make no further attempt to go beyond that.

(*La Phalange*, DECEMBER 15)[16]

1908

The Salon des Indépendants

Félix Vallotton—André Derain—Georges Braque—Othon
Friesz—Albert Marquet—Maurice de Vlaminck—Marie
Laurencin—Kees Van Dongen—[. . .]—Paul Signac—Raoul
Dufy—Pierre Girieud—Charles Camoin—Henri Rousseau—
Georges Rouault—René Prath—Edward Diriks—Tristan
Klingsor—[. . .]—Francis Jourdain—[. . .]—Pierre Laprade

There has been almost no talk about this 24th Exhibition of the
Artistes Indépendants. Art critics have their reasons for obeying an
order emanating from heaven knows what smoke-filled rooms.

May their inhabitants abide in peace!

And yet, the silence has not been total. Despite the tongue-tied
critics, it has been impossible not to talk about certain works whose
success could not be ignored.

In *La 628-E8*, M. Octave Mirbeau reports how highly esteemed
M. Vallotton is in Germany.[1]

Who are the strange Frenchmen who have been able to prevent
the recognition of the talent and method of this artist in Paris?
Time will doubtless rectify many a false judgment.

People in France are too wary of foreign tastes. Yet foreign tastes

could at least serve as an indication. It should be admitted that a foreigner, who is outside the Parisian coteries and free of the influence of critics who are often submissive and rarely disinterested, will be naturally drawn to the most important works, works whose beauty appears to him to be the newest and the least debatable. Above all, the foreigner freely seeks out those paintings whose meaning appears to him to be the most elevated and the most revealing. He seeks out what he does not have in his own country and reserves his warmest glances for works with originality. Other countries have their portraitists, landscapists, etc., but today only France is producing examples of that honest, healthy, and magnificent art whose development is astonishing the world and which will be the glory of the twentieth century.

In other countries, there are no artists comparable to Félix Vallotton, and if in France there are some whose views are more elevated, there are none whose techniques are more masterful than his. The *Women Bathing* that he is exhibiting this year is an illustration of what I am saying here.

It is regrettable, however, that this artist seems to have reached the terminus of his efforts. It is to be feared that henceforth M. Vallotton's self-satisfaction may not live up to the expectations of the elite public that admires him.

Above all, let M. Vallotton beware of his foreign admirers! For if it is the critics' duty to take notice of foreign tastes and to attempt to account for them, I believe that an artist must not concern himself with them; nor, to be sure, should he obey them.

M. André Derain's reasons for creating furnish him with a standard of perfection. There are few painters who possess such certainty on this subject.

And let there be no more talk of abstraction. Painting is certainly the most concrete of the arts.

Here, sublimely fulfilled, is one of the purest inspirations of our time. Derain's effort does not disperse itself in luminosity, linearity, or volume. His plastic sincerity is revealed by another means: by the terrible calm with which he expresses himself, passionlessly in conformity with his passions.

Toilette, Portrait, and *Landscape with Cypresses* exemplify that

noble discipline that purifies reality and "endows nature with authenticity" (Mallarmé).

M. Georges Braque's large composition appears to me to be the most original effort of this Salon.[2] Certainly, the evolution of this artist from his tender *The Valley* to his latest composition is considerable. And yet, these two canvases were painted at an interval of only six months.

One must not dwell too much on the summary expression of this composition, but it must be recognized that M. Braque has unfalteringly realized his will to construct.

The science of construction poses many as yet unresolved problems for a painter. M. Braque courageously confronts some of them. This is but one of the eventful stages in the proud ascent of the artist, whose anxiety will doubtless soon diminish.

The large painting by Othon Friesz, *Work in Autumn*, obtained the greatest success at the Salon this year. That fact makes it, in my eyes, no less disquieting.

It was evident for some time that M. Friesz was changing. If he seems now to have regained his former calm, one cannot doubt that it was at the price of regrettable compromises with his conscience.

His effort here is retrograde.

Without having reached the end of his experiments, M. Friesz suddenly interrupted them in favor of a bombastic display of what he knows, of everything he knows. But everything he knows is not of equal quality. His painting, therefore, is full of incongruities. And yet, talented painters like M. Friesz are rare.

His work has little depth. In a single painting of enormous dimensions, he presents us with what are in fact several factitiously joined pieces. This inconsistent grouping emphasizes above all the superficial character of the composition.

M. Friesz doubtless justifies this procedure by saying that he does not want to isolate and fragment his efforts. It is as if he wanted to summarize in order to conclude. But this effort, however considerable it may be, necessarily appears hasty, and the kind of minute work it required excludes all rapture and all heroism.

M. Marquet's studies possess all his well-known qualities. Marquet's talent is, in my opinion, greater than he himself supposes. And this

modesty of his is not all to the good. It forces him, in a sense, to repeat himself, for fear of going astray.

M. de Vlaminck has a Flemish sense of gaiety. For him, painting is a kermis. In his eyes, everything is joyous. People are now discovering in him a taste for exoticism, which he seems to have picked up in some booths at street fairs. It is not without a certain piquancy.

De Vlaminck did not grope for a long time before finding his style. The wealth of his talent is evident, and he spends it extravagantly. His curiosity is never at rest. Contemporary painting is indebted to his sincerity and to his sense of wonder for a few discoveries that it has quickly put to use and for which the future will be grateful.

I find no words adequate to define the totally French grace of Mlle. Marie Laurencin.[3] She is endowed with the greatest possible number of feminine qualities and is free of all masculine shortcomings. Perhaps the greatest error of most women artists is that they want to surpass their male colleagues, and in attempting to do so, they lose their feminine taste and gracefulness.

The case of Mlle. Laurencin is very different. She is aware of the profound differences that exist between men and women[4]: difference in origin, difference in ideals. Mlle. Laurencin's personality vibrates with joyfulness. Purity is her natural sphere; she breathes in it freely.

Woman has created many myths and many divinities that are not explained by euhemerism. *Diana at the Hunt, Allegory*, and *Artemis*, their faces wet with tears of happiness, are the tender manifestations of this childlike and fabulous aspect of the feminine mind.

M. Van Dongen aggressively manifests some formidable appetites. He feels at home in the midst of turmoil and seems to be exhibiting his political opinions. This is not the bitterness of a Multatuli, but rather the violence of a Domela Nieuwenhuis.[5]

M. Van Dongen transports us among giants who resolve social questions shamelessly. He always leaves us with a painful impression. He prostitutes his noblest and most beautiful colors to these urban humiliations, which he notes with the eye of a foreigner.

Living in Paris has not helped M. Van Dongen. [. . .]

M. Signac has become the master of an art that is too special for me to find it enchanting. He has purposely limited his means of

expression. Since, unfortunately, he does not possess the sensitivity required by such limitation, he has succeeded by means of sheer will and hard work in substituting observation for sensitivity. He is a master.

I do not think that M. Dufy is quite satisfied yet with his drawings. His desire to succeed in this direction is evident, and one can only congratulate him for it. M. Dufy's hesitations are an honor to him. We shall soon find him completely transformed.

M. Girieud has intentions that I do not grasp. I wonder whether his paintings are not the result of a piece of bad advice that someone gave him.

The honest art of M. Camoin is fairly well represented at the Indépendants. But this artist seems to have abandoned all effort and all experimentation, a fact I note with genuine regret.

M. Rousseau's exhibit is at once touching and amusing.[6] This autodidact has undeniable natural talents, and it seems that Gauguin admired his shades of black. But still, the Douanier clearly lacks education. One cannot quite abandon oneself to his ingenuousness. One is too aware of its hazardous and even of its ridiculous aspects.

Henri Rousseau knows neither what he wants nor where he is going. Like Alfred Poussin,[7] the bewildered little poet, Rousseau could pray:

> *Seigneur! éclairez ma pensée,*
> *Et donnez un but à mes pas.*
> *Chacun a sa route tracée:*
> *Je ne l'ai pas!*

> (O Lord! Enlighten my thoughts,
> And give me a goal to pursue.
> Everyone else has his road:
> I cannot say that I do!)

And one is irritated by Rousseau's tranquillity. He has no anxieties; he is contented but without pride. Rousseau should have been no more than an artisan.

M. Rouault's hair is turning white, white. . . . Is this a sign of premature old age? It appears that M. Rouault is above all a Catholic. These are indeed the decorative motifs of a man who is a

1908

familiar of the Holy See. Light or dark, M. Rouault's paintings always seem intended as decorations for the study of Father Tourmentin.[8]

M. René Prath has a dilettante's eye for the surface appearance of things. He does not translate forms and colors pictorially, but rather transfers them bodily, as it were, onto canvas. His conscience commands him to be faithful to the most immediate reality. One cannot really blame him for it, for his talent as a painter transfigures objects despite himself: if their forms are not idealized, at least their colors are.

M. Diriks, with his ever-childlike ardor and his unquestionable mastery, remains the man who has very justly been called "the painter of wind."

His frankness excludes all affectation, and his power allows him to tame the whirlwind.

M. Tristan Klingsor endows his painting with the same sentimental delicacy that lends so much charm to his slightly artificial and slightly outmoded poetry. But personally, I much prefer the poet to the painter. [. . .]

The esteem enjoyed by M. Francis Jourdain is justified by the qualities he manifests. He does not aim as high as one could expect from a painter of his age and talent, but no one can remain indifferent to his *Ports*, his *The Bay of Saint-Tropez*, his *Fields*, or his *Evening*. [. . .]

M. Laprade is a man of his time; his art, therefore, is as ephemeral as everything that is based neither on a profound knowledge of the past nor on a divine foreknowledge of the future.

To sum up, the Salon des Indépendants of 1908 is as interesting as its predecessors. It contains fewer novelties, but its tendencies are more firmly stated; differences are affirmed, and the various directions point more clearly to what young painters are thinking about and aiming for.

This Salon is already a thing of the past. And if it is true, as I believe it is, that a few painters manifested more than mere efforts to attain beauty, then it may not be entirely useless to recall this sentence of Mallarmé, which is so beautiful because of the hope it proclaims: "Nothing that was beautiful in the Past can be wholly effaced."[9]

(*La Revue des Lettres et des Arts*, MAY 1)

The Three Plastic Virtues

The three plastic virtues, purity, unity, and truth, stand triumphantly over vanquished nature.

In vain do the seasons tremble, and crowds rush with one accord toward the same death; in vain does science undo and remake what exists, and worlds forever rush away from our conceptions of them; in vain do our mobile images repeat themselves and revive their unconsciousness; in vain do colors, odors, sounds astonish us and disappear from nature.

This monstrous beauty is not eternal.

We know that our breath had no beginning and will have no end, but our imagination is touched above all by the creation and the end of the world.

At the same time, too many artists, and especially painters, still adore plants, stones, the waves, or men.

One quickly becomes accustomed to the enslavement of mystery. And in the end, servitude creates the sweetness of leisure.

Workers are allowed to master the universe, and gardeners have less respect for nature than artists do.

It is time we became the masters. Good will is not a guarantee of victory.

On this side of eternity dance the mortal forms of love, and nature's name sums up their accursed discipline.

Fire is the symbol of painting, and the three plastic virtues are aflame and radiant.

Fire has the purity that suffers the existence of nothing foreign to itself and cruelly transforms into itself whatever it touches.

It has that magic unity which means that if it is divided, each particle will be like the single flame.

Finally, it has the sublime truth of its light, which no one can deny.

The virtuous painters of this Occidental era esteem their purity in the face of natural forces.

Purity is the forgetfulness that comes after study. For a pure artist to die, all those of past centuries would have had not to exist.

1908

Painting is becoming purified, in the West, by that ideal logic that the old painters have transmitted to the new, as if they were giving them life.

And that is all.

One cannot forever carry on one's back the body of one's father. He must be abandoned, together with others who are dead. In remembering him, we speak of him with admiration and we miss him. But if we, in our turn, become fathers, we must not expect one of our children to be willing to carry our corpse on his back all his life.

But it is in vain that our feet leave behind the earth that contains the dead.

To esteem purity is to baptize one's instincts, humanize art, and exalt the personality.

The root, the stem, and the flower of the lily show the progression of purity up to its symbolic blossoming.

All bodies are equal before light, and the modifications of shadows are the consequence of that luminous power which constructs as it wishes.

We do not know all the colors, and every man invents new ones.

But the painter must above all be aware of his own divinity, and the paintings he offers up to the admiration of other men will confer on them the glory of experiencing also, for a moment, their own divinity.

To do that, one must take in at a single glance the past, the present, and the future.

The painting must present that essential unity which alone produces ecstasy.

In that case, nothing fugitive will lead us astray. We will not suddenly turn back. Being free spectators, we will not abandon our life for our curiosity. The salt-smugglers of knowledge will not fraudulently carry our statues of salt past the tollbooth of reason.

We will not wander in the unknown future, which, separated from eternity, is but a word destined for the temptation of man.

We will not exhaust ourselves in attempting to seize the too-fugitive present, and what for an artist can be only the mask of death: fashion.

The painting will exist ineluctably. The vision will be whole, complete; its infinity, instead of signaling an imperfection, will only accentuate the relationship of a new creature to a new creator, and nothing else. Otherwise, there will be no unity, and the relationships that will exist between various points on the canvas and various essences, objects, and kinds of light will produce only a multiplicity of disparate and unharmonious parts.

For if there can be an infinite number of creatures, each attesting to its creator without the interference of any creation in the expanse of those that coexist, it is impossible to conceive of them all at the same time, and death comes of their juxtaposition, their mingling, their love.

Every divinity creates in his own image, and that is true of painters. Only photographers make reproductions of nature.

Purity and unity do not count without truth, which cannot be compared to reality since it is the same, outside all the natures that attempt to retain us in the fatal order in which we are but animals.

Above all, artists are men who want to become inhuman.

They are painfully looking for the trail of inhumanity, a trail one finds nowhere in nature.

That trail is the truth, and outside of it, we recognize no reality.

But reality will never be discovered once and for all. Truth will always be new.

Otherwise, it would be nothing but a natural system, more pitiful than nature.

In that case, the deplorable truth, more distant, less distinct, and less real every day, would reduce painting to the state of a pictorial writing designed simply to facilitate communication between people of the same nationality or community.

Our modern technicians would quickly find a machine to reproduce such writing, mindlessly.

> (*Catalogue de la III^e Exposition du
> Cercle de l'Art Moderne*, City
> Hall, Le Havre, J U N E)[10]

Georges Braque

Only a short time ago, the efforts made by a certain number of artists to renew the plastic arts were mocked not only by the public but by all the critics, as well. Today, the mocking voices have ceased; no one would dare to ridicule these admirable attempts without, at the same time, attacking order and harmony, proportion and grace, qualities without which one cannot have art but only a furious storm of more or less noble temperaments attempting to express feverishly, hastily, and unreasonably their astonishment before nature. These are the characteristics by which one recognizes impressionism. The name was well chosen; those people were really "impressed" by the sky, by the trees, by life itself, in light. Such is the dazzled look of night birds at the break of day; such is also the bewilderment of primitive men, savages terrorized by the flash of a star or the majesty of the elements. Neither savages nor primitives, however, have ever thought of seeing in their terrors a specifically artistic emotion. Feeling that their emotion was related above all to religious passion, they cultivated it, measured it, and applied it; then they erected their gigantic monuments, deducing the style of their decorations and creating by comparison, like God himself, the images that expressed their conceptions. Impressionism, on the whole, was no more than a feebly and exclusively religious moment in the plastic arts. Alongside a few magnificently talented masters who knew what they were doing, one saw a crowd of zealots and neophytes manifest in their paintings that they loved light and were in direct communication with it, a fact they proved by not mixing their colors. One became a painter simply by applying unmixed colors to the canvas, the way one becomes a Christian by baptism, which does not necessarily require the consent of the one who is baptized. To attain mastery, all one needed was a lack of taste. I will not mention all those, of all ages, who turned themselves into painters without any previous study, impelled by the profit motive and by the fact that it was easy to impress in an art governed by

chance. Ignorance and frenzy—these are the characteristics of impressionism. When I say ignorance, I mean a total lack of culture in most cases; as for science, there was plenty of it, applied without much rhyme or reason; they claimed to be scientific. Epicurus himself was at the basis of the system, and the theories of the physicists of the time justified the most wretched improvisations.

But that time has passed. Those absurd pictorial efforts are already in the museums, next to the masterpieces [*chefs-d'œuvre*] and the messy pieces [*mal-œuvres*] one finds jumbled together in museums. There is room now for a more noble, more measured, more orderly, and more cultivated art. The future will tell how influential in this evolution were the magnificent example of a Cézanne, the solitary and determined toil of a Picasso, the unexpected meeting between a Matisse and a Derain, following upon the meeting between a Derain and a De Vlaminck. Success has already rewarded the Picassos, the Matisses, the Derains, the De Vlamincks, the Frieszes, the Marquets, and the Van Dongens. It should equally crown the works of a Marie Laurencin and a Georges Braque; it should recognize the purity of a Vallotton, and install a master like Odilon Redon in the place that is his due. I have no doubt that time will accomplish the task I am assigning it.

Here is Georges Braque. He leads an admirable life. He strains passionately toward beauty and he attains it, one could almost say, effortlessly.

His compositions have the harmony and the plenitude we were waiting for. His decorations bear witness to a taste and a culture guaranteed by his instinct.

Seeking within himself for the elements of the synthetic motifs that he depicts, he has become a creator.

He no longer owes anything to his surroundings. His mind has purposely induced the twilight of reality, and suddenly a universal rebirth is taking place plastically within him and outside him.

He expresses a beauty full of tenderness, and the mother-of-pearl of his paintings gives iridescence to our understanding.

A richly colored lyricism of which we have too few examples fills him with harmonious enthusiasm, and St. Cecilia herself plays on his musical instruments.

In his valleys, the bees of all youthfulness buzz and gather their

1909

Vladislav Granzow

M. Vladislav Granzow does not present himself as a reformer of the plastic arts. He has visited all the museums and professes to have learned a lesson from them that has protected him from the dangers of paradox. He has no intention of being modern in the narrow sense in which that word is sometimes understood.

For several years, he labored to copy the Velázquezes, the Titians, and the Rubenses at the Prado in Madrid, in order to penetrate some of the secrets of classical painting. He acquired, in the company of the masters, a taste for composition that has at least preserved him from certain of the excesses of realism.

By yielding too much to facility, realism—which basically subordinated knowledge and talent to cleverness and sensibility—only led the artist to impressionism.

M. Granzow takes great pains to construct a painting according to what he considers to be traditional laws.

After all, no one has yet demonstrated the futility of this discipline; on the contrary, many artists consider it an excellent thing and are beginning once again to practice it, each according to his means. In opposition to all kinds of whims and to the excessive cult of personality, emphasis is now being placed on artistic integrity.

53

1909

Let me make myself clear. I do not mean to say that we should look distrustfully at the personal aspects of an artist's talents; but it does seem desirable to distinguish between artists who are grounded in their art and thereby have the right to practice it with integrity, and the know-nothings who, lacking the power to exercise that right, simply take pride in their unskillfulness and use it to impose plastic phantoms in places where what is really needed is the logical expression of genuine culture.

In Spain, M. Granzow experienced what he considers to have been his purest emotions. It was in Toledo that he discovered a palette that is peculiar to him. Elsewhere, in Greece and in the gardens of Sicily, he found landscapes to whose purity he did not remain indifferent; yet they made less of an impression on him than the scorched landscapes of Spain.

This preference, combined with his taste for classical sobriety, indicates in this painter certain tendencies that he is attempting to reconcile by generalizing his composition into tonalities in which local colors are blended. This way of painting is not descriptive, and a decorative feeling is predominant here.

M. Granzow seems at home whenever he frees his conception from the realistic aspect of his models. His ambition is to attain a style by economizing on details and by heightening the linear structure of his paintings, in which he animates the landscapes with figures that are indispensable to the composition.

To be completely faithful to M. Granzow's intention, one might add that he has striven to obtain a balance between contrasts by veiling the various parts of the painting. This search for pictorial harmony clearly tends toward nobility of expression and cannot fail to endow the subject with charm.

This is how true painters have expressed themselves.

M. Granzow's works, for all their variety, present a unity of effort that gives one an idea of his personality. They contain emotion, a certain gravity, and sometimes a kind of harshness.

(Preface to the *Catalogue de l'Exposition Vladislav Granzow*, E. Druet Gallery, OCTOBER 25–NOVEMBER 6)

[*L'Enchanteur pourrissant*]

Filled with brand-new and striking ideas whose philosophical embodiment has no counterpart in any literature, *L'Enchanteur pourrissant*, by Guillaume Apollinaire, is one of the most mysterious and most lyrical books to come from the new literary generation.

This work, whose roots extend all the way to the Celtic depths of our traditions, has found its illustrator in André Derain.

The most outstanding reformer of the plastic aesthetic has produced a series of woodcuts—consisting of pictures, ornamental letters, and decorative motifs—that make this book a pure artistic marvel.

Intimately linked to the invention of the printing press, the woodcut—among all the various kinds of engraving—is the one whose style is best suited to the appearance of a printed page; its typographical tradition, however, was quickly lost, and since the nineteenth century, it has become merged with that of metal engraving.

It is worth recalling that the first work printed in movable type and illustrated with woodcuts was entitled *Letters of Indulgence*, published in 1454.

We know of few books in which the harmony between the genius of the author and the genius of the artist appears more evident than in *L'Enchanteur pourrissant*. This harmony, which is largely responsible for the beauty of the famous Aldine edition of the *Hypnerotomachia Poliphili*, is all too rare a phenomenon, as bibliophiles know.

The taste for beautiful editions seems to be reviving. The bibliophile publisher Henry Kahnweiler today offers art- and book-lovers a volume whose literary and artistic merit is enhanced by a typography that its publisher has sought to make irreproachable.

(Subscription flyer for *L'Enchanteur pourrissant*)[1]

1 9 0 9

Portrait of a Fauve

Born in Cateau (Department of Nord) on December 31, 1869, M. Henri Matisse is, at the age of thirty-nine, one of the leaders of the group of painters whom those who were frightened by them have named the *fauves*.

It should be added that people sometimes have difficulty in judging these painters. Take the case of M. Henri Matisse, for example. While a great number of critics considered the appellation of "fauve" too moderate and preferred instead to call him "the fauve of fauves" or the "wild beast," M. Frantz Jourdain, being more reasonable if not more perspicacious, likes to compare him to Cabanel. M. Henri Matisse is, in fact, an innovator, but he renovates more than he innovates. One has to have a particularly foggy vision, and be used to looking more at artificial objects than at artistic ones, in order to be disagreeably impressed by M. Henri Matisse's purity of line and color.

Bearded, with eyes full of mischief behind his gold-rimmed glasses, M. H. M. lives in Paris and in Collioure. This "wild animal" is a man of refinement. He likes to be surrounded by antique and modern works of art, by precious fabrics, and by those sculptures in which the Negroes of Guinea, Senegal, and Gabon have represented, with a rare purity, their most passionate fears.

A likable Amphitryon, he often receives his friends, with the help of an exquisite little wife, who, since he is a *fauve*, has herself become a *fauvette* [a wood warbler]. His cuisine is refined without being ostentatious. A general good humor and the games of three children increase yet further the charm that permeates the home of this Cartesian master.[2]

1910

The Cézanne Exhibition

Bernheim Gallery

Among the nineteenth-century masters of painting, Paul Cézanne must be reckoned one of the greatest.

Most of the young painters today have a marked predilection for his work. That is because Cézanne, like all artists of genius, was able to remain admirably young to the end of his life. He was also able to endow his paintings with a greatness and a personality that are extraordinary. No one has ever surpassed him in the art of composition.

The paintings that make up this exhibition allow the visitor to form a general idea of the work of the master from Aix. To tell the truth, all of this has been seen before. But all of it deserved to be seen again, to be studied and thought over.

Here, for example, are the many admirable studies of Mme. Cézanne. The fabrics of the workingmen in *The Cardplayers* recall the draperies of Giotto. The admirable *Women Bathing* constitutes a formidable argument against the critics who used to tell us in their inimitable fashion that Cézanne did not know how to paint nudes! The trees in these delicate landscapes are so alive that they appear almost human.

Truth is everywhere manifest in the works of Cézanne; it ennobles the most hurried watercolor and the hastiest sketch.

With his unique talent and admirable knowledge of his craft, Cézanne could allow himself to follow his most daring impulses. His audaciousness is sometimes frightening; above all, it bears witness to his efforts, his uncertainties, and his suffering. No one is more reminiscent of Pascal than Cézanne. The literary genius of the former was of the same order as the plastic genius of the latter. Both of them have expressed in their works a greatness "that sometimes surpasses understanding."

(*Paris-Journal*, J A N U A R Y 20)

The Annual Exhibition of the Cercle de l'Union

Or, What Is Worthy of Note at the Salon
in the Rue Boissy-d'Anglas

The Cercle de l'Union Artistique opened its annual exhibition to the critics today.

Pleasant paintings, witty sculptures . . . As could be expected, the galleries in the Rue Boissy-d'Anglas contain only well-mannered works of art. However, since an art for high-society people does exist, it is regrettable that the chief influence on it has been that of the eighteenth-century English painters, who were so superficial and ultimately so lacking in elegance. . . . What a lamentable sign of today's bad taste is this artistic Anglomania! The charming qualities of the French eighteenth century really deserve to be better understood by our contemporaries.

There is nothing more to be said about the art of M. Bonnat. He is exhibiting two portraits, one of M. Isidore Leroy and one of Dr. Pozzi. The former appears more polished, but the latter is more spontaneous. The two portraits of women by M. Dagnan-Bouveret are somewhat lacking in character. On the other hand, the portrait of M. Jean Aicard in the uniform of the Académie Française by J.-F. Bouchor captures its subject perfectly. Alfred Agache's *Study* is worthy of note, as is the witty, perhaps even too witty, portrait

of a gentleman on his morning walk in the Bois de Boulogne, by M. Axilette.

We can thank the painters who are exhibiting in this show for not having given us paintings of the Seine overflowing. We shall be seeing plenty of those at other exhibits. M. Billotte in his *The Seine at the Jatte* shows us a Seine before the flood, a nice, calm Seine that is a pleasure to watch. That was the Seine that should have been painted, and M. Billotte is an intelligent man. [. . .]

(*L'Intransigeant,* F E B R U A R Y 28)[1]

The Art World

[M A R C H 5]

The Louise Breslau Exhibition

"A portrait painter is a confidant who makes his influence felt and who reveals to his models what they never thought they said."[2]

This definition by M. Arsène Alexandre characterizes very well the talent of Mme. Louise-Catherine Breslau. She has stood in contemplation before the bodies of young girls, whose unclouded eyes have inspired her delicate and expressive pastels. Her *Little Girl in White Muslin* looks like a little Czarina

> *Qui savait tout d'avance et n'a jamais souri.*

(Who knew everything in advance and who never smiled.)

The *Two Little Sisters,* one holding a piece of tapestry and the other a pair of scissors, calls to mind some tale by Andersen in which the wool and the scissors might have some very moving symbolic significance.

The name of the *Little Girl in Red Shoes* is George, like that of the lady from Nohant. This truly romantic name, inscribed in a corner of the painting, endows it with a more explicit meaning.

Mme. Louise-Catherine Breslau indulges a bit in that kind of archaism, or rather of outmodedness, that recalls the very recent past and that we find so appealing: it is the archaism, the outmodedness of only yesterday, of the nineteenth century.

59

She lovingly paints *Young Girls Singing with a Harp* and a *Young Girl next to a Piano*; in the latter composition there is a bouquet of lilies-of-the-valley so fresh that it seems to have been picked today, while the rest of the painting, the young girl and the piano, recede into the past.

Besides these pastels, Mme. Louise Breslau is exhibiting flowers and four *Door Lintels Designed for Two Small Drawing Rooms*. If our age is to attain what can be called a genuine style, it will surely come from the painters. Artisans follow in the footsteps of great artists, which is why it is always interesting to examine a piece of ornamentation whose purpose has been precisely defined by the painter.

[MARCH 8]

Exhibition of Decorative Artists
at the Pavillon de Marsan

This 5th Exhibition of Decorative Artists is extremely interesting. Nevertheless, it is regrettable that so many artists today have a tendency to sign their craft works.

The artisan who chisels, shapes, or carves out an object meant for everyday usage ought to remain anonymous. The taste of which the object is a manifestation, like the decorations that adorn it, belongs to a given period, nation, and environment. I for one would have preferred that the names of all the Greek vase painters had remained unknown. I would certainly have long ago forgotten the name of Douris, if it did not remind me of the name of a friend now dead. . . .

What strange times we are living in! We are surrounded by ugliness on every side. We allow horrible buses to disfigure the streets of Paris without protest, and our houses are the ugliest possible. . . . Yet, there is not a young girl going into town with her mother who does not carry on herself a whole museum: her ring is signed Such-and-Such, her tooled-leather book cover is signed So-and-So, her belt is signed This-and-That, etc.

Our time will have a style of its own when people attach less importance to signatures; then even buses will be graceful. I recognize,

however, that there is more than a mere promise in the general effort of our artists to endow us with a style. We may, in fact, have a style . . . "without knowing it," the way Molière's M. Jourdain spoke prose. [. . .]

The Bonnard Exhibition

I like Bonnard's painting very much. It is simple, sensual, witty in the best sense of the word, and, I do not know why, it invariably makes me think of a little girl with a sweet tooth.

It is true that my taste in general leans toward more ambitious painters, toward painters who are straining toward the sublime in plasticity and whom even the fear of stumbling does not prevent from reaching for such an elevated art. Nevertheless, I willingly abandon myself to the charms of M. Bonnard's cultivated and appealing manner.

The grace and delicacy of some of his nudes—those entitled *Drying Herself* and *Half Nude*, for example—have no counterpart in the history of art.

Among the landscapes, there are paintings of great forcefulness without brutality, such as *Train and Barges*, whose effect is at once very powerful and very light in touch. There is emotion, a slightly mocking emotion, in a small canvas showing a violet roof, a crumbling wall, a barely darkening sky, and two very small children going off to the fields.[3]

M. Bonnard is full of fantasy and ingenuousness. Someone once told me, as we were standing in front of his paintings, that he felt like reciting one of La Fontaine's fables; as for me, I thought of Bernardin de Saint-Pierre. . . . One of these days, just for the fun of it, M. Bonnard ought to illustrate *Paul et Virginie*.

The Charles Guérin Exhibition[4]

I like M. Charles Guérin's modern paintings less than those in which he seeks to evoke the *fêtes galantes* of Banville and Verlaine,

I 9 I 0

the novels of 1830, the outmoded, slightly coarse, and slightly awkward grace of old lithographs, the crinolines and graciousness of a bygone age; in a word, all the *bonheur de vivre* that existed in the period from the Regency until the resignation of President Grévy.

People have talked a lot about literary painting, but there is in fact less of it than they think.

A kind of painting inspired by the same sentiments that inspire poets and novelists is perfectly justifiable, just as some music can be adapted to words, or to feelings that come under the heading of literature. Some of M. Charles Guérin's small paintings, paintings full of vivaciousness and bursting with colors borrowed from the fiery wings of exotic birds, are a perfect illustration of what I am saying. *The Love Note* calls to mind a novella by Stendhal. *The Bouquet*, with its sunny women surrounded by flowering geraniums, awaits an engraver who will place four lines of poetry by Musset beneath it.

Since literary painting is here to stay, and since M. Charles Guérin is moved by images of the masquerades and mandolinades of another age, let him give free rein to his brush; let him tell us tender and romantic stories, stories that are a bit vulgar, to tell the truth, but that are more successful than his portraits and his still-lifes. . . .

[MARCH 13]

Exhibition of Painters and Sculptors

The exhibition of the former "Société Nouvelle" is on the whole excellent. Auguste Rodin has contributed two busts. Albert Besnard is showing works that are a bit stern without, however, being austere. Prince Troubetzkoy, the Michelangelo of Miniatures, is exhibiting a little man who, it seems, is a grand personage;[5] the Prince has also attempted to capture the grace of choreographic movements.

M. Jacques-Emile Blanche is still painting for Petronius, the arbiter of elegance, and for Brummell, whose chic astonished the high society of Caen, in Normandy. These dandies have no one to equal them today. But M. Blanche's paintings are created in their image. [. . .]

The Maurice de Vlaminck Exhibition

A very important exhibition has just opened at Vollard's gallery in the Rue Laffitte. The catalogue, prefaced by a letter from M. Roger Marx, contains only forty listings.

The paintings here are all first rate.

M. Maurice de Vlaminck is one of the most talented painters of his generation. His vision is broad, powerful; his restrained and intensive execution allows his lines all their freedom, his volumes all their prominence, his colors all their brightness, all their beauty.

M. de Vlaminck is fond of painting places around Paris, and he is especially fond of the banks of the Seine. Viaducts, the bridge at Chatou, the bridge at Triel, the bridge at Meulan, the hills of Louveciennes, bright-colored tugboats, pot-bellied canal boats, barges slowly moving down the river—these are the very simple subjects most often treated by this audacious painter. On the few occasions when he abandons "those flowering banks watered by the Seine," De Vlaminck goes as far as Versailles and returns with brilliant interpretations of the château and the park. M. de Vlaminck's paintings are, as it were, saturated with blue. The intensity of his skies endows the whole painting with a remarkable brilliance that is one of the hallmarks of this painter. So much so, in fact, that he is obliged to alter his manner if he wants to paint something other than a landscape—a still-life, for example. There he instinctively uses colored forms placed in layers on the canvas to obtain a decorative effect that in his landscapes he obtains from his skies, by the use of contrasting daubs of color and oppositions of light.

De Vlaminck is also showing some earthenware pieces: plates and painted vases, a bit barbaric but extremely unusual and sumptuous in effect.

(*L'Intransigeant*)

Watch Out for the Paint!
The Salon des Indépendants
6,000 Paintings Are Exhibited

[MARCH 18]

General Impression of the 26th Annual
Exhibition—No Unfamiliar Names—The Downfall of
Impressionism—Young Artists
Are Returning to Composition

Someone recently told me a delightful anecdote.

It was at the time when Manet, exposed to the general mockery of the public, nevertheless went on exhibiting his paintings.

Stéphane Mallarmé was teaching English in a lycée, and one of his pupils had so annoyed him that the master had been obliged to punish him by making him stay after class.

The mother of the boy, practically in tears, came to beg the teacher to waive the punishment.

"I beg you, sir," she said, "please let my boy go. There is a Manet exhibit on, and all of Paris is going to it to laugh at his paintings. I will never forgive myself if my child is deprived of this unique amusement, which, furthermore, will help to educate his taste."

"Madame," replied Mallarmé, "your son behaved in an unbearable manner. This is the first time that I have ever thought it necessary to inflict a punishment on one of my pupils. I hereby double that punishment. Good day, madame."

If the child in question is still alive and if he sometimes goes to the Louvre, he must be astonished indeed to see in a place of honor the same *Olympia* that made his mother laugh so hard and that Mallarmé prevented him from seeing under such unfavorable conditions, even though it meant that he had to be unjust as a teacher.

I have been thinking of all this the last few days, while preparing my review of the 26th Exhibition of the Artistes Indépendants. How careful one must be, and how prudently one must refrain from pronouncing hasty judgments. It is so easy to be wrong; and there is

not always a Mallarmé around to double the punishment called for by sacrilegious laughter.

In the plastic arts today, France reigns unchallenged. The Salon des Indépendants is excellent in informing us every year about the work of young French artists, thereby allowing us to foresee what will become the universal taste of tomorrow. Despite the inevitable and considerable presence of mediocre or ridiculous works, and despite the presence of a few examples of pure bunk, the Indépendants predicts the future of the plastic arts every year, the way a barometer predicts the weather.

This year's exhibition, while giving a few artists the chance to confirm their talents—talents we were already aware of or whose existence we at least suspected—has brought no new names to the attention of the public.

By no means does this imply that France is producing fewer artists. It is due simply to the fact that since the demolition of the greenhouses on the Cours-la-Reine, the Société des Artistes Indépendants is without a home, and the expensive makeshift booths that house the present exhibit are too small; the Société is thus prevented from accepting new members whose paintings it cannot be sure of exhibiting. Even so, the Salon contains 6,000 works, which is a lot. If we had to sum up the general sense of this exhibit, we would say—and with what pleasure—that it means the definitive downfall of impressionism. This fact becomes apparent if one examines Rooms 18 and 21, which contain the truly significant works of the Salon.

Matisse, Artist of Integrity—Othon Friesz,
Manguin, Puy, De Vlaminck, and Marquet

Each room is divided into three sections. The right-hand section of Room 18 contains the paintings of Henri Matisse, Othon Friesz, Manguin, Puy, De Vlaminck, and Marquet.

Let us first talk about Henri Matisse, one of today's most disparaged painters. Have we not seen the Paris press (including this very newspaper) recently attack him with unusual violence? No man is a prophet in his own country, and while the foreigners who acclaim him are at the same time acclaiming France, France is

getting ready to stone to death one of the most captivating prac-
titioners of the plastic arts today. I am happy to have the opportunity
once again to praise the integrity of his art. Matisse is one of the
rare artists who have completely freed themselves from impressionism.
He strives not to imitate nature but to express what he sees and what
he feels through the very materials of painting, the way a poet uses
the words of the dictionary to express the same nature and the same
feelings.

Matisse is, besides, an artist of genuine talent, and his single paint-
ing,[6] exhibited in the midst of works that still carry traces of the
impressionists' influence, appears all the more outstanding. This is
an authentic work of art. . . .

Othon Friesz's *Adam and Eve* marks an important stage in his
artistic development. It constitutes a considerable effort in the direc-
tion of composition.

I found some of his experiments with figures especially interesting.
He has a very pretty landscape, highlighted by a charming selection
of flora and fauna. I also like very much one of his small canvases,
showing a group of skaters.[7] It contains a plastic interpretation of
modern dress that is very original.

Manguin's *Reflection* is a very carefully wrought and harmonious
canvas, showing a nude in front of a mirror. I am perhaps equally
fond, however, of his *Woman in a Green Turban*, a small, elegantly
simple, and extremely well-executed canvas.

Puy is making great progress. His seascapes are transparent, *like
the sea on the sunniest days*, and his fleecy nude has the slenderness
and boldness of a little Venetian courtesan whom Casanova might have
loved once and in front of whom Jean-Jacques would have felt em-
barrassed. Laprade is exhibiting an important *Still-Life*, imbued with
sensibility, artistry, and assurance.

Marquet's two canvases, for all their simplicity, command attention.
This painter looks at nature with a kindly eye. There is in him some-
thing of the gentleness of St. Francis. His *The Sea at Naples* and
A Dutch Street Bedecked with Flags reflect that kind of goodness,
tranquillity, and joy. Here once again are the rivers of De Vlaminck,
with their rowboats, tugboats, and white sails, broad and very beau-
tiful views of the banks of the Seine, together with the minute
observations of Lacoste.

The Mysticism of Girieud—Dufy—The Charm of
Marie Laurencin—A Solid Nude by
Jean Metzinger—The Vulgarity of Van Dongen

In the middle section of Room 18 are the canvases of Girieud,
who is attempting to attain a sublime mysticism. His is a modern
mysticism that reflects a very noble human ideal.

The talent of Raoul Dufy has analogies with the work of the
Umbrian painters, on the one hand, and with that of the old wood
engravers, on the other. His pictures are well ordered, and he paints
with assurance. One must place great value on the little things he was
satisfied to exhibit.

The three paintings by Mlle. Marie Laurencin indicate consid-
erable progress in this artist's work. Her art is more masculine than
that of other women who devote themselves to the plastic arts; and
coupled with this ideal virility are a grace and a charm that one
will find nowhere else. One feels, in her canvases entitled *The Dress-
ing Table*, *Study*, and *Still-Life*, that she has a self-assured command
of her craft and an imagination imbued with a very decorative plastic
lyricism.

The purity of such an art constitutes the honor of an age.

Jean Metzinger is exhibiting a solidly constructed—some would
say solidly scaffolded—nude, some views of Avignon and of Laon,
and the portrait of your humble servant. Metzinger aims high. He
undertakes—a bit coldly, perhaps—works that many masters could
not bring off successfully. His art is never petty. This young fellow
deserves attention.

Robert Delaunay is less anxious. Unlike Metzinger, he is not ready
to try everything for the sake of art. His moderation, however, does
not prevent him from doing some very strange things, and the
influence of a Friesz of a few years ago has made him paint some
solid canvases that unfortunately look as if they were commemorating
an earthquake.[8]

Rouault is showing some sinister paintings.[9] These frightful cari-
catures of the works of Gustave Moreau are really painful to see. One
wonders what inhuman sentiment can have inspired the artist who
conceived them.

M. Van Dongen's pictures are the expression of what middle-class gentlemen suffering from enteritis like to call audacity. As for me, I find that they manifest some painterly talents but also a vulgarity that the artist is attempting to transform into brutality. Let us, after briefly mentioning Modigliani, Lhote, Jack's *Nude* and his *View of Camaret,* now pass on to the Douanier Rousseau. Rousseau's contribution is a large painting entitled *The Dream.* On an 1830-style sofa, a naked woman is sleeping. All around her is tropical vegetation inhabited by monkeys and birds of paradise, and while a lion and a lioness pass calmly by, a Negro full of mystery plays on his pipe. That this painting is very beautiful is incontestable. . . . I think that this year no one will dare to laugh. . . . Ask the painters. Their admiration is unanimous. They admire it all, I tell you, even that Louis-Philippe sofa lost in the virgin forest, and they are right. Let us also mention the large figures of Le Fauconnier, who is directing his experiments toward majesty and nobility, going so far even as to sacrifice beauty.

The Neo-Impressionists' Light—Roussel,
Bonnard, Maurice Denis—Signac
Exhibits an Impressionist Masterpiece

In Room 21, we find some impressionists, together with the neo-impressionists, who constructed a theory on how to paint the light that the impressionists had caught so roughly.

Roussel and Bonnard, tender and witty painters whom M. Octave Mirbeau finds charming—doubtless for the same reason that makes our sturdy city policemen prefer the company of very pretty young women—have each sent one canvas. M. Maurice Denis is showing a *Nausicaa* inspired by a modern feeling for decoration and the spirit of antiquity. If clarity is one of its characteristics, imprecision is another. M. Maurice Denis is not at home with Homer. Having attempted to apply André Chénier's precept

Sur des pensers nouveaux faisons des vers antiques

(On modern thoughts let us write ancient verses)

to painting, M. Denis is nevertheless more successful in interpreting a Catholic miracle, the legend of St. George.

The Signac exhibit is admirable. This painter's talent has blossomed wonderfully, without being inhibited by the very exacting discipline of pointillism. *The Tree* is one of the masterpieces of neo-impressionism, which, in the final analysis, is not at all the same thing as impressionism. Signac is also showing a vibrant and perfect water-color and a superb, luminous Middle Eastern city—I don't know which.[10]

But next to this master, the disciples cut a less impressive figure. One should, however, mention Henri-Edmond Cross and Lucie Cousturier.

M. Lebasque is exhibiting two honest, sober, beautifully executed paintings: *Fish* and *Children Eating Fruit in a Marine Landscape.* There is no longer anything to say about the art of Sérusier. Alas! . . . It is better to look at Valtat's decorative panels representing fish, or a pretty decoration by Deltombe—flowers, fruits, and vegetables harmoniously mingled. Jean Deville's *Trees* have a graceful feeling. M. Deville is also exhibiting a *Landscape with a Railroad* and a delicate *Still-Life.* Mme. Georgette Agutte has done a large amateurish painting. It is not very entertaining to look at, and as the lady is audacious, one is frightened by what she dares to do. . . . Let us look, finally, at the paintings of [. . .] Peské, which are quite bad and boring; Maximilien Luce, direct and honest; and Petitjean, who appears definitely out of place next to artists such as Luce, Bonnard, or Signac. . . .

[MARCH 19]

THE *VERNISSAGE*

More Than Ten Thousand People Flock
to the Booths on the Cours-la-Reine,
Stepping on Humid Ground That a Month Ago
Was Covered by the Seine—A Cheerful
Opening on a Cloudy Day

Vernissage . . . The word has completely lost its meaning, since painters no longer varnish their canvases, or if they do, it's before the opening

of an exhibit or in a different place. Yesterday was the *vernissage* for art dealers who came to buy. Also present was M. Dujardin-Beaumetz, who buys for the government. He has not yet made his choice and will come back one of these days. Today, it was the public's turn. The crowd was immense in the booths on the Cours-la-Reine. . . . It was a human flood, coming after the fluvial flood whose traces are still on the humid ground! Barely a month ago, the Seine reached all the way up here. . . .

The general arrangement of the Salon is extremely pleasing. In place of the Oriental hangings that decorated the entrances to the rooms last year, there is now some gray cloth that does not interfere with the paintings.

The impression on the public is excellent. This Salon is cheerful, young, and pleasant to visit. Rarely have today's artistic currents been more clearly indicated. . . . The influence of a Renoir, of a Picasso, or of a Matisse is predominant among other, less clearly marked, influences.

In Room 12, the Diriks exhibit is outstanding. The Norwegian artist has sent a painting showing a *Half-Nude Blonde Woman*, whose strangeness contrasts sharply with Diriks's usual robust qualities. Next to it is a self-portrait, striking in its likeness and evidencing great mastery on the artist's part. Spread out above it are some views of Norwegian fiords, painted with the calm vigor, the powerful and skillful serenity of a French master of the 1830s. [. . .]

It is useless to look at the *gaillardises* of Galard, poor sad things. . . . *La chair est triste, hélas!* . . . Let us observe, rather, the contributions of René Juste, who has a very *just* sense of spatial relations. [. . .] Let us note [. . .] Pierre Chapuis, who appears to be a kind of Van Gogh painting with fondant. Chapuis is, nevertheless, a painter; his *Flowers*, his *Pigeon-toed Man*, and, above all, *The Halt* are very pretty. [. . .]

In Room 13, one finds: [. . .] *Women Bathing*, by Weise; in this pretty painting, one feels the direct influence of Cézanne. Nevertheless, Weise has a personality that is already manifest. He applies himself, quite rightly, to a search for composition.[11] Manzana's artificial Orientalism has already obtained great success. . . . Yet there is nothing more vulgar, more trumped-up than these panels decorated not with paint but with that sealing wax in metallic colors that young

girls like to use. I find nothing worthwhile in these impastos imitated from Anglada, in this virtuosity that will never attain a style! And here are the pictures of Tristan Klingsor, whose delicate and delightful poems I admire greatly. [. . .]

In Memoriam: Lempereur—Many Names Ending in "Sky"—
The Religious Painting of Little Russia

In Room 15 are hung some paintings bordered with black crape by Lempereur, who died last year. I had known this painter, who was an artist of considerable talent, at school, where he was a few years ahead of me. I can still see him, always making drawings, especially of soldiers—Alpine infantrymen. I do not look at this posthumous exhibit without emotion. A shimmering and gay canvas, painted at the races, especially holds my attention. [. . .] Jasinsky,[12] who draws his inspiration from the Chinese, the Persians, the Hindus, and the Aztecs, has not yet freed himself from the School of Byzantine Revival, which I will speak of in a moment. [. . .] The large decorative panel by Brunelleschi astonishes one by its insignificance. It gives evidence of much pretension and no knowledge. [. . .]

[. . .] J. Crotti has adopted pointillist theory, not in order to obtain pure tonalities, but simply to distinguish himself from others, to give himself a certain flair. Marinot is looking for decorative effects. Let us mention Pierre Dumont; Duchamp's very ugly nudes; Kantchalowsky, who paints with his boots; Lewitska, whose painting representing a naked couple dancing in a park is quite joyous; and let us pass on to the School of Byzantine Revival, which includes three painters—three artisans, rather—two men and a woman: Boïtchouk, Kasperowitch, and Mlle. Segno. The ambition of these artists is to preserve intact the traditions of religious painting in Little Russia.

They succeed fully, and their well-drawn, expertly finished works are perfectly Byzantine in manner. They have also applied the simplicity, the gold-leaf backgrounds, and the minuteness of their art to a few small, more modern paintings: *The Goosegirl, The Architect, Woman Reading, Idyll,* etc. The trouble is that, having purposely confined themselves to an imitative technique, they are not yet skillful enough to adapt it to a modern subject; despite all their good will,

when they paint a gentleman in a stiff collar, all their Byzantinism disappears, and there remains only the slightly awkward painting of Little Russians who have everything to learn about modern painting, which is very different and more difficult, in the end, than that of the gilded icons of the cathedrals in the Ukraine.

This School of Byzantine Revival had, at one time, quite a few more members.

A certain number of these have now formed a dissident sect, whose imperfect works have been placed next to the canonical paintings executed under the direction of M. Boïtchouk. [. . .]

[M A R C H 20]

Let us continue our tour of these miles and miles of paintings.

An immense hall, hung from one end to the other with canvases— that, in a word, is the Salon des Indépendants. [. . .]

Rooms 22 and 23 are, in fact, just one room. Most noteworthy of all here is Mme. Vasticar's exhibit, which consists of pieces of furniture decorated with delicate watercolors. This is an unexpected and altogether charming use of watercolor, and Mme. Vasticar's contribution to the Salon will certainly be appreciated. The warm, dark tones of the polished wood and the modern, comfortable, light, and very simple designs of the furniture chosen by the artist all emphasize the grace and freshness of the watercolors.

I was beginning to be astonished at not having found any paintings by Vladislav Granzow when I suddenly saw three of them: *The Park* and two very lyrical *Corfu Landscapes* painted in those muted colors of his—simply looking at them makes one dreamy. Here are the very sensitive drawings of Louise Hervieu and Lanson's hardware, where I noticed an unfortunate combination of copper with iron. Looking at a voluptuously sculpted *Eve* and a relief of three full-figured young women, I am tempted to cry, "Catch the thief!" That is because both the *Eve* and the relief look like the work of Aristide Maillol, but they are both by Hoetger. This artist, who takes his goods where he finds them, had already, at various times, appropriated goods belonging to Constantine Meunier, Bourdelle, or Rodin. But Hoetger has a great deal of talent, and after all, he has the right to do as he pleases, even to plagiarize, as so many great men have done. The same

goes for Ciolkowski,[13] who, taking this art for inverts, inverts it even more. Let us skip for now the humorists' room—not, however, without mentioning Pascin, who is a witty man, and the wretched *Target* painted in *trompe-l'œil* by Abadi.

End of a Stroll Among 6,000 Paintings

[. . .] The Boronali is a pleasant joke, and not at all excessive.[14] Nothing is rarer than excessiveness, nothing more difficult to achieve. The heroes of the Iliad hurl excessive insults at each other; since Homer, few artists have attained that kind of excessiveness. One does not become Homeric simply by trying. [. . .]

In Room 24 [. . .], Verhoeven's paintings are a monument of ignorance and bad taste. Lombard imitates Van Dongen, without possessing any of his gifts as a painter. [. . .]

In Room 26, Albert Gleizes is exhibiting a *Portrait of the Poet Arcos.* I like Gleizes's landscapes better than this portrait. [. . .]

In Room 27, I note Henri Ghéon, who is a hard-working painter, a writer of great delicacy, and perhaps a brutal doctor.

In Room 30, one must look respectfully at Marcel Lenoir's exhibit, because there is both piety and pity in his canvases. One must also look attentively at the paintings of Stuckgold, who seems to be lingering over experiments that other artists have already carried to completion, but whose efforts are far from banal. One really does not know what to say about M. Dunoyer de Segonzac. He wastes a great deal of canvas and paint. The same cannot be said of Mlle. Maroussia, who paints with sobriety and strives for expression and power, somewhat to the detriment of beauty. I hope she will not hold it against me if I say what I think. I was told that another proud artist, about whom I said something similar, holds it against me. M. Le Fauconnier would be wrong to do so, because no one is more favorably disposed toward him than I. I esteem a work of art to the extent that the artist has come close to what I consider beauty, not power, forcefulness, goodness, or any other attribute of the Divinity. [. . .]

Conclusion

On the whole, the Salon des Indépendants indicates that young artists today are tending toward composition. In order to compose, artists employ a great variety of methods. There has never been as systematic an art and as great a number of artistic systems as today.

(*L'Intransigeant*)

The Art World

The Othon Friesz Exhibition[15]

Here is an exhibition that will give much pleasure to all those who like French painting—all those who like that pure light, neither too pale nor blinding, that illuminates the paintings of Poussin as well as those of Le Lorrain, and that expression that endows Clouet's portraits and the figures of the Le Nain brothers with so much truth.

Without wishing to crush M. Friesz beneath the weight of such justly famous names, I want to praise him for his tender violence, a violence that forces nature itself to conform to the dimensions conceived by the painter.

In the work of great painters, every canvas is a microcosm of the sensible world. It is very possible that the future will perceive this in the *Landscape* that bears the number 20 in the catalogue. A soft and shining light imbues this canvas with a quality that one could not find in works painted outside France or conceived in a spirit different from that which predominates in French art.

Consider, for example, the simplicity, the softness, and the light of *Entrance into Cassis*, a first-rate painting that has been placed among the *Studies in Provence*. The latter are still very impressionistic, and a bit too flooded with sunshine. M. Friesz, who has now completely freed himself from impressionism, has retained his legitimate love and genuine knowledge of light.

The Acrobats evidences a search for expressive style. *The Fisher-man*, naked in that periwinkle-blue light, is a strong and delicate little work. Worthy of note also are the two compositions entitled *Water*, the smaller of which is perhaps the greater painting.

As for me, I was quite taken with a watercolor entitled *The Port*, which calls to mind the seascapes of old. It shows a felucca with full-blown sails entering a port in which a group of sailors—perhaps con-victs—are at work.

On a second viewing, the large *Work in Autumn* produced an even stronger impression on me than it had before. In the background, the immobile mass of the forest and the houses, and in the foreground, the mobile group of figures gathering wood and fruit while a mother lies nursing her child—all this forms a composition full of emotion and grandeur. Perhaps the only thing lacking to make this painting a masterpiece is for the artist to have been the simple interpreter of a universal doctrine in an age of religious beliefs.

M. Friesz is also exhibiting a certain number of still-lifes and some studies of Munich, which I like less than his landscapes: light, water, and vegetation, inhabited by essential figures.

(*L'Intransigeant,* A P R I L 6)

The Salon de la Nationale
Before the Opening

[A P R I L 13]

A Quick Look at the Exhibition
During the Painters' Opening

The plethora of individual exhibitions tends to weaken the effect of the large annual salons. The curiosity of the public is less keen, since many painters have already shown in the galleries the most important, if not the best, examples of their work during the year. Nevertheless, the large salons have an undeniable merit: they give art-lovers and artists themselves a chance to make comparisons and check up on current taste.

In this respect, the 20th Salon de la Société Nationale des Beaux-Arts

provides the most precious information. The artists exhibiting in it are those whose works are most appreciated by the public. Almost all of them possess a virtuosity and a skill that can easily replace mastery in our time—a time that lacks neither original talents nor original theories, but in which the great traditions have for the most part been forgotten.

It is only fair to add that many of the works in this Salon—both painting and sculpture—attest to a moral strength and a genuine discipline on the part of the artists who conceived them. In other works, those of very great artists, one detects a restlessness, a desire to compete with the masters in the museums that must fill with joy all those who love art.

There are few works that can be called romantic, in the pejorative sense of the word. Next to the sometimes dazzling elegance of the most modern portraitists, the influences of Poussin, of the Italian masters, of Corot give this Salon a praiseworthy air of timid nobility.

This exhibition, furthermore, has a rare quality: it is not at all boring. One does not get tired walking through its numerous exhibit rooms.

Sculpture this year is represented by a few first-rate works.

The mass of the public will doubtless look at Rodin's pieces without realizing how much intelligence and erudition went into their making. These richly modeled forms open to the free play of light attest to an incomparable mastery.

Bourdelle seeks to impose a style on the fragmentary art of Rodin; everyone will be struck by his great intentions in *Hercules Killing the Stymphalian Birds*. My own preference leans toward the more sober art of Despiau, who is exhibiting a marvelous, if unfortunately unfinished, work: the bust of a young girl in which there is the unity of design and the modeling of antiquity. [. . .]

In the section devoted to painting, one stands dazzled before the brilliant light of Besnard's audacious and triumphal *Morning*. Jacques Blanche is showing, among other splendid paintings, a *Portrait of the Duchess of Rutland*. On the ground floor, a series of preparatory sketches, studies, and fragments enlighten us about the craft of this famous painter and, at the same time, provide an excellent lesson on the refined taste of our time.

La Gandara's portraits of great ladies have a slightly faded, slightly

melancholy grace that is full of charm. Boldini's electric portraits are as modern as one could wish. No one's curiosity will be aroused by the retrospective exhibition of Guillaume Dubufe, the bourgeois portraits of Dagnan-Bouveret, and the crimson fantasies of Carolus-Duran. [. . .]

[APRIL 14]

THE PRESIDENT OF THE REPUBLIC OPENS THE SALON AT THE GRAND-PALAIS

A Detailed Examination—A Stroll Among the
Sculptors—The Retrospective Exhibition

The President of the Republic and Mme. Fallières, accompanied by M. Ramondou, Secretary-General of the Presidency, arrived at the Grand-Palais at two o'clock, to visit the Salon de la Société Nationale des Beaux-Arts.

The Head of State was received by Messrs. Dujardin-Beaumetz, Undersecretary of State for Fine Arts; Roll, President of the Société Nationale des Beaux-Arts; Carolus-Duran, Jean Béraud, Besnard, Rodin, and a great number of officials, as well as personalities in the arts and in society.

The cortege, accompanied by M. Dujardin-Beaumetz and M. Lépine, began its visit in the room devoted to painting.

It stopped before the paintings of Simon and Anquetin and gazed for a long time at the *Portrait of the King of Sweden* by Osterman and the canvases of Jacques Blanche.

After accepting a glass of champagne at the bar and passing by the Boutet de Monvel with a smile, the President stopped for a long time before the painting by Besnard.

M. Jean Béraud presented the works and their authors to the President.

After that, the cortege moved on to the sculpture section. There it was Auguste Rodin who made the presentations. The President gazed for a long time at Desbois's *Human Suffering*. He stopped before the

large bronze composition by Bourdelle, and after that, the sculptor Lamourdedieu was introduced to him; he lingered over the Rodins, among which he recognized the portrait of the Duc de Rohan.

During the course of the morning, M. Dujardin-Beaumetz had already proceeded to select a number of works to be bought by the State.

After that, the President visited the section devoted to the decorative arts.

Yesterday's rapid glance having given us a general idea of the Salon of 1910, today we shall begin a detailed examination of the Salon.

A Pastel by Dufresne

I wish first of all to call the attention of the public to a pastel exhibited in one of the rooms on the ground floor. *The Chaste Susanna*, by Dufresne, is one of the best paintings in the Salon and far surpasses the shoddy Orientalism to which we have become accustomed.

And now let us proceed in order, beginning with a close look at the sculptures.

Rodin, the Greatest Modern Sculptor—The Influence of Despiau—Bourdelle, a Powerful Artist

At the moment, sculpture is an art represented by purer works than painting. Auguste Rodin is the master who has attracted a number of first-rate sculptors, some of whom, like Despiau, are in turn exerting a beneficial influence.

Sculpture today possesses a quality that almost all the painters lack, except perhaps a few who do not exhibit in the official salons. Goethe called this quality *virility*, and he defined it as follows: "A certain penetrating force that in past centuries existed in all the arts." He also called it *character*, saying that "in the arts and in poetry, character is all."

Thus, if one contemplates the *Female Torsos* that Rodin has sent to the Nationale, one senses not only the artist's virtuosity but also his

enormous power both of conception and of execution; similarly, the bust by Despiau is animated by an energetic sensibility and the sculptor's thought has penetrated every part of the marble visage.

This power of the artist's character is also to be found, in part, in Bourdelle. He is a powerful artist, and he has a genuine style, but he has perhaps not understood Rodin's most valuable lesson. He seems to have been attracted only by the fragmentary works of the master. Besides his *Hercules as Archer*, a noble work with a fine movement, Bourdelle is exhibiting a *Portrait of Rodin*, represented as the god Terminus. I believe I can say with certainty that no allusion is meant to April 15, the opening date of the Salon. [. . .]

In the sculpture garden, one must above all look at the retrospective exhibit of the late, lamented Lucien Schnegg. He was a fine sculptor to whom many are indebted. He was an artist who took the trouble to be an artisan, as well. He blazed the way for a great number of young sculptors. Many of his works are of a very pure artistry, such as the admirable bronze representing the head of Aphrodite or the stone figure of an old man, which evokes the memory of Donatello. This very French artist sometimes makes one think of Houdon. Lucien Schnegg will go down in the history of modern sculpture, and even in those works in which he had not yet freed himself from the deficiencies of facile realism, one can feel the presence of genuine artistic torments. [. . .]

[APRIL 15]

THE *VERNISSAGE* OF THE NATIONALE

A Large Crowd on a Rainy Day

Despite the rain, the opening of the 20th Salon de la Nationale was very brilliant. The day was quite dark; the public did not notice how much better the lighting of the Grand-Palais was this year than last, but they will realize it with the first ray of sunshine. The reason for the improvement is simple: the windows of the Palais had not been cleaned or dusted since 1900, and as a result, light could no longer pass through

them. The Société Nationale des Beaux-Arts spent a great deal of money to have the windows washed—they were as filthy as St. Labre[16] —and daylight once again made its appearance in the Grand-Palais. The public's interest was directed especially at the sculpture, whose excellence I pointed out the day before yesterday.

If this year the paintings at the Nationale are not quite as interesting as the sculptures, one will nevertheless encounter a few good canvases.

Bellery-Desfontaines—The Lovely Ladies of La Gandara—Henri Lebasque

Room 1. [. . .] Some of the works of the late Bellery-Desfontaines are exhibited here. People will especially notice the canvas entitled *Among Friends*. It shows an evening gathering in the home of a bourgeois artist. Tea is being served, people look at engravings, men smoke their pipes, the women do not look as if they were having a good time. All in all, I prefer the portrait of *Antoine Jorrand*. Bellery-Desfontaines's painting in general is not devoid of craftsmanship, but it is sad and boring. The same element of sadness is to be found in the lovely painted ladies of La Gandara, whose art lacks neither distinction nor integrity. These qualities, joined to the artist's virtuosity, make one regret that he does not place his talent at the service of a genuine artistic ideal. The wind of enthusiasm has never touched this sorrowful painter, with his somewhat icy elegance. One would wish, if there is still time, that as the song puts it,

> *Le vent soulève la Gandara.*

> (The wind should lift La Gandara.) [. . .]

Room 2. It is certain that the Henri Lebasque exhibit, all luminosity and harmony, is unequaled in this Salon. The *Little Girl with a Goat*, the *Little Girl at the Piano*, the *Young Woman in a Blouse*, and the *Little Girl in a Yellow Dress* are paintings in which the sensibility of the artist becomes one with the light that inspired it. [. . .] *The Afternoon of a Faun*, by Lucien Monod, is far removed, very far removed, from the admirable poem of Mallarmé.

As for M. Lévy-Dhurmer, he has obviously forgotten to decorate

the *Decorative Panels* that he is exhibiting; these artists are so often absent-minded! [. . .]

Room 3. [. . .] Gustave Courtois's *Hercules at the Feet of Omphale* is as effeminate as one could wish. This bad painting would certainly be appreciated by the Prince of Eulenburg.[17]

But is it appropriate to inform the public that M. Gustave Courtois is also the favorite painter of the Douanier Henri Rousseau? [. . .]

Room 3-B. Leonetto Cappiello's portrait of *Henri de Régnier* is quite a good likeness of the poet. He is shown standing up, dressed for town. His face, with its long drooping mustache, has that disdainful and dreamy expression that gives those who know the author of *La Sandale ailée* the impression that although his body is present, his mind is elsewhere. Cappiello's work is *here* a good painting whose sobriety must be praised, together with what appears to be a certain contained power. This portrait, however, will not at all diminish the pleasure I will have in looking, as I have looked in the past, at the pretty and lively posters on the walls of Paris, showing the agile movements *of a single figure*.[18] [. . .]

Room 4. [. . .] Bernard Boutet de Monvel is showing some large portraits. He has obviously remembered those admirable engravings in which Callot represented the noblemen of Lorraine. Nevertheless, this fashionable gentleman on the Place de la Concorde and this *Polo Player* are no more than pretentious caricatures. One can smile as one walks by them, the way M. Fallières did. After that, one should stop for a long time in front of the paintings of Anquetin, which are first rate. They reveal an understanding of design and color that is above praise. What matter if in looking at these paintings one thinks of such and such an old or modern master! Anquetin took into account only their good qualities, and he was right. His *Nudes* and his *Landscapes* are excellent pieces. [. . .]

[APRIL 17]

Continuation of a Stroll Among the Painters

Today there is a genuine school of sculpture. A master, Rodin, has pupils who work under his orders and learn everything they have to know before becoming masters themselves.

That is how an apprentice like Despiau, in command of every aspect of his craft, can meditate upon his art. In painting, on the other hand, there are no longer any masters, since there are no longer any pupils. There are only artists without certitudes, who submit themselves to uncertain influences. That is why in the absence of mastery one must sometimes praise the virtuosity and even the consummate art of pastiche in the paintings of the Nationale.

Room 4-A. [. . .] There is some irony in the fact that M. Aman-Jean should have entitled his large canvas *The Collation*. I know very well that phantoms do not eat; and certainly the figures painted by M. Aman-Jean belong among the pale inhabitants of Limbo, where one is neither happy nor unhappy, neither sad nor gay. From the point of view of decoration, M. Aman-Jean's manner is tolerable. Suffering souls who smile as they suffer are, I suppose, as good a subject as any for a painting, as are also the wedding feasts of victims of tuberculosis. I find M. Aman-Jean's portraits of *Sick Intellectuals* less appealing. [. . .] Lucien Simon's exhibit is interesting. This robust painter has intuitions that reveal to him some of the secrets of genuine painting. Or perhaps, in addition to knowing the museums, he is familiar with the work of more modern painters. The five paintings he is showing are interesting because of the tendencies they reveal, but that is about all. If this painter has understood that a regeneration in painting was in order, he has not known how to bring it about. This year Willette has painted *Love and Madness*, a canvas whose symbolism is somewhat difficult to understand but in which one finds all the wittiness of the painter together with the sentimental charm that emanates from it. [. . .]

Room 5. [. . .] Louis Gillot paints elegant industrial landscapes: blast furnaces and coal mines for the drawing rooms of rich factory owners. It does not surprise me that this painter has recently enjoyed great success in England. He treats his subjects with the craftsman-like skill and the superficial flair of the English school.

Armand Point is exhibiting a *Venus Triumphant*, a clever pastiche in the grand style. Such pastiches contain a lesson, and the Salon is so full of useless paintings! [. . .]

Room 6-B. Jules Flandrin's calm and beautiful landscape is full of feeling and should be seen. It is one of the best canvases in the Salon and by far the best in this room. Although this painting has been placed above a door, it will not help the antique landscapes of René

Ménard. [. . .] The bourgeois portraits of Dagnan-Bouveret are as insipid as his sentimental *Ophelia*. [. . .]

Room 7. [. . .] Simonidy has stuck *The Poet Vielé-Griffin* on top of a tall peak. Blanche had already painted a portrait of the author of *Phocas le jardinier*. Simonidy's canvas is more broadly executed, but it has the same artificial manner. [. . .]

Room 8 is devoted in its entirety to a retrospective exhibition of the painter Guillaume Dubufe. While painting his ceilings, he had in mind a vague and inaccurate image of Tiepolo. There is nothing to be said about his other works. May he rest in peace.

In Room 9, people particularly notice the paintings of Maurice Denis, who in my opinion could do better, especially from the point of view of execution. Nevertheless, his exhibit is one of the more attractive ones of this Salon, and there is a delicately religious sentiment in his Christ shown in the midst of the artist's family, with the artist himself contemplating this touching scene. [. . .]

[APRIL 19]

End of a Stroll in the Grand-Palais

One must congratulate M. Dujardin-Beaumetz for his enlightened taste. Despiau's marble bust of a little girl, exhibited at the Nationale, has been acquired by the State. This bust, whose qualities I have already discussed, will be on exhibit in the new Luxembourg Museum.

Jacques Blanche

In Room 11, Jacques Blanche has hung six paintings in which the Anglomania that has corrupted the taste of so many of our contemporaries is clearly apparent. In a room on the ground floor have been placed a large number of sketches, preparatory studies, and unfinished paintings by the same artist. On view in this room are: a study of a hand of the Comtesse de Noailles, a portrait of the novelist Thomas Hardy, and another of M. Bernstein; among a group of motorists in a decorative panel entitled *The Breakdown*, one recognizes M. Maurice Barrès. These are conscientious and important

documents on the celebrities of our time. M. Blanche's dry authority has many admirers. England has assumed great importance in art. At the recent exhibition of "One Hundred Portraits," the public could hardly find words to express its admiration of the English portraits, which were often coarsely executed, badly drawn, and painted with vulgarity, but which also had a deliberate manner and a lavish appearance. Certain snobs were even seen going rapidly and with a touch of scorn through the room in which the French portraits displayed their grace and nobility. Anglomania is, in fact, as regrettable in painting as in language. Does M. Blanche not think that some of his works may resemble the language of those who feel obliged to speak a French loaded with English words? Nevertheless, his pictures provide some useful information about the refined taste of our time. . . . What a subject for a thesis by a scholar from Boston in the year 2000: "Jacques Blanche and the Elegant Literature of His Time." [. . .]

In Room 13, M. Boldini's sensual and nervous mannerism recalls no other painter. But these overly elegant portraits have nothing to do with art. [. . .]

In the architecture section, a retrospective exhibit of the work of the Catalan architect Gaudí has been organized. May our architects not be inspired by his fantasies.

The section on the decorative arts, which should be one of the main concerns of the Société Nationale des Beaux-Arts, is, to put it bluntly, very bad. [. . .]

(L'Intransigeant)

The President of the Republic Opens the Salon des Artistes Français

[APRIL 30]

The Exhibition Is Extremely Interesting
A Considerable Number of Works Are on Exhibit

The President of the Republic and Mme. Fallières, accompanied by M. Ramondou and by Commander Bard, formally opened the Salon des Artistes Français at the Grand-Palais at two o'clock this afternoon.

They were received by Messrs. Doumergue, Dujardin-Beaumetz, De Selves, and Lépine, and by the President and the members of the Board of Directors.
The visit to the exhibition rooms began immediately thereafter.

About two or three days ago, I witnessed the unforgettable spectacle of the installation of sculptures at the Grand-Palais. It was all a chaos of marble and plaster. The still-unfinished statues, the apprentice sculptors wearing paper hats, the trucks, the horses, the artists dressed in the traditional painter's smock that one sees these days only at the Artistes Français—all this formed an incongruous whole that was not without grandeur. . . .

My attention was diverted by the arrival of a small troop of people dressed in black and wearing top hats. At its head was a robust man whose energetic gait also had something abrupt and uneven about it. He would often turn around, shouting brief phrases in English at his companions. . . . Whenever a "ssh" sound came to his lips, he produced an extraordinary grimace that gave his mouth the magic shape of a hexagram. And that six-cornered vermilion star, beneath which gleamed a set of unclenched teeth ready to bite, revealed the identity of the personage more unfailingly than his American accent. It was none other than President Roosevelt, whose face, when he wishes, displays the starry symbol of the United States of America. Every once in a while, Roosevelt would stop his troop of gentlemanly Yankees, in whose midst one could occasionally detect the austere physiognomy of a member of the Institute. He harangued all these people in English, gesticulating and vigorously slapping his left hand with the gloves he held in the right. . . . After looking for a few moments at the marble groups executed by the American sculptor Barnard for the main entrance of the Pennsylvania Legislature, President Roosevelt turned around, and addressing himself this time to the members of the Institute, who tried to force themselves to smile, he said to them in French:

"Gentlemen, I am sorry that I do not know French well enough to be able to communicate to you the artistic impressions that I have experienced during this visit. I will say only that everything I have seen . . . it is really astonishing!"

He then shouted a few sentences in English, and after allowing

one of the stars of the Union to make its appearance two or three more times on his face, he climbed into an automobile and left. . . .

No description and no explanation could more aptly characterize this 128th Salon de la Société des Artistes Français than the concisely eloquent exclamation of President Roosevelt:

"It is really astonishing! . . ."

The Artistes Français and the Nationale

One is first of all astonished at the prodigious number of works being exhibited—works of all kinds, including large historical paintings and artificial flowers, monumental fountains and ivory miniatures. One is even more astonished at the fact that this collection, in which there is no lack of puerile and useless works, contains on the whole more lessons than the mannerism that predominates at the Nationale; all the works exhibited there hew to the fashion of the moment, while here almost everything seems outmoded.

Anglomania, which is one of the artistic follies of our time, is manifested here more timidly than anywhere else, with the exception of the Salon des Indépendants.

Democratic painting can be seen only at the Artistes Français. Workmen's injuries are doing very well this year.

One occasionally notes a spirit of innovation, but it is nothing to worry about. Have I not been told that M. Comerre himself was at one time considered a revolutionary in art?

Portraits are rare, especially those of women. It seems that that clientele has gone over to the Nationale, where all the painters who have made themselves specialists in elegance are exhibiting.

The principal characteristic of the Artistes Français is, after all, artistic integrity. This quality is of capital importance, but it cannot replace the others. Most of these artists are behind the times; if almost all of them have learned the rudiments of their art, they appear to be unaware of the life and beauty even of the works in the museums. . . . And that is why a group of sincere people skilled in their craft are too often condemned to perpetual mediocrity.

There are forty-three rooms of paintings at the Artistes Français,

not counting the balconies or the rooms on the ground floor or sculpture or architecture. [. . .]

The opening of the Salon this year was as brilliant as at any time since 1673, when the Société des Artistes Français was founded.

Lovely ladies, handsome gentlemen, academicians, generals, painters, models, bourgeois, men of letters, and bluestockings all stopped in front of Jonas's *The Tyrant*, the canvases of Detaille, the *Monument to Ferry*, etc. Despite the uncertain weather, many ladies were dressed in light colors. People pointed out the originals of the portraits, and they gossiped and gossiped. . . .

It is very pleasant for a man of letters to walk around the Salon des Artistes Français. History is taught there in the most attractive way possible: through pictures. The sad or joyful anecdotes that inspired the painters can just as easily entice the imagination of the novelist and the playwright; the archaeologist and the historian can determine with what degree of accuracy the artists have reproduced famous sites or re-created the attire of heroes.

I know a man who has the reputation of being a delightful conversationalist. Every year, he visits the Artistes Français two or three times. There he finds enough material to sustain his conversations until the following spring, and it is worthy of note that this witty gentleman never touches on contemporary questions. The other salons don't offer this advantage.

The art critic must here limit himself almost exclusively to a description of the works exhibited. Their execution being based on legitimate principles, these works are above criticism; but as inspiration and invention are often lacking, rarely do they merit any praise.

In the first room, one will stop first of all in front of the large canvas in which M. Béringuier has depicted the *Municipal Vote of February 3, 1793, at Clichy-la-Garenne*. As far as the world is concerned, this event is but minor history, but the inhabitants of Clichy-la-Garenne must justifiably accord a great deal of importance to it. [. . .]

M. Tessier's *Improvisation* represents a young woman playing the violin in the countryside at twilight. It's very funny. . . .

The *Death of Henri Regnault*, by Frédéric Levé, is vigorously painted. It is one of the impressive canvases in this Salon, where

artists have not hesitated to exhibit pictures with frightening subjects. There is a kind of art here that is equivalent to melodrama in the theater. M. Frédéric Levé's canvas, however, soberly executed and showing a very small number of characters, is an exception to this comparison. M. Orange will have a great success with his *Guardsmen Charging the Crowd on the Calle de Alcala, May 2, 1808.* [. . .]

M. Anselmo Bucci has given the title of *Youth* to an excellent painting in which a young woman in a camisole and a young girl in a red bodice and a skirt printed with violet flowers, are shown picking pomegranates. In my opinion, this is one of the best paintings in the Salon. [. . .]

In Room 2 is the first example of that democratic painting which abounds at the Artistes Français. M. Jules Adler has painted some robust workers loading the kiln *Inside a Bottle Factory.* [. . .]

In Room 3, [. . .] M. Balestrieri, whose works have enjoyed the popular distinction of being reproduced by the thousands, offers us another aspect of the democratic painting I spoke of with his *Subway Construction.*

People will willingly stop to look at the faithful portrait of *Jean Richepin*, by Marcel Baschet. The poet is dressed in a red bathrobe, and several people have mistaken him for a cardinal. [. . .]

In Room 4 [. . .], two droll canvases by M. Brispot will catch the eye of those who like good humor. One of them, entitled *The Captain's Story*, depicts a scene that includes several cardinals. (Cardinals play an important role at the Artistes Français.) The other is entitled *Day of Rest* and has a democratic subject: an honest clerk in shirtsleeves, carrying his child and followed by his wife, is leaving the Bois de Boulogne by way of the Porte Dauphine at twilight:

> *Dimanches de Paris, comme vous êtes tristes!*

> (Sundays in Paris, how very sad you are!)

[M A Y 3]

No one writes parallels any more, and it is a pity. One could establish some pretty lively ones between the salons of the Artistes Français and the Indépendants, between the Nationale and the Salon d'Automne. . . .

Our stroll amid the picture frames brought us to Room 5, where

one finds the honest paintings of M. Léon Comerre, a painter who, I am told, was at one time considered terribly revolutionary. When was that, good heavens! M. Comerre has painted some not very divine nymphs, dryads who have not forgotten the rough bark beneath which they were born. *A Venetian Canal*, by M. Maurice Bompard, is in my opinion the best painting in this room. A good, old-fashioned seascape by Gribble has been placed very high up. It shows a naval battle about to begin . . . ships on the high sea . . . general quarters. This kind of painting always looks good in small-town museums, Dutch city halls, and even in private homes. I find it surprising that naval battles are so rarely treated in painting. It is true, of course, that they demand of the artist a great effort at composition and an ample talent.

In Room 6 is *The Tyrant*, which has turned out to be the main attraction of this Salon. [. . .] I have not really understood the meaning of this allegory. On the opening day, someone invented a very amusing little game that consisted in asking all those one met: "Who is the tyrant?" and then disagreeing with the answer in every case. A terrible joke that has something Athenian about it. . . . But you may be sure that everyone in Paris will be playing the tyrant game. M. Jonas's painting cannot possibly be explained; it has a politician in a red tie, a Belgian officer, some butchers, an equestrian statue whose bronze horseman lies broken on the ground while a hoodlum sits on the horse. This is democratic painting again, combined with some hollow philosophy and an obscure symbolism reminiscent of Wiertz. [. . .] M. Descudé's *Convalescent Woman* is treated in somewhat too vague a manner. M. Descudé's ambition is to compete with Carrière and Maeterlinck at the same time, and he thinks that the way to do this is to give his characters the bewildered look that Aman-Jean gives his. Three different methods are too much for one man. [. . .]

In Room 7, M. Paul Chabas's eternal little girls bathing have dipped their charms this year in Lake Annecy. [. . .]

Room 9. [. . .] M. Avy shows us girls drinking champagne. The name of the piece is *The Buffet*. It is doubtless destined for a ballroom. [. . .]

[M A Y 4]

Who would deny that the model has crippled the talent of a great number of painters exhibiting at the Artistes Français? If the skill of

most of these painters allows them to copy a model or nature more or less faithfully, how many of them are incapable of creating themselves a model and a nature that would be the expression of their art!

In Room 9, M. Edouard Detaille's large composition, *The Rue du Petit-Pont on July 29, 1830, at the Moment When the Appearance of the Tricolor on the Towers of Notre-Dame Announces the End of the Struggle to the Defenders of Liberty*, is a very successful work in its genre—some would even say too successful. A prodigious talent and extraordinary patience went into its making. Here the art of *trompe-l'œil* has been carried as far as it can go: real smoke, perfectly imitated houses, more than credible postures. One has the impression not so much of being present at the scene as of witnessing it in a panorama. It is true that the color is not luxuriant, but the painting as a whole is witty and full of good humor. This gaiety can be felt in all the details of the composition, from the elegant young man in violet trousers, green frock coat, and canary-yellow vest who is dying on a pallet in the foreground, to the Polytechnique student standing on the barricade next to a *gavroche*. It is possible that the future will find lyricism in this work. It unquestionably reveals a rare feeling for the picturesque, without lacking in sobriety. Do I need to add that all this does not represent my artistic ideal? But there are qualities of vivacity and precision that are precious and distinctively French. Paintings like this one are not unlike the songs of Béranger.

Chocarne-Moreau's *Victims of the Flood*, on the other hand, is related to a less spontaneous genre of folk art: the mournful romance that drags on in almost regular verse and tries vainly to compete with the *complainte*. M. Deutsch painted his *Bark on the Nile* filled with watermelons, to show what benefits one can expect from a flood when one is used to it and knows how to take advantage of it. A praiseworthy sentiment, a satisfying painting. [. . .]

Room 12. [. . .] M. Devambez is a kind of Gulliver, and for several years he has been living in Lilliput, where it seems that airplanes practice flying in a place called *Port-Aviation*. In the capital of the kingdom there is also an Eiffel Tower from whose top the inhabitants look no bigger than the fleas of the famous flea tamer, Mme. Sténégri. M. Devambez, who knows how to be amusing, is enjoying a great success. [. . .] Let us mention a *Portrait of Mme. H. P.*, by A. Calbet. It is a pleasant picture whose title alone is disconcerting, given the

fact that "H. P." usually stands for "horsepower," and is generally preceded by a figure that indicates the number of horses.

In Room 13, M. Bonnat has hung two portraits: of *M. Isidore Leroy* and of the economist *Edmond Théry*. One could hardly produce a better likeness of either subject. Nevertheless, I confess that I would gladly exchange these portraits, and many others with them, for a single one of the Rembrandt drawings that M. Bonnat owns and that I had the opportunity to see at the time of their exhibition in Leiden in 1907.[19] The man who has assembled such a collection is a man of very sure taste. [. . .]

A *Swan-necked Edith Finding the Body of Harold* in Epping Forest, near Waltham Abbey, after the battle of Hastings, recalls the poem by Heine:

> *Gefunden hat Edith Schwanenhals*
> *Des toten Königs Leiche.*
> *Sie sprach kein Wort, sie weinte nicht,*
> *Sie küsste das Antlitz, das bleiche.*[20]

> (Swan-necked Edith found
> The body of the dead king.
> She did not say a word, she did not shed a tear
> She kissed the pale visage.) [. . .]

In Room 16, *The Surrender of Yorktown* by Jean-Paul Laurens, commissioned by the American government for the Baltimore Courthouse, is amusing, but its composition is disconcerting. The right side of the painting is empty, while the left is crowded by the serried ranks of the red-uniformed English soldiers. How much better than this enlarged miniature is the small canvas by the same painter exhibited in Room 17! The scene takes place in the Middle Ages, in a church where a young girl is giving a lesson in biblical history to a group of children.

Room 18. [. . .] In order not to be confused with Henri Matisse, M. Matisse-Auguste paints very dark pictures. [. . .] M. Yarz shows us some harvests: *trompe-l'œil* impressionism.

In Room 21, two good portraits by François Flameng hang next to a tree by Harpignies. This fine painting evokes the whole Barbizon school and shows us that lyricism must renew itself with every generation.

Room 22 is devoted to the pacifists. M. d'Estournelles de Constant would do well to inspect it at length; it merits his praise.[21] Humbert Vignol shows us the horrors of strikes.[22] M. Chigot is exhibiting a decoration for the Peace Palace in The Hague. This government commission will increase the admiration of the Dutch for Paul Potter. They will be overjoyed. A kermis will be organized on the spot. One can already see it in the painting by M. Hanicotte, a fiery, joyous, simple painting—in a word, full of fine qualities, the best painting in the Salon. M. Stanhope Forbes is a practitioner of pacifist art. His picture, a democratic painting in the American manner, was awarded a medal by the Carnegie Institute. [. . .]

In Room 25, M. Chabannes la Palice tells us one of those terrible anecdotes that too many painters at the Artistes Français do not hesitate to recount. And for what purpose, oh Lord! In this case, the story has been taken from the *Courrier de Saïgon*. Some Boxers are its heroes, and two Frenchwomen are its unfortunate heroines. M. Lecomte du Noüy paints for the glory of Venice, and recalls to us those who sang or painted that city: Byron, Musset, George Sand, Ruskin, Veronese, Tiepolo, Ziem, etc. Since not all of the names on the list are those of men now dead, why was M. Barrès not included? [. . .]

[M A Y 5]

End of a Stroll Among the Painters

Here we are in Room 26 of the Salon. . . .

Mlle. Morstadt admires Anglada's painting and remembers it even when she is painting Merino sheep. Mlle. Morstadt is searching for a style, without having yet tapped all her talents. M. Loir-Luigi is exhibiting, as always, some views of Paris, to which he has, naturally, added a scene of the flood.

In Room 27, we find a democratic painting by M. Jules Pagès: some tugboats are pulling a barge that you may be sure will never become Rimbaud's drunken boat. M. Roger's painting is even more democratic, if that is possible, than M. Pagès's. Its title: *An Accident at Work.* Looking at M. Paul Legrand's *River Policemen and Rescue Dog*, one

really feels proud to be living in a city whose policemen appear in so many different guises. [. . .]

In Room 28 [. . .], M. Fernand Sabatté has a painting showing the street where I live during the flood. Alas, my house is not shown! The artist neglected to include it. [. . .]

Room 30 is an important room; it contains Tito Salas's *Procession in Spain*. This painting has been acquired by the State, a fact that shows the broad-mindedness of the Ministry of Fine Arts. It patronizes religious painting as well as the other kinds. . . . M. Albert Laurens's nude is not at all amusing. M. Jean Patricot is exhibiting the portrait of *A Patriot* wrapped in a tricolor. The sentiment is noble, but the painting is weak. Doesn't M. Patricot feel some nostalgia for the time when he was an engraver, giving Gustave Moreau a genuine style that was perhaps due more to the engraver's art than to the painter's?

[. . .] I note the idealism of M. Marcel-Béronneau, whose *Salome* looks as if she regretted the departure of the good King Herod, the massacrer of innocents who ended up an unhappy man in Lyons. . . .

Room 33 was greatly admired by the Americans. A few Germans have also said their prayers there. M. Max Nordau contemplated and commented at length, in English, on M. Gorguet's cartoon for a tapestry that is to be hung in the Rennes Courthouse and executed at the Gobelins tapestry works. Perhaps the Gobelins could be given something else to execute. . . . [. . .]

In Rooms 34 and 35, there is a *Salammbô* by M. Surand that makes one smile. But I very much like the way M. Corabœuf remembers his Ingres. Nevertheless, for next year's Salon M. Corabœuf should test his talent by giving us a male nude and a male portrait.

A view of eighteenth-century Venice by M. Saint-Germier evokes the memory of Casanova and his licentious nuns.

In Room 36, a regrettable *Icarus* by M. Styka does not, I hope, give us an idea of contemporary Polish art.

In Room 37, M. Suau portrays himself with his children, one of whom is building a house of cards. This is a serious painting, and it evokes the most serious of Florian's fables—the one whose moral applies so perfectly and so unexpectedly to the conquerors and founders of empire. [. . .]

1 9 1 0

In Room 38, there is a fine painting by Pascau: *The Flowered Dress.* It is a rich and delicate work, and its title hides an enigma that a large neighboring canvas allows one to penetrate. The author of the canvas is M. Zingg. . . . You will recall that this word, which M. Rostand is the only one ever to have used, occurs in *L'Aiglon*, where it serves both the purposes of rhyme and of onomatopoeia.[23] . . . And now you know as much as I do about M. Pascau's *Flowered Dress.* . . .

Really, one can see the paintings of Messrs. Jean and Tadé Styka in almost every room. Here are some more of them. [. . .]

In Room 40, destiny has placed yet another painting by Styka. . . . You must have your pictorial revenge, gentlemen of Poland!

Rooms 41, 42, and 43 [. . .] Father Van Hollebeke shows us a priest leaving his rectory *After the Separation.* This is a canvas charged with emotion and is the only one relating to this important religious event.[24] I strongly advise the state to acquire this painting and put it in the Luxembourg. It is a welcome document and a picturesque study. [. . .]

[M A Y 7]

Watercolors, Miniatures, Drawings, Engravings,
Stained-Glass Windows, Objets d'Art, Architecture

There are so many watercolors, pastels or other kinds of drawings, miniatures, engravings, and *objets d'art* that the art critic cannot possibly hope to describe them in detail. Any such attempt would cause his newspaper serious problems of space.

In any case, everything that is neither sculpture nor painting tends to be sacrificed at the Salon des Artistes Français. The pastels, the miniatures, and the engravings are strewn about pellmell. [. . .]

Mlle. Hortense Richard paints modernistic miniatures, such as the portrait of a chauffeur at the wheel of his automobile. [. . .]

M. Corabœuf, who has every sort of talent, excels equally in colored engraving. One should mention Albert Wéber's lithographs, and Vibert's polychrome woodcuts. The woodcut is currently enjoying a renaissance. Many talented artists are attempting to restore this truly artistic form of book illustration to a place of honor. Nevertheless, no salon has yet shown this to the public. [. . .]

Sculpture

The sculpture section has been nicely installed at the Artistes Français. Never before this year, incidentally, have we seen such a great number of colossal statues and gigantic monuments at the Salon.

It is undeniable that there is a renaissance in sculpture in France. Nevertheless, it must be admitted that the sculptures so badly exhibited in the dark entrance halls of the Nationale give us a better and more genuine proof of this renaissance than what we see here.

Let us quickly pass by the white crowd of statues. There is a *Bishop* by Hippolyte Lefebvre whose miter is absolutely enormous. Gardet's animals, and particularly his giant *Stags*, are in my opinion the most important exhibits in the sculpture section.

Here, as at the Nationale, young sculptors are tending toward expressive simplicity. One must mention in this respect Niclausse's *Old Women*. The faces, however, seem to have been molded by a different hand than the rest. The same tendency leads to mistakes in the case of some good artists. *To Meet Again!*, by M. Roger Bloche, and the *Violinist*, by F. David, could be cited here as examples. [. . .]

The style of the monument to *Mustafa Kemal Pasha* will appear strange to the great Egyptian Sphinx. She will gossip about it with the forty-one centuries that live above her.

M. Landowski is a very prominent sculptor. He is exhibiting a monument to *Anonymous Men*, which the state, always full of solicitude for great men, even for those who are unknown, is planning to install in the Pantheon. The interested parties will certainly be overjoyed. [. . .]

M. Barnard is an official American sculptor. The State of Pennsylvania commissioned him to do two groups that will be placed at the entrance of the State Legislature. M. Barnard has entitled his works *Human Life*, and he was right to do so, for they contain plenty of incongruities. But what would Penn and his Quakers have said at the sight of so much nudity? [. . .]

(*L'Intransigeant*)

The Art World

The Gauguin Exhibition

Among the very numerous strange figures produced by the nine-
teenth century, none is more mysterious than Paul Gauguin, who left
the Paris Stock Exchange and went off to die in a primitive hut on the
Marquesas Islands.

All his paintings—whether of Brittany, Arles, Tahiti, or the Mar-
quesas—were conceived in the same spirit of piety.

His is a liturgical painting in which colors have a symbolic mean-
ing that reinforces their decorative appeal. The work of this most
religious of modern painters was the first challenge to the impression-
ism that still reigns supreme, not only in the plastic arts, but also in
contemporary literature.

In his gallery on the Rue Laffitte, M. Vollard is currently exhibiting
fifteen paintings by Gauguin, chosen from among the best of each
period.

As a matter of fact, Gauguin's piety toward his art never changed.
The unity of his work is remarkable. This painter has neither several
manners nor several periods; he has only one, which he never
abandoned, even though he forced himself several times to change
climates, and with climates, subjects.

Both his Breton and his Marquesan landscapes express a unique
feeling of artistic piety before the decorative and endlessly renewed
marvels of nature. His canvases of Oceania are no more religious than
his paintings of Brittany, such as *Jacob's Struggle with the Angel*. The
draftsmanship of this painting is admirable, and its vigorous colors
seem to be singing the glory of the Holy Trinity. . . .

Gauguin's paintings have been admitted to the Luxembourg, but it
is the Louvre that should house these harmonious works by a man
who for the sake of his art "willingly endured grief and every kind of
suffering," in the words of M. Charles Morice.

Possessing outstanding qualities that will doubtless earn him a place

among the very greatest artists, Paul Gauguin journeyed to the outer limits of humanity in order to capture the divine purity of art. . . .

[M A Y 13]

At the Bagatelle Palace—Tomorrow
Is the Opening Day of a Retrospective Exhibition
of Children's Portraits and Toys

Famous children! . . . When we ourselves were children, these words evoked in our minds a glory that we would one day certainly share, to the astonishment of our teachers and the loving joy of our parents.

Who among us has never dreamed of being as courageous as the young Spartan who let a fox cub he had stolen literally eat his heart out? . . . Who among us has never imagined himself in Bara's place, beating the drums? . . . We used to see ourselves in the heartrending situation of the unhappy and mysterious Gaspard Hauser. . . . We would even go so far as to compete in kindness with the ghost of the poor midget king of Lorraine. . . .

Famous children! Their portraits have been assembled at the Bagatelle, under the direction of the Société Nationale des Beaux-Arts. It was a charming idea to group together all these little faces, which grown-up children will come to look at with melancholy smiles. . . .

All you grown-up children who learned about life in the adorable and cruel stories of the Comtesse de Ségur, *née* Rostopchine, and in the fantastic and realistic novels of Jules Verne, how curiously you will study the fixed gaze of these children of another age who used to read the works of Mme. de Genlis or of Bouilly the hypochondriac!

How anxiously we will look at all the portraits of ill-fated children at the time of Louis XVI—especially the portraits of the Dauphin, whose fate still remains a mystery! . . .

It was an idea of great subtlety, and one that will surely increase the already great emotion of the viewer, to assemble, next to the portraits of the royal infant, those of the imperial infant whose fate was no less tragic.

The King of Rome, by Prud'hon, by Isabey, by Benoist, and by Roger, seems to smile sadly at the *Dauphin*, painted by Drouais, by Greuze. . . .

Louis XVII and Napoleon II reign here over a tender, charming

nation of children from their time to ours. Here are the pastels of the eighteenth century, and the canvases of Greuze, Fragonard, Drolling. Here are the *Duc d'Orléans* by Greuze and the *Duc de Bordeaux* by Dubois-Drahonet and by Hersent. Here is a pastel of *Pigalle's Nephew* by La Tour, and here is *Metternich As a Child* by Lawrence. Here are *Murat's Children* by Ingres.

Here, too, are modern children, most of them still alive. One should note in passing how beautifully and with what art Renoir has succeeded in expressing the grace, the freshness, and the playful innocence of children. [. . .]

Together with the portraits of children of old, their precious and charming toys are exhibited. What Father Christmas in overembroidered and outmoded clothes, what St. Nicholas of the *ancien régime* brought you these rich toys, oh, children of kings? Who brought you these all too sumptuous toys, made expressly for display in a retrospective exhibition?

And yet, you famous children, you children of a bygone age, you also had toys you could really play with—cheap toys that you used to break "to see what was inside"!

[J U N E 7]

The Georges Desvallières Exhibition[25]

Among all the masters who were professors at the École des Beaux-Arts, it was, without a doubt, Gustave Moreau whose teaching produced the greatest number of innovators.

None of Gustave Moreau's pupils thirsts more after novelty than M. Georges Desvallières. It may even be feared that M. Desvallières suffers from that modern malady which makes all those it afflicts consider that the sole aim of art is to express contemporary life. This was the least of Gustave Moreau's concerns, but a handful of today's painters seem to be obsessed by it. They inherited this concern from the impressionist painters, who themselves had inherited it from the romantics; indeed, one could trace it back to that passion for verisimilitude and reasonableness which is one of the most legitimate passions ever to have inflamed the French mind.

Nevertheless, one has the right to believe that this praiseworthy

feeling for truth has become perverted. Every work of art must find its logic and its verisimilitude in itself, and not only in the fugitive aspects of contemporary life.

Until now, all of M. Desvallières' talent, intelligence, and efforts seem to have been absorbed by the useless attempt to reconcile his art with the modern aspects of nature. One wishes that an artist so happily gifted were less preoccupied with the present.

(*L'Intransigeant*)

Benjamin Rabier

Before I met Benjamin Rabier, I thought that he was hunchbacked like Aesop and absent-minded like La Fontaine. He is, in fact, neither. Such defects, useful as they may be to men of letters like the slave of Xanthus and the friend of Superintendent Fouquet, would be extremely bothersome to a graphic artist. Benjamin Rabier's slim figure is not marred by any dorsal hump. His liveliest distractions consist in studying the physiognomies and gestures of all the animals, from the so-called inferior species all the way up to man and to the autobus, which is the most superior animal of all.

And yet, despite the many marked differences between them, our artist has more than one trait in common with the two fabulists; first and foremost is the fact that if they wrote fables, he draws them.

I have been told—but then, one is told so many things—that Benjamin Rabier had a dog whose language he understood perfectly.

It would seem that this animal of superior intelligence undertook to interrogate his canine friends and to bring back to his master a whole host of stories, each more extraordinary than the one before. There were stories about Azor, Medoro, and Briffaut, about snowmen and Mother Goose and Peter Rabbit, and even about Chanticleer. . . .

Was my informant telling the truth? . . . One thing is certain, and that is that nobody seems to know more than Benjamin Rabier about what is going on in the animal world, and nobody has drawn or is currently drawing the scenes of their quasi-human life in a more amusing manner. . . .

1 9 1 0

The public will react with great interest to this first exhibition of watercolors by the wittiest of our animal painters.

(Preface to the *Catalogue de l'Exposition Benjamin Rabier,* Deplanche Galley, J U N E 8–J U L Y 4) [26]

The Art World

[J U N E 14]

The Manguin Exhibition

M. Manguin is a voluptuous painter. The fifty-odd paintings he is exhibiting at the Druet Gallery are imbued with a slightly languid sensuality. Colorist that he is, Manguin confines himself to the expression of contrasts that produce flashes of half-livid, half-flesh-colored light.

The strangeness of his colors contrasts sharply with the academic design of his nudes. A very real but disconcerting charm results from this bizarre opposition between a painter and a draftsman who are one and the same artist.

Manguin's nudes have a pagan freshness about them. His wonder-struck landscapes tell of the young glory of natural sites in June, after sunrise.

Manguin's well-constructed still-lifes appeal to the eye perhaps even more than his other paintings. That may be because in these compositions M. Manguin's instinct as a colorist reveals itself fully, without being hindered by the desire to formulate principles, as it is in the nudes.

[J U N E 15]

The Manet Exhibition

The Bernheim Gallery is the scene of a pleasant assemblage of oils and pastels by the man who, through his rejection of the old prejudice in favor of chiaroscuro, is responsible for all the innovations in contemporary painting.

One will have the pleasure here of seeing once again the beautiful Manets of the Pellerin collection: *Luncheon in the Studio, Marcellin*

Desboutin, Nana, In the Café, The Stroll, The Lady in Pink, Manet with His Palette, and the astonishing *Bar at the Folies-Bergère,* whose colors and composition appear ready to be pasteurized by Seurat, the microbiologist of painting.

Some of Manet's pastels already contain Toulouse-Lautrec. But the latter never went higher, whereas Manet . . .

It should be noted that the paintings assembled for this exhibition are not all of equal quality.

There are some works far superior to the *Olympia,* whose interest is, above all, historical, and which the Louvre has unexpectedly paired up with Ingres's *Odalisque.* There are also some minor works of no importance, some insignificant little pictures.

Such as it is, this Manet exhibit is very interesting. As we walk through it, we are, in a sense, witnessing the origins of the formidable movements that revolutionized the plastic arts at the end of the nineteenth century—movements that have not yet come to an end, nor can anyone predict when and where they will end.

The lesson would be more complete if this Manet retrospective were followed by a Cézanne exhibit. . . .

[JUNE 16]

The Engravings of Richard Ranft

Richard Ranft's exhibition at the J. Chaîne and Simonson Gallery consists of his private collection of his own works. This means that we have a chance to view some rare proofs, single states, and engraved sketches that will never be run off again.

The original colored etchings by a man who in England is considered to be the best interpreter of Turner are full of precise elegance. With intelligence, Ranft evokes the refined fantasies offered by his imagination, and the rare spectacles offered by the civilization of our cities. His love of masks, ballerinas, and clowns is as tender as the feeling that inspires him to engrave an old barge or a windmill on a cliff.

For Ranft does not limit nature to its urban or its rustic aspects; the poetic inventions of men of genius appear to him as real as the ocean.

1910

Certain verses by Ronsard or by Gustave Kahn have inspired him to do some charming works.

As the second of these poets states in the preface he has written for this exhibit:

"This painter is by no means a literary painter; he is a literate painter, which is not at all the same thing."

Richard Ranft loves literature enough to lend it the prestige of his very evocative art. He has excellently illustrated several luxurious editions offered "to the happy few."

His illustrations for Gustave Kahn's delightful and poetic *Contes hollandais* capture very well the richly colored irony and the opulent melancholy of those legendary stories.

One would have liked to see here the illustrations—168 colored copperplate engravings—that Ranft did for Elémir Bourges's admirable tragic novel *Le Crépuscule des dieux*, published by the Sociéte du Livre Contemporain.

One would have liked to see how the artist solved the problem of matching his style to the steely style stained with royal blood that characterizes the finest work of the greatest contemporary writer, the great poet of *La Nef*.[27]

An accident has deprived us of this pleasure. Let us hope, however, that the damage is not irreparable.

[JUNE 17]

Watercolors and Travel Notes by Jeanès

Jeanès is a refined painter who has carried the art of the watercolor to great heights. The evocative character of his pictures, the rare and sober brilliance of his colors, and the summits he likes to paint incontestably give him the right to be called "the Turner of Mountains." But the figure of rhetoric known as antonomasia has been outmoded for some time.

It would be better to say more simply that Jeanès is one of the rare European artists who have succeeded in painting the actual height and nobility of mountains.

He is exhibiting some fifty paintings at the Chaîne and Simonson Gallery, among them some lyrically colored visions of the Dolomites and the Vosges.

Visitors will also like the delicate and violent canvases whose ostensible subjects are some intensely observed views of Venice.

A few landscapes of the Île-de-France nicely round out the group. Although this exhibit does not give us a comprehensive view of Jeanès's talent, it does offer us at least an abridged version that is most agreeable to look at.

Green mornings in Venice, dawn in the Dolomites and daybreak in the Vosges, poplars along the banks of the Seine, watercolors and clear pastels—all the works of Jeanès appear to have been painted with crushed diamonds and precious stones.

[J U N E 19]

M. Antoon Van Welie—Benjamin Rabier

At the Georges Petit Gallery, M. Antoon Van Welie is exhibiting some portraits of, among others, Edmond Rostand, Sarah Bernhardt, Cécile Sorel. M. Van Welie has a pleasant time commenting pictorially on the physiognomies of his most famous contemporaries, and he endows all of their faces with the same smiling expression. They are pleased at their celebrity, pleased with themselves. And they are happy to be painted by M. Van Welie.

The Deplanche Gallery is showing some extremely cheerful and hitherto unseen watercolors by Benjamin Rabier. Benjamin Rabier's wordless stories show us animals who speak, like those of the imperial poet, Father Casti, a century ago. Talking animals and stories without words—these two things seem difficult to bring together in one and the same watercolor. But Rabier manages to do it, to the untiring delight of his numerous admirers.

[J U N E 21]

Three Hundred Drawings by Steinlen

The art publisher M. Édouard Pelletan has invited us to an exhibit of three hundred original drawings by Steinlen. These drawings were made to illustrate Jean Richepin's *La Chanson des gueux* (in the unexpurgated edition) and his *Dernières Chansons de mon premier livre.*

1 9 1 0

Almost everything has already been said about Steinlen's verism. His influence has been far too great—not only on the men of letters, but also and above all on the painters of my generation—for anyone to speak of him lightly. Is it not true that even today the most widespread artistic and literary ideal is the representation of the miseries and the dreariness of contemporary life?

All this is to be found in these illustrations, whose flavor complements the lyrical truculence of the poems. Speaking of the poems, does everyone know that the original—and unexpurgated—edition of *La Chanson des gueux* is still kept in the locked cases of the Bibliothèque Nationale?

Steinlen's illustrations for the songs of Jean Richepin are certain to please; and yet, the undertaking was a risky one. Is it not very risky to illustrate poetry with drawings that are not at all decorative in feeling?

The severe and melancholy verism of Steinlen and the forceful and vivid exaltation of M. Jean Richepin go together very well.

[SEPTEMBER 27]

Faces by Cézanne at the Vollard Gallery

M. Vollard has the habit of extending his exhibitions beyond their original termination date. The Cézanne exhibition entitled "Faces" is still going on. This means that those who have not yet been to see this severe and moving collection will still have time to do so. This visit may be useful before the opening of the Salon d'Automne. It will help to gauge some of the influence the master from Aix exerts on today's young painters. It is well known that most of the new painters claim to be followers of this sincere and disinterested artist.

Some people have said that Cézanne made himself into a primitive in order to pave the way for a new classicism, by which they seem to mean that his paintings, full of ignorance and defects, could serve as guideposts to an honest and legitimate art.

What! Are we supposed to think that evil can give birth to goodness? Is paradise then but one form of hell? Is beauty but the old age of ugliness, and perfection but the quittance of the imperfect?

It is true that I am perhaps misled as to the meaning attributed to the word "classicism." Classicism has become an equivocal term, which everyone interprets as he wishes. But if we limit ourselves to the oldest accepted definition, we will find that "classic" applies to works that are generally esteemed and that are set up as models of their kind. It is not up to me to decide whether Cézanne is a classic or not.

I do know, however, that I could not possibly consider Cézanne a primitive. In his art, I see no room for the agreeable attention to minutiae that gives an equivocal charm to the works of primitive artists and to flawed literature.

Cézanne a primitive, an ignoramus, a painter not blessed with reason? Really now, who will believe that? The primitives' attention to detail borders on insensitivity. In Cézanne, great simplicity is informed with reason. Painting from nature, he brought all of his genius to bear on making of impressionism an art of reason and culture.

All of this appears clearly in the expressive faces that M. Ambroise Vollard is currently showing us. A reckless hand took it upon itself to varnish these paintings, thus disturbing—temporarily, it is to be hoped —their general harmony.

But what exquisite and forceful refinement there is in these simple, severe portraits! Transcendent painter and provincial artist that he is, Cézanne sometimes lacks charm. But these faces—even the most rustic ones—possess nobility, and one may be certain that he always went beyond the humanity of his models.

(L'Intransigeant)

A Little Opening at the Grand-Palais
German Artists Are About to Storm
the Faubourg Saint-Antoine

[SEPTEMBER 30]

The Painting and the Furniture Exhibits—A
General View of the Salon d'Automne—The Germans
Are Not Exhibiting Any Clocks

Tomorrow, September 30, the Germans will storm the Faubourg Saint-Antoine. The Bavarian troops encamped on the Avenue d'Antin

are occupying eighteen rooms on the ground floor of the Grand-Palais.[28] They have usurped a lot of space from the Salon d'Automne, whose opening is scheduled to take place during the battle.

The lack of space has obliged our painters to exhibit only a small number of canvases.

These canvases tell us nothing new about the concerns of young French artists.

On the whole, we find the same disregard for form, which is here sacrificed to an effect that takes the name of color. A few of the youngest artists have enough presence of mind to try to stop being slaves to their senses. They are beginning to suspect that their senses must be purified and ordered if they are to have any part in the creation of a genuine work of art.

Nevertheless, they are generally uneducated and are only too willing to put up with this slight defect.

A great number of powerful artists are not exhibiting at the Salon d'Automne.

And we are told that the lack of space obliged the jury to refuse almost all the works submitted by artists who are not members of the Société. But what is most unfortunate for the Société du Salon d'Automne is the quality of most of the canvases that the jury did not refuse. Their mediocrity is overwhelming. And to think that the same sorts of juries used to reject the works of Henri Rousseau, that poor old angel who only recently went to join his Maker! They used to reproach the Douanier for his ignorance. They would have done better to reproach him for his inspiration, for as far as ignorance is concerned, he has plenty of company both in the past and in the present, and even in the rooms of this Salon d'Automne. . . .

Everyone is familiar with that witty best-seller *À la manière de* . . . , which promoted the pastiche to the level of a literary genre.[29] There are a great many *à la manière de*'s in this year's Salon d'Automne, but unfortunately there is not the slightest trace of humor in any of them. There are fake Marquets, fake Frieszes, and fake Girieuds, not to mention the many works imitating painters who are not exhibiting at the Salon.

Was it a good idea to assign so much space to the German decorative arts? I don't know. But it would be unfair not to add that the French decorative arts also take up a great deal of space.

There is a furniture exhibition at the Grand-Palais every year that could very nicely accommodate both.

Decorative Arts from Munich

The public will think that the emphasis placed this year on Bavarian furnishings and decorations is perhaps excessive. The artists and manufacturers of Munich have nothing astonishing to show us. Together with a few pleasant works in which one recognizes the influence of French or English taste, we are being asked to look at a great number of mediocre ones. I must admit that I was hoping for a few oddities to bring a touch of novelty to these furnishings, most of which are just plain boring and industrial. I am not afraid to say it: between the bizarre and the boring, I always prefer the bizarre.

But what a mistake it was to combine this exhibit of furnishings with an exhibit of paintings done by German painters! The honest efforts of the Bavarian artisans to come up to the standards of their French or English counterparts are very badly served by the evident poverty of Bavarian painting.

Let us, however, take a look at the eighteen German exhibition rooms. Here, first of all, is an entrance hall pleasantly decorated by the mosaics of Julius Diez. M. Theodor Veil's large drawing room looks good. The harmonious colors of the carpet are especially appealing. Crystal chandeliers and our own Louis-Philippe furniture seem to be very fashionable in Germany. I didn't see any clocks in this room. In general, there are very few clocks here, and it is not hard to understand why.

The library executed by M. Troost appears quite imaginative, and a number of attractively produced books may exert a healthy influence on the taste of our publishers. It is best not to speak of the paintings that decorate this room. The dining room that follows it is very bourgeois, too bourgeois even. It is the work of M. Niemeyer, who also designed a bathroom that there was no point in exhibiting. One can see the same thing in the stores, and it has nothing to do with art. Only a certain intimate object will hold our attention. It is quite large, and has four faucets. We were mercifully spared the W.C.

Let us skip the well-known Nymphenburg porcelain and cross a hallway containing a bronze *Männekenpiss* whose rakish air will not fail to amuse the visitor. We enter a boudoir designed by M. Otto Baur, which is not devoid of taste. The silver frames of the mirrors, however, appear to me to have been a mistake.

Next is a lady's bedroom. M. Karl von Bertsch, who designed it, does not quite possess all the refinement of taste that one could wish. But one must praise his courage in exposing himself to the expert and sure taste of French women.

As for the gentleman's bedroom, it is not beautiful, but apparently it is practical. A useful but cumbersome triple mirror occupies the place of honor. M. Riemerschmid has a feeling for what is comfortable. From there, we go on to the room devoted to art objects: we find some pretty jewelry boxes, a few curious wax figures and even a paschal candle, some pieces of jewelry without any personality, plus some dolls by Mme. Wenz.

The display from Munich's royal schools of decorative arts and crafts is worth all the rest of this exhibit. These are the works of apprentices who practice at night and who, I must say, are already quite skillful. I think that in Munich the pupils are better than most masters. There are some very interesting works here executed in stone and designed to serve as emblems, some fabrics printed in the wax technique known as batik, and even some medallions that are not without merit. We must, therefore, give our unreserved praise to the professors of the school, Messrs. Berndl, Niemeyer, and Waderé.

In its room, the Munich Künstlertheater is exhibiting the costumes for *Chantecler*. That, at least, is what one would think at first glance. But, no—after inquiry, it turns out that these are costumes for Aristophanes' *The Birds*. That M. Rostand's fame should force the Germans to take lessons from the Greeks, now there is a fact that tells us all we need to know about the influence of France throughout the world! There are some amusing marionettes, and sketches for costumes and stage settings that I find not uninteresting. A fairly tasteful drawing room by M. Berndl is marred by a very ugly thing that seems to be a stove. Following it are a drawing room by M. Wenz about which I do not know what to say, and a music room that seemed to me pretty ordinary.

The last is by M. von Seidl, who I am told is the best-known architect in Germany. On the ceiling are a number of bays in the form of police helmets, which would perhaps be more appropriate in a guardhouse.

To sum up, there is nothing very new here: a few honest and agreeable pieces, executed with care if not with taste, and many mediocre ones.

I have not yet had a chance to see the goldwork or the medals, but among the other art objects there are hardly anything but mistakes.

At the same time, the exhibit of the schools seemed excellent.

So the attack on the Faubourg Saint-Antoine will end peacefully, after all. The attackers, led by the obliging M. Walther Zimmermann and the active M. Grautoff, a German who is very well acquainted with everything French, will calmly make their way back to Munich, where they will sell the greatest possible number of Louis-Philippe armchairs, while our own fine cabinetmakers continue, in the face of any and all obstacles, to propagate Henri II or Louis XVI. Anything not to disturb the habits of our people.

[OCTOBER I]

THE OPENING OF THE SALON D'AUTOMNE

Few Surprises in Painting, Hardly Any Sculpture,
but a Great Deal of Decorative Art

The opening of the Salon d'Automne was a brilliant spectacle. People crowded around the decorative panels by Maurice Denis and by Sert and admired the French furnishings on the second floor. They had discussions about the decorative art from Munich. They were scandalized, as always, by Matisse's paintings.

Bourdelle's *Carpeaux* and Maillol's *Pomona* provoked varied comments. There were many foreigners present, especially Russians and Germans.

As far as painting is concerned, the Salon d'Automne this year

offers few surprises. The two decorative panels by M. Henri Matisse[30] produce a powerful impression. The richness of color and the sober perfection of line are undeniable this time and it is probable that the French public will not continue to ignore one of the most significant painters of our time. *The Old Fisherman*,[31] by Othon Friesz, is one of his best works. This dramatic painting, which the artist clearly ripened in his mind, is also remarkable for its poetic qualities. There is a great deal of humanity in this old man worn out by storms, whose eyes retain something like a reflection of faraway lands. And the background, with the sea and a ship, contributes to the emotion.

I want to mention a *Medea* by Marinot which is a far from insignificant canvas. Apart from the question of craftsmanship, M. Marinot is an audacious painter.

M. Van Dongen is making progress in banality, but his gifts as a painter are evident. [. . .]

M. Pierre Girieud's painting, *Women Bathing*, is among the most important works in this Salon. I am less enthusiastic about his design for a stained-glass window, which, in my opinion, is a mistake. M. Lallemand is exhibiting some flowers that bear the imprint of Girieud.[32] Verhoeven is complicated in his insignificance. [. . .] Laprade's *View of Marseilles* tells us nothing new about the artist but proves that his virtuosity in no way impairs his sensibility. Guérin's *Nude* is pleasant. *The Flagellation of Christ*, by M. Desvallières, bears testimony to that artist's preoccupations and anxieties.

M. de Vlaminck's canvases, dipped in azure, are a pleasure to look at. His manner is becoming more agreeable without losing any of its power. Did M. Alcide Le Beau have his canvases painted in Nagasaki? His exhibit is amusing.

M. Lebasque is making admirable progress in simplicity, as is Camoin, whose landscape is one of the only ones here that are more than a mere view. . . . M. Manguin's nudes are strained.

M. Vuillard is showing us works that in their genre are perfect. This artist has now attained the fullness of a talent composed of good taste and delicate vigor. Kars seems to have drawn a few lessons from Friesz. Diriks is showing some beautiful clouds, with rounded shapes like those of angels. It is better not to stop this year in front of Vallotton's painting.[33] Francis Jourdain's canvases, on the other

hand, are a pleasure to look at, as are Tristan Klingsor's *Still-Life* and Mme. Agutte's *Garden in Springtime*.

M. Maurice Denis's eight panels entitled *Florentine Evening* have their good points, although one wonders how they could have been inspired by Boccaccio's *Decameron*, as is stated in the catalogue. By obstinately striving for purity, M. Maurice Denis ends up with the bizarre. He paints shadows.

M. Russell's academic nudes inspired by Cézanne are regrettable. [. . .]

The imposing decoration that M. Sert has called *The Dance of Love* indicates a great deal of experience and knowledge, as well as a sure discipline on the part of the artist. M. Sert makes no attempt to deny that he has a poetic imagination, which is a rare thing these days.

M. Sert's work, which will appear even better when it is seen in the setting it was designed for, is undoubtedly one of the exhibits most worthy of attention in this Salon.

Jean Deville's paintings will be looked at with interest, for he is an honest artist. M. Manzana-Pissarro is exhibiting a portrait of Mme. Delarue-Mardrus; it is all silver and gold, and in my opinion it constitutes a serious artistic error.

Hung in a corner, as if in punishment, are the two canvases by Jean Metzinger.[34] Metzinger has set himself the task of experimenting with all the various methods of contemporary painting. He is perhaps losing precious time and expending his energies to no advantage. This seems clear enough in the paintings he is exhibiting here, in both of which he appears to me to have taken a step backward. Let him find his own way and stick to it. It is sad to see an intelligent painter wasting his talent on sterile undertakings.

Le Fauconnier has painted a landscape in shades of gray, which is very difficult to do; the picture is imaginatively conceived, if not very well constructed.[35]

This artist has made some genuine progress, for which he must be congratulated. M. Stuckgold is exhibiting flowers. He has painted them full of color and sensuality. Instead of paintings, Raoul Dufy has sent some beautiful and very decorative woodcuts. He is also showing some samples of a series of woodcuts designed to illustrate a book of poems.[36] Naudin's *Christ and Gypsies* is a tumultuous, mov-

ing, and skillfully engraved work. [. . .] People will like a very
detailed miniature by Mme. Van Bever de La Quintinie. [. . .]

Retrospective Exhibits

This year's Salon d'Automne includes three retrospective exhibits,
the most important and most significant being that of the works of
Frédéric Bazille, who died in 1870, at the battle of Beaune-la-Rolande.
Bazille was a friend of Monet, Manet, Renoir, Sisley, Pissarro, and
Fantin-Latour. Manet's influence on this painter is evident, and it
is said that one section of the painting entitled *Studio Interior* was
painted by Manet himself. Nevertheless, one can also detect the
influence of Courbet, and even more so of Stevens. The exhibit of
the works of Lempereur, who died this year, has brought together
some pleasant landscapes. There is also a retrospective of the works
of Trigoulet.

The Decorative Arts

Messrs. Süe, Baignières, Bonnard, and Miss Lloyd have designed
and furnished a very pleasant-looking apartment. For one of the
rooms, M. Bonnard has painted some decorative panels that pro-
duce a most agreeable impression. There are monkeys, gazelles, doves,
little girls, all whimsically but very tastefully arranged; the land-
scapes that constitute the backgrounds are executed in the same
fanciful and witty manner. I will also mention an armchair by
M. Paul Follot, who is responsible for some well-designed and
perfectly proportioned pieces of furniture.

M. Follot has a feeling for furniture that is at once comfortable
and beautiful to look at. He has also designed some tasteful pieces
of jewelry, examples of which are on exhibit here.

Sculpture

There are a very small number of sculptures at the Salon d'Automne.
Emile Bourdelle's *Carpeaux* is the first work to command our

attention. Nevertheless, I tend to believe that this fine statue would have been finer still if the artist had endowed it with different, much smaller, proportions. Maillol's *Pomona* is a remarkable work, which I had already had the opportunity of seeing in a bronze cast. I admit that I prefer it in its present form. The statuettes by Mme. France Raphaël bear witness to a vigorous talent; her *Study of a Nude* is very audacious, and not at all lacking in gracefulness. People will stop to look at a beautiful stoup in chased silver, done by Francisco Durrio, who knows how to mold human shapes into everyday objects; finally, let us mention a disconcerting *Fertility* by Quillivic, who, it would appear, envisions this quality as an obese female Buddha.

(L'Intransigeant)

The Salon d'Automne

Although one could see only a few really first-rate works at this year's Salon d'Automne, there were a number of very interesting paintings. I would certainly be reproached if, writing in this review, I did not mention first of all a fine portrait of the poet Touny-Léris,[37] shown in a charmingly romantic pose. The artist, Mme. Van Bever de La Quintinie, has perfectly captured the likeness of her model; her line is graceful, and her colors are tender without lacking vigor. It is an excellent portrait of the poet and a very attractive picture, as well.

Henri Matisse, whom so many uninformed viewers find disconcerting, is an extremely appealing painter. Very rare and very beautiful color is his trademark, and only a willful disregard for truth could make one deny the decorative power of his works. I personally consider the two panels he exhibited this year the best things done by this artist, whom—and I say this proudly—I alone have consistently championed.

The most substantial work in this Salon is the series of decorative panels by M. Maurice Denis, inspired by the *Decameron*. Maurice Denis is a great and cultivated artist who puts his cultivation to good use. The religious feeling that impels him endows his works

with great purity. One finds purity in these paintings, and one is pleased to see that, on the superior level of culture, the Christian humility and love of a Maurice Denis have succeeded in interpreting, without betraying it, the humanistic paganism of a Giovanni Boccaccio. There is an exquisite music in these paintings, and after becoming aware of it, I was angry with myself for not having heard it the first time.

It must be noted that some very important artists—André Derain, Marie Laurencin, Puy, and others—did not exhibit any works. There has been some talk about a bizarre manifestation of cubism.[38] Badly informed journalists have gone so far as to speak of "plastic metaphysics." But the cubism they had in mind is not even that; it is simply a listless and servile imitation of certain works that were not included in the Salon and that were painted by an artist who is endowed with a strong personality and who, furthermore, has revealed his secrets to no one. The name of this great artist is Pablo Picasso. The cubism at the Salon d'Automne, however, was a jay in peacock's feathers.[39]

A large section of the Salon d'Automne was devoted to furnishings. I will say nothing more about the art from Munich, which is grotesque, as cultivated Germans are the first to admit. As for French furniture, it is hardly any better. I should note that M. Süe did organize an exhibit that appeared to me to have been inspired by genuine good taste, and a boudoir decorated in the most unexpected and charming manner by Bonnard proves that the decorative arts in France can still produce some excellent works.

(*Poésie*, A U T U M N)

The Art World

[O C T O B E R 18]

Marcel Lenoir

The academic correctness of M. Marcel Lenoir's hieratic illuminations might have satisfied a less intense artist. By contenting himself with being merely skillful and sincere, he could have attempted to

rehabilitate the art of religious imagery as it is practiced in the neighborhood of Saint-Sulpice. Having soon found the effort unrewarding, he allowed his excitable temperament to be carried away by the various and difficult endeavors that several times a year revolutionize the plastic arts. He painted hurriedly and drew feverishly, transforming his style with a frequency that is a little disconcerting. Today, M. Marcel Lenoir is exhibiting a hundred paintings and large drawings at the Cercle International des Arts, on the Boulevard Raspail. As an indication of the artistic appeal of these works, it may not be irrelevant to add that M. Auguste Rodin has acquired not less than fourteen of them.

Even if he has not yet freed himself from the most disparate kinds of influences, M. Marcel Lenoir possesses a mastery of his craft and an imagination that is often charming. But uncertainty and an excessive and hitherto unsatisfied desire to be original sometimes hinder the successful realization of attempts that deserve, for a number of reasons, a great deal of praise. Nevertheless, there is no doubt that M. Marcel Lenoir is made for more carefully finished, more patiently deliberated, less hurriedly executed works. He owes it to himself not to shirk these disciplines, which are the signs of such a fine talent.

[OCTOBER 31]

The Russian Painters in the Impasse Ronsin—
The Truth About the Steinheil Case

Who said that the Steinheil case was closed?[40] . . . The Russian painters have just reopened it. I confess that the spectacle awaiting me in the Impasse Ronsin was enough to impress the most cool-headed man. In the courtyard of the famous and sinister villa, I saw a group of persons—Russian or Polish Jews, no doubt—prowling about, dressed in Levitical gowns. As I approached them and saw their faces, I suddenly realized the truth about the Steinheil case.

What looked like a group of Ukrainian Jews was in fact a troupe of French painters, among whom I recognized (I name them in the order in which I recall them) M. Henri Matisse, M. Othon Friesz,

Mlle. Marie Laurencin, M. Van Dongen, M. Alcide Le Beau. Also among them was a sculptor, M. Bourdelle. After what I saw, I think that one must not hesitate for a moment to render these honorable artists responsible for a crime that still remains unpunished; if they did not kill the body of Meissonier's mediocre disciple, they have at least assassinated his work, with a cruelty and a cynicism heretofore unequaled. The new painting, animated by genuinely artistic concerns, reverting to the traditions of periods when masterpieces abounded, and attempting to create powerful works conceived and executed with energy and grace, has killed the dreary painting in which mere cleverness could replace style and talent.

Moved by a spirit of extraordinary subtlety, these unusual assassins have come to exhibit their paintings in the very studio where M. Steinheil painted his. And to carry to its logical conclusions the fantasy that made them choose as disguises the costumes of the polar ghettos, our painters invited some Russian and Polish artists to join them in exhibiting their works. Prince Troubetzkoy sent a few of those wiry and delicate figurines to which he owes his reputation as a sculptor.

The sculptor Elie Nadelman is exhibiting some drawings in which the charm of perfect execution is joined to a noble and graceful style that justifies the pretensions of an artist who is as yet too unknown to maintain that he is continuing the tradition of the great sculptures of Greece. M. Stuckgold has some landscapes, still-lifes, portraits, and sketches that are the result of praiseworthy efforts. The boldly drawn line of his nudes tends to express the soul as well as the body, all with a sensuality that further cultivation will endow with agreeable contours.

Mlle. Vassilieff composes artful and sensual portraits of young women with knowing eyes and feline gestures; the acidity of modern colors endows them with a charm that occasionally compensates for their crudity of form. [. . .]

In a room next to the studio is an exhibit of *koustarys*—earthenware objects, embroidery, and wood carvings done by Russian peasants. The good taste and decorative sense apparent in these works make one think very highly of the artistic aptitudes of the Russian people.

But who would have said it? Who would have believed it?

The Steinheil case was nothing but a practical joke perpetrated by a bunch of daubers.

Henri-Edmond Cross

There is currently an exhibition of works by Henri-Edmond Cross.[41] Cross was one of a group of painters—along with Signac, Luce, and a few others—who, influenced by the great artist Seurat and the theories of Charles Henry, created the branch of neo-impressionism known as pointillism. This branch, which can claim an affinity with the Byzantine mosaics and certain Italian paintings, has over the last twenty years produced a certain number of extremely luminous works.

These canvases are among the last works of the artist, who died a few months ago. The blinding brilliance of these landscapes, the dazzling whiteness of these nudes, and the lyricism that is everywhere apparent in these splendid harmonies are certain to arouse lasting admiration.

As M. Maurice Denis, who was a friend of the late artist, writes in his rich and moving preface: "Let us, in the vibrations of his skies and in the blazing of his fields crushed by the heat of day, listen to the reverberation of terrestrial harmonies; or rather, let us hear the palpitations of a heart and the voice of an enchanted soul."

[NOVEMBER II]

The Ramón Pichot Exhibition

M. Ramón Pichot is a member of that brilliant group of Spanish painters in Paris who are continuing the tradition of Goya or, better still, of Velázquez. There are some among them who, like Pablo Picasso, a man of lofty and powerful culture, have applied their genius to the search for the sublime in art, thus creating works whose influence will increasingly be felt the world over. There are others like Zuloaga, whose powers of observation and virtuosity are second to none.

It is particularly in his marvelous colored etchings that Ramón Pichot proves himself a member of the Spanish school. He shows us gypsies, old sailors, ladies' fans, and flowering pomegranates.

1 9 1 0

In his paintings, which often depict the festivals and fairs of Spain, Ramón Pichot offers us the crowds of Teniers and the colors of "Velvet Brueghel."

This exhibition [42] includes some luscious still-lifes and flowers so delicate and so beautifully arranged that one would think they were painted by a woman. Equally arresting is a pastel of a young woman with a moving expression that reflects the soul within.

[NOVEMBER 13]

The 10th Exhibition of French Graphic Artists[43]

The art of engraving is more respected than ever, and the mechanical processes that at one time seemed liable to do it great harm have served only to emphasize its artistic merits.

This exhibition as a whole is pleasant.

Auguste Lepère's etchings are as distinctive as his woodcuts. His *High Tide on the Rocks of Sion* bears witness to some remarkable gifts and to an expertise that guards its secrets.

Bernard Naudin works conscientiously in the manner of the French and Spanish masters. His inspiration is refined and picturesque. This artist already has a public that follows and supports him.

Louis Legrand has devoted himself to the task of devising shining surfaces and cleverly contrived effects that are widely appreciated. His specialty is the interpretation of poses by barely adolescent ballet dancers.

Let us also mention Jacques Villon's *Nudes* of little girls. [. . .]

(*L'Intransigeant*)

The Exhibition of Decorative Arts from Munich

This year's Salon d'Automne is treating us to an exhibition of Bavarian furniture. These distressingly dreary furnishings and hangings look more as if they had been designed and executed in Berlin than in the artistic city of Munich.

The Decadence of Bavarian Art was the title of a pamphlet published in Germany a few years ago. To tell the truth, the artistic efforts of the Bavarians have for a long time been totally lacking in significance.

Nevertheless, one could praise them for their efforts, if they didn't have the brazenness to come to France and act as though their efforts had produced magnificent results.

It was a mistake to assign such a large space to these gentlemen. We are told that it was a necessary gesture of politeness, in return for the welcome they have accorded our artists in various exhibitions.

However, these individual exhibitions were of an absolutely noncommercial nature. The same cannot be said about the veritable furniture mart that is at present occupying the ground floor of the Grand-Palais.

If it is true that these pieces of furniture were designed by artists or professors, it is also true that the designs were bought and executed by commercial firms who are financing this exhibit and who have already received some very large orders since their arrival in Paris. This business venture, promoted by the immense publicity given to this exhibit, is doing great harm to our own manufacturers and artists, who receive neither state nor private support, whereas in Munich the decorative arts are heavily subsidized. But the real danger is not in the commercial harm that this exhibit is doing to France; it is in the confusion that will certainly be sown in the minds of our artisans, who are already so far removed from the tradition they never should have abandoned. The gracious and comfortable furnishings that adorned the homes of the seventeenth and eighteenth centuries are the finest works ever produced by the domestic arts. Left to their own devices, our artisans would have taken masterpieces as their models and as their point of departure. Unquestionably, the modifications that their taste, their skill, and the necessities and fashions of modern life would have wrought on the art of the cabinetmakers of the late eighteenth century would have produced today a style as honest, as decorative, and as comfortable as those that preceded it. Instead, today's artisans want to start from scratch, without owing anything to the past. It is conceivable that such an ambition can revolutionize the major arts, when the artists involved possess

genuine culture. But in the productions of artisans, only the details must be left to their fancy. And if they are allowed to see the follies of foreign peoples, they will be utterly confused. At the Grand-Palais, the Germans are showing us a kind of distorted and utterly bizarre Louis-Philippe style: armchairs shaped like old women, and lugubrious dining rooms whose furniture and chandeliers seem to be made from gallows trees. This grim effect, turning a dining room into some macabre Montfaucon,[44] would be enough, I think, to kill anyone's appetite.

I won't go into detail about all the worthless jewelry and other knickknacks that do not even carry the imprint "Made in Germany," which the English have forced on the Germans.

It is true that in France the decorative arts are undergoing a crisis of ugliness. That is not a reason, however, for exposing our miseries to the incurable defects of the Germans. We still have at least a residue of good taste that provides some basis for hope. . . .

(*Les Marches de l'Est,* N O V E M B E R 15)

The Art World

[N O V E M B E R 25]

[. . .] M. Eug. Blot invites us to visit an exhibition of sculptures, wood carvings, and potteries done by Gauguin while he was in Tahiti. This artist, whose religious sentiment was vague but profound, and who felt so strongly the need to live in a state of nature at the antipodes, was an artisan full of skill and charm.

[D E C E M B E R 7]

Paintings by Granzow[45]

Since his first exhibition, for which I had the pleasure of writing the preface, Vladislav Granzow has worked hard and long, and has greatly strengthened his decorative talents.

How right Granzow is to show his very fine copies of Velázquez, Rubens, Ribera, and Titian! Let no one consider this a sign of vain ostentation on the part of a traveler anxious to prove that

he is familiar with the great museums of Europe. It is rather the sign of a desire, on the part of a painter in love with his art, to show us that he has studied the masters and has tried to penetrate the secrets of their genius. A high level of culture is nothing to be ashamed of, contrary to what our great ignorant gentlemen and lovely ignorant ladies would have us believe.

These copies of the masters in no way discredit the original paintings by Granzow that hang next to them. As a result of his assiduous study in the museums of the most sublime works of art, Granzow has acquired a taste for composition that has saved him from the excesses of modern realism and that makes one appreciate even more all the qualities of his painting. One senses the presence of some academic formulas in the work of this independent artist, but one also senses other things—tendencies that he is attempting to reconcile by generalizing his compositions within a decorative framework. Granzow is attempting to attain a style.

[DECEMBER 12]

The First Group Exhibition at the Druet Gallery

The Druet Gallery has just opened the exhibition of its first group of modern painters.

We find here a well-known painting by M. Maurice Denis, and some colored drawings in the style of Ingres by M. Vallotton. Also represented are M. Laprade and a Belgian pointillist, M. van Rysselberghe.

M. Odilon Redon, who rarely exhibits his works, has sent some very curious mystical blobs.[46] The modest M. Sérusier has been relegated to a corner, where his paintings seem to be meditating on those of Gauguin. The sculptor Maillol is represented by a relative, M. Gaspard Maillol, whose art appears more unsure than his own. Finally, there are the beautiful and oh, so folkloric! Fatimas of M. Verhoeven. A few Hermann-Pauls and some paintings by Lebasque, who is wearing himself out trying to have something in every exhibit this year. I am certain that the fourth group will be the most interesting of all these group exhibits at the Druet Gallery.

Let us look forward to it.

[DECEMBER 15]
The 28th Exhibition of the Société Internationale de Peinture et de Sculpture is extremely interesting from the point of view of sculpture. Looking at the works on exhibit here, one can witness the great struggle currently taking place between a stiflingly dull academicism and the need to create, however haphazardly, that even the least gifted artists are experiencing today. Let us face it! Not everyone can be God these days. . . . But let us praise M. Théodore Rivière for his love of precious materials. His elephantine sculpture entitled *Bacchus* is agreeably Dionysiac. M. Landowski's *Dancer* captures marvelously the rhythm of a ritual step. In the painting section, we note a portrait of the jovial M. Brisson[47] (let us hear no more about his sadness; in his gaiety he is straight from Portugal, and with no remorse, since it has become a Republic), which is obviously the main attraction of this exhibit. Besides this historic painting by M. Carrier-Belleuse, there are exhibits by Messrs. Henri Zo, Gorguet, Laparra, etc.

An important exhibit of the works of M. Alcide Le Beau is currently being offered to the public in the artist's own studio. These works manifest a great diversity of inspiration, an instinctive ingenuity, and a great deal of learning. Alcide Le Beau enjoys interpreting the art of the Japanese *à la française*—and artists never go wrong when they enjoy themselves.

[DECEMBER 21]
The Vollard Gallery has just opened an exhibition of the very highest quality. It consists of paintings by Pablo Picasso. Although the works shown here were painted some time ago—one could even call them youthful works—the personality of the artist, the force of his talent, and the beauty of the paintings make this exhibit very important. And since Picasso does not exhibit in any of the salons, everyone will at last be able to see in the Rue Laffitte these beautiful works hitherto unknown to the public.[48]

[DECEMBER 23]
Several characteristic works by Pablo Picasso have been added to the exhibit that opened at the Vollard Gallery three days ago. These

paintings, together with the other works in the exhibit, form a very beautiful ensemble that I shall be speaking about again.

Jean Deville, a very versatile and energetic painter who is also known for a number of remarkable woodcuts—among them portraits of Nietzsche and of Moréas—is exhibiting his latest works in his Montparnasse studio. A handsome preface by M. Léon Werth introduces the public to the restless and extremely gifted artist named Jean Deville.

At the Bernheim-Jeune Gallery, there is a first-rate group exhibition entitled simply "Fauna." There are oxen by Corot and Van Gogh; cats by Bonnard with their hair parted down the middle like fashionable gentlemen;[49] stags by Courbet; horses by Degas, Delacroix, Constantin Guys, K.-X. Roussel, and Maurice Denis; dogs by Gauguin, Manet, Monticelli, and Toulouse-Lautrec; peacocks by Cézanne; wild animals by Barye and Delacroix. It all adds up to an admirable ensemble that everyone must go to see. One will also see Seurat's *Circus* and his sketch for *A Sunday Afternoon at the Grande-Jatte*, works that contain all the innovations that modern art can have discovered.

[DECEMBER 25]

Some readers have been asking about the catalogue of the Picasso exhibition currently at the Vollard Gallery in the Rue Laffitte. No catalogue has been printed, just as no invitations were sent out for the opening. The paintings have not even been framed. Although works of such great artistic merit can do without the luxury of frames, it does seem probable that a slightly less casual treatment would not have been out of place.

[DECEMBER 26]

I recently visited the Ecole des Beaux-Arts, to see the exhibition of works purchased by the state this year from the various salons. Before these works are sent off to sleep in the provincial museums, we Parisians are being given a chance to view them all together. As could be expected, the majority of these acquisitions are honest works and nothing more. The only significant things are the sculptures

by Rodin, Despiau, and Bourdelle, and the group by Landowski, which at least reveals a great deal of knowledge. People will be pleased or displeased, according to their aesthetic preferences, to see once again the large panel by Henri Martin and the immense heap of worthless paintings by artists from every corner of the earth. In the meantime, the most beautiful modern paintings are being acquired by foreign museums.

At the Bernheim-Jeune Gallery, along with the very beautiful exhibition of "Fauna," one can also see thirty drawings of women by Constantin Guys. This artist's sketches are finished works, and one understands Baudelaire's enthusiasm for his nervous, precise, modern, rapid, and pithy style.

[DECEMBER 28]

At the Druet Gallery, Raoul Dufy is exhibiting some woodcuts that will illustrate *Bestiaire ou Cortège d'Orphée*, to be published in January.[50] These woodcuts, which display great technical mastery, are treated in a broad manner: details are never avoided, but Dufy does not get bogged down in minutiae. One must point out Dufy's curious interpretation of the legendary figure of the Sirens. Since they disappeared together with the whirlpool of Scylla, at the time of the unforgettable catastrophe that destroyed Messina, it would be extremely difficult to say what they really looked like. The Greeks represented them with the faces of birds and the torsos of women, while, according to the Romans, these charming monsters bore a fishtail, *desinit in piscem*; Dufy has combined these two views: his Sirens have wings and their bodies end abruptly in a round, firm shape, like the bodies of tunas.

[DECEMBER 30]

A poet who is an art dealer? Such a thing has never been heard of, and the one example of it is relatively recent. M. Charles Vildrac is the art dealer–poet, and it seems that among all the artistic professions, none is more poetic than the one he chose. Henceforth, *Ut pictura poesis* will doubtless be his motto.

Having entered into partnership with M. Marseille, M. Vildrac has opened his gallery on the Rue de Seine, a few steps from the

corner of the Rue des Beaux-Arts. He is exhibiting paintings, statues, drawings, and engravings by the pioneering artists who are currently most talked about: Charles Guérin, Pierre Girieud, Bourdelle, Marie Laurencin, Gleizes, Marcel Lenoir, Herbin, Raoul Dufy, etc.

A few days ago, a painting that is already famous[51] made a brief appearance at the gallery. It was a large painting by Picasso, whose exhibition in the Rue Laffitte, at the Vollard Gallery, is enjoying such great success. The painting in question, which was reproduced a long time ago in *La Plume*, figured a few years ago in the Venice exhibition. Bought by a French art-lover whose collection was dispersed at his death, Picasso's work went from auction to the Rue de Seine, but it did not stay there for long.

(*L'Intransigeant*)

1911

Chinese Art

Chinese Raphaels and Rembrandts—Mme. de Wegener's
Famous Collection Is Exhibited in Paris

Several times it has been announced that the famous collection of
paintings Mme. de Wegener brought back from China would be
shown in Paris.

Last year, it will be recalled, the paintings were to have been
exhibited at the Musée Guimet. The invitations had been printed
and sent out, but no one saw the Wegener collection. At the last
minute, the lady from Berlin changed her mind and ordered that the
cases containing the precious scrolls remain unopened.

Today they have been opened, and thanks to M. Brummer, the
paintings of the Raphaels and Rembrandts of China are on view at
the Bernheim-Jeune Gallery, where the public can see them.

When Mme. de Wegener's collection was shown in London, it
was a great success, and the British Museum spent several hundred
thousand francs to acquire some of these ancient paintings.

It caused quite a scandal in Berlin! People heaped violent re-
proaches on the German museums for having allowed a first-rate
German collection to escape from them while they were spending

thousands on a *Flora* falsely attributed to Leonardo da Vinci. But it was too late, and in order not to let it seem as if they regretted their earlier decision, the representatives of the German museums are continuing to look down on Mme. de Wegener's collection.

It is said, by the way, that Mme. de Wegener refused to allow her paintings to be shown at the Musée Guimet because she thought the rooms there were too dark.

The exhibition as a whole strikes one as being very unusual. The Chinese paintings, or *kakemonos*, painted on silk or paper with vegetable pigments, look like infinitely precious advertising posters. In fact, they are scrolls that the Chinese art-lover unrolls when he wants to look at them, then rolls up again and puts away in boxes in order to protect them from light.

The most precious of these paintings is, it seems, the one that depicts a *Shepherd and His Sheep*. It is supposed to date back to the ninth century A.D. There is an *Assembly of Gods* that recalls Giotto and a painting of *Two Sisters* that makes one think of Botticelli.[1] People will look with curiosity, if not with emotion, at a large *kakemono* showing two women, one of whom—the one who is seated —was actually a concubine of I don't know which Chinese emperor of the sixteenth century. She was slandered by her enemies, and the emperor, believing the slander, had her smothered.

Personally, I prefer a charming painting showing a young woman in a transparent red gown, with a few figures of animals and birds whose gracefulness and truthfulness are perfection.

There are also some paintings dating from the end of the Ming dynasty that recall the nervous delicacy and the freshness of impressionist landscapes.

I would gladly tell my readers the names of the great Chinese painters who figure in Mme. de Wegener's collection. But what would be the use of it? Their names are difficult to remember, and there is no chance that they will become popular in France.

All the same, Chinese art—powerful, noble, and sweeping—might well inherit the admiration that has hitherto been reserved for the

Japanese, who, aping the great art of China, have produced only a dwarf.

(*L'Intransigeant*, J A N U A R Y 3)

La Cimaise[2]

The Group's 3rd Exhibition at the Georges Petit Gallery

Today the exhibition of La Cimaise opened at the Georges Petit Gallery. The society, whose honorary president is M. Couyba, has dedicated its third exhibition to Albert Samain. Samain is definitely the poet in vogue these days, and although being in vogue is often a synonym for being outmoded, that does not apply in his case. The members of La Cimaise did very well to place as an epigraph to their catalogue some fine verses such as this:

> *Fais ton pain simplement dans la paix du Seigneur.*

> (Make your bread simply in the peace of the Lord.)

One could hardly find a wittier way of suggesting that the exhibition contains no half-baked products. [. . .]

(*L'Intransigeant*, J A N U A R Y 5)

The Art World

[J A N U A R Y 10]

[. . .] Do you like photography? You will find photographs to your heart's content at M. Druet's gallery. They are lovely and quite accurate reproductions of famous paintings from Leonardo da Vinci to Maurice Denis, including works by Titian, Ingres, Toulouse-Lautrec, and Cézanne.

As for me, I know someone who will rush to buy a reproduction of Seurat's *Circus*, not because he is fond of photographs but because he is very fond of Seurat.

"Realism, the plein-air school, and impressionism," writes M. Théodore Duret in his preface to the Jean Puy exhibition at the Blot Gallery, "produced the same hackneyed forms as the classical and traditional schools that preceded them. In the long run, it turned out to be no more difficult to paint in a conventional manner, using unmixed colors and pure tonalities, than it had been using oppositions of light and shade or by dimming bright colors under a general aura of obscurity."

These just criticisms do not apply to the work of Jean Puy; they are, however, relevant to one part of his work—to certain bathing scenes, certain set pieces like the painting of a plaster torso, and even certain landscapes.

Nevertheless, Jean Puy's often undeniable talent and originality are beyond question. His fleecy and charming nudes have a sensuality that would justify the adventurous passion of a Casanova. Puy's paintings are completely devoid of sadness and imbued with a witty and voluptuous grace that is rare today.

People are certain to like a composition entitled *The Painter*, which would be even better if it were done on a larger scale that is perhaps beyond the capabilities of the artist. But in my opinion, the best piece in the exhibit is an intimate and playful little canvas called in the catalogue *At the Piano*. The painting *Old Man* manifests a genuine effort to attain style and nobility, and succeeds, without losing any of the fine qualities of color and subtlety that are Jean Puy's most pleasing characteristics.

(*L'Intransigeant*)

The 8th Salon de l'École Française

Opens to the Public Tomorrow at the Grand-Palais

At one time, people used to speak of *the* Salon; today, we speak of salons in the plural. Today there are big salons and little salons,

but here at last is a medium-size salon. Its title is the Salon de l'École Française, but it does not represent all of contemporary French art. It does not even come near to doing so. Let us say that it represents a very small part of contemporary French art, the most touching part, to tell the truth: Here we find the naïve, painstaking, and slightly awkward art that we are used to seeing every year in the first rooms of the Indépendants. If several of these artists charm us by their application, their sincerity, and their good will, only a few canvases scattered here and there demand our attention.

The first two rooms contain drawings, watercolors, and pastels. One should look at a curious *Thatched Cottage* by M. C. Clain, who endows what he paints with a heroic aspect, and at the delicate pastel *Landscapes* of M. A. des Fontaines. M. Ed. François's *Stream* is a vigorous watercolor that recalls the slightly somber manner of certain English watercolorists. [. . .]

In Room 3, where there is no shortage of banality, there is a *Dante* even more painful to look at than the French translations of the great poet. [. . .]

M. Albert Duprat has seen the vegetation of Venice, and he may be the only painter ever to have done so. Besides this quite remarkable originality, M. Duprat possesses some talent as a painter. [. . .]

(*L'Intransigeant*, J A N U A R Y 20)

Adolphe Willette

His Works Are on Exhibit at the Louvre, in the
Museum of Decorative Arts

Ah, Willette, what beautiful allegories you compose! One of them, lovingly painted, unquestionably entitles you to the Nobel Peace Prize. The title you chose for it explains it well: *Disarmed, France Will Be Even More Beautiful.* Indeed, your painting shows France as an exquisite and vigorous young girl emerging naked from a suit of armor that could only detract from her beauty!

Willette's credo consists of three finely drawn letters that everyone

will be able to read at the Museum of Decorative Arts, where his exhibit will continue through February 12. "AMO," says Willette. And when he is very old, he will recall, like St. Augustine: *"Amabam amare."*

And yet, this man of love harbors at least three hatreds: he hates M. Bérenger,[3] he hates the English, and he hates War.

It is true that the English and M. Bérenger look at Love with a jaundiced eye; Love, that bizarre activity whose practice is not forbidden but whose description and depiction are considered felonious, under the empty pretext that there are children around. Now I ask you, dear virtuous defenders of the young—if there were no Love, would there be any children?

About Love, as about Arts and Letters, Remy de Gourmont has said all there is to say. Read his *Nouveaux Dialogues des amateurs.* It is a delightful book, full of good sense. Willette, too, has defended Love against the attacks of the preachers. He has sometimes done it impertinently but always with good taste and always to the great benefit of Art. For love is not only another word for French art— it is Art itself, it is universal Art.

As for War, it was inevitable that Willette should hate it, since it is the opposite of Love; one can say that the whitest Pierrot ever to inhabit the heights of Montmartre has made almost as many drawings against War as against the hypocrisy of those who detest Beauty. I will say it again: If anyone deserves the Nobel Prize, it is Willette; and if he should win it, I would give a lot to see M. Bérenger's face!

Willette's art consists above all of a charming alliance between intelligence and poetry, painting and song, allegory and life itself. If there is a great deal of gaiety and carefreeness in the faces he paints, one also finds melancholy in them.

All you Pierrots and Columbines, dreamers, and naughty little girls with lovely breasts, you Eve of Montmartre who use the serpent as a jump rope, and you, too, Willette, all you who smile with such sweetness, you are charming

> *Et tristes comme l'Amour même.*

> (And as sad as Love itself.)[4]

> (*L'Intransigeant,* J A N U A R Y 26)

The Art World

Watercolors by Signac—Tapestries by Maillol

From the Byzantine mosaics to the Libreria of Siena, there are enough works of art from the past to justify the neo-impressionist technique of pointillism. The division of colors has made the painter aware of all their potential brilliance. The slowness of execution demanded by this discipline obliged painters to pay greater attention to the composition of their pictures. These evident advantages would be enough to make one take notice of a school whose members were never numerous. Still, it produced some first-rate painters: Seurat, whose place is among the very greatest, Henri-Edmond Cross, and Paul Signac, who is currently exhibiting his latest works at the Bernheim Gallery. There are a few paintings, some watercolors in pure tones, and the cartoons that Signac uses in planning his paintings. These last have not been seen before. They are very beautiful drawings, broadly executed and well composed. Signac's works, whether drawings, watercolors, or paintings, bear no sign of haste—a fact that sets them far apart from impressionism.

The watercolors all deal with different aspects of the Seine at Paris, and they are combined under the general title *Bridges of Paris*. After all, are the Seine and its bridges not the most beautiful things in Paris?

Also being shown now at the Bernheim Gallery are some tapestries by Aristide Maillol. The material is lovely, but the compositions are ridiculous.[5]

(*L'Intransigeant,* J A N U A R Y 28)

The Salon of Women Painters and Sculptors

At the Grand-Palais, Many, But Not Too Many, Flowers—
and What a Pity! Not Enough "Feminine" Works

The 30th Salon de l'Union des Femmes Peintres et Sculpteurs opened at two o'clock today at the Grand-Palais.

Anywhere outside France, perhaps even in Italy, an exhibition of this kind would be ridiculous and pretentious. But in France, even the most insignificant things possess a grace and a freshness that save them. Here, for example, is an exhibit almost totally lacking in important or remarkable works; yet, there are so many pretty landscapes, so many fresh bouquets of flowers and innocent portraits of young girls that one cannot help being enchanted.

I am not among those who discount in advance the works of women, and especially of French women. I am of the opinion that their influence on the arts will be beneficial, and I count on their good taste, on the gracefulness with which they try to reproduce what appears to them beautiful, on their sense of order and elegance to lead our painters themselves back to the simple and pure beauty known to antiquity and rediscovered by the Renaissance. Yet, one finds here not a single one of those women who, if they wish, can assume this role in the renaissance that will arise from the ruins of impressionism. I will not name them. Let everyone guess who they are.

But let us take a look at this exhibit, which, if lacking in force and sublime grace, nevertheless has a very delicate charm.

Oh, vanity of formulas! Impressionism was one of them, and it produced very weak works in the hands of women, as this exhibit makes only too clear. [. . .]

(*L'Intransigeant*, FEBRUARY 5)

The Art World

The State of Painting Today

In a very important little book entitled *Le Dernier État de la peinture*, M. Michel Puy, the art critic of *Marges*, describes the artists and the schools that have succeeded impressionism. As M. Puy rightly states, "The interest of the pictorial movement in the last few years has focused on the painters who claim descent from impressionism." The book begins with an unexpected and very zestful tribute to M. Jacques Blanche, then goes on to speak of neo-impressionism and Signac. One chapter deals with the painters that M. Maurice Denis depicted as a group a few years ago in his *Homage to Cézanne*: Roussel, Bonnard, Vuillard, Sérusier, M. Maurice Denis himself, and M. Vallotton. "It appears," adds M. Puy, "that Bonnard may be considered the most incontestably gifted of today's painters." The book next deals with the group of painters who were quite incorrectly called fauves and whose preference for composition and pattern makes them, despite some serious errors, the current heirs to the most lofty artistic tradition. M. Puy has some excellent things to say about Matisse: "He is responsive," he writes, "to every inflection of form, every variation of color." Although he does not sufficiently appreciate all the beautiful sensuality of the work of his namesake Jean Puy, Michel Puy tells us what he thinks of Marquet, Manguin, De Vlaminck, Friesz, Girieud, Van Dongen, and Braque, and his pages on them abound in solid observations. Mlle. Marie Laurencin's draftsmanship is perhaps more deliberate and more carefully thought out than M. Puy admits, and if he does not give Derain all the credit that is his due, not only as an artist but as an innovator, and makes no mention of this painter's influence on a Matisse, for example, he is even more unjust with regard to Picasso, whose name he mentions only once and whose work, despite the blindness of those who should be more clear-sighted, is . . . But how is one to explain these things in the pages of a newspaper at a

time when every exhibition hall in Paris proclaims the triumph of the most mediocre paintings, while the independent painters, harried by a hatred that is all too easy to understand and pursued by every jackass in Christendom, find no home for their works? By all means read Michel Puy's little book; it is an excellent summary of the state of the new painting in France today. "By talking so much about tradition and constantly invoking it," concludes the author, "one runs the risk of falling victim to a word; to the Academy, none of the great painters of the nineteenth century—not Delacroix, Corot, Chassériau, Courbet, Manet, or Puvis—represents tradition. Ingres himself did not represent it during his lifetime. What justifies the new painters is that they have rejected precepts and undermined canons only in order to rediscover the laws of painting."

(*L'Intransigeant,* F E B R U A R Y 14)

The Aquarellistes Français

Their 33rd Exhibition at the Georges Petit Gallery

The President of the Republic and M. Dujardin-Beaumetz have opened the Exhibition of the Aquarellistes Français. This devotion to and enthusiasm for the arts would be charming, if only it were directed toward truly interesting works. Alas! Every day brings the writer on art a dozen new exhibitions. Alas, and again alas! What happens to all the paintings one sees exhibited? I think that they probably melt away. *Mais où sont les neiges d'antan?* And that is the best thing that could happen to them. Why, oh, why, are most of the watercolors one sees here on exhibit? What rage or madness inspires so many altogether worthy people to want to become artists in spite of art itself? What singular habit—the result of atavism or of education—forces our eyes to see these painted landscapes, portraits, and animals, all of them absent and all of them, one hopes, never to be seen again!

Let us note the paintings and the names of the painters: M. Adan and his nooks in Versailles. How moved I was before the children's

portraits by Maurice Boutet de Monvel. They are painted meticu-
lously, so that they are more like miniatures. I remember a book
I loved to read when I was little. It was by Lucien Biart, illustrated
by Boutet de Monvel, and its title was *Quand j'étais petit!* Here
are some drawings touched up with watercolors by Mlle. Carpentier.
They are views of Versailles, and in two or three of them there is a
pretty sentiment. The watercolors brought back from Egypt by M.
Georges Clairin held M. Fallières's attention for a long time; M. Doig-
neau is interested in centaurs and centaurettes. [. . .]

(*L'Intransigeant*, F E B R U A R Y 19)

The Art World

[F E B R U A R Y 23]

The Société Moderne is holding its third exhibition at the Durand-
Ruel Gallery, 16 Rue Laffitte. If there are no masterpieces here,
there is at least a great deal of variety, and not always in the best of
taste. That characteristic impressionist device of placing objects and
figures all askew, pellmell on the canvas, still predominates here in
many a painting. [. . .]
One must pause before the series of paintings by M. Alcide Le
Beau based on Flaubert's *La Tentation de saint Antoine*. Technically,
there is nothing very remarkable about these paintings, but they are
certainly as bizarre as anyone could wish. Startling visions, a bit
comical but very personal! Le Beau is not faithful to Flaubert's text,
which has inspired in him nothing but oddities. However, they cannot
possibly leave us indifferent, and I am thinking especially of the
paintings that translate texts such as "*Je me suis réfugié à Colzim et
ma pénitence fut si haute*" ("I sought refuge in Colzim and my
penitence was so great"), or "*J'ai envie de voler*" ("I feel like fly-
ing"), or, above all, "*J'ai envie de nager*" ("I feel like swim-
ming"). . . . [. . .]

There is no doubt that one of the most interesting exhibits going
on at the moment is the Vuillard show at the Bernheim Gallery. One
has an opportunity to compare the artist's recent productions with
his older works. I personally prefer the paintings he did in 1910,[6] in

which the elegance that marks all Vuillard's works appears purer, simpler, more powerful. Details are carefully finished, and the whole imparts a great sense of calm. The delicacy of the tones is surprising, and colors contrast delightfully. What an intimate and charming art! Here intelligence takes the place of the sublime.

M. Henri Rousseau's signature[7] looks a little bit like the signature of his namesake, the Douanier.

But the first M. Rousseau need not worry—no one would dream of confusing their paintings. The principal interest of this exhibit at the Georges Petit Gallery is in the similarity of signatures.

At the Druet Gallery, M. Hermann-Paul is showing caricatures of M. Vallotton's paintings. There is nothing more disagreeable than the errors of intelligent men, and M. Hermann-Paul is very intelligent. [. . .]

M. Cachoud loves the night, and he proves it by exhibiting a large number of nocturnal paintings at the Georges Petit Gallery. "They make one dream," says the catalogue.[8] That is a nice way of saying that they make one go to sleep. [. . .]

[FEBRUARY 24]

The Americans of Paris

A group of American artists living in Paris has just organized a very pleasant exhibit at the Devambez Gallery. These Americans have all, it seems, been influenced by contemporary French painting. One finds here all the tendencies of our various schools of painting, with the notable exception of the École des Beaux-Arts.

M. Alfred H. Maurer is visibly under the spell of Matisse, even down to his signature. The colors of M. Butler's *Sunsets at the Seashore* are too faded, too green, too pink, too pale. K. A. Buehr's *Waiting* is the vehicle for a rather amusing contrast of blues and yellows. Then there are ample impressions of Scandinavia! The Americans of Paris often go to Norway to paint, as did M. Walter Griffin and M. W. H. Singer. M. Edward M. Steichen paints sym-

bolic pictures, among them Rodin's *Balzac* haloed by moonlight, a *Spring Landscape* painted in soft colors, a *Summer Afternoon* with pleasantly decorative flowering branches, and a *Spring Night* all in green, with a nymph stepping out of her clothes.

M. Eugène-Paul Ullmann paints seascapes reminiscent of Boudin's. Miss Francesca Thomason finds her inspiration in the Luxembourg Gardens, whose nobility and beauty were praised by Jean Moréas. M. Lionel Walden paints mists with too much care and too much mist.

Let us also note a plump young woman by Frieseke, dressed in a negligee and examining herself in a mirror, as well as Parke-Custis Dougherty's *Washhouse in Vannes*, Harold Heartt's pale gouaches, Richard Miller's *Nude*, a portrait by Lawton Parker, and W. E. Schumacher's *Bedtime*.

Noteworthy among the engravings are Joseph Pennell's beautiful and delicate drypoints, especially *A View from Horseback of the City of Puy* and *A View of Toledo*. M. Webster has captured some aspects of Old Paris in his etchings. Let us also mention the etchings by M. Aid and the woodcuts by Timothy Cole, as sharp as steel engravings, the engravings by M. MacLaughlin, the charcoal drawings by M. Fromuth, and the bronzes by M. Bartlett. To conclude, we can say that in the absence of an outstanding personality, the work of these American artists exhibits skill, intelligence, and sometimes even elegance.

(*L'Intransigeant*)

The Former "Société Nouvelle"

Its Exhibition Was Opened Today,
with Auguste Rodin Presiding

The former Société Nouvelle opened its annual Salon today at the Georges Petit Gallery, under a new title: "Exposition des Peintres et Sculpteurs."[9] This exhibition was, with good reason, placed under Rodin's chairmanship. It is, in fact, this Salon's sculptures that are the most audacious, the most masterful, and the most inspired.

1911

Auguste Rodin's contribution—a bronze head of a man—is a figure full of life, pride, and power. Rodin's hand is as sure as ever, and his art is full of charming youthfulness.

Despiau has sent a portrait in plaster, the *Bust of Mme. Fabre*. It is one of his best works. The head is full of that harmonious life which animates true works of art. Despiau usually works directly in marble, as in the statuette he is exhibiting here. His nude is emerging from the immaculate block of stone like some Aphrodite enclosed in a frozen wave. The entire upper part of this statuette—head, torso, and hips—is delightful.

Mlle. Jane Poupelet has a bronze *Cow Returning to the Stable*, a lovely work worthy of the greatest sculptors. It is the outstanding work of this Salon and of this very gifted artist. Mlle. Poupelet is also showing an audacious nude, beautifully finished and harmonious. [. . .]

The paintings on exhibit here are of less interest than the sculptures. They are the works of very successful painters whose achievements one no longer dares question. One must mention the decorative panels of M. Aman-Jean. M. Jacques Blanche's *Salome* is a dancer at rest and dressed for town, so that only her dancing slippers indicate the model's profession. M. Blanche is also exhibiting a portrait of the dancer Vaslav Nijinsky, some interiors, and some English landscapes. [. . .] M. André Dauchez is, as usual, showing some harsh landscapes with skeletal trees. [. . .] Here too are the sunny confetti of M. Le Sidaner, and M. Henri Martin's landscapes.

(*L'Intransigeant,* MARCH 11)

*

[*Bestiaire ou Cortège d'Orphée*]

The sober poems that make up Guillaume Apollinaire's *Bestiaire ou Cortège d'Orphée* constitute one of the most varied, most charming, and most finished works from the new generation of lyric poets. This collection, although very modern in feeling, is closely linked in inspiration to the works of the noblest humanist tradition. The same spirit that moved the poet has inspired the illustrator, Raoul

Dufy, who, as everyone knows, is one of the most original and skillful reformers of the arts that France can claim today.

Printing on a hand press is a very slow operation, and one that requires a great deal of care. It alone produces perfect results. Bibliophiles who are also connoisseurs of arts and letters will be grateful to the Deplanche publishing house for offering them a book whose handsome typographic execution is assured by the reputation of the Gauthier-Villars printing firm.

Bestiaire ou Cortège d'Orphée deserves to be considered one of the rarest and most beautiful books of our time.

(Subscription flyer for the *Bestiaire*)[10]

The Art World

The Second Group Exhibition at the Druet Gallery

[. . .] M. Georges Rouault is exhibiting some designs for chinaware decorations[11] in which one finds a tumultuous grandeur and something like a touching hatred for beauty. [. . .]

(*L'Intransigeant*, M A R C H 15)

English Art
The Pastelists of the Eighteenth Century

The Exhibition on the Rue Royale—The Most Admired Works

I must say first of all that no comparison can be made between the English pastelists of the eighteenth century and the French pastelists of the same period, just as no comparison can be made between the French art and the English art of the eighteenth century in general.

The English would come out by far the losers in any such com-

parison; in pastels alone, the English have nothing to equal the works of La Tour and Peronneau.

After these preliminaries, I hasten to add that a visit to the exhibition just opened at the Brunner Galleries, 11 Rue Royale, is an extremely pleasant experience.

If the English pastelists have less craftsmanship and a greater tendency toward caricature than their French rivals, they had female models of incomparable beauty, and their portraits of men and women have a touch that reveals character. Richardson and Fielding, and more recently Dickens and Thackeray, have given us the literary equivalents of the expressive faces that we see in today's exhibit.

The Italianate English artists are, as one expects, the least interesting, with the exception of one Hoare whose name was unfamiliar to me but one of whose figures, *Sleeping Woman*, recalls Ingres.

English life in the eighteenth century, especially in London, was extremely free and voluptuous. Courtesans triumphed at every level of society, all the way from the poor painted creatures, their eyes darkened with India ink, who would wait all night in the taverns for the rakes, up to the young women who could be found in the bagnios and seraglios of Vauxhall Gardens or on the list kept by the manager of the Shakespeare Head, or the beautiful wenches from the provinces, such as the famous Mary MacIntyre, nicknamed Polly Brown, who lived in Scotland and whose fine portrait by Masquerier is on exhibit on the Rue Royale, and even up to the adorable Lady Hamilton, whose defenders slandered her by thinking her virtuous. The exhibit contains a beautiful sketch of this lovable Fury by Henry Singleton.

Only the model's rank justifies the inclusion of a very bad *Portrait of Queen Charlotte* by the famous Swiss artist Angelica Kauffmann, whose reputation far exceeds her talent. She was an execrable painter, but she had many lovers among the painters—Reynolds was one— and elsewhere. There has even been some gossip about her relations with Queen Charlotte. But let us not insist on that, and let us admire unreservedly the admirable series of portraits painted by John Russell, whom the catalogue justly calls "the greatest pastelist of the English School." There is the charming *Portrait of Miss Winifred Egan*; the *Portrait of the Artist's Uncle, Mr. Russell*, a magnificent pastel with a model who would have enchanted Dickens; *The Little Girl*

with Strawberries, a masterful portrait of the artist's granddaughter; the truculent portrait of the *Rev. John Newton*, who was a Rabelaisian caricaturist; the voluptuous sketch of Miss Dowden; the *Portrait of the Artist*, a fine strong head with penetrating eyes and a mop of gray hair over a young face; the *Portrait of the Artist's Wife and his Son William*, a picture of joyful maternity; the romantic portrait of *John Bacon, Jr.*; the portrait of the swimmer at Brighton, *Old Smoaker*, who is a character out of Thackeray; the portrait of a likable Moor with languid eyes, *Mohammed Sumny*; the dramatic portrait of Mrs. Wilton and the lively face of Mrs. Wormald under her large bonnet. People will also look at the fading but pretty pastel by Lady Diana Beauclerk: *Portrait of Mary and Elizabeth Beauclerk*.

Curiosity will likewise be aroused by the *Portrait of One of the Daughters of the Marquess of Bristol*, painted by the Countess of Buckinghamshire, nee Bertie, who is the great-grandmother of the English Ambassador.

The Irish pastelists, such as George Chinnery, with their gray backgrounds and delicate shades, are certain to appeal to French taste. There is also a portrait by the landscapist Constable, and one of the *Countess of Errol*, that fine and merry dame, by Francis Cotes, the "father of the English pastel."

One of the real pleasures of this exhibit will be the discovery of the pastels of Gardner, who was, without a doubt, one of the most artistic of Englishmen. People will especially like his precise and elegant *Sir John Taylor*. They will also look at the *Young Madwoman*, which was the first work exhibited by Sir Thomas Lawrence. There is also a portrait of a child by Pack, who rarely signed his works, many of which are attributed to the illustrious Russell. Let us also mention a lovely *Portrait of the Miniaturist Eliza Phelps*,[12] an exquisite young woman in a large straw hat. [. . .]

English pastels, colored and charming dust, the Parisians will love you! They will love you too much, in fact, for my taste. All these refined English works have a certain bizarre mélange of mawkishness and brutality, of gracefulness and the most puerile, most affable bad taste, which Frenchmen should find a bit disconcerting. But Anglomania has its rights. After all, does not one of the best and

most penetrating writers of our time, M. Abel Hermant, nurture an incomprehensible passion for English art? It is, in truth, an art whose candor is captivating and whose good humor rejoices the heart.

(*L'Intransigeant,* APRIL 8)

The 31st Salon de la Nationale

[APRIL 14]

The Painters' Opening—A General View of the Exhibition

Art critics will be overworked this year. In the space of less than two weeks, they will have to examine in detail three different salons: the Nationale, the Indépendants, and the Artistes Français. The difficulties raised by the authorities concerning the exhibit of the Indépendants have caused a delay in the opening of that interesting salon; while the art season is usually inaugurated by the Indépendants, this year it is the Société Nationale des Beaux-Arts that will have that honor.

The Painting Section

The abundance of decorative works gives this year's Salon a particular character. One can distinguish something like a general striving toward harmony, a general attempt to attain a style. This is an excellent tendency, and in my opinion, one cannot praise it too much.

What an admirable firmness of line there is in M. Eugène Burnand's *Sermon on the Mount*! In this severe and ardent work, the artist has grouped beneath the inspired face of Christ a whole people anxious to hear the holy Word. A noble art shines forth in these cartoons. Every character is rendered with austere truthfulness. The arid and grandiose landscape bounded by the horizon forms a harmonious background. One is truly moved by so much faith and grandeur. In this simple and excellently ordered composition, even the splendid triangular hill that rises behind Christ has an evident significance.

The fragment of a ceiling painted by M. Besnard for the Comédie-Française is a brilliant work that cannot yet be properly judged. From what we see today, it promises to be a beautiful and very decorative work. The portion exhibited by M. Albert Besnard is a felicitously expressed allegory. It represents *the* original drama. On the right side of the panel stands the tree of knowledge of good and evil, with the serpent—shown as a human figure, with a woman's bust—offering the apple to the first couple. The figures of Tragedy and Comedy are nearby, while the statues of Racine, Corneille, Molière, and Hugo, enshrined in glory, watch the spectacle, as figures of Fame sing praises.

Equally allegorical is M. Anquetin's cartoon, which will be executed at the Gobelin tapestry works. It is a symbolic representation of Burgundy, and although it is irreproachable from the point of view of execution, it is so conventional and so impersonal that the best one can say about it is that it looks like a copy of some famous work. [. . .]

M. Hanicotte's painting of *The Fisherman's Burial* in winter, in Volendam, Holland, will also attract attention. It is a large, overly tragic canvas, in which facial expressions are exaggerated to the point of caricature. It produces a powerful impression and is powerfully expressed, yet on the whole it is less successful than this artist's *Kermis*, which everyone found delightful last year. People will also look, as they should, at M. Jacques Blanche's interpretations of the Russian ballet, and at his still-lifes. M. Jacques Blanche is changing his manner: He is abandoning London in favor of Tehran. [. . .] This first visit to the Nationale must not end without a mention of Muenier's *Harpsichord Lesson*, which contains some charming things—the hat placed on the ground and the ray of sunlight, for example—but in which the bouquet of flowers is out of place, since it is not of the same season as what we see in the rest of the picture and constitutes, therefore, an extremely jarring detail.

Sculpture

In this year's sculpture section, there are a few excellent works. As of this morning, neither Rodin nor Bourdelle had sent his

statues, which we will discuss at another time. It seems to me, how-
ever, that the large stone group by M. Marcel-Jacques, entitled *Love
and Servitude*, is the chief glory of this Salon. It is a first-rate work.
Its art is wholesome, its conception fine, its execution perfect. For
my part, I was enchanted to see it. Mlle. Jane Poupelet's exhibit is
also excellent, full of harmony and of a simplicity that is at once
graceful and powerful. She is exhibiting a plaster cast entitled *Facing
the Wave* and a bronze *Cow Returning to the Stable*, which is
extremely pleasant to look at. [. . .]

<p style="text-align: right">[A P R I L 15]</p>

The President of the Republic visited the Salon de la Société
Nationale des Beaux-Arts today, accompanied by M. Dujardin-Beau-
metz and by several prominent figures from the world of arts.
The President made the tour of the various exhibition rooms and
asked to be introduced to a number of artists. In the sculpture sec-
tion, he especially admired the works of Rodin, Bourdelle, and Marcel-
Jacques. Among the paintings, he gazed for a long time at the ceiling
of the Comédie-Française by M. Besnard, at the works of Roll,
René Ménard, and Eugène Burnand, at the cartoons for the frescoes
of the Petit-Palais by Paul Baudouin, etc.

Let us begin a more detailed visit of the Salon today. First of all,
let us take a look at the ground-floor rooms reserved for sculpture.

Sculpture

As of six o'clock last night, the two works by Rodin listed in the
catalogue under the titles of *Bust of the Duc de Rohan* and *Eighteenth-
Century Bust* had not arrived. The master sculptor had, however, sent
a splendid marble work, in which light plays marvelously over per-
fectly beautiful forms. The works sent by Bourdelle are also very
beautiful: *The Fruit*, a bronze statue of a young girl; *The Bust of
the Writer Charles-Louis Philippe*; and *A Blonde*, a stone bust of
a woman. Bourdelle has captured the essential likeness of Charles-
Louis Philippe, his female bust is full of a perverse grace, and *The
Fruit* is a noble and sensual work.

As for the rest of the exhibition, I have already expressed my admiration for Marcel-Jacques's beautiful group, in which nothing essential is lacking, in which everything indicates a robust and first-rate talent. It is to be hoped that this work, which was commissioned by the state, will remain in Paris, adding a touch of beauty to some spot where it might console us for all the ugly things we are forced to see in the public parks and squares. [. . .]

The Painting Rooms

Room 1. On view here is a painting by Roll, *The Liberator José de San Martín*, to be executed by the Gobelins tapestry works for the Republic of Argentina. I prefer Fox's *Girl Students* and certain details of his *Repose*, even though a certain mauve shirt and the painting as a whole . . . Hmm . . . M. José Belon's *Sorrow*, which the artist placed in Provence, is a well-lighted and conscientious painting. M. de la Gandara shows us a lady in a gray riding habit, with yellow leather boots and suède gloves; a young girl in an old-rose satin dress, with lace and ribbons at the waist; and a lady in black, with a lace stole and a dark red rose. [. . .]

Room 2. [. . .] The works of M. Aman-Jean constitute the most substantial exhibit in this room. The series of decorations entitled *Saltimbanque* and *Girl Playing a Viol* belong to the Museum of Decorative Arts. M. Aman-Jean is also showing a decorative panel and some portraits, among them one of Mme. Lucie Delarue-Mardrus. All these works are imbued with the artist's usual mannerism, which gives everything he does somehow the appearance of still, green water, a lagoon, or a pond.

Room 3. M. Alexandre Séon is showing an *Orpheus Reclining*, crowned with pale gold and holding an antique lyre; he is half-dressed, and the site of his meditations is a seashore with rocks. I like the spirit of the work, but I detest the sight of it. [. . .]

Room 3-A. This room contains [. . .] the work of Mlle. Olga Boznanska, whose slightly German mannerism has enabled her to capture perfectly the Teutonic traits of the poet Emile Verhaeren.

Room 5. [. . .] Willette's exhibit is very amusing, and full of an audacity that will make maidens and hypocrites blush. There is a

Siesta and a perfectly modern *Temptation of Saint Anthony*. Willette's is a familiar, natty, and very amusing art.

Room 4. This room contains *Burgundy*, the cartoon by Anquetin that I have already spoken about; a skeleton strolling in a garden, by Marcel Roll; a landscape by Lebourg, who likes Turner very much; and a naked woman in front of a triple mirror, a *tour de force* by M. Bracquemond, who has succeeded in showing us a woman seen from the back, the front, and in both left- and right-hand profiles, without revealing her stomach and her nether region. This is a nude *ad usum Delphini*, one that is certain to please M. Bérenger.[13] [. . .]

[APRIL 16]

Finally, all Rodin's works have arrived. Besides the beautiful piece in Italian marble that I spoke of yesterday (its title is *The Broken Lily*, and it is destined for the tomb of a young man), we can now see the *Portrait of the Duc de Rohan*; this is a replica in marble from Asia Minor of the bronze bust that elicited our admiration last year, and personally I prefer the bronze.

Let us continue our visit to the rooms devoted to painting. [. . .]

In the works of Messrs. Francis Jourdain, Guérin, Flandrin, Desvallières, and Maurice Denis, we see the new spirit making its appearance at the Nationale. [. . .]

Room 6-A. The three decorative paintings by Maurice Denis are entitled *The First Steps, September Evening*, and *The Sunny Square*. Although personally I do not find them wholly satisfying, they constitute, as one would surmise, one of the most significant exhibits of the Salon, and they form a striking contrast to the banality of the rest. Let us admit, however, that they would appear less striking at the Indépendants or at the Salon d'Automne. [. . .]

Room 13. This room contains the lovely ladies of Boldini, very tense and seemingly painted with a single brushstroke. His style would be high-spirited, if it were not so dispirited.

Rooms 15 and 16. M. Auburtin has painted Sirens this year, and they are not the birds that led navigators astray and that the Greeks invented; they are Scyllas with fishtails. [. . .]

Room 18. *The Lover's Sacrifice*, by M. Caro-Delvaille, appears

purposely and somewhat falsely ingenuous. That, at least, is my impression. [. . .]

The Decorative Arts

[. . .] Very special mention must be made of Brindeau de Jarny's electric chandeliers, executed with great taste and success. I especially like the bulbs that look like sea urchins. M. Brindeau de Jarny finds his inspiration in nature, and he neither avoids nor hides rational elements, such as screws and nails. His iron fixtures, locks and keys, are excellent and very sensible works. How precisely—with a minuteness that has nothing vulgar about it—he has been able to render a leaf dried up by the sun, or a cherry pecked at by the birds! It is details like these that reveal an artist. [. . .]

(*L'Intransigeant*)

The Salon des Indépendants

[APRIL 20]

The Opening Is Scheduled for Tomorrow—A General View of the Exhibition—The Triumph of the Douanier Rousseau

We have an excellent Salon de la Société des Indépendants this year. The battles it was obliged to fight have strengthened the Société. More than four hundred new members have come to swell its ranks. Some people thought they had succeeded in overthrowing the Indépendants. But the Indépendants shares the fate of Antaeus: Thrown to the ground, it arises stronger than ever.

The general appearance of the Salon has been completely altered. Certain groups that formed a compact block last year have now been divided and set far apart from each other. One can note a kind of fission in the group known as the fauves—a fission that is not only apparent to the eye in the exhibition rooms but is particularly noticeable in the spirit of the works exhibited. A striving for composition has now taken precedence over impressionist efforts, and hardly a trace of impressionism remains in Rooms 41 and 43,

which contain all that is energetic and new in this year's Salon. I shall speak of these rooms again; for the moment, let me simply mention the important works by Delaunay, Le Fauconnier, Marie Laurencin, Metzinger, Gleizes, Léger, Lehmbruck, Maroussia, De Vlaminck, Girieud, and Van Dongen in Room 41, and the works of Dunoyer de Segonzac, Albert Moreau, La Fresnaye, Detaille, André Mare, and Mainssieux in Room 43. This is not to say that there are no other rooms with fully realized works: but they do not have the same note of novelty. Room 27 contains Matisse's painting,[14] which is a marvelous harmony of highly personal colors, as well as the modest and very beautiful exhibit by Raoul Dufy; Room 40 displays the compositions of Lhote and Granzow; and Room 28 has an admirable exhibit of the works of Henri-Edmond Cross, who died last year, as well as a luminous group by Signac. I will speak about these in detail later; today, I want to devote the space that remains to Rousseau the Douanier.

Today's young artists wanted to express the admiration they feel for the works of that poor old angel, Henri Rousseau the Douanier, who died at the end of the summer of 1910. They have organized a retrospective exhibition of his work [. . .] which has been installed in Room 42, exactly between the two most significant rooms of the Salon that will open tomorrow; these are, as I said earlier, Rooms 41 and 43. [. . .][15]

Will the public understand the importance of this exhibit? I very much hope so. One can find modest taverns where the dishes cooked by the owner's wife and the wines lovingly tended by her husband are more delectable than those of certain brilliant restaurants where everything is outstanding except the food and wine. In the same way, the Douanier's painting is an excellent thing in a setting that is not luxurious. Oh, his is not a hygienic art; it is simply a wholesome art, well worth the visit.

[APRIL 21]

Today's Young Artists and the New Disciplines

Having expressed my thoughts about Rousseau, I now turn to Room 41, which, together with Room 43, is the most interesting room

in the Salon. That is doubtless why almost all my colleagues, the art critics, are ignoring them. Yet one finds in these rooms more forcefully than anywhere else—and I mean not only at this Salon but anywhere else in the world—the sign of our times, the modern style that everyone pretends to yearn for, that everyone is seeking without being willing to recognize where it is to be found. We are witnessing today the formation of a stark and sober art, and the rigid aspects it occasionally still shows will soon become humanized. Future historians will tell what influence the works of a Picasso had in the development of such a new art. But the influences one could find dating back to the most noble periods of French and Italian art in no way lessen the merit of the new painters. Among the most talented of these artists, one must acclaim Robert Delaunay; his robust talent is endowed with both grandeur and richness. The exuberance he manifests assures his future. He is developing as a draftsman and as a powerful and lively colorist. His *Eiffel Tower* has a dramatic impact, and his skill is already very sure. Le Fauconnier's mighty effort has resulted in *Abundance*, a rich composition in sober colors whose forms and figures, objects and landscape are all conceived in the same spirit and are harmoniously linked in expression and sensibility. Marie Laurencin's two paintings—*Portrait* and *Young Girls*—are sober, firm, and audacious; the gracefulness and nobility of her work makes it worthy of the very highest praise. As for the sureness of her taste, to my knowledge only Picasso has equaled it.

Metzinger's are the only works here that can properly be called cubist,[16] and the attractiveness they all possess proves that the discipline of cubism is not incompatible with reality. This art, which can in a sense be called cinematic, aims to show us every facet of plastic reality, without sacrificing the advantages of perspective. On the whole, the method is not tiresome, and it is firmly stated. This is an art that plays with difficulties and conquers them. I thoroughly enjoy the painters I have just mentioned.

Albert Gleizes's delicately shaded, broadly conceived landscapes recall those of Le Fauconnier. That, however, is not their only merit. Gleizes's hard work has produced results in his figures—*Nude* and *Woman with Phlox*—which are full of personality and vigor. M. Firmin [sic] Léger's works are probably the least human in appearance of any in this room.[17] His is a difficult art. He creates cylindrical

painting, if one may use that expression, and he has not avoided giving his composition the wild appearance of a heap of tires. But never mind! The discipline he has imposed on himself will soon bring order to his ideas, and one can already perceive the originality of his talent and of his palette. Let us mention the instinctive canvases of Maroussia, imbued with gaiety and feeling. The sculptor Lehmbruck, who does not lack merit, is exhibiting some drawings.

Some Old Fauves

This room also contains some paintings by old fauves: Van Dongen, who is exhibiting what amount to posters, Girieud, sad, sad. . . . and Maurice de Vlaminck, who should attempt some more substantial works. He is made for large, tumultuous canvases! He is ruining his talent by painting calling cards. It is a crime.

Some Young Fauves

The young fauves are to be found in Room 43. Luc-Albert Moreau has a few paintings intensely Baudelairean in feeling. Dunoyer de Segonzac, whose drawings capture the grace of choreographic movements, is making an effort to paint forcefully. His well-stated *Group of Nudes* proves that his palette is becoming more human. He is also showing a delicate *Landscape*. La Fresnaye's *Cuirassier* is an excellent piece. This artist is approaching military painting with complete frankness and wholly new methods. His is one of the more beautiful exhibits in the Salon. M. de La Fresnaye must now tackle some large compositions. But where would Gros have been without the battles of the empire? La Fresnaye owes it to himself to hope for a war. The mannerism of G. de Miré's exhibit is not unpleasant. Marchand deserves a great deal of praise: his *Legend of St. Martin* is an excellent canvas. His talent is somewhat analogous to Raoul Dufy's, as far as his palette is concerned. One can expect fine things from Marchand, and I personally will follow his progress with great interest. Let us mention Paul Véra's *Women Bathing* and Lotiron's pretty still-lifes. Chabaud is not ungifted either, and there is great sincerity in his talent.

The Fauves of the Past

They have assembled in Room 27, very far from their young rivals. There is some coquettishness on their part in making themselves seem so old. Never has Henri Matisse's talent been younger. I have been striving to defend this fine painter for four years now. Almost every art critic was against him. But finally, people get used to everything. Matisse has not changed. His colors are bolder than ever. His line has the same character it had in years past. Yet this year, the critics, although not dazzled by it, approve of his very expressive and harmoniously painted *Andalusian Woman*. Dufy's modest exhibit is of a high caliber; he has sent a still-life with a very noble poetic and mystical sentiment, and a few proofs of some woodcuts admirable both in craftsmanship and in tone that make my *Bestiaire* a work worthy of the greatest periods of printing. This is so true that a man of taste who has founded a school of decorative arts told me yesterday that the *Bestiaire* is the only modern work whose illustrations he allows his students to look at.

[APRIL 22]

I have devoted a great deal of space to painters whose importance it seemed to me necessary to emphasize. But there are many other painters at the Indépendants whose merits and talent are first-rate. In Room 27, for example, the exhibits by Camoin, Mlle. Charmy, Mme. Marval, Laprade, Manguin, Lebasque, and Manzana-Pissaro are extremely interesting.

Rouault is making great progress, and I am very fond of his designs for chinaware decorations. The canvas by Friesz is excellent and full of sensibility.

Cross, Signac, Luce, etc.

One can have nothing but the greatest admiration for the Henri-Edmond Cross retrospective. He was among the most lyrical of

painters. His architectural landscape with cattle is an admirable, luminous poem. Signac remains the unrivaled master of pointillism. This careful and sober art has unique merits, and it has produced some excellent painters. Besides Signac's large pictures, people will admire his watercolors and a cartoon that is a finished study for a painting. Luce's *Scaffolding* is without any doubt one of his best-constructed works. He knows how to paint workers with taste. His is a very simple art, devoid of declamatory flourishes.

The Russians

Among foreign painters, it is the Russians who seem to have best understood the lessons of the French painters. It was a wise decision to group some of these artists together in Room 44. Mme. Vassilieff likes what is exotic; Mlle. Szerer is the last disciple of the neo-Byzantine Boïtchouk, who filled last year's Indépendants with his paintings and the paintings of his students, thus perhaps teaching the French a useful lesson by reminding them that painters, no less than poets, can play tricks with history. Mallarmé made no mistake in saying so. Machkoff is very gifted. I will also mention Roudnieff, Chapchal, etc., and the sculptor Archipenko, who is talented. In a word, these Russian artists have personality and their experiments are probing. [. . .]

(*L'Intransigeant*)

The Humorists' Salon

Like a fresh and restful oasis in the middle of the artistic Sahara of our salons, where paintings are more numerous than grains of sand in the desert, we find the Humorists' Salon, organized by the review *Le Rire*. Doubtless as an added touch of humor, the Salon takes place every year at the Ice Palace. [. . .]

(*L'Intransigeant*, APRIL 23)

The Ingres Exhibition

[APRIL 27]

Ingres's Palette and His Violin Are Exhibited
Together with His Paintings and Drawings

H. Henry Lapauze, who cherishes the glory of M. Ingres, has succeeded, with the kind cooperation of their owners, in assembling the famous paintings and four hundred and fifty drawings by the master from Montauban. He has grouped them around the artist's violin, which has become proverbial.

M. Lapauze intends thus to offer "a double lesson in energy and beauty"[18] to today's young artists, who are quite capable of understanding it if they have the patience to listen to it all, which is not certain; as for today's official painters, the double lesson would do them even more good!

M. Ingres was the only painter with a genuine knowledge of antiquity. That is because he grew up in a time that saw the transformation of architecture. All the marvels of the great periods of Greek art that were suddenly revealed to Ingres taught him that style had to be sought where the Greeks had found it: in nature itself.

And at the same time as the sculptor Bartolini, whose portrait is on view at the Georges Petit Gallery, was condemning the conventional classicism of Canova in Florence, M. Ingres, who, as Baudelaire said, was "a revolutionary in his own way,"[19] was quietly protesting against the erudition and the fake Atticism and Romanism of the school of David.

It was at the high point of romanticism that Ingres became famous, with the exhibition of *The Oath of Louis XIII* at the Salon of 1824. This painting, on loan from the cathedral of Montauban, is on view at the present exhibit. And yet, M. Ingres was not a romantic, unless one uses that term to designate those who have a deep feeling for nature. Ingres did not diverge one step from nature, as one can

see in his figures, all of which are individually characterized, just as every living being bears the imprint of his own individuality and the mark of his destiny. But what really shows M. Ingres's affinity with the Greeks and proves that he was their disciple is his ability to discern in each figure the sublime aspect of its particular beauty. And that amounts to nothing more nor less than style.

In characterizing his models, M. Ingres wished to endow even those who were ugly with their own particular beauty.

He did this out of his love for nature, in which even ugliness can be viewed happily as the incarnation of a particular character. He wanted to express beauty and truth—an admirable aim of transforming the life that is within the *individual* into a universal *type* that is spiritual in kind.

This is magnificently evident in the rare, smooth beauty of his *Angélique*, with her arched throat and wandering glance.

To understand style, Ingres studied nature; from the Greeks he sought their sense of measure and their feeling for beauty; the Etruscans gave him a taste for simplification, which is one of the sources of grandeur.

It is this same powerful manner of expressing life through style that explains the purity of his *Golden Age*, the small replica of his unfinished decoration for the château of Dampierre, commissioned by the Duc de Luynes. Ingres painted this small and beautifully finished picture at the age of eighty-four. Here also, and even more imbued with grandeur, is Ingres's master drawing, *The Apotheosis of Homer*, a work that took him twenty-five years to perfect and that conclusively earns him a place in the ranks of the Carpocrations, members of a sect that worshiped Homer and among whom I willingly count myself. Here are the *Three Greek Tragedians*, and here is the *Birth of the Muses in the Presence of Jupiter*, a work that has the powerful and gracious simplicity of a fresco.

One will soon be able to see the *Virgin with the Host*, which the Czar has just sent to Paris and which was painted in 1839.

I am less fond of some of Ingres's small canvases, the results of an impulse that made him want to compete pointlessly with the most widely divergent artists and artistic periods: German primitives,

enamelists, and many others. One is too aware in these compositions that the imagination they required was wholly lacking in a painter who was richly endowed with perhaps every other natural gift.

I will make an exception, however, for *The Odalisque with the Slave*, a miraculously finished and successful work that surpasses all the Persian miniatures in its nobility and expression, while at the same time possessing the inventiveness and all the other qualities proper to that ordered and refined art form.

An energetic painter of beauty—even of hidden beauty—M. Ingres knew how to reconcile art with nature, life with style.

He painted the ideal and the real at the same time.

To accomplish such a difficult task, he had to possess a talent that cannot be acquired but that reason can develop.

If he never had any true disciples, it was because he never could have any. He lacked the necessary talent and reason.

[APRIL 28]

Due to a lack of space, my article on Ingres did not include what I had written about the portraits; furthermore, a typographical error in the last sentence made it appear that I had said that Ingres lacked talent and reason, when in fact my statement referred not to Ingres but to those who considered themselves his disciples.

(*L'Intransigeant*)

The Salon des Artistes Français
The Opening

[APRIL 30]

Paintings: A Few Good Landscapes—The Influence of
M. Maurice Denis—Women Painters—Military Paintings

Thirty good landscapes—that is the sum total of works in this Salon that appear to have been painted with any concern at all for the rules. The rest are full of a disorder that does not even claim to be revolutionary.

But, my Lord! How strongly one feels the influence of M. Maurice Denis at the Artistes Français! In almost every room, one can find women bathing like his own, all of them trying to be classical, Christian, modern, Russian, and German at the same time.

Aside from some good landscapes, this Salon contains scarcely any interesting paintings; among them are a few portraits and compositions, several done by women.

Military painting is on the decline, and seems to have taken refuge at the Indépendants.

A Visit to the Exhibition Rooms

Room 1. This is the largest room in the Salon, and a thorough tour of it takes close to two hours. On view here is a *Woman with a Swan* by Martens, whose divisionism is conceived along the same lines as Henri Martin's.

Jean-Gabriel Domergue, who is a very young man, has a very promising talent. His charming and perverse portrait of *Mlle. Gina Maletti* dressed in men's clothes is certain to be noticed. However, the artist must not overlook the fact that much of the charm of his painting is due to the charm of the model. . . . But I think that one can expect some serious works from M. Domergue. [. . .]

M. Bertin, whose name was immortalized by Ingres, is showing us bloodless nymphs who look as if they could use Pills for Pale People.[20]

Arthur Midy presents the *Day of the Poor* in a poor light; it is a painting adapted to its subject. M. de Pibrac has painted a portrait that is beyond his present capacities. He will get better. . . . In the past, his namesake[21] wrote quatrains; one must know one's limits. [. . .]

And here is the *piéce de résistance* of this room: M. Calbet's painted ceiling for the theater in Agen. This ceiling is about on a par with M. Cormon's,[22] and should perhaps be made to change places with it: Calbet's work could go to the Petit-Palais, and M. Cormon's poultices could go to Agen, since they have exactly the color of ripening plums. [. . .]

Besides his usual heather, M. Didier-Pouget is showing us a moon-lit landscape: a pine forest with water, which will make a fine post-card.

M. Joseph Aubert is showing us a few pillars of the Church, in a very cold, dignified, and boring painting.

M. Gaston Bussières has composed and decorated a provincial opera version of Cleopatra about to sip her infusion of pearls and vinegar. [. . .]

Room 2. [. . .] M. Gorguet is exhibiting a cartoon for a tapestry in which one can see the arms of the city of Quimper.

That is enough to make me recommend this cartoon to the poet Max Jacob, who is interested in everything that has to do with his birthplace. [. . .]

Room 3. [. . .] Mme. Virginie Demont-Breton is exhibiting seals, and by a peculiar stroke of the imagination she has made one of these amphibians look like Paul Verlaine. [. . .]

M. Duvent's *Villa in Florence* contains a collection of very poetic things: fountain, bathers, monkeys, rose laurels. With all that, how can the artist have cooked up such a tasteless stew? [. . .]

Finally, here is the most popular canvas in this room: *Leblanc Winning the Eastern Circuit Race: The Landing at Issy-les-Mouli-neaux*, by Duvent. . . . An interesting document for the history of aviation. [. . .]

[MAY 2]

[. . .] Room 5 [. . .] M. André-Gabriel Ferrier has painted an allegory on the following epiphonema:

"Lulled by the perfume of a wilted flower, I remember a woman I have never seen." Jules Renard would have frowned on so much imprecision.

M. Louis-Antoine Leclercq has painted a young girl getting ready to paint a moss rose. It is pretty. But here is the pearl of this room; it is by Debat-Ponson, and it shows France, that "rebellious and indomitable steed," having just broken the back of a straight-haired Napoleon. This is a painting for a series that could be entitled "Poetry Through the Ages."[23]

Here too are Guédy's *Officers on Half-Pay*. They have had dinner at

a restaurant (and a very good dinner, too, I must say), and are reading a newspaper after their dessert and coffee; but let us go on to the next room. [. . .]

[. . .] Among the works in Room 9, [. . .] I should mention a quite astonishing *Nocturne* by M. A. Faugeron. It shows a nymph and some characters from the Italian *commedia* in a festive outdoor setting, while at the left, M. Henri de Régnier walks resolutely into the night, flanked by two modern ladies who undoubtedly represent the Parnassian and the symbolist schools of poetry. The dreariness of this allegory does not prevent it from appearing somewhat burlesque.

Room 11. [. . .] Etcheverry has given up the love scenes that made him so popular with *midinettes*. His *Young Italians at the Fountain* will doubtless be less appreciated by his following.

Room 12. M. de Joncières is exhibiting *An Infanta*, "unsmiling and preoccupied," according to the poem by M. Henry Bataille. [. . .]

Room 13. On view here is *The Easel* by M. Jean-Paul Laurens, who would like to appear terrible and cruel, but who has passed the age of ruthlessness.

The Arab scene by Anne Morstadt is excellent. I am less fond of Marguerite Delorme's little girl looking at goldfish. We have seen an awful lot of goldfish at this year's exhibitions!

Room 14. M. Franc Lamy has painted a little gypsy girl from Granada, who makes me think of Eugène Montfort's great voyage. Fauconnier has painted a mystical canvas on the following theme: "A miraculous bark led by two white eagles bears back to Noble-Val the head and the left hand of St. Antonin, the martyr of Pamiers." A noble and conscientious art. [. . .]

Not wishing to be mistaken for his namesake, Henri Matisse, who is fond of color, M. Matisse-Auguste is making his paintings blacker and blacker. The one he is exhibiting in this room is a canvas for mourning. The two Matisses know each other, and at the time when Henri was attacked on every side, Auguste told him when they met: "Let's always be sure to sign our first names. That way no one will mistake us for each other."

Room 16. This room contains the decorations by M. Cormon. I have already said how bad I think this exhibit is. [. . .]

Room 18. [. . .] M. Maxence has exchanged his red-haired model for a blonde, and like her predecessor, she is holding a book of hours. It's a melancholy sight. Here is an excellent painting by Miller, *La Toilette*, which is one of the best things in this Salon. [. . .]

Room 21. M. Orange shows us the First Consul visiting the marketplace in Cairo, where one never ran the risk of being bored, what with all the beautiful naked slave girls. Achille-Fould has also indulged in Napoleonic lore, with a Mme. Sans-Gêne when she was still a laundress.

Room 22. [. . .] Here are some greenish deliquescences by M. P. Marcel-Béronneau, and some more goldfish. They are by M. Fernand Toussaint. People say that cyprinoids are in fashion this year because of the Chinese exhibitions. [. . .]

Room 23. M. Matignon shows us a lady opium-smoker out of some novel. Opium has a lot of faults and disadvantages, but it has more charm than this painting. [. . .]

[M A Y 4]

Room 26. M. Bonnat is showing two honest bourgeois portraits: the *Portrait of Mme. Audard* and that of *M. Alexis Rostand.* These are solid effigies with no vain ornamentation, but they are neither indifferent nor useless works. M. Louis C. Spriet has an excellent painting in this room, entitled *Hut at the Entrance to a Village.* This very expressive canvas, with its delicate shades and very interesting experiments in color, deserved a more prominent place. [. . .]

Room 27. [. . .] M. Lionel Royer knows how to move us, with a very small canvas that is very moving: *Execution of the Duc d'Enghien.* This work has nothing of the historical anecdote about it; it is powerful and simple, like a story by Mérimée. [. . .]

Room 28. M. Rochegrosse is exhibiting a *Combat at Marathon* full of heavily made-up young warriors who look less like fighters than like young men ready to be corrupted by Socrates. [. . .]

Room 32. M. Comerre shows us a *Flood* with white water. It is as ugly as any one could wish. [. . .]

Room 33. [. . .] The influence of M. Maurice Denis is evident. I have already noted it in many of the rooms. The time is ripe for M. Maurice Denis to submit his candidacy to the Institute. His talent, his works, his opinions, aesthetic or otherwise, as well as the circle of his acquaint-

ances, give him an incontestable right to that honor. He could also influence the spirit of the establishment, should he become a member, bringing to it a spirit of liberalism and thereby rendering invaluable service to the arts. [. . .]

Room 34. M. Ribera bears a name not easy to bear. M. Biloul is offering us nothing less than an *Olympia*, as if one could remake a masterpiece. [. . .]

Room 36. In this room, M. Richter is exhibiting the funniest painting of the Salon: some fat women frolicking in the forest.

Room 37. M. Joseph Bail's *Servants Folding Linen* is a pleasant and intimate work that deserved to be painted. M. Bail has done it with taste, and also with austerity and kindness. [. . .]

Room 40. Here is a very handsome landscape by Nozal and more goldfish by Euler. Really, it is an obsession!

Room 41. Here is a rich interior by Henri Tenré, and a *Republic of Snow* by M. Boutigny. Is this perhaps a symbolic canvas? I confess that its meaning escapes me.

M. Pierre Ballue has painted a pleasant landscape that would have delighted the eyes of La Balue, the famous cardinal who lived in a cage.

Corabœuf, Georges Scott

Room 42. M. Corabœuf is exhibiting a delicate portrait of Mlle. Geneviève Vix. The beauty of the model and the talent of the artist have come together happily in a work of excellent draftsmanship. Its colors, however, are not above reproach. In Corabœuf, as in Ingres, color is only an ornament; Corabœuf, however, does not yet endow his colors with all the life, the vivacity, and the precision we admire in the portraits of the master from Montauban. But how precise Corabœuf's draftsmanship is, and how much one would like to be drawn by him!

Room 43. M. Henry Bonnefoy shows us Robinson Crusoe as a cobbler, which would be a perfect role for Gnafron in a play at the Lyons Guignol.[24]

If journalism can lead to glory, the illustrated documentary can lead just as high. It made the reputation of Constantin Guys, and it led M. Georges Scott all the way to the court of England, where he

painted the official portrait of *His Majesty the King*. It seems that a number of special boats and trains have been hired to bring the island-dwellers to the Grand-Palais, so that they can sing "God Save the King." As for us, let us content ourselves with crying: "Long Live the Republic!"

<div align="right">[M A Y 5]</div>

[. . .] Drawings, Cartoons, Watercolors, Pastels, Miniatures, Stained-Glass Windows, and Ceramics

This section of the Salon of 1911, although it abounds in interesting works, contains scarcely anything that can be said to have a striking personality or be especially remarkable.

The miniature, which is an eminently French art form, appears to be in a very critical situation, despite the great number of examples of it.

That photography and the mechanical arts of reproduction should have done some harm to it is not surprising. Nevertheless, the precious art of the miniature could occupy an enviable place alongside them. Increasingly, this art is becoming the exclusive domain of women, many of whom are clumsy, a very great number of whom lack taste, and almost all of whom lack the patience of an Augustin.[25] [. . .]

Engravings and Lithography

Let us mention [. . .] the engraving by M. Greuze based on a painting by his namesake, whom Diderot held dear; [. . .] the original etchings by M. Jouas-Poutrel, who reproduces some aspects of Old Rouen tastefully and with a great deal of feeling, and the woodcuts by M. Pierre-Eugène Vibert, especially his portrait of the great writer Remy de Gourmont.

<div align="right">[M A Y 6]</div>

[. . .] Sculpture

On the whole, the sculptures exhibited at the Artistes Français are far inferior to those we saw at the Nationale. Gathered around the sub-

lime Rodin, there are a great number of great sculptors such as Marcel-Jacques, Bourdelle, and Niederhausern-Rodo, as well as young artists who, instructed by the works of the late and regretted Schnegg and those of the admirable Despiau (who did not exhibit this year), are moving directly toward the most ancient and most modern kind of beauty. I have in mind sculptors as admirably gifted as Durousseau, as pure as Wlérick, who is one of the best, as delightful, delicate, and simple as Jane Poupelet, as fervent and knowledgeable as Arnold and Cavaillon. This galaxy of artists constitutes the glory of contemporary sculpture. No one surpasses them, either in France or abroad. And despite the almost complete absence of architects grounded in their art, which is the noblest art of all, one can hope for great accomplishments from the artists I have just named. Their effort to attain a genuine plastic awareness cannot remain sterile. Beauty itself and the whole of civilization are at stake. But one must wish for the emergence of an architect who would make possible the great works that a Marcel-Jacques, a Bourdelle, or a Despiau might conceive.

At the Artistes Français, there are many sculptures and few genuine works. One cannot see here any of the beautiful busts that abound at the Nationale. [. . .]

(L'Intransigeant)

Chinese Art—An Opening at the Parc Monceau— Retrospective Exhibition of Chinese *Objets d'Art*

M. Steeg, Minister of Public Education, and M. Bellan, President of the Municipal Council, this morning opened the retrospective exhibition of Chinese art at the Cernuschi Museum. The exhibition was organized by the museum's curator, M. d'Ardenne de Tizac, who is well known in the world of letters under the pseudonym of Jean Viollis.

A Year of Chinese Art

Chinese art has been very much in fashion this year; the two exhibits at the Bernheim and Durand-Ruel galleries, together with the mag-

nificent exhibit that just opened at the Cernuschi Museum, constitute three excellent lessons for Europeans. In all Chinese art, there is a feeling—that is not small minded—for the preciousness of works of art, an admirable refinement devoid of affectation.

The Collectors

It is due to the kind cooperation of collectors that M. d'Ardenne de Tizac was able to assemble so many rare and priceless objects. One must note the charming and truly American alacrity with which Mme. Potter Palmer responded to the request of the exhibit's organizer. Mme. Palmer, who is detained at her father's bedside in Chicago, received a telegram the day before yesterday requesting the loan of her collection, whose value is inestimable. By yesterday noon, these magnificent objects were in their display cases at the Cernuschi Museum. Let us also mention the beautiful collections of the Marquise de Ganay, Mme. Langweil, Mme. Camescasse, Dr. Nième, Messrs. Bouasse-Lebel, Michon, Doucet, Rouart, Philippe Berthelot, Wanninck, Claude Anet, etc.

The Exhibition

It would be futile to attempt to enumerate in the space of a newspaper article all the marvels that are on view at the Cernuschi Museum. One of the most delicate and beautiful groups is unquestionably Mme. Potter Palmer's admirable collection of jades and ambers. There are blocks of amber sculpted to perfection, iridescent, tinted in the rarest shades; some of them—and it is these that the Chinese value most highly—have insects or small plants embedded in them.

The archaeological novelty of the exhibit is some extremely rare and extremely ancient carved tombstones. The officials of a whole province had to be bribed in order to obtain them.

The Chinese rugs constitute another of the attractions of this exhibition. Until now, these rugs were hardly known in France. The most beautiful of them is a small speckled rug dating from the sixteenth century and belonging to M. de Goloubew.

1911

Pottery and terra-cotta are here in abundance; this is the first time that so many pieces have been seen together. The Hellenic influence is apparent in the poses and in the truly human expressions. Among these terra-cotta figures, some of which are glazed, there are works of the highest quality. They are extremely rare, and until now we had a chance to see only a few of them, at Mme. Langweil's exhibition at the Durand-Ruel Gallery.

Also on view at the Cernuschi Museum is the treasure plundered from the Summer Palace by Palikao and usually kept at Fontainebleau. I will not mention the baubles exhibited here for the delight of the crowd: jewelry made of kingfisher feathers, Marie-Antoinette's fan, a game chest belonging to the Princesse de Lamballe, and a fan painted with no particular talent by that great Empress of China who died recently and who to her country was a cross between Agrippina, Catherine, and Victoria.[26]

(*L'Intransigeant*, M A Y 9)

The Art World

[M A Y 9]

Jean Julien

A young painter, Jean Julien, is exhibiting his works for the first time at the Boutet de Monvel Gallery. These works, or rather these studies from nature, manifest gifts and qualities that will develop with time. Jean Julien is ardent and enthusiastic, and he is a keen observer. What else is needed to guarantee an artist's future? All these studies were painted in Provence, and Jean Julien has made excellent renderings of the figures, the colors, and the atmosphere of Provençal landscapes.

A charming preface by André Salmon enhances the catalogue.

"In these forty studies," writes Salmon, "there are no false adornments. . . . Transported by his passion and guided by his reason, Jean Julien has made a sustained effort, from which we can expect a great deal, and gone beyond the now academic aspects of impressionism to lay the groundwork for a lucid, human *œuvre* full of religious fervor."

One could hardly say more, or wish more for an artist. Let us hope that Jean Julien, who lives far from Paris, will come back from time to time to prove to us that he is making progress in his art, which is already more than promising.

[M A Y 10]

I have just received a book with an inside cover adorned by three *ex donos*: the author's, the illustrator's, and the printer's. These three people all contributed their particular talents to the embellishment of the work, and it was indeed appropriate for each one to make a present of a book that contains a great deal of his personality. The book in question is *Les Danses d'Isadora Duncan, 25 dessins de Dunoyer de Segonzac, précédés de la Danseuse de Diane par Fernand Divoire*; it was printed by François Bernouard on the presses of La Belle Édition.

Fernand Divoire, who evinces for Miss Duncan's choreography an admiration that I do not share, has expressed his enthusiasm in a beautifully lyrical prose whose cadences are above all praise.

Dunoyer de Segonzac's drawings are graceful and alive. They succeed very well in rendering the movements of the dancer, and they capture her exactly in those moments when, by chance, I find it possible to appreciate the character of her steps. After all, rather than celebrating a dancer, Divoire and Segonzac have celebrated the dance, that sacred and exquisite art of Eurythmia, that ardent art of movement.

And the book, excellently printed on fine paper, is very handsomely presented.

[M A Y 11]

Pastels anglais by R.-R.-M. Sée

While living in Naples, from 1786 to 1788, Goethe had a chance to see, at the home of the diplomat and archaeologist Sir William Hamilton, a young Englishwoman named Miss Hart, who displayed her extraordinary beauty in a gilded frame that Sir William Hamilton had had especially made for her. Posing against a black background, she would produce with striking fidelity the most beautiful statues of antiquity, or else a figure inspired by one of the frescoes of Pompeii.

167

At other times, she would dance with a gracefulness that seemed to be Greece reborn.

Emma Hart, who was the originator of "attitudes" and of "pantomime dancing," became under the name of Lady Hamilton one of the most famous women in Europe, while the craze for "Olympian poses" or, as we say today, *"tableaux vivants"* (the English call them "living statues"), spread all over the continent.

During my recent visit to the "English Pastelists," I thought I could see Emma Hart in her gilded frame as Goethe saw her at the home of Sir William Hamilton; then suddenly all the portraits became animated, allowing me to admire the most agreeable *tableaux vivants* anyone could hope for. It is not one of the least of the charms of English pastels that they remain full of life.

And without a doubt, Miss Hart seemed less alive in her golden frame in Naples than in the sketch by Henry Singleton; thanks to an art full of frankness, all these fresh and expressive physiognomies painted by Russell, Chinnery's *Beautiful Irishwoman*, the charming works of Russell's daughters, and the figures of Gardner are endowed with an elegant and gracious life that is a marvelous continuation of natural life.

It would have been a pity for such a pleasant and elegant exhibit to end without leaving a trace; we therefore owe a great deal of praise to M. R.-R.-M. Sée, who (with M. Robert Dell) thought of assembling these portraits and who has published a book whose accurate dates and biographical details and abundant and beautiful reproductions will not only provide a magnificent souvenir of the 1911 exhibit, but also render the greatest service to art-lovers through its treatment of an interesting aspect of the history of art. *Pastels anglais (1750–1830)* is an important and to all appearances definitive work.

M. R.-R.-M. Sée has published everything one needs to know about the English pastelists. It now remains for him to publish Russell's stenographic notebooks, after which he will become, if he wishes, our most important authority on the history of English art. The subject has hardly been treated.

It can provide one with a very pleasant occupation, enough for a lifetime.

(*L'Intransigeant*)

The Forgeries at the Bagatelle

They Were Authenticated This Very Day by M. Fallières, the President of the Republic

Every year, concurrently with its exhibition of pictures by living painters at the Grand-Palais, the Société Nationale des Beaux-Arts organizes a retrospective exhibition of great interest at the Bagatelle. The exhibition opening tomorrow in the Bois de Boulogne is entitled "Portraits and Costumes."[27] It is a charming collection of portraits, drawings, engravings, miniatures, costumes, fans, gloves, canes, and a thousand other bagatelles, all so deliciously faded and so wistfully frivolous that one cannot look at them without shedding a tear and smiling at the same time. The very name of the exquisite dwelling that houses them seems to have been bestowed in their honor.

It is a pity that the commission appointed by the Société Nationale des Beaux-Arts to organize the exhibition was not a bit more fastidious, if not in the admission of the paintings that.were graciously lent by collectors and dealers, then at least in the attribution of some of these works to famous masters.

Clearly, it is to the interest of the owner of a painting to have it mentioned in a catalogue of the Société; what is less clear is how the Société can have so lightly undertaken the task of authenticating such a great number of dubious works.

I will certainly not quibble about the authenticity of the *Child's Head* listed as No. 26 in the catalogue and attributed to Chardin. It seems that this painting is provided with papers establishing its origin. If it were shown to have come straight from Italy, I would not be at all surprised.[28]

But the Goyas are indescribable. Would Goya have been capable of painting this incredible *Portrait of the Duchess of Alba* with the ring and the canary? With all due respect, let me say that I do not believe it for a moment![29]

1911

What a good laugh the painters and connoisseurs who make up the commission must have had! And to think that the asking price for *that* Goya may be as high as fifty thousand francs!

Here is a *Portrait of a Young Girl* attributed to Baron Gros. The picture is owned by a man of taste. Has he not noticed that a large part of it was repainted? One does not need to be a great scholar to see that there are cracks in the hair while there are none in the face, and that the technique in the face owes nothing to the painters of the Empire but a lot to the English.

Of the six paintings attributed to Largillière, there is at least one that he seems really to have painted: it is the portrait of a woman belonging to Count André de Ganay.

As for No. 95, the *Portrait of the Architect d'Aviler, His Wife, and His Three Children*, it is without any doubt an excellent old painting but is more likely to have been done by a contemporary of Largillière.[30] Parts of *Diana the Huntress* are old, there is no doubt about it; but more than half of the painting has been redone.

The same can be said of the pretty portrait of *Mme. de Montmorency-Laval*, by Nattier; it certainly seems to have been redone, and very cleverly, too![31]

Were you charmed by the *Portrait of Bellecourt in the Role of Crispin*? I think it is more likely to be Italian than by Carle Vanloo.[32]

But here is the choicest bit of all: *The Village Bride*, attributed to Watteau.[33] It is a private-label Watteau and smells terribly of heresy, which is sufficient reason to burn it at the stake, together with its neighbor, a bizarre self-portrait by Chardin that is not even listed in the catalogue. The President of the Republic, who visited all this, saw lots of other fakes, for they are everywhere, to the great detriment of the good works: the three portraits by Baudry, the charming little work by Léonard Defrance, a painter from Liège, the large English pictures by Gainsborough and Hoppner, the two very beautiful portraits by Roslin, Raeburn's *Melville as First Lord*, the handsome *Bar at the Folies-Bergère* by Manet, the drawings by Fragonard, the excellent drawings by Chassériau, the Constantin Guys, the Lamis, etc.

Lord, let us be spared further fakes in official exhibitions! Admittedly, it is difficult not to let a few fakes slip into even the finest collections; but please, let there be no more exhibitions with such a great quantity

of paintings of dubious authenticity. Send them to America, but let's not see any more of them in Paris!

Gentlemen of the trade, have pity on us! Don't show us the rest of your merchandise.

<div align="right">(L'Intransigeant, M A Y 14)</div>

The Art World

Mme. Clifford Barney

Mme. Clifford Barney, of Washington, is exhibiting close to sixty pastels at the Devambez Gallery that display a refined taste and an admirable skill.

Half of the exhibition consists of portraits, finished pieces or simple sketches that reveal considerably more than the surface physiognomy of the models so marvelously depicted by Mme. Clifford Barney.

Among the portraits of contemporary celebrities, the one that interested me most was that of *G. K. Chesterton, Esq.*, an English journalist who will soon be well-known in France and whose works are a mixture of mysticism, burlesque, horror, and buffoonery. Despite this incongruous combination, he is a man of good sense, and "he is a real card," as Jean Florence once wrote to me. Florence is trying to introduce Chesterton to French readers; Paul Claudel, Elémir Bourges, and André Gide are already his admirers.

Mme. Clifford Barney shows us a Chesterton who bears more than a slight resemblance to our own Stuart Merrill, but who appears more jovial than Merrill, with a joviality that has a touch of bitterness.

Mme. Clifford Barney has also given us a few large pastels: Mme. Lucie Delarue-Mardrus, Mme. Wanda Landowska at the piano, M. Francis de Miomandre, the dancer Ruth St. Denis, the painter José de Charmoy. The artist has also done several portraits of her own charming face.

Besides these portraits, there are other compositions, some of them symbolic: a kind of decorative painting inspired by Italian frescoes, and personal enough to make us want to look at it and find it

wholly to our liking. Still other pastels are intimate, so to say: reflections in a mirror, the light of a lamp, motherhood, dancers of Malaga, etc.

A few nudes show us how flexible and varied Mme. Clifford Barney's art is, and how skillfully she can breathe life into a bit of colored dust.

(*L'Intransigeant*, M A Y 17)

[The 8th Salon of the Indépendants at Brussels]

The new painters who jointly proclaimed their artistic ideal at this year's Indépendants in Paris accept the appellation of cubists which has been bestowed on them.

Nevertheless, cubism is not a system; the distinctive differences, not only in the talents, but also in the manners of these artists are ample proof of that.

These artists do have one trait in common, however: if the chief merit of the painters known as fauves was their return to first principles in color and composition, the aim of the cubists has been to enlarge still further the scope of an art thus revitalized, by returning to first principles in line and inspiration. If one considers, moreover, that most of the cubists were at one time counted among the fauves, one will realize how much ground has been covered, and in how short a time, by these young artists, and how logical their conceptions are.

The result of these two artistic movements, which have succeeded and complemented each other so well, is a simple and noble art, at once restrained and expressive, ardent in its search for beauty and ready to approach the vast subjects that yesterday's painters did not dare to undertake, leaving them to the presumptuous, outmoded, and boring daubers of the official salons.

I think that in these few words I have indicated the real significance of cubism: It is a new and very noble manifestation of art, without being a system that fetters talent.

In any case, it would hardly be likely that at the very time when

scholars and thinkers are abandoning systems, artists should wish to indulge in such dangerous games.

<div align="right">

(Preface to the *Catalogue du 8ᵉ Salon Annuel du Cercle d'Art "Les Indépendants" au Musée Moderne de Bruxelles,* J U N E 10–J U L Y 3)[34]

</div>

The Covered Graveyard at Blois

If one day you should happen to find yourself in Blois, do not fail to visit the suburb of Vienne. There, in the Rue Munier (formerly Rue du Poirier), you will find the graveyard of the parish of Saint-Saturnin. This covered or galleried cemetery is one of the few of its kind remaining in France. It is still almost wholly intact, and it has been classified as a historical monument. It seems to date from the same period as the part of the church that was built through the generosity of Queen Anne of Brittany. The great Gothic portal and its wicket are equally ancient. The timbered galleries, which are in an excellent state of preservation, exhibit remarkable workmanship, and the wainscoting that remains bears traces of camaïeu frescoes.

The sculptures on the stone pillars in the north gallery have been very well preserved under a thick layer of whitewash, which has made people think until now that they were the work of unskilled artisans.

And yet, these sculptures are not without merit, far from it, and if one scratches at the whitewash, one can find traces of paint and gilding that have retained all their original brightness.

It was in this cemetery that the aristocrats of the city were buried. The grounds were also a gathering place for men of leisure. On certain days, they danced here, and their festivities often ended in scenes of debauchery.

Today, the covered graveyard is part of the laundry facilities of the hospice of the city of Blois. They have hammered in nails which serve to hold up the lines for drying laundry. If something is not done about it, this unusual monument will soon be mutilated. The inhabitants of Blois care very little about it and are generally ignorant of its history. There is an architect, however, M. Jean-Gaston Lafore, who recently

undertook to describe the covered cemetery and who has reproduced all its details with the utmost scrupulousness.[35] He would have liked the administration to permit him to scrape away the whitewash in order to uncover the painted sculptures beneath it, and he also asked to be authorized to make casts for the Museum of Comparative Sculpture at the Trocadéro. He was willing to assume all expenses, but the administration opposed it on the grounds that the stone of the capitals was too soft to survive his operations and would crumble. On the contrary, he found that the stone is quite hard, and even if it were soft and in danger of crumbling, it seemed to him that that would be all the more reason to make a cast in order to preserve some record of its appearance. But the administration is inexorable. It prevents people from admiring the graveyard of Blois, and it opposes the enrichment of the Museum of Comparative Sculpture at the Trocadéro. A covered graveyard that was also the site of debauchery—who cares about it? All that such an edifice is good for is to be the laundry room of a hospice. And in the meantime, M. Lafore goes desperately from office to office, begging to be allowed, at his own expense, to save his beloved cemetery.

(*L'Intransigeant*, JULY 16)

Drawings of the Great Masters

Le Dessin par les grands maîtres, a Work Scheduled
to Appear in Monthly Installments, Will Provide Artists with
Invaluable Documents and Will Make Available the
Treasures Owned by the Louvre

When I recall the drawing class at school, I remember the awful lithographs they used to give us as models—works without artistry by unknown drawing teachers whose solemnity and lack of daring were equaled only by their unskillfulness.

Their timid scribbles were enough to impart a distaste for art even to those students who would later come to adore it.

And yet, there was always Nature, *the master teacher of them all,*

as Aretino wrote, apropos of Titian, I think. There were also the drawings of the great masters. But only the masters know how to look at nature, whose secrets schoolboys don't even suspect. As for the drawings of the masters, a student in a small town with no museum has no idea they even exist.

Today, a number of perfected and inexpensive methods of reproduction are available. One would assume that the forty-odd thousand drawings by great masters that constitute the incomparable collection of the Louvre have been reproduced in thousands of copies.

Nothing is further from the truth. Almost none of the drawings owned by the Louvre has been reproduced, and they are, for all intents and purposes, unknown to the public.

It is, therefore, a fine work of popularization and instruction that Messrs. Louis Lumet and Ivanhoë Rambosson have undertaken in publishing *Le Dessin par les grands maîtres*, a work appearing in monthly installments and containing collotype plates of the most beautiful drawings in the Louvre.

These plates are accompanied by explanatory notes written by very competent art critics, and each one has been executed with painstaking care. The editors have taken the trouble to make all the reproductions removable, so that they can be framed to serve as a tasteful and extremely noble decoration for schoolrooms and private homes.

Including works by masters of all the French and foreign schools and academies, general studies and details, landscapes, flowers, animals, historical scenes, religious scenes, etc., these drawings are reproduced with scrupulous exactness and sold—that is one of the most interesting aspects of this publication—at an extremely reasonable price.

In keeping with the wishes of its editors, therefore, this work is designed for schools and for people of taste with modest resources. It will provide students with admirable models, while at the same time the work as a whole will constitute a valuable course on the history of art.

The installments that have thus far appeared consist of drawings by Poussin, Andrea del Sarto, Van Dyck, Raphael, Holbein, Tintoretto, Lebrun, Watteau, Claude Le Lorrain, etc.

These drawings were selected with unquestionable artistic com-

petence, with an eye toward fulfilling their double aim of instruction and decoration.

Artists will find them invaluable documents; art-lovers and collectors will derive a rare pleasure from leafing through these marvelous portfolios, which constitute the first inexpensive work whose reproductions are artistically satisfying.

But *Le Dessin par les grands maîtres* will have yet another, most unlikely, effect: It will make people aware of the treasures in the Louvre, thus inspiring them to go and look at the drawings in the museum itself, while the curators will be encouraged to exhibit drawings that they never show and that are allowed to rot in the national attics.

(L'Intransigeant, J U L Y 19)

From Eugène Delacroix to Neo-Impressionism

A rare monograph by M. Paul Signac, originally published in a limited edition by *La Revue blanche,* has just been reissued in a popular edition.

D'Eugène Delacroix au néo-impressionnism is the title of the little work that Paul Signac has devoted to the memory of his friend, the great painter Georges Seurat.

Seurat's importance has not yet been sufficiently appreciated. Aside from the originality of his works—through the neo-impressionist theories, which he was the first to put into practice—Seurat's paintings in their draftsmanship, in their composition, and in the very modulation of their lighting, have a style that sets them apart from, and perhaps far above, most of the works of his contemporaries.

No painter reminds me more of Molière than Seurat—the Molière of the *Bourgeois gentilhomme,* which is a ballet full of grace, lyricism, and good sense. And canvases like the *Circus* or *Le Chahut* are also ballets full of grace, lyricism, and good sense.

The neo-impressionist painters, of whom M. Paul Signac is the

most gifted and the most famous, are those who, to quote our author, "originated and, since 1886, developed the technique known as *divisionism*—using as their mode of expression the optical blending of shades and tonalities." This technique could be compared to the art of the Byzantine mosaicists, and I remember that, in a letter addressed to Charles Morice, M. Signac also claimed an affinity with the Libreria of Siena.

But what good is it to trace one's antecedents so far into the past!

In his book, Signac furnishes ample proof that this very luminous technique, which imposed order on the innovations of the impressionists, was perceived, even applied, by Delacroix, who in turn had discovered it by studying Constable's paintings.

M. Signac also examines in detail the contribution of the impressionists and of their precursor, Jongkind.

He then comes to Seurat, who in 1886 exhibited the first divisionist painting, *A Sunday Afternoon at the Grande-Jatte.*

Pointillism was born and was to give rise to brilliant works that no one now would dare to make fun of. Painting today seems to be heading in a direction opposite from that taken by the neo-impressionists. Delacroix's two famous statements, "Gray is the enemy of all painting!" and "Dull colors must all be banished," would no longer be understood by the young painters who want to return to first principles in form and line, just as their predecessors returned to first principles in composition, light, and intensity of color.

On the contrary, the new painters are painting in difficult shades of gray, and they seek elegance in dull colors.

The art of the neo-impressionists attracted only a small number of adherents. It requires, in reality, a great deal of application and knowledge, not to mention talent.

The discipline it requires discourages fickle or hurried artists.

It has contributed to modern art a certain number of very beautiful and very luminous works—those of Seurat, Signac, Henri-Edmond Cross, Luce, Van Rysselberghe, etc—which are justly admired today and which the future will remember.

M. Signac's little book marks an important date in the history of contemporary art.

(*L'Intransigeant,* A U G U S T 7)

And "the Guards Who Keep Watch at the Gates of the Louvre . . ." The Theft of the *Mona Lisa*[36]

The *Mona Lisa* was so beautiful that her perfection had become one of the commonplaces of Art.

There are not many such works.

The *Apollo Belvedere*, the *Venus de Milo*, the *Mona Lisa*, the *Sistine Madonna, The Last Judgment, The Embarkation for Cythera, The Angelus, The Isle of the Dead*—this is about the sum of the works that humanity has set apart from the artistic productions of all times. These are the most famous works in the whole world.

This does not mean, incidentally, that the reputation of some of these works is not greater than their actual artistic merit. Böcklin's *Isle of the Dead* and Millet's *Angelus* are doubtless more highly prized than they should be, but the fame of the *Mona Lisa* was equal to its beauty, and was perhaps even unequal to it. . . .

But what can one say about

"The guards who keep watch at the gates of the Louvre"?

There is not even one guard for each room; the small paintings of the Dutch galleries that surround the Rubens Gallery are literally abandoned to thieves.

The paintings, even the smallest ones, are not chained to the wall, as they are in most foreign museums. It is also certain that the guards have never had any fire drills.

A general air of indifference and carelessness reigns over these halls.

The Louvre is guarded less than a Spanish museum.

Nevertheless, if we had to seek consolation at any price for the disappearance of a masterpiece, we should seek it in Germany, where the curators and restorers of the nineteenth century effaced and re-painted all the ancient works that were placed into their keeping. As a result, in the German museums, one no longer sees old paintings, but only the flashy works of this or that Herr Professor who is as guilty, in the last analysis, as the abductor of the *Mona Lisa.*

(*L'Intransigeant,* A U G U S T 24)

The Art World

A Warranty Office for Works of Art

M. José Théry is planning to resume his campaign for the creation of an office to guarantee the authenticity of works of art.

It is proposed to create what might be called legal pedigrees for works of art, which would provide buyers with less risky proofs of authenticity than the ones commonly accepted today.

The establishment of such an organization would be a protection against the manufacture of *forgeries*, which is multiplying by the tens if not by the hundreds the productions of famous artists.

The register of the Warranty Office would constitute the inventory, the *book of truth*, of contemporary works of art.

Furthermore, the artist would be entitled to a percentage of the increased value his works would acquire as they were sold. This is a point that should incite all artists to wish for the prompt creation of a Warranty Office.

Admittedly, there would always be beautiful works whose pedigree the office would not have. But it is certain that the majority of important works would be registered with the office, which could eventually establish branches all over the world.

(*L'Intransigeant,* SEPTEMBER 21)

The Salon d'Automne Before the First Opening

[SEPTEMBER 30]

The Ground-Floor Rooms Are Not Yet Ready—A Visit to the Second Floor

The Salon d'Automne will have two openings this year—one for the rooms on the second floor and one for the ground-floor rooms, which will exhibit the decorative arts, furnishings, scenery, etc. These rooms,

179

which were intended to be the main attraction of the Salon, were not ready in time for the opening; invitations for the second opening will be sent out in about ten days.

The Retrospectives—Camille Pissarro

This year marks the triumph of ceramics, which have reached a very high degree of perfection. The arrangement and distribution of the paintings in the rooms speaks most highly for the taste and talent of the organizer, M. Le Bail. It is regrettable, however, that it was not deemed necessary to organize an important retrospective exhibition, as has been done in other years. There was no shortage of possibilities. We could have been shown a collection of paintings and lithographs by Daumier, or else of drawings and lithographs by Delacroix. Jongkind was another possibility, among many others.

There are, in fact, two small retrospective exhibits, one of etchings and lithographs by Camille Pissarro, the other of works by Konrad Starke, a member of the Société who died this year. There is not much to say about the latter, and the former would have benefited from the added support of Pissarro's paintings. There are eighty etchings so faint that one has to get very close to see them, and twenty equally faint lithographs. All these are exhibited in Room 2, but it would have been better to place these beautiful engravings in a revolving case to enable people to see them more easily. Here are the famous views of Rouen, the portrait of Cézanne, and some rustic landscapes and characters. These works, characteristic of the artist, are executed from nature. They are firmly drawn, and as a body they constitute one of the most interesting curiosities of impressionism, of which Camille Pissarro was one of the great masters.

A General View of the Salon

The Salon as a whole is excellent. One has the impression that all the painters here are making progress, and there is no lack of legitimate innovations. In Room 8, one can see the cubists, whom I shall speak about tomorrow. In Rooms 1, 3, 3-A, 4, and 5, called the rooms of the masterpieces, there are certainly some first-rate works. People

will notice the decorative panels by Bonnard and Flandrin, the canvases by Roussel, Francis Jourdain, Le Bail, Charles Guérin, Henri Matisse, Marchand, Marquet, Valtat, Girieud, Friesz, etc.

The cubists' room might well have been the main attraction of the Salon, if they had all exhibited, if it weren't for the absence of Delaunay and Marie Laurencin and for the equally noticeable absence, in an adjacent room, of the young masters whom hardly anyone speaks about but whose influence can nevertheless be felt: Picasso, Derain, Braque, Dufy. Such as it is, however, Room 8 is the newest and most interesting room in the Salon and the one that will be most commented on.

The chief attraction of the Salon d'Automne is incontestably the exhibit of Henri de Groux's works.

Henri de Groux[37]

How can I express the range of feelings that Henri de Groux's works have aroused in me over the past week? I saw these works arriving at the Grand-Palais in a moving van—it looked almost like a big paddy wagon—and I watched for a long time as the porters removed from the van so many great and famous people: Napoleon, Tolstoy, Wagner, Baudelaire, etc. Later, inside Room 10, where the exhibit was being set up, I saw the artist sitting disconsolately on a packing crate, like an exile in the midst of ruins. Until then, I had known neither Henri de Groux nor his paintings, and of the man I knew only his legend, which is marvelous and unbelievable. I thought, moreover, that he had been dead for many years when, suddenly, I found myself in the presence of a ghost full of life and vigor, whose conversation is witty and whose face recalls Baudelaire's. At first, his painting seemed to me to be the most outmoded thing in the world; I felt that these Shakespearean and Dantesque evocations were purely literary. How sadly I looked, without daring to linger, at his *Humiliation of Christ*, at the tragic *Napoleon Crusoe*,[38] and at his portraits! But then, I gradually grew accustomed to this poetic tumult; Henri de Groux's lyrical imagination was revealed to me, and I understood the meaning of this plastic delirium; suddenly, the romantic crowds, the mournful and solitary figures came to life before my eyes.

Certainly, the Belgian painter's technique is not new. It is outmoded today and clashes violently with all the works exhibited at the Salon d'Automne. In the work of this painter, imagination has the predominant role. But where is the harm in that? Painters have perhaps for too long placed all their trust either in nature or in theories; yet imagination also gives birth to great works.

The group exhibited by Henri de Groux gives one the impression of an immense labor and a sensibility of the highest order. A canvas like his *Humiliation of Christ* is worthy of any museum. And if his other paintings do not all command our admiration, they do at least command our attention by the probity of their execution, the cultivation they bear witness to, and the talent and enthusiasm they display. This exhibit will undoubtedly have a positive effect. Many young painters will first look at Henri de Groux's works with a glum distrust; but little by little, those who really love their art will be touched by the simplicity with which the artist has revealed his means, his poetic thoughts, his brainwork, his obvious manual skill, his visionary ardor. And, from these paintings which already belong to the past they will draw some excellent lessons.

[OCTOBER 10]

The Exceptional Attention Accorded Cubism by the Press
Proves Its Importance

By providing a great deal of copy for the newspapers, the war between Italy and Turkey interfered with the publication of articles on art. I therefore ask the painters to excuse Italy, mother of the arts.

Before visiting the painting rooms, I must speak a bit about cubism. I find myself practically alone among art critics in defending a group of artists whose efforts I know about and whose works I like. The mockery that greeted the exhibition of their works at the Salon d'Automne, while indicating the importance of their undertaking, proves absolutely nothing about their art. Those who consider cubism to be a hoax are completely mistaken. Their attitude shows simply that if the lesson of Ingres was not lost on these artists, it has been completely lost on the public and on many art critics.

The Cubists

In a tiny room, Room 8, are the works of a few painters known by the name of cubists. Cubism is not, as is generally thought, the art of painting everything in the form of cubes.

In 1908, Picasso showed a few paintings in which there were some simply and firmly drawn houses that gave the public the illusion of these cubes, whence the name of our youngest school of painting.[39] This school has already aroused passionate discussion. Cubism can in no way be considered a systematic doctrine; it does, however, constitute a school, and the painters who make up this school want to transform their art by returning to first principles with regard to line and inspiration, just as the fauves—and many of the cubists were at one time fauves—returned to first principles with regard to color and composition.

However, the public, accustomed as it is to the brilliant but practically formless daubs of the impressionists, refused to recognize at first glance the greatness of the formal conceptions of our cubists. People were shocked to see contrasts between dark forms and lighted segments, because they were used to seeing only paintings without shadows. In the monumental appearance of compositions that go beyond the frivolities of contemporary art, the public has refused to see what is really there: a noble and restrained art ready to undertake the vast subjects for which impressionism had left painters totally unprepared. Cubism is a necessary reaction that will give rise to great works, whether people like it or not. For is it possible, can anyone believe for an instant, that the undeniable efforts of these young artists will remain sterile? I will even go further, and without underestimating the talents of all sorts that are manifest at the Salon d'Automne, I will say that cubism is the most noble undertaking in French art today.

Metzinger's imagination has given us, this year, two canvases whose elegance of color and line bear witness at the very least to a high degree of culture.[40] Metzinger has the additional and currently uncommon merit of really finishing his paintings. He is now in full possession of his art. He has rid himself of outside influences, and his palette is rich and refined. Gleizes shows us two aspects of his great

talent: invention and observation. Take, for example, his *Portrait of Jacques Nayral*; it is a very good likeness, yet in this impressive canvas, there is not one form or color that was not invented by the artist. This portrait has a grandiose appearance that should not escape the notice of connoisseurs. Grandiose painting seemed to be the preserve of M. Detaille, and we all know what use he made of it. It is time that young painters turned toward the sublime in their art. *The Hunt*, by Gleizes, is well composed, and beautiful colors sing in it.

Firmin [*sic*] Léger is searching for his personality. His painting is entitled *Essay for Several Portraits*. This canvas bears witness to a great effort, and it also reveals a great deal of modesty and an even greater amount of talent.

Le Fauconnier has sent us only three small landscapes.[41] They are first rate. The delicacy of his colors constitutes one of the merits of this artist. The sites he has painted are attractive, and they are imbued with an ineffable charm.

M. de La Fresnaye has sent not only a *Statue*, which is one of the best pieces of sculpture in the Salon, but also some woodcuts done with a sure hand, a nude figure, and two excellent landscapes.

Here is the powerful *Boxing Match*, by D. de Segonzac, whose palette and means of expression are in full development; here is the *Nude* by Albert Moreau, whose melancholy imagination expresses itself with a great deal of lyricism; here are interesting exhibits by Duchamp, Kars, and Doucet, whose pictures, like the important composition by Lhote, *The Port of Bordeaux*, seem quite out of place in this room devoted to cubism.

[OCTOBER 11]

People are desperately searching these days for a style in furnishings; doubtless, they will have found it in time for the Decorative Arts Exhibition of 1915. The Salon d'Automne invited the public today to visit its furnishings exhibits, among which one must single out the consummate pieces of furniture by Paul Follot, as well as the dining room and the study conceived in perfect taste by André Mare and executed with the help of Mlles. Laurencin and Bernouard and Messrs. Rouault, La Fresnaye, Duchamp-Villon, Segonzac, Villon, Moreau, Léger, Miré, Desvallières. [. . .]

As I have already said, except for the cubists, there are very few sensational innovations at the Salon d'Automne. Nevertheless, the exhibition as a whole is excellent, and there is perhaps not a single room without some very good pictures. People have made a lot of fun of the cubists, refusing to notice that their influence can already be felt on many other painters; this observation, which can be verified in the course of a visit to the Salon, provides sufficient justification for an effort that people scoff at, though they cannot deny its existence—and ridicule, even though they are forced to admit its importance.

Room 1. [There is . . .] *The Siesta*, by Ottmann, who is becoming more powerful, and a handsome decorative panel by Charles Guérin, *Women, Flowers, and Fruit*. This is without a doubt one of the best works in the Salon. Its composition and its coloring are very attractive. It's a kind of *fête galante* that Verlaine would have liked.

Rooms 3, 3-A, 3-B. There is a *Lighthouse* by Marquet, painted with simple mastery.[42] Girieud's Viennese landscapes have a timid appearance that is quite unexpected in this artist's work. Here are Laprade, elegant and nervous, [. . .] Valtat, who chose a silver frame for his slightly overwhelming *Women Bathers*, and Le Bail, who possesses logical means of expression that do not lack daring. Here are [. . .] Dufrenoy and his overly robust paintings of Venice, and here is Puy with an important exhibit: I am very fond of his *Little Lacemaker* and his *Roaming Through the Woods*.

Rooms 4 and 5. Bonnard's *The Mediterranean*, in three decorative panels, is a savory ragout of colors, but the colors are less beautiful than those of Henri Matisse, who knows how to paint more formally when he wishes. The paintings by Bonnard and Matisse present a total absence of forms. That is the very opposite of cubism. Mme. Marval is exhibiting the prettiest picture in the room, *Homage to Gérard de Nerval*, in which the blond Adrienne is shown singing a folk song. The artist did not dare to include a portrait of the poet in this gracious composition; Nerval, as everyone knows, looked like a provincial schoolteacher. [. . .] Here are flowers by Mme. Georgette Agutte, who is also exhibiting a firm and appealing portrait of a woman, a bold, enthusiastic painting. I like Marchand's poetic composition and K.-X. Roussel's mythological compositions, as fine and beautiful as the

sonnets of the poets of the Pléiade. Georges Desvallières is showing a grave and harmonious decoration designed for a library. Here are the showy canvases of Van Dongen, a lyrical *Seascape* and a mysterious *Oasis* by Friesz, Vlaminck's flowing earthiness, Lombard's *Open Window*, with some painterly qualities and a total absence of composition. Here also are the Flandrins, full of a rather icy elegance. [. . .]

Francisco Iturrino and the Last of the Fauves

In Room 6-A, Iturrino is exhibiting a collection devoted to life in Spain. Painted in clear colors, Iturrino's canvases are without a doubt the most luminous works produced by Spanish painting. His women bathing, his cigar-makers, his gypsies, and his dancers will enjoy great success. Iturrino will enjoy it next year, when he has cultivated his ambition as a decorator and when, gifted colorist that he is, he has strengthened and varied the shades of his palette.

Room 7. Here we find the colorful canvases of the epigones of fauvism. A very good likeness of *Henri Matisse* by Mme. Meerson makes this group serve as an homage to the master of powerful and pleasant colors. [. . .]

[OCTOBER 14]

[. . .] Rooms 12, 13, 14, 15. One must make special mention of the exhibit by Echevarría, who is showing, among other excellent pieces, a *Portrait of P. P. Plan*, to whom good writing is so very much indebted. It has not been sufficiently remarked that Echevarría's exhibit reveals a temperament of the very first order. [. . .] Here are Steinlen's *Negresses*, and the chubby-faced portraits by Jacques Villon. [. . .]

Sculpture

The largest sculpture exhibit consists of José de Charmoy's fragments for a *Monument to Beethoven*. There has been a great deal of talk about it here, and doubtless we shall soon see this colossal work in a public square. Jean Baffier, on whom M. Charles Achard has

just published an interesting study, is exhibiting a bust and some decorative pieces; Marque's *Woman Bathing*, Bourdelle's *Bust*, the wooden bust of *Maurice Denis* by Lacombe, the busts by Pimienta and Niederhausern-Rodo, Andreotti's *Gorgon*, Duchamp-Villon's *Baudelaire*, and the work by Archipenko are among the better pieces of sculpture in this Salon, which has a fairly small sculpture section. [. . .]

The Decorative Arts

It is truly regrettable that Raoul Dufy decided not to show us his color prints on precious fabrics. They would without a doubt have been the main attraction of the decorative section of the Salon d'Automne. I have already spoken about the furnishings exhibits, which suggest—especially the sober ensembles by André Mare—that we shall soon be seeing some new furniture designs that will not be positively atrocious. Today's decorators are perhaps too wary of gilding, and tapestry is also being unjustly neglected. Messrs. Groult, Louis Süe, Jaulmes, and Paul Follot are among the best of the new decorators. [. . .]

(*L'Intransigeant*)

The Art World

The Sacha Guitry Exhibition

M. Sacha Guitry occupies his leisure hours with the most agreeable and least innocent of pastimes. Between two theatrical hits, he displays his undoubted talents as a caricaturist of his contemporaries.

He is currently exhibiting some very amusing portraits at the Bernheim Gallery. The portrait of Marcel Schwob toward the end of his life, with his waxy complexion and his resemblance to a meek old featherless eagle, is terribly moving.

Here also are Henri de Régnier with a very funny mustache shaped

like a circumflex accent, Ernest La Jeunesse, Tristan Bernard, Anatole France. . . .

Yet, even when M. Sacha Guitry paints, one feels that he is not really a painter, but his verve, his wit, and his talent easily compensate for qualities that are necessary only to professional artists.

Just look at his portrait in oil of *M. Victor H———*. Even at first glance, one can be sure that he will publish yet another volume of verse this year.

There are also a portrait of *Renan*, a *Self-Portrait*, one of *Mme. Colette Willy*, some flowers, and some landscapes executed with talent, daring, and even more good humor.

(*L'Intransigeant*, OCTOBER 31)

An Opening

The Gallery of Contemporary Art invited the public today to the opening of an exhibition in which all the different tendencies of young French painting are represented.[43]

I have almost no space to speak to you about it. Go see it for yourselves. That will be much better.

The most audacious group is well represented by Mlle. Marie Laurencin, Albert Gleizes, R. de La Fresnaye, Firmin [*sic*] Léger, Duchamp, who is making a lot of progress, and Jean Metzinger, who has become a colorist.

This gives me yet another chance to declare that I consider the concerns of the young artists known as cubists to be the most noble of today's artistic concerns. One should also point out the works by Dunoyer de Segonzac, Luc-Albert Moreau, Lotiron, Verdilhan, Alfred Lombard. Special mention should be made of a very beautiful *Nude* by Raoul Dufy, a hallucinatory *Crucifixion* by Alcide Le Beau, the works of Mme. Hassenberg,[44] Paul Véra, etc., and the sculptures of Messrs. Archipenko and Duchamp-Villon.

The only works lacking to make this exhibition truly representative are those of Picasso, Derain, and the great painter Seurat, whose name I wish particularly to emphasize.

(*L'Intransigeant*, NOVEMBER 19)

Letter from Paris

[Thanks to his professional activity, our Paris correspondent was able to attend the first meeting of the Committee for Freedom of Art, whose existence is due to the ingenious idea of our eminent colleague, Paul Reboux.[45]

Our correspondent has sent us a report of the proceedings of this meeting; his great journalistic feat, destined to have world-wide repercussions, will henceforth take its place amid the illustrious accounts that make up the Golden Book of the Press.]

FOR FREEDOM OF ART . . . —The committee met last Sunday in M. Reboux's own residence, on the Rue de Clichy. I had bribed one of the servants of the house—I am forbidden to say which one by a sense of professional discretion that I am sure everyone will understand. This person—I do not even want to say whether the person was male or female—had hidden me inside one of the ingenious machines that adorn M. Reboux's study: the reading machine. Thanks to this machine, M. Reboux can read fifteen books at a time, in the short space of eighteen minutes.

The partisans of Freedom of Art arrived around seven o'clock in the morning; an executive board was constituted: M. Charles-Henry Hirsch presided, M. Reboux vice-presided, etc.

At eight o'clock, the President called the meeting to order. The first to speak was M. Aching Waterlily, man of letters.

M. WATERLILY: Naturally, I am in favor of Freedom of Art. Nevertheless—and I believe that I am expressing the sentiments of all the citizens here present—I request (it goes without saying) that Jews, foreigners, Protestants, and freethinkers should not be allowed to invoke this freedom in order to spread their abominable doctrines. . . . (*Stirrings in the audience.*)

The President rings his bell; then, protesting against the words of the speaker, he covers his head as is the custom in the synagogue in

order to show that, despite his name, he harbors no hostility whatsoever against the Jews.* Finally, order is re-established, and the President uncovers his head.

M. ERNEST LA JEUNESSE (*whom a circumcision doubtless too zealously performed has endowed with an extremely high-pitched voice*): Down with the Jews!† Long live the Emperor!

M. Georges de Porto-Riche denounces the works of M. Alfred Capus before the honorable assembly. . . . "Certainly I see no harm in being ribald, free, and obscene, but I protest when a villain is presented to the public in a sympathetic light. We must take action against villains in the theater. . . ." (Since it appears that M. de Porto-Riche is a gate-crasher and that he is on the editorial board of a rival newspaper, he is expelled from the meeting with indignant cries.)

M. URBAIN GOHIER: I too am certainly in favor of Freedom of Art, but we must not go too far in that direction. I demand that we take action against the cubists, whose paintings I find extremely offensive.

VICE-PRESIDENT PAUL REBOUX: I demand that action be taken against all those who write in free verse and, in general, against all those whose books I don't quite understand.

M. JEAN ROYÈRE: On the contrary, severe action should be taken against all those who express themselves clearly. Not every truth is fit to tell, and the work of art must be obscure and sibylline.

M. EUGÈNE MONTFORT: Let us mercilessly prosecute all those who don't know Latin, for they are endangering the French language.

M. BRUNOT: You don't know what you're talking about. We must definitely suppress the study of Latin, which is a national peril.

M. Such-and-Such, a family man, asks that the freedom of writers not extend so far as to inform children of what they will find out one day. "I mean the sexual act, gentlemen. Let us think about it always, but speak about it never!"

M. IMPOTENT (*member of several academies*): I propose, moreover that we prosecute the sexual act. Modern thought is sufficient unto itself. Let us free ourselves of all bestial habits.

* It seems to me that our correspondent is a bit confused here.
† No doubt about it! Our correspondent is confused again.

The President, noting that the discussion is becoming sidetracked, rings his bell.

THE VICE-PRESIDENT: It seems to me that we are all in agreement. We all consider Freedom of Art to be inviolable.

At this moment, a letter is brought to the President, who opens it and reads it.

THE PRESIDENT: M. Hervé reminds us that Freedom of the Press is inseparable from Freedom of Art. . . . (*Stirrings in the audience, with interruptions.*)

A VOICE: Freedom of the Press was all right under the Empire.

ANOTHER VOICE: We are here to talk about Freedom of Art. Freedom of the Press does not concern us.

Enter a messenger.

THE MESSENGER: M. René Bérenger, the senator, has sent me to find out what you have decided.

THE PRESIDENT: Tell your master that we are here for Freedom of Art and that we will not leave here before starting to take action against all those who compromise that freedom by making use of it.

The meeting having adjourned, I climbed out of my reading machine without being seen by anyone, and leaving the crowd of delegates, I went off to a literary banquet.

(*Le Passant*, Brussels, N O V E M B E R 25)

The Art World

Kees Van Dongen

[. . .] Van Dongen himself wrote the preface for his exhibition. "Here are some paintings. Some licentious dancers. A woman strolling. A beautiful child. A mother suckling her infant. Music. Flowers. Colors. Green, which is the optimism that heals; blue, which is light and repose; royal yellow, a few colors of forgetfulness, and all the colors of life."

An exhibition by Van Dongen is a feast of colors. At the Bernheim Gallery, one can rediscover the colorist's gifts that characterize the energetic, sensuous, gay artist named Van Dongen.

(*L'Intransigeant*, DECEMBER 13)

1912

The Salon d'Hiver

An Opening at the Grand-Palais

Today was the opening of the Salon d'Hiver at the Grand-Palais on the Champs-Élysées. This is the youngest of our large salons. It has grown quickly, and one can predict that in a few years it will attain the size of its elders. This year's Salon d'Hiver is on the whole a great deal better than last year's. One finds some young talents, colorists full of enthusiasm, and landscapists intoxicated with open air and light. This comes as an agreeable surprise. We are no longer used to seeing canvases painted with a fresh and naïve originality in our Salons. Lack of space unfortunately prevents me from speaking in detail about all the interesting exhibits. I hope I will be pardoned for not doing so. [. . .]

M. Gabriel Ferrier is exhibiting a portrait of a woman and two portraits of men: General Lacroix and M. Georges Cain. The latter is a curiously impressionistic canvas, showing him with a red and green starched collar and a purple face. Evidently, the professors of the École des Beaux-Arts also want to become modern. [. . .]

Some of the public will be especially fond of [. . .] M. Renard Brault's frightening *Death of Galope-Chopine*, inspired by Balzac's

1 9 1 2

Les Chouans. As for me, I prefer to linger over [. . .] the very curious works by M. Georges Raynard, whose coloring (especially in the still-life entitled *Lamplight at Twilight*) recalls that of the cubist *Still-Life* recently exhibited by M. Metzinger. [. . .]

(*L'Intransigeant*, J A N U A R Y 20)

The Art World

The "Pompiers"—Félix Vallotton

Academicism is not in fashion. One is only too aware of that fact in visiting the exhibition of the "Pompiers" at the Georges Petit Gallery. These painters call themselves *pompiers*:[1] they are indeed, but they would like not to be. Their first exhibition, moreover, is a great success. The catalogue is superb, well illustrated, and embellished with a sonnet by M. Jean Aicard.[2] As for choosing among the works on exhibit, I would willingly leave that task to others, were it not for the presence of works by Messrs. Baschet and Harpignies, and of a canvas by Ziem that is among the best he ever did.

As for the rest, you will never get me to say why I do not like the paintings, drawings, and sculptures by Messrs. Joseph Bail, Bompard, Bouchor, Browman, Paul Chabas, Raphaël Collin, Dagnan-Bouveret, Déchenaud, Friant, Gosselin, Laparra, Jules Lefebvre, Lorimer, L.-O. Merson, De Migl, Miller, Aimé Morot, Meunier, Olive, Pointelin, H. Royer, Saint-Germier, Vignal, A. Vollon, Cordier, E. Dubois, A. Injalbert, Peter, C. Puech, Sicard, Verlet, and Vernon. These gentlemen are all more or less members of the Institute, and one does not correct the spelling of an academician.

If M. Vallotton is not a *pompier*, he would like to be.[3]

But not daring to call himself a follower of M. Courtois, he pretends to draw his inspiration from Ingres, while, in fact, he imitates one of the most astonishing modern painters and the only *pompier* that the *pompiers* do not really understand, since he is a *pompier* and something else as well. I am referring, of course, to the Douanier Rousseau. M. Vallotton imitates him lovingly, as is evident in his *Cart*, his

Poplars, his *Ravine,* and many other canvases, not to mention the still-lifes.

Rousseau would have been delighted to have such a pupil, but I do not think he would have wanted to sign any of these paintings.

(*L'Intransigeant,* J A N U A R Y 27)

From Michelangelo to Picasso

Oh, you crowd pressing forward to see the paintings of this Chauchard collection,[4] with its host of mediocre paintings! You crowd of little people who are interested only in *The Angelus,* and you ultra-respectable old gentlemen who care only about the Meissoniers, examining them with a magnifying glass the way the English examine Memling's paintings in Bruges! Oh, you crowd in whose midst I finally saw the models for the chromos they used to sell in marketplaces when I was a child—several times I was tempted to cry out to you Michelangelo's words on Flemish art:

"This painting is nothing but rags, huts, vegetables, shadows of trees, and bridges and rivers, which they call landscapes, with a few figures here, a few figures there. And all of this, although some people consider it good, is in reality done without reason or art, without symmetry or proportion, without discernment, or choice, or ease, in a word without the least substance or vigor."

These words can be found in a book whose existence no artist is unaware of: *Quatre Dialogues sur la peinture,* translated by M. Rouanet. The author of the book, a Portuguese by the name of Francisco do Hollanda, traveled all over Italy in the sixteenth century and recorded Michelangelo's statements on Art. This book seems to me to have the same importance for painting as Goethe's conversations with Eckermann have for literature.

Yet, the words I was tempted to cry out in the respectable rooms of the Louvre that house the Chauchard collection could easily be re-

peated elsewhere. The great majority of modern paintings fit Buon-arroti's description of Flemish painting.

What a joy it is, therefore, to find a painter today who cares about "reason," "art," "symmetry," and "proportions."

The discernment, the ease, the substance, and the vigor that Michelangelo considered to be the qualities of good painting can be admired in the works of Pablo Picasso.

I remember the words I wrote when I first saw the paintings of the blue period:

"Picasso has looked at human images that floated in the azure of our memories. . . . How pious are his skies stirred by the movement of wings, his lights heavy and low like the lights of grottoes. . . . These women who are no longer loved remember. They are tired of ironing their brittle ideas today. They do not pray; their devotion is to their memories. They huddle in the twilight like an ancient church. . . . Enveloped in icy mists, the old men wait without pondering, for children alone ponder. Stirred by faraway lands, by the quarrels of animals, and by hardened tresses, these old men can beg without humility. Other beggars have been worn out by life. They are the cripples, the disabled, and the knaves. They are astonished at having reached the goal that has remained blue yet is no longer the horizon."[5]

Picasso breathed life into these paintings as blue as the depths of the sea; later, he created paintings that were more perfect still.

Next to these works of a fathomless blue, one sees the much more recent rose paintings. A wonderful calm reigns over them, and one feels in the latest ones that the painter who created all that young and sober grace is already moving toward the most objective forms of art, in order to raise it to the sublime.

For Picasso ranks among those of whom Michelangelo said that they deserve the name of eagles, because they surpass all others and pierce through the clouds until they reach the sunlight.

And today all shadows have disappeared. The last cry of the dying Goethe—"More light!"—echoes in the sublime and mysterious work of a Picasso, as it still echoes in the work of Rembrandt.

(*Les Marches de Provence*, F E B R U A R Y)

On the Subject in Modern Painting

The new painters paint works that do not have a real subject, and from now on, the titles in catalogues will be like names that identify a man without describing him.

Just as there are some very skinny people named Portly and some very dark-haired people named Fair, I have seen paintings entitled *Solitude* that show several figures.

Painters sometimes still condescend to use vaguely explanatory words such as *portrait*, *landscape*, or *still-life*; but many young painters simply employ the general term *painting*.

If painters still observe nature, they no longer imitate it, and they carefully avoid the representation of natural scenes observed directly or reconstituted through study. Modern art rejects all the means of pleasing that were employed by the greatest artists of the past: the perfect representation of the human figure, voluptuous nudes, carefully finished details, etc. . . . Today's art is austere, and even the most prudish senator could find nothing to criticize in it.

Indeed, it is well known that one of the reasons cubism has enjoyed such success in elegant society is precisely this austerity.

Verisimilitude no longer has any importance, for the artist sacrifices everything to the composition of his picture. The subject no longer counts, or if it counts, it counts for very little.

If the aim of painting has remained what it always was—namely, to give pleasure to the eye—the works of the new painters require the viewer to find in them a different kind of pleasure from the one he can just as easily find in the spectacle of nature.

An entirely new art is thus being evolved, an art that will be to painting, as painting has hitherto been envisaged, what music is to literature.

It will be pure painting, just as music is pure literature.

In listening to a concert, the music-lover experiences a joy qualitatively different from that he experiences in listening to natural sounds, such as the murmur of a stream, the rushing of a torrent, the whistling

of the wind in the forest, or to the harmonies of a human language founded on reason and not on aesthetics.

Similarly, the new painters provide their admirers with artistic sensations due exclusively to the harmony of lights and shades and independent of the subject depicted in the picture.

We all know the story of Apelles and Protogenes, as it is told by Pliny.[6]

It provides an excellent illustration of aesthetic pleasure independent of the subject treated by the artist and resulting solely from the contrasts I have just mentioned.

Apelles arrived one day on the island of Rhodes to see the works of Protogenes, who lived there. Protogenes was not in his studio when Apelles arrived. Only an old woman was there, keeping watch over a large canvas ready to be painted. Instead of leaving his name, Apelles drew on the canvas a line so fine that one could hardly imagine anything more perfect.

On his return, Protogenes noticed the line and, recognizing the hand of Apelles, drew on top of it another line in a different color, even more subtle than the first, thus making it appear as if there were three lines on the canvas.

Apelles returned the next day, and the subtlety of the line he drew then made Protogenes despair. That work was for a long time admired by connoisseurs, who contemplated it with as much pleasure as if, instead of some barely visible lines, it had contained representations of gods and goddesses.

The young painters of the avant-garde schools, then, wish to do pure painting. Theirs is an entirely new plastic art. It is only at its beginnings, and is not yet as abstract as it would like to be. The new painters are in a sense mathematicians without knowing it, but they have not yet abandoned nature, and they examine it patiently.

A Picasso studies an object the way a surgeon dissects a corpse.

If this art of pure painting succeeds in disengaging itself entirely from the traditional way of painting, the latter will not necessarily disappear. The development of music, after all, did not cause the disappearance of the various literary genres, nor did the acrid taste of tobacco replace the savor of food.

(*Les Soirées de Paris*, F E B R U A R Y 1)[7]

The Art World

The Italian Futurist Painters

"The simultaneity of states of mind in the work of art: that is the intoxicating aim of our art."[8]

This declaration by the Italian futurist painters reveals both the originality and the weakness of their painting. They want to paint forms in movement, which is a perfectly legitimate aim, and at the same time, they share the mania of the majority of *pompiers*, who want to depict states of mind. While the paintings of our avant-garde painters no longer have subjects at all, the subject is often the most interesting thing in the paintings of the *pompiers*. The Italian futurists declare that they will not abandon the advantages inherent in the subject, and it is precisely this that may prove to be the reef upon which all their artistic good will will be dashed to bits.

The futurists are young painters who would deserve a lot of credit, if the boastfulness of their declarations and the insolence of their manifestos did not dispel any indulgence we might be tempted to feel toward them.

They declare themselves to be "absolutely opposed" to the art of the avant-garde French schools, yet at this point, they are nothing but imitators of those schools.

Take, for example, Boccioni, whom I consider to be the most gifted of the futurist painters. Picasso's influence on his work is undeniable, as it is undeniable on all contemporary painting. Boccioni's best canvas is the one most directly inspired by Picasso's recent works. It even includes the printed numbers that give Picasso's recent productions such a simple and grandiose reality.

The titles of futurist paintings often appear to have been borrowed from the vocabulary of unanimism. Let the futurists beware of syntheses that have no plastic equivalents and that, therefore, lead the painter only to the cold allegories of the *pompiers*.

One must look carefully at the *Pan-Pan at the Monico*, which

is the most important work yet painted by a futurist. Movement is well rendered in this canvas, and since no optical fusion of colors occurs, everything is in motion, as the artist wished. I am less fond of Severini's other canvases, which have been overly influenced by the neoimpressionist technique and by Van Dongen's forms.

Let us also mention Carrà, who is a kind of Rouault but more vulgar than our artist, and who sometimes calls to mind the academicism of a forgotten painter, Mérodack-Jeaneau.

Russolo is the one least influenced by the young French painters. One must look for his mentors in Munich or in Moscow. Someday we shall find him more interested in truly plastic problems.

The young futurist painters can compete with some of our avantgarde artists, but they are still nothing but the awkward pupils of a Picasso or a Derain; as for gracefulness, they have no idea it exists.

(*L'Intransigeant,* FEBRUARY 7)

Art News: The Futurists

M. Marinetti wants to play the same role in Italy today that St. Francis of Assisi played in times gone by. He wants to be a reformer of the arts.

Il Poverello owed his power to his inspiring faith, which awoke the plastic sense of artists and the lyricism of poets all over the peninsula. And it was this faith that inspired the mystical flagellants known as the *giullari di Dio* to wander all over Umbria, reciting dialogues in the public squares with a kind of holy frenzy. These dialogues are the oldest dramatic works in Italy after the decline of antiquity. The nature of St. Francis's life suggested to painters that they should strive for greater truthfulness in the expression of faces and attitudes. Great painting was born as a result of the efforts painters made to render the saintly beauty of the stigmatized saint.

For a long time now, Italian art has been immobilized in that academicism that is sometimes the slumber of Art and often its death.

After having led the world's artistic movements for such a long

time, Italy, justly proud of its glorious past, fell behind France, Holland, England, Spain, and Belgium in the arts.

It was a long time ago that a Michelangelo could assert that to be a great painter, one had to be born in Italy! . . .

But here now is a young poet who is attempting to restore the arts and literature.

It seems to me that in Italy the arts are much more in need of restoration than is literature. This point of literary criticism, however, is not relevant to the present discussion. It is true that the arts on the peninsula have become mere exercises in professional skill. Even the divisionists maintained a vulgarly academic line, and their inspiration was idiotic.

F. T. Marinetti, a gallicized Italian, wants to change this state of affairs. He wants to awaken Italy from its torpor. He has taken France as his model because France is the leader in the arts and in literature; without telling his compatriots what he is up to, he is presenting them with France as an example.

He has found a number of poets, musicians, and painters to follow him. At present, there are five painters in the group: Boccioni, Carrà, Russolo, Balla, and Severini.

Only Messrs. Boccioni, Carrà, and Russolo have been futurists from the start.

They alone appeared, on March 8, 1910—a date that may become famous if futurism should become a great literary and artistic movement—on the stage of the Chiarella Theater in Turin. That was the third soiree organized by the futurists. The first one had taken place in Trieste, the second in Milan. In Turin, the leading futurists appeared along with M. Marinetti. They were Messrs. Boccioni, Carrà, Bonzagni, Russolo, and Romani.

Together they read their manifesto, which, according to their press release, "is a great cry of revolt against academic art, against museums, against the domination of professors, archaeologists, second-hand merchants, and antique dealers." At that point, a great uproar broke out in the theater. There were fist fights, duels with canes, the police were called, etc.

Since that day, the futurist painters have lost two of their members.

Who will ever know the fate of Messrs. Bonzagni and Romani? Did the futurists realize, by chance, that the latter name was that of Mme. Juana Romani, a famous *pompière* in her own right, who had infiltrated the futurists' inner circle?[9] Did M. Bonzagni make the mistake one day of admiring Titian? We lack information on all this. The fact is, however, that the five original futurist painters have remained five. But two of the names have changed, without our being informed about the fate of their predecessors: Bonzagni and Romani have been replaced by Balla and Severini.

It was the latter pair who signed a manifesto that, crammed as it is with banal antiplastic ideas, can nevertheless, by virtue of its violence, be considered a healthy stimulant for the debilitated artistic senses of the Italians. In a similar way, the invectives and poetic follies of a Jacopone da Todi were able to awaken Italy's lyrical sense and call forth a Dante.

The most original aspect of the futurist school of painting is that it seeks to reproduce movement. This is a perfectly legitimate quest, but the French painters solved the problem long ago, insofar as it can be solved.

In fact, the futurist painters have to date had more philosophical and literary ideas than plastic ones.

They declare, with an insolence that might more aptly be called ignorance: "We can declare without boasting that this first exhibition of futurist painting in Paris is the most important exhibition of Italian painting ever to have been offered for the judgment of Europe."[10]

This is sheer idiocy. . . . One does not even dare to pass judgment on so much foolishness. . . .

Further on, they add: "We have become the leaders of the European movement in painting."

And as far as French painting is concerned, knowing neither Corot, Cézanne, Gauguin, Renoir, Seurat, nor Matisse, they imitate the painters who have most recently come to work in Paris:

Boccioni is above all under the influence of Picasso, who dominates the work of all young painters today, not only in Paris but the world over.

Carrà seems to have seen a great number of Rouaults and Mérodeck-Jeaneaus. Rouault is a powerful painter, toward whom I myself have

often been very unjust. Carrà could have chosen a considerably worse master.

Russolo seems to be more influenced by the painters of Munich, Berlin, Vienna, and Moscow. Let us hope that he takes good advantage of his current stay in Paris.

Balla has not yet sent in his painting.

Severini is, together with Boccioni, the painter who appears to me to have the most to say among the futurists. He is under the influence of Renoir, Van Dongen, and the neoimpressionists Signac, Cross, and Van Rysselberghe, but he does have originality and his large canvas, *Pan-Pan at the Monico*, is the most important and most finished work yet done by a futurist painter.

Well! These painters—so obviously influenced by the newest contemporary painting that one of them could in all honesty call himself a pupil of Picasso, another a pupil of Rouault, a third a pupil of Van Dongen—these painters declare themselves to be *absolutely opposed* to the art of the French painters.

And the point on which they oppose the new French painters is precisely the point that, in my opinion, dooms futurist art.

The art of the new painters in France is distinguished from the academicism of the *pompiers* by its fierce, relentless observation of nature. The new painters scrutinized nature, they dissect it, they study it with infinite patience. One should not find it astonishing, therefore, that such pure plasticians are not at all interested in the "subject" and that they now entitle their pictures simply "painting," "study," or "landscape."

I have even been led to ask recently whether such purely plastic concerns would not lead to a totally new art that would be to painting what music is to literature.[11]

The futurists, however, are scarcely interested at all in plastic problems. Nature does not interest them. Their chief concern is the "subject." They want to paint "states of mind." That is the most dangerous kind of painting imaginable.

It will inevitably lead the futurist painters to become mere illustrators.

The futurists do, however, include Gino Severini, who seems determined to draw inspiration from realities that are strictly forbidden by the futurists' declarations. He has thus produced the most living work,

in which colors are not blended and therefore produce the illusion of movement; the title of the work is *Pan-Pan at the Monico*.

Nevertheless, the exhibition of the futurist painters will teach our own young painters to be even more bold than they have been up to now.

Without a good deal of boldness, the futurists would never have dared to exhibit works that are still so imperfect. The futurist exhibition will also allow our young painters to gauge how far ahead they are of their rivals in Italy, and indeed in the world as a whole.

It will also teach them how to choose better titles for their paintings. Here are Boccioni's titles: *The Farewells, Those Who Go, Those Who Stay, The Noise of the Street Penetrates the House, The Laugh, The City Rises, Simultaneous Visions, Modern Idol, The Powers of a Street*, and *The Raid*; Carrà did not hesitate to reproduce an event he had witnessed: *The Funeral of the Anarchist Galli*; Gussolo has painted a canvas entitled *The Revolt*.

In contrast to the deliberately analytic canvases of most of our young painters, these titles contain some clues for a more synthetic kind of painting.

In short, the new art that is being fashioned in France seems until now to have limited itself to melody, and the futurists have taught us —by their titles, not by their works—that it can attain the fullness of a symphony.

Among the statements in the manifesto of the futurist painters, none appeared more foolish than this one:

"We demand, for ten years, the total suppression of the nude in painting."

And yet, this statement is the unconscious affirmation of an unintentional agreement among all modern artists. While the aged Renoir, the greatest painter of our time and one of the greatest painters of all times, is spending his last days painting wonderful and voluptuous nudes that will be the delight of times to come, our young artists are turning their back on the art of the nude, which is at least as legitimate an art as any other.

They are doubtless prompted by a desire to go beyond humanity, as it were, and not consider it, and it alone, as the criterion of beauty.

One must admit, however, that modern art is dominated by an austereness unknown to any period until the present.

As for futurist art, it seems a bit silly in Paris, but it should not seem silly to the Italians; if it does, too bad for them.

(*Le Petit Bleu*, FEBRUARY 9)[12]

The Art World

The Salon de l'École Française

Artists are by no means idle in winter. It is in winter that they show us what they did in the fall. It is certain, however, that the chilly season brings us too many collective exhibitions whose characteristics are all the same. "Salon d'Hiver," "École Française," etc.—they all seem to be the same salon. I personally think that the various winter salons will eventually be united, and that, as a result, the painters who exhibit in them will be in a more authoritative position than they now are. After this preamble, let us come to the Salon de l'École Française, which has no lack of interesting exhibits. The small paintings by M. Léopold Delbeke, showing the interiors of the château of Versailles, are painted with a great deal of distinction and are bathed in a very agreeable golden light. [. . .] M. Eugène Damblans is a painstaking painter who brings off some masterfully executed pieces, witness his *Crouching Venus*, with its very bold reds. I also want to mention the works of [. . .] M. Weismann, whose well-painted *Kippered Herrings* reminded me of Charles Cros's famous monologue: "A long . . . long . . . long . . . kippered herring."[13]

M. Guinier's illuminations artfully commemorate some family events: births, weddings . . . It is a charming idea. M. François Pillet, an enterprising architect, is exhibiting a project for renewal of the neighborhood surrounding the École Militaire. M. Pillet knows how to be daring and modern, while conforming to the limitations imposed by the proximity of Gabriel's edifice. In concluding, I must cite a curious collection of glazed pottery by Messrs. Ponchelet and Léger, whose artful blending of metallic colors produces a delightful effect.

(*L'Intransigeant*, FEBRUARY 14)

Four Letters on Painting

Everyone is aware of the profound influence that the genius of Paul Cézanne has exerted on today's young painters.

Here are four letters[14] written by the old master from Aix to the painter Charles Camoin, whose artistic efforts had aroused his interest. One will find in these short notes Cézanne's intimate thoughts on his art: "I will speak to you about painting better than anyone else," he cries proudly. We hope that his lesson will prove profitable.

In these letters, Cézanne often speaks of the poet Léo Larguier, who recently published his reminiscences of the great painter. In Cézanne's handwriting, the *t*'s are crossed with a very long line, and he used the double *s*, whose elimination from typography had been advocated by Restif de La Bretonne; it was, in fact, eliminated by the Didots. Cézanne often used a grave accent in place of an acute. His signature is adorned with a flourish encircling the *P* to the left, and enclosing the whole name.

(*Les Soirées de Paris,* M A R C H)

The Art World

Marie Laurencin—Robert Delaunay

At the invitation of M. Robert Delaunay, Mlle. Marie Laurencin is exhibiting at the Barbazanges Gallery a small number of canvases and watercolors, chosen for the most part from her latest works.[15] The refined and elegant art of Mlle. Laurencin is one of the most strikingly original to be found today. And if these paintings are absolutely unique in their composition and line as well as in their coloring, it is nevertheless evident that the feelings and the taste that inspired them are analogous to those that inspired the French

artists of the Renaissance.[16] I imagine that when Mlle. Laurencin is painting, the Graces and the Muses are not far away.

An artist with a future like Mlle. Laurencin, Robert Delaunay, who is exhibiting here the majority of his works, is one of those rare painters of the younger generation who, after taking part in all the foremost artistic movements, has now cut himself off from them in a reaction against their exclusively decorative tendencies. Robert Delaunay's art is full of movement and does not lack power. Rows of houses, architectural views of cities, especially the Eiffel Tower—these are the characteristic themes of an artist who has a monumental vision of the world, which he fragments into powerful light. It is a pity that most of Robert Delaunay's large canvases are unfinished, whether by design or by accident.[17] One would like to see the effect produced by his intense colors in a carefully finished work. Robert Delaunay has already come to occupy an important place among the artists of his generation. This exhibit will certainly reinforce the good opinion we have formed of the integrity of his art.

(*L'Intransigeant*, M A R C H 5)

[Reply to an Inquiry on Cubism]

DEAR SIR:[18]

I am happy to repeat once again what I have never ceased writing: that, in my judgment, the movement known as cubism is the most noble artistic manifestation of our time.

The considerable importance that the press has in a sense been obliged to accord to a very small number of painters who, in the smallest room of the Salon d'Automne, exhibited the least obtrusive paintings in the whole Salon, proves how vigorous their art really is.

I am further of the opinion that if, on the whole, one compares the art of the cubists to the art of the impressionists who preceded them, one will find that it is the cubists who have more nearly attained the expression of beauty.

I must add that my praise is directed primarily at the trends in

the new painting, and that I reserve my judgment concerning the particular talent of each of the new painters.

<div align="right">

GUILLAUME APOLLINAIRE

(*L'Action*, MARCH 10)

</div>

Art News: The Decorative Arts and Female Painting

While waiting for the International Exhibition of Decorative Arts, which will probably take place in 1915, we have an opportunity each year to see the Salon of Decorative Artists.[19] A visit to this Salon is very instructive. This year, there is not a trace of the so-called *art nouveau style*. On the other hand, we are now witnessing the beginnings of a struggle between two opposing tendencies in decoration which cannot fail to be interesting. This is a struggle between the sumptuous decoration that jewelers already excel in, and the domestic decoration that, returning to the tradition of the Louis-Philippe period (the last period to have produced a genuinely beautiful style of furniture), is directed only toward forging an original style for our time. Let us add that in the latter tendency, which is also the more recent, the art of the interior decorator plays an important role.

Artists in both schools, however, are working extremely hard; in the first school, which arose around 1900, there are audacious experiments that, if not always successful, nevertheless testify to efforts that will not be wasted.

M. Paul Follot, who is a remarkable artist, is exhibiting an oval boudoir in inlaid maple.

M. Paul Follot's efforts to revive the art of wooden mosaic are extremely interesting.

This art, which attained perfection a few hundred years ago in central Italy, produced a master whom M. Follot might well aim to surpass; the master was Damiano of Bergamo, who lived in Bologna in the sixteenth century and who devised the technique of dyeing wood in all sorts of colors.

In his marquetry, M. Paul Follot uses not only wood, but mother-of-pearl as well. He has designed a small, luxurious boudoir, with a tastefully conceived fireplace in sculptured marble, in a lovely setting of mosaic and wrought iron. M. Follot, furthermore, is a marvelous jeweler who knows how to bring out all the beauty of the gems he works with. The heavy jewels of captive sultanas are not for him. M. Follot's rings are charming, and his necklaces are delightful.

Another jeweler, M. Lalique, is exhibiting a drawing room that is certainly the most surprising thing to be found at this Salon. It is entirely of pale ceramic, executed by the Sèvres porcelain works according to a process invented by the artist. Tapestries play, and are meant to play, no role whatsoever here, since the decorations of the floor and walls consist of branches of enameled platinum encrusted in the artificial stone created by M. Lalique's Baudelairean imagination. Baudelaire would certainly have loved this incredibly luxurious mineral dream; this is doubtless the first time that platinum has been lavished in such profusion. It is really a pity that such a singular lyrical fantasy should not be perfect; Baudelaire would perhaps have deplored, as I do, the banality of the medallions, furnishings, and glassware that disturb the noble and luxurious simplicity of this structure.

So much for the sumptuous school. I imagine it will exert a beneficial influence on the official decorative art of public buildings, exhibition halls, and theaters.

Let us now pass on to the other school, the school of domestic decoration, whose innovations seem perfectly suited to its aim, which is to make homes comfortable and pleasant places to be in. Not that the work of this school is above criticism, but I think that artists such as Mare, who is not exhibiting this year but who is one of those chiefly responsible for this renaissance, together with Léon Jallot and André Groult, have formulated the principles that will allow decorators and cabinetmakers to work in peace, knowing what must be done.

Nevertheless, the drawing room by Léon Jallot, which is based on these principles, is full of needlessly ill-matched pieces of furni-

ture, and the shape of the electric sconces is, in my opinion, not very attractive.

M. André Groult͏ has understood that a minor art such as furniture making must follow the lead of the major arts, such as painting. The majority of today's painters are colorists. M. André Groult has, accordingly, become a colorist, and for a few years to come, decorators will tend to use bright colors. After that, they must become daring enough to use a bit of gilding, which is somewhat lacking in these stylish but rather bourgeois interiors, where the excessive use of green curtains often introduces a slightly bureaucratic touch that is perhaps not very evident today, when these things are a brand-new fashion, but that people of taste will soon become aware of. The fear of gilding has been one of the characteristics of decorative art since the impressionists, who rejected gilded frames for their paintings. One can say that the public took up the impressionists' aversion to gilding well before it took up their paintings.

It seems to me that it would obviously be in the decorators' interest to study carefully the works of today's female artists, who alone possess the charming secret of the gracefulness that is one of the most original traits of French painting. This is true both of the works of the so-called French primitives and of the delightful and tasteful marvels that could have been only produced in France and that were painted by Watteau, Fragonard, Corot, Berthe Morisot, and Seurat. Female artists have brought to painting a new feeling that has nothing to do with finicking affectation, but that could be defined as follows: the courage to look at nature in its most youthful aspects. This new delicacy, which is like an innate sense of Hellenism possessed by the French woman, can be found to a high degree in the works that Mlle. Marie Laurencin is currently exhibiting at the Barbazanges Gallery. A decorative style that, issuing from the great French styles, would blend with the harmonies of works like these—frank, simple, free of all social or doctrinaire tendencies, and above all spontaneous —would, in my opinion, have a glowing future and would ultimately shed luster on the period in which we live.

(*Le Petit Bleu*, M A R C H 13)

The Salon des Indépendants

[MARCH 19]

The Opening Will Take Place Tomorrow, in Booths
on the Quai d'Orsay—A General View of the Salon

Today, when the Indépendants are about to open their exhibition,
I can say that for the last seven years, in the columns of this news-
paper and in other publications, I have been stating certain truths
about contemporary art that no one else would have dared to write.
People were sometimes dazzled by these truths, as they are by a
piercing light. Yet I had the satisfaction of knowing that my state-
ments were enlightening to a chosen few. One's eyes quickly be-
come adjusted to brightness. The torches I ignited have, in turn,
ignited others. Today, I am no longer alone in defending the disci-
plines of the new French schools. But in the future, as in the past,
I shall speak of everything that merits the attention of artists and
of the public.

The Trends

This year's Salon is one of the most important we have seen
in a long time. Each artist was limited to three canvases. And with
admirable enthusiasm, each artist decided that if his exhibit were to
be thus reduced, it should at least be particularly significant. Every-
one made a great effort, with the result that this Salon occupies
twenty rooms fewer than last year's. It no longer stretches on to
infinity, and the exhibitors sent their best works.

The various schools are not as compactly grouped as they were in
previous years. Painters representing the same trend will often be
found in widely separated rooms.

There is the Friesz-Dufy trend, the Vallotton trend, the Douanier
Rousseau trend, and the Matisse trend, which is now represented by
very few painters.

In the very rear of the Salon, one can see the group exhibit of the pointillists, which is very beautiful. There is a religious composition full of nobility and inspiration by M. A. de La Rochefoucauld and luminous pictures by Signac, Mme. Cousturier, and Luce. The cubists and other artists of a similar outlook occupy Room 20. In my next article I shall speak in detail about the efforts of F. Léger, Metzinger, whose only thought now is of grace and beauty, Gleizes, who has skillfully constructed a difficult work, Segonzac, who is exhibiting a fine still-life, Luc-Albert Moreau, R. de la Fresnaye, Lhote, Marchand, and Mme. Lewitska.

In a few of these latter artists, a dubious trend is beginning to make itself felt. They are trying to avoid the difficulties of painting by giving in to a deplorable penchant for illustration.

I shall soon have occasion to emphasize what I consider to be an incorrect interpretation of the lessons that are to be found in the works of Friesz and especially in those of Dufy.

The great event of this Salon is undoubtedly the *rapprochement* between Robert Delaunay and the neo-impressionists exhibiting in the last rooms. Delaunay's painting is definitely the most important picture in the Salon. *The City of Paris* is more than an artistic manifestation. This painting marks the advent of a conception of art that seemed to have been lost with the great Italian painters. And if it epitomizes all the efforts of the painter who composed it, it also epitomizes, without any scientific paraphernalia, all the efforts of modern painting. It is broadly executed. Its composition is simple and noble. And no fault that anyone might find with it can detract from this truth: It is a painting, a real painting, and it has been a long time since we have seen anything of the kind.

Le Fauconnier's painting *The Hunter* represents an even greater effort. From his trip to Italy, the artist has brought back a taste for natural backgrounds and a love of composition, which he knows enough not to confuse with anecdote.

Among the new painters, one must mention Juan Gris, Jankes, and Mme. Benz-Bizet.

Among the sculptors, three names command attention: Brancusi, Centore, Archipenko. And now, let us look at the Salon in detail. . . .

THE OPENING

It Was Very Brilliant and Very Parisian—
The Sun Figured as a Prominent Guest

There was quite an attendance at the opening of the Indépendants today. This morning, when the doors opened, a dense crowd was already pressing into the small rooms of the booths on the Quai d'Orsay. But M. Bérard will not be able to make his visit until tomorrow. In yesterday's article I explored in detail the various trends that our young artists are following. The first rooms of the exhibit are, as usual, the least interesting; a few paintings scattered here and there, however, hold our attention.

Rooms 2, 3, 4. A painting inspired by an extraordinary feeling of otherworldliness and signed Germaine Vasticar holds our attention here. One must mention Jacques Garnier's curious triptych, the tomb by Jean-Jacques, and above all the works of Jankes, a painter as yet unknown who is full of restless talent. Kern's *Armida* and his *Venus* are interesting works. Although he uses classical subjects, Kern's painting is modern. Mme. Andrée Benz-Bizet deserved to be exhibited elsewhere than in the first rooms. She has undeniable gifts as a colorist. [. . .]

Rooms 5, 6, 7. Mignote's exhibit is the most curious one in these rooms, and it is among the more interesting in the Salon. Mignote sometimes reminds one of Rousseau, but a Rousseau who had never been to Mexico. His paintings do not lack power, and if he wishes, he will soon rise to the level of decorative composition. M. Jacques Lederer imitates Mme. Gyp's manner in the drawings she signs under the name Bob, and M. Jack Yeats is exhibiting a piece of lunacy representing a man in a barrel who is throwing sticks up in the air.

Rooms 8, 9, 10. Here is the impressionist Hervé, a truly popular painter who sells his paintings in the street.[20] [. . .]

1912

Rooms 11, 12, 13. Let us mention the names of Dameron, Goldner, and Lemaître, who again reminds one of the Douanier and who is exhibiting some charming, minutely wrought landscapes.

Room 14. Dubois is a kind of careless and soulless Rousseau.

Room 15. Those who are in a hurry would do well to begin their visit to the Salon in this room, which contains the first really significant works. The Russian Chagall is exhibiting a golden donkey smoking opium. This canvas had outraged the police, but a bit of gold paint smeared on an offending lamp made everything all right.[21] [. . .]

[MARCH 25]

Room 17. Mme. Exter remembers Delaunay's first studies, as dramatic as landslides. This room contains only works by foreigners. Mme. Lewitska's exhibit is one of the best women's exhibits in the Salon. She has studied the landscapes of the Douanier, but her personality has remained intact and the sentiment that infuses her painting *The Countryside* is as rich as the songs of the villagers in her native country. Kandinsky is exhibiting his *Improvisations*, which are not without interest, since they are about the only works showing the influence of Matisse. But Kandinsky carries Matisse's theory on obeying one's instinct to an extreme, and the only thing he obeys is chance. [. . .] Juan Gris is exhibiting an *Homage to Picasso* that reveals a praiseworthy effort and a noble disinterestedness. Juan Gris's exhibit[22] could be entitled "Integral Cubism." A Czech painter, on whom the Destiny that presides over the distribution of patronyms bestowed the name of Kubišta, wandered through the Indépendants yesterday in search of works by his quasi namesakes, the French cubists. Having made a complete tour of the Salon, he stopped in front of Juan Gris's paintings and would be there still, if the merciless cry of "Closing time!" had not interrupted his meditation.

Room 18. M. André Lhote's painting is a compromise between the various tendencies shared by our young painters of talent. The public, that overgrown child, will not fail to appreciate his pictures. I am very fond of the drawing that Marchand is exhibiting, but I am less fond of his large popular illustration, *Tilling the Soil*. It contains some interesting experiments with movement, but I prefer the exhibit

by Mlle. Bailly, who in the space of a year has improved her work and whose large figures, although unattractive in their wine-red color, make a very respectable composition. Lotiron's views of Laon are honest and peaceful. Dusouchet is exhibiting some frescoes whose dismal colors I find unforgivable. Here is Tobeen, whose *Pelota Players* make a pleasant composition; all ten of them, in their various poses, are portraits of M. Olivier Hourcade, the great master of cubism in Aquitaine.[23] Verhoeven's paintings are less colorful but better constructed than usual; Frank Burty or the Timid Cubist, Suzanne Valadon, Pierre Huard, etc.

[APRIL 3]

Room 19. The best picture in this room and one of the best in the Salon is Mlle. Laurencin's *Women and Fans*. It is a gracious composition, personal and original in its arrangement of lines and choice of colors. Vlaminck's exhibit gives no indication of what the artist is currently working on; not long ago we saw some more recent paintings by him. In his military painting, R. de La Fresnaye's art is less pure than it was last year. This time he diminishes his subject somewhat. His *Portrait of a Woman*, which appears less successful, nevertheless indicates a more serious and very personal effort, especially in its coloring.

Luc-Albert Moreau dreams of a voluptuous and melancholy kind of painting; he paints bodies full of languor . . . *and as sad as love itself*. These words, from an admirable sonnet by Théodore de Banville,[24] can be repeated in front of D. de Segonzac's still-life, *Plaster Venus*, in which light plays artfully on forms that revive the Beauty that took the Parian road and the Antiquity that still throbs beneath the mass of ruins. Let us also mention the works by [. . .] Destable, whose name furnishes a too easy rhyme for "detestable."

Room 20. This is perhaps the most important room in the Salon. Perceptive visitors will see that it contains more than mere foolishness. I have already spoken of the paintings of Le Fauconnier and Gleizes. The painting by F. Léger also deserves attention.[25] It is an unfinished work that will impress only the well-informed viewer. In subject it is related to the works of Seurat, and Léger's line is marked by the wit that distinguishes the pointillist master.

Molière and Voltaire would have liked this painter. Metzinger wants to rise to the level of the great tradition. He has understood Ingres's lesson. His *Seaport* is a perfect canvas that would look very good at the Luxembourg Museum, which does not contain a single work by our new painters. The time is perhaps past for speaking about cubism. The time of experimentation is over. Our young artists want now to achieve some definitive works.

Above all, one must not confuse painting, illustration, decorative art, and caricature. [. . .]

Rooms 37–41. [. . .] Here is Tristan Leclère, who reserves his magician's name, Klingsor, for his poetry.

Here also are [. . .] Marcel Fournier, who has brought back from Madagascar some delicately shaded canvases intensely colonial in feeling; Makowski, a painter of genuine talent whom we shall doubtless have occasion to speak of again [. . .]; Asselin, whose intuition becomes more sure every day; [. . .] Rouault, a powerful, stark painter whose compositions are irreproachable. [. . .]

Rooms 41 to the end. [. . .] Deltombe is made for large decorations; he must be given some walls to paint. I have already said what a high opinion I have of Robert Delaunay's large canvas, *The City of Paris.* [. . .] Francis Jourdain has sent only one painting, which is excellent. [. . .]

Sculpture and the decorative arts. The Salon contains few pieces of sculpture, but they are very significant. Here are Centore, who knows how to sculpture great works boldly; Brancusi, a delicate and very personal sculptor whose works have great refinement; Archipenko, who has the same feeling for elegance that one finds in certain Gothic sculptors; Lehmbruck, whose talent makes one overlook the banality and stiffness he has inherited from the sculptors of Düsseldorf; Agéro, who this time has created a beautiful bust, simple, honest, and noble in feeling, with a very new technique. The decorative arts have provided very few exhibits. Let us mention Mare's bookbindings, which are charming and personal.

(*L'Intransigeant*)

New Trends and Artistic Personalities

The Salon that has just opened in the booths on the Quai d'Orsay is among the most important of the many memorable salons organized by the Société des Artistes Indépendants.

Signac told me one day about the beginnings of the Société, of which he is currently president; it is a touching story, and its hero was a retired police officer who used to paint in his spare time.

An equally heroic role was played by a young art critic, who was the only one to visit the Salon of the newly founded society; his name is Arsène Alexandre, and we saw him the other day visit the Salon des Indépendants for the twenty-eighth time.

This 28th Salon is a very significant one. Since each artist was limited to three works, everyone sought to exhibit only the best of his new ones. The Salon as a whole thus represents a considerable achievement whose importance will escape only those art critics who consider the official status of an artist more important than his talent.

One is aware of several clearly discernible trends in visiting the various rooms. Picasso's influence is the most profound, although it is becoming modified and even the artists who were most imbued with it have exerted so much effort over the last two years that their personality appears now enhanced and strengthened by the harsh discipline to which they have submitted lovingly and painfully.

Matisse's influence appears to have disappeared almost completely. That is really too bad. A master like Matisse, who gave an entirely new meaning to color and whose boldness in composition is truly astonishing, deserves to be studied carefully. His lessons would prove useful to more than one artist, and especially to those painters of little faith who yield to any facile penchant for illustration.

Apart from these influences, there are two other general and well-defined tendencies; one of these, in its rejection of the anecdotic and in its attempt to attain the sublime by means of efforts that are not to be disdained, constitutes the greatest glory of contemporary painting. This tendency unites artists such as Delaunay, Le Faucon-

nier, Metzinger, Gleizes, Marie Laurencin, Dunoyer de Segonzac, Luc-Albert Moreau, Vlaminck, Rouault, etc.

The other tendency, pursued by those who, through the influence of Friesz, have misinterpreted the work of Girieud or of Dufy, a great and misunderstood artist, appears to me deplorable. André Lhote is the most typical representative of this tendency today. His facileness and versatile talent have enabled him to assimilate whatever was original in Dufy and Girieud, and he has used it to paint merely pretty pictures, which have attracted a number of artists who were daunted by the difficult ascent toward the harsh summits of pure painting.

Thus it seems to me that a Marchand, a La Fresnaye—to mention only the most gifted and the most enthusiastic of these artists—are evolving toward a facileness that would render useless the efforts of several generations of artists to attain the summits of great painting.

The influence of Vallotton is also making itself felt. His manner is related to Ingres's only on the surface; possessing neither Ingres's boldness of line nor his Raphaelesque purity of color, Vallotton is more closely related to the Italianate Germans of the eighteenth and nineteenth centuries. Vallotton is starting a school. One can expect old maids the world over to begin applying his formula in all its cold sterility.

Among the younger artists, Le Fauconnier seems to me to be the one whose influence is making itself felt most strongly. The richness, the variety, and the depth of his coloring made his influence predictable. And yet, I hope that his manner will not become too fixed and that it will not imprison an artist who has produced some highly significant works and who seems to have been determined this year to produce definitive ones.

One can also detect at the Indépendants an impressionist trend, represented by artists such as Marquet and Jean Puy, and a Rousseau trend in which one should not, however, look for the direct influence of the Douanier's works. Rather, these are original works painted by autodidacts, but autodidacts of talent, who have always existed in France, and who seem to arise from the very depths of this country's civilization. Those who refuse to see any value in these spontaneous works should by the same token scorn the poetry of folk songs, which may, in fact, be too highly valued today, to the detriment of great

poetry. One must like these charming paintings, but one must not confuse them with the paintings of the masters, for the masters know what they are doing.

Finally, one of the trends honored at the Indépendants is neo-impressionism, with Signac, Lucie Cousturier, and Antoine de La Rochefoucauld; this is a school with well-defined limits, but within these somewhat narrow limits, it has produced some very remarkable and luminous works, as well as one of the greatest French painters, Seurat.

Having attempted to sort out the various trends and influences in evidence at the Indépendants, I shall now discuss the outstanding works of the exhibition.

First of all, Room 38 contains the most imposing painting, imposing in size as well as in inspiration. This picture, entitled *The City of Paris*, was done by a young painter[26] whose works until now have certainly been interesting, but unfinished. His dramatic interpretations of the Eiffel Tower had shown that he had a powerful talent, but we did not yet dare to hope for such a complete realization of his promise. *The City of Paris* is a painting that concentrates in itself the sum total of artistic effort ranging as far back, possibly, as the great Italian painters.

One must have the courage to say so. It is no longer a question of experimentation, of archaism, or of cubism.

Here is a candid and noble picture, executed with a passion and an ease to which we are no longer accustomed. On the left, the Seine and Montmartre; on the right, the Eiffel Tower and some houses; in the center, three slim, powerful figures who critics claim are copied from the wall paintings of Pompeii but who nevertheless are incarnations of French grace and power, as Jean Goujon[27] conceived them. The simplicity and boldness of this composition are happily combined with everything new and powerful that several generations of French painters have discovered. Not an ounce of pretension, not the slightest desire to shock or to appear obscure, yet here is an important work that is epoch-making in the history of modern painting. From now on, young artists will dare to approach and interpret subjects plastically . . .

Mlle. Marie Laurencin's work *Women and Fans* is also a painting. It manifests a unique instinct for composition, one that owes nothing

to any known school of painting. Everything in this work is executed boldly, and the details, the facial expressions, are incomparably graceful, without any trace of finicking affectation.

Le Fauconnier's painting *The Hunter* displays the greatest effort in this Salon, and if it had a broader theme, it would deserve, because of its originality and the power and variety of its colors, to be ranked with the very best.

Metzinger's exhibit is one of the most significant. This painter is now striving for grace and beauty. Here is a painter who really remembers Ingres, and if his sensuality became manifest, he would be a great painter.

Gleizes's *Women Bathing* marks, in the work of this artist, not a pause but a new effort toward construction and line. This effort has not been wasted, and *Women Bathing* is a great painting, despite its small dimensions.

Léger's picture is an example of pure painting: no subject, a great deal of talent. There is reason to fear, however, that if the artist's inspiration is not nourished by ideas, it will soon dry up.

D. de Segonzac's exhibit is less important. It is a still-life, very refined in feeling. A feeling of refinement also characterizes the double nude by M. Luc-Albert Moreau, who is pursuing the ideal of a melancholy and sensual art.

There are a great many other artists with a distinct personality at the Indépendants, but it seems to me that the artists I have just mentioned have displayed their personality most clearly.

(Le Petit Bleu, MARCH 20)

An Opening

The Salon of the Society of Cartoonists and Caricaturists—
A Second Opening Will Take Place This Evening from
Nine to Midnight

The sun was laughing heartily today, because it visited the Salon of the Society of Cartoonists and Caricaturists at 64 *bis* Rue La Boétie. Frenchmen have not forgotten the great art of laughter. We shall

see how skillfully Hansi and Zislin discharge the task of teaching this art to the Germans. No man, with the exception of Molière, has equaled Forain in rising to that sublime comedy that is not without a trace of bitterness. Here are Willette and his *Mopheaded Miss Grime* with the shiny eyes, Willette who is the Musset of drawing. Here is Chéret, who ennobled the art of street decoration. Here is Léandre, the Jordaens of caricature, whose drawings would have made the young Gargantua split his sides with laughter. Here is Léone Georges-Reboux, a princess out of the *Thousand and One Nights* who shows us how one can be Persian without ceasing to be French. And here is Louis Morin, who has brought some neat and charming things back from Venice and Nice. Guy Arnoux is reviving the old folk art of clock decoration. In his cartoons, Moriss remains a man of the theater, and his characters double up with laughter like those who see them. Here is Maxime Dethomas, who has transformed the art of scenery, costume design, and staging. Here is Jules Depaquit, whose fame has not yet attained the level of his talent, which is first rate.

The retrospective exhibit of Delannoy's works will make people appreciate that artist's gifts, and will heighten the sorrow of those who knew how great his promise was. [. . .] Galanis is aware of all the new developments in art and does not disdain them. His drawings have an Attic feeling. [. . .] Here is Charley with his troopers, young brothers of the marvelous Chapuzot of our childhood.[28] Here is [. . .] André Hellé, who is so versatile in his talents and who knows how to make us laugh to our heart's content. Louis Jou is powerful and has a keen sense of observation.

[. . .] Poulbot, a moved and moving observer of children, is exhibiting some delightful works here. [. . .] Mar Kous[29] wittily scoffs at the various schools of modern painting—cubism, fauvism, *pompier*-ism, and futurism. Jean Véber stands for lyrical irony. Carlègle has done wonderful illustrations for *La Rôtisserie de la reine Pédauque*. Tiret-Bognet's *Ghosts* demand comparison with Raffet. Here is H.-G. Ibels, whose penetrating works are always surprising. It will not be long now before this great artist is discovered by the public. Here are Hermann-Paul, a pitiless observer, [. . .] and Maurice Neumont, whose incisive talent captures the gracefulness of his subjects. [. . .]

The hero of this Salon is incontestably Poulbot, to whom a great many of his colleagues wanted to render the homage he deserves. In a few days, we shall see the opening of a Museum of Horrors in the basement, which I shall speak of in due course. And now, ladies and gentlemen, put on your spectacles and go have a good look at the horrific and side-splitting drawings of our humorists.

(*L'Intransigeant*, M A R C H 27)

The New Painting: Art Notes

The new painters have been sharply criticized for their preoccupation with geometry. And yet, geometric figures are the essence of draftsmanship. Geometry, the science that deals with space, its measurement and relationships, has always been the most basic rule of painting.

Until now, the three dimensions of Euclidean geometry sufficed to still the anxiety provoked in the souls of great artists by a sense of the infinite—anxiety that cannot be called scientific, since art and science are two separate domains.

The new painters do not intend to become geometricians, any more than their predecessors did. But it may be said that geometry is to the plastic arts what grammar is to the art of writing. Now today's scientists have gone beyond the three dimensions of Euclidean geometry. Painters have, therefore, very naturally been led to a preoccupation with those new dimensions of space that are collectively designated, in the language of modern studios, by the term *fourth dimension*.[30]

Without entering into mathematical explanations pertaining to another field, and confining myself to plastic representation as I see it, I would say that in the plastic arts the fourth dimension is generated by the three known dimensions: it represents the immensity of space eternalized in all directions at a given moment. It is space itself, or the dimension of infinity; it is what gives objects

plasticity. It gives them their just proportion in a given work, where-
as in Greek art, for example, a kind of mechanical rhythm is con-
stantly destroying proportion.

Greek art had a purely human conception of beauty. It took man
as the measure of perfection. The art of the new painters takes the
infinite universe as its ideal, and it is to the fourth dimension alone
that we owe this new measure of perfection that allows the artist
to give objects the proportions appropriate to the degree of plasticity
he wishes them to attain.

Nietzsche foresaw the possibility of such an art:

"O divine Dionysus, why are you pulling my ears?" Ariadne asks
her philosophical lover in one of the famous dialogues on the Isle
of Naxos.

"I find something very pleasant, very agreeable about your ears,
Ariadne. Why aren't they even longer?"[31]

In this anecdote, Nietzsche put an indictment of Greek art into
Dionysus's mouth.

Wishing to attain the proportions of the ideal and not limiting
themselves to humanity, the young painters offer us works that are
more cerebral than sensual. They are moving further and further
away from the old art of optical illusions and literal proportions, in
order to express the grandeur of metaphysical forms. That is why
today's art, although it does not emanate directly from specific
religious beliefs, nevertheless possesses several of the characteristics
of great art, that is to say, of religious Art.

One could give the following definition of art: creation of new
illusions. Indeed, everything we feel is only illusion, and the function
of the artist is to modify the illusions of the public in accordance
with his own creation. Thus, the general structure of an Egyptian
mummy conforms to the figures drawn by Egyptian artists, even
though the ancient Egyptians were very different from one another.
They simply conformed to the art of their time. It is the function of
Art, its social role, to create this illusion: the type. God knows that
the paintings of Manet and Renoir were ridiculed in their time! Yet

one has only to glance at some photographs of the period to see how exactly people and objects conformed to Manet's and Renoir's paintings of them.

This illusion seems quite natural to me, since works of art are the most dynamic products of a period from a plastic point of view. This dynamism imposes itself on human beings and becomes, through them, the plastic standard of a period. Thus, those who ridicule the new painters are ridiculing their own faces, for the humanity of the future will form its image of the humanity of today on the basis of the representations that the most vital, that is, the newest, artists will have left of it. Do not tell me that there are other painters today who paint in such a way that humanity can recognize its own image in their works. All the works of art of a period end up resembling the most dynamic, most expressive, and most typical works of their time. Dolls, which are popular or folk art, always seem to be inspired by the great art of their period. This is a fact one can easily verify. Yet, who would dare assert that the dolls that were sold in any emporium around 1880 had been fashioned with a feeling analogous to Renoir's when he painted his portraits? No one noticed it at the time. What it means, however, is that Renoir's art was dynamic enough, and alive enough to impose itself on our senses, while to the public that first saw his early works, Renoir's conceptions seemed to be so many absurdities and follies.

Today's public resists the works of the young painters, just as the public of 1880 resisted Renoir's works. It goes so far as to accuse them of being cheap tricksters, and at most, it will condescend sometimes to say simply that they are wrong.

Now, in the whole history of art, there is not a single case known of a collective hoax, or of a collective artistic error. There are isolated cases of hoax and error, but there cannot possibly be collective ones. If the new school of painting were one such case, that would constitute an event so extraordinary as to be called a miracle. To imagine a case of this kind would be to imagine that suddenly all the children in a given country were born without a head or a leg or an arm—clearly an absurd idea. There are no collective errors or hoaxes in art, there are only diverse periods and diverse

schools of art. All are equally respectable, and according to the changing notions of beauty, every school is, in turn, admired, scorned, and admired again.

I personally am a great admirer of the modern school of painting, because it seems to me the most audacious school that ever existed. It has raised the question of what beauty is in itself.

The modern painters want to represent beauty detached from the pleasure that man finds in man—and that is something that no European artist, from the beginning of recorded time, had ever dared to do. The new artists are searching for an ideal beauty that will no longer be merely the prideful expression of the species.

Today's art invests its creations with a grandiose, monumental appearance that exceeds anything the artists of previous periods had conceived in that respect; at the same time, today's art contains not a trace of exoticism. It is true that our young artists are familiar with Chinese works of art, with African and Australian effigies, and with the minutiae of Islamic art, but their works reflect none of these influences, nor that of the Italian or German primitives. Today's French art was born spontaneously on French soil. That proves the vitality of the French nation; it is far from decadence. One could easily establish a parallel between contemporary French art and Gothic art, which planted admirable monuments in the soil of France and of all Europe. Gone are the Greek and Italian influences. Here is the rebirth of French art, that is to say, of Gothic art—a rebirth wholly spontaneous and free of pastiche. Today's art is linked with Gothic art through all the genuinely French characteristics of the intervening schools, from Poussin to Ingres, from Delacroix to Manet, from Cézanne to Seurat, and from Renoir to the Douanier Rousseau, that humble but so very expressive and poetic expression of French art.

The vitality of this dynamic and infinite art that springs from the soil of France offers us a marvelous spectacle. But no man is a prophet in his own country, and that is why this art encounters more resistance here than anywhere else.

(*Les Soirées de Paris,* A P R I L – M A Y)[32]

The Art World

Robert Mortier

There was an elegant opening at the Devambez Gallery. M. Robert Mortier, a distinguished musician and a billiard theorist, is also a painter of talent.

This curious and refined artist has studied all the new techniques that inspire our young painters today. Cézanne's art held his attention for a long time; Monticelli appealed to him because of his impasto, which seems to be made from crushed gems (see the painting entitled *From a Corner in the Park*); Van Gogh taught him a great deal (see *The Hills of Compiègne*); Matisse uttered his great colored cries before him (see *Morning*); M. Mortier has looked at light with Sisley (see *July on Suburban Houses* and *Roads and Houses*); even the cubist experiments are not unknown to him, and a large number of studies here evidence his desire to construct. I dare say that these studies, which are by no means timid, constitute the most interesting part of this exhibition— see *Trees and Water, A City in the Distance, Road and Mountain, View and Mountain*, and *Pond in the Forest*. These experiments in line and color come together in an excellent canvas, *In the Garden*, in which a variety of bright colors harmoniously complement one another. One must mention yet another subtle and delicate study, *Trees over the Ravine*. Robert Mortier is a sensitive painter, and his personality is sufficiently defined not to fear the influence of others. His talent is not at all forced; it has freshness. Finally, one observes some charming impastos that produce bouquets of flowers, some pretty pastels, a few figures . . .

(*L'Intransigeant*, A P R I L 2)

Art News: Women Painters

Just as our age has allowed some female talents to blossom in the world of letters, so it has produced a number of female personalities in art who cannot be ignored.

During the 1911–12 season, a large number of individual exhibitions have displayed works of art done by women.

Never before this winter, either in Paris or elsewhere, has one seen so many women prove that their artistic abilities are in no way inferior to those of men.

What women contribute to art is not technical innovations, but rather taste, intuition, and something like a new and joyous vision of the universe.

There have been women painters in every age, and it is certainly curious that there have not been more of them.

The sixteenth century in Italy produced Sophonisba Angussola, praised by Lanzi and Vasari. Paul IV and the King of Spain competed for her works. They can be seen in Madrid, Florence, Genoa, and London. The Louvre does not own any. Born in Cremona around 1530, she rapidly surpassed her master, Bernardino; she carried the art of the portrait to great heights, and modern scholars have even, at times, attributed some of her paintings to Titian. After years of great success at the court of Philip II, she retired to Genoa, where she became blind. Lanzi says that she was considered by her contemporaries to be the foremost commentator on the arts, and Van Dyck, who went to hear her, maintained that he had learned more from that old blind woman than from the *most clear-sighted* of painters.

The eighteenth century produced only second-rate women artists, such as Angelica Kauffmann or Mme. Vigée-Lebrun. It was only in the nineteenth century that genuine female personalities began to manifest themselves in France; Rosa Bonheur, Louise Abbéma, and Berthe Morisot were not uninfluential painters, and the works of Berthe Morisot, who was one of the most accomplished artists of her time, will certainly endure.

And yet, it was not until the beginning of the twentieth century that female [*sic,* for French?] art, which is the only one that counts in the world today, produced its own Sophonisba Angussolas, who today form a veritable constellation of noteworthy artists, each of whom deserves to be studied individually.

I have no intention of enumerating all our women painters in this article; leaving aside such artists of talent as Mmes. Lucie Cousturier, Galtier-Boissière, Benz-Bizet, Léone Georges-Reboux, Georgette Agutte, Beaubois de Montoriol, Becagli, Montchenu-Lavirotte, etc., none of whom has exhibited individually this year, I shall speak only of those who have recently shown important groups of their works.

Mlle. Hélène Dufau has exhibited a series of female portraits. Her art is very cerebral, and fantasy plays little or no part in it. One feels that Mlle. Dufau is strongly influenced by the modern masters she admires most. Mlle. Dufau has often attempted to reach the heights of allegory, and she has been more successful than most of her male colleagues. Her compositions are not very original, but she has a very remarkable talent for observation. Painters rarely possess this. If she concentrated on her talent, she would doubtless succeed in composing some enduring works. In the meantime, her portraits of women are far from being insignificant. She has succeeded in revealing the social aspect of her models, and although she paints Parisian women, she shows them to us, not as dolls, but as faces reflecting an intelligence that women often hide for fear that it might detract from their beauty. Still, one would wish for a surer line, a bolder palette, and more expression, too; for if such an art is not speedily bolstered by a striving toward genuine composition, it risks slipping into banality.

Mme. Marval has offered art-lovers an entirely different kind of treat. This artist has imagination, and a very personal talent. Abstraction is not her strong point, but she has a marvelous ability to reveal the poetic reality of her subjects. In her *Homage to Gérard de Nerval,* she was able to derive the elements of an agreeable and not at all mannered composition from the sentiment that gives such charm to the old songs of the Valois. Men are generally unsuccessful in such compositions, which require a combination of good taste and delicacy. And if Ingres was able to endow his *Apotheosis of Homer* with so much grandeur, that is because he was nurtured on good

literature and had a feeling for antiquity. Since his time, we have seen some less successful homages. I remember a certain *Homage to Gauguin* that was the most pitiful thing imaginable. It looked like a gathering of ghosts, and it was an embarrassment to the craft of the painter who had conceived this work: he had planned his picture as if he were a funeral director planning a third-class funeral. I also remember the famous *Homage to Cézanne* by Maurice Denis, in which nothing gives the slightest indication either of an homage or of Cézanne. It is a joyless work that seems to be more a document than an apotheosis.

In her large canvas of odalisques, Mme. Marval has given the measure of her talent and has achieved a work of importance for modern painting. This strong and sensual work, freely painted and wholly personal in composition, line, and coloring, deserves to survive.

Mlle. Marie Laurencin's exhibition showed us what we can expect from this artist. She has created works that owe nothing to any other kind of painting, ancient or modern. She suggests above all the joyfulness and power of the poets of the Pléiade.

Her portraits of women will perhaps come to characterize the style of her time, and people will perhaps speak of "a Marie Laurencin woman," as they now speak of "a Jean Goujon woman." She has participated in the two great artistic movements of the past few years: fauvism and cubism. But among the wild fauves, she was the *fauvette*; and if an Italian art critic chose to call her Our Lady of Cubism, M. Fernand Fleuret, who wrote the preface to the catalogue of her exhibition, riposted with an homage that gave that appellation its true meaning: "Hail, Marie, full of grace."

Grace is the thoroughly French artistic quality that women like Mme. Marval and Mlle. Marie Laurencin have maintained in art, even when, as in the last few years, art became severe, and painters, engrossed in new technical experiments that involved mathematics, chemistry, and cinematography no longer cared about charming their admirers.

Mlle. Marthe Galard, whose first exhibition is currently on view, has less authoritativeness than the artists we have just mentioned.

Mlle. Galard is, nonetheless, an artist of talent whose sensuality is sometimes combined with a mysticism wholly free of vulgarity. She does not command the singular boldness of line that endows Mlle.

Marie Laurencin's works with such an individual and penetrating style, nor does she possess the culture that endows Mme. Marval's compositions with a profound significance; but she does possess, to a high degree, a mysterious sense of the universe that is fully her own. Let her beware above all of admirers, of professionalism, and of sentimentalism.

Mme. Lisbeth Delvolvé-Carrière has remained faithful to the misty ideal of her father, the great painter Carrière, and no one has described her art better than M. Gabriel Mourey, who writes: "While still a child, you learned to speak softly and to understand the nobility and beauty of the profound words that are never spoken above a whisper."[33]

Clearly, women painters have worked hard this year. One could say without exaggeration that the artistic interest of the year has consisted entirely of the exhibits by women.

The one who has made the most outstanding effort is Mlle. Laurencin, who not only organized an exhibition of her own, but sent to the Indépendants a painting that is the most finished work she has done so far. M. Mario Meunier, Rodin's secretary and the excellent translator of Sappho, Sophocles, and Plato, recently told an amusing anecdote about this last painting. One day he was showing Rodin some photographs of futurist and cubist paintings, among which was a photograph of the painting by Mlle. Laurencin. "Here, now, is a woman who is neither futurist nor cubist," said the Master. "She knows what gracefulness is; it is serpentine."

That is really it—women's painting is serpentine, and it may well be that it was that great artist of line and color Loïe Fuller who became the precursor of the women's art of today when she invented that brilliant mixture of painting, dance, drawing, and coquetry that has very properly been called "the serpentine dance."

And it was apropos of another woman that Rodin's genius rediscovered that same expression!

(Le Petit Bleu, APRIL 5)[34]

Before the Opening of the Salon de la Nationale

Official Visit of the President of the Republic—
A General View of the Salon

At two o'clock this afternoon, the President of the Republic and Mme. Fallières, accompanied by the Secretary-General of the Presidency, M. Ramondou, arrived at the Grand-Palais.

With the President of the Société Nationale des Beaux-Arts as his guide, the President of the Republic visited the various rooms of the Salon, stopping occasionally in front of the canvases or sculptures that he found most remarkable.

At three-thirty, the visit was over; the President of the Republic returned to the Elysée Palace.

The differences between the four large annual salons are gradually becoming blurred. In a few years, they will be indistinguishable from each other. The audacious feats of modern painting have taken the official salons by storm, and this year's Nationale resembles the Salon d'Automne like a brother.

Let no one deplore this new life, with all its freshness and restless talent! In any case, although the majority of French painters are enthusiastic about innovation, a few painters remain who masterfully defend the old ways of painting.

The painters I have in mind are not at all those who recently claimed the name *pompiers* and who are, in fact, "Indépendants," without knowing it and without possessing the necessary boldness. I want to talk about Armand Point, whose concern for mastery is so extreme that he gives a patina to his paintings to age them the way time ages paintings in museums; and Anquetin, who is not kept awake at night thinking of Frans Hals and Rubens, since he knows all their secrets. I also want to talk about José María Sert, who is exhibiting a large dining-room ceiling[35] worthy of rivaling the Venetians, although the artist neither imitates them directly nor seeks to make his painting appear old. This ceiling, actually, is by no means a pastiche. It is

231

one of the important works in the Salon, and the background is completely independent of the figures. I want to talk above all about Zuloaga, a first-rate artist who is exhibiting three pieces that may become the chief attraction of the Salon: *The Victim of the Fiesta, The Bloody Christ,* and *Daniel Zuloaga and His Daughters.*

Zuloaga's subjects are modern, and he paints like the Spanish masters, which is perfectly legitimate. His paintings, however, are above all museum paintings that would look out of place anywhere else. I also want to talk about M. Caro-Delvaille, who is exhibiting some decorations full of lovely pagan nudities, and, finally, M. Maurice Denis, who wants to join the masters in inspiration and composition but whose technique is wholly modern. The few artists I have just mentioned would have more right than anyone else to claim the name *pompiers,* if it is true that this pejorative term will henceforth serve as a euphemism to designate the disciples of the old masters. [. . .]

In the sculpture section, which I shall talk about in detail tomorrow, the place of honor is occupied by Bourdelle's *Penelope,* for Rodin is not exhibiting this year. [. . .]

[APRIL 14]

A varied crowd, elegant women, furs, brilliant sunshine, bitter cold, groups arguing in front of the Zuloagas, the Besnards, the Maurice Denises, and Sert's ceiling, people circling around the statues by Bourdelle, Despiau, Marcel-Jacques, Wittig, and lingering in the lovely garden so handsomely adorned by Halou's fountain and Roche's pottery—that is how I would sum up today's opening.

Sculpture

Bourdelle's *Penelope* is a powerful work, strikingly decorative in its effect. It is a statue symbolizing Hope and Despair at the same time.

> *Belle Philis, on désespère*
> *Alors qu'on espère toujours.*
>
> (Fair Phyllis, we give up hope
> And yet we go on hoping.)[36]

The bust of a woman by the same artist is perhaps even more striking in its vigor and lifelike simplicity. Despiau's marble bust is one of the most luminous works of modern sculpture. Despiau has left stylization behind; he now approaches life directly. This bust, in which Rodin's influence is evident, is nevertheless a very personal work because of the softness and subtlety of the light that plays over it.

I consider Marcel-Jacques's *Pursuit of the Dream* a matchless work, into which he has poured all his toil, all his thought. For a long time, as one pursues a dream, he has pursued the realization of this great and simple work. It has first-rate qualities. The busts of young girls by the same artist are also admirable.

M. Wittig's *Eve* evokes the perfect contours of Baudelaire's imaginary giantess. Our sculptors have returned to simple and full forms. They are becoming less and less interested in the fragmentary art that has been the sole aim of their efforts in the last few years. Wittig's *Eve* is an excellent example of the new trends in sculpture, which exclude neither stylization nor life. [. . .]

[APRIL 16]

Room 1. People will look at the *Ballets Russes*, which inspired M. Hochard as it has inspired many other artists. His *Fourteenth of July in the Country* is an amusing work, as is his *Procession* leaving the Rouen Cathedral. Henry-Baudot continues to paint galloping ponies. He has also painted a tiger mounted by a naked Bacchante. [. . .] Let us also mention Lewysohn's Spanish dancer, and his bathers, [. . .] and let us next speak of

Zuloaga,

whose three large canvases constitute the main attraction at this year's Nationale.

In these three paintings, the artist sought not to copy nature, but to convey a synthesis, inspired by reality, of Spain, its land and people. To do this, he decided to make romantic characterizations of the family life, the diversions, and the mysticism of the Spaniards. In *Daniel Zuloaga and His Daughters*, the portrait of the old woman

sitting on the left is an excellent piece, inspired by a very appropriate sentiment. In *The Victim of the Fiesta*, we are shown the pitiful figure of a bleeding horse in a bullfight outlined against the harsh landscape of Old Castille. Finally, *The Bloody Christ*, with its emaciated figures in the manner of El Greco, its candles, and its Christ, livid and bleeding, with long locks, gives us a fairly precise image of the mystical and sensual faith that forms the basis of religious belief in Spain, a country where one can still see processions of flagellants and where the joy of pain can still transport souls as it did at the time of St. Teresa.

And yet, one does not feel, in this mystical canvas, the presence of the same inspiration that moved the Cretan whose stark canvases unite the beauties of Hellenism with the splendors of Christian faith.

Having expressed this reservation, one can in good conscience go on to praise the qualities that are to be found in Zuloaga's works. [. . .]

[APRIL 18]

[. . .] Room 5. The large decorative panel that Aman-Jean painted for the new Sorbonne is the result of a great deal of work by the artist, who has intensified his hues. However, his representation of the allegory of the *Elements* is rather feeble. Some of the details, though, are graceful. [. . .]

Room 6. Montenard shows us Mary Magdalene leaving the Church of Ste.-Beaume; he also shows her preaching to the sailors of Marseilles. A sweet, simple faith infuses these pretty compositions. [. . .]

Room 8. M. Maurice Denis is becoming more and more conventional, although some of the figures in his *Golden Age*, in which he allowed his feeling for truth to guide him, are excellent. [. . .]

Room 12. [. . .] The portraits by M. de la Gandara, particularly the one of Mme. Cavalieri, have the haughty and distant elegance that one finds in the novels of M. Henri de Régnier. [. . .]

Room 14. The Boldinis are as splendid, as luminous, as sketchy, one is tempted to say, and as pleasantly surprising as ever.

(*L'Intransigeant*)

This year, as in preceding years, the Salon des Artistes Français offers the public thousands of works of art of every variety; among the works commissioned by the State and the municipalities, there are anecdotes, portraits, etc. Almost all of these have been executed with an artistic integrity that is beyond praise.

Honesty is no less a virtue in art than in life. This is not the salon where one customarily finds the exciting or disconcerting personalities that constitute the chief interest of the other large salons. Nevertheless, there are audacious artists here; some of them affirm their mastery without breaking any rules, while a few others succeed in imposing their particular techniques. We had been promised an important decorative arts exhibition, and I regret to have to say that the results do not correspond at all to what we were led to expect.

It is always the same collection of jewelry, fans, and precious and charming objects that one finds exhibited in the gloom of the ground-floor rooms, instead of on the balcony where they could be seen more easily. All this does not add up to much; yet it would be to the Société's honor if it made an effort to encourage the decorative arts, whose evolution is the object of so many interesting experiments today. I will also be forgiven for not dwelling too much on the works of the few Orientalists who are exhibiting in this Salon.

It is understandable that after visiting and revisiting Albert Besnard's admirable exhibition, I should be unable to bring myself to admire other, much less beautiful works. An exception must, however, be made in the case of M. Edouard Fer, who has brought the neo-impressionist technique to the Artistes Français in a bold canvas representing a *Japanese Woman*.[39] M. Fer has fortunately avoided distortion, and his canvas, whose draftsmanship conforms to the lessons of the masters, will shock no one. Room 1 contains some of the most outstanding works, among them M. Jean Roque's *Fishermen Unloading Fish*, a work in which the young painter reveals great power as a colorist. The enormous decorative canvas by M. Jean-Paul Laurens, showing the *First Official Meeting of the Floral Games (March 3, 1324)*, is weak in draftsmanship and dull in coloring; the only nice thing about it is the luminous landscape that forms the background. M. Louis Belle's canvas is not only one of the best in the Salon, but also the most moving. Entitled *Resignation*, it shows a young invalid girl looking through an open window as the lights

of Paris go on at twilight. There is a sad and tranquil poetry in this painting, combined with an excellent and delicate craftsmanship that cannot fail to affect everyone. [. . .]

THE OPENING

Proceeds at the Artistes Français, to Go to
Military Aviation, Are Good

Vernissage! At one time, that word used to evoke ladders, flat brushes, pretty models admiring their own image and carrying bunches of lilies-of-the-valley in their hands, old connoisseurs examining small paintings with a magnifying glass, a bit of pushing and shoving, palettes planted like flowers on top of maulsticks, and painters arguing passionately in front of what they called the "big machines." For several years now, however, the *vernissage* has become a rendezvous for elegant Parisians. Today was no exception, and if those who attended were even more select than usual because they had to pay for admission, their numbers were as large as ever, despite the cool and cloudy weather, because the proceeds are to go to military aviation. [. . .]

Room 2. [. . .] M. Joron shows us in a single painting *several portraits of M. L. S.* in various poses. Could this be a kind of futurism? [. . .]

Room 4. M. Jean-Paul Laurens shows us lovers amid some tombs, in a scene updated from the novels of Ann Radcliffe. M. Lapeyre depicts, with a great deal of precision and some talent, how Spartan women used to tear each other's hair out. [. . .] M. Paul-Albert Laurens shows us a red-haired *Susanna* about to enter her bath, before the eyes of some peeping elders.

Room 5. The major piece in this room, and perhaps in the Salon, is M. Henri Martin's *Women Winding Thread.* M. Martin, as we know, paints in hachures, according to a technique that he has made his own; for while the neo-impressionists expect that the optical

blending of pure colors will produce the effect of a single shade, M. Martin seems, on the contrary, intent on preventing the optical blending of the colors he uses. It is undeniable that this makes his works eminently poetic. Poetic intensity is M. Henri Martin's aim, and if he attains it, his technique is obviously valid. One must admit, however, that the composition of his *Women Winding Thread* is far from successful; it has the disconcerting shape of an *M*, and in order to praise it at all costs, one would have to say that it has the shape of a double pyramid. Is an abundance of pyramids a good or bad thing? [. . .]

In Room 6, we meet M. Henri Martin again, with a composition entitled *Autumn*. It is a more richly decorated and more frankly stated work than his *Women Winding Thread*. The sun has reddened the leaves of the woodbine, whose divine flame shines with a poetic mellowness. And all the charm of late autumn is personified in soft feminine figures.

The portrait sent by Mme. de Montchenu-Lavirotte is a significant composition whose various elements—the furniture, the dog, and the young woman in black—combine to create an intensely artistic effect. The artist observed her models with passion, and it is this feeling, rather than her consummate skill, that enabled her to find the means to resolve the many difficulties presented by this painting. The enigmatic figures by M. Sarluis are finished works. His taciturn *David*, whom the artist has endowed with an androgynous grace, combines the charms of Il Sodoma's paintings with the mythic profundities of Nonnus's divine lyrics. [. . .]

Rooms 7, 8, and 9. [. . .] M. Ernest Laurent is exhibiting a group of women in which his divisionist technique is extremely attractive. It is as though the painting were covered by a colored mist, which endows this work with an intense poetry. Also very poetic in feeling are the works of M. Maxence, full of a contained lyricism that has nothing conventional about it. [. . .]

Room 16. Georges Scott's *On Horseback* aspires to an epic tone but falls far short of it. M. Monchablon's *Galley Slaves* is a touching canvas in which the artist has not stinted on lovely colors. He attains the effect he aimed for, but how shaky the composition of this painting is! Why is there an empty space in the foreground? Why is the face of the galley master so small?

I really like M. Max Bohm's composition, *Joyous Youth*; it is very imaginative. M. Chabas's *Bather*[40] looks like all M. Chabas's bathers and is not inferior to the ones we know so well. M. Joseph Bail's *Reading* is imbued with a delicate sentiment, and the artist's skill is too well known to need mentioning. Mlle. Maillart has painted her father's studio. It is a perfectly successful genre scene, very feminine in its delicacy and ably executed. [. . .]

(L'Intransigeant)

The Art World

[M A Y 15]

An Exhibition of Works by Carpeaux and Ricard

Later generations will realize that the Second Empire was a period with a genuine style. And the purest expression of this artistic style is to be found in the works of the sculptor Carpeaux, who was to an ultimate degree a man of his time. The exhibition that will open tomorrow at the Jeu de Paume is the first one to include almost all the works of the great sculptor. The public will be able to admire a group of original marbles that have never, I think, been seen together: the *Portrait of Mlle. Benedetti*, the portrait of the architect Garnier, the exquisite *Shivering Girl*, who is missing a few fingers that the artist broke off accidentally, the charming *Flora*, the wonderful bust of *Baroness de Sipierre*, and the equally wonderful bust of *Mme. Lefèvre née de Sourdis*. This bust has a pair of exquisite hands that will astonish those who love art; a ring on one hand testifies to yet another finger that the sculptor broke and repaired by this stratagem.

Among the terra-cotta figures, the most winning of all is the group representing the dance, a work at least equal to the group at the Opéra. We know that it was Mlle. Racowitza, who died recently in tragic circumstances after a very troubled life, who posed for the figure of *The Dance*. The story is told that after the group had been installed, a lady wrote to the artist asking him for the address of his model, who represented the very ideal of masculinity that she had always dreamed of but never encountered.

Here too is a haughty portrait of *Her Majesty the Empress Eugénie*, together with a portrait of *La Palombelle*, who was Carpeaux's first mistress. Among the works in plaster, people will admire the *Portrait of the Imperial Prince*. The *cire-perdue* bronzes, the charming studies for the monument to Watteau and for the Luxembourg fountain, and a project for the *Façade of the City Hall of Valenciennes*, which was never executed and is being exhibited at the request of Rodin, will also be greatly admired. Among Carpeaux's paintings, all of which are interesting, people will certainly want to see *The Tarantella*, a small painting that the artist took with him everywhere and that provided the inspiration for *The Dance*.

It was an excellent idea to bring together in one exhibit two artists as different in temperament and method as Carpeaux and Ricard. M. Charles Roux and the museum of Marseilles have contributed generously to this exhibition. Here are some ravishing portraits, and so many *sweet hands with long, delicate fingers!* It is above all the hands that I must admire in Ricard's portraits. These mysterious, elegant, and charming portraits represent *Mme. Arnavon, Mme. Coppens de Fontenay, The Marquise de Lendolfo Carcano, Mme. Szarvady,* etc. People will be equally impressed by the portraits of men—the exceedingly noble and picturesque portrait of *Prince Demidoff*, those of painters of the time, such as Ziem, Hamon, Papety, Paul Chenavard, etc. But it is the portraits of women that we keep returning to, and we will dream for a long time in front of a delightful study that depicts simply a woman's hand.

[MAY 31]

Claude Monet

Venice is no longer the gateway to the Orient—that is what Claude Monet, in his concern for truth, has taught us.[41] He has painted the misty aspects of the city of canals. And this new technique, full of discretion and almost drab, will come as something of a surprise to those who had grown accustomed to the impressionist master's richly colored palette, as well as to those who think of Venice only as a city in which everything is multicolored, even the sky. Until now, painters have always thought of Venice as a kind of brilliant mirage

above the Adriatic, whose flaming hues were orchestrated by none other than Morgan le Fay. Claude Monet has dispelled this vision, but if the new Venice exalted by his realistic art appears less remote, it is no less beautiful than the rainbow-colored city we thought we had seen up to now.

The Renaissance in the Decorative Arts

It has been said that there is no such thing as a modern style.[42] I personally believe that those who say so are mistaken and that a modern style does exist; but I believe that the characteristics of this style are to be found not so much in the façades of houses or in furnishings as in iron constructions—machines, automobiles, bicycles, and airplanes. I once overheard the following exchange between two painters standing on the Pont d'Iéna:

"How ugly the Eiffel Tower is! It has no style at all!"

"Excuse me, but its style is pure Louis XIV."

The Eiffel Tower does indeed have a style. It may even be Louis XIV but it is above all modern, just as the Renaissance works of art that were based on the imitation of antiquity are nevertheless and above all works of the Renaissance.

The masterpieces of the modern style are made of cast iron, steel, sheet metal. The invention of the airplane gave artisans a chance to practice on wood, and their efforts, which will certainly exert some influence on taste in decoration, will give birth to a style that will later be known as the style of the twentieth century. In the meantime, the past twenty years have seen a succession of styles, none of which has succeeded in establishing itself definitively with the public.

First we had *art nouveau*, which was succeeded by the *Exposition Universelle* style, and more recently, we have witnessed a renaissance in the art of interior decoration that is still going on and that seems to be based on an imitation of Louis-Philippe furnishings, just as *art nouveau* seemed to spring from Japanese works of art.

The truth is that every period has its style, but people do not notice it until long after it is over.

Our modern decorators are full of imagination. Some of them have

241

taste, and a few of them are professional craftsmen who really have ability; it is their works that future generations will admire.

It is also true that a taste for bric-a-brac hindered the efforts of our modern artisans for a long time.

The furnishings and art objects of the eighteenth century reigned supreme everywhere. Of course, the eighteenth century produced many works of art that were perfection in taste, but how many ugly things, too, people cluttered their homes with simply because they had been made in the eighteenth century! And just as Belgium is the country of reproductions, so the elegant apartments of Paris and New York became storehouses of genuine antiques. All that is over now, and so much the better. The Goncourts, who were responsible for this situation, can turn over in their graves.

Countess Greffulhe, a veritable fairy godmother of taste and elegance, has decided that the works of contemporary artisans and decorators should no longer be disdained in favor of second-rate furnishings whose authenticity is often doubtful.

The double exhibition that is opening today at 15 Avenue des Champs-Elysées and at 1 Rue de Talleyrand confirms the renaissance in the decorative arts: upholstery, ironwork, weaving, embroidery. There are also modern paintings, among them Willette's decorations for the Auberge du Clou and works lent by M. Deny-Cochin and the Prince de Wagram. And how can anyone doubt the existence of a modern style, when so many admirable Delacroixs, Corots, Puvis de Chavannes, delicate Renoirs, Monets, Cézannes, and Van Goghs prove that no other period was more fertile in decorative miracles!

[J U N E 22]

The charming Bonnard triumphs with his recent works at the Bernheim Gallery. His fantasy is the daughter of truth. We find in his works the mysterious joy that characterizes the eighteenth century for us.

After Marseilles's Salon de Mai, Rouen offers us its Salon de Juin, organized by the Société Normande de Peinture Moderne. The Société manifests its preference for the artists of the new schools. The catalogue, illustrated with works by M. Marcel Duchamp, Mlle. Marie Laurencin, Albert Gleizes, Léger, Juan Gris, and Picabia, in itself

constitutes an important document of modern art. Besides these artists, one notes among the exhibitors Raoul Dufy, Verdilhan, Mlle. Ritleng, J. Laurier, Marchand, André Lhote, Mme. Lewitska, Jacques Villon, Tobeen, R. de la Fresnaye, Pierre Dumont, A. Agero, etc.

<div align="right">[J U N E 30]</div>

La Triennale

[. . .] The organizers of La Triennale have sought to prevent the dispersion of artistic efforts by assembling, at three-year intervals, the works of our four major salons. The idea is a good one, but it has the disadvantage of creating yet another salon.

An enlightened eclecticism governed the choice of works shown in this exhibition; next to some of the illustrious dead of contemporary French art, one finds artists such as Signac, Marquet, and Henri Matisse.

One wonders, however, why, having gone as far as Matisse, the organizers of La Triennale did not choose to go as far as Derain, whose influence on young painters is considerable, or as far as the cubists, who, whatever one might think of their works, represent the newest tendency in French painting. One is either eclectic or one is not.

This exhibit at the Jeu de Paume has two admirable pictures by Puvis de Chavannes, *The Grape Harvest* and a *Pietà* painted under the influence of Chassériau. The catalogue also lists a bust of Puvis by Rodin, who, I understand, finally decided not to exhibit anything.

Delacroix has been completely neglected, and nothing compensates for his absence; but we can see the *Crowned Virgin* by Ingres, whose bust by Bourdelle seems to gaze wrathfully at the impressionist pictures, and especially at Marquet's, which are nevertheless excellent works. [. . .]

<div align="right">(*L'Intransigeant*)</div>

Exoticism and Ethnography

In France, it is the collectors and the curiosity seekers who are really fulfilling the role of connoisseur that the Constitution seems to have

<div align="right">243</div>

intended for the Ministry of Fine Arts. For example, a few art-lovers like M. Guillaume, whose name should be remembered by anyone wishing to be up to date on the annals of curiosity, have started to collect the sculptures and all the works of art in general of those African and Oceanic peoples who are usually called savages.

Until now, these objects were collected only because of their ethnographic interest. Today, art collectors regard them with the respect that used to be accorded only to the art works of the so-called superior peoples of Greece, Egypt, India, and China.

Despite all this, the state persists in regarding these works, whose beauty is now recognized by a great many Europeans, as no more than crude fetishes, grotesque manifestations of ridiculous superstitions.

The Trocadéro museum, which contains a great number of masterpieces by African and Oceanic artists, is almost totally neglected by the administration responsible for it. The museum is open only three days a week; it has no guards, other than the city policemen posted on duty there. The collections are arranged to appeal to ethnic curiosity, not to aesthetic sensibility.

And yet, one can see here some first-rate works of art. I have in mind especially the gem of the Dahomey collection—a large iron statue representing the god of war, which is without doubt the most unusual and one of the most graceful works of art to be found in Paris.

The school of Flora, founded by the poet Lucien Rohmer and having as its aim the cultivation of graceful art, would profit greatly from the contemplation of the Dahomey god of war.

The human figure certainly provided the inspiration for this singular work. And yet, by a stroke of invention as funny and as profound as a page of Rabelais, not one of the elements that compose it resembles any part of the human body. The African artist was obviously a creator.

I am certain that this surprising divinity is as yet almost totally unknown to Parisians. There is hardly anyone at the Trocadéro museum except on Sundays, and the only ones who go there then are soldiers on leave and nursemaids out for a walk.

People also do not know about the delicate Maori tombs, whose decorations remind one of seashells and marine plants, or about the rare sculptures of Easter Island, of which the Trocadéro museum has

some precious specimens and which are perhaps all that remains of the prehistoric civilization of Atlantis.

As for adding to its collections of exotic art, the government is not even thinking about it. And while the curators of the German and British museums, with generous funds at their disposal, are hunting everywhere, including France, for the works of the ingenious, untutored artists of Africa and Australia, the Trocadéro museum does not even own an interesting collection of the very distinctive native art of Madagascar. The same is true of the refined works of the ironsmiths of equatorial Africa, which seem to have been totally neglected. And yet, make no mistake about it: African art is arousing more and more interest with each passing day. Many a fetish from central Africa evidences an aesthetic not very different from that of the ancient Egyptians. And even in the modern works, one finds an exquisite sense of proportion possessed by very few European artists.

It seems to be high time that the government took an interest in this situation. Prices are going up every day. People are especially interested in art works from Guinea and from the Marquesas Islands, and M. Guillaume is also interested in the works of the peoples of Alaska.

Fetishes that five or six years ago could be had for a louis are today considered extremely precious, and dealers themselves do not hesitate to pay thousands of francs for them. There is still time for France, with its varied colonies—almost all of them rich in works of art—to save the remains of these exotic civilizations. The ethnographic museum of the Trocadéro deserves to be developed, not only from an ethnographic point of view, but above all from an artistic one. The museum should also be given more space, so that the statues and other works of art are not piled up haphazardly in glass cases, together with household utensils and old rags of no artistic interest.

One could go even further: There is no reason why the state should not found a great museum for exotic art, corresponding to what the Louvre is for European art. To begin with, the museum might house the collection of Far Eastern art that is now at the Louvre. The various works of art at the Trocadéro museum could also be transferred there. It would be the task of the various colonial administrations to enrich the museum, which would soon become one of civilization's most useful monuments.

Then, having been cleared of the works of art that now encumber it, the Trocadéro museum could enrich its purely ethnographic collections; for it is a pity to see, in the room devoted to the French provinces, that some very promising collections were never added to since the day they were installed. The only new addition—and it has been tucked away at the top of a staircase—is a donation consisting of a collection of cheap commercial trinkets, such as pins, metal rings, rosaries, etc. Pipes—especially clay pipes—which still bear a great deal of artistic ornamentation, are not represented at the ethnographic museum of the Trocadéro. That is really too much!

The gap, however, is easy to fill; I have no doubt that the major pipe manufacturers, whose models are often funny or cleverly grotesque, or else shaped to look like portraits of great men, would be happy to donate racks full of pipes that would make any topman on the mizzenmast blanch.

The Trocadéro museum is in urgent need of reform. Objects of a principally artistic nature should be separated from the ethnography and placed in another museum. The ethnographic collections should be enlarged and developed, and as far as France is concerned, a new museum might be created to act as the repository of national folkways and customs. The room of the French provinces now at the Trocadéro could form the basis of the new museum.

The Trocadéro could also be devoted wholly to colonial and foreign ethnography. Guards should be provided for it, and it should have the same visiting days as the other museums.

But we have strayed far afield from M. Guillaume and the other collectors of African art.

Their number is increasing every day, and most of them are becoming veritable fanatics. Many are themselves artists, and people have already noted the influence that primitive fetishes have exerted on contemporary art.

(*Paris-Journal*, SEPTEMBER 12)[43]

The Opening of the Salon d'Automne
Will Take Place Tomorrow

[S E P T E M B E R 30]

A General View of the Salon Before the Opening

The opening of the Salon d'Automne will take place tomorrow, Monday. This year's Salon does not have the battle-scarred look it had in 1907, 1908, and last year. Henri Matisse, Van Dongen, and Friesz, accepted by the public, occupy the places of honor in their respective rooms. Defended and admired by many students of the École des Beaux-Arts, they would doubtless smile to hear anyone still calling them "fauves," for they have become very tame.

To tell the truth, Van Dongen did try to create a little scandal, but the jury averted it by not exhibiting the one canvas by him that might have shocked a few people from the provinces. The cubists, grouped together in a dark room at the far end of the retrospective exhibit of portraits, are no longer ridiculed the way they were last year. Now the feeling they arouse is hatred. They are getting ready for their group exhibit, the Section d'Or, which will open October 10.

The chief interest of the Salon d'Automne, which is somewhat lacking in character this year, centers on the exhibition of nineteenth-century portraits, an essentially interesting collection but full of gaps that should have been filled. The young artists who visited it yesterday especially regretted the absence of David, Ingres, and Prud'hon. On the other hand, our living artists, whatever Salon they belong to, are very amply represented. Here are Bonnat, Carolus-Duran, Albert Besnard, Renoir, Degas, Jacques Blanche, Hermann-Paul, Charles Guérin, Lebasque, Bonnard. There are also some Cézannes, a first-rate Fantin-Latour, and a portrait of a woman by Vallotton that makes one sorry that the artist has changed his manner somewhat.

The really big attraction of the 1912 Salon d'Automne will be the decorative arts groups displayed on the ground floor and the second floor. Unfortunately, we can say nothing about them yet, because our decorator friends are not yet ready. M. André Mare will probably be

247

ready by tomorrow. But based on the little we have seen of them, we can say that these decorative ensembles are elegant, simple, and in good taste. The sense of comfort that was certainly lacking in those who conceived the *art-nouveau* style has been rediscovered by our young decorators. I think that the public will be greatly impressed by the progress that has been made this year in the domain of the domestic arts.

[OCTOBER 1]

THE OPENING

A Minor Incident at the Grand-Palais

Today was the opening of the Salon d'Automne. Our decorator friends are busily at work. Their exhibits are not yet ready.

At ten o'clock, M. Guist'hau, Minister of Public Education, arrived at the Grand-Palais. He was received by M. Frantz Jourdain, President of the Society of the Salon d'Automne, together with the vice-presidents, the chairmen of the various sections, and the members of the steering committee. The visit to the exhibition rooms began at once.

The Paris art season is beginning; in a few weeks, it will be in full swing. Indeed, everyone who is anyone in Paris art circles was at today's opening; the elegant crowd that followed the minister on his rounds included many notables from the world of the arts, as well as all the "first-nighters" of the salons.

Among those present were the composer Debussy, Messrs. Théodore Duret, Paul Fort, Ernest La Jeunesse, Rouché, director of the Théâtre des Arts, etc.

A minor incident occurred this morning, when a few cubist painters descended on one of our colleagues, M. Vauxcelles, and insulted him roundly. But it was all confined to a lively exchange of words.[44]

People stopped to look at Joseph Bernard's monument, *To the Victims of the Inquisition*, as well as at his other works: *The Embrace*, the *Portrait of the Poet André Rivoire*, etc.

In the painting section, there are no new group exhibits. Paintings

representing the various trends have been dispersed throughout the rooms, and the cubists are virtually the only ones who have been grouped together. Again this year, they constitute the most distinctive group in the Salon d'Automne. The jury was not at all inclined in their favor, however, and if most of them had not been saved at the last minute, there would be no cubist exhibit at this year's Salon. That would have been a pity for the Salon d'Automne, which is above all a salon of modern art. As a matter of fact, the jury reversed its earlier decision regarding the cubists only because this group of young French painters has taken on considerable importance over the past year. The influence they are already exerting on foreign artists did not escape the attention of the organizers of the Salon d'Automne.

These new works by the cubists, which are no longer executed, as before, with the elements of visual reality but with the purer elements of conceptual reality, are certainly open to criticism as far as individual works are concerned; but the general tendency that they represent seems to me worthy of the interest of everyone who cares about the future of art.

During a rapid stroll through the exhibition rooms, we noticed a terse statuette by M. Andreotti; [. . .] some delicate sculptures full of promise by M. Archipenko; [. . .] and two interesting works, *The Terrace* and *The Dovecote*, by Jacques-Émile Blot. The four paintings by Bonnard are among the most pleasant works one could see; they are both graceful and witty. Bourdelle's double medallion commemorating two great Breton writers, *Edouard and Tristan Corbière*, has a great deal of character and nobility. [. . .]

I note [. . .] a charming sketch by M. Dethomas; [. . .] an exalted and incomprehensible canvas by M. Van Dongen, entitled *To Sailors, Travelers, and Clowns*; [. . .] some charming and unpretentious landscapes by M. Dunoyer de Segonzac, a painter of biting candor.

Echevarría's *Portrait of Don Cayetano Cervírez* is one of the handsome pieces in this Salon. It is at once an audacious and masterful work. People will look at [. . .] a delicate and singular watercolor by M. Fauconnet, *Napoleon on St. Helena*; some powerful views of Italy by M. Fiebig; [. . .] the *Bathers* and the *Cardplayer* by M. de La Fresnaye, who has done interesting work; and *Women at the Fountain* by M. Othon Friesz, who has brought new visions of nature back from Portugal. [. . .]

There is no dearth of interesting works exhibited by women this year. I have already mentioned some of them, and all the newspapers have noted the well-deserved success obtained by Mme. Marval. There are also some pleasant sketches by Mme. Geneviève Granger and some curious designs for tiled floors by Mme. Rosa Riera.

M. Gropeano has sent some accurately observed scenes of working-class life. I note [. . .] Henri Matisse's remarkable exhibit; [. . .] a severe and penetrating etching by Louis Marcoussis; the fresh, shimmering landscapes by Francis Jourdain; Jean Metzinger's *Dancer*, a strangely, strikingly poetic work; [. . .] Laboureur's fine woodcuts, very modern in feeling; Georges Lacombe's handsome wooden sculpture, a portrait of Antoine, King of Odeonia; and Laprade's *Puppets*, a sensitive work. [. . .]

The two large pictures by Picabia, new and excellently painted works by an artist who has been trying to find his way for a long time and who knows his art; the *Judgment of Paris*, a slightly hesitant work by André Lhote; [. . .] *Mountaineers Attacked by a Bear*, a very important work by Le Fauconnier; [. . .] and Albert Gleizes's *Man on a Balcony*, which demonstrates the enormous progress this artist has made since last year. Here is the work of Marcel Lenoir, whose symbolic intentions are lofty; Luc-Albert Moreau's *Nymphs of the Seine*, painted with a very modern feeling; [. . .] Fernand Léger's *Woman in Blue*, a painter's painting with very considerable charm; and Nadelman's *Juggler*, a bronze that recalls the works of the Renaissance. [. . .]

All the decorative arts exhibits will soon be ready. Those that were ready yesterday and the day before drew a curious and receptive public. There is already talk of a new style continuing the old traditions. In any case, it is certain that this exhibition will obliterate the memory of the decorative arts from Munich, whose bad taste *L'Intransigeant* was almost the only paper to remark on.

Let us conclude our visit to the painters. Verdilhan is showing some brilliant views of Provence. Marchand is presenting himself as a precursor of the futurists. I must also mention Maurice de Vlaminck's

violent impressions of the Ile-de-France and England, the very strange drawing by Marcel Duchamp,[45] the very original still-life by Jacques Villon, etc.

Nineteenth-Century Portraits

[. . .] Despite some regrettable gaps, this retrospective has enjoyed genuine success with the public, who, quite aside from the quality of the works exhibited, is always interested in portraits. People looked especially at the two portraits of women by Renoir, which are sheer masterpieces, the admirable *Family Portrait* by Albert Besnard, the work by Degas, whose art is as penetrating as Holbein's, the three sober paintings by M. Jacques Blanche, [. . .] the three Cézannes, which are not all of equal quality, [. . .] Fantin-Latour's *My Two Sisters,* a marvelously inspired work, [. . .] the two Manets, which show plainly that he was the most modern painter who has ever lived, [. . .] two bronzes by Lucien Schnegg, whose influence on young sculptors was beneficial, the *Portrait of M. Aman-Jean* by Seurat, the three Toulouse-Lautrecs, proud and pitiless, [. . .] and *Père Tanguy*, the curious effigy Van Gogh made of an art dealer whose story will doubtless be told one day by M. Octave Mirbeau, the owner of the painting. [. . .]

The retrospective exhibit of the works of Albert Braut includes most of the paintings by this sensitive, refined, and often melancholy artist. [. . .]

(L'Intransigeant)

The Art World

"Ensembles" by Cappiello

Leonetto Cappiello has transformed the art of the advertising poster. He has peopled our streets with tiny, multicolored industrial genies who nimbly proclaim to passers-by the merits of products whose artistic aspects were unearthed by his talent.

Cappiello, who was not afraid to engage in street decoration, was the perfect man to undertake interior decoration. He has invited the public to come admire the *tearoom*, the *reading room*, and the *smoking room* that he designed and executed for a large department store.[46] What are department stores if not extensions of the street?

Cappiello has succeeded far better than anyone could imagine. His ensembles, gaily colored, graceful in outline, and tastefully assembled, are marvelously modern; visitors will like and admire everything: the stained-glass window of the *smoking room*, the chandeliers of the *reading room*, the rugs, the kiosk, the glass panes, and the uniforms of the waitresses in the *tearoom*.

Everyone must go see these "ensembles"—as people call them nowadays. Everyone must go see these rooms designed by Cappiello for a department store on the Right Bank.

(*L'Intransigeant*, OCTOBER 8)

Young Painters, Keep Calm!

Several young men—writers on art, painters, poets—have united to defend their plastic ideal, and that is ideal.

The title they have chosen for their publication, the *Section d'Or*, itself indicates sufficiently that they do not consider themselves isolated in art, and that they are linked to the great tradition. It so happens that the great tradition is not the tradition espoused by most of the popular art critics of our time. That is too bad for the art critics.

Some of these gentlemen, in order to add weight to their flightiness, have not hesitated to propose that their opinions be reinforced by penal sanctions against the artists whose works they dislike.

These poor people are blinded by passion. Let us forgive them, for they know not what they say. It is in the name of nature that they are trying to crush the new painters.

One wonders what nature can possibly have in common with the productions of the degenerate art that is defended by the citadel on the Rue Bonaparte[47] or with the paintings of the mediocre heirs of the impressionist masters.

It is not they who will bring us back to the study of nature but rather the strict investigations of the young masters who, with admirable courage, have taken as their own the burlesque name with which people tried to ridicule them.

The cubists, whatever individual tendency they belong to, are considered by all those who are concerned about the future of art to be the most serious and most interesting artists of our time.

And to those who would seek to deny a truth so manifest, we reply simply that if these painters have no talent and if their art deserves no admiration, then those whose job it is to guide the taste of the public should not talk about them.

Why so much anger, honored censors?

The cubists don't interest you? Then don't be interested in them. But instead, we have indignant cries, gnashing of teeth, and appeals to the government.

Such a venomous spirit in our art critics, such violence, such lamentations, all prove the vitality of the new painters; their works will be admired for centuries to come, while the wretched detractors of contemporary French art will soon be forgotten.

We must not forget that people fired at Victor Hugo. His glory was not diminished by that fact. On the contrary.

(*Bulletin de la Section d'Or*, O C T O B E R 9)[48]

The Section d'Or

This Evening the Cubists Will Open Their Exhibition

We are at the Section d'Or, the new Salon whose name is borrowed from antiquity's Measure of Beauty. The opening will take place this evening, from nine o'clock to midnight. By one strategem or another, a few elegant young women have succeeded in being admitted to the exhibition room on the Rue La Boétie while the paintings are being hung. The painters are directing this work, to the accompaniment of the ladies' chatter.

LOUISE (*who prides herself on understanding cubism*): My goodness! I thought it was much more difficult to understand.

GERMAINE: I don't understand it at all, but I like the colors and the lines.

LOUISE: That's as good a way as any of understanding it. These pictures awaken an aesthetic feeling in you, just as music does. That's something already.

MARCELLE: That's true, but everyone says that these painters are just jokers having fun at the public's expense.

LOUISE: If that were true, it would be something extraordinary, for in the whole history of art there is not a single known case of a collective hoax. If we had one for the first time, that would be interesting in itself.

MARCELLE: I agree. According to you, then, what we are seeing here is a kind of plastic music, a supremely mystical art.

LOUISE: I wouldn't say that. Each of these painters follows his own bent. Some of them are realists, others are mystics. But since all of them are concerned with the rhythm of their paintings, we can respond to whatever is musical in their compositions.

MARCELLE: You may be right, but I personally prefer to remain faithful to my first loves. I love the masters of the great periods in painting, and above all, I love the impressionists, who, as far as I'm concerned, are the masters of modern painting.

LOUISE: Right. But to my mind, these young French painters are the natural heirs of the impressionists, and it would be a mistake to confuse them with the futurists.

GERMAINE: I would really like to know the names of these painters, whose work still astonishes me and bothers me a bit.

LOUISE: There's Metzinger, whose art is so refined. There are Jean [*sic*] Gris, the demon of logic, Albert Gleizes, who has made great progress, Marcel Duchamp, who is disquieting, Jacques Villon, who is trying to break away from a few artistic formulas, Dumont, whose work interests me, Valensi, who is trying to express the charm of beautiful Mediterranean cities, R. de La Fresnaye, whose talent is taking shape, Marcoussis, who is very modern, Picabia, whose compositions have a very powerful lyricism, Léger, whose paintings have beautiful colors . . .

MARCELLE: I do believe, my dear Louise, that you are making fun

of us. All I see here is an absolutely incomprehensible chaos of forms and colors.

LOUISE: I know, these paintings are Greek to you. Yet there are people who understand Greek, just as I understand these paintings.

MARCELLE: It's not the same thing at all. You must admit that these painters are really trying to make fools of the public. . . .

They continue their discussion as they stroll away.

Read and approved:
GUILLAUME APOLLINAIRE

(*L'Intransigeant,* OCTOBER 10)

Futurism

Futurism, in my opinion, is an Italian imitation of the two schools of French painting that have succeeded each other over the past few years: fauvism and cubism. I myself introduced M. Marinetti, who was the first theoretician of futurist painting, to the works of the new French painters; it was also I who described, in the *Mercure de France*,[49] the visit of the futurist painters Boccioni and Severini to Picasso's studio.

Neither Boccioni nor Severini is devoid of talent. However, they have not fully understood the cubists' painting, and their misunderstanding has led them to establish in Italy a kind of art of fragmentation, a popular, flashy art.

In painting conceptual reality, the futurists borrow elements from visual reality, which means that in order to depict an object, they represent its different aspects, as is sometimes done in popular illustrations. And while the cubists assemble the different ideas they have about an object in order to elicit a single emotion, the futurists, who do not think of taking the concept of duration into account, would like to elicit as many emotions as they have ideas about a single object.

The cubists paint objects, not as people see them, but as people imagine them, and their art is extremely lucid and pure.

The futurists, who scatter over a canvas the different aspects of an

object and the manifold feelings provoked by these aspects, are easily led into confusion.

A rigorous discipline underlies the art of the cubists. The art of the futurists is governed by arbitrariness, despite their explanations and manifestoes.

The futurist artists, supported by the ample funds of the Futurist Movement, whose headquarters are in Milan, are doing very nicely financially. At the same time, most of the young cubists, whose art is the most noble and most lofty existing today, are abandoned by all, ridiculed by practically every art critic, and living at best in semi-poverty, at worst in the most abject penury.

> (*L'Intermédiare des chercheurs
> et des curieux*, O C T O B E R I 0)

Cubism

Cubism is the art of painting new configurations with elements borrowed not from visual but from conceptual reality.

That is no reason, however, to accuse this kind of painting of intellectualism. Every human being knows the meaning of this internal reality. One need not be a man of great culture to conceive of a round figure, for example.

The geometric aspect that struck so many people upon seeing the first cubist paintings was due to the fact that those paintings rendered an essential reality with great purity, and that the accidental or anecdotal aspects of the subject had been eliminated.

By representing reality as it is conceived, the artist can produce a three-dimensional effect; he can, in a sense, *cubify* his subject. This effect could not be produced by a representation of simple visual reality, unless one did a foreshortened *trompe-l'œil* or a *trompe-l'œil* in perspective, both of which would distort the quality of the form as it is conceived.

The importance that this new French school accords to line makes one understand—as I had the honor of telling M. Henry Lapauze after reading his fine work on the master from Montauban—why the cubists

can claim to be descendants of Ingres: for them, as for Ingres, *line is the probity of art.*

The name cubism, which this new school has adopted, was applied to it in derision by Henri Matisse after he had seen a painting representing some houses whose cube-like appearance struck him greatly.

This school, which for a long time I was alone in defending, had as its founders Pablo Picasso and Georges Braque. Picasso's discoveries were corroborated by the good sense of Braque, who exhibited a cubist painting at the Salon des Indépendants as early as 1908; they were also confirmed by the studies of Jean Metzinger, who showed the first cubist portrait at the Salon des Indépendants of 1910, and who that same year became the first cubist to have a work accepted by the jury of the Salon d'Automne.

It was also in 1910 that some of Marie Laurencin's paintings related to this school were exhibited at the Indépendants. That same year, the painter Albert Gleizes, who was to play a dominant role in the new movement, became a cubist, together with the painters Le Fauconnier, Robert Delaunay, and Fernand Léger.

The first group exhibition of cubism took place in 1911 at the Indépendants, where the room reserved for the cubists—Room 41—made a profound impression on the public. On exhibit there were the erudite and charming works of Jean Metzinger; some landscapes by Albert Gleizes, together with his *Male Nude* and his *Woman with Phlox*; the *Portrait of Mme. Fernande X.* and *Young Girls* by Marie Laurencin; Robert Delaunay's *Eiffel Tower;* Le Fauconnier's *Abundance*; and Fernand Léger's *Nudes in a Landscape.*

The first appearance of cubism outside France took place that same year in Brussels; in the preface to that exhibition, I adopted, in the name of the exhibitors, the appellations "cubism" and "cubists."

At the end of 1911, the cubists' exhibition at the Salon d'Automne caused a considerable stir; neither Gleizes (*The Hunt, Portrait of Jacques Nayral*), nor Metzinger (*Woman with a Spoon*), nor Fernand Léger escaped the mockery of critics. The artists had been joined by a new painter, Marcel Duchamp, and a new architect-sculptor, Duchamp-Villon.

Other collective exhibitions were held in November, 1911, at the Gallery of Contemporary Art on the Rue Tronchet in Paris and in 1912 at the Salon des Indépendants, when Juan Gris joined the move-

ment. In May, 1912, the young French painters found an enthusiastic reception in Barcelona, and in June an exhibition of their works was organized in Rouen by the Société Normande de Peinture Moderne. It was at this time that Francis Picabia joined the new school.

It should also be noted that a certain number of cubist painters—Mlle. Marie Laurencin and Messrs. Georges Braque, Jean Metzinger, Le Fauconnier, and Robert Delaunay—belonged to the fauves a few years ago. They were the youngest members of the group.

Picasso, who already had a considerable body of work to his credit when he founded cubism, had always kept his distance from the fauves. As for Messrs. Jean Metzinger and Robert Delaunay, they had started out as members of Seurat and Signac's divisionist movement.

The exhibition of the Section d'Or, which will be the most important cubist exhibition to date, will take place next October.

Besides the works of the above-mentioned artists, the exhibit will contain the statues of the sculptor Agéro, who should have joined the new movement a long time ago, and the beautiful engravings of Louis Marcoussis, who is the newest of the cubists. The youngest member of the group, M. Georges Deniker, is now doing his military service as a balloonist; he has not yet shown his cubist works, and so far we have seen only one sculpture by him, at the Nationale in 1911.

The French art of cubism has already exerted its influence abroad, particularly in Spain and in Bohemia, where all the young painters are cubists. By a curious coincidence, the real name of one of the Czech cubists is Kubišta.[50] There are also cubists in Germany, and by an almost equally curious coincidence, one of them is named Kubin. In a review published in Prague, I recently saw some photographs of cubist furniture that struck me as not uninteresting.

The publisher Figuière will shortly be issuing two works that will contain information on the new French school of painting: *Le Cubisme,* by Jean Metzinger and Albert Gleizes, which is above all a theoretical work, and *Méditations esthétiques*, in which I have tried, after some general observations, to characterize the personality of the new school, the cubists: Mlle. Marie Laurencin, Messrs. Picasso, Georges Braque, Jean Metzinger, Albert Gleizes, Fernand Léger, Marcel Duchamp, etc.

(*L'Intermédiaire des chercheurs
et des curieux*, OCTOBER 1 0)

J'Aime l'Art d'aujourd'hui parce que J'Aime

avant tout la Lumière et tous les hommes

Aiment avant tout la Lumière

ils ont inventé le Feu

MÉDITATIONS

GA

L'impressionnisme en peinture c'est la naissance de la lumière. la lumière nous vient de la sensibilité

Proof sheet from *Méditations esthétiques* corrected by Apollinaire. (Collection Mme. Sonia Delaunay-Terk, Paris.)

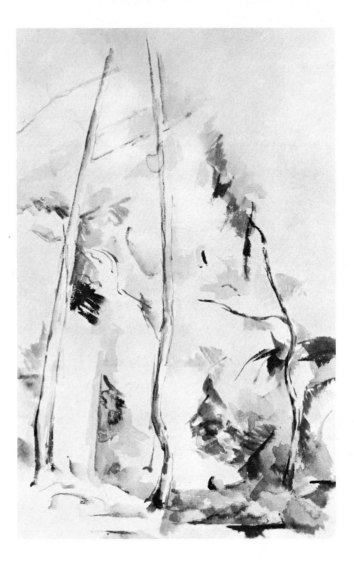

Paul Cézanne, *Pine Trees at Bibemus*, watercolor, 1895–1900.
(Collection Mr. and Mrs. John Warrington, New York.) / "Most
of the young painters today have a marked predilection for his
work. That is because Cézanne, like all artists of genius, was able
to remain admirably young to the end of his life. . . . The trees
in these delicate landscapes are so alive that they appear almost
human. Truth is everywhere manifest in the works of Cézanne;
it ennobles the most hurried watercolor and the hastiest sketch."

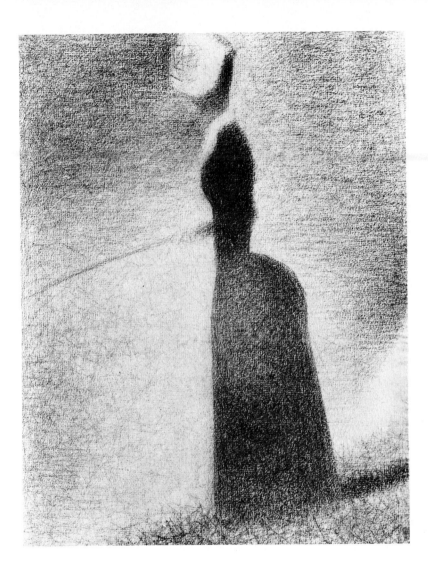

Georges Seurat, *Lady Fishing*, Conté crayon, ca. 1885. (Collection Metropolitan Museum of Art, New York, Purchase, Joseph Pulitzer Bequest, 1951, from the Museum of Modern Art, Lizzie P. Bliss Collection.) / "Making light and life burst forth on Ingres paper with the stroke of a Conté crayon —that is the artistry of Georges Seurat's draftsmanship. The contrast between the deep black of the crayon and the white that he leaves showing between the grains of the Ingres paper gives all Seurat's drawings a luminous intensity, an animation that one finds in no other artist."

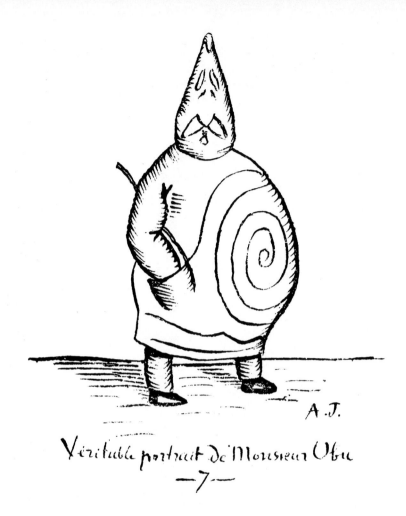

Véritable portrait De Monsieur Ubu
—7—

Alfred Jarry, *Veritable Portrait of Monsieur Ubu,* woodcut, from *Ubu Roi,* 1896. / ". . . it is in his drawings and woodcuts that this last of the great burlesque poets gave us the full measure of his artistic abilities. Jarry was an amateur, but he had a gift for expression that is lacking in all too many professionals. Some of his woodcuts have a singularity about them that is almost cabalistic."

André Derain, woodcut illustration for *L'Enchanteur pourrissant*, 1909. /
"Filled with brand-new and striking ideas whose philosophical embodiment
has no counterpart in any literature, *L'Enchanteur pourrissant*, by Guillaume
Apollinaire, is one of the most mysterious and most lyrical books to come
from the new literary generation. This work, whose roots extend all the way
to the Celtic depths of our tradition, has found its illustrator in André Derain.
The most outstanding reformer of the plastic aesthetic has produced a series
of woodcuts—consisting of pictures, ornamental letters, and decorative motifs
—that make this book a pure artistic marvel."

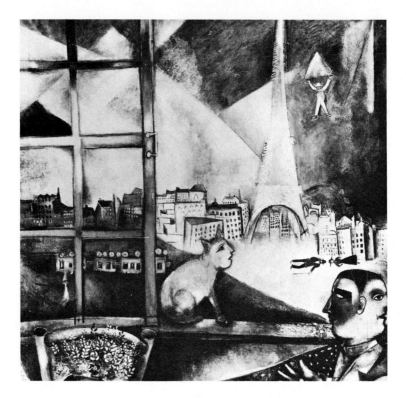

Marc Chagall, *Paris through the Window*, oil on canvas, 1912–13. (The Solomon R. Guggenheim Museum, New York.) / "Chagall is a colorist imbued with an imagination that occasionally finds its source in the fantasies of Slavic folk illustration but always goes beyond them.

"He is an extremely varied artist, capable of painting monumental pictures, and he is not inhibited by any system. . . . I prefer his recent works, especially his *Paris through the Window*."

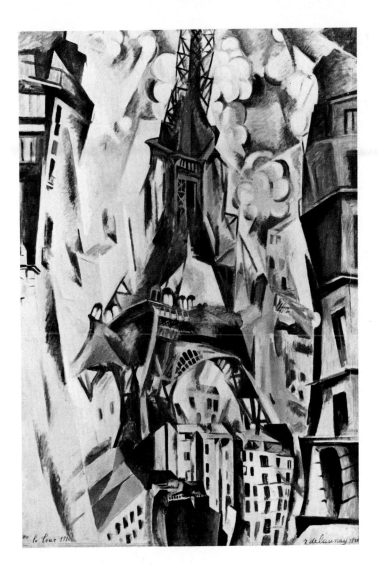

Robert Delaunay, *Eiffel Tower*, oil on canvas, 1910. (The Solomon R. Guggenheim Museum, New York.) / "[Delaunay] . . . is one of those rare painters of the younger generation who, after taking part in all the foremost artistic movements, has now cut himself off from them in a reaction against their exclusively decorative tendencies. Robert Delaunay's art is full of movement and does not lack power. Rows of houses, architectural views of cities, especially the Eiffel Tower—these are the characteristic themes of an artist who has a monumental vision of the world, which he fragments into powerful light."

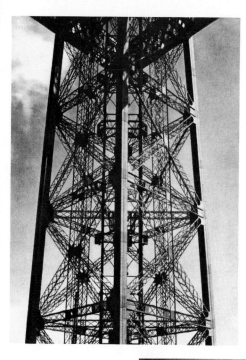

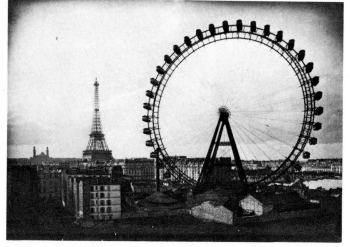

LEFT: *The Eiffel Tower*, photograph by H. Lacheroy from P. Peissi: *Eiffel*, Paris, 1946.

RIGHT: *"Vers 1910,"* photograph from Louis Cheronnet: *À Paris . . . vers 1900*, Paris, 1932.

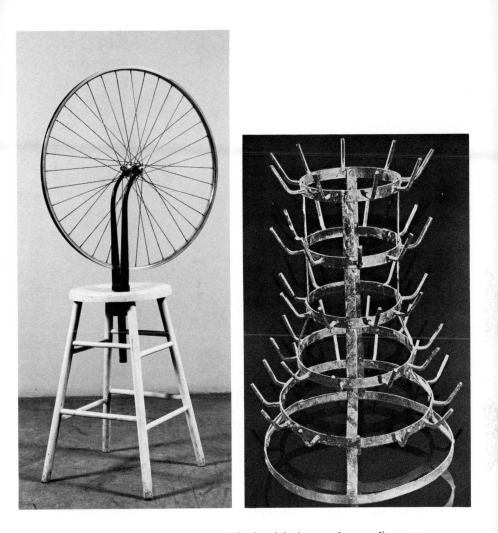

LEFT: Marcel Duchamp, *Bicycle Wheel*, original 1913, lost; replica 1951. (The Museum of Modern Art, New York, The Sidney and Harriet Janis Collection.)

RIGHT: Marcel Duchamp, *Bottlerack*, original 1914, lost. Man Ray photograph included in *Valise*, 1943. (The Museum of Modern Art, New York, James Thrall Soby Fund.) / "It has been said that there is no such thing as a modern style. I personally believe that those who say so are mistaken and that a modern style does exist; but I believe that the characteristics of this style are to be found not so much in the façades of houses or in furnishings as in iron constructions—machines, automobiles, bicycles, and airplanes. . . . The Eiffel Tower does indeed have a style. . . . The masterpieces of the modern style are made of cast iron, steel, sheet metal."

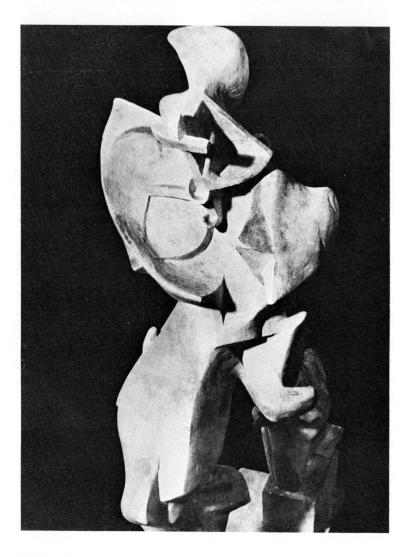

Umberto Boccioni, *Unique Forms of Continuity in Space*, bronze, 1913. /
"Boccioni introduces movement into sculpture. Hogarth has bequeathed to
Boccioni his serpentine 'line of beauty,' of which so much was made in
the eighteenth century. Varied materials, sculptural simultaneity, violent
movement—these are the innovations contributed by Boccioni's sculpture.
. . . Boccioni's 'plastic groups' are varied. They are all joyful celebrations
of energy: 'muscles at full speed,' 'synthesis of human dynamism,' 'spiral
expansion of muscles in movement,' a real athletes' cemetery. . . . *Last-
minute news:* We have been informed that Boccioni's 'muscles at full speed'
have taken to the road. As of this writing, they have not been recaptured."

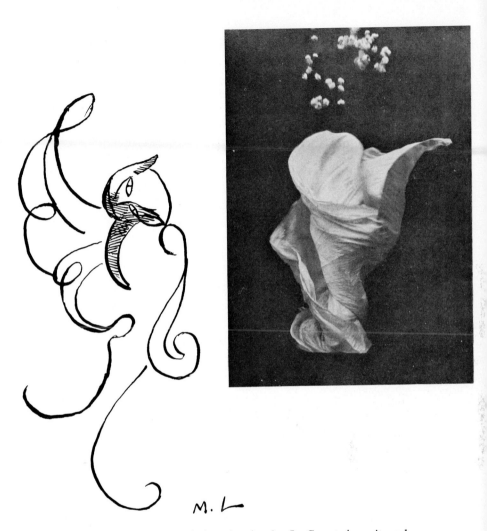

LEFT: Marie Laurencin, frontispiece drawing for *Le Carnet des nuits*, published 1956.

RIGHT: *Loïe Fuller*, photograph around 1895. / "M. Mario Meunier, Rodin's secretary . . . was showing Rodin some photographs of futurist and cubist paintings, among which was a photograph of a painting by Mlle. Laurencin. 'Here, at least, is a woman who is neither a futurist nor a cubist,' said the Master. 'She knows what gracefulness is; it is serpentine.'

"That is really it—women's painting is serpentine, and it may well be that it was that great artist of line and color Loïe Fuller who became the precursor of the women's art of today when she invented that brilliant mixture of painting, dance, drawing, and coquetry that has very properly been called 'the serpentine dance.' "

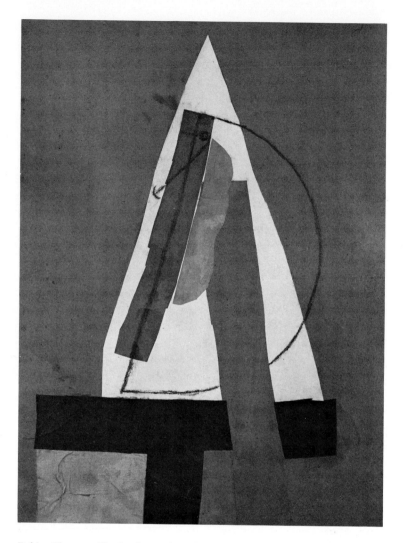

Pablo Picasso, *Head,* charcoal and papiers collés on cardboard, 1913?
(Formerly collection André Breton, Penrose Collection, London.) / "The
object, either real or else in *trompe-l'œil,* will doubtless be called upon to
play an increasingly important role. It constitutes the internal frame of the
painting, marking the limits of its depth just as the frame marks its exterior
limits. . . . [Painters] can paint with whatever they wish—with pipes, postage
stamps, postcards or playing cards, candelabra, pieces of oilcloth, starched
collars. For me, it is enough to see the work. . . . One does not choose what
is modern, one accepts it—the way one accepts the latest fashions, without
arguing about them. Painting . . . An astonishing art, and one whose depth
is limitless."

Alexander Archipenko, *Bather*, painted relief, 1915. (Louise and
Walter Arensberg Collection, Philadelphia Museum of Art.) /
"Archipenko's daring constructions timidly but firmly proclaim
the singularity of this new art . . . that unites internal plastic struc-
ture with the supreme charm of a sensuously beautiful surface.
The archings, the complementary forms, the differentiation of
planes, the hollows and the reliefs, never abruptly contrasted, are
transformed into living stone that the passionate touch of the chisel
has endowed with sculptural expression. Let us look at . . . this
Bather who, ever-changing, appears ever-new. . . ."

Irène Lagut, *Portrait of Apollinaire*, drawing from *SIC*, Nos. 37–39, 1919. /
"Poets did not write art criticism 'at the time that Gauguin was living in
wretched poverty in Tahiti, and Van Gogh, ignored by everyone, was paint-
ing his passionate pictures.' Today, the poets have ignored neither Matisse
nor Picasso. They have not made up their minds to admire everything new.
They are trying to distinguish the good from the bad so that the energies
liberated by the good should not be lost."

Francis Picabia, *Guillaume Apollinaire*, watercolor drawing, 1918. (Private collection.) / ". . . the Luxembourg is completely inadequate. It is really unthinkable that a country like France, which for two centuries has been at the forefront of the arts, occupying a position comparable to Italy's during its most glorious period, should have only the paintings at the Luxembourg to offer to those who want to have an accounting of France's artistic prosperity. . . . The museum contains none of the most vital art of the last few years—no Matisse, no Picasso, no Derain, no Braque, no Laurencin, no Picabia. . . ."

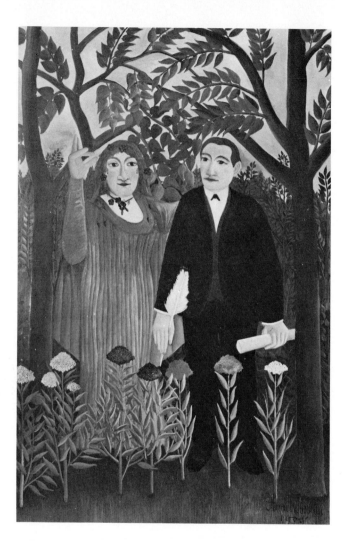

Henri Rousseau, *The Muse Inspiring the Poet*, oil on canvas, 1909.
(Collection Oeffentliche Kunstsammlung, Basel.) / "I tend to
think that that portrait was such a good likeness—at once so
striking and so new—that it dazzled even those who were not
aware of the resemblance and did not want to believe in it. Paint-
ing is the most pious art. In 1909, we witnessed a phenomenon
of mass suggestion similar to those that gave birth to the purest
religions. It was a sublime adventure that was definitely worth
living through. My face served in a unique experiment that I shall
never forget."

Art and Curiosity
The Beginnings of Cubism

Does the cubism everyone is talking about make any sense? What are
the theories professed by the cubists, and under what circumstances
was the movement born? We addressed these questions to one of the
first defenders of cubism, M. Guillaume Apollinaire, who provided
us with the interesting information that follows.

In 1902,[51] toward the beginning of autumn, a young painter, De
Vlaminck, was painting the Chatou bridge as seen from the island of
La Grenouillère. He was painting rapidly, using pure colors, and his
canvas was almost finished when he heard someone discreetly coughing
behind him. It was another painter, André Derain, who was examining
his work with great interest. The newcomer apologized for his curiosity,
explaining that he, too, was a painter, and proceeded to introduce
himself. The ice was broken, and the two talked about painting.
Maurice de Vlaminck was familiar with the works of the impression-
ists—Manet, Monet, Sisley, Degas, Renoir, Cézanne, whose work
Derain was not yet acquainted with. They also talked about Van Gogh
and Gauguin. Night fell, and a fog rose, but the two young artists con-
tinued their conversation, and it was midnight before they parted.

This first encounter was the starting point of a serious and friendly
association.

Always on the lookout for aesthetic curiosities, De Vlaminck had
bought, from the secondhand dealers he had met during his wanderings
in the villages bordering the Seine, some sculptures, masks, and
fetishes carved in wood by the black artists of French Africa and
brought back to France by sailors or explorers. In these grotesque and
crudely mystical works, he doubtless found some analogies with
certain of Gauguin's paintings, engravings, and sculptures, inspired by
the Breton calvaries or by the native sculptures of Oceania, where
Gauguin had withdrawn in flight from European civilization.

Now these curious African effigies made a profound impression on
André Derain, who gladly studied them, admiring the artful way in

which the sculptors of Guinea or of the Congo succeeded in reproducing the human figure without using any of the elements of direct visual perception. Maurice de Vlaminck's appreciation of barbaric African sculptures, together with André Derain's musings on these bizarre objects—all this at a time when the impressionists had finally freed painting from its academic shackles—were to exert a great influence on the destiny of French art.

At around the same time, in Montmartre, there lived an adolescent with restless eyes whose face recalled at once those of Raphael and of Forain. Pablo Picasso—who at the age of sixteen had already acquired a kind of fame with canvases that people rightly compared to Forain's biting paintings—had suddenly abandoned this manner in favor of painting mysterious works in a deep blue. He was living at the time in the queer frame house on the Rue Ravignan that was the home of so many artists who today are famous, or who are becoming so. I met Picasso there in 1905. His fame then had not yet spread beyond the confines of the hill. His blue overalls, like an electrical worker's, his sometimes cruel jokes, and the strangeness of his art were known all over Montmartre. His studio, cluttered with paintings of mystical harlequins, with drawings that people walked on and that anyone could take home if he wished, was the meeting place of all the young artists, all the young poets.

In that same year, André Derain met Henri Matisse, and from that meeting was born the famous school of the fauves, which counted among its members a large number of young artists who were to become cubists.

I mention this meeting because I feel that it is valuable to stress the role that André Derain, an artist born in Picardy, played in the evolution of French art.

The following year, Derain and Picasso became friends, and the almost immediate consequence of their association was the birth of cubism, which was the art of painting new configurations with elements borrowed, not from visual, but from conceptual, reality. Every human being is conscious of this internal reality. One need not, in fact, be a cultivated man in order to understand that a chair, for example, in whatever position one places it, will always continue to have four legs, a seat, and a back.

The cubist paintings of Picasso, Braque, Metzinger, Gleizes, Léger,

Jean [*sic*] Gris, etc., provoked a lively reaction from Henri Matisse; profoundly struck by the geometric aspect of these paintings, in which the artists had sought to render essential reality with great purity, Matisse uttered the mocking word "cubism," which was quickly taken up by everyone. The young painters in question adopted it too, because by representing conceived reality, the artist can in fact produce the illusion of three dimensions. This could not be produced by simply rendering perceived reality, unless one used *trompe-l'œil* with foreshortening or perspective, which would distort the quality of the form conceived.

Before long, new tendencies appeared within cubism. Picabia abandoned the conceptual formula at the same time as Marcel Duchamp did and began to practice an art governed by no rules whatsoever. Delaunay, for his part, silently invented an art of pure color. Thus, we are evolving toward an entirely new art that will be to painting, as it has hitherto been envisaged, what music is to poetry. It will be an art of pure painting. Whatever one may think of such a hazardous undertaking, one cannot deny that these artists are men of conviction worthy of respect.

(*Le Temps*, O C T O B E R 14)[52]

The Art World

La Jeune Peinture française

André Salmon has just published a charming book entitled *La Jeune Peinture française*, in the "Collection des Trente" series. This witty, well-written book contains a great deal of useful information for those who would like to know about the evolution of the young artists in France. Since a certain number of the ideas expressed here are my own, I can say that I fully appreciate this book. Salmon's ideas on contemporary women painters, for example, are expressed in terms almost exactly identical to mine. A number of amusing anecdotes enhance the interest of this volume, whose typography is as attractive as its style.

(*L'Intransigeant*, N O V E M B E R 29)

Reality, Pure Painting

In the midst of the battle that is being waged in France against the
young French artists who, as proof of the profundity of their art,
proudly bear the name cubists—a name originally used to ridicule
them—I felt a personal obligation to organize the defense of a group
of artists whom I was the first to discuss in the major French news-
papers *Le Temps* and *L'Intransigeant* and in my book *Méditations
esthétiques* (Figuière, 1912),[53] [which contains] some definitions of
cubism, as well as an attempt to pinpoint the differences that must be
established between the traditional art of imitation and the art in which
a well-known painter like Picasso has distinguished himself.

The diversity of opinion among these artists reassured me about the
future of an art that is not a technique but represents, rather, the en-
thusiasm of a whole generation for a sublime aesthetic that rejects the
traditional rules of perspective and other conventions.

It so happens that at that time I often saw a young painter whose
work has provoked a great deal of discussion over the past few years,
both in France and abroad. His name is Robert Delaunay, and he is
one of the most gifted and daring artists of his generation.

His conception of colored volumes, his sudden break with perspec-
tive, and his notion of surfaces have influenced a great many of his
friends. I also came to know of his experiments with pure painting,
which I reported in *Le Temps*.

Delaunay had never completely explained his theories to me, how-
ever, and recently I had the pleasure of being shown his latest works,
in which reality is as full of movement as living light; furthermore,
Delaunay decided to explain to me, for my own edification, the
principles of his discovery, which will exert a greater influence on the
arts than the sudden changes provoked by his most famous painting,
The City of Paris. I believe I shall be rendering a service to everyone
by quoting his aesthetic declaration "on the construction of reality in
pure painting":

"Realism is the eternal quality in art; without it there can be no permanent beauty, because it is the very essence of beauty.

"Let us seek purity of means in painting, the clearest expression of beauty.

"In impressionism—and I include in that term all the tendencies that reacted to it: neo-impressionism, precubism, cubism, neocubism, in other words, everything that represents technique and scientific procedure—we find ourselves face to face with nature, far from all the correctness of 'styles,' whether Italian, Gothic, African, or any other.

"From this point of view, impressionism is undeniably a victory, but an incomplete one. The first stammer of souls brimming over in the face of nature, and still somewhat stunned by this great reality. Their enthusiasm has done away with all the false ideas and archaic procedures of traditional painting (draftsmanship, geometry, perspective) and has dealt a deathblow to the neoclassical, pseudo-intellectual, and moribund Academy.

"This movement of liberation began with the impressionists. They had had precursors: El Greco, a few English painters, and our own revolutionary Delacroix. It was a great period of preparation in the search for the only reality: 'light,' which finally brought all these experiments and reactions together in impressionism.

"One of the major problems of modern painting today is still the way in which the light that is necessary to all vital expressions of beauty functions. It was Seurat who discovered the 'contrast of complementaries' in light.

"Seurat was the first theoretician of light. Contrast became a means of expression. His premature death broke the continuity of his discoveries. Among the impressionists, he may be considered the one who attained the ultimate in means of expression.

"His creation remains the discovery of the contrast of complementary colors. (Optical blending by means of dots, used by Seurat and his associates, was only a technique; it did not yet have the importance of contrasts used as a means of construction in order to arrive at pure expression.)

"He used this first means to arrive at a specific representation of nature. His paintings are kinds of fleeting images.

"Simultaneous contrast was not discovered, that is to say, achieved,

by the most daring impressionists; yet it is the only basis of pure expression in painting today.

"Simultaneous contrast ensures the dynamism of colors and their construction in the painting; it is the most powerful means to express reality.

"Means of expression must not be personal; on the contrary, they must be within the comprehension of every intuition of the beautiful, and an artist's *métier* must be of the same nature as his creative conception.

"The simultaneity of colors through simultaneous contrasts and through all the (uneven) quantities that emanate from the colors, in accordance with the way they are expressed in the movement represented—that is the only reality one can construct through painting.

"We are no longer dealing here either with effects (neo-impressionism within impressionism), or with objects (cubism within impressionism), or with images (the physics of cubism within impressionism).

"We are attaining a purely expressive art, one that excludes all the styles of the past (archaic, geometric) and is becoming a plastic art with only one purpose: to inspire human nature toward beauty. Light is not a method, it slides toward us, it is communicated to us by our sensibility. Without the perception of light—the eye—there can be no movement. In fact, it is our eyes that transmit the sensations perceived in nature to our soul. Our eyes are the receptacles of the present and, therefore, of our sensibility. Without sensibility, that is, without light, we can do nothing. Consequently, our soul finds its most perfect sensation of life in harmony, and this harmony results only from the simultaneity with which the quantities and conditions of light reach the soul (the supreme sense) by the intermediary of the eyes.

"And the soul judges the forms of the image of nature by comparison with nature itself—a pure criticism—and it governs the creator. The creator takes note of everything that exists in the universe through entity, succession, imagination, and simultaneity.

"Nature, therefore, engenders the science of painting.

"The first paintings were simply a line encircling the shadow of a man made by the sun on the surface of the earth.

"But how far removed we are, with our contemporary means, from these effigies—we who possess light (light colors, dark colors, their

complementaries, their intervals, and their simultaneity) and all the quantities of colors emanating from the intellect to create harmony.

"Harmony is sensibility ordered by the creator, who must try to render the greatest degree of realistic expression, or what might be called the subject; the subject is harmonic proportion, and this proportion is composed of various simultaneous elements in a single action. The subject is eternal in the work of art, and it must be apparent to the initiated in all its order, all its science.

"Without the subject, there are no possibilities. This does not, however, mean a literary and, therefore, anecdotic subject; the subject of painting is exclusively plastic, and it results from vision. It must be the pure expression of human nature.

"The eternal subject is to be found in nature itself; the inspiration and clear vision characteristic of the wise man, who discovers the most beautiful and powerful boundaries."

Such words do not require commentary. They seek to be understood directly and to arouse the simultaneity that alone is creation. All else is but notation, contemplation, and study. Simultaneity is life itself, and in whatever order the elements of a work succeed each other, it leads to an ineluctable end, which is death; but the creator knows only eternity. Artists have for too long strained toward death by assembling the sterile elements of art, and it is time they attained fecundity, trinity, simultaneity.

And Delaunay has attained them, not only in words, but also in his works—pure painting, reality.

(*Der Sturm*, D E C E M B E R)[54]

The Art World

M. Jean Marchand

[. . .] The first consequence of the Jean Marchand exhibition at the Marseille Gallery was to return M. Jean[55] Vignier to the world of

letters, which he had abandoned. Before writing the preface to the catalogue of this exhibition, M. Vignier had been known as a poet and one of the founders of the symbolist school.

Jean Marchand, some of whose paintings at the Indépendants made people consider him a precursor of futurism, belongs, in his best paintings, to cubism. In this exhibition, M. Marchand, who has come under a variety of influences, is showing mostly his older paintings. One can certainly enjoy these melancholy landscapes, these tender portraits, this meditative and poetic painting.

La Comédie Humaine

The Salon of La Comédie Humaine, organized every year by M. Arsène Alexandre, has become a regular Paris event.[56]

The Balzacian title chosen by the exhibitors indicates the aim of the Salon: to restore to eminence the observation of manners, the study of life, genre painting, which has almost disappeared from the other salons, both official and unofficial. At least, what has replaced it is not worthy of attention. Besides genre painting, we can see at this Salon a revival of the graceful *fantaisie*. [. . .]

(*L'Intransigeant,* D E C E M B E R 15)

1913

Modern Painting

France in the nineteenth century produced the most varied and most innovative artistic movements, all of which together constitute impressionism. This tendency is the opposite of the old Italian painting based on perspective. If this movement, whose origins can be discerned back in the eighteenth century, seems to have been confined to France, that is because in the nineteenth century Paris was the capital of art. Actually, this movement was not exclusively French, but European. Englishmen like Constable and Turner, a German like Marées, a Dutchman like Van Gogh, and a Spaniard like Picasso have all played major roles in this movement, which is a manifestation not so much of the French genius as of universal culture.

Nevertheless, this movement first took hold in France, and French artists expressed themselves in this art more felicitously and in greater numbers than the painters of other nations. The greatest names in modern painting, from Courbet to Cézanne and from Delacroix to Matisse, are French.

From the point of view of artistic culture, one can say that France played the same role that Italy played in earlier painting. Later, this movement was studied in Germany almost as ardently as in France before the fauves. At that time, impressionism began to be refracted

267

into individual tendencies, each of which, after a period of groping, has now taken its own road in order to arrive at a living expression of the sublime.

The same thing has happened in French literature; each new movement includes several different tendencies. The name "dramatism" does not express the rejection of description that dominates the works of certain poets and prose writers, among whom are Barzun, Mercereau, Georges Polti, and myself.

Similarly, new tendencies can be found in modern painting; the most important of these seem to me to be, on the one hand, Picasso's cubism, on the other, Delaunay's orphism. Orphism is a direct outgrowth of Matisse and of the fauve movement, especially of their luminous and anti-academic tendencies.

Picasso's cubism is the outgrowth of a movement originating with André Derain.

André Derain, a restless personality enamored of form and color, gave, once he had awakened to art, more than mere promises, for he revealed their own personality to all those he encountered: to Matisse, he revealed his feelings for symbolic colors; to Picasso, his feeling for sublime new forms. After that, Derain retired to live in solitude and, for a while, failed to participate in the art of his time. His most important works are the calm and profound canvases (up to 1910) whose influence has been so considerable and the woodcuts that he did for my book *L'Enchanteur pourrissant*. The latter gave rise to a renaissance of the woodcut, thanks to a technique that is broader and more flexible than, for example, Gauguin's; the effects of this renaissance were felt all over Europe.

Let us return to the major tendencies in modern painting. Authentic cubism—if one wishes to be categorical about it—might be defined as the art of painting new compositions using formal elements borrowed, not from visual, but from conceptual reality.

This tendency leads to a poetic painting independent of all visual perception; for even in the case of simple cubism, the artist who wished to achieve the complete representation of an object—especially of objects with a more than elementary form—would be obliged

by the need to disclose all the facets of the geometric surface to render it in such a way that, even if one took the trouble to understand the resultant image, one would find it far different from the object itself, that is, from its objective reality.

The legitimacy of such a method cannot be doubted. Everyone must admit that a chair, from whatever angle one looks at it, will always have four legs, a seat, and a back, and that if one takes away one of these elements, one takes away something essential. The primitives painted a city not as it would appear to someone looking at it from the foreground, but as it was in reality, that is to say, whole, with its gates, streets, and towers. A great number of innovations introduced into this kind of painting confirm its human and poetic characteristic every day.

Picasso and Braque introduced elements such as letters from signboards and other inscriptions into their works of art, because in a modern city inscriptions, signboards, and advertising posters play a very important artistic role and are easily adapted to that end. Picasso sometimes abandoned customary paints in order to compose three-dimensional pictures of cardboard or collages; in these instances, he was obeying a plastic inspiration, and these strange, rough, and disparate materials became ennobled because the artist endowed them with his own strong and sensitive personality.

To this movement belong Georges Braque, Jean Metzinger, Albert Gleizes, Juan Gris, and certain works by Marie Laurencin.

Another minor current can be distinguished within this major current: physical cubism, which consists in the creation of new combinations with elements borrowed from visual reality. This is not a pure art, and the movement is related to cubism only in its constructive aspects.

Another wing of impressionism soars toward the sublime, toward light. The efforts of the impressionists had led them to paint the appearance of light. Then came Seurat; he discovered the contrast of complementary colors but he could not detach himself from the image, for a contrast can exist only through itself. But Seurat's in-

vestigations were of considerable importance, particularly because they paved the way for many other seekers.

Delaunay believed that if a simple color really determines its complement, it does so not by breaking up light into its components but by evoking all the colors of the prism at once. This tendency can be called orphism. This movement, I believe, comes closer than the others to the sensibility of several modern German painters.

This dramatic movement in art and poetry is becoming stronger and stronger in France; it is represented particularly by the works of Fernand Léger, whose investigations are esteemed very highly by the young painters; also, in some of Mlle. Laurencin's paintings, in Picabia's recent works, whose smashing violence is shocking the public at the Salon d'Automne and the Section d'Or, and, finally, in the strange paintings of Marcel Duchamp, who is attempting to symbolize the movement of life, etc.

The most interesting German painters also instinctively belong to this movement: Kandinsky, Marc, Meidner, Macke, Jawlensky, Münter, Otto Freundlich, etc. To orphism likewise belong the Italian futurists, who, originally an outgrowth of fauvism and cubism, considered it wrong to abolish all the conventions of psychology and perspective.

These two movements are movements of pure art, because they determine only the pleasure of our visual faculty. They are movements of pure art because they attain the sublime without depending on any artistic, literary, or scientific conventions. We are drunk with enthusiasm. We are soaring here toward plastic lyricism.

In the same way, the new poetic movement known in France as "dramatism" soars toward the concrete, direct lyricism that descriptive writers can never attain.

This creative tendency is now spreading throughout the universe. Painting is an art not of reproduction but of creation. With these movements, orphism and cubism, we are attaining the fullness of poetry in the bright light.

I love the art of these young painters because I love light more than anything else.

And because all men love light more than anything else, they invented fire.

(Translated from the German in *Der Sturm*, F E B R U A R Y)[1]

The Art World

[F E B R U A R Y 2]

The Volney Society Exhibition

Impressionism is slowly but surely invading all the salons, all the painting exhibitions. At this rate, by the year 2000 most of the painters at the Artistes Français will be indulging in orphism.

The annual salon of the Volney Society is not among those where one sees particularly daring works; yet the painting by M. Guillonnet, *Beneath the Lemon Trees,* has a certain pictorial daring. M. Guillonnet's vibrant colors notwithstanding, the masters here are M. Cormon —mythology—and M. Gabriel Ferrier, whose portraits will suffice to reassure forever all those who are worried by the innovations of the young painters. [. . .]

[F E B R U A R Y 6]

[. . .] Van Dongen

[. . .] At the Bernheim Gallery, M. Van Dongen is exhibiting thirty-seven paintings that appear to me colossally useless. At this moment, on the walls of Paris, there are a large number of posters that, without claiming to be Great Art, contain almost as much art —from the point of view of craftsmanship as well as of thought— as the thirty-seven canvases by M. Van Dongen, who this time was really counting too much on his talent and facility.

(*L'Intransigeant*)

Aesthetic Meditations

[...]

(*La Vie*, FEBRUARY 8)[2]

The Death of M. Clovis Sagot

Contemporary painting has suffered a great loss in the person of M. Clovis Sagot, the victim of a cerebral hemorrhage.

M. Clovis Sagot was an original personality. In a sense, he was the Père Tanguy of today's young painters. Art-lovers used to delight in browsing in his shop. There they would find excellent things, which he parted from with a touch of regret, for *he knew that he was selling masterpieces for well below what they were worth.*

Poor Clovis Sagot! He died just at the moment when the works he had defended so persistently were beginning to become famous.

The great event in M. Clovis Sagot's life was his meeting with Picasso. He immediately sensed the future of the penniless painter, and I remember the day when, in order to buy some paintings from the young artist, M. Sagot pawned his watch chain to raise the necessary sum. I do not know whether he ever redeemed it, but I do know that he never wore it after that.

M. Sagot could be seen every day between one and one-thirty in the afternoon, sitting at his table in a café on the Rue de Châteaudun. He would drink his coffee while glancing at the new painting catalogues and reading the art columns, for he kept scrupulously abreast of the newest developments in art.

He was a fine man, and among the young painters who will miss him, one can mention Picasso, Herbin, Juan Gris, Mlle. Marie Laurencin, Utrillo, Savreux, Mme. Valadon, Metzinger, Van Rees, Chabaud, Gleizes, Léger, Vilette, Marchand, Mme. Lewitska, and many others.

(*L'Intransigeant*, FEBRUARY 13)

The Art World

The Salon of Animal Artists

Barye is a widely appreciated artist; the Louvre and the exhibition that has just opened on the Rue La Boétie[3] offer us the surest reasons for admiring him, which are his works. Nevertheless, he is not yet admired enough, for he is the greatest sculptor of the nineteenth century (and I am not forgetting Rude).

At the Rue La Boétie exhibition, one can see a large number of watercolors, paintings, lithographs, drawings, bronzes, original plaster casts, and works in wax by the great animal artist who was one of the greatest artists of all times. [. . .]

(*L'Intransigeant,* FEBRUARY 26)

Decorative Artists at the Pavillon de Marsan

A Curious Exhibit—Works of Art and Bibelots— The Reign of the Eucalyptus

For several years now, the stock of period furniture has been in the process of being renewed. All the beautiful things made before the Republic of 1848 are making their way to French and American museums. People thought that new apartments ought to be furnished with fine furniture, and while artists of taste are creating a biannual style—one at the Pavillon de Marsan and one at the Salon d'Automne—the connoisseurs are already hunting for Second Empire sofas (an exquisite period, the Second Empire!) or even the padded chairs and puffy hassocks of the 1870s. I recently met some one who collects works in the so-called *art nouveau style.* "There are very few of them," I was told by that well-informed gentleman, "and their rarity might well make them beautiful in less than fifty years."

The Pavillon de Marsan is thus the temple of taste—one could say, of tastes—at the moment, and it is not always easy to get one's bearings among so many different tastes. [. . .]

The eucalyptus is the fashionable plant this year; it is widely used as a decorative motif on fans as well as on sideboards. I must call your attention to M. Eugène-Louis Capon's *Eucalyptus*. Here is [. . .] the dining room designed by M. Croix-Marie, who is one of the *ensembliers*—to use the current word for decorator—in this Salon. [. . .]

M. Guimard has so strongly marked out what has been called the Guimard style that one cannot possibly fail to mention his plans and photographs of apartment buildings.

M. Jallot's dining room is charming: Jouve's *Captured Animals* is remarkable: panthers, leopards, tigers, antelopes; it's like a souvenir of that cinematographic film everyone is talking about at the moment, and from which we have learned that hunting permits in Africa are very expensive indeed. [. . .]

(*L'Intransigeant,* FEBRUARY 28)

François Rude

The nineteenth century was not a great century for sculpture in the classical sense of the word. The age of marble was coming to an end; the age of stone was already over. And yet, even as a new sculpture was being born, composed of materials not used before and whose first elements could be found in the objects that steam endowed with life and movement, three sculptors, three stonecutters, were endowing geogenous blocks with the very appearance of life. They were François Rude, Barye, and Carpeaux. This is not the moment to praise Carpeaux, whose simple and powerful grace took the shape of supple groups with a delicate mass that contains more refined intelligence than any work in relief—*Mens agitat molem* ["The mind stirs the mass"].

We shall also have to reserve for another time our praise of Barye, who was without a doubt the greatest sculptor of the nineteenth century, through his artistic gifts and powerful plasticity. But both

Barye and Carpeaux lacked that divine ferment of novelty, that thrill before the unheard of and the unforeseen, that sublime prelude to repose that is the definition of creation.

If one day we shall see the advent of new sculptors whose heroic works offer us not, as hitherto, the semblance of life but its very representation, then it will be neither Rodin, nor Rosso, nor the sculptors of antiquity whom we must consider their precursors; the formal elements of their art will be furnished by the machine, but its subject—which is simply life modeled by movement, imagination, and sensibility—will be found wholly in the simple, powerful, and living works of François Rude.

On the day that the new President of the Republic, Raymond Poincaré, was elected, I was in Germany, in Berlin.[4] All day long, the newspapers of the city on the Spree put out special editions, yellow sheets containing hardly more than a few lines. In the evening, when the result of the election was finally certain, I found myself in one of the large cafés of Berlin W.W., that all-new western section of the sprawling, futuristic, American-style capital of the German Empire. Suddenly, the orchestra struck up the heroic notes of the *Marseillaise*, which everyone listened to in pious silence. Similar scenes were taking place all over the city, and all at once, my mind turned to the discourse in praise of François Rude that I was scheduled to deliver in the not-too-distant future.[5] In my mind's eye, I saw the dramatic relief sculptured by Rude on one of the pillars of the Arc de Triomphe.

Poised in the air, light and heavy at the same time, like the new aerial forms that pierce the clouds above our heads and seem destined at last to reach the stars, the figure of Liberty, wings quivering and arms upraised, was crying out: "Aux armes, citoyens, formez vos bataillons"; and beneath her tall figure that filled the sky, I saw the citizens, men and children together, forming their battalions.

"There," said Rude, "was a *genuinely dramatic composition.*"

And later, while I was addressing an audience of Brandenburg art-lovers on the broadest expression of our time, orphic dramatism —a movement whose name encompasses the definition of all contemporary literary and artistic tendencies, from the cubism of the painters to the lyricism of our poems—the first name that came to my lips was that of François Rude.

Allegory is one of the noblest forms of Art. Academicism had reduced it to a banal figment of the imagination, yet nothing is innately more in harmony with nature; indeed, our brain can hardly conceive of compound things except through allegories. If we want to describe springtime, a luminous allegory immediately conjures up before us fields, flowers, fresh foliage, sun on the rooftops, and eternal subjects that, apart from the composition, are merely insignificant anecdotes: courtships and engagements, schoolboys' games, Easter bells, birds' nests, melancholy twilights illuminated by the lights of distant hearths appearing one by one, and the double note of the cuckoo's call; the charming smoke of cities and the teeming movement of boulevards; a flying fish in a tiny harbor of the Antilles, and the silvery face of an old Negro reflected in the bottom of a well in Timbuktu.

Rude's *Marseillaise* is the first work to have attained a modern expression of the sublime; its subject is modern, its movement and its life are modern, and the synthetic dramatization of what it represents is also modern.

The world will forever deplore the fact that political passions deprived it of one of its most grandiose and most original works, and that Rude was not allowed to carve the reliefs of all four pillars of the Arc de Triomphe; for while on one of them we see the tangle of bodies engaged in that collective activity known as *War*, dominated by the fearful ardor that illuminates the face of the beautiful and solitary figure of *Liberty,* on the other pillars Etex's cold reliefs seem to illustrate Baudelaire's famous paradox: "Why sculpture is boring."[6]

And yet, sculpture should not be boring. The admirable efforts of a Rude did not succeed in freeing sculpture completely from the banality into which it had been led by the profound knowledge of the masters who tried to transcend humanity by endowing it with gigantic proportions. Traces of this tendency can be found even in the *Marseillaise*, whose conception and composition I have just praised so highly. When he undertook to carve a single figure, Rude advanced sculpture yet another pace. He erected his monument to Marshal Ney on the very spot where the disarmed soldier had been downed by the bullets of the firing squad.[7] A recent catalogue of Paris monuments estimated the value of the Ney monument at the

modest sum of 9,000 francs; it might as well have declared it price-less, for I know of no statue more alive, more modern, or more daring than this one. Rodin has pointed out the implausibility of the gesture and the pose—it would be more correct to speak of gestures and poses, even though a single figure is involved. But the master from Meudon has also praised the statue's lyrical truth, and when I see this image of valor, I also see, springing up around the hardy reaper whose upright sickle is a sword, the living and multitudinous harvest of armies ranged in battle formation. There is nothing outmoded or forbidding in this eternal, marvelously intimate glorification of heroism.

Let us admire Rude's work, which is so simple that it is often overlooked; in a joking vein, it makes me think of Coppée's verses:

> *Ces choses-là sont rudes*
> *Il faut pour les comprendre avoir fait ses études.*[8]

> (These things are so rough and rude,
> You must have schooling to understand them.)

And yet, for all its roughness and simplicity, Rude's work con-tains the first elements of contemporary sensibility, which rejects both the romanticists' vulgarization of things that were always vulgar and the classicists' ennobling of things that were always noble. What it aims for is the ennobling, the poetization, the lyrical transformation, and the dramatization of what is true for all time, that is, of every-thing that forms part of the human sensibility.

(Poème et Drame, M A R C H)

For Kandinsky

I commented often and at length on Kandinsky's work at the time of his exhibition in Paris. I am happy to be given this occasion to express all my admiration for an artist whose art appears to me to be as serious as it is significant.

(Translated from the German in *Der Sturm,* M A R C H)[9]

The Art World

L'Oeuvre Libre

This little association is interesting, for at its annual exhibitions one can see more clearly than anywhere else how the daring innovations of the new painters gradually come to modify the vision of other artists.

The place of honor at this exhibit, which has just opened at the Devambez Gallery, is rightfully occupied by M. Zuloaga, who is exhibiting three paintings: his *Reclining Woman* shows that the lesson of the fauves was not lost on him. M. Zuloaga has given free rein to the richest tonalities of his palette. A prodigious talent is expressed here with a somewhat muted violence; the *Woman with a Fan* is graceful too, but its gracefulness is a bit conventional; as for his *Gypsy Woman*, it reminded me (although I may be wrong) of the paintings of Nonell, the gifted young Spanish painter who died a few years ago. In this last painting, M. Zuloaga reveals touches of gentleness and emotion that we have not been accustomed to seeing in his work. [. . .]

Auguste Renoir

"In this exhibition, which summarizes the artist's development year by year, Renoir emerges as the equal of the very greatest artists whose glory is ratified by universal assent." These are the opening lines of Octave Mirbeau's spirited preface to the catalogue of the Renoir exhibition currently at the Bernheim-Jeune Gallery. Renoir is an artist who is constantly growing. His latest pictures are always the most beautiful and also the youngest, as is proved by the *Woman at the Mirror* (1913,) the *Little Girl with an Orange* (1911), and the *Nude on the Cushions* (1908). These last works are so calm, so serene, and so mature that I do not believe he can surpass them.

As Octave Mirbeau rightly says: "Renoir has never thought of fulfilling his destiny. He has lived, and he has painted. He has exercised his craft. Perhaps that is the definition of genius. His whole life and his whole work are a lesson in happiness. He has painted joyfully, so joyfully that he never felt the need to proclaim the joy of painting, which joyless painters lyrically proclaim. He has painted women, children, trees, and flowers with the admirable sincerity of a man who believes that nature offers itself to his palette as simply as if it had been created for all eternity just to be painted. . . ."

(*L'Intransigeant*)

Pablo Picasso

Several exhibits are currently establishing the fame of this painter, one of those who have exerted the greatest influence on the artistic consciousness of our time.

He has questioned the universe severely. He has grown accustomed to the immense light of unfathomable spaces. At times, he has not hesitated to entrust real objects to the light—a two-penny song, a real postage stamp, a piece of newspaper, a piece of oilcloth imprinted with chair caning. The art of the painter could not add any pictorial element to the truth of these objects.

Surprise laughs wildly in the purity of the light, and numbers and block letters insistently appear as pictorial elements—new in art but long imbued with humanity.

It is impossible to foresee all the possibilities, all the tendencies of an art so profound and painstaking.

The object, either real or in *trompe-l'œil*, will doubtless be called upon to play an increasingly important role. It constitutes the internal frame of the painting, marking the limits of its depth just as the frame marks its exterior limits.

Picasso represents volumes by imitating planes, and in doing so, he enumerates the various elements that compose an object so com-

279

pletely and so acutely that these elements take on the appearance of the object, not because of the effort of the viewers who necessarily perceive their simultaneity, but because of their very arrangement on the canvas.

Does this art have more depth than height? It does not dispense with the observation of nature, and its effect on us is as intimate as that of nature itself.

Picasso conceived the project of dying when he looked at the face of his best friend and saw his circumflex eyebrows galloping in anxiety. Another of his friends led him one day to the borders of a mystical country whose inhabitants were at once so simple and so grotesque that they could easily be re-created.

And besides, anatomy, for example, really no longer existed in art; it had to be reinvented, and everyone had to perform his own assassination with the methodical skill of a great surgeon.

The great revolution in the arts that he produced almost single-handedly is that the world is as he newly represents it.

An immense flame.

He is a new man, and the world is as he newly represents it. He has enumerated its elements, its details, with a brutality that knows, on occasion, how to be gracious. He is a newborn child who orders the universe for his personal use, and also in order to facilitate his relationships with his fellow creatures. His enumeration has the grandeur of an epic, and with the coming of order, the drama will burst forth. It is possible to contest a system, an idea, a date, a resemblance, but I do not see how it is possible to contest the simple action of an enumerator. People might say that from a plastic point of view we could have done without all this truth, but once the truth appeared, it became essential. And then there are the scenes in the countryside: a forest grotto with people doing somersaults, a ride on muleback on the edge of a precipice, and the arrival in a village where everything smells of hot oil and sour wine. There is also the stroll toward a cemetery, with a stop to buy a porcelain wreath (a wreath of immortelles) inimitably inscribed with the words "Undying Sorrow." I have also heard of clay candelabras that had to

be pressed on a canvas to make them look as if they came out of it. Crystal baubles, and the famous return from Le Havre. The guitars, the mandolins.

I personally am not afraid of Art, and I harbor no prejudices about the materials painters use.

Mosaicists paint with pieces of marble or colored wood. Mention has been made of an Italian painter who painted with fecal matter; at the time of the French Revolution, someone who painted with blood. They can paint with whatever they wish—pipes, postage stamps, postcards or playing cards, candelabras, pieces of oilcloth, starched collars.

For me, it is enough to see the work, one must be able to see the work. It is the amount of work accomplished by the artist that determines the value of a work of art.

Subtle contrasts, parallel lines, a worker's craftsmanship, sometimes the object itself, sometimes an indication of it, sometimes an enumeration that becomes individualized, always less softness than coarseness. One does not choose what is modern, one accepts it— the way one accepts the latest fashions, without arguing about them.

Painting . . . An astonishing art, and one whose depth is limitless.

(*Montjoie!*, MARCH 14)

The Salon des Indépendants on the Quai d'Orsay

[MARCH 18]

There Are Forty-eight Rooms to Visit—From Cubism to
Orphism—A General View of the Young Painters' Salon

A poet—I think it was Rimbaud—foresaw these great Art fairs, immense exhibitions of painting stretching over several miles.[10] This year's Salon des Indépendants contains forty-eight exhibition rooms. Those who visit the Salon this year will have the impression of sailing on a frozen sea whose waves are the many admirable efforts of French art to find unexpected forms of beauty. In every room, even in the first ones, in which the least successful works are usually hung, there is a profusion of fresh, delicate landscapes full of light and truth.

1 9 1 3

The visitor will linger for a long time in the neo-impressionists' room, with works by Signac, Luce, and Mme. Cousturier. Neo-impressionism plays a leading role this year, for its founder, Seurat, or at least some of his investigations, inspired the painters who for the first time are exhibiting canvases that fall under the heading of aesthetic orphism. This tendency is heroically manifest in Delaunay's gigantic canvas, *The Cardiff Team, Third Representation*,[11] in Fernand Léger's *Female Nude*, in Bruce's landscapes, in Mlle. Laurencin's *Society Ball*, in Albert Gleizes's *Football Players*, and even—yes, even—in Metzinger's *The Blue Bird*. A great many art critics habitually become angry when they see new endeavors by artists. It would perhaps be more appropriate to become angry at the lack of endeavor, at the lack of novelty.

There is no lack of either at the Indépendants, and I tend to think that most of the paintings I have mentioned will become historic.

Besides the canvases that I have already mentioned, people will doubtless talk most about the painting by Mlle. Alice Bailly and Mondrian's *Trees*. There are numerous landscapes of the region around Céret (Roussillon)—the Barbizon of cubism. The ones by Marchand and by Mme. Lewitska are particularly good. I should also mention [. . .] Dunoyer de Segonzac's *Still-Life*, L.-A. Moreau's *Idols,* Utter's *Three Nudes*, and Marcoussis's *Violins*.

In the last room, there is a poor futurist painting, together with a large canvas representing microbes.

Neither Matisse nor the symbolists—who are busy painting the new Théâtre des Champs-Elysées—exhibited this year.

At the last moment, Delaunay's canvas is being hung, and there is an announcement that Le Fauconnier may exhibit a huge painting; and while a few workers nonchalantly finish hanging the pictures, most of the young painters stand around talking, talking. . . .

[MARCH 19]

THE OPENING

By ten o'clock this morning, the Salon des Indépendants was full of people. Pretty women, young, beautiful, elegant, established

painters, painters soon to be established, art lovers . . . Félix Fénéon is enchanted; he tells me how very happy he is to see the new tendencies in this Salon. An interesting document, typewritten, was distributed to most of the exhibitors this morning. Its subject is orphism, and it bears the signature "Georges Meunier." Who is Georges Meunier?[12] Here is Deputy District Attorney Granié, surrounded by a group of people; here are Messrs. Blot, Alphonse Kahn, the painter Flandrin, the painter Anglada. People are waiting for M. Bérard's visit. A gentleman asks worriedly: "Where are the orphic singers?" Matisse's name is mentioned. People talk of cubism, pointillism, disciplines of all sorts. . . . Who could remain indifferent in the face of such ardor, such youthfulness? [. . .]

[MARCH 20]

The really interesting part of this Salon begins in Room 14. Here we are. Robert Mortier has an ardent and keen sensibility. His *Bouquet* is conceived with a decorative feeling that is still very unsure of itself. His talent should not be imprisoned in a doctrine. [. . .]

[MARCH 21]

[. . .] Rooms 33 and 34. Francis Jourdain, delicate, restless, but a limited vision. Victor Dupont, a good painter with a broad manner. A screen by Deltombe. Mlle. Charmy, influenced by the fauves. Alfred Lombard, whom the thought of Flandrin prevents from sleeping. Here again is Fornerod, with pretty rustic scenes; Asselin, who would like to be sharp; Jacques Blot, who has a pretty vision. Laprade, with a charming canvas: garden, roses, little blonde girl. Sérusier . . . Ah! the school of Pont-Aven . . . bygone days. [. . .]

Room 35. The neo-impressionists' room assumes special importance this year because of the new tendencies that are related to the inventions of Seurat and Signac, whose *Port of La Rochelle* is one of the most luminous canvases of our day.

[MARCH 22]

[. . .] Room 35. The pointillists' room. This school, which today appears to us so closed, is perhaps the one most responsible for liberating the artistic consciousness of the younger generation. Besides Signac, let us mention:

Maximilien Luce, whose *Workers* testifies to his wish to be modern.

Mme. Lucie Cousturier, whose three *Still-Lifes* seem to blaze in the sunlight that ripened them. [. . .]

In the following rooms, 36 to 41, let us note [. . .] the refined delicacy of Crotti; the portrait of *Canudo* by Mme. de Saint-Point. [. . .]

Room 43. The Dutch room. Cubism has penetrated one museum in Amsterdam. Picasso and Georges Braque are exhibited there next to the Rembrandts. Let us mention Mondrian's highly abstract paintings. His *Trees* and his portrait of a woman are of great interest; *Provençal Landscape*, a powerful and well-balanced painting by Louis Schelfhout; Alma, who has a little of Van Gogh's temperament; the curious studies by Mlle. Van Heemskerck, Van Riss[13] with his range of colors. [. . .]

[MARCH 25]

Room 45. People have already talked a great deal about orphism. This is the first time that this tendency is manifesting itself as such. This school groups together painters with quite different personalities, all of whom have, in the course of their investigations, arrived at a more internal, less intellectual, more poetic vision of the universe and of life. Orphism was not a sudden invention; it is the result of a slow and logical evolution from impressionism, divisionism, fauvism, and cubism. Only the name is new. Many painters were surprised to find themselves included in this group, and it is interesting to note how many very different painters converge in their investigations and tend to achieve the same expression independently of one another. [. . .]

This new tendency can be found in almost all the canvases in the following room, and especially in the painting by Fernard Léger. This artist deserves to be praised, because for the first time he is exhibiting a "picture."[14] He has made a very considerable and very serious effort. Picabia's *Procession*[15] must be regarded as an important but unfinished effort by a gifted painter.

Room 47. *Society Ball*, by Mlle. Marie Laurencin, is a charming work, and is among the most powerful and freest works in this Salon.

Metzinger's large composition, *The Blue Bird*, is his most important work to date. It is a very brilliant painting, with an enameled

glaze pleasantly borrowed from the outside world. It is a fairy-like fantasy. [. . .] Chagall's *Adam and Eve*, a large decorative composition, reveals an impressive sense of color, a daring talent, and a curious and tormented soul.[16]

Let us also mention in this room: Korody, who is worthy of interest; Bolz and Tobeen, who are ardently striving for beauty; an unpretentious work by Dunoyer de Segonzac, who was at one time a very bold painter; Mlle. Alice Bailly, an interesting artist; Marcoussis's *Violins*, etc. [. . .]

[APRIL 2]

In the course of another visit, I noticed some works that had escaped my attention before. Also, the sheet of paper on which I had written how very much I liked Gleizes's large painting, *Football Players*, somehow was mislaid. This painting represents a great striving toward light and movement; it is a dense composition, difficult in conception and execution. But everything in it—except perhaps certain little flowers—is new and vigorous.

The sculptor Agéro has sent a group of stone figures whose force-lines move irresistibly. This is not the most pleasant kind of sculpture, but it is the newest, despite all its poverty of inspiration and its wretched execution. [. . .] Bruce, whose name I am writing for the first time,[17] is a daring painter. The zones (this excellent term, designating colored masses of disparate values, was proposed by M. Fernand Roches, editor of the handsome art journal *L'Art décoratif*;[18] I adopt it willingly), the zones in his paintings are almost the living representation of nature. Yet another effort. Here is [. . .] *Summer*, by Cœuret—the true independent. I saw him arriving with his wife, his children, and his paintings loaded on a cart pulled by a wooly little donkey. [. . .]

[. . .] Here is Tobeen, who is related to the new schools by his horizontal hatching à la Cézanne, but whose draftsmanship is quite dead. Here are Utrillo's landscapes, which, I understand, M. Octave Mirbeau likes a lot; Valensi's *Expression of Algiers*, which should have been exhibited next to Léger; [. . .] two landscapes of the Vendée by Charles Péquin, an intelligent, gifted, but timid artist. [. . .]

(*L'Intransigeant*)

1913

Through the Salon des Independants[19]

[MARCH 18]

The historic role of the Salon des Indépendants is today recognized. The art of the nineteenth century is nothing but a long revolt against academic routine: Cézanne, Van Gogh, the Douanier Rousseau. For the past twenty-five years, it is the Indépendants that has brought to light the newest personalities and tendencies of French painting, which is the only painting that counts today and which is pursuing in the face of the universe the logic of the great traditions.

This year, the Indépendants is more alive than ever.

The newest schools of painting are represented in it: cubism, the impressionism of forms, and its latest trend, orphism, pure painting, *simultaneity.*

Light is not a technique. It comes to us from our sensibility (the eye). Without sensibility, there is no movement. Our eyes serve as the essential sensibility between *nature* and our *soul.* Our soul maintains its life in harmony. Harmony is engendered only by the *simultaneity* with which the *measures and proportions of light* reach the soul, the supreme sense of our eyes. This simultaneity alone is creation; everything else is merely enumeration, contemplation, study. This simultaneity is life itself.[20]

The modern school of painting seems to me the most daring school that has ever existed. It poses the problem of the beautiful in itself.

It wants to represent beauty no longer associated with the pleasure that man finds in man—and that is something that no European artist, since the beginning of recorded time, had ever dared to do. The new artists are searching for an ideal beauty that will no longer be only a prideful expression of the species but rather an expression of the universe, to the extent that it has been humanized by light. [. . .]

Room 7. Here is a pretty room, tastefully arranged. In previous years, the rooms of the "Pompiers des Indépendants" variety, which resembles the Artistes Français variety like a brother, extended at least as far as Room 15.

Most of the paintings exhibited in this room would have aroused

very lively interest just five years ago. And if, in this Salon which contains so many new efforts, we are less moved in looking at paintings that are not outmoded but are simply less audacious than the others, these paintings are nevertheless very pleasant to look at.

The portrait of the poet André Fontainas, who was an enlightened defender of the young painters, occupies the place of honor here. It is a somewhat heavy but not at all boring work by Zinoviev, who in his landscape seems to be greatly influenced by Friesz. A young girl playing with a lizard was painted in a slightly divisionist manner by Maurice Lefebvre.

G.-K. Benda's nude woman, a rather unpleasant painting, betrays the influence of Vallotton. The most interesting work in this room is M. Destrem's: two strange seascapes and a portrait of a man, which deserves especially to be noticed. [. . .]

Room 12. This is the room with the big "machines." It contains a *Gorilla*, a *Woman,* and a *Red Lantern* by Miot. We advise him to continue in this vein if he does not want to overwork the public at the Indépendants. [. . .]

Room 14. This is the first room of real interest.

Robert Mortier has fervor, he seeks to capture the feeling of an instant. He feels keenly, but he has not yet found his way. Very pretty notes.

If Krieg's *Arab Cemetery* were painted with greater care, it would be possible to appreciate the artist's gifts as a colorist.

Franck de Walque, with naked dancers on the edge of a pond:

"Garlands, a flute and the sound of cymbals"—a bit silly, in its excess, but sweet. [. . .]

Room 17. Marc-Git[21] would like to paint the way Forain draws. [. . .]

Room 27. A pair of high-button shoes without feet by Paul Lavalley, to illustrate Picasso's dictum: "There are no feet in nature."

Room 28. Marcel Lenoir, who changes too much. He has a style for every exhibition.

A. Altmann, a great sincerity in his landscapes. A white frost as always, broadly executed. The Indépendants has a noteworthy abundance of fresh and beautiful landscapes that constitute the originality of this Salon.

Marthe Galard showed greater promise last year.

1913

Room 29. I. Yackimov has given the title *Still-Life* to his painting of Beethoven's head in a hatbox. [. . .]

Room 33. This is a room of incongruities.

Francis Jourdain's studies are delicately muted. One has the impression that this artist, who is not lacking in sensitivity, does his best to express himself in the most limited way possible. [. . .]

A naked woman by Asselin—it is almost as biting as a Puy. [. . .]

Sérusier . . . I don't understand him.[22] [. . .]

Room 34. [. . .] Lotiron, influenced by Delaunay, with some views of Paris. [. . .]

Room 35. This is the pointillists' room; they have been placed, symbolically, in a room that is separated from the section of the Salon devoted to the new painters only by the buffet (Room 36), which contains a number of large but characterless paintings belonging neither to the old nor to the new schools. The pointillists, in fact, reached only the outer borders of today's art. Their atmospheric dots dance, as it were, in front of the buffet; and yet, this school that appears to us today so closed, so limited, may well be the one chiefly responsible for the liberated artistic consciousness of the younger generation.

Paul Signac has just come back from La Rochelle.

A watercolor, doubtless painted on the spot and with a great variety of colors, was a sketch for the large painting showing the *Port of La Rochelle*. The artist's talent seems to have rejuvenated itself in this painting: he has gained in power, his contrasts are more unexpected, and the canvas has depth. It is one of the best pieces of the neo-impressionist school.

Maximilien Luce's construction workers standing in front of some unfinished houses testify to his wish to be modern.[23] One sees in this canvas perhaps more clearly than in the artist's other works in what sense he is a neo-impressionist. His divisionism is very apparent here, and it makes one think of certain works by Seurat.

Mme. Lucie Cousturier's three still-lifes—of vegetables—seem to blaze in the sunlight that ripened them. One senses her intoxication with light, but the composition is somewhat dry. [. . .]

Mme. Georgette Agutte has become a great deal freer—her impressions of nature now appear to be completely liberated from Matisse's influence. [. . .]

Room 42. The Fauve Room. [. . .] Some passionate and penetrating *Portraits* by the poetess Valentine de Saint-Point. One finds in them the same ardent and personal qualities that were evident in the works she exhibited at the Salon d'Automne.

A brilliant interior by Gwozdecki.

And the retrospective of the works of Pirola, a young artist of whom great things were expected. Sincere studies of nature, sketches for compositions that would have been powerful. I want especially to mention the fine canvases he painted in Marseilles.

Room 43. Finally we enter the domain of the new painting. This is the Dutch room, even though a few young French painters are exhibiting here. The tendency here is clearly cubist. Yves Alix's *Studio* evinces great effort. It is a powerfully constructed canvas. Its personality is above all in its coloring.

The *View of Nevers*, by André Favory, is even more directly influenced by Gleizes. It lacks variety, but the left side of the picture, showing the railway, is bearable.

M. Gromaire comes from the north of France. His canvas, *The Wandering Jew*, testifies to his Flemish ancestry; he is influenced by Rubens and Brueghel, but his painting has a great deal of personality. This is a composition full of good humor, joviality, and forcefulness.

The highly abstract cubism of Mondrian, a Dutchman (we know that cubism has penetrated the museum in Amsterdam; while in France our young painters are being ridiculed, in Amsterdam they are exhibiting the works of Georges Braque, Picasso, etc., next to those of Rembrandt)—Mondrian, an offshoot of the cubists, is certainly not their imitator. He seems to have been influenced above all by Picasso, but his personality has remained wholly his own. His trees and his portrait of a woman reveal an intellectual sensibility. This kind of cubism is heading in a direction different from that currently pursued by Braque and Picasso, whose experiments with materials are proving extremely interesting.

Louis Schelfhout's *Provençal Landscape*, a powerful and well-balanced canvas. This imaginary landscape appears more real than many a study done from nature. Alma—a Dutchman like Van Gogh, whose temperament he shares to a degree; his small landscape has great delicacy in its grays and greens. His painting is serious and passionate.

1 9 1 3

Let us mention the strange and sincere studies by Mlle. Van Heemskerck, who owes a great deal to cubism; Van Riss,[24] ranges of color—not to be dismissed; Makowski, colors full of sensitivity; Mme. Gerebtzoff, mystical, intellectual, childish. A canvas entitled *The Immortal Communion*: Is this Chinese art? Mme. Vassilieff: effort and talent; so very much of both!

Room 44. The most interesting aspect of this room is the work by Dufy, who for the last few years has exhibited only a few small things done a long while ago. Dufy, who for some time had devoted all his energies to decorative art, was quite right in coming back to painting. He had exerted a decisive influence on the art of Friesz and of Lhote, and perhaps even on the futurists.

Mme. Lewitska's landscapes of Roussillon are solid and full of poetry. A delicate art bordering on cubism, especially in its honest treatment of backgrounds. Locquin fearlessly throws the light of his landscapes out of balance.

Marchand, a sensitive artist, lovingly paints views of Céret. His art has some analogies with the detailed art of certain primitives.

But how many views of Céret, that Barbizon of cubism!

Lhote, who is improving markedly, localizes tones in a rather gray atmosphere; he has tried very hard to get away from the illustrative tendency that influenced him so very much until now.

Utter is exhibiting an extremely realistic *Three Graces*; his talent is developing.

Kisling is giving a new life to his art through the discipline of André Derain's paintings. I especially like his large, powerful study of the sculptor Manolo's dog, painted in Céret.

Frank Burty is also improving.

I must also mention the interesting studies by Mme. Valadon, Fauconnet's pretty drawings, and Van Dongen's posters.

Room 45. Here is orphism. This is the first time that this new tendency, which I foresaw and proclaimed, has manifested itself.

Delaunay is one of the most gifted and most audacious artists of his generation. His dramatization of colored volumes, his sudden breaks in perspective, and his irradiation of planes have influenced a great many of his friends. People are also familiar with his experiments in pure painting, about which I spoke in *Le Temps*

on October 14, 1912. He is searching for a purity of means, for the expression of the purest kind of beauty.

Delaunay's latest picture indicates still further progress. His painting, which appeared to be wholly intellectual (to the great joy of the German *Privatdozents*), now has a definitely popular character. I believe that this is one of the highest tributes one can bestow on a painter today.

The Cardiff Team, Third Representation, by Delaunay: the most modern painting in the Salon. There is nothing successive in this painting, which not only vibrates with the contrast of complementary colors discovered by Seurat, but in which every shade calls forth and is illuminated by all the other colors of the prism. This is simultaneity. A suggestive, not merely objective, kind of painting, which acts on us in the same way as nature and poetry! Light is here revealed in all its truth. This is the new tendency of cubism, and we find this tendency toward orphism in almost every canvas in the next room; this is especially true of the studies of Fernand Léger, who must be praised for his great artistic integrity, since he refused to exhibit his large canvas,[25] because he thought that he had not yet attained the goals he was pursuing.

I find that Picabia has made progress. His *Procession* lacks a genuine subject, and all its surfaces are dead, but he is making progress nevertheless; his blues assail the eye, while his wine-red squares and a certain curved line on the left produce a powerful effect.

We must look at this unfinished effort by a gifted painter the way we would look at a machine whose function we do not know but whose movement and power astonish and worry us. All this appears too unconscious to be considered cubic orphism. Cerebration, intuition—let us wait before praising it, and wait, too, before scorning it.

Room 47. Here at last is the great room—like the Salon Carré of the Louvre.

Society Ball, by Mlle. Marie Laurencin, is the most charming work in this Salon and one of the freest and most powerful. One would have to write a poem to express the grace of its composition, the delicacy and depth of its very feminine coloring; we are dealing here with a totally original artist.

Peonies awake like the dawn, and while a seated musician, her

legs crossed, plays on a small banjo, two dancers—one pink, one black—move toward the stole and the fan. The dais is pink. The depths are as blue as silence, and the indifference of the glances fills with uneasiness the greenery grazed by the swiftness of the dance. This is no longer cubism but orphism.

Mlle. Laurencin's art is tending toward pure arabesque, humanized by attentive observation of nature; its expressiveness differentiates it from mere decoration, while it retains all the charm of decoration.

With his *Football Players*, Albert Gleizes has taken an enormous stride forward. This is his most diverse and richly colored painting. In the upper portion, I still see a few unpleasant heavy blurs, but the composition is varied and new. Gleizes undertook a difficult composition, which he succeeded in ordering like a master. The subject has come back into painting, and I am more than a little proud to have foreseen the return of what constitutes the very basis of pictorial art.[26] The subject of Gleizes's canvas is movement.

Metzinger's large and poetic composition, *The Blue Bird*, is the most important work yet painted by this controversial artist. It is difficult to express in a few lines, and without having pondered it beforehand, all the imagination and all the fairy-like magic of this well-painted canvas.

It can no longer be said that cubism is a melancholy kind of painting; a festive painting, rather, noble, measured, and audacious.

M. Luc-Albert Moreau is following a course parallel to Metzinger's; his *Idols*, a poetic and sensual composition, reveals a gifted talent.

In R. de La Fresnaye's *Farm*, there is more freedom than in his previous paintings—and that means progress. The colors, however, are dull and badly placed.

Szobotka: intelligent efforts to free himself from the colors and the line of the academy. [. . .]

Dunoyer de Segonzac has sent what amounts to a calling card: a pitcher and all that goes with it. An unpretentious work by a painter of talent who knows how to be audacious and who was three years ago, when he exhibited his *Childbirth*, a canvas it would be interesting to see again.

Mlle. Alice Bailly has completely altered her style. Her modified cubism is one of the interesting novelties of this Salon.

Marcoussis painted his *Violins* with a joyous skill that deserves attention.

One must also mention the arrangement of the paintings in this room. Innovation in painting, innovation in hanging. The decorators will not fail to be inspired by it.

Fernand Léger's exhibit is in this room. See my remarks on it in connection with orphism, Room 45.

Room 48. Giannattasio: *The Turnstile,* a futurist painting that seems to have come from the *Riding Ring* exhibited by Delaunay a few years ago.

A vaguely orphic painting by Morgan Russell, and a vaguely cubist painting by Hugot.[27]

[MARCH 29]

THE SALON DES INDÉPENDANTS: SEQUEL TO OUR SPECIAL ISSUE

Certain peevish individuals, who, instead of coming to the defense of art, feel obliged to contribute to the history of human folly, have applied the term "madmen" to the latest French painters. Yet with a minimum of good will, these same individuals would have understood that these young painters are the product of a protracted evolution. Even though individual errors are possible, it has never happened in the whole history of Art that an entire school of painters took the wrong road. This very simple fact should suffice to enable people to approach the audacious works of the latest French painters with more confidence.

If cubism is dead, long live cubism. The reign of Orpheus is beginning.[28]

[. . .] Let us also mention the works of M. Crotti, the elegant sculptures of Archipenko, who is one of the finest sculptors today, and the interesting figures by Brancusi and Agéro.

(*Montjoie!*)[29]

The Opening of the Society of Humorists

The exhibition of the artists of the Society of Humorists opened today at the La Boétie Gallery. The opening will continue until midnight.

A charming exhibition, with a very great deal of wit, a very great deal of talent, a very great deal of discretion. Ah! too much discretion. I except, of course, Forain, for that great artist is always admirable. But, except for Forain's work, there is no great satire today. Still, there are also Hansi's *Pictures*, taken from the *Histoire d'Alsace*; this is simple, gay satire, and it has a barb.

I didn't see anything that I found funny enough to make me "laugh until it hurt." There was much, however, to make one smile, and I am sure that people will find a subtle pleasure in examining [. . .] the brilliant, lively, electric pastels of the inimitable and much imitated Jules Chéret; [. . .] the *Lovers* by Falké, who is not afraid to arouse laughter; the lovely etchings—especially the illustrations for Gérard de Nerval's *Les Nuits d'octobre*—by Galanis, who is the only cubist in this Salon; [. . .] the delicate and marvelous *Masquerades* by Mme. Léone Georges-Reboux, whom I would like to see illustrate Verlaine's *Fêtes galantes*; [. . .] the woodcuts by J.-E. Laboureur, a penetrating, elegant artist; [. . .] the astonishing compositions by Tiret-Bognet, a great, extremely modern humorist who deserves to be talked up; [. . .] the curious drawings by André Warnod, whose talent has developed greatly; [. . .] Willette's admirable work, so mischievous and so heroic: *Our Little Maria, My Rosebush Is Dead*, which is pure Verlaine, and *The Communard*. This is not only humor; it is poetry.

(*L'Intransigeant*, M A R C H 28)

The Art World

Albert Marquet

A spirited painter, in whom a refined, somewhat literary sensibility struggles with a taste for power. His extremely accurate eye saves

him from vulgarity. His individuality is assured by his familiarity with
the latest trends in painting, and his pleasure in picturesque, irregular
terrain has earned him a following among exhibition goers. (At the
Druet Gallery.)

(*L'Intransigeant*, A P R I L 6)

David and His Pupils at the Petit-Palais

A Period of the French School

An exhibition organized by M. Henry Lapauze is always assured
of a brilliant success. To many people, Ingres had always remained
"Monsieur" Ingres. Thanks to M. Henry Lapauze, we have seen the
triumph of Ingres the sensualist, Ingres the lover.

This current David exhibition does not propose to strip the *pompiers*
of their helmets,[30] for no one today could possibly confuse the David
who was beguiled by antiquity (the *pompier*, in a word) with the
David who *regenerated the French School of painting*. Rather, the
purpose of this exhibition is to acquaint people more fully with a period
of French art that has been neglected by art historians. This exhibition,
organized by the city of Paris—which is personified, on this occasion,
by M. Henry Lapauze, with all his taste, knowledge, and energy—is
perhaps the best we have ever had in Paris. The rational arrangement
of the paintings in the various rooms appears to me excellent, and in
the words of M. Lapauze, "After a visit to the Petit-Palais, a visit to
the Louvre will suffice to make one understand the full development
of the French School from the Revolution and the Consulate through
the Empire and the Restoration."[31]

David is the favorite master of some of today's most daring young
painters, and I personally am of the opinion that his *Death of Marat* is
a masterpiece that could have been painted today, exhibited at the
Salon des Indépendants, and ridiculed by most of my colleagues and
by most connoisseurs. It is a pity that we must still lament the dis-
appearance of its companion piece, a sublime painting of the death of
Le Peletier de Saint-Fargeau. Among the works of the Boucher period,

especially remarkable are the marvelously forthright portraits of Sedaine and his wife. *The Young Boy* (No. 13 in the catalogue) is a sober and powerful piece. All of Couture is there. David's portraits constitute the most vital—if not the most admirable—part of his work. I must say that the *Portrait of the Marquise d'Orvilliers* seems to me the masterpiece of this exhibition. It is a painting at once frank and sober, harmonious in its colors and precise in its details without appearing labored; it is, in a word, alive.

After this, one can do without looking at *The Death of Socrates*, which could have been signed, let us face it, by Duval Le Camus the Elder. As for the equestrian portrait of Count Potocki, it is too pompous for my taste. But I shall come back to see the portraits of the *Flutist Devienne* and of the *Marquis de Sorcy de Thélusson*, the very poetic sketch of *Bonaparte as First Consul, The Family of Michel Gérard*, two adorable studies—the *Portrait of Baroness Meunier* and, even more engaging, the portrait of *Baroness Jeanin*—and the astonishing portrait of Sieyès. I stood sadly for a long time in front of David's last painting, *The Wrath of Achilles*, showing an Achilles and an Agamemnon so innocent that they look as if they had been painted for the firehouse on the Rue Blanche, a Clytemnestra who is pure Winterhalter, and an Iphigenia crowned with roses, looking very much as if she belonged on the walls of the Théâtre des Champs-Elysées. Must I enumerate all of David's pupils? I shall mention, in alphabetical order: Cochereau, whose art has a truly popular character; Couder; Debret; Delécluze, whose writings are considered authoritative; Drolling, whose father, they say, painted with royal ashes after the desecration of the tombs at St. Denis; Dubufe, who painted so many pretty women for the bourgeois of his time; Ducis, for whom his uncle, the translator of Shakespeare, had written his *Vers pour un jeune homme*:

> *Ah! craignons ce qui nous enchante!*

> (Ah! Let us fear what enchants us!)

Duval Le Camus the Elder . . . but he still has rivals. . . .

Fabre, who painted some exquisite portraits of the young Bacciocchi; Fragonard (Alexandre-Évariste), who at least had the merit of having studied the surprising effects of light.

Baron Gérard, who was a charming man, amply endowed with the virtues as well as the vices of his time.

Ducis composed a thousand lines of verse in his honor:

> *Héritier du Corrège, heureux dépositaire*
> *De sa grâce et de son pinceau*
> *Sur qui Vénus dans son berceau*
> *Souffla trois fois le don de plaire.*

(Correggio's heir, fortunate possessor
Of the master's gracefulness and brush
Whom Venus in his cradle came to bless,
Bless triply with the art of pleasing.)[32]

Ducis's verses have little in common with Ossian's, yet they bear witness to Gérard's Ossianesque inspiration.

> *Dans la plus douce extase, Oscar et Malvina*
> *Que le tendre hymen enchaîna . . .*

(In the sweetest ecstasy, Oscar and Malvina
Whom tender Hymen enchained . . .)

Girodet, the famous Girodet who must have read the writers of antiquity in the translations he illustrated.

As for Granet, he emerges—but *emerges* is the wrong word—he is *born* in this exhibition. His popular and expressive manner foreshadows Courbet, and Courbet foreshadows the latest tendencies of today's young painters. The young painters and I are not the ones who say so.

In a widely read article,[33] M. Anquetin, moved by noble anger, held Courbet responsible for today's new painting. As for Granet, he was unjustly judged by Baudelaire, who wrote: "It is generally admitted that M. Granet is a clumsy artist full of sentiment, and people usually say in front of his paintings: 'How simple his means are, yet what an effect!' Is there really a contradiction in that? It simply proves that Granet is a very skillful artist who puts his considerable knowledge to good use in painting Gothic and religious banalities, which are his specialty; he has a very shrewd, very decorative talent."[34] He also has a free manner, at once new and personal, and an intelligence that is not incompatible with feelings.

Baron Gros—the pictures in the Louvre suffice to assure his glory. Those at the Petit-Palais in no way diminish it, and one must not

forget that Bonington was his pupil—albeit a pupil who did not follow the counsels of his master. Gros, incidentally, did not hold it against him. "Color," he would cry, "ah, color! Just look at the things by Bonington, they're admirable!"

Ingres! I won't speak of him. *The Odalisque with the Slave* is a jewel. What can one say about Isabey, except that he painted good likenesses? Navez, a Belgian painter and the teacher of Henri de Groux. How close David is to us. Ponce-Camus, who seemed important to me, but who has only two paintings on exhibit.

Abel de Pujol, about whom Baudelaire said the last word. Riesener, Léopold Robert, Schnetz and his tales of Italian bandits, Wicar. A group of drawings and miniatures completes this marvelous exhibition.

(*L'Intransigeant,* APRIL 10)

Before the Opening of the Salon de la Nationale

[APRIL 12]

A General View of the Works on Exhibit

This year, upon the fortunate initiative of, I believe, M. Aman-Jean, the works of young artists have been grouped together in the first room. The Nationale can only gain from this rejuvenation.

One would have liked to see the same emphasis on freedom and youth in the sculpture section as among the paintings. Alas, the very opposite is the case.

The exhibition rooms of the Nationale are totally inhospitable to sculpture. And yet, only at the Nationale do we still see a little good sculpture every year. The beneficial influence of Schnegg, Rodin, and Despiau has given us a school of sculpture, a small one to be sure, but full of genuine plastic qualities. In any case, I believe it to be the best school of sculpture anywhere in the world today. A few artists of this school exhibit at the Artistes Français, but most of them are trying to stay with the Nationale. And that is no easy thing, God knows! This year, their enemies seem to have won out; that is a pity, especially for sculpture, which is reduced these days to counting its good works on the fingers of two hands. A few of the more talented

sculptors were almost excluded from the exhibition because they had not paid their dues on time or for some such unimportant reason, and their names are not listed in the catalogue.

That is why I consider it my duty to call the attention of the public first of all to the works of Durousseau: *Eros, Hercules,* and the bas-relief of *Weeping Women.* The extremely bad lighting of the cellar in which these graceful and vital pieces are exhibited does them a great disservice. I would say the same about Rodo's two works, *Jeremiah* and *Venus Passing in Front of the Sun.* [. . .] On the pedestal of his *Jeremiah,* the sculptor has inscribed his protest: "Not listed in the catalogue." As I write this, the works of Despiau, Rodin, and Marcel-Jacques have not yet arrived. In the present state of the sculpture rooms, it seemed to me that this year's best work was Mme. Jane Poupelet's: *Seated Woman, At the Water's Edge,* and a *Study* in plaster. Wittig's marble *Pax* and his *Bust* of a woman are also excellent pieces. I am equally fond of Henry Arnold's heads of young girls.

In the painting section, among the works of young artists, people will above all notice Louis Charlot's *Peasants Around a Table.* It is without a doubt the most important piece in the Salon. This canvas, in which Cézanne's influence is evident, is the work of an authentic painter. M. Roll is exhibiting a large ceiling—democratic painting. Albert Besnard, who is getting ready to make his entry into the fine city of Rome, sent only a masterful portrait. Here, too, among the young artists is Ozenfant, a colorist but not much of a painter. Here is the *Knight of the Woeful Countenance,* into which M. de la Gandara poured all his pity for that noble and human creation of Spanish knighthood. [. . .]

[APRIL 13]

THE OPENING

A Lovely Day—A Stroll Through the Exhibition Rooms

Although the bereavement of the President of the Republic deprived the Nationale of his visit, it did not dim the splendor of this pre-opening day.

I 9 I 3

Despite the cold, despite the wind, the sun participated in the festivities, and those who had invitations were there.

We noticed M. Tittoni, the Italian ambassador; M. Isvolsky, the Russian ambassador; Generals Pau and Marion; Messrs. Rodin, Cottet, Paul Adam, Georges Lecomte, and Gervex, and a few pretty women, but on the whole a rather small crowd.

The Painting Rooms

The Nationale has become a bit younger, and if it is still the meeting place for every kind of contemporary mannerism, one must at least say that considerable effort has been made to emphasize some powerful and forthright works. We also note that the influence of Cézanne and of Gauguin is keenly felt.

Room 1 is one of the most interesting in the Salon. An attempt was made to group together here interesting works by very gifted young artists.

I said yesterday how highly I esteem Louis Charlot's *Peasants Around a Table*. I heard several people lamenting the fact that the little boy in red was not as carefully detailed as the craggy faces of the Morvan mountaineers who make up the picture; one of the reasons they cited for this was that the model—a good little devil—had refused to sit still.

I confess that I found nothing to criticize in this child's form; on the contrary, it revealed to me the real personality of Louis Charlot, who cannot be imprisoned in a set formula. [. . .]

Amédée Ozenfant's *Recollection of Lago Maggiore*[35] appears to me to be the work of a colorist wary of his talents. [. . .]

Room 2. M. Muenier takes great pleasure in studying the rays of sunshine that leave spots of light in city apartments. The *Awakening* that he is exhibiting this year will enjoy the same success as his *Music Lesson*. [. . .]

[APRIL 15]

The opening of the Nationale took place on a cold and sunless day. The visitors were not very numerous . . . *rari nantes* . . . and did their best to keep warm.

Room 3. There is something faraway and melancholy about M. de la

Gandara's Paris landscapes. Their muted and delicate atmosphere resembles that of certain summer days. As for his *Don Quixote*, it marks a new phase in M. de la Gandara's art. Let us hope, however, that M. de la Gandara has not given up painting portraits of women. It must be said, however, that this picture of the *Knight of the Woeful Countenance* is one of the most objective works in the Salon, and the one that shows perhaps the least concern with the artistic fashions of the moment. M. Lavery's *Death of the Swan* suggests the thought that this swan emitted no song before dying. [. . .]

Room 3-A. M. Lucien Simon's exhibit is very important. I like his *Bretons* best of all; it has a family sentiment that M. Simon's talent knows how to capture. I find his *Nude* and his carnival fantasy less appealing. [. . .]

Room 3-B. I cannot say that I like Willette's *Rollicking Waltz*. Simonidy paints sad pictures of classical sites; Henry de Waroquier has given up his Japanese imitations and is finally showing his true face as a decorator; Dinet is an honest Orientalist, and his *Ouled Naïls*[36] is graceful. [. . .]

[APRIL 17]

Rooms 4 and 4-A. [. . .] M. Aman-Jean's decorations are more powerful than the work he has exhibited previously, and they make one feel more than ever how profoundly cultivated this artist is. But I consider Lepère's work one of the best, one of the most honest and unaffected in the Salon. [. . .]

Room 5. Many paintings here aiming for elegance: Mme. Madeleine Lemaire, Mlle. Nourse, M. Dumoulin, M. Alexandre Séon, M. Edgar de Montzaigle, and the ceiling by M. Roll, whose aim is not at all to be elegant. Allegories, these days, are like spiders; they find their refuge on ceilings. M. Roll's ceiling is frankly republican. Having noted that, let us admire the verve with which the artist has treated an allegorical subject that must, in all honesty, be described as boring. [. . .]

[APRIL 20]

Room 6. Frieseke is a delicate painter of women; Guiguet's mischievous malice struck me exactly as it was meant to: I liked it. Mlle. How is the little babies' big sister, but perhaps this year she made too many concessions to elegance. The symbolist poets trans-

formed the servant girl into a kind of modern nymph, young, graceful, a bit melancholy, and always to be found in groups. This is pretty much how M. Myron Barlow represents her.

In the poetry of vast parks, M. Charmaison finds a charm that is ever new. [. . .]

Room 6-A. M. Le Sidaner has made a great effort to transform himself. This year, he has painted sky as sky. His pictures each depict a nocturnal sky. This was truly a gamble that could have resulted in something as invisible as black cats in a pitch-black room. But the artist succeeded in realizing his celestial design, and all to his honor. [. . .]

[APRIL 24]

Room 7. Dufresne's exhibit, in which one feels the influence of Cézanne and of Gauguin, is the most interesting in this room. If this year's Nationale is, on the whole, lacking in character, that is not the fault of the artists who have made an effort to modernize it; what is lacking, rather, are really strong personalities. But here are the photographs—oh, excuse me, the portraits—by M. Weerts. I like La Villéon's romantic landscapes, in which one can feel a little "Cézannism." [. . .]

Room 8. M. Lévy-Dhurmer's decoration, *Despite the Fates*, is placed in such a way that one can barely judge its decorative effect. In any case, it bears witness to a subtle imagination. This room is devoted to stylistic experimentation. [. . .] A very respectable room, somewhat cold in feeling. [. . .]

Rooms 11, 12, and 13. [. . .] M. Baudouin's frescoes this year have the unpleasant look of fake tapestries. Let us mention the work of [. . .] J.-J. Rousseau, who—as his name compels him to do—has a feeling for nature.

Room 14. M. Boldini's portraits are as amazing as ever. He would doubtless be very much astonished to hear that his manner has some similarities to that of the futurist painters. [. . .]

[APRIL 26]

Room 15. M. Carolus-Duran is exhibiting a Golgotha: *Behold, the Veil of the Temple Was Rent in Twain . . . and the Earth Did Quake. . . .* This is one of the most tumultuous and most interesting canvases in a Salon that does not boast too many of them. [. . .]

Room 18. My favorite canvas in this room is Osterlind's *Servant Girls*, broad and simple in manner and very independent in its precision. M. Anquetin and M. Armand Point no longer leave the museum. [. . .]

The Rotunda, Balcony, and Stairwells. Flandrin's *Horsemen*, a rather cold and conventionally elegant work. Hanicotte's painting should have occupied a place of honor in one of the rooms; among today's painters, he is perhaps the one best able to express joy. [. . .]

Sculpture. I shall cite here only works that are worth mentioning: first of all, the monumental figure by Despiau exhibited in the garden; this is one of his most substantial works (in size) and one of the most beautiful pieces of the new school of sculptors. The bronze he is exhibiting together with his friends' works is delightful. On the whole, I am really happy to see the success achieved this year by sculptors whom I was one of the first to defend. [. . .]

(*L'Intransigeant*)

The 33rd Salon de la Nationale
Through the Salon

Notes. What follows are simply some notes hastily scribbled at the Nationale before everything had been installed. As the works had not yet been numbered, I was obliged to skip over many canvases whose signatures were either illegible or nonexistent, and which were, therefore, impossible to identify.

What must be noted first of all is how quickly the fashionable, almost *pompier* painters of the Nationale have assimilated the innovations imposed on them by the avant-garde artists. It takes no more than four or five years for a movement originating at the Indépendants to arrive, washed-out and ready to die, at the Grand-Palais, where the worst enemies of the new aesthetics welcome it with open arms and coddle it into decrepitude.

In many paintings at this year's Salon, one can see the influence of Cézanne, Gauguin, the fauves, and even of Picasso, the Picasso of years gone by.

All of this is so timorous that it would hardly be worth talking about.

But it is still the custom to accord an importance to the large annual salons which perhaps they still deserve from a fashionable or social point of view but which they have totally forfeited from an artistic point of view.

Sculpture

Nevertheless, the sculpture section at the Nationale is generally interesting, but the partisans of bad sculpture seem to have won out this year. At the time I am writing this, however, not all the exhibits have arrived yet, and it is impossible to draw any definite conclusions. I might mention [. . .] Andreotti, who has some good qualities and some bad taste; [. . .] Despiau, one of the masters of modern sculpture who one wishes were more daring; [. . .] Marcel-Jacques, who is perhaps the frankest of our image-makers; Wlérick, who possesses a fine talent and who I wish possessed some daring.

There is a great, great deal of talent in all this, but not a trace of daring.

Painting

Room 1. The organizers had the good sense not to sacrifice this room, and as it is now, it is one room where the pictures are serious, have character, and were painted by young artists. It is hardly surprising that they have been influenced by artists who are usually ignored by the official salons!

Here, for example, is Chapuy's *Saltimbanques*, in which one finds the direct influence of Picasso's clowns. Charlot's *Peasants Around a Table* is under Cézanne's salutary influence. It is one of the best canvases in the Salon, and it is my duty to say so. The figure of the child, which appears less finished than the other figures, is in fact the most interesting element in the picture, and the one that reveals the personality of the artist.

[. . .] Amédée Ozenfant is exhibiting *Women Bathing*, which I do not like very much, even though it shows that this overcultivated painter has some gifts as a colorist.

[. . .] M. Armand Point does excellent pastiches with a skill and

erudition that should be put to use by the curators of our museums, who more often than not entrust restorations to clumsy ignoramuses. [. . .]

Room 3. Lavéry, no, no, most emphatically no! [. . .] The important exhibit in this room is that of M. A. de la Gandara, who is not showing any portraits of women this year. I think that was a mistake on his part. Perhaps he listened to bad advice from his friend in Versailles, M. Jacques Garnier. Here are three views of Paris, a Paris as distant as a memory. Here too is the *Knight of the Woeful Countenance*, surrounded by the sad flock of his chimerical visions—a Don Quixote in rags, on whose head Mambrino's helmet does not blaze in the sun. This may be Avellaneda's *Don Quixote*, but it is not Cervantes'. [. . .]

Rooms 4 and 5. A ceiling by Roll, a ceiling as ugly as most of those painted over the last twenty years. Democratic painting? No! Parliamentary painting rather. Alexandre Séon: the Renaissance. Edgar de Montzaigle: Greece. Louis Dumoulin: China. Madeleine Lemaire: the Grand Siècle. Henry-Baudot observes wild animals the way Fabre observes insects; every profession has its dangers.

Room 4-A. [. . .] René Ménard, who would like to be a Greek, and a pagan mystic, like Louis Ménard before him. [. . .]

As usual, Aman-Jean paints the wedding feasts of charming tubercular wraiths.

A. Lepère offers us one of the best and most forthright works in this Salon.

Room 5. Frieseke: pink and white.

How: some excessively elegant images of motherhood.

Myron Barlow: servant girls who read Maeterlinck. [. . .]

Room 7. Good but somewhat confused work by Dufresne. Decidedly, Cézanne reigns at the Nationale and Gauguin is also visible. [. . .]

Migonney: a nude woman, some lynxes and stags, meadow saffron, all under Gauguin's influence and all too much for a single autumn. [. . .]

Room 11. [. . .] The Albert Guillaumes, which are perhaps the only works in this Salon to have had the honor of being reproduced in color by an American photographer . . .

My God, one wonders why!

A fresco by the erudite M. P. Baudouin. But was there really any point in imitating fake tapestries?

1913

Room 12. Gustave Courtois has given up painting pictures of Hercules.

Costeau, who is not so "costeau" as all that.[37] [. . .]

Room 13. Abel-Truchet, a futurist, destroys Venice with a few strokes of his brush.

Room 14. Boldini, an Italian futurist and prestidigitator. Eugène Cadel, Jean Béraud and his small genre paintings with philosophical intentions; (M. Jean Béraud's art is not so outmoded; using modern means, the Italian futurists pursue the same ends as he). [. . .]

(*Montjoie!* A P R I L 14)[38]

The Art World

Henri Matisse

Henri Matisse has brought back from Morocco a small number of paintings and drawings that will be exhibited for only a few days.

In the work of a great colorist, which Henri Matisse is, colors have a symbolic value determined by the artist's sensibility. Line, which in Matisse's work is purely instinctive, expresses the most subtle and refined sensuality to be found in any artist today.

The Turkish Café[39] and *Gate to the Casbah* are among the very few acceptable works inspired by contemporary North Africa.

(*L'Intransigeant,* A P R I L 17)

The Salon des Artistes Français

[A P R I L 29]

Before the Opening—There Will Be No Official Opening—
A General View of the Exhibition

There was no official opening today. But the *petit vernissage* this morning was very well attended and very animated. There were many foreigners, especially Americans, both North and South. As everyone knows, Americans are the best foreign customers of the painters who

exhibit at the Artistes Français. What may seem unbelievable, although it is the truth, is that at this *petit vernissage*, many painters were actually varnishing their canvases. Mlle. Maillard had to repair hers, which had been damaged. The limited space I have available here spares me the trouble of having to explain why I find this year's Salon des Artistes Français much superior to the Nationale's Salon. Nor was this merely an initial impression, since the first paintings to be hung were the worst, and I can assure you that we art critics saw some really terrible things on our first visits.

In the sculpture section, there are some excellent pieces. First of all, one must put Niclausse's *Orphan* in a class by itself; it is a first-rate work, admirably unaffected in craftsmanship and very noble in character. The bust of a young woman by the same artist is also excellent. Jean Boucher's *Victor Hugo* is a superbly eloquent piece. His *Fra Angelico* is also certain to be noticed. I must make special mention, as well, of the *Nude* by Raset, a young sculptor with great talent. [. . .]

In the painting section, one must see [. . .] Etcheverry's *Beneath the Mask*, which will unquestionably be very popular; Guillonnet's work; Grün's *End of the Midnight Supper*, containing numerous portraits of Parisians, which will also be one of the great popular successes of the Salon—this morning all the rooms were ringing with praise for this picture. I should also mention the Clairins, very pretty this year; the works of Maxence and Benedito; and Sabatté's *Tombs*, which will have a fine and well-deserved success. [. . .]

[APRIL 30]

THE OPENING

A Look at the Sculpture Section of
the Artistes Français

There were so many people at the opening of the Salon des Artistes Français that I ended up not recognizing anyone. But everyone was there: diplomats, socialites, members of the Academy, and, of course, Americans. I even saw a few Americans sporting in their

buttonholes the tiny green pine of the "New Spirit"—the new spirit that recently resulted in the sale, in New York, from a single exhibition, of 395,000 francs' worth of new French paintings, from Cézanne to the cubists.[40]

Standing in front of Patricot's handsome portrait of M. Alapetite, I recognized the sculptor Jean Boucher. "I need your help," he said to me, "for the strangest thing has just happened. My *Fra Angelico*, you know, that plaster figure that some people have found rather nice? Well, it has come to life, and what gives him life is a surprisingly genuine spirit, the spirit of Giotto himself. Go see the dear gentleman from Fiesole—he is down in the sculpture section, commenting on the art of my colleagues. Please, whatever you do, don't let him come up to see the paintings. If he ever did, what a scandal, for despite all his mildness, the good Giovanni has an awfully quick tongue. As long as he talks only about the sculptures, the worst will be avoided."

I rushed toward the stairs and saw M. Fra Angelico walking around, dressed not in a *frac*, as his name would seem to indicate but in a *froc*, as his position demanded.[41] I must say that no one paid any attention to him; people thought he was a guard dressed in his working clothes. However, as he spoke very loudly, it was imperative that he be calmed down. I reached him just as he stopped before Niclausse's *Orphan*.

"Monsieur Fra——" I said to him. But he did not let me go on. "Be quiet," he said with a smile, "and admire the purity of this composition. The artist has expressed the soul of the Brie countryside with an art that is at once powerful and refined. . . . My dear sir . . . in this stone group, there is a certain Giottesque purity that I find most edifying. . . . In the roundelay that we will dance one day in paradise, Niclausse will be among us because of his sweet purity, a quality I also find in his delightful little bust of a woman, which, it must be said, shows traces of Despiau's influence."

M. Angelico had raised his voice. I felt embarrassed. A few people were looking at us curiously. I could not be sure who they were, but I have no doubt that they were either aviators (because of the way they were dressed), or else the angels of M. Anatole France (because of their faces, for they all looked like M. d'Annunzio—*angelos* in Greek).[42] I tried to steer Fra Angelico toward the exit, but he insisted on stopping for a while in front of Bouchard's *Fishermen* and his

Claus Sluter: "Two noble efforts, very different from each other," said my guide, but it was clear that he preferred *Claus Sluter*. He stopped successively in front of Landowski's monument *To Unknown Dead Artists*, the chaste nudes by Mengue and Grange, the fountain executed by Fernand David for the city of Nantes, the monument by Pierre Falize, Quillivic's work, Pommier's *Maternity*, and the bust by Renaud. Upon reaching Mme. Whitney's fountain, so nobly decorative in its effect, he was moved at the sight of the delicate figure cast by M. Raset himself: "Here is an artist we shall have to take into account," said M. Fra Angelico in his soft and charming way. He was absolutely enchanted by M. André Abbal's angelic wrestlers, and I realized that the wrestling matches in paradise must be as charming as this one. But then I turned my head for a moment, and when I turned back to look at my guide, he had disappeared. However, among the vast crowd of busts representing M. Massenet, I saw the upright and immobile figure of Fra Angelico da Fiesole, rendered in plaster by Jean Boucher.

[M A Y 6]

Let us recall what Chardin said at the Salon of 1765: "Gentlemen, gentlemen, be kind. Among all the pictures here, look for the very worst one, and then realize that two thousand poor devils broke their brushes in despair, knowing they would never be able to do anything half so bad."

Today, many people think that they are showing real artistic courage by attacking the Salon des Artistes Français, when actually they are only whipping a dead horse. To anyone who might violently criticize the colors used by M. Georges Ohnet, the proper retort would be: "Take it easy, my dear sir. That job has been done and done well, and it need not be done again."

Still, this year's Salon des Artistes Français is much better than its neighbor; it is more varied and less mannered than the Nationale.

Even the color of the rugs varies from room to room, and a desire for variety is an excellent thing.

Let us begin our visit:

Room 1. Those who are easily amused will laugh heartily at M. Chocarne-Moreau's *Sacristy*. Hilarity is still with us, then? One tends to doubt it when one visits the so-called humorists' salons. It looks as

though humor has taken refuge at the Artistes Français. People are talking about André Brouillet's bright-colored *Portrait of Her Imperial and Royal Highness, Princess Napoleon, and Her Daughter, Princess Marie-Clotilde.* [. . .]

Room 2. People who like only humorous scenes must avoid this room. The best piece here, and it is excellent, is Sabatté's *Tombs.* The talented Sabatté is continuing Granet's art. [. . .]

Room 3. Roybet! A whole epoch is in that name. Roybet was much decried around 1890. Today's young painters have never heard of him. In any case, he is truly an aesthetic curiosity. Here is a Breton sailor tanned by the salt air and by the painter Désiré-Lucas. [. . .]

[MAY 13]

One of my readers who is interested in miracles has sent me a list of statues that have come to life. It is a long list. Nevertheless, and with all due regrets for the damage I may be causing to my reader's convictions, I must declare that I walked only in spirit with Jean Boucher's *Fra Angelico,* and that neither the sculptor nor the statue spoke to me.

Room 6. Standing in front of M. Rochegrosse's large canvas, *The Burning of Persepolis,* one sees clearly that Persepolis was a diocese *in partibus infidelium.* Perhaps the conflagration has no other aim but to call attention to the luminosity of the painting. [. . .]

Room 7. I like Jean Patricot's portraits very much. This year, my favorite is the portrait of *M. Alapetite, French Resident-General at Tunis.* An inner life animates this handsome, simple, and modest likeness. This portrait has been pondered for a long time, and I prefer it to the one of Gaston Chérau, the daring and powerful author of that fine novel *L'Oiseau de proie.* [. . .]

Room 8. This is the room that contains M. Cormon's portrait of Paul Déroulède, a portrait whose only merit is that it is furiously declamatory. The portrait of a woman by M. Henri Zo does not possess that merit. [. . .]

Room 9. The exhibit by M. Jules Adler, whose inspiration I usually find less than compelling, is one of the most interesting in the Salon. I am thinking not so much of his *Old Sea Dog,* as of his painting of sailors' wives at Etaples. This is the familiar scene of women anxiously

waiting out a storm, but M. Adler has treated it with such emotion and truth that the subject is completely new. [. . .]

Room 12. M. Léon Bonnat is a man of note. People say that he is a man of fixed opinions. His opinions are not so fixed, however, that he will not consent to change them when he recognizes that he was wrong, as happened recently in connection with the three Marlets at the exhibition of "David and His Pupils" at the Petit-Palais. This incident gave rise to a nice anecdote about M. Léon Bonnat's good faith. His inflexible attitudes, it seems, have earned him a special place in contemporary painting. His name is gradually tending to replace the names of Cabanel, Bouguereau, and Roybet, who are hardly mentioned by young artists and are almost forgotten.

M. Bonnat has become the enemy. The most varied and doubtless farfetched rumors are circulating about him. The modern French school is very incompletely represented at the Luxembourg museum, and people say that M. Bonnat is to blame for it. It is also rumored that he is personally collecting the works of today's most audacious painters. Whatever the case may be, and wherever the rumors come from—whether from Octave Mirbeau or from Messrs. Reboux and Muller—it has become the proper thing in art circles to turn up one's nose at the works of M. Bonnat, who nevertheless enjoys a great deal of official authority. It is true that he is not a very charming painter; his portraits of men are vulgar but expressive, and not at all conventional. Let us mention, also in Room 12, the amusing *Reading by Father Duchesne* and the hair-raising *End of a Riot in Peking*, by Devambez; I have already said that the only humorists we have today are to be found at the Artistes Français. [. . .]

Room 13. [. . .] Two pleasant female portraits by M. Paul Chabas. What an artist this painter would be, if only he possessed the excellent vice of *gourmandise!* [. . .]

[MAY 14]

[. . .] Rooms 21, 22, 23, and 24. Clairin's exhibit is, in my opinion, the best thing this painter has done since I have been practicing the art of titillating artists. Did he draw his subjects from *The Arabian Nights?* It is possible. In any case, there is lyricism in these canvases. M. Etcheverry's *Vertigo* made him an international success a few years back;

after various attempts to regain his fame, M. Etcheverry has decided to paint another *Vertigo*. He has disguised his characters, and the picture is entitled *Beneath the Mask*, but the subject is the same. This is a very interesting picture, for it provides a measure of the artistic taste of the majority of contemporary humanity. This is an art that corresponds to the music of certain dances, a music whose charm some very refined people find irresistible. I confess that I did not find the charm of this picture irresistible, but I am certain that I will find it so when I see it reproduced as a postcard. Let us not scorn the popular arts, and let us not keep confusing them with folklore and archaeology. [. . .]

On the day of the preview, as I was taking a close look at M. Edgar Maxence's *The Book of Peace*, someone who was looking at the same painting said to me very helpfully: "You are no doubt looking for the signature; it's "a Maxence." Yes, indeed, it is a Maxence. One would really like to see this talented artist abandon a manner that provided him with some good pictures, but that he ought to try changing, even at the risk of making some mistakes; otherwise, I fear that his art, which today is flatteringly termed medieval, will become simply something out of the Dark Ages.

(L'Intransigeant)

The Salon des Artistes Français

The art critics, my dear colleagues, are in the habit of saying that there are far too many pictures at the Indépendants every year. I, on the other hand, am in the habit of asking one of the young painters from the Indépendants to accompany me on my tour of the painting section of the Artistes Français every year, since that Salon is rarely attended by the modern painters.

I remember the startled look on the face of one of them when, after visiting all those enormous rooms—not including the sculpture section and the exhibits on the ground floor—I showed him the endless vistas on the balcony.

Another of these young painters, who prides himself on his sturdy

constitution, had to take to his bed for two days after visiting the Artistes Français; he was completely exhausted, and had a violent headache. Thereupon, I concluded that if the old critics think there are too many paintings at the Indépendants, the young painters think there are too many at the Artistes Français. I believe one could also conclude that there are far too many paintings today, in general. But this opinion would be voiced only by painters and art critics, all of whom consider a painting their worst enemy. It is not an opinion shared by the public, which goes as willingly to the Artistes Français as to the Indépendants.

Frankness and impartiality toward art reign at both these salons, a fact that gives me infinite pleasure.

These two important salons offer several points of comparison. They resemble each other to the extent that about three-fifths of the paintings exhibited at the Indépendants could just as easily be shown at the Artistes Français. The two salons also differ from each other, since they played opposing roles in the art of the nineteenth century; and the disrepute that seems to attach today to the works exhibited each year at the Artistes Français proves that in the struggles between these two adversaries, the smaller one vanquished the larger.

At the Indépendants, or at least in a few of its rooms, a genuinely modern spirit reigns that deserves to be called "subtlety," and in many cases this term constitutes the antithesis of "plasticity." This quality, which exists today in poetry as well as in the arts and sciences, cannot be found in any work of the past, or in any work based on the principles of the past.

It is the principles of the past that are being applied at the Salon des Artistes Français, although not without some of the most absurd modifications. But the vulgarity of the art of the Salon des Artistes Français was itself enough to deprive these principles of all their efficacy. They do not admit vulgarity, whereas the subtlety of modern art embraces everything that exists.

Official art, the art of the Salon des Artistes Français, appeals in vain to the imagination; the imagination no longer understands it, and the plastic language that is spoken here would appear extremely vulgar to the plastic artists of the past.

Vergil, after all, would have had very little regard for a poem written in Low Latin.

In the future, people will be interested in the painters of the Salon des Artistes Français the way they are interested in certain Latin poets of the Middle Ages or the Renaissance; it was from their works that Baudelaire derived some of the elements of his modernism.

Sculpture

Four days before the opening, half the sculptors had not sent in anything at all. [. . .]

Niclausse, who is one of the interesting sculptors of this Salon, did not exhibit anything this year.[43]

Painting

As for the paintings, I shall simply cite the names of the exhibitors whose works are, to my mind, the most interesting, and I must say that there are really very few of them.

One sees less divisionism at this Salon than in previous years. I find that a pity, for the divisionist paintings added a very pleasant note. [. . .]

If one's imagination is rarely stirred at this Salon, one's judgment can be exercised usefully. M. Cachoud's moonlit nights take on some importance when one learns that he, like Henri Matisse, was a pupil of Gustave Moreau. [. . .]

[. . .] Chocarne-Moreau: his paintings represent the artistic ideal of the Salon des Artistes Français, and it is true that we don't have enough genre paintings, especially of this genre. Georges Clairin is a fine Egyptologist. M. Léon Comerre will never console himself for his kinship with cubism. [. . .] M. Sabatté is a man of talent modestly continuing the work of Granet. Two portraits by Roybet, a magic name that young painters have by now repeated thousands of times: Bouguereau and Roybet, proverbial names that people liked to hurl as insults only a few years back. Let us add that their vogue is beginning to wane. [. . .]

Half the people who visit the Salon go there to see Didier-Pouget's heather, Etcheverry's tender scenes, and the portraits by Messrs. Gabriel Ferrier and François Flameng; with the names of these two members

of the Institute, let us conclude this rapid visit to the Artistes Français, to which one can return if he has the inclination and the leisure.

(*Montjoie!*, APRIL 29)

Pretty Pictures
Walks and Gardens of Paris

Today was the opening of the exhibition of the Library and Historical Society of the City of Paris, organized with many loans from the collections of M. G. Hartmann, Vice-President of the Society of Friends of the Library. The exhibition is being held at the Hôtel Le Peletier de Saint-Fargeau, 29 Rue de Sévigné.

The exhibition is devoted to the walks and gardens of Paris from the fifteenth century until 1830. The art of landscaping is very much in fashion these days: exhibitions, albums, new parks, workers' recreation grounds, open spaces. That is all anyone talks about. Even the antique dealers are getting involved: There is talk of restoring the gardens of the Place des Vosges.

This exhibition is very attractive, and the interesting, often rare, pieces that make it up have been arranged in the simplest fashion and the one most pleasant for the visitor.

But where are . . . the gardens of the Palace as they are reproduced in a miniature in the *Très Riches Heures* of the Duc de Berry, the green arbors at the western tip of the Ile de la Cité enclosed by the crenelated walls of the Palace?

The garden of the Louvre in the fourteenth century had purslane, lettuce, 1,750 grapevines, and benches, chairs, and steps cut into the lawn.

Ah! if only they could restore the Peultres, Gobelins, and Cordeliers gardens at the same time as the gardens of the Place des Vosges!

Does everyone know that the garden of simples created by the good apothecary Nicolas Houel about the end of the sixteenth century—a garden "filled with many beautiful fruit trees and rare, fragrant medicinal plants of various species"—was the ancestor of our Jardin des Plantes?

But here is an unusual engraving, taken from the *Second Volume*

des plus excellents bastiments de France, by Jacques Androuet Du Cerceau, that shows the Tuileries Gardens as they looked in 1579.

Let us look now at the walks and gardens of the seventeenth century: the mall of the Arsenal, the boulevard of the Porte Saint-Antoine, the Cours-la-Reine, the promenade of the Place Royale, which was converted into a garden and became the first public park in Paris; Renard's garden, an elegant annex to the Tuileries that became a meeting place for the heroes and heroines of the Fronde; the garden of the Temple, the garden of Saint-Martin-des-Champs, the Jardin des Plantes, the Luxembourg, and the Palais-Royal. Here, too, are Le Nôtre and his Tuileries Gardens, the beginnings of the Champs-Elysées, which is linked to the work of Le Nôtre. Then comes the eighteenth century with its terraced gardens, the changes in the Tuileries, the riding academy, "the damsels of the little group," and the amorous composition by Saint-Aubin, accompanied by a charming quatrain:

> *Le faste se repose en ces jardins charmants.*
> *Les cercles sont formés autour de chaque belle.*
> *Nonchalamment assis, mille couples d'amants*
> *S'y jurent à leur aise une flamme éternelle.*

> (Luxury reposes in these charming walks.
> Every beauty is surrounded by admirers.
> A thousand couples sit in languid poses,
> Exchanging pledges of undying love.)

It was at this time that Marigny transformed the Champs-Elysées and laid out the Widow's Walk.

Changes also at the Palais-Royal, where storytellers would gather in the shelter of the Cracow tree; this was a chestnut tree whose name came not from the old Polish city but from the "crackers" who would spin their tall tales beneath its shade.

After the French gardens, here are the English gardens sung by the Abbé Jacques Delille, that famous poet from whom only M. Anatole France can still recite long passages by heart. Here are Boutin's Tivoli, the gardens of Auteuil and Chaillot, Bagatelle and Saint-James; Beaumarchais's gardens, of which we know very little but which Victorien Sardou could still see when he was a child; the Parc Monceau, a masterpiece by Carmontelle, with a Dutch windmill, a fort, some

obelisks, the Willow Bridge, a Gothic castle in ruins, a farm, the remains of the Temple of Mars, the statue of Perseus, a minaret, the famous naumachia, a Tartar tent, some Turkish tents, a marble temple, a ring game with its "Chinese parasol held up by three Chinese pagodas," etc.

Then come the Revolution, the Directory, the Consulate (*the ultimate in bon ton*), the Empire, the Restoration, and the enchanting drawing by Marlet showing little girls playing in the Tuileries around 1820; and here is Mayeux the hunchback, who might well personify that whole era.

What a charming exhibit! We must thank its organizers, Messrs. Marcel Poëte, G. Hartmann, Gabriel Henriot, Ruinaut, and Dr. Le Pileur.

Gardens, parks, open spaces! Demolition work has now begun on a few old and curious houses on the Rue Simon-le-Franc, and exhibitions on the art of landscaping will soon be taking place at Bagatelle and at the Pavillon de Marsan.[44]

(*L'Intransigeant,* MAY 17)

The Art World

P. Boyer, Painter of Picturesque Brittany

At the La Boétie Gallery, 64 *bis* Rue La Boétie, M. Boyer is exhibiting a handsome group of pictures very aptly entitled *Picturesque Brittany*. The sites chosen by the artist are, in fact, among those that most clearly convey the idea of that delicate and infinitely mysterious landscape whose charm has never ceased to attract artists the world over to Brittany.

M. Boyer, an artist sensitive to the immensity of the ocean, has attempted, like Courbet, to capture the fleeting power and titanic fury of its impetuous waves.

The sea is his favorite element, and even when it is calm, he contemplates it with pleasure and tries to render its transparencies and delicate horizons.

(*L'Intransigeant,* MAY 20)

An Opening at the Bagatelle
The Art of the Garden[45]

I like gardens in the rain, and those who feel as I do must have been infinitely pleased at the capricious showers that alternated with the lovely May sunshine in the Bagatelle Park last Saturday and today.

The park was crowded with visitors, all of whom appeared absolutely delighted. Among them were the Duke and Duchess of Clermont-Tonnerre, the Duke of Luynes, Count Comminges, Count and Countess Fels, M. Grosjean, Dr. Charpentier, M. Roll, Mlle. Breslau, M. Montenard, M. Louis Metman, M. Lucien Corpechot, M. de Passillé, Maurice Barrès, M. and Mme. Bartholomé, Messrs. Forestier, Halou, Lamourdedieu, etc.; also present were the members of the associations that organized the exhibition: the National Society of Fine Arts, the Central Union of Decorative Arts, and the Amateur Gardeners' Society.

> *Dans le parc au noble dessin*
> *Où s'égarent les cydalises*
> *Parmi les nyades surprises*
> *Et les marbres du clair bassin.*

> (In the park so nobly drawn
> Where the cydalises roam
> Amidst astonished naiads
> And amidst the marble forms
> Reflected in transparent pools.)

The visitors wandered about, astonished at every few steps to discover a *Woman Bathing* by Bartholomé or Halou, a *Satyr Tending Goats* by Bourdelle, a *Belling Stag* by Froment-Meurice, or a *Child Playing with a Swan* by Dampf.

There were also the pavilion, with Rodin's beautiful marble *Creation*, and the orangery, with a masterly decorative ensemble by Süe and a small salon painted by the same artist. People admired the awning by Jaulmes, the miniature garden by André Véra, who is an innovator in landscape art, the paintings by Paul Véra, which bring an extremely interesting decorative element to cubism, the wicker furniture executed

at the National School at Fayl-Billot (Haute-Marne), André Mare's furnishings, the tiny salon by Gampert and La Fresnaye, the handsome decorations by André Groult, etc.

(*L'Intransigeant*, M A Y 20)

The Art World

[M A Y 27]

The Salon des Peintres Militaires

Great Art today is becoming more and more suggestive, in the sense that, although nature is never rejected, an attempt is made to achieve reality by eliminating accidental (visual or anecdotic) elements. On the other hand, we are going to be witnessing a revival, not only of genre painting, but of all the different genres in painting.

The Salon des Peintres Militaires has just opened at the La Boétie Gallery; its principal attraction is a retrospective exhibition of the works of Alphonse de Neuville. [. . .]

Besides a few pieces of real merit, this Salon contains many paintings of great documentary value. One regrets, however, the absence of Detaille, Meissonier, and Willette, all of whom made numerous military drawings.

[M A Y 28]

The Blot Gallery is exhibiting the work of a young artist who is already famous in Montmartre and in some art circles. He is Maurice Utrillo, a colorist of keen sensibility and a very gifted painter. Octave Mirbeau is one of his admirers.

At the Druet Gallery, there is an exhibition by the sculptor Nadelman, whose first exhibition, a few years ago,[46] influenced some of our very important young painters. Nadelman's drawings were especially remarked. Nadelman is a lover of beautiful materials and harmonious forms. He is very familiar with classical art, and possibly he is too wary of his own ideas regarding the art of our day.

319

1 9 1 3

There is an interesting exhibit at the Marseille Gallery, on the Rue de Seine.[47] The participants include Dufy, who has become audacious again, and rightly so; Dunoyer de Segonzac; Georges Kars; Kisling; Lewitska, whose landscapes have a new poetry; Lhote; Mainssieux; Jean Marchand, who is showing two beautiful still-lifes; L.-A. Moreau, who is becoming a colorist; and Rouault.

(*L'Intransigeant*)

[J U N E 21]

First Exhibition of Futurist Sculpture
by the Futurist Painter and Sculptor Boccioni

The Exhibition by the futurist sculptor Boccioni opened today at the La Boétie Gallery.

This sculptor breaks matter down into a certain number of different materials: real hair, glass eyes, plaster, fragments of banisters, bits of color, etc.

The problem of dynamism in sculpture is thus clearly called into question.

Boccioni is attempting to restore architecture to its lost eminence. But since his experiments with form always appear to be interpretations—or better still, imitations—of nature, his effort to restore to architecture all the importance that is its due must also be considered almost totally lost.

We must not forget that, for a long time now, the sculptor Auguste Agéro, in his hollowed-out statuettes, in his wide-open figures, has given space the architectural role that it must play in new sculpture, and his works also contain the "force-forms equivalent to the expansive energy of bodies."

Three years ago, Picasso did a bronze[48] in which he concentrated the greatest possible quantity of light; this possesses something of the same dynamism. But these attempts do not detract at all from the importance of this first exhibition of modern sculpture, now being shown on the Rue La Boétie.

Boccioni introduces movement into sculpture. Hogarth has bequeathed to Boccioni his serpentine "line of beauty," of which so much was made in the eighteenth century.

Varied materials, sculptural simultaneity, violent movement—these are the innovations contributed by Boccioni's sculpture.

In Paris, the experiments of young sculptors have been directed toward the renewal of forms, and in this area Archipenko's latest efforts have led to some striking innovations.

Boccioni's "plastic groups" are varied. They are all joyful celebrations of energy: "muscles at full speed," "synthesis of human dynamism," "spiral expansion of muscles in movement," a real athletes' cemetery about which we should like to have Lieutenant Hébert's opinion.[49]

In a number of excellent drawings, we see Boccioni's efforts to express energetically the multiplicity of life; this is one of the most interesting parts of this first exhibition of new sculpture.

Flash: We have been informed that Boccioni's "muscles at full speed" have taken to the road. As of this writing, they have not been recaptured.

(*L'Intransigeant*)

Burgundian Sculpture

[Reply to an Inquiry: "Can a Burgundian School, a Burgundian Style, Be Re-created in the Twentieth Century?"][50]

M. Guillaume Apollinaire is a critic whose temperament is too unusual for him to be overlooked in a survey of this kind. Sympathetic toward all experiments, even the most misunderstood; favorably disposed toward the sometimes disquieting tendencies of young artists and always generous toward those engaged in any artistic effort, M. Guillaume Apollinaire does not disapprove of our intentions in this survey, but . . .

I believe that one can speak of a school only if it exists; one cannot speak of what it might be if it did exist. First you must create the regionalist movement you talk about, and then it will be possible to compare it to the Flemish-Spanish, Dutch, or Burgundian schools for which I share your admiration.

1913

M. Guillaume Apollinaire reminded us—and very rightly so—of the close relationship between the Burgundian and the Flemish schools. This is all to the credit of our province.

(Marcel Mayer, "*La Sculpture bourguignonne*," in *La Revue de Bourgogne*, J U L Y)

The Art World

The Prix de Rome Competition (Painting)

Today's young painters are generally occupied with subjects more modern than that of *Rhapsody*.

And the crowd that comes to see the paintings in the Prix de Rome competition is somewhat astonished to see all these rhapsodies.

One certainly feels that M. Domergue does not often think about rhapsodies. Nevertheless, his canvas is extremely attractive, especially the upper part.

M. Palz's picture possesses the virtue of simplicity; but what a disparity there is among the various parts of the canvas!

M. Font is theatrical, but he shows a praiseworthy concern for composition.

I found M. Darbefeuille's *Rhapsody* lacking in style, but it is the brightest painting in this exhibit—and that, after all, is something.

M. Hillemacher's piece is comical but full of movement.

M. Cazes has painted a composition with some interesting parts, but the figure of the rhapsody itself is unpleasant.

M. Giraud must have been thinking of M. Jean Richepin's *Hobo* rather than of Homer.

M. Geny has succeeded in painting some expressive and pleasant female faces.

M. Bouffanais is trying hard to be a subtle colorist.

M. Bécat has some feeling for classical antiquity.

On the whole, a boring exhibition.

(*L'Intransigeant*, J U L Y 18)

M. Bérard Opens the Salon d'Automne

A General View of the Exhibition
at the Grand-Palais

M. Bérard opened the Salon d'Automne this afternoon, before the grand opening, which will take place tomorrow. It was a very intimate inauguration. M. Bérard was welcomed to the Grand-Palais by M. Frantz Jourdain, M. Charles Guérin, and the principal members of the society, who did the honors of the exhibition rooms.

The preface to the catalogue of the 11th Salon d'Automne was written by M. Marcel Sembat. It is a passionate and often eloquent defense of the freedom of art and of the freedom to exhibit. The freedom of the Salon d'Automne had been threatened, as everyone knows.[51] M. Sembat, who is an enlightened lover of the arts, recalls the services that the Salon d'Automne has rendered to contemporary art. The services rendered by the Salon des Indépendants are even more incontrovertible, and yet . . . Do you want to hear a charming parliamentary and literary anecdote? M. Sembat tells it with great relish. It concerns the *Tombeau d'Edgar Poe*, by Stéphane Mallarmé:

"One day, I recited that sonnet to Camille Pelletan. Yes, one day when we were downstairs at the bar talking about poetry, I recited it to him, in front of Clémentel, who knows all Mallarmé's poetry by heart. Camille Pelletan is, I assure you, a man of the most refined intelligence, with an education second to none. But after hearing the sonnet, he grumbled: 'So that's the poet you say is among the easiest to understand?' He shook his head vigorously, and only the ghost of Cambronne ever knew his true feelings on the subject."

And so much for him, as the Arabian storytellers say.

The influence of the new tendencies in painting—cubism, orphism, simultaneous contrasts—which have provoked such keen discussion and resistance within the Salon d'Automne, can be keenly felt in almost every room. The excellent arrangement of the paintings, conceived by M. Charles Guérin, whose breadth of outlook cannot be praised too

highly, allows one to see this influence most clearly. Indeed, if this modern painting were not present, the Salon would be totally lacking in interest. It is certainly not the Hodler exhibit that would provide it. Outside of France, this Swiss or, rather, Germanic painter is beginning to enjoy "an exceptional reputation comparable only to Rodin's," writes M. Mathias Morhardt.[52] This is really an exaggeration, and I personally do not believe that Hodler will ever be deeply admired in France. His large fresco entitled *Unanimity*, painted for a Munich alehouse, seems to me the work least likely to win great popularity here. There is, in France, a very lively, very ardent, very national, very refined, very modern, very varied art. We do not need the brutal comparison with a Hodler, who appears more Prussian than Swiss.

There has been much admiration for Bonnard's canvas, which is pleasantly Vuillardian in mood, but I greatly prefer the canvas by Henri Matisse that hangs in the same room.[53] This portrait of a woman is the most voluptuous work that painting has produced in a long time. Its coloring is extremely sensitive, and the external qualities of this internal painting are so intense and so special that one understands why the artist who created it occupies a place of his own, outside the currents of his time, and also why he cannot have any disciples. If there is a masterpiece at the Salon d'Automne, it is here and nowhere else.

People will also admire Albert Gleizes's *Fishing Boats*. This painter has made unbelievable advances. I also like his *Portrait of the Publisher Figuière*, a fantasy overflowing with exuberant and wholesome joyfulness.

Matisse's *Woman* and Albert Gleizes's *Fishing Boats*—these are enough to do credit to any salon. We shall also see a delightful *chinoiserie* by Jean Metzinger, entitled *Boating*. This painting has an unmistakable affinity with Ingres's Chinese contours, and it is not idle to mention this at a time when people are finding Ingresque qualities in the funereal M. Vallotton (see his *Wrestling Match*).

I like the large, very pure, very lucid paintings by Picabia very much: *Edtaonisl* (*Ecclesiastic*), *Udnie* (*Young American Girl; Dance*),[54] curious titles that have erupted into ardent, lyrical paintings from the imagination of the artist in contact with nature.

There is great striving toward pure color in Roger de La Fresnaye's *Conquest of the Air*; with this painting and with Bruce's *Composition*,

we are practically in the realm of simultaneous contrasts. Boussingault's *Decoration* also shows great effort and contains some good things; this composition reveals the influence of Marie Laurencin, who is exhibiting a charming *Amazon* on the ground floor. [. . .]

On the ground floor, the decorators are working with great haste. The Exhibition of Russian Folk Art will attract much attention, for it is full of pictures and charming toys. Every French province could furnish the elements of an equally moving and pleasant exhibit, and something should be done about that before it is too late. . . . As a start, it seems to me that an exhibition devoted to the folk art of Paris and the Ile-de-France would be a great success.

[NOVEMBER 15]

THE OPENING

The Salon d'Automne opened its doors to the public today for the eleventh time. By two o'clock, the Avenue d'Antin was jammed with automobiles and carriages. This, however, was not the elegant crowd of a first night; it was the dense, colorful, heterogeneous crowd of artists, models, and foreigners. The spectators were as colorful as the paintings on the walls.

Amid the capes and fedoras of the daubers and the ulsters of our friends from beyond the Rhine and beyond the Channel, there were the innumerable Salon d'Automne dresses of women who are frightened neither by the riotous palettes nor by the cubism of today's avant-garde tailors.

The visitors were the real spectacle. As for the paintings, they heard comments of every shade and hue; naturally, the Gleizes, the Matisses, and the Vallottons are always a stupefying success.

But the greatest competitor of the painters was the exhibition of decorative art, which by three o'clock was crowded to capacity.

The official opening of the Salon d'Automne took place too late yesterday to permit me to publish a detailed description of it in yesterday's edition. The Undersecretary of State for the Fine Arts,

accompanied by Messrs. Frantz Jourdain, Charles Guérin, and Olivier Sainsère, who had appointed themselves to guide his steps and his taste, stopped first of all in front of the large cubist decoration by M. Boussingault. He looked without much interest at Diederich's *Greyhounds*; after that, the cortege [. . .] continued on its way.

M. Bérard's longest stops were in front of Chéret's *Masquerades*, La Fresnaye's *Conquest of the Air* (here the minister asked for explanations), and Gleizes's *The City and the Port*, where he exclaimed: "Ah! Here is one of the doctrinaires of cubism . . . this is freedom!" He stopped for a long time at the retrospective of François Bonhommé, a *bonhomme* [good old fellow] of 1848, a democratic painter of miners and metalworkers who often signed his paintings "François Bonhommé, Alias the Blacksmith," and who defined his work as "the pictorial history of the peaceful conquests of the soldiers of industry." [. . .]

The minister appeared unmoved by Hodler's *Unanimity*, but he seemed to like Girieud's painting. To M. Sainsère, who seemed determined to make him like Henri Matisse's canvas, M. Bérard replied with a number of totally uninterested "Ahs!" and "Yeses," and Bonnard's decoration made absolutely no impression on him. But the minister's taste manifested itself in front of Maurice Denis's work, and he asked to speak to the artist, who was not present; M. Bérard also admired the glazed pottery of M. Lenoble, who was duly introduced to him. He complimented M. Charles Guérin on his talent and modesty. After that, he looked for a long time with genuine admiration at the work of M. Desvallières. Then, as it was getting late and the rooms were growing darker—the lighting had not yet been installed— the ministerial cortege quickened its pace.

M. Sainsère spoke to him enthusiastically about the talent of M. Dunoyer de Segonzac, but M. Bérard preferred to look at M. Gleizes's canvas, *Fishing Boats*, whose subject he took to be a train crash. He condescended to express some pleasure at M. Metzinger's colors, and seemed determined not to hear a word about M. Van Dongen, who, in keeping with his biannual custom, had exhibited a canvas that the police had immediately ordered withdrawn. A petition against this decision was circulating among the members of the cortege and had already been signed by Mme. Gardelle, Mme. Marval, Messrs. René Jean, La Fresnaye, Dunoyer de Segonzac, Flandrin, Luc-Albert

Moreau, etc. The cortege finally disbanded in the middle of the Nieder-
hausern-Rodo retrospective (Rodo was a friend of Verlaine), for
which Rodin wrote the following preface, so brief and so eloquent:

"I am very happy to say that Rodo was a genuine sculptor, in love
with his art, and the culmination of his efforts was a masterpiece:
Jeremiah.

"It is an utterly beautiful work and will remain a fine example for
all of us."

In Room 1, besides Gleizes's *Fishing Boats*, people will notice the
Visitation, The Good Thief, and the *Flight into Egypt* by M. Des-
vallières, a mystical and incomplete painter whose anxiety has some-
thing really painful about it. Mainssieux's landscapes have some merit.
Marchand's canvas is restrained; Dunoyer de Segonzac's *Summer*,
executed in somber tones, indicates a praiseworthy indifference to
popularity. He seems thus to have returned to his starting point, the
Childbirth of four years ago, a bold and austere painting. I do not
much care for Verhoeven's yellow woman. Friesz's work shows
progress. [. . .]

The funereal M. Vallotton plunges Room 3 into mourning with a
picture entitled *Man and Woman.* [. . .]

[NOVEMBER 16]

Today was the opening day of the Salon d'Automne. Early in the
morning, a large crowd of visitors thronged the exhibition rooms. The
decorative-arts section aroused particular interest.

Let us continue our rapid walk through the rooms. The two most
widely admired works in the Salon are in Room 3-A. Certain people,
myself among them, consider Matisse's portrait the masterpiece of this
exhibition. I have already spoken of it at length. Other people prefer
M. Bonnard's painting, which to me seems weaker than the Matisse.
It's a matter of taste. [. . .]

In Room 4, Girieud's *Toilette of Venus* offers us the lamentable
spectacle of the artist's evolution. M. de Chirico, an awkward and very
gifted painter, is showing some curious landscapes full of new inten-
tions, powerful architecture, and great sensitivity. [. . .]

In room 6, André Lhote seems to have made progress back-
ward. [. . .]

Room 7 is devoted to the Bonhommé retrospective, which I wrote

327

about yesterday and which is really worth visiting. In Room 6-A, one will find Roger de La Fresnaye's simultaneous panel and the paintings by Gleizes that I have spoken about. It is, therefore, one of the important rooms in this Salon and one that must be studied carefully by anyone who wants to know what is happening in painting today.

P.S. An important exhibition of twenty-four watercolors by Cézanne, none of which has been exhibited before, will open at the Blot Gallery next Monday. These works will reveal a new facet of the master of Mont Sainte-Victoire. People are saying that this exhibition of luminous pages will do more than a little to enhance the glory of the painter from Aix.

[NOVEMBER 18]

[. . .] In Room 6-A, Luc-Albert Moreau deserves his surname; he is morose. The paintings of his friends, on the whole, are as sad as his. Kisling, it seems, is having some success; I confess that his manner, reminiscent at once of Derain, Segonzac, and L.-A. Moreau, does not appeal to me very much. I would say that I prefer Kars, if I could like an artist who lacks a genuine personality. [. . .]

Room 11. The Belle Édition publishing house is exhibiting some works whose presentation departs from the conventional. One can argue about the value of the Belle Édition's innovations and of its borrowings from tradition; the fact remains that it is the only publisher that has dared to attempt something new. [. . .]

Room 13. Dorignac paints shadowgraphs—a cultivated artist led astray. Here are Charlot, a Cézannesque painter of peasants; Fornerod, whose art is personal; and Suréda, who, if he wished, could invent some new and lovely decorations. Ottmann is repeating himself; Marthe Galard always retains her personality. [. . .]

[NOVEMBER 19]

[. . .] Room 17. I have already said how highly I think of Metzinger's painting. Véra is searching for his way, as is Jacques Villon, who has made great progress. A very rich still-life by Mme. Hassenberg. Flandrin's *Fantasy on the Prelude by Nijinsky* is a noble and cold work. [. . .]

Room 18. [. . .] Let us mention [. . .] the two canvases by Van

Dongen, a kind of poor man's Matisse. Van Dongen does not lack talent, but his qualiites are all surface ones.

Balcony and Staircases. *L'Intransigeant* has already spoken about *Fruit*, the painting by Mlle. Paule Mathelin, who is twelve years old. Hers is a promising beginning. The two paintings by Bruce speak well for that sensitive artist. I have already spoken about Picabia's paintings. I consider them very important, and the mockery of some people does not change that at all. It is the works of Bruce and Picabia that strike one's eye first in this Salon—*they are what we see best.* Now, paintings exist above all to be seen. I don't deny that they may have other qualities, but the best bed is the one in which you sleep best; other qualities, such as style, ornamentation, or richness, are only secondary. The paintings of these two artists possess at least the first quality to a very high degree, but they possess others, as well. It is a pity that they have blinded those whose job it is to have good eyes. [. . .]

Sculpture. I have already spoken about the retrospective of Niederhausern-Rodo, who was not, perhaps, as great a sculptor as M. Rodin says he was. I have also mentioned Nadelman's statuettes, which reveal a great deal of knowledge and an extremely refined taste; a *Relief* by Duchamp-Villon, showing some unusual experimentation with movement and atmosphere; *Autumn* and *Life and Death* by Wittig, whose meditative and highly plastic art has reached the fullness of its strength and generosity; a truthful art, without adornments. [. . .]

[NOVEMBER 29]

Since the exhibits of furnishings were not ready in time for the opening, a new opening had to be held for them. It took place today and was a great success.

We should perhaps not congratulate ourselves too much on the present state of the decorative arts but instead lament that the ideals of French decorators appear rather similar to those that inspire the deplorable decorators of Munich and their dismal colleagues in Vienna.

Unfortunately, French artists are devoting their energies increasingly to the decorative arts. Their minds are made up. Artists whose contributions to the major plastic arts have made them world-famous now want to execute or direct the work of artisans. And that is a pity. People

tell me that artists have become artisans because there is a shortage of artisans. Let us train some then, and quickly, so that our artists can return to their easels and our artisans to their workbenches.

For now, let us mention among the most interesting exhibits those by Louis Süe, Groult, Maurice Lucet, and Follot; for his exhibit, André Mare had the collaboration of the painter R. de La Fresnaye and the sculptor Duchamp-Villon, who may have more important things to do.

Reptile skins are in fashion. Sharkskin is being widely used for chests of drawers and escritoires. Lizard is appropriate for writing tables.

Among the best pieces of furniture, we should not forget those of M. Francis Jourdain.

But there is too much gauze, too many light fabrics, not enough solid pieces of furniture, and among all these decorators, I would like to see a single solitary craftsman.

(*L'Intransigeant*)

The Salon d'Automne

[NOVEMBER 15]

Henri Matisse

Henri Matisse's portrait of a woman is the best thing in the Salon, which is more than weak this year. In my opinion, this portrait, together with the *Woman with a Hat*, in the Stein collection, ranks as the artist's masterpiece. Never before, I believe, has color been endowed with so much life. After a period of austerity such as had not been seen in the arts since David's reform, internal art—which is the art of today—no longer disdains what is pleasant to the eye, and the orphism of some painters is a sacred and admirable intoxication with color. Henri Matisse has always had a hedonistic conception of art, but at the same time, he has profited greatly from Gauguin's teachings. He has not remained a slave to verisimilitude, and he has understood as well as anyone the necessity for a double

distortion—both objective and subjective—proclaimed by the solitary painter of Oceania. Matisse's great merit and the characteristic trait of his personality is that, apart from the symbolism of his colors, there is no trace of mysticism in his work. This moral soundness is combined with a wonderful instinct that he has known how to respect. His art is all sensibility. He has always been a voluptuous painter. Yet his earlier works struck one above all with the eloquence of their hues and the subtle choice of forms. The portrait he is exhibiting here, full of voluptuousness and charm, marks, in a sense, a new period in Matisse's art, and perhaps in contemporary art as a whole: until now, voluptuousness had almost completely disappeared from contemporary art, and was to be found almost nowhere except in the magnificient sensual paintings of the aged Renoir.

Hodler

Unanimity, a kind of *Grütli's Oath*, done by the Swiss or rather Germanic painter Hodler, belongs to that category of municipal art that in Holland produced masterpieces of realism. The problem is that municipal art today is becoming indistinguishable from the art of beer cellars; I for one (and I don't hesitate to say it) prefer Willette to Hodler.

Albert Gleizes

Gleizes's canvases are cubist works whose roughness contrasts with the delicacy and refinement of the majority of the painters of his school. That is his outstanding quality. He must try, with good reason, to preserve it. It reveals itself forcefully in his *Portrait of the Publisher Figuière*, a painting whose insolent and farcical fantasy is a marvelous manifestation of robust and healthy joy in the midst of the outmoded aestheticism of this all too autumnal Salon.

His best picture, however, is *The City and the Port*, in the first room. It is one of the best canvases in the Salon, and the one that best indicates the artist's progress.

1 9 1 3

Jean Metzinger and Vallotton

I don't believe that this year the public will resist the charm that radiates from Metzinger's *Woman with a Parasol*. No one who is sensitive to the beauty of the pigment, the variety of the forms, the flexibility of the lines, and the imaginativeness of the composition can view this delightful canvas with indifference.

Compare it to the somber *Struggle* by the funereal Vallotton, and you will have not the least hesitation in transferring to the cubist Jean Metzinger the Ingresque qualities that until now were so rashly attributed to M. Vallotton. I love the delightful *chinoiserie* of your painting, my dear Metzinger, almost as much as I love M. Ingres's Chinese contours.

Marie Laurencin

In a landscape that contains all the features of Athens, Rome, Paris, Melbourne, Timgad, the villages of the Congo, and the great American cities built barely a year or two ago, a river in whose waters are intermingled the great waves of the famous rivers that never flow backward, a tree that sings the fateful songs of Homer, a tree more ancient than the giant sequoias, a tree which sustains the legends of every phytolatry and which, while all the future is in its fruits that, overripe, fall to the ground one by one, gives pertinent replies to all those who question it, dances the demon of the arabesque. That is Marie Laurencin. She is showing a delicate horsewoman, tender as a farewell.

Francis Picabia

Edtaonisl and *Udnie*—these are the titles of Francis Picabia's big canvases. They can cite Poussin's statement in their defense. "Painting has no aim other than the pleasure and delight of the eye." These are ardent, mad works that recount the astonishing struggles between pictorial substance and the imagination.

La Fresnaye

Among the very few interesting works in this Salon, one of the
most outstanding is Roger de La Fresnaye's distinguished and lucidly
composed *Conquest of the Air*. Again Delaunay's influence. In this
unpretentious, clear picture, I note an effort that is surely heroic these
days—an effort not to be astonishing. To hide nothing of his inspira-
tion, La Fresnaye is also exhibiting the sketch for his painting. I
am less fond of his other watercolors.

Boussingault

A large canvas, containing several fine things: a seated woman
with her back turned, some staircases, some dogs. A great effort,
perhaps this artist's greatest. I think that, reduced to a smaller scale,
this composition would be a great deal more appealing.

I must mention a few more works: Marchand's *Washerwomen*,
a restrained canvas; *The Hammock*, by Othon Friesz, who finally
seems to be abandoning the illustrations he had stooped to over the
past few years, which was a pity, for Friesz is a talented painter who
has often, I imagine, been the victim of a group of painters to which
he did not properly belong; a pretty, empty painting by Bonnard;
the melting mists of M. de Chamaillard; the composition by Girieud,
who is not yet as skillful as Armand Point; an *Annunciation*, by
Maurice Denis, equal in quality to Le Vésinet's frescoes; an *Entomb-
ment*, by Marcel Lenoir, who takes pains to emphasize the most
bombastic qualities in Maurice Denis's painting; a portrait by Chabaud;
the metaphysical landscapes of M. de Chirico; the *Equestrian Fan-
tasies of the Pink Lady*, by Mlle. Alice Bailly; *The Rest*, by M. Luc-
Albert Moreau; *Summer*, by Dunoyer de Segonzac; the head of a
man, by Kisling; some *Women Peeling Lemons*, by Kars; a *Cat*, by
Fauconnet; the works of Jacques Villon, who is in search of his per-
sonality, as is Lhote, who is skillful besides; Charles Guérin; Van
Dongen; etc. . . .

The sculpture section is not as rewarding as the painting section.

1 9 1 3

I noticed the large, austere figures on a relief that Wittig has had cast for a tomb and the delicate statuettes by Nadelman, whose art is reminiscent at once of El Greco's and of Primaticcio's.

[DECEMBER 15]

Second Article

No artistic school since the romantics has created such a great stir in the world as the new school of painting. Its success is the reason for the resistance it is encountering from every quarter. And this resistance will become more violent still. It seems that the philosophers have laid in a whole arsenal of sophisms, as my old friend Delormel used to say, in order to combat modern art.

From what I have read, the philosophers confuse all new painting with futurist painting. Now, in France, there is not a single futurist painter as defined by the manifestoes published in Milan.*

I myself published a manifesto that was not particularly futurist, acclaiming various new experiments,[55] and by publishing it, the futurists simply showed that they did not wish to be excluded from the general striving for modernity that has manifested itself all over the world, but especially in France.

Futurism is not unimportant, and the futurist manifestoes written in French have no small influence on the terminology used by today's newest painters.

From an artistic point of view, futurism bears witness to the world-wide influence of French painting, from impressionism to cubism.

But the futurists have found no followers here, and their painting of rapid movement has remained stationary in its country of origin.

Painters have always philosophized. Their habit of looking closely at nature leads them to reason about it; but their frequent philosophizing does not make the new painters philosophers, especially not modern philosophers. Goethe and Victor Hugo often philosophized, yet they were by no means philosophers. Forms and matter—these are the objects and the subjects of today's best painters, who are not at all concerned with movement, becoming, and other fluid qualities that properly belong only to music. If some of today's painters

* Cf. M. Julien Benda's interesting pamphlet *Une philosophie pathétique*.

have been led to invent, to create, without seeming to imitate nature, they have thereby initiated a new art that may be to the old imitative painting what music is to literature. But their painting has no other resemblance to music, for in painting everything is presented at once, and the eye can wander over the picture, returning to certain colors, looking first from bottom to top, or the reverse; in literature and in music, everything is successive, and one cannot return to certain words or sounds at random. That the new painting is different from the old is evident; that it is more human is certainly possible; but that it presents the least danger to art I do not believe at all. The brilliant, astonishing, and austere studies of the new painters are profoundly realistic. Their art does not discourage its adherents from studying nature; their concern is to determine and combine all the aesthetic possibilities.

Let the philosphers, then, visit the Salon d'Automne. They will not receive a comprehensive lesson in modern art, far from it; but when they see how Messrs. Maurice Denis, Vallotton, and Desvallières, those mystical dissidents from the great religion of the Institute, are doing their best to debase the last vestiges of great classical art, they will realize that it was perhaps necessary to bring painting back to its most basic elements. That is what the painters of our day have tried to do, and if they have made mistakes, that was inevitable; but the effort that went into making them will further the development of art.

Too much innovation? Who knows? I repeat, it is not dangerous for art, only for mediocre artists. And since whatever they do, they will remain mediocre, what does it matter, after all, if they are absurd as well?

(Les Soirées de Paris)[56]

Monthly Chronicle

[The 1st German Autumn Salon in Berlin]

The 1st German Autumn Salon in Berlin, organized by the review *Der Sturm*, opened in September. The aim of the organizers, as

stated by M. Herwarth Walden in his preface to the catalogue, was to provide a glimpse of what is happening in the plastic arts today throughout the world. It would be more accurate to say that this Salon presents the new tendencies in the plastic arts.

The place of honor at this exhibition has been accorded to the late, lamented Henri Rousseau, who is represented by twenty-one canvases and an ink drawing. I find this German homage to French painting extremely touching. Although Rousseau was not a member of the intellectual elite either by birth or by education, he nevertheless partook of French culture in general. He had the great good fortune to incarnate, as fully and sweetly as possible, that delicate, ingenuous, elaborate naturalness, combined with playfulness and an irony at once knowing and naïve; that have belonged only to a few French artists and poets. Such were Villon, Restif de La Bretonne. . . .

The Douanier could not have been born in Germany, where even the most gifted young men must study if they want to become artists. It is a country of professors and doctors. The homage rendered to the Douanier is thus also rendered to France, the only country where he could have been born.

As a whole, the Berlin Autumn Salon is a glorification of the tendencies of the young painters, either French or working in Paris, and especially of orphism. The futurists are also represented, but they, too, are part of an artistic movement whose capital is Paris.

The references in the catalogue to Delaunay's works are so tantalizing that one must eternally regret not having seen his exhibit:

Simultaneous Contrast Movement of Color Depth
Simultaneous Contrast Movement of Color Depth Prism Sun 1
Simultaneous Contrast Movement of Color Depth Prism Moon 2
Sun 1
Sun 2
Sun 3
Sun 4
Simultaneous Sun Tower Airplane
Simultaneous Sun Moon 1
Simultaneous Sun Moon 2
Moon 1
Moon 2
Moon 3

Simultaneous Seine Tower Wheel Balloon Rainbow
4th Simultaneous Representation: Paris New York Berlin Moscow
 the Simultaneous Tower, Colored Pencils the Representation for
 the Book of the Colors of the Tower Simultaneous to All
3rd Simultaneous Representation: The Cardiff Team
The Pigs' Carrousel
Portrait of Henri Rousseau the Douanier

Through his persistence and talent, Delaunay has made the term
"simultaneous" (originally borrowed from the futurists' vocabu-
lary) his own, and he deserves henceforth to be called by the name
he uses as a signature: Le Simultané.

First Showing of the Prisms, Simultaneous Sculpture, of which he
 is exhibiting three examples:
Horse Prism Sun Moon
Parisian Woman Electric Prism
Bird Prism of Morning

The idea,[57] conceived by the writer of these lines, had been com-
municated to Delaunay, Gleizes, Léger, Duchamp-Villon, and Marcel
Duchamp a few months before Boccioni's exhibition. The idea was
to organize an exhibition of new sculpture before everyone else.
The writer of these lines is happy that somebody finally understood
him.

The exhibition by Mme. Sonia Delaunay-Terk is no less exciting.
It includes: the first simultaneous poster, the first simultaneous book
bindings, the first everyday objects with simultaneous decoration:

Halo depth (lamp and lampshade)
Depth Movement (curtains)
See Movement Colors Depth (cushion)
Astral (cushion)
Moon Absinthe (goblet)
Water Wine (goblet)
Wine (goblet)

And if this intoxication with simultaneous color is one of the new
tendencies in painting, it is also the newest and perhaps the most
interesting tendency in the decorative arts. We are still lacking a
polychrome architecture. Greek architecture was polychrome.

Albert Gleizes appears in the Berlin exhibition with his *Football Players*.

Among the painters working abroad (he paints in Munich), Kandinsky is one of the few who, after studying the new French painting, has most successfully freed himself from its influence in order to follow his own direction. He is represented here by several paintings.

Fernand Léger sent nine canvases and some drawings.

Metzinger sent *The Blue Bird*, and he could have made a better choice.

Picabia showed two orphic paintings.

Balla, Russolo, and Ardengo Soffici, futurists.

I should also mention Boccioni, Severini, and the volcanic Carrà, futurists.

This Berlin Salon is not complete, since it lacks works by Matisse, Picasso, Derain, Braque, Marie Laurencin, Dufy, and many others. Yet it is a historic exhibition, and if orphism first revealed itself at the Indépendants, this is the first salon of orphism.

We have received the following letter from Berlin:

"It is annoying to find oneself in agreement, even once, with men of inferior intelligence, such as M. Westheim, the art critic of the *Frankfürter Zeitung*. But the Autumn Salon in Berlin, organized by M. Walden, editor of *Der Sturm*, was a disappointment. The Rousseau retrospective was a great success, and its success meant, in the end, the triumph of the reactionary spirit in art. We are happy about it to the extent that it was the triumph of French taste, and the other French painters who also represent French taste—Gleizes, Léger, Metzinger—appeared moderate, unaffected, and refined in comparison with the German revolutionaries. We left this exhibition convinced that the German and Italian avant-garde painters are like certain converted Jews who, while retaining all of their original virtues or defects, become the most intolerant Catholics of all.

"All the artists who could be identified with French taste and even with Slavic taste, such as Kandinsky, scandalized Berlin, but they scandalized it by their distinction."

(*Les Soirées de Paris*, NOVEMBER 15)[58]

1914

The Douanier

Henri-Julien Rousseau was nicknamed the Douanier because he had been a toll-station inspector, a rank more loftily designated by the term *douanier*, or customs official.

The Douanier was discovered by Alfred Jarry, whose father he had known very well. But to tell the truth, I believe that Jarry was at first much more attracted by the old fellow's simplicity than by his qualities as a painter. Later, however, the author of *Ubu Roi* came to think very highly of the art of his friend, whom he called the miraculous Rousseau. The latter painted his portrait, showing him with a parrot and with the famous chameleon that, for a while, was Jarry's bosom companion. Part of the portrait was burned; in 1906, when I saw it, all that remained was the very expressive head.

The first to encourage the efforts of the painter from Plaisance was M. Remy de Gourmont. He even commissioned a lithograph from Rousseau, *The Horrors of War*, which was published in *L'Imagier*. It is a very rare work, and few people have seen it. Remy de Gourmont had become aware through Jarry that the Douanier painted with the purity, the grace, and the consciousness of a primitive. He had seen some of the sheaves of wheat that Rousseau painted as signboards for the bakeries in his neighborhood, and he had also met

the old gentleman a few times on certain street corners on the Left Bank. There Rousseau would stand, playing melodies he had composed on the violin and encouraging the little working girls around him to sing the latest popular songs. He also used to play at that time in the concerts at the Tuileries. His music nourished his painting, and if Ingres's violin has given us a proverb,[1] without the Douanier's violin we would not today possess those strange decorations that are the only contribution that American exoticism has made to the plastic arts in France.

Rousseau had, in fact, been to America, as a soldier during the Mexican campaign.

When he was questioned about that period in his life, the only things he seemed to remember were some fruits he had seen over there that the soldiers were forbidden to eat. But his eyes had retained other memories: tropical forests, monkeys, bizarre flowers. . . .

Wars occupied an important place in the Douanier's life. In 1870, Sergeant Rousseau's levelheadedness spared the city of Dreux the horrors of civil war. He liked to recount the details of this noble feat, and his old voice would take on an unusually proud note whenever he told how the people and the army acclaimed him to the cry of "Long live Sergeant Rousseau!"

Those who knew Rousseau remember his marked predilection for ghosts. He encountered them everywhere, and one ghost tormented him for more than a year while he was at the toll station.

Whenever the good man was on duty, his familiar spirit would appear two feet away from him, taunting him, thumbing his nose at him, and breaking wind with a stench that nauseated the poor official. Several times Rousseau tried to shoot him down with a shotgun, but a ghost cannot die a second time. And if Rousseau tried to grasp him, the ghost would melt into the ground and reappear in a different spot.

Rousseau also maintained that Catulle Mendès had been a great necromancer. "He came to get me at my studio one day," he used to say, "and took me to a house on the Rue Saint-Jacques. There, on the third floor, lay a dying man whose soul floated through the room in the shape of a luminous, transparent worm. . . ."

It is possible, of course, that Rousseau was pulling our leg and

that there was not a word of truth in the story, but he told it exactly as I have reported it, and he had a vast repertoire of other ghost stories.

Rousseau was not only a painter and a musician; he was also a writer. He wrote plays and poems, and he left behind some fragments of memoirs. Probably one could easily find among his papers some lovely pieces of poetry, as well turned as any of the poems we already know by him.

Following a complicated affair involving some checks, which he had never really understood, Rousseau was once convicted by the Court of Assize. He was given a reprieve, however, by virtue of the Bérenger Law.[2] In fact, he should have been acquitted, for his action had been imprudent, not criminal; he had been duped by a former pupil who had taken clarinet lessons from him.

When the judge informed him of his right to a reprieve, the Douanier was overjoyed. "I thank you, Your Honor," he said politely, "and if you like, I'll paint the portrait of your missus."

This affair came back to poison his last years. He had been in love all his life—first with a Polish girl, Yadwigha, whom he never forgot and who inspired his masterpiece, *The Dream,* then with his two wives, both of whom he painted in simple and gracious portraits.

At the age of sixty-four, he fell in love once more, with a fifty-four-year-old widow whom he wanted to marry. He went to ask her parents for their daughter's hand, but they refused to listen to him, saying that he was a man with a police record and a ridiculous painter.

The poor old Douanier was heartbroken.

He went to all his friends, begging them for certificates attesting his talent and honesty. I almost had tears in my eyes when I wrote him mine. His dealer, M. Vollard, wrote him one on officially stamped paper, but nothing did any good. I also think that the lady in question did not love him. He once bought her 5,000 francs' worth of jewelry, and she didn't even come to his funeral.

From the time he began to devote himself exclusively to painting, Rousseau lived a life of hard-working penury. He painted many family portraits for the merchants of Plaisance, the neighborhood where he lived.

1 9 1 4

During the last years of his life, some distinguished foreigners began to buy his paintings. French art collectors and dealers commissioned pictures from him, and he began to enjoy a bit of wealth. This did not last long, however, for love made the Douanier munificent, obliging him to spend every penny he had put aside.

The Douanier was one of the luminaries of the Société des Artistes Indépendants, whose young painters paid homage to him in 1911 by reverently organizing a retrospective exhibition of his works. His canvases elicited comparisons to Taddeo Gaddi, Paolo Uccello, Cézanne, Poussin, the Sienese and Pisan primitives, and the Dutch painters. . . .

But it is useless to make these comparisons, for Rousseau's personality was too powerful to resemble anyone else's, even if he had tried to imitate or, indeed, to copy another artist, and he himself is inimitable.

Rousseau liked to hold soirees to which he would invite men of letters, a few painters, some beautiful foreign women, and the unmarried ladies of his neighborhood. His pupils would give a little concert, someone would recite a few verses, and Rousseau would sing the gay little songs of his youth. After that, everyone would drink a glass of wine and go home, completely happy at having spent a few hours in the company of a fine man.

Here, for example, is the text of an invitation to one of these soirees:

M. Rousseau hereby invites you to honor with your presence and your talents the very private and artistic soiree that will take place Saturday, July 10, 1909, at 2 *bis* Rue Perrel.

H . R O U S S E A U

Please announce to your friends.

He himself used to letter the programs for these soirees, running them off in red or violet ink by means of a gelatin process. These programs are precious and rare pictures. I still have a few of them.

SOIREE ON NOVEMBER 14, 1908
held by
M. Henri ROUSSEAU at His Studio
2 bis Rue Perrel

— ORCHESTRA —

Ave Maria GOUNOD
The Pierrots' March BOSC
Réginette BOSC
Babble GILLOT
The Two Brothers ROUSSEAU
 LA MARSEILLAISE

Madame FISTER with songs from her repertoire.
Mademoiselle JEANNE with songs from her repertoire.
M. ROUSSEAU (*violin solo*) performing his works and creations.

All guests are invited to perform.

Here is the program for the soiree on February 25, 1909:

PROGRAM

Orchestra
La Marseillaise
Cécilette
Martha
The Bells
On the Beach
Réginette

M. Henri Rousseau begs his numerous guests to be kind enough to
lend their gracious participation to this

Soiree of
Song and Recitation

And here is the program for the soiree on April 1, 1909. Among those present were M. Durtain and his wife, Marie Laurencin, Mme. Blanche Albane, Georges Duhamel, Max Jacob, Jules Romains, René Arcos, etc., etc.

343

1 9 1 4

PROGRAM

Cécilette (Polka)
The Bells (Mazurka)
Wild Rose (Waltz)
The Babies' Polka
An Angel's Dream (Mazurka)
Clémence (Waltz)

At M. Henri Rousseau's Studio

2 bis Rue Perrel, Paris, 4-1-09

Yet another program consists of four pages. On the first page:

PROGRAM

La Marseillaise (Orchestra)
La Paloma
Babble
Cécilette
The Tam-Tam (Solo)
Réginette

December 19, 1908. 2 bis Rue Perrel

On the second page:

FAREWELL SOIREE
Given in Honor of
M. WEBER

M. Weber was a young American painter who had the honor of organizing the first exhibition of the Douanier's works in New York. The third page reads:

M. Weber *Tenor*
Mme. Fister *Song*
M. Van Hecthel *Song*
Mlle. Lescafette *Recitation*
M. L. van Hecthel *Song*
Mme. Queval *Song*

M. Dispieglar *Mandolinist*
Mlle. G. Parin *Song*
M. Henri Rousseau *Song*

On the fourth page:

M. HENRI ROUSSEAU
Academy of
Drawing, Painting, and Music
Lessons at Home
Moderate Prices

Since we have given the programs of Rousseau's soirees, it may also be of interest to publish the Douanier's stationery. Here, first of all, is his calling card:

Henri ROUSSEAU
Artist-Painter
Professor of the Philotechnic Society

2 *bis* Rue Perrel Paris

Next, here is the letterhead of his art school:

School of Drawing, Watercolor Painting
Private Lessons

Henri ROUSSEAU ❦
Professor
at the Philotechnic School of the City of Paris
2 bis RUE PERREL (14ᵉ)
IN THE RUE VERCINGETORIX
Desiring the rapid progress of his pupils, the professor will
limit the number of students in all classes
COEDUCATIONAL COURSE
For children and teen-agers, Saturdays, 2–5
For adults, 16 years and older
Academy, Live Models
Thursdays, 8–10 P.M.
Tuition: 8 francs per month
Parents are welcome to attend both day and evening classes

345

Later, the tuition for these courses was raised to 12 francs per month.

The Douanier painted my portrait twice, in the two versions of the composition entitled *The Muse Inspiring the Poet*. The first version had gillyflowers in the foreground; in the second, larger version, they were replaced by poet's carnations.

When the painting *with the gillyflowers* was shown at the Salon des Indépendants, the press without exception was delighted by my portrait, which was reproduced in *Comœdia*.

The press was unanimous in its conclusion: the portrait bore no resemblance to me whatsoever. Some found the painting touching, others thought it bordered on the grotesque, but as far as the resemblance was concerned, everyone was in agreement: there was none at all. For my part, I was astonished. How could people have recognized me, since the portrait did not look like me? I had asked the Douanier not to mention my name; he must have gone back on his word! But after consulting the catalogue of the exhibition, I had to pay tribute to the artist's good faith; for I ascertained that the catalogue carried only this information: *The Muse Inspiring the Poet*.

Moreover, neither the Douanier nor I frequented any newspaper offices, and we knew few journalists.

The latter did not think much of me at the time, nor do they now; as for the Douanier, they had utter contempt for him. Under these conditions, how could they have recognized me sufficiently to judge that the portrait did not look like me? And why, despite the title given in the catalogue, did all the newspapers refer to the painting as *Apollinaire's Muse* or *Apollinaire and His Muse* or *The Poet Guillaume Apollinaire Inspired by the Muse*? All this is still a complete mystery, and the sources from which newspapers obtain their information are indeed unfathomable.

I tend to think that that portrait was such a good likeness—at once so striking and so new—that it dazzled even those who were not aware of the resemblance and did not want to believe in it. Painting is the most pious art. In 1909, we witnessed a phenomenon

of mass suggestion similar to those that gave birth to the purest religions. It was a sublime adventure that was definitely worth living through. My face served in a unique experiment that I shall never forget.

In any case, *it would have been impossible for the portrait in question not to be a very good likeness.* I posed for the Douanier at his house a good number of times, and the first thing he did was to measure the length of my nose, my mouth, my ears, my forehead, my hands, my whole body; and he then very carefully transferred these measurements onto his canvas, reducing them to the dimensions of the stretchers. During this time, to entertain me and relieve the boredom of posing, Rousseau would sing me the songs of his youth.

> *Moi je n'aim' pas les grands journaux*
> *Qui parl' de politique*
> *Qu'est-c' que ça m'fait qu'les Esquimaux*
> *Aient ravagé l'Afrique*
> *Ce qui m'faut à moi c'est* L'P'tit Journal,
> La Gazett', La Croix *d'ma mère*[3]
> *Tant plus qu'y a d'noyés dans l'canal*
> *Tant plus qu'c'est mon affaire.*

> (I don't like the big newspapers
> That talk of politics
> What do I care if the Eskimos
> Are ravaging Africa?
> What I need is *Le Petit Journal,*
> *La Gazette,* and my mother's *La Croix*
> All the more so since there are drowned bodies in the canal
> All the more so since that's my affair.)

Or else:

> *Aïe! aïe aïe que j'ai mal aux dents.*

> (Ay ay ay, what a toothache I have!)

And I would stay there without moving, marveling at how careful he was not to allow any fantasy but the one that characterized his own personality to come and destroy the harmony of his drawing,

mathematically faithful to the human figure he sought to represent. If he had not succeeded in painting a likeness of me, the error would not have been the Douanier's—the numbers alone would have been to blame. But we know that even those who did not know me recognized me immediately. . . .

And that picture, so long and carefully thought out, was nearing its perfection. The Douanier had finished fashioning the folds of my Muse's magnificent dress, and he had finished dying my jacket black with that black that Gauguin proclaimed inimitable. He was getting ready to put the finishing touches on a painting without a trace of literature, when suddenly a new and charming idea occurred to him: in my honor, he would paint a delicate row of poet's carnations in the foreground of the painting. But thanks to the shaky knowledge of the botanists of the Rue Vercingétorix, pure and pious painting once again got the better of literature, and during my absence, the Douanier bought the wrong flowers and painted gillyflowers instead.

He rectified his error during the course of that same year by painting my portrait again, this time *with poet's carnations.*

It was in connection with this portrait that M. Arsène Alexandre, who later published a strange account of his visit to the Douanier, wrote: "But it goes without saying that of all these ways of drawing or distorting, the only one that has any real value is the one we find in El Greco, Delacroix, and Toulouse-Lautrec; this may be defined more exactly as an impulse to express form as the artist feels it, using means he finds directly and involuntarily in himself, without thinking about them at all—for as soon as he thinks about them, he becomes either mediocre or overemphatic.

"Now the majority of the works one sees at the Indépendants suffer precisely from this defect: their creators *thought about them.* Only the gentle Douanier Rousseau would have been incapable of *wanting* to do what he did. If he had listened to these touching allegories by an act of will, if he had drawn these forms and these colors according to a calculated, coolly elaborated system, he would be the most dangerous of men, while in fact he is the most sincere and most candid. If they weren't so expensive, one would like to own some of

his works, not to hang them on a wall, where they would exert a dangerous fascination on our minds, but simply to look at them from time to time, whenever we needed to be recalled to good faith. If he had possessed what he totally lacked—technical knowledge— and, at the same time, had been able to preserve this freshness of conception, Rousseau would be the Paolo Uccello of our century" (*Comœdia*, review of April 3, 1909).

There is one thing to object to in this otherwise very perceptive appraisal. Rousseau's lack of technical knowledge was amply compensated for by an abundance of artistic qualities and by a forcefulness that derived, if not from academic knowledge, at least from his consciousness, from his knowledge of things; and in any case, after painting for forty years as Rousseau did, one would have to be very strange indeed not to acquire a certain mastery; one must admit that between Rousseau's work of the last ten years and the work of any number of exhibitors at the Nationale or the Salon d'Automne who started painting a year or two ago and are already enjoying enormous success, there is a certain difference—and it is entirely in favor of the marvelous and kindly Douanier.

He had such a strong sense of reality, that sometimes when painting a fantastic subject, he would become terrified and, all atremble, would be obliged to open the window.

When he did someone's portrait, he was more calm. He would begin by taking his model's measurements and, as he did in my case, would very carefully note them on his canvas, reducing them to the dimensions of the stretcher. During this time, to keep himself amused, the Douanier would sing songs of his youth and also of the days when he was a toll-station inspector. He sang the songs I mentioned earlier, as well as "Le Vin de Suresnes," "La Puce," etc. . . .

Occasionally, he would stop and drink a little coffee.

Young artists today, not only in France but also in Germany, Russia, England, and even America, where the first exhibition of the Douanier's works was organized shortly after his death, have now given evidence of the esteem in which they hold the works of that

poor old angel, Henri Rousseau the Douanier. He could also be called the master of Plaisance, not only because he lived in a neighborhood by that name but because his paintings are so pleasant to look at.

Few artists were more ridiculed during their lifetime than the Douanier, and few men faced more calmly the derision and the indignity that were his lot. This courteous old man always maintained the same tranquil spirit, and through a fortunate trait of character he insisted on regarding even mockery as a sign of the interest that the most malicious critics were in a sense obliged to take in his work. The Douanier was aware of his power. Once or twice, he even allowed himself to say that he was the most powerful painter of his time. And it is possible that in many respects he was not far from the truth. If he lacked an artistic education in his youth, it appears that later, when he wanted to paint, he looked at the masters passionately and that he, almost alone among the moderns, divined their secrets.

His only defects were an occasional excess of sentiment and an almost constant folksy joviality that he could not rise above and that contrasted rather sharply with his artistic efforts and with the place he came to occupy in contemporary art.

But beside these defects, how numerous were his virtues! And it is extremely significant that the young artists have divined these virtues! They can be congratulated, especially if their intention is not only to honor them but also to receive them as a heritage.

The Douanier carried each of his pictures as far as it could go, which is a rare thing today. His style was free of all mannerisms, tricks, systems. Hence the variety in his works. He had as much confidence in his imagination as in his hand. Hence the grace and richness of his decorative compositions. Having participated in the Mexican campaign, he had retained a very precise plastic and poetic memory of tropical vegetation and fauna.

As a consequence, this Breton and long-time inhabitant of the Paris suburbs is without a doubt the strangest, most daring, and most charming of exotic painters. His *Snake Charmer* is sufficient proof of that. But Rousseau was not only a decorator, he was not merely an illustrator, he was a painter. And this is what makes an understanding of his works so difficult for some people. He had a sense of order, and that is evident not only in his paintings but also in his drawings,

which are as ordered as Persian miniatures. His was a pure art; his female figures, the construction of his trees, the harmonious song of his varying tones of one color, all are imbued with a style possessed only by French painters and that stamps French paintings, wherever they may be. It goes without saying that I am referring to the paintings of the masters.

This painter had an extraordinary strength of will. Would anyone deny it after seeing the minute details of his paintings (which are not weaknesses), or after contemplating the rising song of blues and the melody of whites in his *Wedding*, where the figure of an old peasant woman recalls certain Dutch masters?

As a portrait painter, Rousseau is incomparable. His half-length portrait of a woman in delicate shades of black and gray is a far more finished work than a portrait by Cézanne.[4] I had the honor of being painted by Rousseau twice, in his little studio on the Rue Perrel; I often saw him work, and I know how much trouble he took over every detail, how he was able to keep the original and final conception of his painting in mind until he had completed it; I also know that he never left anything to chance, and above all, that he never let go of what was essential.

Among Rousseau's lovely sketches, the most astonishing of all is the small canvas *La Carmagnole*. It is the study for a *Centenary of Independence*, beneath which Rousseau had written:

> *Auprès de ma blonde*
> *Qu'il fait bon, fait bon, fait bon . . .*

> (To have my love beside me
> Is oh! so fine, so fine, so fine . . .
> —*French folksong*)

The nervousness of its line and the variety, attractiveness, and delicacy of its colors make this sketch an excellent piece. His paintings of flowers show us what reserves of charm and expression lay in the soul and the hand of the old Douanier.

Rousseau painted with extreme care. When spring arrived, for example, he would go into the woods around Paris and pick a very large quantity of leaves, which he would then copy.

1 9 1 4

His studies from nature are very moving and very interesting. They were all over his studio, scattered among his ˙paintings. They gave a cheerful air to the sparsely furnished interior, where he also slept, and when people asked him whether it was not uncomfortable to sleep in a studio, he would reply: "You see, this way, when I wake up, I can smile at my paintings."

I have mentioned how at the age of sixty-four Rousseau fell in love with a fifty-four-year-old widow, on whom he lavishly spent the little money he earned. A few days before his death he sent her a beautiful and touching letter, and as early as 1909 he had drafted a bequest in her favor; it never became effective, however, because the widow refused to marry him and Rousseau neither signed nor dated the document, which read as follows:

BEQUEST

I hereby bequeathe to Mlle. Eugénie Léonie V——, widow of M. Auguste V—— by her first marriage (spouse of M. Henri Rousseau, artist-painter, by her second), everything remaining after my death—furnishings, jewelry, money, and paintings— in recognition of my eternal gratitude to her, my closest friend. In addition, I authorize her to claim a royalty of 20 per cent on any painting sold by an art dealer or by others. My dear Léonie will, I trust, consent to share what remains with my daughter, Julia Bernard nee Rousseau, residing in Angers, department of Maine-et-Loire.

Paris, —— 1909

Rousseau died on September 2, 1910. M. Uhde, who later wrote a fine book about him, went to see him; since many of his friends were not in Paris, only seven people attended his funeral, among them the painter Paul Signac, president of the Société des Artistes Indépendants.

It was only after the funeral that we received the following announcement:

1914

You are hereby invited to attend the funeral services for

Monsieur Henri Julien ROUSSEAU
Artist-Painter 🌿

Deceased September 2, 1910, at the age of 66, in the Necker Hospital

Services will be held Sunday, September 4, at 3:30 P.M. sharp in the Church of Saint-Jean Baptiste de la Salle, Rue Dutot.

DE PROFUNDIS

The funeral procession will assemble at the Impasse de l'Enfant Jésus, 146 Rue de Vaugirard.

The deceased is mourned by:

Monsieur and Madame BERNARD, his daughter and son-in-law; Mademoiselle BERNARD, his granddaughter, and Madame ROUSSEAU and their son; Monsieur and Madame Henri BRIDEL, his nephew and niece; his brothers, sister-in-law, nephews, nieces, and his many friends.

In case of oversight, please notify.

The interment will take place at the Bagneux cemetery.

In 1911, thanks to Robert Delaunay and to the Douanier's land-lord, M. Queval, a thirty-year plot was purchased and a tombstone was erected with a medallion representing the deceased, who lies not far from his friend Alfred Jarry.

In 1913, the sculptor Brancusi and the painter Ortiz de Zárate engraved the stone with the following epitaph, which I had inscribed there in pencil:

Gentil Rousseau tu nous entends
Nous te saluons
Delaunay sa femme Monsieur Queval et moi
Laisse passer nos bagages en franchise à la porte du ciel
Nous t'apporterons des pinceaux des couleurs des toiles
Afin que les loisirs sacrés dans la lumière réelle
Tu les consacres à peindre comme tu tiras mon portrait
La face des étoiles

(Gentle Rousseau you can hear us
We greet you
Delaunay his wife Monsieur Queval and I

353

I 9 I 4

Let our bags cross the gates of heaven duty-free
We shall bring you brushes paints and canvases
So that you can devote your sacred leisure moments
In the genuine light
To painting as you painted my portrait
The face of the stars)

(*Les Soirées de Paris*, J A N U A R Y 15)⁵

The Salon des Indépendants

[F E B R U A R Y 28]

Before the Opening

The historical role of the Salon des Indépendants is becoming easy to define.

The art of the nineteenth century—the art through which the integrity of the French artistic genius manifested itself—was nothing but a long revolt against academic routine, which true artists opposed through the authentic traditions ignored by the masters of the degenerate art that has enjoyed all the official honors for over a century.

Delacroix, Corot, Courbet, Manet, Cézanne, and even Rodin in turn were all "refused" admittance to the "salons" presided over by "masters" such as Cabanel, Bouguereau, Gérôme, Benjamin Constant —bureaucrats of an official art whose lives were tainted by the administrative vices and whose death plunged them into eternal oblivion.

Since its founding, the Salon des Indépendants has played a predominant role in the evolution of modern art; over the last thirty years, it has revealed the currents and the personalities that have become the integral body and soul of the history of French painting, which is the only painting that counts in Europe today and which alone pursues the logic of the great traditions in the face of the universe and alone continues to manifest intense vitality.

It should be added that the proportion of freaks and maniacs is no higher at the Salon des Indépendants than in the so-called legitimate art at the official salons.

Besides, artistic culture, in our day, is totally divorced from any social order. Artists, therefore, have the right to express themselves

as they please and not care if their works are considered outrageous. In such a situation, it is difficult for new talents to become known to the public, which, in fact, is already bewildered by the diversity of today's artistic efforts and is further misled by the bureaucrats of governmental incompetence in art.

This year's Salon des Indépendants is not inadequate to its task, even though one can discern occasional signs of weariness, as well as the presence in this anti-academic salon of a kind of anarchic *pompier*-ism which is no less harmful to art than academic pompier-ism. The truth is that the success of this salon and the manner in which its exhibitors are recruited tend to encourage the presence of artists who a mere ten years ago would have preferred to exhibit in the official salons and who are introducing an offensively fashionable note into the midst of the Société des Indépendants. Let us recall that the Société was founded by a retired policeman, Dubois-Pillet, and that its most characteristic representative was a one-time customs official, the Douanier Rousseau.

The most innovative and most graceful exhibit, in my opinion, is Archipenko's: polychrome sculptures in various materials. Glass, wood, and iron are combined here in the most novel and successful way. In the sculpture section, I should also mention the very important polychrome work by M. Rossiné and the statuettes by Mlle. Lodron.

Among the paintings, I shall rapidly mention the following artists, whose works are among the most interesting: Gleizes, with a portrait of a woman, Jean Metzinger, R. de La Fresnaye, whose still-lifes show great progress, Édouard Férat,[6] a newcomer of some significance, Dufy, Lhote, Mlle. Bailly, Mme. Halicka, Favory, G. de Chirico, Pierre Roy, Chagall, Fauconnet, Victor Dupont, Delmarle, Yeats, and, of course, painters who are already famous, such as Signac, Mme. Marval, Mme. Cousturier, Luce, Bonnard, Laprade, etc. Tomorrow we shall begin our visit of the exhibition rooms and our examination of artistic tendencies in 1914.

[MARCH 2]

The tendencies of young artists in 1914 are so diverse and so widely dispersed in this Salon that we shall lay aside the labels of doubtful validity that have been used to distinguish them until now.

1914

There are two main currents, one of them issuing from the cubism of Picasso, the other from the cubism of André Derain; both currents stem from Cézanne. This, I believe, is the clearest and simplest thing one can say about modern art, although one must keep in mind the influence of folk art, Couture's studio, the Douanier Rousseau, Seurat, the impressionists (especially Pissarro), and even the theories of the futurists.

The rooms on the right as one enters have even numbers, while those on the left bear the odd numbers. The last few odd-numbered rooms contain the works that for the last three or four years have played the leading role in this Salon. We shall begin with them.

Rooms 11 and 9. Here is where one can see Archipenko's sculptures. One of them is made of different materials—glass, zinc, wood —all polychromed. It represents a very great effort to go beyond the conventional in sculpture. Those of my colleagues who are so certain that they possess the ultimate truth in aesthetics have, of course, the right not to mention such a surprising work, executed with such ease and grace. As for me, I am happy to say how delighted I was at the sight of such a delicate work. The other polychrome statuette exhibited in the middle of Room 9 is no less interesting, and I really pity anyone who remains indifferent to the charm and elegance of Archipenko's gondolier, a slender black statue exhibited in Room 11.[7]

The paintings in these rooms are very varied. I cannot say that I am wholly enthusiastic about the *Synchromy in Orange* by M. Morgan Russell, who is an artist of talent. On the other hand, the somewhat dry but very precise and elegant refinement of Picabia's canvases— *Negro Song* and *Physical Culture*—will not go unnoticed, and the influence already exerted by this much-maligned painter is sufficient proof of his importance. Here is Chagall, whose material is rich and who finds his inspiration in folk art. He is one of the finest colorists in this Salon. [. . .]

Room 9 is even more varied. In the center of the small room on the right, there is a canvas by Van Dongen, graceful, colored, and a bit sketchy. Not far away is Jean Metzinger, whose materials are becoming richer and whose colors are becoming more and more vigorous. His brilliant portrait of a smoker calls up thoughts of Van Gogh, and if certain bilious censors do not see anything in it,

too bad for them. Here is Édouard Férat, who is exhibiting for the first time and arousing a great deal of comment. His handsomely colored compositions give promise of important works.

Gleizes's portrait of a woman is varied and full of passion. It is accompanied by a very sensitive study.

In La Fresnaye's exhibit, I like the still-lifes best of all. This artist has been working on colors, and his efforts have not been wasted. His draftsmanship here is summary but interesting. In particular, there is a bottle that is truly beautiful.

Dufy's importance results from his talent, and also from the fact that he was the first of the new painters to borrow motifs from folk art. He can justly be considered one of the young masters of this Salon. An exhibit of his works would bring out the full significance of his role. It really must be held.

[MARCH 3]

Here we are in front of Mérodack-Jeaneau's work. In a number of recent pamphlets, this artist has complained of being plagiarized. He is exaggerating perhaps, but it is true that he has had a great influence on Van Dongen and others, an influence they may not have been aware of, but one that is there nevertheless. Villon has made progress in the art of shading colors. Marcoussis is freer than last year. Mme. Rousseau is following in the footsteps of Juan Gris, and Mlle. Bailly's work has a certain freshness about it.

G. de Chirico constructs harmonious and mysterious compositions in the midst of silence and meditation.[8] A plastic conception of the politics of our day. These purely disinterested studies, whose aesthetic expression is very impressive, deserve to be noticed. [. . .]

Seen as a whole, the paintings in the little room next door give the impression of having come straight out of Thomas Couture's studio. Seen individually, they produce a different effect. I don't like Segonzac's exhibit at all. I think he is making a mistake. The same goes for Boussingault and Luc-Albert Moreau.

Under Derain's influence, Marchand has made great strides forward. His exhibit is excellent. [. . .] I want to call attention to Pierre Roy, who is exhibiting two very delicate and very sensitive still-lifes. Fauconnet, as everyone has said, recalls Rousseau. He was, in fact, a great friend of the Douanier, who was very fond of him.

1 9 1 4

[MARCH 4]

Each year a woman is brought to grief at the Indépendants; this tradition has been scrupulously observed. Three years ago, some bindings belonging to Mme. de Saint-Point were stolen; last year, a small painting by a young woman was taken, without the Indépendants considering itself responsible for it in the slightest way. This year, the opening-day crowd broke the statuettes exhibited by Mlle. Lodron, thus reducing a whole year's work to rubble. It is true that the Société des Indépendants cannot be held responsible.

Here we are in Room 7. What a quantity of landscapes! [. . .] Utrillo is exhibiting some delicate landscapes, but I have seen better things by this talented painter. People will also look at Claude Chéreau's pretty drawings, especially his finely observed *Horses*. [. . .]

And here, at last, is the most independent of the Indépendants: M. Cœuret, who, I believe, best represents that unique species of really simple artist—some of whom had such a fresh and charming talent—who appeared in France at the end of the nineteenth century. Cœuret's arrival at the Indépendants in a small cart pulled by an unclipped donkey is almost as delightful as Rousseau's arrivals used to be. The titles of Cœuret's paintings are very pretty: *Caresses, Treasure, Near the Cherry Tree*. It is really a pity that he has seen too many paintings.

[MARCH 5]

[. . .] The Central Room. Nadelman's two plaster heads, representing two modern young men, one wearing a top hat, the other a bowler, are the first works in which a piece of modern clothing has been treated in an artistic manner. M. Robert Delaunay is perfecting his experiments with compositions through color, and here is the title of his most recent work: *Solar Discs Simultaneous Form; For the Great Constructor Blériot (1913–1914)*. The semicolon doubtless plays an important role here; its upper half, the period, represents an end, while the comma acts like an Ariadne's thread through all these labyrinths of swirling futurism. In a word, talent. He has been an excellent influence on Ottmann, whose large and very pleasant canvas deserves more attention than his previous works.[9] The French futurist Delmarle is exhibiting a picture that is not without

interest, in which one can detect the influence of Albert Gleizes. The French futurist Rossiné is exhibiting a polychrome metallic sculpture, *Symphony*, which has some fine qualities. I prefer the paintings Bruce exhibited at the Salon d'Automne; the subject of the canvas here is so vast that I am not at all surprised at his inability to encompass it all. It is entitled simply *Space*, or to be more exact, *Movements, Colors, Space, Simultaneity*. After the *concetti* of the Cavalier Marino, the *concetti* of the Cavalier Marinetti are in the process of inundating France. I should also mention Léna Pilico's cutouts. There is no doubt about it, the cutout is a very modern thing. Here are the exhibits of [. . .] Renée Finch and Mme. Gérébtzoff, whose painting is as minutely detailed as certain Persian compositions or the Persian painting Gustave Moreau left unfinished. Mme. Gérébtzoff's canvas is like a summary of her activity as an independent and neglected artist; in it, she has reproduced, in miniature scale, all the pictures she has done to this day. Souvenir or testament, the idea is, in any case, a moving one, but I shall not attempt to penetrate precisely into the thoughts of a painter so full of rare and singular intentions: wishing to paint a map of Italy[10] (geographical maps are such beautiful things!), wishing, as I say, to paint a map of Italy at a time when that nation was doing its best to give birth to a colony, Mme. Gérébtzoff made careful studies of the anatomy of a pregnant woman before undertaking her work. Only a great artist could have had such an idea, and if I mention this incident, it is certainly not with the aim of making her appear ridiculous.

A Barye Room at The Louvre

A new room containing works by Barye has just opened on the second floor of the Louvre. Exhibited here are canvases, drawings, watercolors, animal sketches, small sculptures, bronzes, *Charles VI Stopped by the Fool in the Forest of Le Mans*, a *Stag and Wolf in Combat*, etc., and, above all, a plaster entitled *Elephant and Mahout*, which is one of the masterpieces of an artist who is perhaps the greatest French sculptor.

(*L'Intransigeant*)

Alexander Archipenko

In sculpture, Archipenko seeks above all the purity of forms. He wants to find the most abstract, most symbolic, newest forms, and he wants to be able to shape them as he pleases.

One perceives, in his art, a total adaptation to tradition. This adaptation may not be evident to superficial minds, but it is clear to those who decide to look for it.

The originality of Archipenko's temperament does not, at first glance, seem to reflect any influence at all from the art of the past. Yet he has taken whatever he could from it; he realizes that he is capable of going beyond it audaciously.

Stupidity and ignorance will always say that the tango and the bear dance are less artistic than the traditional dances, even though they encompass all the tradition that they oppose.

Archipenko was reared on the best that tradition had to offer. And the charm of his works is due to the internal order that is evident in them without his having sought it; this order constitutes the framework of his strange statues, whose elegance of form is wholly new and exquisite.

If one wished to reduce his art to a concrete image, I should like to see it represented by a magnificently tattooed queen from the Marquesas Islands; her skin, whitened by the *pappa* berry, is almost like a European's; this queen dances the cancan before the altar of the sea goddess Atua; she must have learned it from a French sailor or a convict who had escaped from New Caledonia.

In the sacred character of Archipenko's art, one senses the religious influence that helped shape his temperament. Undoubtedly, pious and naïve images were a source of joy to his childish eyes, which, in their astonishment, transfigured and magnified them. I would not be surprised if as a child he had built tiny altars out of soapboxes and lacy blue paper and placed on top of them a gilded plaster figure of the Holy Virgin or a Byzantine picture of a saint, surrounded by tiny candles in silvery candlesticks.

As with all mystics, his senses were awakened at an early age. Had the union of the two movements that can be called the father and the mother of his work taken place by that time?

He understood the supreme necessity of belonging to his times, and of integrating contemporary life into his art.

One notices in his work that he was attracted from the beginning by the sacred nudity of Oriental mythological art. He was reared on Greek sculpture. But it was the purer, more mystical sculpture of the Egyptians that revealed plasticity and style to him and exerted the strongest influence on him.

A papyrus of hieroglyphics from Teutamoin appealed to him because of its erotico-symbolic representation of heaven and earth. The statues of the priestesses, the gods barely covered by leopard skins, the figures of the athlophores of Berenice Euergetes and the canephores of Arsinoë Philadelphus or Arsinoë Philopator, the religious dancers represented on the tombs of Thebes or Beni Hasan stimulated his imagination. Fleeting visions excited him.

He had been dazzled by the barbaric features of the African tribal idols represented on the bas-reliefs of the subterranean temple of Beit Qualli, and the strange gestures of the African prisoners of war in the great subterranean temple of Abu Simbel awoke his passion.

He continued his investigations and began to study Chinese art. The Sakyamuni of the India House museum revealed to him the superficiality of Greek art.

The representations of the birth of Buddha, the bamboo garden of Kiä-Lan-Hio, and the cycle of metamorphoses had aroused his pious soul. It was at this time that he understood his vocation and began lovingly to sculpture human forms. He applied his intelligence to the study of the methods of the modern masters whose temperament appeared to him the closest to his own. He was influenced by the sensuality of the Florentines, and Da Vinci, Botticelli, and Jean Bologne gradually revealed to him the secrets of their art. Jean Goujon also influenced him, as did the French sensuality of the eighteenth century in the works of Falconet and Clodion. He learned the practice of his craft from these masters, without, however, becoming their slave. Nevertheless, his own artistic creations seemed empty to him. The subtleties of these masters did not satisfy his savage temperament. He felt, as the philosopher put it, that one had to add a dash

of folly to all that wisdom! He saw nothing there but manual dexterity and a superficial sensuality. His sense of beauty found in their art only a representation of sensual desires, something worldly and bourgeois that sickened his soul. Spirituality was missing.

The need to believe with all his sensual soul inspired him as much as the necessity of giving that need external expression. For a long time, his restless spirit had been repelled by the extremist tendencies of the various schools. Their constant preoccupation with ethics appeared no less than criminal to him. He had certain desires and anxieties; he discovered other notions that shook him to the core. Religion did not enlighten him; science was mute. Now his curious and restless soul was leading him ever deeper into the realm of superstitious ideas, which he found rich and consoling. The cornerstone of his artistic creation was revealed to him, and he produced works that others looked down upon—but works that were generous, passionate, clumsy, and yet perfect. In them, superstition reigned.

The atuas of Nonka the Islander, the zemis of the Caribbean, the delicate but repellent idols of black Africa, the sacred images of the tree and of the house, indeed the whole host of gods who symbolically reflect the phenomena of nature appealed to his intense, nostalgic imagination. He lived at their stone altars, near the statues of their gods and the sculptured fetishes that were consecrated as offerings to them: the gods of war and procreation with their enormous genitalia, a delicate feminine visage offered by an unhappy lover to the god of love, an ancient dancer with deep-set eyes surprised in a sensual pose, her breasts pointed and heavy, and many other divinities.

By studying these ancient sculptures, which are younger than we are, Archipenko became enlightened.

Simply by following the artistic conception of their creators, he divined what an artist can learn from his contact with this art.

He was not content with viewing sculpture merely as an art of reproduction or of suggestion. He created votive images, expressions of his most profound ideas, which he presented as offerings to his desires; for guidance, he listened only to his own chaste and marvel-

ously childlike soul. He was no longer working only for the pleasure of his eyes, but for his superstitious soul schooled in formal abstractions.

He made fetishes that protected him at painful moments, and others that awoke memories. He sculptured memories inspired by certain visions or gestures. He gave free rein to his fantasy, stimulated by Orientalism, but always remembered the teachings of his European masters, who prevented him from falling into arbitrariness and whose well-assimilated knowledge and controlled dexterity acted as a restraining influence.

The art of the young Russian Archipenko, who works in Paris, is rushing toward brand-new horizons.

I was a witness to his first artistic efforts. At that time, one could already find in his works that abrupt but smooth mutation that could be compared to a "shifting of gears."

Archipenko constructs reality, and his art is drawing closer and closer to pure sculpture.

Archipenko possesses the gifts necessary to achieve a plastic synthesis.

The only artists who are moving in that direction are our young painters. The way is open to an interior sculpture in which all the elements of beauty will be fused, perceived the way our sensibility, that is, our eye, perceives them. Archipenko's daring constructions do no more than proclaim, but proclaim loudly, the immense possibilities of this art.

The radiations of color envelop and penetrate these forms that have become human. The archings, the complementary forms, the differentiations of planes, the unlimited concavities and convexities all make for a living construction, for sculptural truth.

Let us look, for example, at his *Salome*, full of life and bathed in a blinding light, at his ambiguous *Two Bodies*, his *Silence*, his *Red Dances*, in which life is almost, yet not wholly, lost in details.

With the exception of a few very vital and exciting works, sculpture until today has been no more than a melody. Archipenko's works are a harmony, the first chords.

> (Preface to the catalogue, *Der Sturm, Siebzehnte Ausstellung: Alexandre Archipenko*, Berlin, M A R C H)[11]

1 9 1 4

Alexander Archipenko

Creative forces are what determine Archipenko's artistic orientation. Even in the first works exhibited by this young Russian sculptor in Paris, one could find changes in orientation, at once abrupt and subtle; if Archipenko continues in that direction, we shall be able to term those changes a shifting of gears, borrowing an expression from the new vocabulary of technology.

Archipenko constructs realities. His art is moving closer and closer to that absolute sculpture that one day must merge with absolute painting and absolute architecture in order to produce a pure plastic art beyond all hitherto known styles, techniques, and means of expression.

Archipenko possesses the strength necessary to achieve this goal of internal plastic unity.

The only artists who have seriously attempted to attain this goal are our new painters. The sculptors have not given it any thought, with the exception, perhaps, of the inspired Rude, who is the greatest of them all. The others, Carpeaux, Rodin, Schnegg, Despiau, observed the plastic power of light, liberated forms, allowed them to play and take on color, and subjected them to the sensual perception of the eye. Nadelman, on the other hand, attempted, albeit timidly, to construct *musical* compositions, thus going beyond the Greeks and the Egyptians. He tried to bring sculpture closer to architecture (scientific cubism). The way is thus opened to an art that unites internal plastic structure with the supreme charm of a sensuously beautiful surface.

Archipenko's daring constructions timidly but firmly proclaim the singularity of this new art.

Colors and lights play on forms that have become human, and seem to penetrate them. The archings, the complementary forms, the differentiation of planes, the hollows and the reliefs, never abruptly contrasted, are transformed into living stone that the passionate touch of the chisel has endowed with sculptural expression.

Let us look at this *Salome*, with her imperious desires illuminated

almost brutally, or this *Bather* who, ever-changing, appears ever-new, this *Silence* or the *Seated Woman* who announces a fragment of life without recounting it.

Until now, sculpture has almost always been content to be no more than a melody. In Archipenko's art, whose first chords are making themselves heard, it seems to swell into great harmony. The power of the creator sculptures the work, the means, and the expression; what animates these works, what they reveal, is the great talent and delicate structure of the artist's personality. What he is looking for is realism. Passionately he works to create his ideal: "Reality."

(*Der Sturm*, MARCH)[12]

The 30th Salon des Indépendants

[. . .][13] Furthermore, one notes the absence of Henri Matisse, Marie Laurencin, Friesz, Marquet, Guérin, etc. . . . , who still exhibited last year.

This year, futurism has begun to invade the Salon, and while the Italian futurists, to judge by the reproductions published, seem to be more influenced by the innovators in Paris (Picasso, Braque), it appears that a certain number of Parisian artists have permitted themselves to be influenced by the theories of the futurists. Besides this characteristic influence, which gives an impressionist cast to the general look of the Salon, one can distinguish the influences of Picasso (on sculpture as well as on painting), Van Gogh, André Derain, Henri Matisse, Marie Laurencin, and Henri Rousseau.

One sees a great many pretty impressionist landscapes—done, as it were, by anonymous artists—which may be the best works produced by the Indépendants and will be considered in years to come as one of the undisputed glories of the French School of this period.

And yet, one must in all honesty say that this year's Salon provides no sensational revelation, as it did in 1909, 1910, 1911, and 1912.

Archipenko's polychrome statues in various materials herald the total liberation of his talent. They are the most strikingly new works in the 1914 exhibition. [. . .]

1 9 1 4

M. Bruce leads us into the colorful domain of realistic abstraction. His composition, while even less pleasing than the one at the Salon d'Automne, is more personal.

Chagall is a very gifted colorist who lets his mystical and pagan imagination lead him where it will; his art is very sensual. [. . .]

The strangeness of the plastic enigmas posed to us by M. de Chirico still escapes the majority of viewers. To depict the fateful character of modern things, this artist relies on the most modern device: surprise. [. . .]

M. Crotti is an artist who, without having any well-defined aims, does not lack a fanciful imagination.

Sensual and sure of himself, Van Dongen succeeds here in imposing a sketchy but pleasant art.

It is rather curious to note that the influence of Cézanne has, as it were, led M. Dunoyer de Segonzac toward experiments that recall Thomas Couture's studio.

Raoul Dufy's exhibit is always among the most interesting; his is a solid art that is linked, by way of Cézanne, to the art of the primitives and the folk painters. [. . .]

R. de La Fresnaye seeks to harmonize his composition by means of learned simplifications.

Morgan Russell's synchromies have a life and a movement that must draw attention to this young colorist. [. . .]

M. Albert Gleizes is a strong-willed artist who has fortunately not succumbed to any system. He is in full possession of a robust, healthy talent.

Mme. Halicka has realistic and virile gifts that enable her to construct her painting methodically, without spoiling the composition.

In Laboureur's picture, there are refinements of sensibility that one did not expect to find in this artist, who until now had shown only woodcuts.

Lacoste, Laprade, Mme. Agutte, Signac, and Bonnard—none of whom needs our praise—continue to display talents that are markedly French in their well-ordered canvases.

Marc Delmarle has shown skill in reconciling traditional technique with modern composition.

Mme. Marval is exhibiting a sensual work, *The Frivolous People*, which is one of her best compositions. It must be noted how strongly,

over the past year or two, the personality of female painters has asserted itself—more so, I believe, than that of male painters, who have been preoccupied chiefly with technical innovations.

Of the painters who exhibit at the Indépendants, Jean Metzinger is one whose art is among the most varied and most experimental. And he concentrates on some of the most difficult aspects of painting.

Picabia's graphic art is growing—more concrete, more precise, more powerful, and more delicate than last year.

Luc-Albert Moreau is making a praiseworthy effort to free himself from somber studio painting.

M. Boussingault is not conventional in his works, which seem more daring than his earlier ones.

Édouard Férat's severe, unadorned style—in which he has some great predecessors—manifests a genuine and interesting personality.

Rivera is not at all negligible. [. . .]

Without containing any great novelties, the 1914 Salon des Indépendants is very much alive, and the manner in which its talents and styles are asserting themselves seems already to mark to young artists a new discipline far from all the beaten paths.

(*Les Soirées de Paris*, M A R C H 15)[14]

The Salon des Artistes Français

[M A Y 1]

A General View

There are two salons whose exhibitors are equally sincere and equally disinterested: the Salon des Artistes Français and the Salon des Indépendants, the latter being the more daring of the two and disinterested to the point of heroism (since it has no jury and awards no prizes).

And just when the Indépendants is folding its tents, the Artistes Français is opening its doors. I sometimes hear people complaining about the artistic overproduction of our time. I, on the contrary, find that very little is being produced. I do not believe that the total annual production in our four major salons would yield even a dozen canvases

worthy to endure and destined to endure. Apart from the work in the salons, about twenty good pictures are painted in Paris each year; the provinces produce another half-dozen, and three or four more are painted abroad, which makes for fewer than fifty important pictures a year in the whole world, and even those . . .

Bad painting abounds at the Artistes Français this year. That will surprise nobody. I hasten to add that bad paintings are sometimes less boring than one might fear, and that the work and care that went into the making of these bizarre pictures must certainly inspire respect.

In the end, I like this Salon because art has little or no role in it and because I myself am not a respecter of art. That is why it never occurred to me, as I strolled through the Artistes Français, to find fault with a single one of the works, not even with Mlle. Dufau's *Eros and Psyche*, which [. . .] is the chief ornament of Room 1, where we also find one of the artistic luminaries of Chatou, M. Réalier-Dumas, together with the African landscapes of Messrs. Cauvy and Dabadie, the Teutonic mannerism of M. Max Bohm, and the capriciously pastoral talent of M. Jouclard.[15] [. . .]

Room 3. It is easy to see that M. Chabas is not a gourmand. He could eat eel pâté all his life without growing tired of it, and he tirelessly paints little girls or young girls going for a swim. I infinitely prefer Bonnat's coarse painting. [. . .]

Rooms 4 and 5. There is no doubt about it: M. Cormon's paintings are a bore.[16] [. . .]

Room 6. M. Henri Martin is, without a doubt, the best painter in this Salon; he expresses general ideas; he is as rustic and as folksy as anyone could wish. All this adds up to works that are a bit queer but worthy of attention. He is the great painter of primary education. [. . .]

Room 17. Here one finds some of the star attractions of the Salon: *The Herd*, by M. Guillonnet, who understands classical landscapes in his own way, and the peasant composition by M. Fernand Maillaud, who paints the province of Berry with a certain emotion. There is no point in my telling you about the Etcheverrys—the Blount or the postcards will take care of it.[17] [. . .]

Rooms 32, 33, 34. I thank M. Tattegrain for a few moments of genuine glee. His exhibit is hilarious. It makes everything else look

pale by comparison. [. . .] M. Zo's exhibit is also amusing, but since I saw the Tattegrains first, I could not laugh as heartily at the Zos.[18]

M. Corabœuf offers us, as always, a sober and delicate portrait devoid of affectation. I do not at all disdain this artist's simplicity and knowledge.

Rooms 35, 36, 37, and 38. Here we are in the middle of the desert, and not an Orientalist in sight. I was hoping to encounter the Emperor of the Sahara. He must have been in M. Cauvy's *Moorish Café*, which is a veritable oasis here. [. . .]

[MAY 2]

I wonder why M. Édouard Fer's canvas has been placed among the decorative- and applied-arts exhibits. It was conceived and executed according to the luminist doctrine of divisionism. This furnished French art with the works of Seurat, one of the greatest painters of the nineteenth century and an innovator whose reputation will grow with the centuries. Henri-Edmond Cross, Paul Signac, and Marie [*sic*, for Lucie] Cousturier have continued this art of light. M. Édouard Fer has courageously followed in their footsteps. He has worked with scientific passion and has finished a book on the very interesting problems of light and color. His picture this year—showing a swan, women bathing, and reflections of light playing on the water—is constructed exclusively by means of color; it is wonderful to see, for example, how M. Fer has constituted the color white through a scientific apportionment of the colors of the prism.

This picture does him great honor and also does honor to the Salon des Artistes Français. [. . .]

Sculpture. A great deal of sculpture but very little good sculpture. That is something we have grown accustomed to. Moreover, there is very little interesting sculpture today the world over. One should, however, mention Henry Bouchard, who, together with a few other sculptors, is attempting to revive the School of Burgundy. A few foreigners are perhaps missing, such as Claus Sluter, whom Bouchard resurrected last year. This year he has breathed life into the effigy of Nicolas Rolin, who founded the Hospital of Beaune and the Collegiate Church of Notre-Dame d'Autun. One senses both knowledge and

vigor in this statue. I personally would ask for no more than a François Rude to cry "Long live the Burgundian School!" as enthusiastically as I cry "Long live the wines of Burgundy!" [. . .]

Jean Boucher's marble version of his *Fra Angelico* and his *Hoche* have earned him a place among the foremost sculptors exhibiting at the Artistes Francais.

Admittedly, this Salon is lacking a Despiau, but it has Niclausse, who is a powerful and intense artist. There is a chaste and very moving gracefulness in the female nude by Fernand David. [. . .]

I must also mention the fountain by M. Alaphilippe (Fountain, I will not drink of your water!)[19] [. . .] etc.

What titanic efforts are needed to tackle so many tall peaks. I was afraid at first that I might get mountain sickness during this war of giants, but I soon realized that I was going to be swallowed up by an ocean of boredom; so I left, humming under my breath, like the victims of the *Titanic*, the only words anyone knows of the famous hymn: "Nearer my God, to Thee."

(Paris-Journal)[20]

The Arts

[M A Y 3]

The Roger de La Fresnaye Exhibition
Levesque Gallery

Roger de La Fresnaye has painted two pictures in his life: *The Conquest of the Air* and a still-life that has not yet come back from the Indépendants.

I found the other paintings he is showing not very expressive, and a second viewing of his *Cuirassier*, which I had found quite moving when it was exhibited at the Indépendants two or three years ago,[21] proved disappointing. Is it the fault of the lighting, or is it something else? It seems to me that there is no more emotion in the horse's hoof than in the soldier's leg. It's dead. Substance is lacking. *Artillery* brings back memories of that unfortunate time when a large number of painters, fascinated by cubism and by Dufy's experiments at the same time, wound up producing colored illustrations. Fortunately, Roger

de La Fresnaye has evolved since then, and if his *Artillery* has not enhanced, it has at least not detracted from, the glory of Georgin, who is currently being celebrated by M. Lucien Descaves in prose and by M. Fernand Fleuret in verse.[22]

The two decorative still-lifes on either side of the *Woman Tending Cows* could, with a bit more work, become paintings worthy of the Nationale. All the artist would need to do would be to put a sheet of music on the music stand, some strings on the violin, and the outlines of Africa or the two Americas on the map of the world.

The cowherd lacks both true proportions and sentimental proportions. After that . . .

What is lacking in all of this is composition and substance. I think that these things must be said to an artist like Roger de La Fresnaye, who has painted that light and living work *The Conquest of the Air.*

[M A Y 4]

The Atl Exhibition: "The Mountains of Switzerland"[23]
May 1–15, 1914, at the Joubert and Richebourg Gallery

M. Atl is a Mexican artist with lofty aims. His taste for ascetic discipline, the simplicity of his life, the difficult goal he has set himself, and even his calling card, which bears the words "World Action" written above his monosyllabic surname—all this contributes to making him an interesting artist. He has roamed in solitude over the tall peaks of his native land. He has seen some simple and beautiful things, and made notations of them; now that he has left Mexico for France, it is these notations he is showing to the public.

His special method makes him an innovator, but in some respects, his work is related to the divisionism of Seurat and Signac.

He himself tells us about his art and about his investigations:

"While noting the form of rocks, the color of an undulating terrain, or the mystery of the night that plunges the energy of the mountain into a strange and silent life, I wished to resolve certain problems exclusively concerned with the techniques of pictorial art.

"I have always believed that in order to express new sensations, new technical means are necessary.

"The problem presented itself to me as follows: to paint with a

solid body that, when spread on a receptive surface, would instantly adhere and dry, thus guaranteeing the greatest possible simplicity brilliance, and durability to the painting; at the same time, I wanted to obtain a *natural* division of tones and to be sure that I could execute a sketch with it as rapidly as I could cover a wall.

"In 1906, I succeeded in producing a mixture that met all my requirements. I then tried it out on all kinds of surfaces—paper, canvas, fibro-cement, plaster, wood, etc.—submitting the colors and the works to the most exacting tests.

"The results obtained so far have surpassed all my expectations. . . . In the present exhibition, the works representing this new technique may be divided into three categories:

"1. Paintings with a mat finish;

"2. Paintings with a gritty surface;

"3. Enameled prints.

"The other works were executed by traditional methods.

"I am also exhibiting two albums: *The Volcanoes of Mexico* and *Night on the Mountain.*

"All new modes of expression, the most advanced theories as well as the most revolutionary principles or the most unexpected discoveries, regardless of their nature, the direction they take, or their form, originate in and are related to previous modes of expression that were lost, intermingled with very remote, extremely diverse antecedents.

"This is also true of my method, as indeed of all the contemporary artistic doctrines and tendencies to which it is related.

"My method is a *solid derivative* of the methods of the Hellenic painters."

Besides these novelties in technique, M. Atl's exhibition has the merit of allowing us to see the work of a painter of mountains. Such painters, as everyone knows, are rare, and the Japanese have had the most success in this difficult art.

Those who love faraway lands and curious places will take great pleasure in these extracts from the travel notebooks of the eloquent M. Atl—American landscapes dominated by forbidding peaks with Aztec or Toltec names: *Popocatepetl, The Summit of Ixtacihuatl, Colima, Citlaltepetl, The Peak of Orizaba, The Valley of Ameca and the Volcano, The Valleys and Toluca,* etc.

(*Paris-Journal*)

The Criticism of Poets

In an article in *L'Effort libre*, M. Thiesson speaks of modern art and modern criticism.[24] Many of his observations appear relevant. They also appear unjust and totally devoid of charity. I bear no grudge against him for what he writes about me. Nevertheless, is he not making a mistake in failing to recognize the freedom and the sincerity of what André Salmon, writing in *Montjoie!*, referred to as the criticism of poets? And as far as my criticism is concerned, does M. Thiesson have any artists to counterpose to those I have defended? Everyone is free not to like Matisse, Picasso, Derain, Braque, Léger, Marie Laurencin, etc., but no one can deny that they have been the most important painters of their time—and that I have defended them.

Whether or not I am interested in what Delaunay and his friends are doing today, the fact remains that I was the first to discover and to write about their art, and all those who are talking or writing about it now are using expressions and ideas that came from me.

It would take an unbelievable degree of innocence or total ignorance of how a daily newspaper works or of the interplay of relationships and friendships in which a critic is involved to reproach him for mentioning a great many names in his review of a salon in which thousands of artists are exhibiting.

I have never tried to discourage a young artist. Nor have I ever encouraged an artist who I felt was occupying a position in contemporary art that he did not deserve.

M. Thiesson thinks that in writing about the Indépendants I was generalizing. He is wrong. What I wrote about the Indépendants was meant to apply only to that Salon. Regarding Archipenko, for example, I did not at all attempt to formulate a judgment about this sculptor. But it cannot be denied that his exhibit at the Indépendants was something new and interesting, while most of the other sculpture shown there was mediocre.

As for Morgan Russell, M. Thiesson forgets that Russell is a very young man who had undertaken an extremely difficult work. I would

not be the one to discourage a very young man with such noble aims. Considering that he was gifted, I thought he should be given credit.

According to M. Thiesson, I should have explained Picabia's pictures, since Picabia allegedly had "spoken to me at length about his experiments and discoveries." It is certain, however, that Picabia has spoken at greater length with my honorable critic than with myself. Why then didn't M. Thiesson, who is an enlightened connoisseur and who had his chance to share his enlightenment with the public, explain his friend's pictures to the readers of *L'Effort libre*, since he found my comments inadequate? My comments expressed exactly what I had felt in looking at Picabia's paintings at the Indépendants. Of late, Picabia has so often been accused of vulgarity, that it gave me special pleasure to mention that he produced an entirely different impression on me. The refined dryness I spoke of has in any case disappeared in his latest compositions, which I recently had the pleasure of seeing.

M. Thiesson wants to know on whom Picabia has exerted an influence. I am perhaps wrong in seeking the influences that might be exerted either on or by the painters I write about, but one cannot deny, I believe, that Picabia has influenced two interesting and experimental painters, Marcel Duchamp and Jacques Villon, the first of whom has a true and great talent.

M. Thiesson also asks to know by whom Picabia is maligned. Evidently M. Thiesson does not read the newspapers and does not spend time with any painters, for the fact is that Picabia is very much maligned. M. Soffici reproached me violently in *La Voce* for having spoken about Picabia; not a day passes without some newspaper or review attacking his integrity or sincerity.

As far as Rochegrosse is concerned, M. Thiesson will certainly recall seeing one of his pictures reproduced on the cover of a magazine just below my name; that was the doing of the editors, not me.

Dufy appears to me to have had some influence—indeed, a very marked influence—on some young painters. There are enough of these painters to allow one to consider Dufy as their master. He has been sacrificed; I tried to show the role that he has played. I consider him talented, but I do not like his influence, and I said so. As for Chagall, I have no doubt that M. Thiesson thinks as I do; this young man, barely twenty years old, was indeed one of the finest colorists in the Salon.

M. Thiesson reserves all his praise for a pamphlet sold at the door of the Indépendants. I found this pamphlet as amusing as he did, but even though I enjoyed its raciness, I am astonished that M. Thiesson, who is a man of taste, should have approved of those who won the author's plaudits. That so much good sense should be expended on insulting women and ending up with ecstatic praise for the florid and banal paintings of Van Dongen, that Rochegrosse of fauvism—these are certainly extraordinary performances, and that is the kind of criticism M. Thiesson calls marvelous.

I have so often been accused of being prejudiced in my criticism in favor of a single school that I am overjoyed to see M. Thiesson accuse me of eclecticism. If my eclecticism existed anywhere except in his imagination, it would still be no worse than his dilettantism.

Poets did not write art criticism *at the time when Gauguin was living in wretched poverty in Tahiti, and Van Gogh, ignored by everyone, was painting his passionate pictures.* Today, the poets have ignored neither Matisse nor Picasso. They have not made up their minds to admire everything new. They are trying to distinguish the good from the bad so that the energies liberated by the good should not be lost. And since M. Thiesson believes that today's poets are bringing about the "triumph of mediocrity," he would do well to complete his argument by telling us which mediocre artists the poets have exalted and which geniuses they have neglected.

(*Paris-Journal*, M A Y 5)

The Arts

[M A Y 6]

Venice and the Côte d'Azur
Ambroise Vollard Gallery

We get much more than "Venice and the Côte d'Azur" in this exhibit by a friend of Renoir, or, as people say down there, of "Monsieur Renoir." There are views of Cagnes and its environs, of *Renoir's House, M. Renoir's Olive Trees, Renoir's Garden.* There is also a portrait of Cézanne. . . .

This is a kind of period painting, practiced by a modest and atten-
tive painter whose sensibility occasionally finds happy expression in
the regions explored by the great impressionists and especially in those
first probed by Renoir, who is the greatest living painter. [. . .]

A painter-reporter like Constantin Guys, Franc Lamy does not
offer work as interesting to the curiosity-seeker as Guys's. Baudelaire's
friend was attracted by cities, ports, city dwellers of all classes. "Mon-
sieur Renoir's" friend, on the contrary, likes only country air.

[M A Y 7]

A Curious Preface

At the B. Weill Gallery, 25 Rue Victor-Massé, M. Diego M. Rivera
is exhibiting a group of studies and drawings that show what a deep
influence modern art has exerted on this young painter. In any case,
the sensitivity of two or three of these drawings would itself have
justified this exhibition.

Someone who signs himself simply "B."[25] wrote a preface to the
catalogue in which he practically insults the artist he is supposed to
introduce to the public. This, to our knowledge, is the first time that
such a thing has happened. Here is what the anonymous author of
the preface writes:

"We introduce to devotees of modern painting the Mexican Diego
H. [*sic*] Rivera, who is extremely enthusiastic about the experiments
of the cubists.

"We do not wish to run the risk of writing a panegyric on this young
artist; we shall allow him to evolve, and sooner or later, some well-
intentioned critic or impresario, some braggart, will turn up to dis-
cover him. A thousand examples prove how dangerous premature
praise can be to an artist: a fellow whose work shows some talent is
pushed, encouraged; a stroke of luck brings him a little fame; bang!
he becomes a bourgeois; he wants to make 'lots' of money; he becomes
very . . . 'upper crust'; like some of the patrons of the *haute-couture*
houses, he thinks he is a direct descendant of the Sun King; his genius
is equaled only by that of . . . the Bastille; what is he doing now?
From time to time, he brings forth a mouse; often, forgetting his

lineage, he cools his heels in waiting rooms, but the wallpaper has found an . . . innovator: hurrah!

"Another has painted himself out, but he is revered as a master and the members of his court, cowering, fight over his scraps; sneering and pleased with himself, he contemplates their scramble; his genius has not increased, even though he is Spanish.

"Still others (the eunuchs, the guardians of the seraglio), stand watch over the treasure: Young men, keep out!

"For God's sake, bring some youth in here! The place smells musty! Let in some air!

"Ah, but they give you a run for your money, those buggers!

"And how many of them have long ceased existing anywhere but in their own imaginations!

"All this in the name of Art? The poor thing! *Servum pecus!* ["A servile herd!"]

"Come see the young, free, independent artists, and you will find in their works, along with countless bits of clumsiness, the spontaneous charm of youth; not a trace of a desire to please, which will please you immensely."

M. Rivera has not been able to find out who wrote this preface, which heaps abuse on everything he respects in modern art. But what is one to say about a critic who agrees, without even being asked by the artist, to write the preface to an exhibition of whose whole tenor he disapproves?

[M A Y 8]

M. de Pinelli

One can hardly open a newspaper or a magazine these days without seeing some mention of M. de Pinelli. Yesterday's *Paris-Journal* showed him on his deathbed, feebly copying a portrait of Balzac by Eugène Giraud.[26] Pinelli's copy is at the Carnavalet museum. Another newspaper shows him on a brief voyage from Brussels to Frankfurt am Main, accompanied by the beautiful Juliette Drouet, who was soon to become Victor Hugo's mistress. Paris art dealers occasionally have prints or watercolors by Pinelli, who died in Paris in 1835. Delacroix

thought highly of his etchings, and it is true that his *Meo Patacca* series is amusing and lively. The Bibliothèque Nationale owns an important collection of his works, including the series on the *Loves of the Gods*. One of our friends who is particularly interested in Pinelli was recently refused permission to look at this series, on the grounds that it was in the same vein as Caracci's albums. We should add that Baudelaire (see *Curiosités esthétiques*) held the "classical Pinelli," as he called him, in very low esteem: "We shall not say of him that he is a caricaturist; he is, rather, a *sketcher* of picturesque scenes. I mention this only because throughout my youth I heard him endlessly praised as the very image of the *noble caricaturist*. The fact is, however, that comedy plays only an infinitesimal role in his work. What we find in all of his studies is a constant preoccupation with line and with classical composition, a systematic aspiration toward style.

"But Pinelli's life was much more romantic than his talent—a fact that doubtless contributed considerably to his reputation. His originality is much more evident in his character than in his works; he was a consummate model of what our good patresfamilias think of as the *artist*—that is, a model of classical disorder, of inspiration expressing itself through immoral behavior and violent habits. Pinelli was endowed with all the charlatanry of certain artists: his two enormous dogs following him everywhere like a pair of confidants and comrades, his heavy gnarled walking stick, his braided hair falling alongside his cheeks, his love of cabarets and bad company, his practice of ostentatiously destroying any work that did not fetch a high enough price— all this was part and parcel of his reputation. Pinelli's household was hardly more orderly than the behavior of its head. Sometimes when he came home, he would find his wife and daughter coming to blows, their eyes popping out of their heads, completely in the grip of the most violent Italian fury. Pinelli found this marvelous: 'Stop!' he would cry. 'Don't move, stay just as you are.' And suddenly the human drama was transformed into a drawing."

[M A Y 10]

Rodin's First Buyer

The collection of Antony Roux, "the first collector who dared to buy a Rodin," will soon be dispersed.[27] In the meantime, however, there

will be a great deal of talk about it, for it contains no less than sixteen bronzes, a stone figure, six original plasters, and the head of a woman in silver, all by Rodin. It also has twenty Baryes in bronze and silver. All in all, this is one of the most important collections of modern sculpture ever seen.

As for its paintings, I believe that this will be the first sale of so many works by Gustave Moreau, the master whose teaching was crucial in the formation of so many innovating painters, each different from the other. One should hear Henri Matisse speak of the freedom that Gustave Moreau permitted his disciples, and of the care he took not to mold their instinctive vision. The Antony Roux collection includes *Orpheus Charming the Wild Beasts*, the *Herald Angels*, the *Persian Woman at Her Toilette*, *Apparition*, *Equality Before Death*, etc. Thirteen remarkable Corots are not the least glory of this collection, which also includes a Delacroix and numerous works by Diaz, Théodore Rousseau, and Ziem.

[M A Y 11]

Seurat's Drawings

Mme. Lucie Cousturier is continuing her articles in *L'Art décoratif* on the work of the great painter Georges Seurat. In the current issue, she studies Seurat's drawings. Making light and life burst forth on Ingres paper with the stroke of a conté crayon—that is the artistry of Georges Seurat's draftsmanship. The contrast between the deep black of the crayon and the white that he leaves showing between the grains of the Ingres paper gives all Seurat's drawings a luminous intensity, an animation that one finds in no other artist. "Seurat," writes Mme. Cousturier, "proceeds as poets do; those who have called him a realist are those for whom the imagination of a painter consists in his ability to assemble, within a picture frame, a number of exotic, rare, or ancient objects that are rarely seen or represented together. If, on the other hand, the painter's imagination consists in his ability to react pictorially to the impact produced on his sensibility by the visible world, then Seurat's imagination must have been exalted indeed; for he could sit down in front of any bench, tree, or wall that so many had depicted before him, yet not for a moment did their formulation interfere with

his own vision. If, for example, he is struck by the cylindrical, rigidly erect aspect of a woman strolling placidly, he forgets everything in her form that does not contribute to this one aspect; he breaks down this aspect alone until he finally succeeds in inventing a kind of columnar architecture that—despite the age-old tradition of pleasing curves—satisfies his new perception of a woman. Seurat's inventions are, in fact, architectural in their balance, their starkness, their solidity; above all, they glorify the voluptuous slowness with which the ample roundness of a tree or a skirt slips from sight; the proud, brusque resoluteness with which parapets and factory roofs, erect with zeal, cleave the ground and slash the sky, making themselves inflexible, for their own imperious ends. Seurat's inventions celebrate masculine apparel with its severe limitations; they would have glorified the broken planes of the staircases that plunge, brilliant as lightning, down to the round caverns of the Métro. We used to call these features of our new cities, our quays, our suburbs, ugly, and we considered their potentialities distasteful. Seurat was able to reveal to us their ample and reserved soul. Many other painters dealt with them, to be sure; but they were afraid to let us see the grimmer sides of their subject. They would modestly veil the starkness of a wall with posters or ivy, the scrawniness of an iron bridge with smoke, the bareness of flat ground with flowers or rays of sunshine. Seurat dusts off the ground, sets the walls aright, shears the grass, and sharpens the angles."[28]

This interesting article is accompanied by ten reproductions from Seurat, three of which are separate plates, including the *Café Concert*, owned by the poet Emile Verhaeren.

Do people know that the Luxembourg Museum owns a few drawings by Seurat, donated by Signac, that have never been exhibited? It is high time they were exhibited, for Seurat's reputation is growing every day. Foreigners are often astonished, and rightly so, not to find in the modern museum of Paris a single work by an artist who was one of the most unalloyed splendors of the late nineteenth century.

[M A Y 12]

Duty-free Art in America

The Joint Committee of the Congress in Washington has just decided that all modern-art objects will henceforth enter the United States duty-

free. Since artists in America are considered to be artisans, it was thought necessary to protect their works against foreign competition; works of art coming from abroad were, consequently, taxed with very high customs duties. American artists had protested vociferously against this so-called protection from the very beginning and had asked Congress to eliminate it. The advancement of the arts in the United States, they argued, required that the country be informed about the latest European, and especially the latest French, artistic developments; the customs barrier made this artistic contact impossible. Taking these arguments into account, the American Congress finally decided, in 1900, to make a first concession and allow duty-free entry only to works that were at least twenty years old. All other works were taxed at 15 per cent of their value. The artists were not satisfied with this decision, and a new campaign for duty-free art was undertaken. M. John Quinn, one of the most highly respected lawyers in New York and a passionate collector of contemporary painting, appealed to the Customs Committee of the House of Representatives. M. Underwood, bringing his great influence to bear on the American Congress, succeeded in obtaining the elimination of duties that the artists had demanded. Henceforth, works of art will have free entry into America.

The new law, however, makes one stipulation: The artists whose works are being shipped to America must go to the United States Embassy and declare, under oath, that they are in fact the creators of the works in question. After this little medieval ceremony, they must sign some papers written in English. Further, they are addressed only in English throughout, and those who do not know that language find themselves in quite an embarrassing position.

Picasso, Braque, and Derain have all gone to take their oaths. Someone with a nasal voice gave a little speech, after which they raised their hands, signed some registers, and left without knowing exactly what they had been made to sign.

If they continue pestering artists like this, a new profession will soon come into being: that of the official oath taker at the United States Embassy; artists will simply deputize him to sign for them, and that will be that.

But why all these formalities? We thought Americans did not like red tape. How wrong we were!

A Lecture by Fernand Léger

A large audience attended the lecture by the painter Fernand Léger at the Vassilieff Academy.[29]

Fernand Léger is a familiar figure to the inhabitants of the neighborhood in Montparnasse where he has his studio. He is one of those tall Normans, blond, a bit heavy, shrewd, and prudent. He is one of the most interesting cubists, because instead of imitating Picasso, Braque, or Derain, he has carved out his own road parallel to theirs, and because he entered modern painting with a certain violence, taking care, however, not to let the impressionists' legacy escape him.

The aim of his lecture was to explain why contemporary painting is the representation (in the modern sense of the word) of the new visual situation brought about by the evolution of new means of production.

In the course of his very clear and candid talk, Léger gave quite a trouncing to all those methods and schools that, under the guise of novelty, are doing their best to oppose the development of the new painting.

He showed that although other kinds of painting are possible today, the only kind of realistic painting possible is the one by which he, together with Picasso and Braque, has been seeking to represent, simply but forcefully, the world as it exists today.

He spoke at length about the technique of contrasting colors, and he cut down to size certain noisy factions of young painters who thought that they were innovators when they applied Seurat's theory of contrasts on such a scale that these contrasts became powerless, as it were, to represent reality.

He defined the role of the Salon des Indépendants and expressed great satisfaction that Paris has become the art center of the world. Instead of complaining about the great number of foreign artists in Paris, we should thank them for having come here to look for aesthetic guidelines and for contributing their new views and their efforts.

Paris has become the great marketplace for painting, and there is nothing pejorative about that term. The marketplace of Paris is the

Salon des Indépendants. People come to it from all over the world, just as they go to Leipzig for certain products, and as they used to go to Beaucaire or to Novgorod.

Léger also defended those painters who no longer exhibit at the Indépendants in order to make room for the younger artists who are not yet established.

There was only one interruption, made by Deputy District Attorney Granié, who, as is well known, is a great champion of the new art movements. His interruption was extremely courteous, for Granié is one of the wittiest men in Paris. The lecturer answered his question most satisfactorily and was vigorously applauded by the audience.

Then Fernand Léger calmly stepped off the podium, smiling his ever so slightly mischievous smile. We all felt then that everything he had told us about the degenerate aesthetic of city dwellers who resist the slightest realistic innovation had been the fruit of his own observations and meditations. Himself a peasant, Léger knows that peasants who are not shocked to see a poster in their fields have not succumbed to bad taste but have simply learned to savor a necessary reality.

[MAY 14]

A Baker's Dozen

Everyone must go and see the exhibition at the Bernheim Gallery of modern paintings belonging to Herbert Kullmann, of Manchester. The collection will be shown intact until Saturday, when it will be sold at auction at the Hôtel Drouot. The sale of this collection, in the midst of the flood of sales that engulfs us daily, will certainly provide lessons for future collectors. There are thirteen canvases in all, but thirteen canvases that can teach one about a whole period and about all the schools of that period. And each of these pictures was chosen from among the best works of the best painter of each school.

First of all, here are the intimist painters with Bonnard and his canvas *The Stable* (1912); then Cézanne, with *The Village Through the Trees* and *The Alley*; pointillism is very well represented by Cross's *Landscape with Cap Nègre*. Degas, as usual, will be the despair of the museums because of his prices; everyone will be bidding for his *Dancers*, a drawing heightened with chalk and pastels. Van Gogh's

Staircase at Auvers is certainly one of his most beautiful canvases; it was his last work.

A still-life by Matisse, *The Ilyssus*,[30] shows what a masterful colorist the leader of the fauves is. Then Renoir, with two delicately shaded, animated canvases typical of that master of impressionism: *Woman Bathing* and *At the River's Edge*. But what art-lovers are awaiting impatiently are the three paintings by the Douanier Rousseau, whose canvases were selling for almost nothing only a few years ago and are now almost impossible to find. The most important of the three is the *Scouts Attacked by a Tiger*, a large canvas (4 ft. by 5 ft. 4 in.) that was bought from a secondhand dealer in Montparnasse for a hundred francs; the two others—*The Footbridge at Passy*, of which Delaunay owns the sketch, and *View of the Fortifications on the Boulevard Gouvion-Saint-Cyr*—are smaller but very expressive. Finally, as a fitting cap to this outstanding collection gathered with such enlightened taste and unerring judgment, there is a picture by Turner, the ancestor of impressionism, which links him to the great tradition of the French landscape as it had been shaped by the lessons of the Italians.

Thirteen is considered today to be a lucky number; we may be sure that the thirteen paintings in the Kullmann collection will be much fought over by collectors, for they constitute an excellent selection representative of the period between the end of impressionism and the emergence of cubism.

[MAY 15]

Art and Medicine

A certain Dr. Artault, from Vevey, recently passed up a beautiful opportunity to keep still; here is what he chose to write on cubism in *La Revue sans titre*.

According to him, the new painters have "simply exploited a temporary pathological phenomenon that doubtless struck, and even fascinated, the originator of cubism. One need only, in fact, look at a cubist painting through half-closed eyes in order to distinguish among the zigzags and the fading flashes of light the distortions and the fuzzy

shapes of objects that are characteristic of jerky, monochrome irisa-
tions, or of what we call scintillating scotoma; it is the most frequent
symptom of ophthalmic migraine.

"I am convinced," continues this doctor, who is not a creation of
Molière but is worthy of him, "that all those who have had this malady
will be struck by the similarity and will not hesitate to admit the
following probability, not to say certainty: that cubism is an attempt
to systematize a pathological transitory visual phenomenon.

"Everything in it is distorted to the same extent and in the same
way; one can distinguish masses, but their contours blend and dissolve
into a field of broken lines with generatrices that are now semicircular,
now polygonal, now oval, now helicoidal; there are continuous series
of angles, almost always of 30 degrees, their sides forming either
parallel or concentric configurations, or sometimes even overlapping
with each other; these "garlands" of angles help to create the illusion
of a web of triangles and cubes that is very characteristic, but also a
bit disquieting, and it may even cause vertigo. It is, in any case, a very
curious and very peculiar thing."

As for Dr. Artault's letter, it, too, is very curious. The reason for that
is evident: it is due quite simply to the mania that doctors have of
seeing diseases everywhere. Lombroso and his imbecilic Italian col-
leagues thought that everyone around them was either sick, crazy, or
degenerate. Until now, French and even Swiss scientists have refrained,
as a rule, from indulging in this kind of nonsense. It would be a great
mistake on their part to begin indulging in it now.

(Paris-Journal) [31]

The Arts

The Exhibition of Paintings by Roger de La Fresnaye at the Levesque
Gallery was a great success. It did not, however, include La Fresnaye's
two best works, *The Conquest of the Air* and a *Still-Life* exhibited at
this year's Indépendants. The exhibition as a whole was not very expres-
sive, because the artist's technique is unsure. Too many dead surfaces;

proportion and composition are wanting. He must sacrifice tastefulness and charm and discover his own qualities in his best works. All of this notwithstanding, his exhibition was the most important by a young painter this year.

At the B. Weill Gallery, Diego A. [*sic*] Rivera exhibited some studies that showed how deeply stirred he is by modern art. A singular preface embellished the catalogue. Its author denigrated all the things that mean most to the artist whose works he was supposed to introduce.

André Favory did some curiously worked woodcuts for an interesting little volume by George Th. Franchi entitled *Proses.*

An important exhibition of works by Girieud was held at the Rosenberg Gallery.

In Düsseldorf, M. Flechtheim exhibited twenty-nine pictures by Maximilien Luce, who paints mostly workers and who was one of the first divisionists.

(*Les Soirées de Paris*, M A Y 15)

The Arts

[M A Y 16]

A Magnasco Retrospective

More often than not, retrospective exhibitions seem perfectly useless. If the artist whose works are being shown deserves to be thus honored, the chances are that he is already known and liked by anyone who is interested in art. If others do not know him, why is there any need to make them aware of him? On the other hand, if he has never attained sufficient fame to save him from oblivion, then what use is there in trying to rescue him?

Now the Levesque Gallery has exhumed the works of the Genoese painter Magnasco, born in 1667. We are told that he was a precursor of realism, for after all, he had to have some virtue to justify this exhibit. Actually, even though he has been called the "Michelangelo of Genoese battle painters," he is at best a somewhat more gifted painter than Horace Vernet. M. Émile Dacier has written an excellent preface for the catalogue, but is he not deceiving himself just a little?

"Magnasco," he writes, "is a wholly spontaneous painter; he is well served by an exuberant imagination and by a technique that is marvelously adapted to the needs of that imagination." Has an exuberant imagination ever been supported by a technique? That is not at all certain. Is there not a kind of incompatibility between them?

All in all, this retrospective has taught us nothing new, and it is this kind of display that makes us realize how much we would prefer an exhibition by a young painter, even if he were not the Michelangelo of anything at all.

[M A Y 17]

French Exhibitions Abroad

Despite the opinion of certain grumpy critics, modern French paint-ing is gaining more and more importance in Europe every day. Anyone traveling abroad these days is certain to find exhibitions of the works of our young painters in all the capitals and major cities. Is this a good or a bad thing? Only time will tell. But our official salons, which at one time were considered very important abroad, have lost just about all their importance; and the bureaucrats of the fine arts in France should draw a lesson from the French exhibitions that are currently going on all over Europe. All, or almost all, the artists who have produced these works have exhibited at one time or another at the Indépendants.

At the Brussels General Exhibition of Fine Arts (Triennial Salon), the excellently installed French section includes Bonnard's *Barge and Sirens in China*; Maurice Denis's large canvas entitled *Dance*; Matisse's famous, wonderfully luminous *Joie de vivre* (1906–07); two canvases by K.-X. Roussel, as well as the models of his set designs for *Penelope*; and Vuillard's *Sunny Morning*, *On the Beach*, *The Bay Window*, and *The Library*.

In Zurich, André Derain is giving Switzerland the benefits of his latest, deeply pondered works.

Düsseldorf is seeing the works of Maximilien Luce, that strongly democratic painter.

At the Royal Museum of Copenhagen, a very important exhibition of nineteenth-century French painters has just opened. Besides painters

such as Delacroix, Corot, Courbet, and Jongkind, it includes the impressionists Manet, Monet, and Cézanne, as well as Seurat, the inventor of divisionism, along with Signac and H.-E. Cross, Henri Matisse, Bonnard, and Vuillard.

At the museum in Mannheim, Rodin and Maillol are demonstrating the superiority of French sculpture today.

At the Society of the Friends of the Arts in Mulhouse, at the museum in Düsseldorf, at the "Manes" Society in Prague, at the Society of Independent Artists in Amsterdam, at the Secessionists in Rome, we find always, everywhere, the same artists, and they are winning great success in all these exhibitions.

[MAY 19]

An Engraving That Will Become a Collector's Item

It is a small etching done by the poet P.-N. Roinard, who is also a painter and an engraver. He himself designed the stage sets for his play *Miroirs*, when it was supposed to be staged by Paul Fort's Théâtre d'Art. How long ago all that seems now! Those were the days before the Charles-Henry Hirsch case, when Hirsch himself was much more interested in artistic and literary innovations than he is today.

On the other hand, Roinard, although he is much older than Hirsch, has never abandoned his interest in everything lively in painting or in poetry. The result of all this is that Roinard has remained very youthful, and never has his poetry been more varied, more flexible, richer than now.

The work in question contains the following deeply etched words:

> *On April 19, 1914, P.-N. Roinard will give a private reading of his verse melodrama* La Légende rouge, *a synthesis of revolutionary ideas, at the home of his friends Jacques Villon and Duchamp-Villon.*
>
> *You are cordially invited to this reading, which will be held at 7 Rue Lemaître, in Puteaux, from one-thirty sharp to six. R.S.V.P.*

Since Picasso and Braque have introduced letters into their paintings, we are no longer astonished to find so many of them in an etching;

what we may find more surprising, however, is to see a poet professing revolutionary ideas today.

To be a real collector's item, the etching in question must bear a hand-written correction changing "April 19" to "May 17."

The reading did in fact take place the day before yesterday, in the midst of Jacques Villon's interesting pictorial efforts and Duchamp-Villon's sculptures. Only Marcel Duchamp's paintings were missing to complete the display. Duchamp, who is the youngest member of this family of Norman artists, is, in my opinion, the most obviously talented and the most original. Having become a librarian at the Sainte-Geneviève library, he catalogues books not far from the same Charles Henry whose scientific investigations concerning painting exerted a great influence on Seurat and ultimately led to the birth of divisionism. And that is why we have seen no painting by Marcel Duchamp anywhere for more than two years.

[M A Y 20]

A Few Words About Hansi

Hansi's arrest on charges of high treason has outraged everyone.[32] The Germans cannot bear to be made fun of, yet there is no nation whose often ludicrous efforts to attain a lofty culture have met with more mockery. Heine made no attempt to spare the feelings of his compatriots, and neither did Nietzsche. The Alsatian artist Hansi was merely continuing a tradition of the Empire.

Hansi's drawings are not devoid of artistic merit. They are witty and full of life. There are few caricaturists today whose technique is as simple and as amusing as his. One would have to go back to Wilhelm Busch or Caran d'Ache to find so much variety and so much jovial good humor.

Condemnations and court actions have never cowed the spirit of a caricaturist. They have, on the contrary, served only to arouse it. The Germans must be well aware of this, since they are a learned people. By persecuting Hansi, they are paving the way to more scathing, more violent, and more vengeful forms of ridicule. For if the gods delight in vengeance, the same can be said of caricaturists.

The Painters of Venice

Currently on view at the Brunner Gallery is a collection of paintings by both Venetians and non-Venetians, but all of them having Venice as their subject. This is a pleasant exhibition to visit, despite the snobbism that currently surrounds that moist city, the vagina of Europe. Guardi, Pietro Longhi, Bonington, Corot, and Whistler show us images of Venice that are as different from one another as the Venice of Baffo, Gozzi, and Casanova is from the Venice of M. Maurice Barrès and Henri de Régnier. I confess that I prefer the Venice of Pietro Longhi, Baffo, and Casanova to that of our illustrious academicians. But the former, alas, is dead; as for the latter, the Venice of *palazzi* and English pharmacies, F.-T. Marinetti and his futurists have sworn to rid us of it.

In the meantime, M. Jacques Blanche, who is an intelligent man and should know better, has taken it upon himself to inform us, with all the shrillness and affectation that have become today's fashion, that "there is a growing tendency to confuse the plastic arts with mathematics or metaphysics. Our art has become so cerebral that it is even trying to evoke the fourth dimension on a two-dimensional canvas."[33] M. Blanche is obviously confusing sensibility with mathematics. To represent the third dimension on a flat canvas is not being cerebral, but to try to discover the composition and the real dimensions of an object is, according to M. Jacques Blanche.

In general, M. Blanche makes peremptory judgments and formulates them rather baldly. Listen to what he says about the drawings of the Venetians: "Just examine the drawings (they are less numerous than the paintings) that Venice bequeathed to us. Their draftsmanship is skillful, but that is all! Titian was a coarse, miserable draftsman; Veronese was only an illustrator, which can also be said of that giant Tintoretto and of Tiepolo as well. . . ."

I forgot to mention that this exhibition is sponsored by the review *L'Art et les Artistes*, with the proceeds to assist the charitable work of the Fraternité Artistique, and that M. Henri de Régnier was chairman of the committee that organized it.

(*Paris-Journal*)[34]

New Music

People who have followed and participated in today's heroic art movements make a very clear distinction between the adjectives *modern* and *new*; and I hasten to say that only the latter is used in speaking of an artist whose work is genuinely new and daring, stunning and powerful.

We know of a few painters and a small number of poets who in our time deserve to be called new; but we had gradually become used to considering music as an outmoded, practically stagnating art. Everything in it was dark, empty, lifeless, immobile—it was a slave to *aesthetics* and *beauty*, two abstractions to which we no longer attach any importance.

Today's music is so impoverished and the role it plays among the other arts is so slight that I have often heard people say it was more the fault of music itself than of the musicians.

A young musician and composer, M. Alberto Savinio, has sought to discover the role of music among the modern arts, and his works can henceforth be considered examples of a *new music*, fragments of which will be heard for the first time this coming Sunday, May 24, at the offices of *Les Soirées de Paris*.

M. Savinio performs his own works on the piano, but it will not be long before he has an orchestra to do it for him.

Those who have the honor and the privilege of attending this first concert of new music will be astonished to see how roughly the young musician treats his instrument.

This is an indication of the tremendous energy that propels our artist.

To see him play the piano is an experience. There he sits in shirt-sleeves, a monocle in his eye, screaming and throwing himself about while his instrument struggles to attain his own pitch of enthusiasm.

Admittedly, Savinio has not brought about a renewal of music, or at least not yet; we should note, however, that he has never indulged in those orgies of good taste to which our so-called modern com-

posers have accustomed us and which put the most advanced of them on a level comparable, in literature, to the artistry of M. Maurice Rostand and, in painting, to that of the exhibitors at the Nationale.

Naturally, I am not referring to composers like Erik Satie or William Molnard, who, although they have blazed no new trails, have at least helped to discredit in the minds of young people that melancholy good taste whose effects were so disastrous.

Having begun to compose while still very young, Alberto Savinio has already produced several works, but he has kept only those few that he wrote during the past two years.

These are: an *opera bouffe* in three acts, *Le Trésor de Rampsénit*, based on an ancient Egyptian legend, with lyrics by M. M.-D. Calvocoressi; two ballets—*Deux Amours dans la nuit*, in two acts (six scenes), by M. M.-D. Calvocoressi and A. Savinio, and *Persée*, in three acts, by Michel Fokine—which were commissioned by M. Fokine himself, and which will probably be given during one of the coming seasons of the Ballets Russes; *Niobé*, ballet in one act by M. M.-D. Calvocoressi; and *Les Chants de la mi-mort*, music composed for a series of dramatic poems written by M. Savinio himself.

As he explained in his recent article, M. Savinio wants to give a wholly new orientation to music composed for the theater. His temperament is eminently dramatic, and he hopes and intends to bring to the stage the powerful spirit of genuine poetry. He believes that he can represent on the stage, and express in his music, all the strange and enigmatic aspects of life in our time; he also wants to make his music resound with the shock of the unexpected, of the truly singular.

M. Savinio's music always appears to be running at a vertiginous speed; it seems to be frenetic and extraordinarily lively, but in fact, it is extremely limpid. It is constructed in orderly fashion; it is based exclusively on melodic line and rejects any experiment with harmony that might give a hint of impressionism. It is very curious to note how such a simple procedure has enabled M. Savinio to compose musical works whose firm construction and powerful severity are totally in keeping with the austerity that stamps our time.

M. Savinio's music for the theater plays an extremely independent role; it is not connected with the drama or ballet in any specific way. It does not translate into sounds the feelings or situations of the story,

but simply plays its own poetic role in the spectacle as a whole. M. Savinio has been applying this method only since *Niobé*.

Connoisseurs of music will perhaps be pleased to know that, in his latest works, the young musician has not divided the music into measures. The sonority of his orchestra will be very different from everything that other contemporary composers have accustomed us to hearing. He takes no account whatever of the sensory effect produced by the fusion of all the instruments, or of any other orchestral effects of the same kind. M. Savinio wants to make modern music into a noble, pure, poetic, and severe art. He wants to restore to it the chaste sentiment, the natural poetry, and the heroic, moving tone that one finds sometimes in the old melodramas of Giuseppe Verdi—the very melodramas that cerain musicographers today look down on as too banal. He also wants to restore to it the spirit of fatality and eternity that breathes in the music of Modeste Moussorgsky.

But these are not meant to be comparisons, for Savinio himself wants neither to look back toward the past nor to copy the art of any new composer. His own art strives to capture all the poetry that bursts from today's world. His artistry consists in presenting it to us under the aspect of eternity. But what really inspires and elevates him is his imagination, for he is not at all like the majority of today's musicians, who possess no abilities outside of their music. M. Savinio, who is also a poet, painter, and playwright, resembles in that respect the protean geniuses of the Tuscan Renaissance. His artistic inventions almost always contain a note of peasant poetry, although his music has nothing in common with folk music or program music. He also believes that an artist's work must relate only to the period in which that artist lives; and only those works will be mighty and everlasting which bear the imprint of their time.

(Paris-Journal, M A Y 24)

1914

The Arts

Futurism and the Ballets Russes

It seems that Mme. Goncharova is the leader of the Russian futurist school, while her husband is the leader and inventor of the rayonnist school. Not long ago, Mme. Goncharova exhibited seven hundred recent canvases in Russia, and we are told that she will soon be exhibiting a hundred and fifty specially chosen works in Paris. According to those who have seen them, these works are a mélange of Matisse, Picasso, Picabia, Gleizes, Metzinger, Kandinsky, fauves of every kind, cubists of every tendency, and futurists of every nationality.

Far from imitating the mistakes of the French public and French officials with regard to their young painters, the Russians have made a real success of Mme. Goncharova; they have not been niggardly in their commissions. She was, in fact, asked to do the scenery for Rimsky-Korsakov's *Coq d'or*, which will be given by the Ballets Russes this season. Russian futurism will thus be given all the honors at the Opera House, while the new French painters, whose work is the source of all today's artistic innovations the world over, will continue to reap nothing but ridicule. We may wager that Mme. Goncharova will not leave France without a decoration and without seeing one of her paintings bought for the Luxembourg Museum.

In the meantime, French painters like Georges Braque, Derain, and Léger are ignored by everyone, and the Luxembourg does not own a single painting or even a sketch by Matisse or Picasso, who have world-wide reputations. Naturally, I will not even mention the younger painters. The Luxembourg will start thinking about them after they are dead, and then they will belong in the Louvre.

An Anglo-French Exhibition of Ancient and Modern Architecture

This exhibition, organized by the Association of Certified Architects, will perhaps be instructive to French architects from the point of view of technical innovations, but it certainly will not teach them anything new from an aesthetic point of view. The English, for the last few years, have done nothing but imitate French neoclassicism.

We know what French neoclassicism is all about.

It has helped to disfigure all of modern Paris.

Consequently, what will appeal to people most at this exhibit at the Jeu de Paume is the retrospective section: domestic architecture under Elizabeth, James I, and the last Stuarts; the old colleges of Oxford; and English gardens. The modern section is less interesting, except for the part dealing with country houses.

What we would have liked to see is the really modern architecture of England, just as what we most like to see in Paris are the new, daring constructions in reinforced concrete or metal, the interior of the Théâtre des Champs-Elysées, movie theaters, the Eiffel Tower, bridges, train stations. . . .

The Lhote Exhibition at the Vildrac Gallery—The Sandor Galimberti and Mme. Valérie Galimberti-Dénes Exhibition at the Weill Gallery

M. André Lhote has had a rather curious history as an artist. At one time he was compared to Gauguin and Carrière, and for a while he acted somewhat as the leader of a group of painters who did popular illustrations with borrowings from cubism. Yet, after all this, André Lhote has not found his own way, as a Dufy, for example, has, or even a Friesz or a Marchand. Lhote almost found himself faced with the necessity of returning to first principles, but he did not dare. His talents as an artist remain, in a sense, unused, for in-

stead of searching for his own personality, he seems to be intent chiefly on painting pretty pictures, on pleasing.

Every once in a while, he decides to let himself be "influenced," by La Fresnaye in a watercolor, by Metzinger in a nude; but all this is a game for him, when, in fact, he could benefit enormously from the more significant influence of Braque or Matisse.

M. Sandor Galimberti and Mme. Valérie Galimberti-Dénes are fervent and not untalented painters, especially Mme. Galimberti-Dénes, who has a real feeling for heroic proportions. This kind of painting is less modern than André Lhote's, but it is freer and perhaps even more personal.

[M A Y 27]

Jean Metzinger at the Weill Gallery

There is no doubt that this simple little exhibition of studies and sketches will enhance Jean Metzinger's reputation.

It will reveal the clear, bold side of his talent, which does not have the public esteem it deserves. I enjoyed looking at these small works assembled at the Weill Gallery. There are some pleasant still-lifes. They have character—a character that is not afraid to seek out any influence that will be valuable.

Jean Metzinger is one of the most appealing figures among today's young French painters. His brief participation in several different schools has disconcerted and irritated their respective adherents and their admirers. In the past few years, however, he seems to have settled down, and some of his portraits have won him the most flattering sort of encouragement and the most encouraging commissions.

If he had been a bit quicker to abandon his penchant for paradoxes—paradoxes he maintains without always believing in them—and if, since he is naturally modest, he resolved to be a bit less self-assertive at every point, no doubt he would soon occupy a position among today's painters both more agreeable and more advantageous; for if he lacks sensitivity, he does not lack subtlety, and his subtlety could be an excellent guide for his imagination.

The Medals of the Ghent Exhibition

The Ministry of Public Education took advantage of the Ghent exhibition to distribute a certain number of medals to various artists. The title of commander of the Légion d'Honneur was bestowed on M. Henri Martin, the vulgarizer of Seurat's divisionism and the inventor of the democratic fresco, featuring well-known personalities such as Anatole France and Jaurès. It is true that M. Martin is less boring than Puvis de Chavannes—and that, quite clearly, is a virtue that must be rewarded.

The title of commander was also bestowed on M. Weerts, who does those tiny portraits one sees first in *L'Epatant* before seeing them again at the Artistes Français.

Among the newly named officers of the Légion d'Honneur, let us mention M. Bompard, who specializes in Venice and seems to be doing very nicely, together with Messrs. Guirand de Scévola, Tatte-grain, and Ernest Baudin, director of the workshops at the Sèvres porcelain works.

Among the newly named chevaliers of the Légion d'Honneur, I want especially to mention Marcel-Jacques, because I was the first person to point out the merits of this simple, vigorous, and modest artist; I am happy to congratulate him today on the recognition that has been accorded to his intense and solitary labor. [. . .]

Inexpensive Paintings

There was a good deal of complaining in Germany, in recent years, about the low prices that young French painters were asking for their paintings. People said that they were preventing young German artists from selling their productions. The truth is that the young Germans in question were less modest in their prices than their French colleagues and also had less talent. In any case, times

have changed, and pictures that were inexpensive then have become very expensive indeed—which does not mean that there are no more painters in Paris willing to sell at low prices; quite the opposite.

But the record for low-priced modern paintings today is held by Italy. In some galleries in Florence, paintings sell for five or six francs. Naturally, they are not the works of well-known futurists, such as Carrà, Severini, Boccioni, or Russolo, but of lesser futurists, Rosaï and others, whose names are not yet familiar to us.

These bargain prices have induced many an Italian to set himself up as a collector of modern paintings.

There is a story going about that Papini, one of the best-known young writers in Italy, commissioned a friend who was going browsing in the above-mentioned galleries one day to buy him a painting for five francs. The friend came back empty-handed:

"I could not find anything for five francs," he said.

"Has the price of paintings really gone up?" asked Papini.

"On the contrary," replied the friend. "I found nothing above three francs!"

[MAY 30]

Rodin and Aurel

Just as you cannot mention Aucassin without Nicolette, Lubin without Annette, Paul without Virginie, and Philemon without Baucis, so from now on you will not be able to mention Rodin without Aurel. Rodin speaks, and Aurel records and comments. There is no doubt that recording and commenting on Rodin's words is at least as agreeable an occupation as posing for Mlle. Dufau. But let us see what Rodin says to Aurel in the pages of *Le Matin*.

I had expected Rodin's words to run somewhat as follows:

"What a pity that sculpture today should be almost a lost art! What a pity that neither I, nor Rosso, nor my pupils, nor anyone else working today should have the strength to conceive a really monumental work."

But in fact, this is not what the great man said.

"I owe everything to women," he said. "They walk like master-pieces."

And further on:

"We have only one advantage over the animals, which is the power of speech; but they have over us the advantage of an ethic and greater severity in facial expressions."

In concluding, we can hope that the transcendent feminism of Mme. Aurel—her aurelism, as someone aptly called it—will exert a beneficial influence on the fate of sculpture.

[MAY 31]

Futurism

The Italian futurists are having two exhibitions at the moment—one in London, at the Doré Gallery, and the other in Naples.

The opening of the Naples exhibition, which contains paintings by Boccioni, Carrà, Russolo, Balla, Severini, and Soffici, gave rise to some curious incidents.

The organizers had thought of everything, except the lighting of the room. At the last minute, Cangiullo, the "parolibera" (that is the name given to writers who practice the method of "*parole in libertà*"), Cangiullo, then, recognizing that the paintings could not be seen without light and scorning the more ordinary forms of lighting, ran out to buy a large supply of signal flares. Red flashes, fumes everywhere, firecrackers going off and crossing the room to the terror of the assembled ladies, yells, shouts, and bursts of laughter.

Marinetti grasped one of the burning flares and began a speech about plastic dynamism (he was somewhat behind the times there, for plastic dynamism has been old hat for at least three months). Anyway, Marinetti launched a violent attack on the passé-ist senti-mentalism, the pastelism and commercial watercolorism of the Neapol-itan pseudo painters.

To finish off the evening, the painters and the public gave a choral rendering of the famous onomatopoeic symphony *Piedigrotta*, by the "parolibera" Cangiullo.

After that, everyone went home to bed.

Honoré Daumier

We know how much interest is being attached henceforth to every-
thing produced by Honoré Daumier, the Michelangelo of the litho-
graph. Daumier's paintings are as much in demand as those of the
greatest masters of the nineteenth century, and people today are inter-
ested not only in his large plates but also in the proofs from *Charivari*,
pictures whose backs carry printing but which were sometimes so finely
produced.

The Association for the Encouragement of the Fine Arts in Liège
has had the excellent idea of organizing, at the Palace of Fine Arts in
that city, an exhibition of the lithographic *œuvre* of Daumier, who
was without a doubt the greatest satirical draftsman of all.

Marc Chagall

The Jewish race has not yet distinguished itself in the plastic
arts. Among modern painters, for example, one can think only of
Pissarro, who played an important role among the pioneers of im-
pressionism.

The Sturm Gallery, in Berlin, which introduced to Germany the
work of a large number of young French painters—and especially
Delaunay and Fernand Léger—is currently exhibiting the works of a
young Russian Jewish painter, Marc Chagall.[35] I hasten to add that
some of Chagall's paintings can also be seen in Paris, at the Malpel
Gallery, on the Rue Montaigne.

Chagall is a colorist imbued with an imagination that occasionally
finds its source in the fantasies of Slavic folk illustration but always
goes beyond them.

He is an extremely varied artist, capable of painting monumental
pictures, and he is not inhibited by any system.

His exhibition, which I saw before it left for Germany, consists of
thirty-four canvases, some watercolors, and some drawings done at
various times. I prefer his recent works, especially his *Paris Through
the Window*.

The Camondo Collection at the Louvre

Today the President of the Republic is scheduled to open the rooms containing the Camondo collection, at the Louvre. Besides the *objets d'art* from the Middle Ages and the Renaissance, besides the outstanding Japanese prints and the eighteenth-century furnishings, besides the Watteaus, La Tours, Perroneaus, and Fragonards, besides Falconet's graceful and famous clock, the *Three Graces*, besides the exquisite masterpieces by Riesener, Gouthière, Sisen,[36] and Saint-Aubin, besides the Gobelins, the Beauvais, the tapestries based on paintings by Boucher, besides all this, the Camondo collection offers something really new and instructive for the visitors to the Louvre, and indeed for the whole world: I am referring to its marvelous pictures from the modern French school, particularly the works of the impressionists.

This collection did not enter the Louvre without some difficulty. When one considers how few really modern works there are at the Luxembourg, one is really astonished to see that the Louvre is now much more avant-garde than the museum ostensibly devoted to the work of living artists.

This contradiction can be accounted for only by the administration that governs the Luxembourg, as well as by the outstanding quality of certain paintings that deserve immediate admittance to the museum of masterpieces.

Ingres, Delacroix, Barye, Millet, Daumier, Corot, and Puvis de Chavannes are all well represented here. But here too are Manet's *Fife-Player* and his "pink and black jewel," *Lola de Valence*, a flower of evil celebrated by Baudelaire. Here above all are the Cézannes, *The House of the Hanged Man* and *The Blue Vase*. Here are the Jong-kinds and the Toulouse-Lautrecs, which are a real triumph; here are the works of Renoir, who one day will be better represented at the Louvre; here, finally, are the Degas.

All this means that the Luxembourg had better get a move on: it must move quickly to new quarters and modernize itself and stop being afraid of the avant-garde schools, be they orphist, simultaneist,

futurist, or cubist. The Luxembourg is very much behind the times, and the real modern museum of Paris today is none other than the Louvre.

Children's Drawings

The Malpel Gallery has had the excellent idea of exhibiting some drawings by children. The Salon d'Automne had already done this, but it showed drawings done by schoolchildren and decorative designs drawn by a whole class from a model that was given them by the teacher.

The exhibition at the Malpel Gallery is totally different. These drawings were made from the imagination. The child drew or painted whatever he liked. It is much more interesting.

Many of the works on exhibit, however, were done by children growing up in an artistic milieu; most of them are either the children or the brothers or sisters of artists. This fact in no way diminishes the interest of the exhibition as far as the intrinsic value of the individual works is concerned, but it does mean that one cannot draw any conclusions from it regarding the plastic intuition of children in general.

In the paintings by Van Dongen's daughter, for example, one can recognize the influence of her father. As they are, these paintings indicate a definite talent and are agreeable to look at.

The son of the painter Peské[37] not only has a very fine talent as an illustrator, but is also a young poet full of freshness. Here is his impression of the forest of Fontainebleau, where one can see:

> *Sous les feuilles fanées*
> *Des petits champignons,*
> *Des cèpes, des giroles*
> *Tout gracieux et ronds.*

> (Tiny mushrooms,
> Chanterelles and morels,
> So pretty and so round
> Beneath the withered leaves.)

Among the most talented of these young exhibitors is Mlle. Adyzia Van Rees, a seven-year-old colorist who is also the daughter of a

painter. She has discovered a gamut of piercing colors, like some of Alberto Savinio's sonorities.

A. Lebec, eleven years old, has an interesting imagination: his painting of clowns in a carriage is amusing. He lives in Orsay, and he is among the few exhibitors here—together with Babet Parayre, seven years old, and Jack Malpel—who are not related to a painter.

The drawings done by Rosa Riera when she was six make one think of the ceramic tiles currently being painted by that Catalan artist; the drawings of her sister Carmen sometimes recall her works.

The drawings of Mlle. Sima Chagall recall the earlier paintings of her brother.

Gaillard junior, eleven years old, is already a skillful landscapist; Picault junior, twelve years old, has painted an interesting still-life.

I remember when Matisse used to show off his children's drawings, some of which were really astonishing. Matisse was very much interested in them.

"Nevertheless," he used to say, "I don't believe that we should make a lot of fuss about children's drawings, because they don't know what they are doing."

[JUNE 9]

The Camondo Collection

Now that the Camondo collection has been installed and the public is crowding in great numbers into the small rooms that contain it, we can say with some certainty that this collection will not enhance Degas's reputation as a painter. He really appears here as *a minor master*. Cézanne's watercolors are the triumph of the collection in my opinion. Someone told me that after he had bought them, M. de Camondo wanted to return them: "These are really trifles for a collector like me," he was supposed to have said. But later he changed his mind, and he was right to do so, for nothing is more important than these watercolors for the study of the few contemporary painters who will matter in the history of art.

I also believe that M. de Camondo would have done wisely not to stipulate that his collection be exhibited as a unit separate from the rest of the museum. It would have been better, in my opinion, if

1 9 1 4

his eighteenth-century furnishings and *objets d'art* had been allowed to enrich the general furniture collections.

(Has anyone noticed the lowboy inlaid with some small pictures that have a curious resemblance to some of Aubrey Beardsley's work in black-and-white?)

The paintings in the collection should have taken their appropriate chronological place, and the collections of the Louvre would have really been enhanced. Instead, we simply have another museum in Paris, the Camondo museum located in the Louvre, like the Chauchard museum, the La Caze museum, the Campana museum, the naval museum, etc.

Moreover, the curators of the Louvre have devised such a complicated schedule of visiting hours for these various museums that it has become just about impossible to know what is open and when. The Campana is closed on certain days during the military-training season, another room is open only on Tuesday afternoons and Wednesday mornings, and the same is true for furnishings and for the Camondo collection. As for the naval museum, it is open only from time to time, and God alone knows when.

[J U N E 10]

Mary Cassatt

The Durand-Ruel Gallery is exhibiting paintings, pastels, drawings, and drypoints by Mary Cassatt. Despite all appearances, Mary Cassatt was not a painter of motherhood. What one finds in the work of this woman is a very special gift for capturing the most feminine attitudes of women. This is evident in her *Woman Leaning on Her Right Hand*, as well as in some of her drawings and especially in her drypoints.

The importance of Mary Cassatt's works resides more in their gauging of the plastic sensibility of women than in their value as paintings in general. Nevertheless, some of her pieces have an artistic value that amply justifies the interest they are arousing in America and in France.

I should add that the paintings by Mary Cassatt that I like least are those in which there are children.

Lola de Valence

I wonder why Manet's *Lola de Valence*, which is one of the glories of the Camondo collection, does not have a tablet beneath it inscribed with Baudelaire's quatrain:

> *Entre tant de beautés que partout on peut voir,*
> *Je comprends bien, amis, que le cœur balance;*
> *Mais on voit scintiller en Lola de Valence*
> *Le charme inattendu d'un bijou rose et noir.*[38]

> (Among so many beauties offered to our gaze,
> I realize, my friends, our hearts must waver;
> But Lola de Valence has a glittering grace,
> The unexpected charm of a pink and black jewel.)

This laudatory inscription is worthy of the painting it would accompany, and Baudelaire expended enough energy defending painters —and defended them very well, despite what Van Gogh and a few others have said about him—to deserve to share in their glory.

Duelists

Two Polish painters engaged in furious battle yesterday at the Parc des Princes.[39] This gives us the opportunity to sketch the portraits of these two figures, both of whom are well known in Montparnasse, a neighborhood that, as everyone knows, has completely supplanted Montmartre, especially as far as painters are concerned.

Gottlieb, who has been working in Paris for quite a few years, is a discreet and simple man whose art has been influenced by Van Gogh and Munch. He is an expressionist who has himself influenced the work of some of his compatriots. His works are usually to be seen at the Indépendants and at the Salon d'Automne. The *Portrait of M. Adolphe Basler* that he exhibited at the Salon d'Automne last December was well received.

1 9 1 4

M. Kisling, on the other hand, has been influenced by French painters like Derain. He painted for quite a long time in Céret, a subprefecture in the department of the Pyrénées-Orientales that has been called the Mecca of cubism. It should be said that in some circles, and especially in Germany, people are placing great hopes in Kisling, who will soon exhibit some of his paintings in Düsseldorf, at the exhibition of works by foreign painters who frequent the Dôme, that famous café located on the corner of Boulevard Raspail and Boulevard du Montparnasse.

Kisling is currently doing some woodcuts for a volume of poetry by Max Jacob entitled *La Souris boiteuse.*[40]

[JUNE 14]

The Midi

Artists today are being drawn to the Midi. Instead of spending their vacations in Brittany or in the area around Paris, as many artists of the preceding generation did, painters are now heading for Provence. They have even abandoned the Pyrenees; Céret is no longer the Mecca of cubism.

After visiting Nevers, Derain is now in Nîmes. Picasso is going to join him there the day after tomorrow, and Braque is going to settle in Sorgues, near Avignon.

The region will doubtless be receiving many other painters, among them Girieud, Lombard, perhaps even Friesz, Matisse, and Edouard Férat.

Thus, in this marvelous period of French art that we are witnessing today, each of the regions of France takes its turn in offering our painters the inexhaustible treasure of its natural beauties to renew their inspiration.

At the moment, the Midi is providing a wonderful haven for painters. I know quite a few people who are not painters who find it equally wonderful.

Schools

There are so many artistic schools today that they no longer have any importance as individual schools, and one could say, in fact, that there are no longer schools but rather painters with diverse temperaments and talents, each trying to express plastically how he feels about life.

At a time when certain freedoms still had to be won, it was in the interest of painters to form schools.

Today, painters think they are free. They must discover new fetters that will allow them to conquer new freedoms.

One must therefore not take literally the names of the various schools: cubists, orphists, futurists, simultaneists, etc. For some time, they have meant absolutely nothing.

Today, there are only modern painters who, having liberated their art, are now forging a new art in order to achieve works that are materially as new as the aesthetic according to which they were conceived.

Today, one can no longer speak of drawings, oil paintings, watercolors, etc. One can only speak of painting, and our electric signs are incontestably more a part of the new painting than most of the pictures exhibited at the Nationale.

The Quat'z'Arts Ball

The Quat'z'Arts Ball will be held Monday, June 22, in a covered marketplace in the Place d'Italie. This slightly out-of-the-way and slightly American-Indian–style neighborhood will receive the stamp of elegance that night: the up-and-coming painters of our salons, disguised as Trojan warriors, will be whirling around the floor with the most charming models in Paris, dressed in the provocative *déshabillé* of the three goddesses on Mount Ida. Yes indeed, this year's mood is wholly classical, wholly Greek in fact.

1 9 1 4

And the *Iliad* is being raided for ideas for costumes. Firemen's hel-
mets will come back into fashion. Agamemnon, Menelaus, Achilles,
and Hector will dance the tango and the maxixe with Helen, Briseis,
and Cassandra. The orchestra will play Offenbach, and at dawn
the half-naked heroes of old Homer, Achaeans and Trojans together,
will perhaps stop for a moment in the Place d'Italie to listen to the
early-rising natives of that distant region exchanging insults with
each other like the heroes of the *Iliad*.

[J U N E 21]

An International Fine-Arts Exhibition in Paris

The question of a new salon has been raised. A recent lead article
in *Paris-Journal* argued in favor of it, and M. Bérard made the
same demand in *Le Matin*.

Basically, all the Paris salons are international; in fact, Paris itself
is a permanent international exhibition of the arts. At the same time,
the idea cherished by the promoters of the new salon is not very
different from the idea that motivated the founders of the Salon
d'Automne.

After all, I see no harm in founding a new salon. One more or
one less. . . !

What might prove more useful, however, than the founding of
yet another salon would be the creation of a truly modern museum
in Paris, for the Luxembourg is completely inadequate. It is really
unthinkable that a country like France, which for two centuries has
been at the forefront of the arts, occupying a position comparable
to Italy's during its most glorious period, should have only the paint-
ings at the Luxembourg to offer to those who want to have an
accounting of France's artistic prosperity. Admittedly, two-thirds
of the paintings in the Luxembourg museum are by distinguished
artists, but by artists who never played any role in the history of Art.

The Luxembourg has nothing by Seurat, and almost nothing by
Cézanne. Guys, Lautrec, and Gauguin are, for all intents and pur-
poses, not represented there. The museum contains none of the most
vital art of the last few years—no Matisse, no Picasso, no Derain,
no Braque, no Laurencin, no Picabia, no Delaunay, no Dunoyer de

Segonzac, no Metzinger, no Gleizes, no Henri Rousseau, no Friesz, no Dufy, no Vallotton, no Guérin, no Manguin.

I certainly do not consider all these artists of equal rank, nor have I defended the aesthetic tendencies of all of them, nor their varying talents.

Nevertheless, it cannot be denied that, for the last ten years, these artists have represented everything that has made France famous abroad. The works of some, both alive and dead, already command very high prices; the majority of them already have paintings in the most illustrious European museums. Only the Luxembourg persists in preferring obscure nobodies who do not even have the merit of vigorously exemplifying the tendency that the Italians have very aptly called "passé-ism."

[JUNE 23]

Montparnasse

Montparnasse henceforth replaces Montmartre. Mountain for mountain, we are still on the heights; art still prefers the summits. Daubers, however, no longer feel at home in the modern Montmartre. It is difficult to climb and full of fake artists, eccentric industrialists, and devil-may-care opium smokers.

In Montparnasse, on the other hand, you can now find the real artists, dressed in American-style clothes. You may find a few of them high on cocaine, but that doesn't matter; the principles of most *Parnassois* (so called to distinguish them from the Parnassians) are opposed to the consumption of artificial paradises in any shape or form.

This is an agreeable country in which heavens are for external use only, a country of fresh air and café terraces: the terrace of the Closerie des Lilas, presided over by Paul Fort, Diriks, Mercereau, Gianattasio, Charles Guérin, Flandrin, Mme. Marval, etc.; the terrace of La Rotonde, where you can see Kisling, Max Jacob, Rivera, Friesz, and others; the terrace of the Dôme, where you find Basler, Goetz, Flechtheim, Pascin, Lévy and all the other Dôme-dwellers ensconced; the terrace of the Petit Napolitain, where Gwozdecki, Pierre Roy, G. de Chirico, and Modigliani refresh themselves; and the terrace

of the Versailles, where Marquet, Bénoni-Auran, etc., like to while away the time.

These cafés are the oases of a region that will soon boast its own journal—*Montparnasse*, a weekly gazette of literature and the arts, edited by our friend Paul Husson.

[JUNE 24]

Watercolors by Jongkind

I have never seen a watercolor by Jongkind without being moved by its vivaciousness and luminosity. I found the same qualities in the fifty watercolors currently on exhibit at the Bernheim-Jeune Gallery. These are his most agitated and impetuous works.

The Scheldt at Antwerp, the *Ourcq Canal*, the *View of Rouen*, the *Landscape in Dauphiné*, the moving *Meudon-Sèvres*, the *Hay Wagon* —all these are bold, spontaneous works that will long remain in the memory of those who have seen them.

In my opinion, these quivering, airy works can be appreciated much better at the Bernheim, where they are exhibited alone, than in the Camondo collection, where it seems to me that they are placed at a definite disadvantage by the paintings that surround them.

"What Lautrec did for the pencil sketch," writes M. G. Jean-Aubry, "Jongkind did for the watercolor, with a perfection that appears almost magical."[41]

I personally would not have compared those two great artists, Lautrec and Jongkind, but the latter was certainly an incomparable landscapist, and after all, he can rightfully be compared to the greatest artists.

[JUNE 25]

At the Galliera Museum

The Galliera Museum is having an exhibition of statuettes and of the pieces of furniture that support and accompany them. I shall speak about this exhibition in detail another day.[42]

The mediocrity of most of our furnishing and decorative-arts exhibitions is, to say the least, disconcerting.

French artists, who are the leaders in the major arts and whose daring there knows no limits, appear timid and unimaginative in the minor arts.

And yet, by God, the most beautiful modern styles are the French styles!

I think that the chief culprit in all this is the nonsensical idea that the minor arts are equivalent to the major arts.

Admittedly, the great artists in the minor arts can be as good as the great artists in the major ones, but the two arts in themselves have nothing to do with each other. To each his own craft . . . Cabinet-makers should practice cabinet-making and painters painting. If artisans remain artisans and artists artists, things will change quickly, and at that point we shall see a flowering of the art of furniture and of the decorative arts in general.

Once and for all, let us be done with those two modern characters worthy of Molière or, at the least, of Balzac: the artist-workman and the artisan-aesthete.

[JUNE 26]

The Sculptor Lehmbruck

This German sculptor, who is currently having his first one-man show at the Levesque Gallery, is not a newcomer to Paris. His works have already been shown at the Indépendants and at the Salon d'Automne.

He is a man of talent, and both M. Meier-Graefe[43] and André Salmon are correct in saying so. His talent, however, is archaic and touches our modern sensibility even less than Nadelman's Hel-lenizing art.

Some people are calling Lehmbruck a little Jean Goujon. That is perfect. Will little Goujon grow up? Yes he will, if he is given sky-scrapers and luxury hotels in South Africa or Oceania to decorate, for an archaic aesthetic would hardly be tolerated elsewhere, and especially not in Paris: Paris is perfectly content with the Louvre, the Fountain of the Innocents, and the excellent articles by M. Péladan.

Jarry the Draftsman

Ubu-roi, which for a long time was out of print, will soon be re-issued in an inexpensive edition (3 francs 50). The edition will contain reproductions of the original woodcuts done by Jarry.

Jarry had a very real talent as an artist. He himself carved the marionettes that were used in staging the play.

But it is in his drawings and woodcuts that this last of the great burlesque poets gave us the full measure of his artistic abilities.

Jarry was an amateur, but he had a gift for expression that is lacking in all too many professionals.

Some of his woodcuts have a singularity about them that is almost cabalistic.

Now that the author of *Ubu-roi* is about to be granted the recognition that is due him, it might be interesting to have an exhibition of the unusual woodcuts and drawings that he left behind.

(*Paris-Journal*)[44]

The Natalia Goncharova and Mikhail Larionov Exhibition

Mme. Natalia Goncharova, who did the set designs for *Le Coq d'or* at the Opéra, and M. Mikhail Larionov, the originator of the Russian rayonnist movement, are having an important exhibition of their works at the Paul Guillaume Gallery, 6 Rue de Miromesnil.[45]

Natalia Goncharova has boldly accepted the influence of the great French painters, or those painting in France, who, for the last twenty years, have alone maintained the noblest tradition of art. This sublime contact with the true Occidental tradition inspired the great Russian artist to seek out the secrets of the rich Oriental tradition that appeared to have found definitive form in the folk art of the Russian Empire.

The very sizable *œuvre* of this prolifiic artist thus stands as a glorification of the infinitely noble and infinitely true artistic objectives that succeeded impressionism in France, thanks to Cézanne. Her work is also a revelation of the marvelous decorative freedom that has never ceased to guide Oriental painters amid their sumptuous treasure of forms and colors.

Natalia Goncharova, then, commands an aesthetic in which the great and intellectually satisfying truths of today's scientific art are combined with the appealing subtleties of Oriental art. To this, Mme. Goncharova has added, first, the modern harshness contributed by Marinetti's metallic futurism and, second, the refined light of rayonnism, which is the purest and newest expression of contemporary Russian culture.

Natalia Goncharova's personality is revealed in all her work. She has a unique gift for endlessly discovering new decorative elements and for evaluating the artistic significance of the most modern objects and feelings.

Movement, in her art, is a dance cadenced to the tempo of creative ardor.

Mikhail Larionov, for his part, has brought a new refinement, not only to Russian painting, but to European painting as a whole: rayonnism.

In rayonnism, the light that constitutes works of art manages to express the most subtle, most joyous, most cruel feelings of modern humanity.

Mikhail Larionov's art reveals an extremely strong personality, capable of expressing the shades of feeling and sensation he experiences with a degree of precision that makes his luminous, extremely sober, and exact art a genuine aesthetic discovery. Some of his works will occupy a prominent place in contemporary art.

Larionov and the rayonnists in the Russian plastic arts and literature conceive of the work of art as a magnet which acts as a focal point for all the impressions, all the lights, all the life around it.

This art is in accord with the newest and most daring experiments undertaken by French artists.

These experiments show that a universal art is being created, an art in which painting, sculpture, poetry, music, and even science in all its manifold aspects will be combined.

And many of the poems published in this review were simply attempts to penetrate the mysteries of this synthesis.

The names of the various schools have no importance other than to designate this or that group of painters and poets. But they all share a desire to transform our vision of the world and to arrive, at last, at an understanding of the universe.

(*Les Soirées de Paris*, J U L Y)[46]

The Arts

[J U L Y 2]

The Dôme and the "Dômiers"

Montparnasse is continuing its energetic activities, and now it has entered the export business.

The Dôme is one of the cafés on the corner of the Boulevard Raspail and the Boulevard du Montparnasse. The "Dômiers" are the German painters who have made it their headquarters. These artists are currently exhibiting their works at the Flechtheim Gallery, in Düsseldorf. The name of their exhibit is "Der Dome," which in German also means "the cathedral." (In Germany, aren't the real cathedrals the beer cellars?)

The Düsseldorf exhibition includes the works of twenty-three artists living in Paris. Few of them have a personal style; several of them are good, promising pupils; a handful are genuine artists, such as Pascin, who is a kind of modern Clinchtel,[47] but Pascin is a Serb, not a German.

The artistic poverty of Germany today is extraordinary—as extraordinary as the patience with which it is attempting to penetrate the secrets of the young French painters.

I am not familiar with the work of all the exhibitors. Bolz, who has a rather penetrating mind, has not yet found his personality. Nils de Dardel does picturesque things; he is a Swede. Ernesto de Fiori, an Italian, is a sculptor whose mannerism is not devoid of gracefulness. Among the most interesting artists here, one could unquestionably cite the painters Georges Kars, a Czech, and Kisling,

a Pole; but the personalities of both of them are still very undefined. Here too is Rudolf Lévy, the former treasurer of the Henri Matisse Academy.

I know nothing about the work of the other exhibitors, but as one can see, more than half of these representatives of German art are not German; they all work in Paris, and there is not one whose work does not display the very strong influence of the French painters of the Indépendants or the Salon d'Automne.

Four New French Artists

There is no doubt about it—Germany is our greatest source of enlightenment today regarding French art.

In Berlin, Munich, Düsseldorf, Cologne, not a day passes without the opening of a new exhibition devoted to the work of a new French artist.

At the Sturm Gallery in Berlin, there is currently an exhibition of Albert Gleizes, Jean Metzinger, Duchamp-Villon, and Jacques Villon.

We know what a robust painter Albert Gleizes is. He occupies the first place in a healthy art that does not exclude refinement. At the height of his talent, Gleizes is now exhibiting some landscapes and figures done with praiseworthy honesty. The Berliners can admire his tumultuous *Passy, The City and the River, The Street, Woman at Her Toilette, Man in a Hammock*, etc.

Jean Metzinger represents an extremely refined art. He finishes his paintings, and not content with draftsmanship, he seeks for exactitude. If M. Ingres did not have such a mixed press these days, despite all the publicity, I would say that Metzinger's work has the Japanese qualities of Ingres's paintings. *The Smoker, Head of a Woman, Seascape, Night, Landscape, Woman Reading*, and *Boating* (this and the above-mentioned *Smoker*, which people say is a portrait of me, are his masterpieces)—these are the works that the connoisseurs of the city on the Spree will be fighting over furiously in a few days.

Duchamp-Villon is an extremely modernistic sculptor. He is among

those who have best succeeded in giving concrete form to movement. Without premeditation, by the sheer force of his powerful instinct, he is very close to Mexican art. The ancient Mexicans, after all, had devised a marvelously abstract ideogram to embody movement, which has always been the aim of Duchamp-Villon's art. These sculptures in terra cotta, plaster, and wood will bring a great deal to the Germans, and I hope that they will know how to profit from them.

Jacques Villon has created a metallic kind of painting whose elaboration undoubtedly cost him some superhuman efforts. I have not seen any of the things he is exhibiting in Berlin, but his most recent etchings seemed extremely original.

Besides these four Frenchmen, the Russian artists Marc Chagall and Alexander Archipenko are also exhibiting. Chagall is showing some drawings, and Archipenko, who is the protagonist of the new plastic aesthetic, is showing three bold and charming sculptures.

[J U L Y 4]

La Triennale

The next exhibition of La Triennale, whose success in 1912 we all remember, will be held from February 1 to March 15, 1915.

This association, whose founder, or at least one of whose founders, is M. Fernand Sabatté, has as its aim to synthesize at three-year intervals, as it were, all the tendencies of French art as found in its best representatives.

In 1912, for example, it went as far as Henri Matisse, who showed two of his best paintings in the exhibition room at the Jeu de Paume.

In 1914, the selection committee of La Triennale will doubtless invite Derain, Braque, Léger, Vlaminck, Delaunay, Gleizes, Metzinger, Segonzac, L.-A. Moreau, R. de La Fresnaye, Tobeen, Marchand, etc. If the organizers of the exhibition are not timorous, and if they rid themselves of all the prejudices that people in the art world so often harbor against new things, they can be assured of a great success, and they will be rendering an enormous service to art at the same time.

It is not a bad thing to have an exhibition every three years that sums up the current state of painting.

Many people believe that painting these days has put on seven-league boots. It would not surprise me at all if the triennial exhibitions showed that, in fact, it is walking at a very reasonable pace.

Georges Rouault's "Albums"

The "Albums" that Rouault exhibited at the Druet Gallery last year did not attract the attention they deserved: the harrowing, anguished drawings full of pity and irony, which alternate with biting, bitter sketches and with singular poems that call to mind the cries of those children of St. Francis of Assisi, the *giullari di Dio*, who used to wander through the villages of Umbria chanting with strange and heart-rending lyricism.

Some of Rouault's friends have advised him to publish his series of five small "Albums" with *black-and-white* reproductions.

I believe that Rouault recently sent forty sketches for colored engravings abroad, where they will doubtless create a sensation. His "Albums," however, are still in France, waiting for a publisher.

These albums were finished two years ago and are entitled: *Versailles, Gentlemen Painters, Miserere, Provincial and International Types, Familiar Types.*[48]

In my opinion, few painters since Daumier have attained such a degree of the sublime in comedy, which is here indistinguishable from the sublime in tragedy.

Modern Spanish Painting

M. M. Nelken has published, in *La Renaissance contemporaine*, an article devoted to the Spanish painters Sorolla, Zuloaga, and Chicharro.[49]

The writer has subtitled the article "Les trois principaux représentants de la peinture espagnole moderne."

Does this mean that modern Spain takes more pride in being the

mother of these three painters than in having given birth to Pablo Picasso?

It is true that he is perhaps not so much a Spanish painter as the principal representative of modern painting in general. Since, moreover, his art was shaped in France, for he has constantly painted in Paris and it was in Paris that he found the paths that have had the most decisive influence on contemporary painting, France would be perfectly justified in considering him a French painter.

No one abroad is misled, and in Germany and Russia Picasso is always listed among the painters of the French school. He is, after Cézanne, its most original artist.

Still, it seems that Spain is being strangely neglectful of its most genuine titles to glory. This proves the truth of the proverb: "No man is a prophet in his own country."

[JULY 7]

Jean Boucher's *Victor Hugo*

A fine, animated face, penetrating eyes, a dark youthful beard, a small round felt hat, a black jacket that he wears rather short—that is the sculptor Jean Boucher, whose statue of Victor Hugo is being dedicated today in Guernsey.

Jean Boucher did not want to compete with Rodin, and his sculpture is not of Hugo the Titan but of Hugo the man, Hugo the exiled poet who dreams of his homeland and looks to the sea for inspiration.

This monument is not meant to glorify a poetic *œuvre* symbolizing the character of the poet; rather, it evokes in a familiar way the man who lived, loved, hated, and sang on those rocky shores.

Jean Boucher's work succeeds extraordinarily well in capturing these memories of the very restless life of the great poet—a poet so prolific that even now, twenty-eight years after his death, not all his works have been published. Almost every year there appears a volume of his hitherto unpublished verse, and its publication unquestionably still constitutes one of the most important events of the literary season.

Marius de Zayas

Caricature is a noble art. The caricatures by Leonardo da Vinci, Gillray, Daumier, André Gill are not inferior works.

I do not include satirists like Hogarth, Gavarni, and Forain among the caricaturists.

Until now, today's art, which is so expressive, had produced only one real caricaturist: Jossot, an unjustly forgotten artist.

Now, however, we have another caricaturist. His name is Marius de Zayas, and his caricatures, employing some very new techniques, are in accord with the art of the most audacious contemporary painters.

I recently had a chance to see some of these new caricatures.[50] They are incredibly powerful, especially those of Ambroise Vollard, Bergson, and Henri Matisse.

The next Salon of Humorists should set aside a room for the works of Marius de Zayas. They are well worth the trouble.

[The Task of the Critic]

A fine essay by Ernest Hello has just been published in the literature column of *L'Effort libre*. It is an essay on *criticism*:

"The man who can say to an unknown apprentice: 'My boy, you are a man of genius!' deserves the immortality he promises. 'To understand is to equal,' Raphael said.

"The domain of criticism is broader than people generally think. The critic is not a gardener who cultivates only one kind of flower: all nature is his domain. Wherever there is a great man in danger, there the critic must be. Criticism was with Vasco da Gama when he rounded the Cape of Good Hope. No tone, no harmony is forbidden to criticism; it can proclaim a preference, it can sustain one who is in danger of falling. Criticism stood next to Columbus five minutes before the fateful cry of "Land! Land!" rang out on the bridge of his blessed ship. There, indeed, is its real place; therein

1 9 1 4

lies its task, its destiny, its glory. Fidelity! Fidelity! that is its triumphant motto. Fidelity is time finally conquered by enthusiasm. The critic must be as accurate as posterity; he must speak in the present the words of the future.

"Standing next to the man of genius who is waiting for his day, the critic must begin to play the role of humanity and serve as a prelude to the choruses that his descendants will sing at the tomb of the man of genius."

Those whose conception of the critic's task corresponds to the conception so beautifully expressed by Ernest Hello can rejoice—for never, I believe, has anyone envisaged more nobly the critic's role in the world of art and artists.

[J U L Y 10]

Drawings by Arthur Rimbaud

Many of Arthur Rimbaud's drawings have already been published; they are very amusing, very curious, and their expressive rather than caricatural distortion reminds me of the drawings by Gogol that I saw reproduced in an edition of his complete works.

The *Nouvelle Revue Française* has just published the descriptions (from the pen of M. Paterne Berrichon) of a few drawings accompanying three unpublished letters by Arthur Rimbaud.[51] I should have liked to see reproductions of the drawings themselves, but I suppose that would be asking for too much.

"*Pen-and-ink drawing.* In the sky, a tiny little man balancing a spade in the form of a monstrance, with the words 'O nature, o my sister!' coming out of his mouth. On the ground, in a landscape of flowers, grass, and trees, a slightly larger little man holding a shovel in his hand and wearing wooden shoes, with a cotton cap on his head. In the grass, a goose with the words 'O nature, o my aunt!' coming out of its beak."[52]

Here is another *pen-and-ink drawing*:

"The hamlet of Roche, or of the house where Rimbaud wrote *Une Saison en enfer* and where he destroyed all the copies of the volume that had been delivered to him by the printer. On the bottom of the drawing, these words: 'Laïtou, my village.'"

Finally, the third *pen-and-ink drawing*:

"At upper left of the letter, a four-story house enclosed by a fence and surrounded by shrubbery; in front of the house, a tiny man stepping hurriedly out of a carriage; beneath all this, slantwise, the words *'Wagner verdammt in Ewigkeit!'* coming out of the mouth of a fantastic personage who occupies the whole left margin.

"At the bottom of the letter, a view of a city, with, to the left, some stakes and bottles in the shape of an oriflamme, bearing the words: *'Riessling, fliegende Blätter'*; running from left to right, a kind of arena, with a group of what appear to be mountains beneath it, and beneath them, the words: 'old city'; after that, some houses, with squares and trees, a tramway turning and climbing toward the top, and farther up, some stars and a black crescent moon. All this covered over with the words *"Riess, Riessling'* in capital letters."

It would be an excellent idea to bring these *pen-and-ink drawings* together in an album. Such an album would be a great success with Rimbaud enthusiasts, whose number is growing every day throughout the world.

<p style="text-align:right">[J U L Y 13]</p>

Antonio Gaudí

Antonio Gaudí is a Catalan architect whose buildings have transformed Barcelona. He is one of the most original modern architects. He has, among other things, made great advances in the art of the terrace and of everything that is generally found on the roofs of houses; his work thus gives the city a tumultuous, animated air that most of the so-called modern constructions have tended to stifle.

The Milá house is one of Gaudí's most complete and most attractive works.

It would be useful for Frenchmen to know the work of this architect. This year's Salon d'Automne, which will give us a chance to see the works of the greatest living Viennese architect,[53] should also introduce us to the works of Antonio Gaudí and the other Catalan architects, as well as to those of Czech architects and the architects of the American skyscrapers. These Americans I believe studied at the Ecole des Beaux-Arts. They put what they learned here to great

advantage; it is only fair that we should be allowed to see what they have done.

New Painters

In 1912, I had occasion to say to a few young painters, such as Chagall and G. de Chirico, "Keep up your good work! You have a talent that is bound to make people notice you!"

Today, people in various countries are indeed taking notice of Chagall. Canudo's article in yesterday's *Paris-Journal* shows that they are even taking notice of him in France.

The same can be said of G. de Chirico, whose art is more severe, more subtle, more classical, and at the same time much newer than Chagall's.

Listen, for example, to what Soffici writes about him in *Lacerba*:

"Imagine a painter who, in the midst of passionate and ever more daring experiments . . . , continues to paint with the calm perseverance of a solitary old master—a kind of Paolo Uccello in love with his divine perspective and oblivious to everything that lies outside his beautiful geometry. Although I mention the name of Paolo Uccello, I do not mean to imply an essential similarity between him and de Chirico.

"G. de Chirico is, above all, an absolutely modern painter. If geometry and the effects of perspective constitute the principal elements of his art—his customary means of expression and emotion— it is also true that his work resembles no other work, ancient or modern, that is based on the same elements. De Chirico's painting is not painting as that word is generally understood today.

"It could be defined as a language of dreams. By means of almost infinite series of arcades and façades, long straight lines, immanent masses of simple colors, and almost funereal lights and darks, he manages to express that sense of vastness, solitude, immobility, and ecstasy that the vision of a memory sometimes produces in us as we are going to sleep. G. de Chirico expresses, as no one else has expressed before him, the poignant melancholy of twilight on a beautiful day in an ancient Italian town: at one end of a deserted square, beyond its loggias, porticoes, and monuments of the past, we see a passing

train belching billows of smoke, while a parked delivery truck stands waiting, and a very tall chimney blows smoke into a cloudless sky."

This is one of the aspects of De Chirico's art. There are other aspects that I shall try to elucidate in this column very soon.

[J U L Y 15]

Colored Rhythm

I had predicted the coming of an art that would be to painting what music is to literature. There is an artist who has made the effort to bring this art into being: his name is Léopold Sturzwage.[54] He lives in a seventh-floor walkup in Montrouge. He has described the main features of his idea in a paper submitted to the Academy of Sciences, and he is now looking for a film company willing to defray the costs of the first experiments with colored orchestration.

Colored Rhythm may be compared to music, but the similarities between them are superficial; we are dealing, rather, with an autonomous art having an infinite variety of resources that are peculiar to it alone.

The origins of this art can be traced back to fireworks, fountains, electric signs, and the fairy-tale luxury hotels we see in exhibitions, which have taught our eyes to derive pleasure from kaleidoscopic changes in shades.

We shall thus have a new art that will be independent both of static painting and cinematographic representation. It will be an art that people will quickly get used to and that will have infinite appeal for those who are sensitive to the movement of colors, their interpenetration, their sudden or slow transformations, their juxtaposition or their separation, etc.

There is no doubt that Léopold Sturzwage, to whom we are indebted for having discovered a new Muse, will soon become famous.

[J U L Y 16]

Forain at the Institute

Forain's presence at Gabriel Ferrier's funeral has been interpreted to mean that the great draftsman is seeking election to the Institute.

1 9 1 4

The Academy of Fine Arts would lose nothing if it elected to its ranks some of today's most important living artists.

Forain is among the most illustrious; he is also among those who are exerting the greatest influence on younger artists and who are most highly esteemed by a discriminating public. He would thus have a well-deserved place in the Academy, as would Rodin, Renoir, and several others.

The Institute lacks the glory of these artists. That is why I think it very possible that these academic wishes will never be realized and that Forain himself, despite his presence at the funeral of a member of the Institute, has never thought of seeking election to the Academy of Fine Arts.

[J U L Y 18]

The *Pompiers* Versus Cézanne

L'Illustration has published a very tendentious article on the Camondo collection by M. Gustave Babin.

One would have thought that Cézanne's genius was today beyond question.

M. Babin's article proves that that is not the case. He dismisses Cézanne as a clumsy dauber—Cézanne, who was the glory of nineteenth-century painting! Cézanne, who with Poussin and Le Lorrain is one of the indisputable giants of French painting![55]

Such a degree of irreverence is truly incomprehensible. One wonders, in reading M. Babin, what interest a Frenchman could possibly have in denigrating a master whose talent has contributed more than any other to assuring the supremacy of contemporary French art over the art of all other nations.

But M. Babin need not worry. When the Camondo collection has been in the Louvre for fifty years, many other Cézannes will be occupying a place of honor in the French painting collections, and the Camondo canvases will go to join them.

In Tiny Pots . . .

The production of modern painters is, I believe, excessively abundant. With the exception of the most important artists, such as Picasso, Braque, Derain, G. de Chirico, etc., who make no attempt to meet the ever-increasing demand for their works, most modern painters (especially those outside France) churn out their canvases without caring whether they are bad or good.

Modern art is in danger of industrialization, and in my opinion, the young painters are finding far too many patrons.

Twenty years ago, one could buy a large canvas by Renoir from a dealer for 25 gold louis at most. The Renoir *Nude*, for example, that Rodin recently bought for 25,000 francs, was sold by Renoir in 1895 for 150 francs to a dealer who was more than happy to resell it for 400. And Renoir, at the time, was past fifty.

This should give today's young painters something to think about.

They should also think about the fact that Renoir, the greatest living painter, whose least production is hungrily awaited by a whole legion of dealers and collectors, is far from industrializing his art. Rather, he likes to relax by decorating tiny pots, thus preserving all his freshness for his paintings.

Folk Painting

The great and legitimate success of the paintings of the Douanier Rousseau has inspired collectors all over the world to look for folk or peasant paintings. Some very beautiful ones can be found in France. M. Guillaume has a remarkable collection of them. I saw a veritable masterpiece of its kind at the home of the painter Maurice de Vlaminck, and Picasso owns a matchless still-life by an anonymous painter.

In Russia, too, people have begun collecting examples of peasant art, especially the folk paintings of the Caucasus. The Russian painter Larionov owns a great many of them already. Dr. Tzanck, the well-

known Paris collector and president of the French Association of Odontologists, is also planning to take a trip to Russia to buy some of these paintings. Soffici has collected a number of remarkable works by Italian folk painters.

Nevertheless, I believe it will be hard to find another Douanier Rousseau, whose artistry and freshness are inimitable.

[J U L Y 25]

Folk Art

Folk art is definitely in vogue these days. As I wrote yesterday, people everywhere are becoming interested in it, and collectors, dealers, and museums are buying it, especially oil paintings by anonymous provincial or peasant artists.

Popular illustrations are no less in demand. A thick volume has just been published on the Épinal prints, and M. Fernand Fleuret, a very talented poet and creator of the already famous Louvigné du Dézert, is currently writing an epic poem in honor of Georgin, the epic engraver of the finest Épinal pictures.[56]

M. Fleuret's poem is well under way. There is a place in it for magic and fantasy, and the imagination that governs it is incomparable.

And so it is that a provincial artist, a modest engraver on wood who certainly never dreamed of glory, is now assured of immortality.

Georgin and Rousseau: in them, French folk art has produced two superbly powerful and accomplished artists of unparalleled freshness and originality. They have given us some of the most striking and appealing works of art of all time.

[J U L Y 26]

Art Books

We are witnessing a renaissance in the art of illustrated books. Bravo! Fine paper, woodcuts or etchings. The prices match the quality of the works: A hundred francs or even more for a slim volume of a few pages is not at all unusual.

The great writers of the nineteenth century are being reissued in luxury editions that they themselves would never have dreamed of.

The ideas of the poets and novelists will thus be transmitted to future generations.

Despite all this, almost none of the young artists are doing illustrations. It is as yet an uncrowded profession, and a most appealing one.

I have no doubt that before long we shall have a valiant phalanx of artists who will render the art of the illustrated book illustrious in the twentieth century.

[J U L Y 28]

The Problem of the Decorative Arts in Our Time

In the current issue of *L'Art décoratif*, M. Fernand Roches explores the problem of the contemporary decorative arts; never has a subject been more appropriate to the review in which it is treated.

On this point, it is worth remarking that the artists who have sought to influence the art of furniture, for example, never considered that their first task should have been to stop worrying about the destination of their decorative pieces.

If an artist starts out with the idea of designing a dining room, a drawing room, or a bedroom, he will inevitably fall back on forms that are already familiar and will modify them only imperceptibly. On the contrary, an innovator who wants to forge a new style for a period must not be concerned with what others have done before him. He must be concerned only with using, according to his inspiration, the decorative elements that his period makes available to him. They will determine their own destination.

This is but a small observation. One could make many others, if one were not certain of preaching to deaf ears; decorators, as everyone knows, are even more irritable than poets and very much more irritable than painters.

(Paris-Journal)

427

Fragonard and the United States[57]

I. "Fragonards" for exportation . . .

During the last few years, American collectors have struck a new track. The Barbizon School, which they had loved so long, and the greatest Dutch painters, with all their charm and majesty, hardly harmonized with any accompanying style in furniture and decoration, not to speak of jewelry and porcelain.

When French eighteenth-century art crossed the Atlantic, it was a revelation to the whole of Fifth Avenue. The youngest and wealthiest aristocracy in the world had at last hit upon a style doing away with the great difficulty of matching one century's paintings with another age's furniture. They had there a complete system of art answering every requirement of comfort and beauty. French eighteenth-century paintings and works of art, drawings and engravings, furniture and sculpture, bronzes and porcelain were already dear; the prices went up in leaps and bounds. The "weight in gold" became hardly an exaggeration; in many cases even these high prices were lower than the actual value.

As America is a long way off and as the art of the expert is no easy one, it often happened that works which no European amateur would touch were passed off onto the unsuspecting American buyer.

A master like Fragonard, whose works fetch very high prices, could hardly escape a misfortune which befell such modern masters as Corot. Many doubtful Fragonards crossed the Atlantic, and it is a most unfortunate occurrence as it spoils the taste of the true collector; by multiplying inferior copies, it does much harm to the genuine examples.

Of these copies, the finest are doubtless not modern; like Boucher, Lancret, and, above all, Watteau, Fragonard was much copied in his own day, and even then, mere copies were sold as genuine.

Down to the present day, in spite of the intelligence and cleverness of art historians, in spite of the minuteness of their researches, a

number of these imitations still retain an usurped rank and are labeled "Fragonard" in great collections.

II. "La Bonne Mère"

Such were my reflections on perusing in the March number of *The Lotus Magazine* an article on Fragonard,[58] published on the occasion of a private exhibition at New York.[59]

The first of the Fragonards reproduced is the much discussed *Bonne Mère* [*The Good Mother*] belonging to Mrs. S. R. Bertron and formerly in the Spitzer collection.

We have vainly searched both the catalogue of the exhibition and *The Lotus Magazine* for any reference to the doubts expressed by art historians as to the above picture. However the publishers of the catalogue (who are at the same time the owners of the galleries in which the exhibition took place) have been cautious enough to protect themselves against any possible reproach by inserting, half-concealed at the end of the catalogue, a note stating that they,

> while giving strict and careful instructions on the subject to the compiler, cannot, of course (*sic*), warrant accuracy of every fact and statement contained in their publications.

That is as much as to say that no picture in the catalogue is warranted genuine; fortunately some of them, from the old Walferdin collection, can do without a guarantee.

The editor of *The Lotus Magazine* would have done well to be as prudent: he produces Mrs. Bertron's *Bonne Mère* as "by Jean-Honoré Fragonard," an ascription which is very [far] from certain.

Mrs. Bertron's *Bonne Mère*, which is said to have cost her *one hundred and fifty thousand dollars*, is not only much discussed but also much open to discussion. Everybody knows (and it is surprising that the editor of *The Lotus Magazine* should never have heard of it) that Mr. Alvin Beaumont published in July, 1913, a memoir establishing that Mrs. Bertron's picture was not Fragonard's original *Bonne Mère* and that Fragonard's original now belongs to a Parisian collector, Mr. Arthur Veil-Picard.

His deductions are so clear that they can be summarized in a few lines.

Fragonard's *Bonne Mère* was engraved by Nicolas Delaunay, Graveur du Roi, before 1789, since it is referred to in that year as one of Delaunay's best engravings, by Basan, in his *Dictionnaire des graveurs*. Delaunay's print bears the following inscription:

> Painted by Fragonard, the King's painter—Engraved by N. Delaunay, the King's engraver—Dedicated to M. Ménage de Pressigny, farmer-general, by his very humble and very obedient servant, N. Delaunay—From the collection of M. Ménage de Pressigny.

Nothing can be clearer than all this information which has been accepted by Baron Portalis in his *Fragonard, sa vie et son œuvre*. As to the picture, we can prove that it is still in Paris: the *Bonne Mère* engraved by Delaunay as in the collection of Mr. Ménage de Pressigny, now belongs to Mr. Arthur Veil-Picard, who has obtained it from Mr. de Charette, who had it in turn from the Baron d'Aubigny, the direct heir of Mr. Ménage de Pressigny.

As for the picture exhibited in New York and engraved in *The Lotus Magazine* with the name of its present and former owners, Mrs. S. R. Bertron (of New York) and the late Frédéric Spitzer (of Paris), if we believe Mr. Alvin Beaumont, and it is very difficult not to agree with him, it is *not* the painting engraved by Nicolas Delaunay. It is not, therefore, the original of the *Bonne Mère*, since the original was engraved by Delaunay.

Neither is it the replica of the *Bonne Mère* which, according to Baron Portalis, was dedicated by the artist to his country and which last appeared in the Goman sale of 1792. The latter, as noted by Portalis, was an oblong painting 28 inches high by 33 broad (75 x 89 centimeters), whereas the picture exhibited at New York and engraved in *The Lotus Magazine* is an oval canvas 64 centimeters high and 54 centimeters broad.

We may thereupon confidently state that the picture reproduced in *The Lotus Magazine* is neither the Ménage de Pressigny *Bonne Mère*, engraved by Delaunay, nor the Goman replica sold in 1792.

Mrs. Bertron's picture shows many differences with Delaunay's engraving, which, on the other hand, coincides exactly with the

example belonging to Mr. Arthur Veil-Picard. It is useless here to enumerate all the points on which these differences bear: a number of them are self-evident. Let me only quote the branches of flowers round the cot, which, clearly visible on the engraving and on the Veil-Picard painting, are not to be found on the New York picture, which, on the whole, seems less graceful and less expressive than Delaunay's engraving.

All this and more may be found in Mr. Alvin Beaumont's remarkable memoir; but we must add to his patiently elaborated chain of reasoning an important argument. Mr. Arthur Veil-Picard's picture can be proved to have come directly from Ménage de Pressigny, since it was obtained from his heir, the Baron d'Aubigny, by Mr. Charrette, from whom it passed to Mr. Arthur Veil-Picard. The pedigree is perfect and no reasonable person can doubt that the original of the *Bonne Mère* belongs, not to Mrs. Bertron, but to Mr. Arthur Veil-Picard.

Mr. Alvin Beaumont's arguments, in spite of their clearness, were discussed and criticized. His chief opponent was my eminent *confrère* Mr. Thiebault-Sisson, who attempted to prove that the model used by Delaunay for his engraving was a drawing now belonging to Mr. David Weill. He thus did away with the great objection to Mrs. Bertron's picture being the original *Bonne Mère*. I am certain, however, that M. Thiebault-Sisson would have withdrawn his argument if he had examined the inscription below Delaunay's engraving "painted by Fragonard, the King's painter." The engraving is after a painting and not a drawing.

I may further add—and it is an excellent answer to Mr. Thiebault-Sisson's conjecture—that a number of critics believe that Mr. David Weill's drawing is a copy made after the engraving. Before it reached the present owner's hands, it was offered to Mr. Arthur Veil-Picard, who after a close scrutiny did not pass it as genuine and refrained from purchasing it.

I really think that the Editor of *The Lotus Magazine* might have allowed his readers to have the benefit of some of the facts given above, since they might have led any reasonable man to doubt the ascription of Mrs. Bertron's *Bonne Mère*: instead of being Fragonard's original,

it is perhaps only a replica or a contemporary copy, and that is by no means the same thing. But doubtless *The Lotus* was misled by the catalogue of the exhibition, which describes Mrs. Bertron's picture as the original engraved by Delaunay; of course, that is the business of the compiler of the catalogue: we cannot blame him for it since the publisher declines to take any responsibility for his assertions. But *The Lotus Magazine* is not in the same position: it owes the whole truth to its readers and in the present case it seems to have considered somewhat lightly its duties towards the American public.

III. "L'Amour" and "Folie"

Among the pictures so candidly reproduced by *The Lotus Magazine* are two companion pieces, "L'Amour" and "La Folie," stated to be by Fragonard and described in the catalogue of the exhibition as having appeared in various sales from 1785 (Marquis de Veri) to 1898 (Tabourier). *The Lotus* reproduces the pictures with part of this noble pedigree.

I have before my eyes the exact photogravure in red of the Tabourier pictures engraved by the Hector Brame process for the Tabourier auction catalogue (Paris, June 20, 1898). It is clear that they are not the pictures engraved in *The Lotus* and now belonging to Mrs. J. W. Simpson.

The *Amour Vainqueur* [*Love Victorious*] of the Tabourier sale shows two doves, which are not to be seen on the New York pictures; other differences exist in the sky, the bushes, etc. . . . Likewise, in the *Amour Folie* [*Foolish Love*] there are variants, somewhat smaller in number, but no less striking. For instance, you see in the Tabourier picture a scarf and several clouds wanting in Mrs. Simpson's painting, where the bells and pigeons are also quite different.

There are quite a number of examples in existence of *L'Amour Vainqueur* and *L'Amour Folie*; in the spring of 1914, no less than three distinct pairs of various merit appeared on the Paris market. But we believe, with M. Léandre Vaillat (*L'Oeuvre de J.-B. Chardin et de H. Fragonard*, 213 reproductions, 7 in heliogravure, introduction by Armand Dayot; Frédéric Giller, éditeur, Paris) that the original pair,

painted by Fragonard for the Marquis de Veri and sold at his sale in 1785 for four hundred and twenty-seven francs, now belong to Baron Edmond de Rothschild and are preserved in his splendid villa at Boulogne-sur-Seine.

It is evident that when the Rothschilds formed their collections, they had practically the pick of the market and that they could choose what they wanted. It seems likely that a Rothschild would have taken good care to buy the originals and not paltry copies.

The Lotus Magazine has missed an exceptional opportunity to make its readers acquainted with the treasures of private European collections.

On the other hand, it is quite unfair to represent Mrs. Simpson's pictures as the pair engraved by Janinet; they differ considerably from the engravings, which, for instance, have in the sky of the *Amour Vainqueur* two doves, which are absent from the New York picture. Who would believe that these doves were added by the engraver?

IV. "Le Moissonneur"—"Le Jardinier"—"La Bergère"—
"La Vendangeuse"—"La Cage"

Is it necessary to insist further on the inaccuracy of the article published in *The Lotus Magazine*, which slavishly copies a catalogue of which the publishers are careful not to guarantee the reliability? And yet we would have been glad to know the thought of *The Lotus* on the series of four decorative panels, *Le Moissonneur* [*The Reaper*], *Le Jardinier* [*The Gardener*], *La Bergère* [*The Shepherdess*], and *La Vendangeuse* [*The Grape Harvester*], described in the catalogue of the exhibition with the greatest praise but without any information as to their previous history.

As a matter of fact, they come from the Kraemer sale of May 5, 1913, and are described in the sale catalogue under numbers 32, 33, 34, and 35 and in the catalogue of the New York exhibition under numbers 22, 23, 24, and 25. In the latter catalogue, no reference is made either to their former or to their present owners. The following paragraph from the Kraemer catalogue has doubtless escaped the attention of the compilers of the exhibition catalogue. It is a pity that the editor of

1914

The Lotus Magazine did not transcribe it; he would have well served the interests of the American collectors who have not seen the Kraemer catalogue. The author of the latter hardly conceals his doubts; to help himself along, he has called Portalis to the rescue, but he evidently has not the courage to say that the four panels are really by Fragonard. Here is [. . .] the quotation from the Kraemer catalogue:

> We have borrowed the designations of these four paintings from a charming little work that Baron Roger Portalis has devoted to them; the following few lines, which we quote from the same work, summarize the opinion of the eminent writer on the work of Fragonard:
>
> "Although in tone and in subject—shepherdess, gardener, grape harvester, and reaper—these works recall François Boucher, their refinement and their subtlety of manner, especially in the delightful figures of women and children, are those of Honoré Fragonard. It is as though Boucher, too busy with other things, had sent Fragonard to paint in his place, and that, perhaps, was in fact what happened. Not a trace of old age or of winter, no somber tints, nothing but light playing on the blond heads of the youngsters dressed in pink and blue in a ray of sunshine.
>
> "While it is probable that Fragonard painted these four paintings under the influence of his master, Boucher, and probable that Boucher himself worked on them, and while we may hesitate to choose between two such exceptional masters, we are taking no risk whatever in pronouncing absolutely on the attribution of these four admirable panels, considering them without any doubt to be among the masterpieces of eighteenth-century French decorative art."

Under such circumstances, since we are at liberty to believe that the pictures are at the same time by Boucher and by Fragonard, we are doubtless also free to imagine that they are neither by one nor by the other. It is probably for that reason that the compiler of the catalogue preferred not to transcribe the note from the Kraemer catalogue, the author of which had perhaps his reasons not to uphold too strongly a very questionable authenticity.

We might also inquire by what accident the *four* Kraemer panels have become *five*. Where does this fifth panel *La Cage* [*The Cage*] come from and why was it not described in the Kraemer catalogue?

The preface to the catalogue of the New York exhibition informs us that it was discovered afterwards: we would like to know where and when and by whom.

The history of the four Kraemer panels is instructive in the highest degree.

They had been sold for a price stated to be seven hundred and fifty thousand francs to a lady living in the north of France. After having them expertized and finding that they were decidedly not by Fragonard, the good lady returned them to the vendor and the deal was canceled.

I have had the curiosity to ask the lady if the story was true and she has been kind enough to answer my questions by the following letter, from which I have suppressed the personal names and address.

<div align="right">June 7, 1914</div>

DEAR SIR:

In answer to your letter of May 10, Madame M——— has the honor of informing you that the four paintings have been appraised as not being the works of Fragonard.

<div align="right">Sincerely yours,
FOR MADAME M———
(Signature of a secretary)</div>

It is probable that at the time the transaction created quite a sensation; but all the persons I have questioned have remained desperately silent on the subject.

After perusal of the above letter, I cannot but congratulate *The Lotus Magazine* not to have published engravings of the four panels. It would have done better still in warning the American public against them. It is a thousand pities that the United States should become the refuge of such works which would do poor credit to one of the most charming artistic characters in the whole history of French art. Would not poor Honoré Fragonard feel dismal if he visited American collections and saw what is there ascribed to him: a few masterpieces no doubt, but also many a canvas his brush never touched?

The Arts

[J U L Y 30]

Monsieur Ingres by Bonnat

Rumor has it that M. Bonnat, not content with having done the portraits of a great number of his contemporaries, has recently been pleased to do a retrospective portrait of *Monsieur Ingres*, which he intends to exhibit at the next salon.

Now that he has perfected his time machine, M. Bonnat will perhaps continue his explorations. We may soon be seeing a whole series of portraits by him, showing David as a delegate to the Convention, Chardin exhibiting his *Ray* in the open air, Le Lorrain watching a ship set sail, Callot engraving his *Martyrdom of St. Sebastian*, Poussin composing his *Deluge*, and Rembrandt painting *The Night Watch*.

There is nothing to prevent M. Bonnat from portraying Titian, Leonardo, Raphael, and Giotto, as well. He can even go as far back as antiquity and show us the features of Zeuxis, Apelles, or the vase painter Douris.

After that, he can do a sudden about-face and devote his clairvoyant talents to portraying, not the painters of the past, but those of the future.

What would you say, for example, to a portrait of Henri Matisse at seventy, dressed in academic robes, or of Picasso at the age of a hundred and six, wearing his blue electrician's overalls? I would also recommend André Derain at ninety-five, wearing a dressing gown and playing bagpipes. A portrait of Braque at seventy-five, dancing a jig on the Pont d'Avignon would not be bad either, or Léger at sixty-eight sipping a glass of old Calvados, or De Chirico at fifty-four, lovingly contemplating a Sidonia in papier-mâché.

[J U L Y 31]

André Rouveyre

The suit brought by Mme. Catulle Mendès against the *Mercure de France* and Rouveyre after publication of a caricature of her which

she considered abusive will not come before the court during its current session, as originally scheduled. It has been rescheduled for October.

In the meantime, Rouveyre is exploring the coast of Normandy by car. He has just finished some delicate sketches of doves.

Accompanying him on his trip are three baby toads, which he treats with loving care.

These tiny beasts are providing him with an excellent subject for study, and we shall doubtless soon be seeing an album of delicate sketches devoted to them.

"They, at least, won't bring a suit against me," he says. "In any case, I think they are just as pretty as can be."

After that, Rouveyre is planning to continue his series of contemporary figures, and I have a feeling that when he grows tired of men, women, birds, and batrachians he will also produce a small album of flies. He has plenty of occasion to study them these days, for he is constantly catching them to feed to his baby toads, who are especially fond of that kind of nourishment.

All of this adds up to a good deal of work for an artist as unprolific as André Rouveyre.

[AUGUST I]

Neurosis and Modern Art

That is the title of a lecture to be given at a university for bathing beauties where I am spending the month of August. If I knew the professor who is to give the lecture, I would invite him to come and take a good look at our modern painters. After that, he could decide for himself whether neurosis or pathology had anything to do with them. I would show him André Derain, Georges Braque, Maurice de Vlaminck, and Fernand Léger, four healthy giants who couldn't be more calm and reasonable in their utterances; Picabia, a sportsman full of cool self-control; Marcel Duchamp, G. de Chirico, Pierre Roy, Metzinger, Gleizes, Jacques Villon, and many others, all intelligent and very gifted artists. Perhaps then my professor friend would decide to change, if not the title of his lecture, at least its conclusions.

(Paris-Journal)

437

1915

Living Art and the War

[MARCH 1]

A German manifesto recently reprinted in the Italian newspapers congratulated German artists on having finally been wrested by the war from the grip of the new artistic ideas of France, cubism, orphism, etc. We do not give a hoot about formulas and words ending in "ism," but artists interest us to the highest degree. Derain is in a motorcycle unit in the North, Georges Braque was recently in Le Havre as a second lieutenant, Fernand Léger is at the front with the supply corps, Albert Gleizes has been at the front since the outbreak of the war, and Dufy is in Le Havre, waiting; he has published a pretty postcard, *The Allies*, which will take its place among the marvelous illustrations that have spontaneously bloomed in this war. R. de La Fresnaye is doubtless still in Lisieux. Groult suffered an arm wound. The sculptor Duchamp-Villon is a medical aide in Saint-Germain; the painter and engraver Laboureur is at the Château of Nantes, serving as an interpreter for the British army. Tobeen, that man of iron, is serving in the noncombatant corps, where he has been practicing to become a man of steel. The Italian futurist Ugo Giannattasio and the Austrian-Pole Kisling are in foreign infantry regiments. There was a rumor that Robert D——[1] is in San Sebastián, but I cannot bring myself to admit the truth of this unlikely assertion. Robert Mortier is slowly recovering

1 9 1 5

from a painful illness. He needs infinite care and a great deal of calm. Édouard Férat is working hard in a hospital.

Drésa is a corporal in a battery of 100 in the Tenth Artillery, to which he was transferred from the Fifty-fifth Artillery in Orange.

Picasso, whose health is too weak to allow him to do anything other than his invaluable work as an artist, "has outdone Ingres in his admirable drawings without even trying," according to a letter I received from the anonymous author of the excellent preface to the catalogue of the *Peau de l'ours*.

Natalia Goncharova and Mikhail Larionov, who were in France when the war broke out, were able to return to Russia. Larionov, serving as a sergeant in one of the regiments that invaded East Prussia, was wounded near the Masurian Lakes.

The painter Zak, whose native city is still in the hands of the Prussians, is languishing, in ill health, in the sunshine of Nice. Also living in Nice is the sculptor Archipenko, whose wife sends sweaters to their friends in the French Army.

Rouveyre, after serving for some time in the armed services, has been transferred to noncombatant duty because of illness; he is now writing poems in honor of his gunner friends. Marie Laurencin is living and working in Madrid.

Henri Matisse has been kept in the noncombatant corps.

Since these details require no commentaries, I shall close up shop. Besides, I have things to do.

[APRIL 1]

[. . .] Francis Picabia must now be at the front as a painter; there is no doubt that he will capture unforgettably the authentic face of the war. We know that Fernand Léger, transferred from the supply corps to the engineer corps, has asked to be sent to cut German barbed wire. Pierre Roy, a supply-corps soldier, will be leaving as a corporal.

Raoul Dufy has also just been assigned to the supply corps. Before he left, his famous *Allies' Handkerchief* was published; it is an absolutely lovely work that will perhaps remain the most beautiful picture to come out of this war, which has seen a renaissance in the art of popular illustration.

René Prath, who was honorably discharged after a probationary period in a field-artillery regiment, is asking to be sent to the front as

a painter. The painter Sainturier, too old to serve in the army, is quietly working at his home in Nîmes.

Juan Gris is doing some very interesting experiments. Zuloaga is in Madrid.

I have no news at all of Derain.

G. de Chirico is calmly painting his tragic and fateful scenes; he is waiting philosophically for the end of the war.

(*Le Petit Messager des Arts et des Industries d'Art*)[2]

1916

[A Letter from M. Guillaume Apollinaire]

At the Front, February 8, 1916

To the Editor:

Having read the article written by my friend Severini,[1] I realize that he has not wholly understood the meaning of my classification, which, moreover, never claimed to be definitive as far as individual artists were concerned.

When I applied the term "scientific" to the art of Picasso and Braque, I meant above all that these artists knew more than the others. . . .

But a great deal of water has flowed under the bridge since I wrote those words, and today many painters know much more than they did. Such is the case (and what greater praise can one give him?) with my friend Severini, whose exhibition I was very sorry not to be able to visit.

I wish him all the success that his very great talent deserves.

He must surely be aware of the very real interest with which I am following the evolution of his art and of the ideas that govern it.

I am, my dear sir,

Very sincerely yours,
GUILLAUME APOLLINAIRE

(*Mercure de France*, MARCH 1)

443

André Derain

It was the German aestheticians and painters* who invented academi-
cism, that fake classicism which true art has been struggling against
ever since Winckelmann, whose pernicious influence can never be ex-
aggerated. It is to the credit of the French school that it has always
reacted against his influence; the daring innovations of French painters
throughout the nineteenth century were above all efforts to rediscover
the authentic tradition of art.

Although it is difficult to characterize the art of the contemporary
French school, one can, nevertheless, safely say that the aim of this
school has always been to submit itself boldly to the disciplines of the
great tradition.

The future will tell how successfully it has accomplished its aim.
But whatever one might say, such sincere, detached, and courageous
efforts could not possibly have been wasted whenever they were sup-
ported by talent and knowledge.

These lines sum up perfectly the case of André Derain who is
currently at the front driving a tractor in a heavy-artillery division
and who is considered one of the most outstanding painters of the
contemporary French school.

There are works by André Derain in many foreign museums. There
are none in any French museum, and yet, Derain is not exactly
unknown.

The rich earthiness of the decorations he exhibited ten years ago
profoundly affected, not only the art of a great many painters, but also
the arts of the street—signboards, posters, newspapers with colored
illustrations—as well as woodcuts, pottery, furnishings, and even dress
design. This influence can still be felt in popular illustrations, posters,

* It must be noted that no artistic school exists in Germany today. Only
an industrial potpourri of every style and archaism imaginable, whose devel-
opment, however, it would be useful to study.

444

and dress design. In other fields, it has been superseded by the artificial good taste, the fake theatrical elegance that came to us directly from Vienna, Munich, and Berlin.

Derain has studied the great masters passionately. The copies he made of their works indicate how intensely he wanted to understand them. At the same time, by a stroke of unequaled daring, he went beyond the most audacious experiments of contemporary art in order to rediscover the simplicity and freshness of the first principles of art, and the disciplines to which these principles give rise.

After his youthful earthiness, Derain turned toward sobriety and measure. These efforts gave rise to works whose greatness occasionally borders on religiosity, and in which some critics, for reasons I cannot fathom, have insisted on finding traces of archaism.

Derain's art is now imbued with that expressive grandeur that stamps the art of antiquity. It comes to him from the great masters and also the old French schools, especially the school of Avignon; but factitious archaism is wholly absent from his work. It is like the classical art of a Racine, who owed so much to the Ancients yet whose work bears not a trace of archaism.

In the works that André Derain is exhibiting today, the viewer will thus recognize a temperament both audacious and disciplined. And a great many of his recent works are very moving because of the traces they retain of the enormous labor necessary to reconcile these two tendencies. He is close to attaining his aim, which is to realize a blissful harmony, at once realistic and sublime.

It is by encouraging boldness and tempering temerity that one produces order. But to succeed in this requires a great deal of detachment.

André Derain is one of those perfectly detached artists.

He has blazed the way for a great number of painters, which does not mean that some of them will not lose their way. Nevertheless, they must follow his example all the way and never stop daring—for daring constitutes the true measure of discipline.

The organizers of this exhibition must also be praised. The fact that artistic activity continues while the nation is at war is an excellent sign.

For a long time now, Germany has not produced a great artist, and

1916

the war has not provided a stimulus for art in that country. The artistic impotence of contemporary Germany is a fact that cannot be overlooked. As far as we know, the hordes of Attila were not artists either.

(Album-catalogue de l'Exposition André Derain,
Paul Guillaume Gallery, OCTOBER 15–21)[2]

The Wonderful Flowering of French Art

Our period is unlike any other. And those who do not realize this do not understand anything about the times they live in. They have eyes but they see not how new and perfect, how bold and beautiful, how young and sensitive and strong we are!

France today is like ancient Greece: the models it offers to a charmed world will provide subjects for meditation for centuries to come, and will be studied and imitated by thousands of artists in every nation.

Probably no country in the world is better prepared to commune with French art than Norway, whose powerful genius brought new life to the dramatic arts at the end of the last century.

Indeed, no other country knows our new school of art better than Norway.

Long in possession of a fine collection of French nineteenth-century paintings, including Delacroix, Daumier, and the impressionists, the National Museum of Norway has already exhibited works by the masters honored by today's young painters—Cézanne, Gauguin, Van Gogh, Picasso—and private collectors take pride in owning works by Seurat, Matisse, Derain, Friesz, Dufy,[3] R. de La Fresnaye, etc.

Paraphrasing a famous line by Voltaire, I would say to you, oh, shining country of the North:

"It is from France today that you receive your light."[4]

The light of France glows wonderfully in all the works that the organizers of this exhibition are offering for your enthusiastic admiration. These organizers are artists—and not only young artists—who have lived in Paris and have a thorough knowledge of French art.

The first result of their efforts will be to create a bridge between

446

French and Norwegian artists; until now, the works of French painters always had to pass through intermediaries before reaching Norway.

This occasion is a testimony to the friendship that Norwegian artists bear toward us; for this, we can never thank them enough.

They have chosen this painful and glorious time of war to show you that, even in the midst of turmoil, and without in the least adopting a position above the fray, French artists have not shirked the pacific and sublime duty imposed on them by the lofty tradition of French civilization.

Modern French art, which has victoriously resisted so many assaults, certainly dominates today the world over, and no other can challenge it.

Intelligent and ever open to ideas, France continues to pursue, even in this period of war, the civilizing mission bequeathed to it by Greece and Rome—a mission to which it is the rightful heir, being the world's most accomplished, most sensible, and most temperate nation.

Here, then, is the art of young France, inspired by moderation, liberty, and pride.

The French genius is a light that illuminates the world without blinding it, a light so mellow that one can scrutinize its depths at will.

(Catalogue of *Den Frankse Utstillung*,
Kunstnerforbundet, Oslo, NOVEMBER–DECEMBER)[5]

Art and the War: Concerning an Allied Exhibition

An association has just been founded "for the defense and affirmation of modern works." On this occasion, we asked M. Guillaume Apollinaire, the habitual spokesman for the most avant-garde artistic doctrines, to give us an article that we publish herewith purely for its documentary value. Of course, it goes without saying that the ideas expressed by M. Guillaume Apollinaire are solely his own and that the hospitality here accorded to his article does not imply that we are wholly in agreement with the convictions he expresses.

Having made these reservations, we are happy to present to our readers a defense that we believe may interest them by keeping them abreast of one of the most recent developments in ultramodern art.

1 9 1 6

A certain press has succeeded in making the French public believe that "modern" is synonymous with "boche." And taking advantage of the *union sacrée* as well as of the fact that the majority of modern artists are of fighting age and serving in the Army, certain journalists are seizing every opportunity to fling the epithet "boche" at their heads.

The trend, however, is beginning to be reversed. As M. Raoul Ponchon himself recently declared, not without a trace of ill-humor: "Cubism is not boche." Also, in response to some articles by my colleague Roger Allard, M. Louis Dimier, who can hardly be suspected of favoring anything even vaguely associated with the word "boche," went so far as to write for *L'Action française* an article that treated cubism without antipathy.

In fact, the Germans have distinguished themselves very little in modern art; confining oneself simply to the field of painting and, within that, to its most avant-garde movement, cubism, one cannot cite a single German name worth mentioning. And yet before the war, there were a great many boche painters in Paris, but none of them succeeded in making even a minor name for himself in the modern school that was flourishing in France.

Actually, cubism and its sister movement, futurism, are so essentially the products of Latin civilization that the small number of artists who constitute these schools—or rather, this school—are all French, Spanish, or Italian.

The bilious censors who are so eager to label anything they do not like "boche" might have seen that the modern school of painting had victoriously and with the most admirable courage fought against academicism. And academicism, which *is* of boche origin, will not recover from the battle.

If those in authority had been aware of this, we would not now have this regrettable Allied exhibition at the Luxembourg Museum. What we are being shown here are the most academically Winckelmannian works of Italy and England, gathered under one roof by people whose incompetence is at times overwhelmingly Ruskinian.

It is truly a pity to see how indifferent the authorities are to the art that constitutes the glory of France in the eyes of foreigners.

People are saying that we must organize good-will exhibitions in neutral countries; we ought to take this opportunity to modernize our unfortunate Luxembourg Museum, which never failed to astonish

foreigners who came to Paris and were scandalized to find how little weight was accorded in France to French painting.

Today, any one who has strolled through the rooms of our national museum devoted to the works of living artists will easily understand why an association, Art and Liberty, was recently formed for the affirmation and defense of modern works of art.

(*Paris-Midi*, DECEMBER 9)[6]

PABLO PICASSO

Voyez ce peintre il prend les choses avec leur ombre aussi et d'un coup d'œil sublimatoire
Il se déchire en accords profonds et agréables à respirer tel l'orgue que j'aime entendre
Des Arlequines jouent dans le rose et bleus d'un beau-ciel Ce souvenir revit
les rêves et les actives mains Orient plein de glaciers L'hiver est rigoureux
Lustres or toile irisée or loi des stries de feu fond en murmurant.
Bleu flamme légère argent des ondes bleues après le grand cri
Tout en restant elles touchent cette sirène violon
Faons lourdes ailes l'incandesce quelques brasses encore
Bourdons femmes striées éclat de plongeon-diamant
Arlequins semblables à Dieu en variété Aussi distingués qu'un lac
Fleurs brillant comme deux perles monstres qui palpitent
Lys cerclés d'or, je n'étais pas seul ! fais onduler les remords
 Nouveau monde très matinal montant de l'énorme mer
 L'aventure de ce vieux cheval en Amérique
 Au soir de la pêche merveilleuse l'œil du masque
 Air de petits violons au fond des anges rangés
 Dans le couchant puis au bout de l'an des dieux
 Regarde la tête géante et immense la main verte
 L'argent sera vite remplacé par tout notre or
 Morte pendue à l'hameçon... c'est la danse bleue
 L'humide voix des acrobates des maisons
 Grimace parmi les assauts du vent qui s'assoupit
 Ouis les vagues et le fracas d'une femme bleue
 Enfin la grotte à l'atmosphère dorée par la vertu
 Ce saphir veiné il faut rire !
 Rois de phosphore sous les arbres les bottines entre des plumes bleues
 La danse des dix mouches lui fait face quand il songe à toi
 Le cadre bleu tandis que l'air agile s'ouvrait aussi
 Au milieu des regrets dans une vaste grotte.
 Prends les araignées roses à la nage
 Regrets d'invisibles pièges l'air
Paisible se souleva mais sur le clavier musiques
Guitare-tempête ô gai trémolo
O gai trémolo ô gai trémolo
Il ne rit pas l'artiste-peintre
Ton pauvre étincellement pâle
L'ombre agile d'un soir d'été qui meurt
Immense désir et l'aube émerge des eaux si lumineuses
Je vis nos yeux diamants enfermer le reflet du ciel vert et
J'entendis sa voix qui dorait les forêts tandis que vous pleuriez
L'acrobate à cheval le poète à moustaches un oiseau mort et tant d'enfants sans larmes
Choses cassées des livres déchirés des couches de poussière et des aurores déferlant !

GUILLAUME APOLLINAIRE

1917

Pablo Picasso

See this painter he takes things with their shadows too and with a sublimatory glance
He tears himself into harmonies deep and pleasant to inhale such as the organ I love to hear
Harlequins play in the pink and blue of a Beautiful sky That memory lives again
he dreams and the active hands Orient full of glaciers Winter is harsh
Chandeliers gold iridescent canvas gold law of the streaks of fire melts with a murmur
Blue light flame silver of waves blues after the great cry
Even while remaining they play that siren violin
Fawns heavy wings incandesce a few strokes more
Bumblebees streaked women blaze of diamond-dive
Harlequins resembling God in variety As distinguished as a lake
Flowers shining like two giant pearls that quiver
Lilies circled with gold I was not alone! make regrets undulate
New morning world rising from the enormous sea

The adventure of that old horse in A m e r i c a
On the night of the marvelous catch the eye of the mask
Airs on small violins in the depths of the angels lined up
In the sunset then at the end of the year of the gods
Look at the immense giant head the green hand
Silver will quickly be replaced by all our gold
Dead woman hanging on the hook . . . it's the blue dance
The humid voice of the acrobats of the houses
Grimace amidst the attacks of the wind which subsides
Listen to the waves and the crash of a blue woman
At last the grotto's atmosphere is gilded by virtue
That veined sapphire makes one laugh!
Ring of phosphorus beneath the trees the ankle-boots between blue feathers
The dance of the ten flies faces him when he thinks of you
The blue frame while the agile air also opened up
 In the midst of regrets in a vast grotto
 Take the pink spiders swimming
 Regrets of invisible traps
Peacefully arose but on the keyboard the air
Guitar-tempest melodies
Oh gay tremolo oh gay tremolo
He does not laugh oh gay tremolo
Your poor the artist-painter
The nimble shadow pale sparkling
Immense desire of a dying summer evening
saw our eyes and dawn so luminous emerges from the waters
heard his voice diamonds enclose the reflection of the green sky and
The acrobat on horseback the mustachioed poet a dead bird and so many tearless children
Broken things torn books layers of dust and dawns unfolding!

(*SIC*, M A Y)[1]

Parade

Definitions of *Parade* are blossoming everywhere, like the lilac bushes of this tardy spring. . . .

It is a scenic poem transposed by the innovative musician Erik Satie into astonishingly expressive music, so clear and simple that it seems to reflect the marvelously lucid spirit of France.

The cubist painter Picasso and the most daring of today's choreographers, Léonide Massine, have here consummately achieved, for the first time, that alliance between painting and the dance, between the plastic and mimetic arts, that is the herald of a more comprehensive art to come.

There is nothing paradoxical about this. The Ancients, in whose lives music played such an important role, were totally unaware of harmony, which constitutes the very basis of modern music.

This new alliance—I say new, because until now scenery and costumes were linked only by factitious bonds—has given rise, in *Parade*, to a kind of surrealism,[2] which I consider to be the point of departure for a whole series of manifestations of the New Spirit that is making itself felt today and that will certainly appeal to our best minds. We may expect it to bring about profound changes in our arts and manners through universal joyfulness, for it is only natural, after all, that they keep pace with scientific and industrial progress.

Having broken with the choreographic tradition cherished by those who used to be known, in Russia, under the strange name of "balletomanes," Massine has been careful not to yield to the temptation of pantomime. He has produced something totally new—a marvelously appealing kind of dance, so true, so lyrical, so human, and so joyful that it would even be capable (if it were worth the trouble) of illuminating the terrible black sun of Dürer's *Melancholy*. Jean Cocteau has called this a realistic ballet. Picasso's cubist costumes and scenery bear witness to the realism of his art.

This realism—or this cubism, if you will—is the influence that has most stirred the arts over the past ten years.

The costumes and scenery in *Parade* show clearly that its chief aim has been to draw the greatest possible amount of aesthetic emotion from objects. Attempts have often been made to return painting to its barest elements. In most of the Dutch painters, in Chardin, in the impressionists, one finds hardly anything but painting.

Picasso goes further than any of them. This is clearly evident in *Parade*, a work in which one's initial astonishment is soon replaced by admiration. Here the aim is, above all, to express reality. However, the motif is not reproduced but represented—more precisely, it is not represented but rather suggested by means of an analytic synthesis that embraces all the visible elements of an object and, if possible, something else as well: an integral schematization that aims to reconcile contradictions by deliberately renouncing any attempt to render the immediate appearance of an object. Massine has adapted himself astonishingly well to the discipline of Picasso's art. He has identified himself with it, and his art has become enriched with delightful inventions, such as the realistic steps of the horse in *Parade*, formed by two dancers, one of whom does the steps of the forelegs and the other those of the hind legs.

The fantastic constructions representing the gigantic and surprising figures of The Managers, far from presenting an obstacle to Massine's imagination, have, one might say, served to give it a liberating impetus.

All in all, *Parade* will change the ideas of a great many spectators. They will be surprised, that is certain; but in a most agreeable way, and charmed as well; *Parade* will reveal to them all the gracefulness of the modern movements, a gracefulness they never suspected.

A magnificent vaudeville Chinaman will make their imaginations soar; the American Girl cranking up her imaginary car will express the magic of their daily lives, whose wordless rites are celebrated with exquisite and astonishing agility by the acrobat in blue and white tights.

(Program for *Parade*, M A Y 18)

1 9 1 7

[Letter to the *Mercure de France*]

Paris, September 22, 1917

T o t h e E d i t o r :

In the July 1, 1917, issue of the *Mercure de France*, M. Gustave Kahn published a few lines about cubism in which he cast doubt upon the origin of this school of painting, which he called Spanish: "If cubism comes from Picasso," etc.

All the credit for this "creation"—if credit there is—must unquestionably be attributed to Pablo Picasso and Georges Braque. They are the real "creators" of a school that could consequently be classed as Franco-Spanish or, more simply, as Latin.

It is true that since the war this school has become so widespread that it could practically be called cosmopolitan, were it not for its significant absorption of Italian futurism, which once again affirmed its Latinity. Consequently, it is accurate to call a school whose principal adherents are Frenchmen, Spaniards, and Italians a Latin school. Furthermore, since the cubist school was born on French soil and since the artists who compose it all work in Paris, it could also be called a Parisian school.

Having no special mandate to reply to M. Gustave Kahn's assertion, I would doubtless have refrained from offering you my testimony as an impartial spectator, were it not for the fact that the problem raised by the eminent art critic of the *Mercure de France* was subsequently reproduced by various other publications, notably *L'Affranchi* of September 20, 1917.

I thought that it would be useful on this occasion to define more precisely the role played by such remarkable artists as Second Lieutenant Georges Braque, who recently underwent trepanning after suffering a head wound and who has just been decorated with the cross of the Légion d'Honneur and the Croix de Guerre for combat duty.

Brothers in arms owe each other such small services when the cause of justice is at stake.

If, however, M. Gustave Kahn does not consider himself sufficiently enlightened by my words, he may turn for further instruction to painters such as Messrs. Henri Matisse, Maurice de Vlaminck, André Derain, and Juan Gris, or to art critics such as André Salmon, Maurice Raynal, etc., all of whom can be said to have witnessed the birth of cubism.

I remain, my dear sir,

Sincerely yours,
GUILLAUME APOLLINAIRE

(*Mercure de France*, OCTOBER 16)

1918

Henri Matisse

Every painting, every drawing by Henri Matisse possesses a certain virtue that one cannot always define but that always strikes one as an authentic force. It is the artist's strength that he does not attempt to oppose this force but allows it to act as it will.

If one were to compare Henri Matisse's work to something, it would have to be an orange. Like the orange, Matisse's work is a fruit bursting with light.

Inspired by a total good faith and by a genuine desire to know and to realize himself, this painter has never ceased following his instinct. He allows his instinct to choose among his emotions, to judge and delimit his fantasy, and to look searchingly into the depths of light, nothing but light.

With the years, his art has perceptibly stripped itself of everything that was nonessential; yet its ever-increasing simplicity has not prevented it from becoming more and more sumptuous.

It is not mere skill that has made this art simpler and this work more intelligible. Rather, as the beauty of light has gradually become merged with the power of the artist's instinct—an instinct in which he trusts implicitly—all the obstacles to this union have disappeared, the way memories sometimes melt into the mists of the past.

Picasso

Picasso is the heir of all the great artists of the past. Having suddenly awakened to life, he is heading in a direction that no one has taken before.

He changes direction, retraces his steps, starts out again with a surer, ever-larger step; he gains strength from his contact with the mysteries of nature or from comparisons with his peers of the past.

Every art has its own lyricism. Picasso is often a lyrical painter. He offers a thousand opportunities for meditation, all animated by life and thought and illuminated by an internal light. Beyond that light, however, lies an abyss of mysterious darkness.

In Picasso, talent is augmented by will and patience. The aim of all his experiments is to free art from its shackles.

Is his not the greatest aesthetic effort we have ever witnessed? He has greatly extended the frontiers of art, and in the most unexpected directions, where surprise awaits us like a stuffed rabbit beating a drum in the middle of the road.

The proportions of his art are becoming ever more imposing, without losing any of their grace.

You think of a beautiful pearl.

Cleopatra, do not dip it into vinegar!

(Preface to the *Catalogue de l'Exposition Matisse-Picasso*,
Paul Guillaume Gallery, JANUARY 23–FEBRUARY 15)[1]

Echoes

Nord-Sud. Is *Nord-Sud*, the monthly review of young writers—including Guillaume Apollinaire, Pierre Reverdy, Max Jacob, Paul Dermée, Roch Grey, and Philippe Soupault—about to die? It is possible. The review's editor in chief, Pierre Reverdy, is complaining about the lack of encouragement and support he is encountering.

But is it not typical of our time that such endeavors should be able to complain about a lack of support!

"In my day, artists did not 'make it'!" Degas told a young painter who had expressed a desire for success.

The exodus of the painters. The avant-garde painters who have not been called up seem to prefer the Midi to the bombardments of Paris. Matisse, for example, is living in Nice, and Kisling has gone to join Iribe and Signac on the Mediterranean coast. Juan Gris, Ortiz de Zárate, Modigliani, Van Dongen, and Georges Braque are also leaving Paris for the countryside around Avignon.

But Picasso stays, impassive, in his Montrouge, on the edge of Paris.

"Before the war we had buses, and now we have Big Bertha. Who knows whether the former did not kill more people than the latter?" declares Picasso jokingly, and he may have a point.

(*L'Europe nouvelle*, A P R I L 6)[2]

Van Dongen

One morning in February, I was looking out of Van Dongen's studio, watching the misty summits of the Bois de Boulogne merge into an atmosphere of incomparable delicacy. Behind me, the artist who likes to sign his works simply "the Painter" was busy moving some canvases. He picked one out and set it up facing the light. At that moment, I turned around to see what he was doing. I saw a modern, naked woman wearing a large hat, and it was as if she were inviting all the women who had ever reigned by their beauty or their wantonness to come crowding around her.

But art, in any case, has very different designs! . . .

The austere zeal of the contemporary arts has generally banished everything that elicits the transport of the senses.

Today, everything that touches on the voluptuous is surrounded by grandeur and silence. But voluptuousness survives among the extravagant figures of Van Dongen, with their violent and desperate colors.

The blaze of made-up eyes sharpens the novelty of the yellows and pinks, the spiritual purity of the cobalt blues and ultramarines shaded to infinity, the dazzling reds ready to die for passion.

This nervous sensuality, so young and fresh, is composed only of light; these colors, so magical and so suggestive, are, as it were, incorporeal.

This colorist was the first to take the sharp glare of electric lights and add it to the scale of nuances.

The result is an intoxication, a vibration, a bedazzlement; color, even while preserving an extraordinary individuality, swoons, flares up, soars, pales, and disappears without ever having been darkened by so much as the idea of a shadow.

And yet, shadow keeps watch in the form of a Negro. Shadow, lushness, mystery, movement is here a synonym for joy, and the wild glances tell of ineffable suffering.

This painter does not express life in incandescent colors; he does, however, translate it with vehement precision.

European or exotic as he chooses, Van Dongen has a violent, personal sense of Orientalism.

His paintings often smell of opium and amber. The immensely widened eyes seem to be abysses of sensuality in which joy becomes one with pain.

Occidental magic has also produced its effects: dances infinitely swaying in the raw shades ripened by electric lights; the dandyism of race tracks; sober and refined elegances in which one finds characteristics that pleased the turbulent but informed mind of Baudelaire.

Luxe, calme et volupté.

This verse from *L'Invitation au voyage* could serve here as a motto: a frightening lushness that is not without a touch of Northern barbarism; the panic calm of high noon during Southern summers; last of all, voluptuousness, a voluptuousness of crystal.

In some of the large canvases, colors rear up, combining in themselves a terror contained in the flaming of great jewels. At times a wave of dazzling blue tries to struggle with a pale skin and elongated dark-ringed eyes. A bizarre light is born from this encounter between the sky and unfulfilled desire.

Van Dongen often touches on the frontiers of folk art; he has

also gauged the limits of decorative art; he is the first artist in a long time to have succeeded in demonstrating the virtues of the nude, which the academic painters had totally discredited by depriving it of grace, harmony, and natural colors. Van Dongen has rediscovered the color of flesh.

How is one to define this curious blaze of flashes as precious as jewels, this mixture of naturalism and sensual poetry?

The term "Orientalism" might perhaps be adequate, were it not intermingled with a certain Northern reverie, so tender that the frenzy of colors sometimes subsides like the shadow of a barge gliding on a canal at night beneath the tumultuous sky of the pensive Zeelands.

(*Les Arts à Paris,* MARCH 15)[3]

News and Views of Literature and the Arts

[APRIL 13]

After a long apprenticeship under the influence of Gauguin and then of Cézanne, the young Italian futurist painters woke up one fine day to find themselves, without knowing exactly why or how, in the orbit of Picasso. Moreover, one of them, who lives in Paris, felt the change so keenly that he renounced futurism and started to call himself a cubist.[4]

Today, the young Italian futurists have found a new master in the person of their compatriot Giorgio de Chirico, who worked in Paris before the war.

De Chirico, incidentally, has a highly personal style; he may be the only living European painter who has not been influenced by the new French school.

[APRIL 20]

The group of seven colored postcards that make up *La Pochette de la marraine* will be in great demand. These cards were designed by talented artists such as Lucien Laforge, Jules Depaquit, Gus Bofa, etc.

But the most noteworthy thing about this work of modern art

and imagination is that the publishers have had the excellent and generous idea of sharing their profits with the artists themselves.

They have thereby set a precedent that will doubtless be followed by other publishers of art works.

[APRIL 27]

At the exhibit of "theatrical costumes and decorations" by M. Mikhail Larionov and Mme. Natalia Goncharova, people noticed with a great deal of interest that the two artists left the gallery accompanied by M. Firmin Gémier. M. Gémier is just now in the process of preparing his next production for the Nouveau Cirque, located across the street from the Sauvage Gallery, where the exhibition is being held. After his production of *Aristophanes* in a circus arena, perhaps M. Gémier is now thinking of collaborating on a play with the two decorators the Ballets Russes have introduced to us. Mme. Goncharova, it will be recalled, did the marvelous set designs for *Le Coq d'or* at the Opéra in 1914, and Mikhail Larionov did the sets for last year's remarkable production of *Contes russes*.

For some time now, M. Ambroise Vollard has been working on a curious play about our colonial administration. The hero of this hilarious work is to be none other than Ubu, the king of Poland lovingly created by Alfred Jarry. The projected title of the play is *Ubu aux colonies*. When Jarry's publisher, M. Fasquelle, first heard about M. Vollard's work, he objected to it on the grounds that it would appear as an imitation of Jarry that might be detrimental to the long-awaited reissue of Jarry's own *Ubu-roi*. These fears, however, were unfounded, and M. Ambroise Vollard, who had been a friend of Jarry's and who had published the second volume of *L'Almanach du père Ubu*, finally succeeded in convincing Jarry's publisher and his heirs of his perfect good faith. *Ubu aux colonies* is in no sense an imitation of *Ubu-roi*. If Vollard chose Père Ubu as his hero, it was partly to pay homage to the genius of Alfred Jarry, and the publication of *Ubu aux colonies* will help to popularize the name of a character who will soon become proverbial, like Gargantua, Panurge, Pantagruel, Gulliver, or Robinson Crusoe.

Ubu aux colonies will soon be published, therefore, with illustrations by Rouault, and M. Ambroise Vollard will not be obliged to

substitute Panurge or Gulliver for Ubu, which he considered doing at one time.[5]

We may recall, in this connection, that M. Vollard recently published a private edition (private because of our implacable censors) of a brief Spartan farce entitled *Ubu à l'hôpital.* It was much appreciated even by doctors, and was staged on the front by the members of a medical corps.

[MAY 4]

André Salmon's *Manuscrit trouvé dans un chapeau,* a work mixing verse and prose, is scheduled to be published soon with forty reproductions of drawings by Picasso dating from the so-called rose period.[6] Parts of this work originally appeared in 1905, in a little magazine that had only two numbers. The first number of this rare publication was entitled *La Revue immoraliste*; the second number, of which only thirty copies are still in existence, appeared under the less aggressive title of *Revue des Lettres françaises.*[7] It was this review that published the first poems of Max Jacob.

[MAY 11]

Opinions flew thick and fast among the crowd attending the Degas exhibition at the Georges Petit Gallery.[8]

"Did you notice," said a painter to his poet friend, "that in Degas's collection, which was sold recently,[9] there were works by practically everyone—Gauguin, Cézanne, Jeanniot—but *there was not a single Toulouse-Lautrec*? Today, I finally understand why."

An American officer who had just finished his tour of the large exhibition room had only one word to say: "Horrors!"

A bourgeois with a hare-lipped wife said to her, loud enough for everyone to hear: "Obviously, the people who like this stuff don't have eyes constructed like ours."

M. Elémir Bourges had come to take a look. He said to a friend of his: "I came because I want to have peace in my old days. If I had not taken the trouble, my life would have been poisoned by all the connoisseurs who would have pitied me for having missed these masterpieces. This way, I have nothing to worry about, and I will be able to tell them exactly how bad I think these works are."

Some art-lovers, on the other hand, were ecstatic. M. Clément-

1 9 1 8

Janin said: "Ha! Would you believe it! These wonders have been hidden from us all this time!"

Someone who overheard him observed sadly: "Come now, Degas knew exactly what he was doing. His secretiveness ensured his fame. He was too good at demolishing the painting of others to be unaware of the faults of his own."

"A genre painter!" observed a lady writer.

"What a miracle of light!" cried a great art critic.

"A great painter!" declared another critic sententiously, "but the state paid a high price for the painting it has just bought."

"It is the war," remarked a shrewd art dealer, and he had a point. "There is no shortage of money. For that price, you could not buy a fine necklace today."

In the meantime, M. Hermann-Paul was looking and admiring.

[MAY 18]

Ferdinand Brunetière did not think that art should provide pleasure, and in this conception, he was close to Tolstoy. In a letter unpublished in France, which he wrote in 1900 to Giovanni Lanzalone, author of *L'Arte voluttuosa*, Brunetière expressed himself as follows:

"It is with the greatest pleasure and not without a certain pride that I accept the dedication of your book on or against *L'Arte voluttuosa*. In Italy, as in France, it seems that since art today is no more than an instrument of pleasure and consequently an instrument of corruption, one cannot fight too energetically against the danger inherent in such a conception of art. It threatens morality first of all, but I would say that it is a fatal threat to art itself. . . . Morality is not art, and art is not morality, but the two cannot be separated with impunity. There is a distinction to be made, however; morality without art remains exactly what it is, whereas art without morality is nothing but charlatanism—first of all useless, second unhealthy, and last of all perverse."

The artist André Rouveyre, who was on active duty at the Saint-Cyr air base, is gravely ill and has been transported to the Villa Molière. He was recently at the front to make sketches for a book on the war. He was also preparing some other works, notably an impressive series of sketches representing the various stages of the

death of Mécislas Golberg, that strange, lyrical Polish-Jewish philosopher who trailed his tuberculosis around with him for such a long time all over Europe. Finally settling in France, he became a friend of the poet Emmanuel Signoret and the teacher of a certain number of contemporary political figures who have doubtless forgotten him.

[JUNE I]

The greatest contemporary Swiss painter, Ferdinand Hodler, has just died. In his lifetime, he had been compared to Michelangelo and to Rodin. Although these tributes were excessive, he was nevertheless a great artist. He had enjoyed great success in Germany, and in fact he was a hundred times better than the German artists who were his contemporaries. His symbolism was, in fact, very Teutonic. His *idée fixe*, a method of composition he called parallelism, which spoils some of his most important works, was just the thing to appeal to the official or academic aestheticians of Berlin and Jena.

All this only adds to his credit for having signed the protest by Swiss artists against the bombardment of the Reims cathedral.

Since he had come to the defense of violated art, Hodler was cursed by the Germans; the University of Jena removed his famous decoration, *The Departure of Volunteers from Jena in 1813*, and wanted to sell it at auction. But the offers did not come up to the asking price, and the famous university was obliged to hang on to its gigantic Épinal illustration.

[JUNE 8]

We have just learned of the death of the painter Maufra, who had been a member of Gauguin's entourage but whose art had not been influenced at all by the symbolist school of Pont-Aven.

Maufra liked to proclaim his indebtedness to the first impressionists, Monet, Sisley, etc. Nevertheless, he owed much more to the landscape schools that had preceded them: the Barbizon school, Rousseau, Corot, etc.

He was an interesting artist, without, however, possessing a very powerful personality. He had a rather strong feeling for nature.

Maufra died the way every painter doubtless wishes to die: He was painting a landscape in the Sarthe when he suddenly fell dead, still clutching his brush and leaving his canvas unfinished.

465

1 9 1 8

With him, the open-air school has lost one of its finest representatives.

[J U N E 15]

It is well known that Rodin never wanted to do the portrait of M. Anatole France. He never actually categorically refused to do it, but once when certain mutual friends sounded out the sculptor from Meudon about doing a bust of the author of *Les Dieux ont soif,* Rodin replied: "I would rather not. If you want to know what I think of your Anatole France: *There is plenty of sauce, but no rabbit.*"

On the other hand, when one of Rodin's friends told M. Anatole France one day that he did not seem to have sufficient admiration for the sculptor of the *Balzac,* M. France replied: "Obviously, your Rodin is a genius, but—how shall I put it? To my mind, *he collaborates too closely with catastrophe.*"

[J U N E 29]

It has been confirmed that M. Mario Meunier, who at present is a prisoner of war in Germany and who before the war was Rodin's secretary, will be appointed curator of the museum in the Hôtel Byron, which will house all of the works bequeathed to France by the great sculptor who completes the plastic trinity: Phidias, Michelangelo, and Rodin.

M. Mario Meunier is a distinguished Hellenist. We are indebted to him for excellent translations of Sappho, Nonnus, and Plato's *Symposium.*

[J U L Y 13]

Rodin's death has not led art critics to turn their attention to M. Medardo Rosso, who is now without a doubt the greatest living sculptor.

The injustice this prodigious sculptor has always been victim of is not, it seems, about to be repaired.

In the meantime, M. Medardo Rosso is working in silence in Paris. In the silence of his studio, he calls to mind those artists of the Renaissance, at once sculptors and founders, masters and workers, who did everything themselves.

For a long time now, M. Medardo Rosso has not submitted any new works to the judgment of the public. He is thinking of modeling the figure of a horse.

(*L'Europe nouvelle*)

Current Events

Death of Guillemet. We have learned of the death of the painter Guillemet, who was a student of Corot, Daubigny, and Courbet. He frequented Manet, Fantin-Latour, Degas, and Duranty. He was a source of inspiration to Albert Wolf, that prototype of art critics, with no convictions other than those of the dealers. Later, Guillemet became spiritual adviser to M. Dujardin-Beaumetz. [. . .]

The Madrid Exhibition. Despite the King's expressed wish to see nothing but academic works at this exhibition, there are works by great painters such as Renoir and Sisley and artists of great talent such as Harpignies, Boudin, John Lewis Brown, Maurice Denis, and Vuillard. It is regrettable that the King's taste did not allow Manet, Degas, Toulouse-Lautrec, Forain, Gauguin, and Cézanne to figure in the Madrid exhibition. One can understand that today's young and still controversial artists were not invited, although it is not quite clear how their presence would have done any harm. What is not understandable, however, is that a number of undisputed masters should have been sacrificed to diplomatic considerations that have as little to do with art as with morality.

Totalism. M. André Lhote, who is currently working far from Paris, at the seashore, has just invented *totalism*. Will this new artistic theory have the same fortune as its predecessors, impressionism, pointillism, and cubism? We wish it with all our heart.

Nord-Sud. The avant-garde review *Nord-Sud* has published some fine drawings by Georges Braque and Fernand Léger. They allow one to grasp the evolution of the new painting. Because of their natural gifts, their knowledge, and their boldness, Braque and Léger

are the most outstanding representatives of the new school, together with Matisse, Picasso, Marquet, Derain, and De Vlaminck.

La Ghirba. *La Ghirba*, the field newspaper of the Italian Fifth Army, has published some powerful and very curious-looking caricatures by Lieutenant Ardengo Soffici. They are made of strips cut from newspapers. The expressiveness of the caricature is increased thanks to this simple and unusual technique.

Ardengo Soffici is not unknown in Paris. A writer and artist, he was the designer for the editions of La Plume, which published Moréas's works with his illustrations. Ardent and restless, Soffici introduced into Italy the most daring and most significant French artists of the last few generations, including Degas, Cézanne, Henri Rousseau, Matisse, Picasso, and Braque. He was also a defender of the sculptor Rosso. Loyal, independent, and impartial, Soffici is bound by ties of friendship to the group of poet-critics such as Guillaume Apollinaire, André Salmon, and Roger Allard, who all defended with conviction and success the painters of the new generations abandoned by the professional critics.

At La Belle Edition. M. François Bernouard is exhibiting, at La Belle Edition, the works of several artists of merit: Louis Süe, architect and decorator; Paul Iribe, whose wittiness and gracefulness made him the prince of caricature and of fashion design; M. Louis Jou, the engraver discovered by M. Anatole France; Charles de Fontenay, who died on the field of battle; Marcel Gaillard, Mlle. Albertine Bernouard, Combet-Descombes, and others.

Young French Painting. The Salon de la Jeune Peinture Française will soon be opening its doors. During wartime, the arts are in need of such initiatives.

The Degas Sale

The Degas sale is not over yet, but its proceeds have already exceeded anything ever recorded in the history of art for an auction held

after the death of a painter. Future historians will have reason to be astonished when they note this passion for works of art, which brings a note of idealism into our calamitous era. In the midst of war, one might have thought that art collectors would have lost some of their acquisitiveness; in fact, the market value of works of art has never been higher. Among our enemies, as well as in neutral countries, works of art have fetched unheard-of prices. Among the Ancients, in Rome during the empire, there was a similar fever. It was during the finest period of the Roman Empire, which gives us reason to believe, judging by the examples of history, that prices like those fetched in Paris and Berlin by the paintings of the modern French schools are far from being a sign of decadence; rather, they presage a magnificent epoch for art after the war.

Humanity, thirsting after the ideal, drinks at the fountains of art. These were the reflections produced in the minds of the spectators by every stroke of the auctioneer's hammer at the Degas sale. And yet, the judgment of the public was not unanimous. In the past, even at the time when the Meissoniers were bringing the highest prices, the public did not argue over the merits of the artists submitted to its judgment; it simply accepted a judgment imposed on it from above. Today, after the great battles for art in the nineteenth century, the public has become divided into two factions. At the exhibit of Degas's works at the Georges Petit Gallery, one could hear the most curious and unfavorable opinions expressed by one part of the crowd—a part, moreover, that did not include common people or even the *petite bourgeoisie*. Degas remained controversial even after his death, which did not prevent his paintings from fetching the phenomenal prices of this sale.

In fact, the works here varied greatly in technique and inspiration; all of them confirmed the prodigious mastery that made the master of ballerinas a unique artist, a cruel but subtle observer who was able to express, without banality, the dazzling, elusive essence of gracefulness.

It is regrettable that the state did not make a bid for more of these infinitely precious works and, above all, that it did not acquire the most characteristic ones.

It is true that many collectors are buying with the intention of bequeathing their collections to the state and that many of these

paintings and marvelous pastels full of life and light will one day find their way to our museums, to bear witness to the depth of our inimitable French grace, a grace so airy that the colored dust of La Tour's and Degas's pastels was what best succeeded in capturing it for times to come. After the secret of this grace has been lost, men will go to look at *The Dancers at the Bar*, *The Green Chartreuse*, or *Two Women Ironing* to try and imagine all the bitterness and all the exquisite charm of the nineteenth century, which people have so often maligned without being willing to appreciate its delicacy, its subtlety, and even its cruel, lyrical truth.

African and Oceanic Sculptures[10]

Curiosity has found a new field of exploration in the sculptures of Africa and Oceania.

This new branch of curiosity, although born in France, has to this day found more commentators abroad. Since it originated in France, however, we have every reason to believe that it is here that its influence is being most deeply felt. These fetishes, which have not been uninfluential in modern art, are all related to the religious passion, which is the source of the purest art.

The interest of these fetishes lies essentially in their plastic form, even though they are sometimes made of precious materials. This form is always powerful, very far removed from our conceptions and yet capable of nourishing the inspiration of artists.

It is not a question of competing with the models of classical antiquity, but of renewing subjects and forms by bringing artistic observation back to the first principles of great art.

In fact, the Greeks learned much more from the African sculptors than has been noted up to now. If it is true that Egypt exerted an appreciable influence on the very human art of Hellas, one would have to be very unfamiliar with the art of the Egyptians and of the Negro fetishes to deny that the latter provides the key to the hieraticism and the forms characteristic of Egyptian art.

The enthusiasm of today's painters and collectors for the art of

fetishes is an enthusiasm for the basic principles of our arts; their taste is renewed through contact with these works. In fact, certain masterpieces of Negro sculpture can compete perfectly well with beautiful works of European sculpture of the greatest periods. I remember an African head in M. Jacques Doucet's collection that can stand up perfectly against some fine pieces of Romanesque sculpture. In any case, no one today would dream of denying these evident truths, except ignorant people who do not want to take the trouble to look at things closely.

It is high time that researchers, scholars, and men of taste collaborate to arrive at a rational classification of these sculptures from Africa and Oceania. When we know all about the workshops and the periods that conceived them, we shall be better equipped to judge their beauty and to make comparisons between them; at present this is hardly possible, since the absence of necessary points of reference does not permit more than conjectures.

(*Les Arts à Paris*, J U L Y 15)[11]

News and Views of Literature and the Arts

[J U L Y 20]

Throughout the war, the Italian newspapers have continued to accord a great deal of space to the modern movement, both artistic and literary, whose development the Italians (unlike the French) would not dream of arresting.

Il Tempo, for example, the new Rome newspaper on which Giovanni Papini is collaborating, has started to publish articles on aesthetics by Carlo Carrà.

This former futurist, who has now come round to the aesthetic views of Giorgio de Chirico, mentions Raphael and quotes Leopardi and Baudelaire. How times have changed!

People are talking a great deal about an English painter of the current war: C. R. W. Nevinson. The secret of his art and his success lies in his manner of rendering and evoking human suffering, his way of communicating to others the feelings of pity and horror that moved him and inspired him to paint.

1918

In other paintings, he captures the mechanical side of this war, in which man and the machine have come to constitute a single force of nature. His painting *The Machine Gun* perfectly expresses this very sound idea. M. Nevinson belongs to the avant-garde English school of painters, whose work combines the influences of the young French and Italian schools.

M. Paul Guillaume is preparing a choreographic spectacle for next season that, he says, will be a sensation. He himself will perform some dances whose attitudes, movements, and gestures were inspired by his contemplation of African fetishes. Dance is the art that boasts the greatest number of reformers, from the Ballets Russes through Mme. Valentine de Saint-Point and Mme. Isadora Duncan to M. Birot.[12]

[AUGUST 10]

In a book bearing the double title *Une Expression moderne de l'art français: le cubisme* and a yellow cube on its cover, M. Roland Chavenon expresses the opinion that:

"One can defend cubism without being a cubist, because everything that is new can be a reason for hope, because this movement goes beyond the worn-out school of impressionism and provides the latest innovators with a raison d'être, and also because it marks a step in pictorial evolution. . . .

"Perhaps cubism will eventually succeed in giving us a style—which impressionism was not able to do."

We may note that M. Chavenon attributes to Juan Gris the recommendation to "avoid the silhouette," which in fact forms part of the teachings of Georges Braque, who, together with Picasso, was one of the initiators of the new period in painting.

Instead of the *silhouette* of the impressionists, Georges Braque proposes the *profile*, which the cubists borrowed from the Egyptians and which renders all the characteristics of an object, making it into a genuine work of art, complete in itself.

[SEPTEMBER 14]

A Catalan writer who uses the pen name Litus has interviewed the Catalan painter J.-M. Sert, an admirer and long-time guest of

France.[13] His interview has been published in the Franco-Catalan review, *L'Instant*. "Sert," writes M. Litus, "does not believe that one can reasonably maintain the existence of two categories of art, one being decadent and the other renascent. According to him, art either is, or is not. History shows us that some very powerful works have been created during a period of artistic decadence, while very weak works have abounded during the most brilliant periods." Later, M. Sert went on to say: "I do not believe in theories that extol the work of young artists and denigrate the work of old ones. The task of artistic regeneration does not belong exclusively to the young, far from it. We have had numerous examples of great artists who proved to be very daring in their old age, toward the end of their career—Rubens, Giorgione, and so many others."

We share M. Sert's opinion wholeheartedly. We should add that when we speak of *youth*, we are referring to art, a new and vigorous art, not to the age of the artists, which is wholly irrelevant. Cézanne and Rodin were always young, and Renoir is young.

[NOVEMBER 2]

At the last minute, we have with great regret learned of the death of a young poet, Justin-Frantz Simon, the brilliant editor of a provincial review, *Les Trois Roses*, published in Grenoble.

Les Trois Roses published works by François Vielé-Griffin, Paul Valéry, Jean Royère, Max Jacob, André Breton, Louis Aragon, Pierre Albert-Birot, Pierre Reverdy, and others.

The Spanish flu, or Asiatic if you prefer, has carried off Justin-Frantz Simon in the space of four days from the side of his young wife, who was laid low by the same illness.

He loved life, this modern life, and his young talent was full of promises that death has just snuffed out.

(L'Europe nouvelle)

473

Notes

1 9 0 2

1. The "scarecrows" were the thirty-two statues of Prussian princes that had just been set up in the Tiergarten by order of the Kaiser.
 The essay in praise of Klinger by Brandes is to be found in his *Moderne Geister*, a new edition of which appeared in 1901.

2. In another article also entitled "The Düsseldorf Exhibition," published in *La Grande France* (October, 1902), Apollinaire gives a more general description of the exhibition. On the works of art, he writes only the following two sentences: "The Hall of Art, where Max Klinger's polychrome *Beethoven* sits enthroned like a challenge, contains the fine flower of modern art in Germany. Except for a few paintings signed by the rare artists I like, I saw nothing worth bothering about" (p. 251).

3. Apollinaire seems to be alluding to Andreas Achenbach (1815–1910). His younger brother, Oswald, however, was still alive (1827–1905).

4. Apollinaire is doubtless referring to Eduard von Gebhardt, Peter Janssen, Gregor von Bochmann, and, in the following paragraph, to Ludwig (known as Louis) Braun.

5. Signed "G. A."

6. The painting by Master Wilhelm had inspired a poem by Apollinaire, dated "Cologne, 1901." It is "La Vierge à la fleur de haricot à Cologne" (published in *Le Guetteur mélancolique*).

1 9 0 3

1. This famous tiara, acquired by the Louvre in 1896 and said to date from the third century B.C., was withdrawn from exhibit on March 23, 1903, after an investigation had shown it to be the work of a forger. When writing the article, Apollinaire did not know that the "unknown Russian master," a man from Odessa named Rouchomouski, would arrive in Paris on April 5 and that his identity would become known.

2. Pollonnais, a Jewish journalist whose conversion to Catholicism had been in the news, wrote for *Le Gaulois*, a widely read anti-Dreyfusard daily.

1 9 0 5

1. This first article by Apollinaire on his friend Picasso appeared on the occasion of an exhibition of paintings by the artists Trachsel, Gérardin, and Picasso, from February 25 to March 6, 1905, at the Serrurier Gallery, 37 Boulevard Haussmann. The article is a reply to Charles Morice, who, in his preface to the catalogue, deplored Picasso's "precocious disenchantment."

2. This essay was accompanied in *La Plume* by untitled reproductions of five paintings that doubtless figured in the exhibition at the Serrurier Gallery. The following notations in the catalogue probably refer to them:

> 1 to 8: *Saltimbanques.* [Three of these paintings are reproduced in Pierre Daix, *Picasso: The Blue and Rose Periods* (New York, 1965): *Two Saltimbanques with a Dog*, XII.17; *Acrobat and Young Harlequin*, XII.9; *Seated Harlequin with Red Background*, XII.10.]

> 21: *La Femme au corbeau.* [Daix: *Woman with a Crow*, XI.10.]

> 24: *Amies.* [Daix: *The Two Friends*, XI.8.]

Apollinaire quoted the first paragraphs of this essay in his

article, "De Michel-Ange à Picasso," in *Les Marches de Provence*, March, 1912 (see pp. 195–96), and reproduced it in its entirety, with variants, in *Les Peintres cubistes* (1913).

1907

1. This article was signed "P. Hédégat," a pseudonym that Apollinaire used again in 1909 for an essay on Matisse.

 For the details of Apollinaire's collaboration with *Je dis tout*, see Marcel Adéma, *Guillaume Apollinaire* (Paris, 1968), pp. 122ff.

2. Paul-Louis Baignières, who was a member of the Selection Committee of the Société du Salon d'Automne. Frantz Jourdain had been President of the Salon since its founding in 1903. In 1907, the other members whom Apollinaire mentions were: Georges Desvallières, Vice-President; Abel-Truchet, Treasurer, who with Maxime Dethomas organized the 1907 exhibition; Paul Cornu, Secretary General; Jansen, Executive Director; and Gropeano, Foreign Delegate. Rouault and R. Piot were members of the committee.

3. Jourdain was also the architect of the Paris department store, the Samaritaine, and he had sent the plans for its new buildings to the 1907 Salon d'Automne.

4. A journey, according to Apollinaire, whose purpose was to choose the Cézannes for the retrospective exhibition at the Salon d'Automne. One cannot be sure just how farfetched Apollinaire's account of this visit is. It is not impossible that Frantz Jourdain, after actually visiting the Bernheim Gallery, refused the twelve paintings in question. On the other hand, Apollinaire seems to be describing some of the paintings that figured in the Salon, such as the "old man," which, according to his description, had to be one of the two paintings so titled (Nos. 50 and 51 in the catalogue; reproduced by Lionello Venturi in his *Cézanne* under the title *Portrait of Vallier*, Nos. 716, 717). As for the "fruit bowl, all lopsided, twisted, and askew," the painting that best fits this description is the famous *Fruit Bowl, Glass, and Apples* (Venturi, No. 341), which Apollinaire may have known even though

it was not exhibited at the Salon of 1907. Finally, it is not impossible that Apollinaire invented a few paintings to make Frantz Jourdain's visit to the Bernheim Gallery even more burlesque.

5. Further on, Apollinaire was to complain of the numerous "typos" in this article of October 12; indeed, we were obliged to replace into their proper context several paragraphs that had been displaced by the printer. But as regards "The reference is to M. Paul Adam," it is impossible to say whether the responsibility for these enigmatic notes belongs to the printer or to Apollinaire himself.

6. This anecdote appears in a somewhat modified form in Vollard's *Paul Cézanne* (1914): "I will add that we may reproach young 'Paul' for the destruction of a few 'Cézannes.' He amused himself by making holes in them, to the great delight of his father: 'The boy has opened the windows and the chimneys; he realizes that it's a house, the little tyke' " (p. 74).

7. This "certain Aaron" was in reality "Aary-Max," according to the catalogue of the Salon.

8. The word "fauve," applied to the famous group of painters of whom Matisse was one, literally means "wild animal." In this article, Apollinaire plays on the literal meaning of the word.

9. The painting Apollinaire called *The Dressing Table* (*La Coiffeuse*) is probably *La Coiffure* (*The Hairdo*), painted in 1907, but in fact smaller than *Le Luxe I*, which was among the paintings accepted by the jury.

10. Albert Soleilland, the "satyr-murderer" condemned to death for having raped and killed a twelve-year-old girl, was pardoned by President Fallières on September 14, 1907.

11. A play on -*cus*, *cul* ("ass"), and *vi-*, *vit* ("penis").

12. "Erdome": Could this be a misspelling of Erdan, the pseudonym of André Alexandre Jacob, who died in 1878? Erdan was convicted for publishing a book entitled *La France mystique*, the first edition of which was printed according to a system of phonetic spelling known as "fonography."

13. This poem is reproduced in Apollinaire's *Oeuvres poétiques* (Pléiade edition, p. 656), with a note on the circumstances of its composition.

14. *Red Rocks.*

15. It was doubtless this series of articles on the Salon d'Automne that Francis Jourdain had in mind when he alluded, in his *Sans remords ni rancune* (Paris, 1953), to "the worthless gossip with which Guillaume Apollinaire sought to amuse the seventeen readers of a vague scandal sheet" (p. 131).

16. This article was accompanied by four untitled reproductions that we have identified as follows: *Portrait of the Artist* (Collioure, 1906); *Le Luxe I* (Collioure, 1907); *Mme. Matisse: Red Madras* (Paris, 1907); *The Hairdo* (1907). On page 485, the following postscript appeared: "This article will be published, with illustrations, in the *Cahiers de Mécislas Golberg* in January. *La Phalange* offers it to its readers a month early." The *Dernier Cahier de Mécislas Golberg*, which was the single issue appearing in 1908, did not, however, carry Apollinaire's article. Instead, there was an essay by Léon Riotor, "Les Artistes d'automne," accompanied by a reproduction of Matisse's *Landscape*, which had been exhibited at the Salon d'Automne.

Apollinaire's article was published in *Il y a* without the illustrations.

1908

1. Mirbeau quotes, in order to ridicule it, the opinion of a German woman he had met in Cologne: "I am shocked to see that M. Vallotton has not yet acquired in your country the status he deserves and is beginning to enjoy in Germany. Over here, we like him a great deal; we consider him one of the most personal artists of his generation . . ." (*La 628–E8*, 1908 edition, p. 390).

2. This is undoubtedly the famous *Nude* (*Grand Nu*). It was not listed in the catalogue, but Fry has definitely established that it was exhibited at this Salon (Edward F. Fry, *Cubism* [New York, McGraw-Hill, 1966], p. 16).

3. This is the first mention of Marie Laurencin, whom Apollinaire met in 1907. Their liaison was to last until the eve of World War I. She inspired some of the most beautiful poems in *Alcools* and it was she who posed with Apollinaire for the Rousseau painting *The Muse Inspiring the Poet*.

4. Cf. the sentence in *Onirocritique*, which also appeared in 1908: "But I was aware of the different eternities between man and woman" (*Oeuvres poétiques*, p. 371).

5. Two compatriots of Van Dongen. Eduard Douwes Dekker (1820–1887) was a Dutch official in the Indies. Outraged by the abuses of colonial power, he denounced them in a series of works published under the pseudonym of Multatuli (Latin for "I have suffered much"). Domela Nieuwenhuis (1846–1919), a militant socialist, wrote *Le Socialisme en danger* (1897).

6. According to the catalogue, Rousseau's exhibit included: 5260: *Tiger and Buffalo Fighting*; 5261: *The Football Players*; 5262: *Portrait of a Child*; 5263: *Landscape*.

7. Poet who died in 1901; author of *Versiculets*. His reputation as an ingenuous bohemian doubtless suggested the comparison with Rousseau.

8. The catalogue listing for Rouault is: Nos. 5221–5226: *Decorative Sketches*.

9. Quotation from *Crise de vers*.

10. This exhibition was composed of works by Bonnard, Braque, Denis, Derain, Dufy, Friesz, Girieud, Manguin, Marquet, Matisse, Metzinger, Puy, Redon, Roussel, Rouault, Sérusier, Signac, Vallotton, Van Dongen, Vlaminck, and Vuillard.

 Apollinaire's preface was subsequently published in *Le Feu* (No. 39, July 1, 1908) and in *Le Flâneur des Deux Rives* (No. 2, September, 1954). Apollinaire incorporated it without the title and with a few variants into the first part of *Les Peintres cubistes* (1913).

11. Most of this essay was reproduced, with variants, in "Georges Braque," *La Revue indépendante* (No. 3, August, 1911). The article contained the following introduction: "Among the new painters, Georges Braque is one of those who most engage our attention. His experiments have been carefully examined and are already exerting an influence.

 "The softness of Corot, combined with a great concern for the renewal of plastic forms—that is what characterizes the art of Georges Braque. He has deliberately stripped himself of everything that could attach him to his time, and having returned to

first principles, he is advancing according to the genius that inspires him" (p. 166).

A commentary on Braque quoted in the *Cahiers d'Art* (8th year, Nos. 1–2, p. 25) is incorrectly attributed to Apollinaire. It is, in fact, by Charles Morice ("Art moderne," *Le Mercure de France*, December 16, 1908, pp. 736–37). See also Henry Hope, *Georges Braque* (New York, 1949, p. 33).

1909

1. Unsigned. The text of this flyer written by Apollinaire himself was reprinted in the catalogue of the exhibition "50 Ans d'édition de D.-H. Kahnweiler," at the Louise Leiris Gallery, November 13–December 19, 1959.

2. This "portrait" was not published during Apollinaire's lifetime. It appeared for the first time in *Arts et Spectacles* (No. 285, November 17, 1950), with a commentary by Marcel Adéma. The manuscript is in the Stein Collection at Yale University. It is signed "Pascal Hédégat," a pseudonym Apollinaire had previously used. Beneath the signature appears the following notation: "Guill. Appolinaire [*sic*]. Certified true copy. H. M."

1910

1. This article, signed "G. A.," is the first of a long series of articles on art for *L'Intransigeant*. After an article describing his impressions of the Paris flood of January, Apollinaire replaced his friend André Salmon as art critic of the paper. He did not, however, sign his column, "La Vie artistique," until March 5.

2. Quoted from the preface to the catalogue *Pastels et dessus de portes, par Louise-Catherine Breslau, exposition du 1er au 15 mars, 1910, Galeries Durand-Ruel.*

3. In the catalogue of the exhibition (at the Bernheim-Jeune Gallery, March 7–26), No. 16 is entitled *The Two Children*.

4. At the E. Druet Gallery (March 7–19).

5. An allusion to the *Portrait of Grand Duke Paul*, listed in the

catalogue of the exhibition (at the Georges Petit Gallery, March 9–April 3).

6. *Young Girl with Tulips.*

7. This painting is not listed in the catalogue, but it is certainly *The Skaters* (1909).

8. Apollinaire may be alluding to the painting entitled *Church* in the catalogue, *i.e., Saint-Séverin No. 2* (No. 44 in the catalogue of Delaunay's works by Guy Habasque). The reference could also be to *The City* (Habasque, No. 72) or to *Tower* (No. 4357 in the catalogue of the Salon).

9. The catalogue lists the following titles by Rouault: *Decorative Figures, Judge, The Bar, Landscape.*

10. According to the catalogue, the two works in question are *The Pine of Bertrand* and *Marseille.*

11. The only painter by that name in the catalogue was a woman, Elsa Weise. Her exhibit included two landscapes (*Paysages*), two studies (*Etudes d'Alve*), and two *Compositions.*

12. The artist in question is Michel Jasinsky, "Jasiensky" according to the catalogue.

13. Two missing lines of type altered the meaning of this sentence, as Apollinaire admitted in his reply to Ciolkowski's letter of protest. Ciolkowski's letter, published in *L'Intransigeant* of April 30, 1910, states that his art is intended "no more for inverts than for courtesans, no more for Sodomites than for Don Juans, no more for impotents than for priapists, no more for old gentlemen than for schoolboys, no more for bigots than for agnostics, no more for moralists than for immoralists, but rather for all those, whoever they may be, who wish to take the time out to look at it." In addition, Ciolkowski quotes the favorable opinions expressed about his work by Roger Marx, Emile Bernard, Alfred Mortier, and others. Here is Apollinaire's reply, published in *L'Intransigeant* of May 3:

TO THE EDITOR:

If letters like the one that appeared two days ago in your newspaper became more frequent, the job of art criticism would become impossible.

The letter was in reply to a passage from my review of the *Indépendants*, misinterpreted by the artist involved.

Two lines of type dropped by the printer attributed to the draw-
ings in question a resemblance with the works of the English
illustrator Aubrey Beardsley, who was so conscious of the perversity
of his art that he had the plates of one of his major works destroyed
just before he died.

In any case, I am in no way opposed to such an art; in fact,
I admire Beardsley, a delightful illustrator who owed much to the
Greek vase painters and to our own Eisen. But I find the imita-
tions of Beardsley by snobs and American misses as execrable
as the verses of schoolboys imitating Baudelaire.

I leave to the critics, whose subtle, erudite, and diverse appre-
ciations lend such savor to the letter in question, the responsibility
for their opinions; I myself shall be content merely to deplore—
in agreement, I believe, with Arsène Alexandre, whose perspi-
cacity as an art critic does honor to our times—the Anglomania
that is invading the arts to the greatest detriment of French taste.

<div align="center">

Yours sincerely,
GUILLAUME APOLLINAIRE

</div>

14. The "pleasant joke" was a hoax engineered by Roland Dorgelès.
Wishing to ridicule modern painting, Dorgelès invented an "ex-
cessivist" painter named "Boronali," whose works had in fact
been painted by the tail of a donkey from Montmartre. The
exhibit of Boronali's works at the Indépendants was accompanied
by the publication of a manifesto of "excessivism." Dorgelès tells
the story of this practical joke in his *Bouquet de Bohème* (Paris,
1947, chap. 11).

The catalogue of the Salon des Indépendants of 1910 con-
tains the following listing:

Boronali, J. R. born in Genoa (Italy), 53, Rue des Martyrs,
Paris.
604. *And the Sun Went to Sleep.*
605. *On the Adriatic.*
606. *Seascape.*

15. At the E. Druet Gallery (April 4–16).

16. Benoît Labre, eighteenth-century mendicant canonized by Pope
Pius IX in 1873. He is famous for his rags, stench, and vermin.

17. The Eulenburg case was still being talked about in 1910. Eulen-
burg, a prince at the court of Kaiser Wilhelm II, had been the

defendant in a series of lawsuits accusing him of homosexuality. The last of these lawsuits took place in 1909.

18. An allusion to Cappiello's advertising posters, which had first appeared in Paris in 1903. The latest ones were the famous poster for Thermogene wool (1909), which shows a Pierrot spitting fire, and the one for Cinzano (1910), showing a horseman riding a zebra.

19. Apollinaire seems to be mistaken about the date, since the Bonnat collection, consisting of nineteen drawings by Rembrandt, was shown at the 1906 exhibition commemorating the three hundredth anniversary of Rembrandt's birth.

20. From the *Schlachtfeld bei Hastings*, in Book 1 of the *Romancero*. The painting is by Léon-Charles Canniccioni.

21. Baron d'Estournelles de Constant had received the Nobel Peace Prize in 1909.

22. According to the catalogue, the painting entitled *A Strike Day* is the work of a woman, Mlle. L. Humbert-Vignol.

23. Apollinaire is probably thinking of the jester's word: "Tzing!" (Act IV, sc. ix).

24. A reference to the law for the separation of Church and State in France, promulgated in 1905. Apollinaire was to write a eulogy of Father Van Hollebeke in *Anecdotiques* (August, 1913).

25. At the E. Druet Gallery (May 17–28).

26. Francis Jourdain claims, in *Sans remords ni rancune* (p. 131), that Apollinaire compared Benjamin Rabier to Hokusai in a lecture, whose text Jourdain supposedly read in *L'Art pour tous*. Jourdain's remark was cited by Jean Adhémar in his preface to the catalogue of the exhibition of graphic works by Jacques Villon at the Bibliothèque Nationale (1959). We have found no trace of this lecture, since the review *L'Art pour tous* apparently ceased publication in 1906, before it is likely that Apollinaire would have known Benjamin Rabier.

27. A somewhat excessive eulogy of Elémir Bourges, the author of grandiose, visionary novels and prose poems at the turn of the century.

28. In fact, an exhibition of decorative arts from Munich, organized

under the auspices of the Salon d'Automne, was occupying the ground-floor rooms of the Grand-Palais.

29. The first book in a series bearing that title, written by Paul Reboux and Charles Muller, had appeared in 1908; a second volume appeared in 1910.

30. *La Danse* and *La Musique*.

31. Entitled *The Fisherman* in the catalogue.

32. The catalogue lists only a "Charlotte Lallemand."

33. *Perseus*.

34. *Landscape* and *Nude*.

35. *Village in the Rocks*.

36. The catalogue lists the following woodcuts: 356: *Dance*; 357: *Love*; 358: *The Hunt*; 359: *Fishing*. The illustrations are: 360: one frame entitled *Bestiaire ou Cortège d'Orphée* (four woodcuts and the title page).

37. Touny-Lérys was one of the editors of *Poésie*. A reproduction of the pastel by Mme. Van Bever de La Quintinie appeared in the same issue of the review.

38. This is evidently the first time that Apollinaire wrote this word.

39. This attack seems to have been directed above all against Metzinger and Le Fauconnier. (See the article in *L'Intransigeant*, October 1, p. 109 above.)

40. An allusion to the trial of Marguerite Steinheil, November, 1909. She was accused of having murdered her mother and her husband, the painter Adolphe Steinheil, in their villa in the Impasse Ronsin, the night of May 30–31, 1908. According to Mme. Steinheil, the two victims had been killed by burglars costumed in Levitical gowns that they had stolen from a Jewish theater. She was acquitted by the jury, and the mystery surrounding the double murder remained unsolved at the time Apollinaire wrote this article.

The exhibition in question was that of the Société Artistique et Littéraire Russe. Besides the Russian artists, several French, Spanish, and Dutch artists had been invited to show their works.

41. At the Bernheim-Jeune Gallery (October 17–November 5).

42. At the Moleux Gallery (October 18–31).

43. At the Devambez Gallery (November 3–16).

44. Site of a famous gibbet erected on the outskirts of Paris in the thirteenth century.

45. Exhibition at the Bernheim-Jeune Gallery (December 5–17). It included fifty-seven works, seven of which were copies of old masters.

46. There are two titles by Redon listed in the catalogue: *Portrait of Mlle. Violette Haimann* (pastel); *Buddha* (pastel).

47. Henri Brisson, President of the Chamber of Deputies; he was known for his stern demeanor, which was often ridiculed by the *chansonniers*.

48. On January 4, 1911, *L'Intransigeant* printed a note by Apollinaire announcing that "M. Ambroise Vollard's gallery will be closed until January 12. It will reopen for the Picasso exhibition, which will run until the end of February."

49. In *The Coffee Service*, No. 11 in the catalogue.

50. Volume of poems by Apollinaire. See the March, 1911, article, p. 140.

51. Probably the *Family of Saltimbanques*, according to D.-H. Kahnweiler. Yet this painting was not reproduced in *La Plume* of May 15, 1905. Could Apollinaire have forgotten which paintings accompanied his article?

1911

1. In the preface to the catalogue, *Peintures chinoises anciennes* (January 3–21), Joseph Brummer wrote that, looking at some of the scrolls, "one is tempted to recall . . . Cimabue, Giotto, Ghirlandaio, or Botticelli."

2. French word for *cyma*, the molding from which frames are hung, and hence, the name of a group of painters.

3. Allusion to René Bérenger (1830–1915), a senator who became famous for his opposition to licentiousness in art and literature.

4. Last line of the sonnet "Promenade galante," in *Rimes dorées*, by Théodore de Banville. Apollinaire was to cite the line again in an article on April 3, 1912.

5. There were seven of them: *Concert on the Grass*; *Reading*; *Three Women*, screen; *Musicians in the Garden*; *The Wave*,

screen; *Dancer with a Scarf*, settee; *Scarf and Baskets*, tabouret. (See the catalogue of the exhibition, *Les Ponts de Paris*, a new series of water colors by Paul Signac. The Tapestries of Aristide Maillol. January 23–February 1, 1911, at the Bernheim-Jeune Gallery.)

6. Vuillard's exhibit included thirteen paintings from 1910 and fifteen from "various dates."

7. Henri-Emilien Rousseau (1875–1933); his exhibition ran February 1–15.

8. In the preface by Léandre Vaillat.

9. This "new title" had already been used in 1910.

10. Unsigned. The text of this flyer written by Apollinaire himself was reproduced by Marcel Adéma in *Guillaume Apollinaire le mal-aimé* (p. 129).

11. There were four of them (Nos. 46–49 in the catalogue).

12. By the Rev. Matthew William Peters.

13. Another allusion to the puritanical Senator Bérenger (see n. 3 above). If M. Bérenger had lived during the *ancien régime*, he would undoubtedly have qualified for the job of censoring all reading matter "for the use of the Dauphin."

14. Probably the painting entitled *Spanish Woman* in the catalogue, which Apollinaire later refers to as *Andalusian Woman*. The painting is better known today as *Mme. Matisse in a Manila Shawl*.

15. We have omitted here several paragraphs on Rousseau, since Apollinaire incorporated them, with variants, in both *Les Peintres cubistes* and an article on "The Douanier" that appeared in *Les Soirées de Paris* (January 15, 1914). The latter version is reprinted in its entirety on pp. 339–54.

16. The catalogue lists the following titles by Metzinger: 4266: *Landscape*; 4267: *Head of a Woman*; 4268: *Nude*; 4269: *Still-Life*.

17. There were three works by Léger: 6713: *Nudes in a Landscape*; 6714: *Drawing*; 6715: *Drawing*.

18. See the preface to the catalogue by Henry Lapauze: *Exposition Ingres*, April 26–May 14, Georges Petit Gallery.

19. See the remarks on Ingres in "Exposition universelle de 1855," in *Curiosités esthétiques*.

20. Product made famous by a Cappiello poster in 1910.

21. Apollinaire is probably referring to Guy du Faur, sixteenth-century author of *Quatrains moraux*.

22. Calbet's ceiling was entitled *Music, Drama, and Comedy* (*The Genius of Music Reveals the Natural Harmonies to Humanity*); Cormon's was entitled *Decoration for the Petit-Palais. Etienne Marcel and the Aldermen of Paris Composing the Charter of 1356.* Agen is famous for its plums.

23. The complete title is: *The Indomitable Steed* (*from Auguste Barbier's Poem "L'Idole"*).

24. The Guignol (the French puppet theater) originated in Lyons in 1795. Guignol, himself a major character in French puppet shows, is often paired with his friend Gnafron.

25. Jean-Baptiste Augustin, a miniaturist who did numerous portraits of Napoleon. He died in 1832.

26. The Empress T'seu-hi had died in 1909.

27. Title of Léandre Vaillat's preface to the catalogue entitled *Les Modes à travers trois siècles.* The exhibition ran from May 15 to July 15, 1911.

28. Georges Wildenstein attributes it to Chardin. See his catalogue *Chardin* (Paris, 1933), No. 643.

29. In fact, it is not listed in the catalogue of Goya portraits assembled by A. de Beruete y Moret (Madrid, 1928).

30. Yet Georges Pascal attributes it to Largillière. See his catalogue (Paris, 1928), No. 20.

31. Pierre Nolhac makes no mention of this portrait in his work on Nattier (Paris, 1925).

32. Yet Louis Réau attributes it to Vanloo in his catalogue (Paris, 1938), No. 153.

33. Hélène Adhémar, in her *Watteau* (Paris, 1950), lists four versions of *The Village Bride* (see her catalogue, No. 130) and mentions none that might have figured in the 1911 exhibition.

34. This first cubist exhibition in Belgium was organized by the Belgian painter André Blandin, with the collaboration of Apollinaire. It contained works by Archipenko, Delaunay, Segonzac, Gleizes, Le Fauconnier, Léger, Marchand, Moreau, Jean Plumet.

35. The work containing the description and the drawings of the cemetery was published by Lafore in 1921 under the title *Les*

Chapiteaux du cimetière couvert de Saint-Saturnin dans le faubourg de Vienne à Blois (Paris, Auguste Vincent).

36. The theft had already been reported by *L'Intransigeant*, in a second evening edition on August 23. This front-page article by Apollinaire in the August 24 edition is accompanied by a three-column photograph showing the crowd in front of the museum. "All day long, a massive crowd in front of the museum talked about the disappearance," read the caption beneath the photograph. The verse that Apollinaire quotes is from Malherbe.

Two weeks later, this event was to provoke the arrest of Apollinaire himself, unjustly suspected of collusion in the theft.

37. See also the article of October 16, 1911, in *Anecdotiques*.

38. Probably a reference to painting No. 19: *Saint Helena*.

39. This account is incorrect. It was the paintings of Braque, exhibited at the Kahnweiler Gallery in November, 1908, that suggested the word "cubes" in Louis Vauxcelles's article (*Gil Blas*, November 14). Apollinaire's error seems all the more curious since it was he who had written the preface to the catalogue of the exhibition.

40. *Landscape* and *The Snack*.

41. *Lakeside Landscape*, *Village on a Lake*, and *Village in the Mountains*.

42. The exact title of the painting is *Port of Honfleur, Low Tide*.

43. Second exhibition of the Société Normande de Peinture Moderne, from November 20 to December 16, at the Gallery of Contemporary Art, on the Rue Tronchet. On November 24, Apollinaire gave a lecture there; the following account of it was given by Roger Allard in *La Cote*, November 25, 1911:

"M. Guillaume Apollinaire gave a lecture yesterday, the first in a series organized at the exhibition of contemporary art that has already been reviewed in this column. If an art movement ever needed justification for its existence, M. Guillaume Apollinaire would be the one to provide it. He explained very well how he was logically led to join the phalanx of the defenders of 'cubism,' whose significance a man of such subtle mind owed it to himself to grasp immediately.

"A select audience listened to him explain his observations, now aesthetic, now scientific, in nature—although an argument

of the second kind provoked in one hot-blooded listener latent apoplexy resulting from the spectacle of an art that was new to him. Among the forthcoming lecturers will be our distinguished colleague, Louis Nazzi."

44. This name does not appear in the catalogue of the exhibit.

45. This "Letter from Paris" is the second in a series that Apollinaire wrote for the Belgian magazine *Le Passant* under the pseudonym "Tyl." This letter is a fantastic "report" probably inspired by the Charles-Henry Hirsch case, which was in the news during the fall of 1911. Prosecuted for publishing a short story termed immoral, Hirsch obtained the support of a great many artists, led by Paul Reboux, who protested against this violation of the freedom of expression. The case ended in a nonsuit on November 4.

Apollinaire's "committee" was composed of some of the more or less well-known figures of the time: the playwrights Porto-Riche and Capus; the satirist Ernest La Jeunesse, whose "castrato voice" had already unleashed the wit of the Goncourt brothers (see the *Journal des Goncourt* of May 17, 1896); Urbain Gohier, a former Dreyfusard turned nationalist, who was to publish a ferocious attack on the "foreigner" Apollinaire in his magazine, *L'Oeuvre*, a few days later; Jean Royère, leader of the neo-Mallarmé movement in poetry; Eugène Montfort, who had published an article on "La Question du latin et les écrivains" in his review, *Les Marges*; Ferdinand Brunot, who had also published an essay, "Le Mal latin," in *La Phalange*; Gustave Hervé, a Socialist journalist and defender of the freedom of the press; and Senator René Bérenger, whom Apollinaire had already ridiculed in his article on Willette (January 26, 1911; see above, p. 131).

1912

1. This was the first group exhibition of the "Pompiers." Their President was L.-O. Merson, a member of the Institute; their Vice-President, R. Verlet, also of the Institute. "Pompier" is a pejorative term for a neoclassical or academic painter, derived

from the French word for *fireman*, presumably because of the fake Roman style of the fireman's helmet, worn since the time of Napoleon.

2. This prefatory sonnet, "written for us by Jean Aicard of the Académie Française," is entitled "L'Art."

3. There was a Vallotton exhibition at the Druet Gallery from January 22 to February 3.

4. The Chauchard collection of nineteenth-century French painting was not put on public view in the Louvre until 1910, when the French government officially accepted the bequest of its donor, the wealthy merchant and art collector, Alfred Chauchard, who had died the previous summer. Meanwhile Apollinaire's friend Léo Rouanet, the French Hispanist, was completing his translation from the sixteenth-century Portuguese of Francisco do Hollanda's dialogues with Michelangelo, which appeared in November, 1910, under the title *Quatre dialogues sur la peinture*. (See L. C. Breunig, "Apollinaire as an Early Apologist for Picasso," *Harvard Library Bulletin*, VII, No. 3 [Autumn, 1953], pp. 365–70.)

5. See the article of May 15, 1905 (p. 14, above). In the translation we have made this quotation agree with the earlier version. In the French text, however, there are several minor variations: the 1912 version has "les images humaines" for the earlier "des images humaines," "ces ciels" and "ces lumières" for "ses ciels" and "ses lumières," "brume durcie" for "brume glacée," and "félibres" for "bélîtres."

6. In his *Natural History*, Book XXXV.

7. This is the lead article in the first issue of *Les Soirées de Paris*, which in its twenty-seven issues, from February, 1912, to August, 1914, was to become one of the principal organs of the avant-garde. Apollinaire incorporated this essay with certain modifications in *Les Peintres cubistes* (1913). This version, along with most of Apollinaire's other articles for *Les Soirées de Paris*, was published in *Il y a* (1925).

8. Sentence quoted from the preface, "Les exposants au public," in the catalogue of the exhibition *Les Peintres futuristes italiens*, at the Bernheim-Jeune Gallery, February 5–24, 1912.

9. The painter in question was probably Romolo Romani (born

in 1884). Mme. Juana Romani (born in 1869) lived in Paris and had studied with Roybet. She exhibited regularly at the Salon des Artistes Français. Aroldo Bonzagni had left for South America as a young man.

10. This is the first paragraph of the preface to the catalogue.

11. An allusion to the essay, "On the Subject in Modern Painting"; see above, p. 197.

12. Apollinaire had begun to write for the financial newspaper *Le Petit Bleu* on January 5, 1912, and he ran the column of "Art News" until April of that year. We have reproduced the articles devoted to painting, of which this is the first.

13. "Le Hareng saur" is undoubtedly the most famous poem by Charles Cros, late nineteenth-century poet and—for the French —the inventor of the phonograph.

14. They are letters CXLVIII, CXLIX, CLX, and CLXIII, published in Paul Cézanne, *Correspondance recueillie, annotée et préfacée par John Rewald* (Paris, 1937).

15. The Marie Laurencin–Robert Delaunay exhibition, February 28–March 13.

16. In his preface to the catalogue of Marie Laurencin's works, Fernand Fleuret also suggests an analogy between the spirit of her painting and that of the French Renaissance.

17. Among the paintings on exhibit, there was an unfinished portrait of Apollinaire.

18. Letter addressed to Olivier Hourcade, who was conducting a survey in the pages of *L'Action*. This same letter was printed in *Le Siècle* on March 12, 1912.

19. In 1912, the 7th Salon was held at the Pavillon de Marsan, from February 27 to April 1.

20. The catalogue lists two painters by that name: Charles Hervé and Julien Hervé.

21. Chagall refers to the same incident in *Ma Vie* (Paris, 1931; English translation: *My Life* [New York: Orion Press, 1960]), p. 162, without mentioning the date of the Salon. He gives the name of the painting as *The Donkey and the Woman*, but the 1912 catalogue does not list that title. Perhaps the painting in question is the one commonly known as *Dedicated to My Fiancée* and

listed in the 1912 catalogue as 652: *The Lamp and the Two People*. Chagall claims to have sent *Dedicated to My Fiancée* to the Indépendants of 1911 (see the catalogue of the Chagall exhibition at the Musée des Arts Décoratifs, Paris, 1959, p. 25); but his name is not listed among the exhibitors in the 1911 catalogue, and Apollinaire makes no reference to him in his review of that year's Salon. Also, two other paintings that Chagall says he exhibited in 1911—*To Russia, Donkeys, and Others* and *Beheaded Man*—seem rather to correspond to titles listed in the 1912 catalogue, 653: *The Aunt in the Sky* and 654: *Drunken Man*. Might Chagall not have been mistaken in recalling that he had participated in the Indépendants of 1911? Histories of the cubist movement do not include his name among the exhibitors in the famous Room 41.

22. According to the catalogue, Gris showed the following: 1426: *Figure*; 1427: *Landscape*; 1428: *Still-Life*.

23. Tobeen's painting does, in fact, contain the heads of ten pelota players, in each of whom Apollinaire sees a resemblance to the Gascon Olivier Hourcade, who defended cubism in the pages of *La Revue de France et des pays français*.

24. See also the article of January 26, 1911; p. 131 above.

25. *Composition with Figures*.

26. Robert Delaunay.

27. Apollinaire is undoubtedly thinking of the nymphs in the bas-reliefs of Goujon's Fountain of the Innocents in Paris (1547–49).

28. Allusion to the character created by Jean Drault in a series of short novels at the end of the nineteenth century: *Le Soldat Chapuzot, Chapuzot à Madagascar, Chapuzot au Dahomey, Chapuzot est de la classe*, etc.

29. Printer's error or misspelling of Markous (Louis), who was exhibiting four drawings: 431: *Fan*, 432: *Mid-Lent Costumes*; 433: *Watch Out, Fresh Paint*; 434: *Fan*. It is worth noting that Apollinaire still writes as Markous the name of this Polish-born painter whom he rechristened Marcoussis, after the name of a village near Monthléry.

30. For a discussion of Apollinaire's use of this term, see the an-

notated edition of *Les Peintres cubistes* by L. C. Breunig and J.-Cl. Chevalier in the Miroirs de l'Art collection (Paris: Hermann, 1965), pp. 103–105.

31. "Skirmishes in a War with the Age," No. 19 in *Twilight of the Idols*.

32. This article was published in two installments in the April and May issues of *Les Soirées de Paris*. It was incorporated, with modifications, in *Les Peintres cubistes*. It was published in *Il y a* in its original form.

33. Quotation from the preface to the catalogue of the Delvolvé-Carrière exhibition that opened the week before.

34. Excerpts from this article were reproduced in the chapter on Marie Laurencin in *Les Peintres cubistes*.

35. *The Marriage of Psyche*.

36. The concluding lines of Oronte's sonnet in Molière's *Le Misanthrope*.

37. Entitled "Voyage to India" (April 23–May 13).

38. Incorrect quotation. Flaubert had written: "Neither gillyflowers nor roses are interesting in themselves, the only interesting thing is the manner in which they are painted. The Ganges is no more poetic than the Bièvre, but the Bièvre is no more so than the Ganges." There follows a critique of Huysmans's "rhetoric," and the paragraph ends: "Have more pride, for God's sake! And don't believe in formulas" (Letter No. 1818, in *Correspondance*, Paris, 1930, 8ᵉ série, p. 225).

39. Cf. the article entitled "M. Édouard Fer," in *Anecdotiques* (June 1, 1912).

40. This is the famous painting *September Morn*.

41. In an exhibition entitled "Venice," at the Bernheim-Jeune Gallery (May 28–June 8). See also the article on Monet in *Anecdotiques* (June 16, 1912).

42. It was probably the ideas expressed in this article that Apollinaire reiterated in a lecture on "Le Sublime moderne" on June 23, 1912, at the Grand Skating Rink of Rouen, on the occasion of the 3rd Exhibition of the Société Normande de Peinture Moderne.

43. This article was discovered recently by Pascal Pia and reprinted

in *Le Magazine littéraire*, November 23, 1968. It is published here in book form for the first time.

44. In a letter to *L'Intransigeant* (published on October 3), Louis Vauxcelles replied: "Please do me the honor of believing that it is not in my character to allow myself to be insulted 'roundly' without responding to the offense. I did in fact inform the two ill-bred young men that the incident would be resolved in the customary way on the dueling ground. At that, they immediately retracted, prevented no doubt by their cubist principles from engaging in a fight."

45. Entitled *Virgin* in the catalogue.

46. The Galeries Lafayette.

47. The street on which the École des Beaux-Arts was located.

48. This article appeared on the front page of the single issue of the *Bulletin de la Section d'Or*, published on the occasion of the Section d'Or exhibition at the La Boétie Gallery. On October 11, Apollinaire gave a lecture there on "The Dismemberment of Cubism," in which he supposedly pronounced the word "orphism" for the first time and enumerated the four categories of cubism that he was later to define in *Les Peintres cubistes* (Chapter VII).

49. On November 16, 1911, Apollinaire describes his meeting with the two futurists but makes no mention of Picasso's studio (see *Anecdotiques*).

50. Presumably an allusion to Bohumil Kubišta. The painter referred to in the next sentence is the Austrian Alfred Kubin.

51. Maurice Vlaminck quoted this article in *Portraits avant décès* (Paris, 1943), pp. 211–15, adding the following note: "The date mentioned by Guillaume Apollinaire is chronologically incorrect. I met André Derain for the first time at the end of the year 1900, while I was still in the Army. And the very day after we met, we went to work together for the first time on the island of Chatou. In 1902, Derain was in Commercy. The Chatou bridge studio dates from the end of 1900 to 1901."

The Apollinaire text in *Portraits avant décès* first appeared, according to Vlaminck, in "*La République* of November 14, 1910." The fact is that *La République française* of October 14,

NOTES 1912

1912, carried a brief résumé of the *Le Temps* article of the same date, quoting only the text of the last paragraph.

52. In Robert Delaunay, *Du cubisme à l'art abstrait* (Paris, 1957), there is a text by Apollinaire entitled "The Beginning of Cubism" (pp. 151–54), which is essentially the same as the one in *Le Temps*, despite a few interesting variants and two new paragraphs added at the end. This text is based on mimeographed copies that Delaunay had run off from an Apollinaire manuscript in his possession. Apollinaire supposedly used the manuscript for a lecture he gave in Berlin in January, 1913.

53. In the end, *Les Peintres cubistes, méditations esthétiques* did not appear until March, 1913.

54. This text, which appeared in German, is essentially the same as the one printed the same month in *Les Soirées de Paris* under the title: "Notes: Réalité, peinture pure" (reprinted in *Il y a*). Since the article in *Der Sturm* contains a more extensive introduction and conclusion, we have selected it for translation rather than the original French text.

Robert Delaunay's *Du cubisme à l'art abstrait* (pp. 154–57) contains a text by Apollinaire also entitled "Réalité, peinture pure," which is an almost exact French version of the published German text, despite a few variants. This text is taken from mimeographed copies that Delaunay had run off from a manuscript in his possession that supposedly served as the basis for the German translation.

Apollinaire's close friendship with Delaunay at this time is well known. In January, 1913, they went to Berlin together to attend a Delaunay exhibition at the Sturm Gallery (January 27–February 20). On the occasion of this exhibition, Delaunay published an album of eleven plates prefaced by a poem by Apollinaire, "Les Fenêtres." (See his *Oeuvres poétiques*, Pléiade edition, p. 168 and pp. 1071–72.) Furthermore, according to Delaunay, Apollinaire had by then written another poem based on his painting. "Even in 1910, in the painting of the destructive period, *The Tower*, there were intuitions of simultaneity. This painting was exhibited in Paris in 1911 and in Berlin in 1912. Apollinaire wrote another poem that accompanied the reproduction of this painting on a postal card published in

Berlin in 1912" (*Du cubisme à l'art abstrait*, p. 171). The poem in question is doubtless the one entitled "Tour" (*Oeuvres poétiques*, p. 200).

55. Evidently a slip of the pen for Charles Vignier, a friend of Barrès, Tailhade, and Moréas. These four friends formed, according to Moréas, "the Alpha and the Omega of what has since been called decadence, deliquescence, symbolism, or some other name" (see J. Huret, *Enquête sur l'évolution littéraire*, p. 96).

56. In 1912, the 6th Exhibition was held from December 3 to December 31.

1913

1. This article appeared in German under the title, "Die moderne Malerei," with the following notation: "Autorisierte Uebersetzung aus dem Französischen von Jean-Jacques." Apparently, this text served as the basis for a lecture Apollinaire gave in Berlin in January, 1913, at the Sturm Gallery. A retranslation of this essay into French was published in Paris in 1929: *La Peinture moderne, retraduit de l'allemand par Anatole Delagrave* (n.p., n.d.), but it is not a faithful rendition of the text published in *Der Sturm*. It is reproduced in Robert Delaunay, *Du cubisme à l'art abstrait*, pp. 162–66.

2. We have omitted this text, since it is a composite, with variants, of the essays, "On the Subject in Modern Painting," "The New Painting: Art Notes," and "Cubism" (see above, pp. 197, 222, 256). It forms the bulk of the entire first part of *Les Peintres cubistes, méditations esthétiques*, which was published on March 17, 1913.

The title of this article is also the one that Apollinaire had chosen as the principal title of the book. In a letter to Madeleine Pagès in 1915, apropos the book, *Méditations esthétiques, les peintres cubistes*, he wrote: "The second part of the title, which should have been a subtitle, was printed in much larger type than the first and thus became the title" (*Tendre comme le souvenir*, pp. 67–68). In fact, the top of every page of text in

the first edition carries the words, *Méditations esthétiques*, whereas the other part of the title appears only on the cover.

Ultimately, Apollinaire intended his little book to be much less a defense of the cubist movement than a collection of general "meditations" on the new painting, followed by the portraits of ten young painters; in fact, he refers to the latter as "cubists" only very rarely in his text.

Apollinaire may therefore be excused for including several old texts in the book, some of them dating from before the founding of the cubist movement. Chapter 1 is the preface to the catalogue of the exhibition of the Cercle de l'Art Moderne in Le Havre in June, 1908 (see above, p. 47). Chapters 2–6 are taken from articles in *Les Soirées de Paris*. It is not until Chapter 7, which is apparently based on Apollinaire's lecture at the Section d'Or, that we find the term "cubism." The chapter on Picasso is composed of the essay in *La Plume* of May 15, 1905, and the one that subsequently appeared in *Montjoie!* on March 14, 1913 (pp. 13 and 279 above); the essay on Braque contains passages from the preface to the catalogue of the Braque exhibition of 1908, together with part of the review of the Salon des Indépendants of 1913 (pp. 50 and 281 above). The pages on Metzinger reproduce several paragraphs of the article entitled "D'Eugène Delacroix au néo-impressionisme," August 7, 1911 (p. 176). The essay on Marie Laurencin contains excerpts from the article on "Women Painters" (April 5, 1912; p. 227), and the eulogy of the Douanier Rousseau has passages from the review of the Salon des Indépendants of 1911 (p. 149).

There are only three artists in the part of the book entitled "Peintres nouveaux" whom Apollinaire specifically calls "cubists": Metzinger, Gleizes, and Gris.

For details on the composition of this volume, see the annotated edition of *Les Peintres cubistes*, ed. by L. C. Breunig and J.-C. Chevalier (Paris, Hermann, 1965).

3. At the La Boétie Gallery (February 17–March 17).

4. January 17, 1913.

5. Nicolas Beaudoin reports that Apollinaire, "according to my notes, gave a talk on this sculptor on Saturday, January 25, 1913,

at the Dîner de Passy, where we used to meet regularly" ("Les Temps héroïques," *Masques et Visages*, No. 39, June, 1956, p. 7).

6. Title of Chapter XVI of Baudelaire's "Salon de 1846," published in his *Curiosités esthétiques.*

7. On the edge of the Luxembourg Gardens, where Ney was executed, December 7, 1815.

8. Actually the lines are from Victor Hugo ("Les Pauvres Gens"), rather than from François Coppée.

9. This brief statement was written at the request of Herwarth Walden, editor of *Der Sturm*, who was the leader of a movement protesting against the extremely harsh criticism of Kandinsky's work by Kurt Küchler in the *Hamburger Fremdenblatt* of February 15, 1913, on the occasion of a Kandinsky exhibition at the Louis Bock Gallery in Hamburg.

10. Doubtless an allusion to the sentence in "Villes," in Rimbaud's *Illuminations*: ". . . and I attend painting exhibits on grounds twenty times the size of Hampton Court."

11. The exact title of the painting is: *Third Representation: The Cardiff Team.* In his reviews, Apollinaire invariably inverted the elements of the title.

12. André Salmon quotes this document in *Action* (No. 10, November, 1921, pp. 12–13), with the following introduction: "On the morning of the opening of the Indépendants of 19——, a mysterious old man in a yellow topcoat was distributing a tract that deserves to be saved from oblivion!" The tract, approximately a page long, is a passionate and very confused defense of "orpheism."

13. This name does not appear in the catalogue. It may be a misprint for Van Rees (Otto).

14. Léger's name does not appear in the 1913 catalogue, but we know that he showed *The Smokers* at the Indépendants in the preceding year.

15. Not to be confused with *Procession Seville*, which was first shown at the Section d'Or and was being shown in March, 1913, at the Armory Show in the United States.

16. This painting is listed in the catalogue as *Couple Under the Tree* (1912).

NOTES 1913

17. Patrick Henry Bruce had been mentioned previously in the introduction to the review of the Salon (March 18).

18. Yet this term does not appear in the various articles by Fernand Roches in *L'Art décoratif*. Presumably Apollinaire heard it by word of mouth. The term may have appealed to him because of his own poem "Zone" in *Alcools*.

19. Apollinaire wrote two reviews of each of the spring salons of 1913, one for *L'Intransigeant* and one for the magazine *Montjoie!* In the latter, the tone of the articles is generally more militant.

20. In this paragraph, Apollinaire repeats some of the ideas of De-launay that he had already cited in "Reality, Pure Painting" (December, 1912).

21. "Mar-Git" in the catalogue.

22. Sérusier was showing: *Apples*, *Temptation*, and *Suzanna*.

23. Luce was showing two paintings: *Men at Work on the Pont Mirabeau* and *Construction Workers Resting*.

24. See above, n. 13.

25. Yet he did send it. (See the review of March 25, 1913, in *L'Intransigeant*, p. 282 above).

26. Cf. the essay, "On the Subject in Modern Painting" (p. 197), in which Apollinaire writes: "The subject no longer counts, or if it counts, it counts for very little."

27. The catalogue has Huyot (Albert).

28. The April 14, 1913, issue of *Montjoie!* carried the following editorial note: "In the conclusion of the review of the *Indépendants* by M. Guillaume Apollinaire published in our last issue, the words 'Cubism is dead, long live cubism' were the result of a printer's error. M. Apollinaire had written: 'From cubism there emerges a new cubism.' "

29. These two articles from *Montjoie!* were accompanied by reproductions of works by Agéro, Archipenko, Bolz, Delaunay, Du-noyer de Segonzac, Gleizes, La Fresnaye, Marie Laurencin, Léger, Moreau, Mortier, Mme. Valentine de Saint-Point.

30. See 1912, n. 1.

31. Sentence quoted from the preface to the catalogue, *Exposition David et ses élèves*, April 7–June 9, 1913.

32. The opening lines of *Epître à Gérard* (1805).

33. See "L'Art en danger," in *Comœdia*, October 14, 1912.

34. "Salon de 1845," in *Curiosités esthétiques*.
35. The catalogue lists only one work by Ozenfant: *Women Bathing*.
36. The title listed in the catalogue is *In the Wadi, the Massage*.
37. A pun on *costaud*, the French word for "hefty" or "husky"—TRANS.
38. This review was accompanied by reproductions of works by Cavaillon, Gandara, Marcel-Jacques, Wittig, and Wlérick.
39. Entitled *Moroccan Café* in the catalogue, *Exposition Henri Matisse, Tableaux du Maroc et sculptures*, at the Bernheim-Jeune Gallery, April 14–19, 1913. In the bibliography of his book on Matisse, Alfred Barr mentions an article by Apollinaire printed in *L'Intransigeant* of April 28 (*sic*), 1913, on the occasion of the Bernheim exhibit. He doubtless had this article in mind.
40. Allusion to the New York Armory Show, held from February 17 to March 15, 1913. The organizers of the show had chosen the pine tree as the emblem of the "New Spirit," since it had served as a symbol during the American Revolution. Thousands of such buttons were distributed in the course of the exhibition.
41. Typical Apollinaire wordplay. *Frac* means "frock coat" and *froc* a "monk's frock." *Froc* is also slang for a workman's pants.
42. *Angelos* means both "messenger" (as in "d'Annunzio") and "angel" (as in Anatole France's *La Révolte des Anges*).
43. He had in fact sent *The Orphan*, which Apollinaire commented on in his review for *L'Intransigeant* of April 29.
44. Most of the information contained in this article comes from the *Notice de l'exposition*, written by Messrs. Poëte, Henriot, and Ruinaut.
45. Title of an exhibition held in the Bagatelle Gardens and Palace from May 20 to July 15.
46. Exhibition of a hundred pen-and-ink drawings, April 26–May 8, 1909.
47. Exhibition of modern painters, May 26–June 7.
48. Probably the *Head of a Woman*.
49. Allusion to a natural method of physical education advocated by Lieutenant-Commander Georges Hébert. (See his book, *La Culture virile et les devoirs physiques de l'officier combattant*, Paris, 1913.)

50. Replies were also received from Remy de Gourmont, Frantz Jourdain, Camille Mauclair, André Michel, Péladan, Valentine de Saint-Point, etc.
51. See reference to Van Dongen on p. 326.
52. Catalogue of the Salon d'Automne of 1913, p. 262.
53. Entitled *Portrait* in the catalogue, this is the painting known today as *Portrait of Mme. Matisse*. The Bonnard canvas is *Country Dining Room*.
54. These two paintings were reproduced with four other works by Picabia in *Les Soirées de Paris*, No. 22, March 15, 1914.
55. *L'Antitradition futuriste. Manifeste-synthèse* (Milan, 1913).
56. This second installment of the review of the *Salon d'Automne* was accompanied in *Les Soirées de Paris* by reproductions of the *Portrait of Mme. Matisse* by Matisse; Marie Laurencin's *Young Girl at the Piano*; Metzinger's *Boating*, a drawing for the painting at the Salon d'Automne; Gleizes's *Fishing Boats*; and Bruce's *Composition*. The first installment, November 15, was accompanied by five still-lifes by Picasso that had no connection with the Salon review.
57. The idea of an exhibit of "simultaneous" and other new sculpture before the futurists. Boccioni's exhibit was in June 1913 (see p. 320).
58. This article is unsigned, but it is certainly by Apollinaire. As he himself admits, however, he did not actually visit the Berlin Exhibition. It will be recalled that he gave a lecture at the Sturm Gallery in January (see note 1 above, p. 497).

1914

1. "To play the violin of Ingres" is to indulge in an art in addition to one's own; to practice a hobby.
2. This law, drafted by the same Bérenger we discussed in 1911, n. 3 and n. 13, extended leniency to first offenders.
3. A play on the name of a Catholic newspaper, *La Croix*, and the cliché of romantic melodrama, "my mother's cross," by which the long-lost child is recognized.
4. *Portrait of the Artist's Wife by Lamplight.*

5. This article was reprinted in *Il y a*.

6. Serge Jastrebzoff, known as Serge or Édouard Férat, was with his sister, the Baroness d'Oettigen, the principal supporter of *Les Soirées de Paris*.

7. Archipenko's exhibit consisted of four works listed in the catalogue: *The Carrousel, Pierrot, The Gondolier,* and *Boxing,* as well as an additional one entitled *Médrano*.

 In this article, Apollinaire is defending the sculptor against an attack published the previous evening by Emile Deflin, Apollinaire's colleague at *L'Intransigeant*. The front page of the March 2 edition carried a photograph of *Médrano*, with the following caption: "We reproduce here the photograph of the work of art (?) praised elsewhere in this issue by our collaborator Guillaume Apollinaire, who assumes sole responsibility for his opinion." It was soon after this incident, followed immediately by the incident detailed in n. 9, that Apollinaire sent his resignation to the editor of *L'Intransigeant*, Léon Bailby.

8. De Chirico had three paintings: *Nostalgia for the Infinite, Joys and Enigmas of a Strange Hour,* and *The Enigma of a Day*.

 On May 25, 1914, *Paris-Journal* printed an unsigned text entitled "G. de Chirico," which was probably written by Apollinaire:

 "For some time now, M. de Chirico has been devoting his talent to painting signboards, for art galleries as well as for midwives. Lounging about his tiny studio on the Rue Campagne-Première, he watches the comings and goings of the fiacres and moving vans that emerge by the thousands from the Société Générale des Petites Voitures. Let us hope that he himself will soon emerge from the apathy into which he was plunged by the sight of the few newly planted saplings on the Place de Rennes. M. de Chirico is the enemy of trees and the friend of statues. The Place de Rennes, which has no statues but which is marvelously adorned by the Gare Montparnasse, used to give infinite pleasure to the young painter, who is the brother of the musician Savinio. Now the city's gardeners have ruined it all for him; they have destroyed the harmony of one of the most beautiful modern squares by giving it a woodsy aspect that is deplorable."

9. The allusions to Delaunay's "futurism" and to his influence on Ottmann provoked a series of letters to *L'Intransigeant*, which

NOTES 1914

we reproduce below. This "aesthetic controversy," coming immediately upon the heels of the Archipenko incident, resulted in Apollinaire's resignation from *L'Intransigeant*.

[MARCH 6, 1914]

In response to the review of the Salon des Indépendants by M. Guillaume Apollinaire—printed under *his sole responsibility*—we have received the following letters, which it is our impartial duty to present to our readers:

"DEAR SIR,

"Allow me to appeal to your obliging impartiality with regard to a critique, more personal than artistic, by M. G. Apollinaire. M. Apollinaire is free to pose in his column as the apostle of futurism in France, even though all French artists regard it only as a foreign movement of no interest to them.

"But I will not permit a critic who, by definition, should know better, to commit such an error on my account. The misinterpretation to which his statement gives rise is totally unacceptable.

"I am not now and I have never been a futurist; no critic has ever had reason to think otherwise. I am surprised by M. Apollinaire's ignorance about the simultaneous contrasts that form the basis and the novelty of my art.

"Sincerely yours,

"ROBERT DELAUNAY"

"TO THE EDITOR:

"I appeal to your courtesy to obtain publication of this letter, which corrects the article by M. G. Apollinaire on the Salon des Indépendants published in yesterday's edition of *L'Intransigeant*.

"M. G. Apollinaire, who has felt called upon to adopt an equivocal attitude, is doing his best to discredit today's living and sensitive French art by extolling dishonesty—which enables him to mislead public opinion—systematic and corrupt tendencies, and the most absurd foreign manifestations.

"I protest most energetically against the so-called influence of M. Robert Delaunay (whose works, of course, I respect), but who had nothing to do with the transformation of my art, M. G. Apollinaire's judgment notwithstanding. I do not know and do not wish to know the unstated reasons behind M. Apollinaire's argument, but I count on your utter impartiality in ensuring that

this necessary correction of the facts appears in your esteemed newspaper. Thanking you in advance, I remain,

"Sincerely yours,

"H ENRY O TTMANN"

[MARCH 8]

AN AESTHETIC CONTROVERSY

In response to *L'Intransigeant*'s publication of letters from Messrs. Robert Delaunay and Henry Ottmann, we have received a vigorous protest from Messrs. Carrà, Papini, and Soffici in the name of the futurist movement. We print below this excerpt from their statement:

"The futurist quality of M. Delaunay's compositions has been pointed out many times (see especially *Les Marches du Sud-Ouest*) by French art critics. We have always recognized the influence exerted on our movement by French painting of the nineteenth century, but we will not allow someone who came after us to rob us of our efforts and we challenge M. Delaunay to prove the priority of his work over ours. As for the universal character of futurism, it has been sufficiently proved today the world over to permit us to let stand without comment the judgment of this movement expressed by M. Delaunay in his letter."

Furthermore, we have been advised by M. Rominé, whom Guillaume Apollinaire presented as a French futurist, that he is neither French nor a futurist.

Finally, a note sent to us by M. Gaston Michell, secretary of the Artists' League, states:

"We would be happy to see *Les Ecrits français, Pan, Les Bandeaux d'or,* or the valiant review *Montjoie!* intervene as arbitrators in this burning conflict and restore calm to this strife-torn artistic region, for goodness is always a very beautiful thing."

[MARCH 10]

We have just received the following letter:

"TO THE EDITOR:

"Yesterday I had the honor of addressing to you a few lines of correction in response to the rumor concerning me that appeared the day before yesterday in your newspaper.

"You will easily understand why it is important that this cor-

rection appear at the earliest possible moment; allow me, my dear editor, to count on that, to count on your faultless courtesy; to the ridiculous challenge flung at me by the little Italian gentlemen avid for publicity in keeping with the futurists' method, I reply that it would have been difficult for me to plagiarize the big art-school paintings to which they apply the term futurist.

> "Very sincerely yours,
> "R . DELAUNAY"

[MARCH 11]

In response to the letter from M. Henry Ottmann published in *L'Intransigeant*, we have received the following report:

"Considering himself offended by a letter from M. Henry Ottmann published in a newspaper, M. Guillaume Apollinaire charged Messrs. André Billy and Fernand Léger to demand an apology from its writer. M. Henry Ottmann chose as his seconds Messrs. Robert Delaunay and Fernand Roches. The latter declared that their principal regretted the interpretation given to his words and that it had never occurred to him to doubt M. Guillaume Apollinaire's scrupulousness and sincerity. Consequently, the four witnesses declared the incident closed.

"Executed in duplicate, Paris, March 9, 1914.
"*For M. Guillaume Apollinaire*:
ANDRÉ BILLY, FERNAND LÉGER
"*For M. Henry Ottmann*:
R . DELAUNAY, F . ROCHES"

10. Allusion to a canvas entitled *A Bird's-Eye View of Italy*, exhibited at the Salon des Indépendants of 1912.

11. This preface to the catalogue of the Archipenko exhibition at the Sturm Gallery in Berlin is accompanied by photographs of two statues: *Venus* and *Two Bodies*. The dates of the exhibition are not indicated in the catalogue, but we know that it took place in March.

Apollinaire published four more photographs of works by Archipenko in *Les Soirées de Paris* (No. 25, June 15): *Woman at her Toilette* (wood, glass, sheet metal); *Portrait of Mme. Archipenko* (wood, glass, sheet metal); *Boxing*; *Statuette*.

12. This article appeared in the review *Der Sturm* on the occasion of the Archipenko exhibition for which Apollinaire had written the preface to the catalogue.

13. We have omitted the introduction, which repeats the opening eight paragraphs of the review in *L'Intransigeant*. See p. 354 above.

14. This article was published in *Il y a*.

15. The only Jouclard mentioned in the catalogue is Mlle. Adrienne Jouclard.

16. The catalogue lists two works by Cormon: *The Triumph of Rama (Ramayana)*; *Portrait of Mlle. Demongeot as Elisabeth in "Tann-häuser."*

17. Blount was the commercial name of an automatic door-closing device, with the motto "The Blount will take care of it."

18. Tattegrain's exhibit consisted of two canvases: *The Infected Palace* and *Marie of Boulogne*. Zo's painting was: *Bonnat and His Pupils from the Basque Country and the Béarn* (decorative panel destined for the Bonnat museum in Bayonne).

19. An old French proverb: "One must never say: Fountain, I will not drink of your water."

20. After losing his job at *L'Intransigeant*, Apollinaire became the art critic of the daily *Paris-Journal*, for which he wrote until the outbreak of the war.

21. At the Salon of 1911. (See the article of April 21, 1911.)

22. Descaves's book was published after the war: *L'Imagier d'Epinal* (Paris, 1919). In an article on July 25, Apollinaire wrote that Fleuret was preparing "an epic poem in honor of Georgin." We have been unable to find this piece among the published works of Fleuret.

23. The title of the exhibition was, of course, "The Mountains of Mexico."

24. Gaston Thiesson, "Le Salon des Indépendants et les critiques," *L'Effort libre*, April, 1914, pp. 445–51. We quote below the passages from the article to which Apollinaire is replying:

 ". . . M. Vauxcelles, in his long article on the Indépendants, does not make a single intelligent remark. . . . Salmon is more amusing than Vauxcelles: 'It is the criticism of poets that has

freed the public from some of its most entrenched prejudices.' Indeed! A close look at the criticism of poets would bring shame upon that brotherhood.

"The poet Apollinaire pities those who might not appreciate Archipenko's sculptures—invented by Picasso—and finds talent in Morgan Russell, whose large canvas is muddy; he finds in Picabia a 'somewhat dry but very precise and elegant refinement' and notes that 'the influence already exerted [on whom?] by this much-maligned [by whom?] painter is sufficient proof of his importance.'

"Monsieur Apollinaire, Picabia has spoken to you at length about his experiments and discoveries: Why not tell the public, then, what Picabia has achieved in *Physical Culture* and *Negro Song*? It needs explanation, which you do not provide by speaking about a dry, precise, and elegant refinement. Words, words, words. But we know that you attach no more importance to Picabia than to Rochegrosse. You write that Dufy is a young master and that Chagall is one of the best colorists in the Salon. Your eclecticism is the result of your curious incomprehension of painting.

"This year, the criticism of poets was 'knocked out' [in English in text—Trans.]. A boxer was selling his article at the entrance to the Salon, just like the real critics. And without any claptrap about art, he executed the mediocre painters. His action appeared daring in this time of cowardice. The majority of readers were not outraged at all by the naïve brutality of this marvelous critic. . . ."

The "boxer" critic was Arthur Cravan, whose "L'Exposition des Indépendants" was published in his review, *Maintenant*.

25. We have been unable to identify this person.
26. Article by Maurice Hamel, "L'Ultime effigie de Balzac," in *Paris-Journal*, May 7, 1914.
27. The auction was held May 19 and 20, 1914, at the Georges Petit Gallery.
28. "Les Dessins de Seurat," *L'Art décoratif*, No. 201, March, 1914, p. 103.
29. Given May 9 and entitled "Les Réalisations picturales actuelles." The text of the lecture was printed in *Les Soirées de Paris*, No. 25, June 15, 1914, pp. 349–56.

30. A review in *Paris-Journal* (May 5, 1914) gives as the title of the painting *The Ilyssus of the Parthenon*.

31. Each of this series of articles from May 6 to May 15 is signed "G. A."

32. Hansi had been arrested in Colmar on May 18 because of the anti-German bias of his book *Mon Village*.

33. See the preface to the catalogue of the exhibition. The rest of the paragraph is worth quoting: "Come and be refreshed at this fountain of Youth, young old men engrossed by transcendental problems! Ask your conscience, and perhaps more than one of you will admit to himself: 'I would have done better to become a scientist, painting is not for me!' " (p. xiii).

34. These articles starting May 6, with the exception of the one of May 23, are signed "G. A."

35. A poem by Apollinaire, "Rotsoge," served as the preface to the catalogue of this exhibit. The poem is published in *Calligrammes* under the title "À travers l'Europe."

36. The catalogue of the Isaac de Camondo collection does not list this name. Could it be a misprint for Sené, who made a Louis XVI armchair that is in the collection?

37. Actually, it was his daughter, Mlle. Claudine Peské. She was awarded the first prize, as Apollinaire himself reported in *Anecdotiques* (August 1, 1914).

38. "Lola de Valence," in the set of poems entitled "Les Épaves," excluded from *Les Fleurs du mal*. These lines were placed beneath an 1863 engraving of the painting that Manet had done of the famous dancer the previous year.

39. According to an account of the duel in *L'Intransigeant* of June 12, 1914, the two adversaries, Kisling and Gottlieb, "fought with Italian sabers, attacking each other with a fury far beyond our customary mores. At one point, M. Dubois, a dueling master and referee of the duel, had to restrain one of the antagonists by force in order to make himself heard and put an end to the fight. . . ."

40. This volume is not among the published works of Max Jacob.

41. Quoted from the preface to the catalogue of the exhibition, "Watercolors by Jongkind," June 20–July 4, 1914. The catalogue

contains reproductions of six watercolors, which are precisely the ones Apollinaire comments on.

42. An unsigned article in *Paris-Journal* of June 26 gives the details of this exhibit.

43. Apollinaire may be alluding to an article by Meier-Graefe, "Pariser Reaktionen," in *Kunst und Künstler* (June, 1912), in which he states that Maillol has numerous imitators in Germany, Lehmbruck being the only original one among them.

44. In this series of articles from May 24 to June 28, the first four are signed "G. A."

45. June 17–30. Apollinaire wrote the preface to the catalogue of this exhibition. The text from *Les Soirées de Paris* that we reprint here is essentially the same as the preface, with a few variants and five new paragraphs added at the end. Earlier, June 18, Apollinaire had announced the exhibition in *Paris-Journal*, quoting his preface in its entirety.

46. Signed "G. A."

47. *Sic* for Klingstedt or Clinchetet (Karl Gustave).

48. Of the five titles mentioned by Apollinaire, only one, *Miserere*, was published. Finished in 1927 and constantly revised, it did not appear until 1948.

49. Margarita Nelken (not M.), issue of June 24, 1914, pp. 596–99.

50. There are four of them in Nos. 26–27 of *Les Soirées de Paris* (July–August, 1914).

51. In the *Nouvelle Revue Française* of July 1, 1914, pp. 49–57. The first two drawings are on a letter to Ernest Delahaye written from Roche, May, 1873; the third is on a letter to Ernest Delahaye from Stuttgart, March, 1875. No facsimile exists of any of these drawings, according to the editors of Rimbaud's *Oeuvres complètes* (Pléiade edition).

52. Rimbaud is ridiculing the typically romantic interjection, "O Nature, ô ma sœur" ("O Nature, o my sister!") by substituting the word "tante" ("aunt") for "sœur."—TRANS.

53. Adolf Loos.

54. Better known under the name Survage.

55. Babin had written that M. de Camondo "owned the only Cézanne landscape acceptable to honest eyes, *The House of the Hanged Man*. It is perhaps the only one in which the horizon is horizontal

and the walls vertical, the only one which is not 'all askew,' a characteristic that, in the eyes of J.-K. Huysmans, constituted the chief merit of Cézanne's paintings. But he also had the pleasure of owning a sketch of *The Cardplayers*—which serious journals label 'famous'—and a few other rather dull sketches by him.

"In any case, the thing is done: The 'Camondo museum' is lodged in the very heart of the national collections. It is all the same, but if anyone is astonished up there, it must be poor old Cézanne, whose sole ambition in life was to be 'admitted to Bouguereau's salon,' as he used to say; who had no hope up to his very death of ever realizing that wish; and who today sees himself installed—before M. Bouguereau himself, his secret ideal —in the galleries that saw the first salons. Survival is all, as someone said. Cézanne died too soon. He missed his apotheosis" (Gustave Babin, "Un petit musée dans un grand," *Illustration*, July 18, 1914, p. 59).

56. See no. 21 above.

57. The four essays that follow were published together in a pamphlet in English during 1914 in Paris, and we have inserted them here instead of the piece in French on Fragonards that Apollinaire published in the *Paris-Journal* of July 29. The publication in English (Paris, L'Union, 1914, month unknown) did not appear in the French edition of *Chroniques d'art* and is reprinted here for the first time. It was discovered subsequently by Noëmi Blumenkranz-Onimus. See her article "Un Écrit inconnu d'Apollinaire: 'Fragonard and the United States,'" in the special Apollinaire issue of *La Revue des Lettres Modernes,* Nos. 85–89, Autumn, 1963, pp. 146–49. The pamphlet contained reproductions of the following paintings: *Love Victorious, Foolish Love, The Good Mother* (engraving by Nicolas Delaunay), *The Reaper, The Gardener, The Shepherdess, The Grape Harvester.* New translations have been provided for passages that were printed in French in the original pamphlet.

58. "Noted Pictures by Jean-Honoré Fragonard in Private Collections of America," unsigned article in *The Lotus Magazine*, V, No. 6 (March, 1914), pp. 387–405.

59. Exhibition of paintings and drawings by Fragonard at the Gallery

of E. Gimpel and Wildenstein, 636 Fifth Avenue. For the bibliography concerning the authenticity of *The Good Mother*, see Georges Wildenstein, *The Paintings of Fragonard* (London, Phaidon, 1960), p. 299.

1 9 1 5

1. Robert Delaunay, who was, in fact, in Spain (information supplied by John H. Field).
2. These two articles, which do not appear in the French edition of the *Chroniques d'art*, were discovered recently by John H. Field and reproduced in the Guillaume Apollinaire issue of *La Revue des Lettres Modernes*, Nos. 183–88, 1968(4). The second of the two is apparently an excerpt from a letter.

1 9 1 6

1. "Symbolisme plastique et symbolisme littéraire," in the *Mercure de France*, February 1.
2. This album-catalogue also contains: "Voyage," by Apollinaire (published in *Calligrammes* under the title "La Traversée"); "Bombay-Express," by Blaise Cendrars; "La Messe du visionnaire" and "La Même en prose," by Max Jacob; "Ronde des signes," by Fernand Divoire; and "Nature morte, portrait," by Pierre Reverdy.
3. Regarding Dufy, it should be noted that at this same time (the end of 1916) Apollinaire was praising him in an essay he was writing on Remy de Gourmont. The autograph manuscript of this essay, consisting of fifteen separate sheets, was published in facsimile after Apollinaire's death in Remy de Gourmont, *Des Pensées inédites, avec dix-huit dessins de Raoul Dufy et une préface de Guillaume Apollinaire* (Paris, Éditions de la Sirène, 1920). The first five pages of the preface reproduce, with variants, an essay already published under the title, "Remy de Gourmont," in *Les Marges*, No. 20, March, 1910 (reprinted in *Contemporains pittoresques*). The other pages, which make up approximately two-thirds of the text, are undated but are written

on paper bearing the letterhead of the Italian Government hospital where Apollinaire was taken after being wounded in March, 1916, and there is an allusion in the text to Maurice Barrès "now at the end of 1916."

These pages tell how Remy de Gourmont, who had been very impressed by the portrait of Apollinaire by Picasso in the first edition of *Alcools*, invited the two friends to visit him so that Picasso might make "a cubist portrait" of him as well. After Picasso refused the invitation, Apollinaire went to see Gourmont with Raoul Dufy, who immediately did a series of "psychological portraits" of the writer. "And Dufy's drawings capture marvelously the expression at once serene and desolate which that mixture of assurance and anguish produced on his face, ill-favored by nature but at the same time full of a strange beauty."

4. In an Epistle to Catherine the Great, Voltaire had written: "It is from the North today that we receive our light" (*Épîtres* CXI).

5. One of the three prefaces to the catalogue of an exhibit of contemporary French painting in Oslo. "Preface I" is by Jean Cocteau, and ends with the words: "I wanted to send my greetings to the Kunstnerforbundet and express our thanks to them, allowing Guillaume Apollinaire and André Salmon to introduce the artists whom they defended against all comers." "Preface II" is by Apollinaire, and "Preface III" by Salmon. The catalogue includes works by Picasso, Vallotton, Marval, Galanis, Matisse, Bonnard, Cross, Gleizes, Marchand, Vlaminck, Signac, Perdriat, La Fresnaye, Agutte, Boussingault, Segonzac, Derain, Marquet, Dufy, Léger, Lhote, Friesz, Mare, Metzinger, Péquin, and Villon.

6. This article, which does not appear in the French edition of the *Chroniques d'art*, was discovered recently by John H. Field and reprinted with his commentaries (see above, 1915, n. 2). The association Art et Liberté published a manifesto in *Paris-Midi* on October 22, 1916.

1917

1. The typographical arrangement of this poem was commented on as follows by Pierre Albert-Birot, editor of *SIC*: ". . . the

blank spaces inside the text of this poem form something like a painting by Picasso." ("Naissance et Vie de 'SIC,' " in *Les Lettres Nouvelles*, September, 1953, pp. 843–59.) It seems doubtful that the spaces represent a particular painting. The poem was published in *Il y a*.

2. This is apparently the first time this term was used. Apollinaire repeated it in the subtitle of his play, *Les Mamelles de Tirésias (drame surréaliste)*, which was performed on June 24, 1917. The first performance of *Parade* was on May 18.

1918

1. The catalogue is accompanied by a reproduction of a Picasso drawing showing a seated harlequin with a guitar. This drawing is not included in the Zervos catalogue, but it is reproduced in Pascal Pia, *Apollinaire par lui-même* (Paris, 1954).

2. This column is entitled "Échos" and is signed "Guillaume Apollinaire." From April 13 to November 9, the column was entitled "Échos et On-dit des Lettres et des Arts," and signed: "L'Écolâtre." We reproduce here only the excerpts dealing with art and artists.

3. This article was published in *Il y a*.

4. Doubtless an allusion to Severini.

5. *Les Réincarnations du père Ubu*, by A. Vollard, with drawings and engravings by Rouault, was not published until 1932.

6. This edition did not appear until 1919, after Apollinaire's death.

7. The exact title was *Lettres modernes*.

8. Exhibition preceding the sale of works from Degas's studio, May 6, 7, and 8, 1918.

9. Allusion to the sale of paintings composing Degas's collection, March 26 and 27, 1918.

10. This article should be compared with the one Apollinaire had already published in the *Mercure de France* of April 1, 1917, under the title, "Mélanophilie ou mélanomanie" (reprinted in *Anecdotiques*), and which he published, with a few variants, April 25, 1917, under the title, "À propos de l'art des noirs," in *Sculptures nègres, vingt-quatre phototypies précédées d'un avertissement de Guillaume Apollinaire et d'un exposé de Paul*

Guillaume (Paris, Paul Guillaume, 1917). After Apollinaire's death, the *Mercure de France* version was published under the title "Opinion sur l'art nègre" in *Action*, No. 3, April, 1920, p. 23; in *L'Art océanien, sa présence,* introduction by Paul Rivet, texts by Guillaume Apollinaire and Tristan Tzara, edited by Madeleine Rousseau, in the series Le Musée vivant, No. 38 (Paris, A.P.A.M., 1951); and in Guillaume Apollinaire, *Airelles* (Liège, 1954), under the title, "L'Art des noirs."

11. This series of articles by Apollinaire for *Les Arts à Paris*, the advertising bulletin of the Paul Guillaume Gallery, is signed with the following pseudonyms: "Current Events": Paracelsus; "The Degas Sale": Dr. Pressement; "Sculptures of Africa and Oceania": Louis Troëme.

12. Pierre Albert-Birot, disciple of Apollinaire and editor of the avantgarde magazine *SIC.*

13. "Un grand artiste catalan: J.-M. Sert," in *L'Instant*, August, 1918, pp. 3–5. Litus was the pseudonym of J. Perez-Jorba, editor of *L'Instant*, a Franco-Catalan journal of art and literature, which included Apollinaire among its collaborators.

Sources

A. The texts in this volume appeared for the first time on the dates indicated in the following periodicals, catalogues, and bulletins:

I. PERIODICALS

L'Action, March 10, 1912.

Les Arts à Paris, March 15; July 15, 1918.

Arts et Spectacles, manuscript dated 1909, entitled "Médaillon: un fauve," published November 7, 1950.

Bulletin de la Section d'Or, October 9, 1912.

L'Europe nouvelle, April 6–November 2, 1918.

L'Européen, October 11; December 13, 1902.

L'Intermédiaire des chercheurs et des curieux, October 10, 1912.

L'Intransigeant, February 28, 1910–March 5, 1914.

Je dis tout, July 25; October 12, 19, 26, 1907.

Les Marches de l'Est, November 15, 1910.

Les Marches de Provence, February, 1912.

Le Mercure de France, March 1, 1916; October 16, 1917.

Montjoie!, March 14, 18, 29; April 14, 29, 1913.

Paris-Journal, January 20, 1910; September 10, 1912; May 1–August 1, 1914.

Paris-Midi, October 18, 1916.

Le Passant, November 25, 1911.

SOURCES

Le Petit Bleu, February 9; March 13, 20; April 5, 1912.

Le Petit Messager des Arts et des Industries d'Art, March 1; April 1, 1915.

La Phalange, December 15, 1907.

La Plume, May, 1905.

Poème et Drame, March, 1913.

Poésie, Autumn, 1910.

La Revue blanche, May 15, 1902; April 1, 1903.

La Revue de Bourgogne, July, 1913.

La Revue des Lettres et des Arts, May 1, 1908.

La Revue immoraliste, April, 1905.

SIC, May, 1917.

Les Soirées de Paris, February, March, April, May, December, 1912; November 15; December 15, 1913; January 15; March 15; May 15; July 15, 1914.

Der Sturm, December, 1912; February, 1913; March, 1913; March, 1914.

Le Temps, October 14, 1912.

La Vie, February 8, 1913.

2. CATALOGUES, BULLETINS, PAMPHLETS, PROGRAMS

Catalogue of the Third Exhibition of the Cercle de l'Art Moderne, City Hall, Le Havre, June, 1908.

Catalogue of the Georges Braque Exhibition, Kahnweiler Gallery, Paris, November 9–29, 1908.

Catalogue of the Vladislav Granzow Exhibition, E. Druet Gallery, Paris, October 25–November 6, 1909.

Subscription flyer for *L'Enchanteur pourrissant*, November, 1909.

Catalogue of the Benjamin Rabier Exhibition, Deplanche Gallery, Paris, June 8–July 4, 1910.

Subscription flyer for *Bestiaire ou Cortège d'Orphée*, March, 1911.

Catalogue of the 8th Annual Salon of the Cercle d'Art: Les Indépendants, Modern Museum, Brussels, June 10–July 3, 1911.

Catalogue of the 17th Exhibition: Alexander Archipenko, Der Sturm Gallery, Berlin, March, 1914.

Fragonard and the United States, Paris, L'Union, 1914.

Catalogue of the André Derain Exhibition, Paul Guillaume Gallery, Paris, October 15–21, 1916.

Catalogue of "Den Franske Utstillung," Kunstnerforbundet, Oslo, November–December, 1916.

Program for *Parade, Ballet réaliste* by Jean Cocteau; sets and costumes by Picasso; music by Erik Satie; choreography by Léonide Massine. Presented at Paris, May 18, 1917, by Serge de Diaghilev's Ballets Russes.

Catalogue of the Matisse-Picasso Exhibition, Paul Guillaume Gallery, Paris, January 23–February 15, 1918.

B. Other texts on art not included in this volume (see also Bibliography):

Anecdotiques. See bibl. 4.

L'Antitradition futuriste. Manifeste-synthèse. Milan, 1913.

Gourmont, Remy de. *Des Pensées inédites.* With 18 drawings by Raoul Dufy and a preface by Guillaume Apollinaire. Paris, 1920.

Oeuvres poétiques. See Bibl. 1. Of special interest among the poems inspired by paintings and painters are the following: "Les Fenêtres" (Delaunay); "Tour" (Delaunay); "A travers l'Europe" (Chagall); "Souvenir du Douanier"; "Trente ans debout . . ." (Rousseau); "Inscription pour le tombeau du peintre Henri Rousseau Douanier"; "Tu te souviens, Rousseau"; "Léopold Survage"; "Irène Lagut"; "À Francis Picabia"; "Noble Picasso."

Les Peintres cubistes—Méditations esthétiques. Paris, 1913. See bibl. 9, 10, 11.

C. Apollinaire signed a great many articles and reviews of more or less passing interest. These texts are not reprinted in this collection, but their titles are listed below. In addition, there are a number of unsigned articles in journals for which he worked that were probably written by him, especially under the heading "Arts" in *Paris-Journal,* May 1–August 1, 1914.

SOURCES

I. L'INTRANSIGEANT:

La Vie artistique: "Exposition du Syndicat des Artistes Femmes et Sculpteurs" (March 7, 1910); "Cercle international des arts" (March 12, 1910); "Exposition Louise Hervieu" (March 14, 1910); "Aquarelles de M. A. Birck—Paysages d'Alfred Veillet" (March 15, 1910); "Au petit musée Baudouin: peintres d'eau et de montagnes—Exposition J.-J. Gabriel" (March 24, 1910); "Vues d'inondation à la Galerie Ch. Brunner—Tableaux à la détrempe de Southall" (March 25, 1910); "Exposition Wenceslas Radimsky" (March 31, 1910); [Various exhibitions] (April 2, 1910); "Aux *Pastellistes français*—Expositions diverses" (April 5, 1910); "Tableaux du Nord par Anne Boberg —Exposition de la place Pigalle" (April 8, 1910); "Première Exposition de la Parisienne—100 Tableaux d'Alexandre Altmann—L'Affiche d'Art" (April 10, 1910).

Les Humoristes vernissent (April 24, 1910).

La Vie artistique: "Alexandre Urbain—Le petit musée Baudouin —International Art Union. Quatrième Exposition des Artistes rouennais" (April 28, 1910); [Romaine Brookes, Cercle international des Arts, Marcel Rieder] (May 15, 1910); "Tableaux modernes" (June 10, 1910); "Pastels de John S. Eland" (June 21, 1910); "IIe Congrès national de l'Union du Dessin" (August 7, 1910).

L'Exposition des P.T.T. (November 9, 1910).

La Vie artistique: [T. E. Butler, Jules Desbois, Luce; miscellaneous exhibitions] (November 25, 1910); "Cercle international des Arts" (November 29, 1910); "Exposition à la Galerie Druet" (December 21, 1910); [Eclectic exhibition. Alexandre Altmann] (December 25, 1910); [Dalou exhibition] (December 28, 1910); [Simmer exhibition] (December 29, 1910); [Gustave Brisgand] (January 4, 1911); [Robert Vonnoh, Bessie Porter] (January 6, 1911); [Rumèbe, Brugnot, Dola exhibitions] (January 10, 1911).

Encore l'art jaune (January 11, 1911).

La Vie artistique: [Leteurtre exhibition] (January 14, 1911).

Au Cercle Volney (January 19, 1911).

Quelques (January 21, 1911).

Le Salon d'Hiver (January 22, 1911).

SOURCES

Les "Unes" (January 24, 1911).

La Vie artistique: [Trevoux, Grand-jouan exhibitions] (January 25, 1911); "Exposition G. Carette, chez Georges Petit" (January 31, 1911).

Les Arts précieux (February 1, 1911).

Les Peintres orientalistes français (February 6, 1911).

La Vie artistique: [Émilie Charmy, Ribot] (February 9, 1911); [Henri Doucet, Mathilde See; various exhibitions] (February 15, 1911); [Vasquez-Diaz, Paul Lecomte exhibitions] (February 23, 1911).

Les Arts décoratifs (February 25, 1911).

Au Cercle Volney (February 26, 1911).

Au Cercle de l'Union artistique (February 27, 1911).

"Les Amateurs" (March 4, 1911).

Groupe libre (March 5, 1911).

Les Rosati (March 6, 1911).

La Vie artistique: "Les peintres de montagne et quatre autres peintres" (March 7, 1911); [Maurice Masson Collection; various exhibitions] (March 9, 1911).

"Le Pastel" (March 17, 1911).

La Vie artistique: "K.-X. Roussel—Georges Barbier" (March 30, 1911).

Les Dessinateurs humoristes (March 31, 1911).

La Vie artistique: [Various exhibitions] (April 5, 1911); "Les Arts décoratifs de la femme" (April 9, 1911).

Les Indépendants: "Les Premières Salles—Les Dernières Salles" (April 22, 1911).

La Vie artistique: "Troisième groupe Druet—Andreotti— Planquette; Filliard—Le Paris moderne—Albert Gouget—Fernand Rumèbe—Quelques noms oubliés dans les comptes rendus des salons" (April 25, 1911); "Céramiques et miniatures persanes—La Parisienne" (April 26, 1911); "Grands et petits maîtres hollandais" (April 29, 1911); [Various exhibitions] (May 12, 1911).

Aux Artistes français: "Mlle. Dufau—Jules Grün" (April 30, 1911).

Au Pavillon de Marsan: Légion d'honneur, Turqueries et Céramiques (June 6, 1911).

521

SOURCES

La Vie artistique: "Exposition Druet—Marcel Lenoir—Dessins d'Aman-Jean—Sculptures de Mme. Bernières-Henraux" (June 19, 1911).

Une Exposition des Arts décoratifs modernes à Paris, en 1915 (September 16, 1911).

La Vie artistique: "Oeuvres d'Axel Haartman et Suen Otto Lindstrom" (November 3, 1911); "Portraits et panneaux par Mlle. Hélène Dufau—Cercle international des Arts—Les danseuses de Gir" (December 2, 1911); "La comédie humaine—Premier groupe Druet" (December 13, 1911); *"La Cimaise*—Henry Hayden. Gsell Maury—Jacques Jourdan—Valdo Barbey—Frantz Charlet" (January 11, 1912); "Nouvelles expositions au Musée des Arts décoratifs: Outamaro—Laques japonais—Daniel Vierge" (January 13, 1912); "Sculptures de Mme. Julien Ochsé, peintures de Paul Prudhomme" (January 16, 1912); "Vernissage au Cercle Volney" (January 17, 1912); "Maximilien Luce—Le lévrier dans les arts" (January 21, 1912); "Paul Deltombe—*L'Effort*" (January 31, 1912); Prix du Salon et boursiers de voyage—Chevalier—Evelio Torent (February 1, 1912); "Association des artistes de Paris et du département de la Seine—Butler—*La Phalange*. Des Fontaines —Henri Jourdain—Lesage—Rosenstock—Édouard Morerod" (February 3, 1912); "Deuxième groupe à la Galerie Druet— Le foyer coopératif" (February 8, 1912); "Frank Brangwyn— Alexandre Altmann" (February 9, 1912).

Le Vernissage de l'Union des Femmes peintres et sculpteurs (February 11, 1912).

Exposition de la Société des Aquarellistes français (February 13, 1912).

La Vie artistique: "Nouvelle Promenade au Salon des Femmes peintres et sculpteurs—Peintures de Mme. Marval—Aquarelles, faïences et terres cuites par Roux-Champion" (February 25, 1912); [Exhibition of the Société Moderne] (February 26, 1912); "Exposition du Cercle de la rue Boissyd'Anglas" (March 5, 1912).

Au Musée Cernuschi (April 4, 1912).

La Vie artistique: "Oeuvres de Mme. Madeleine Lemaire et Mlle. Suzanne Lemaire" (May 17, 1912): [Mme. Besnard

exhibition; Jules Flandrin exhibition] (May 21, 1912); [Louis Morin, Charles Stern, Nicolas Gropeano] (May 27, 1912); [Ancient Persian miniatures; Princess Eristoff exhibition] (June 16, 1912); "Boleslas Biegas" (June 28, 1912); "Gustaw Gwozdecki" (July 3, 1912); "Art contemporain" (October 16, 1912); "L'Exposition des Dandys—Nels Ariès" (November 8, 1912); "Louis Bausil" (November 23, 1912): "La Gravure sur bois—André Méthey" (November 29, 1912); "Mme. Madelaine Lemaire" (December 15, 1912); "Les Aquarellistes français" (January 28, 1913); "Vernissage du Cercle Volney—Peintres de Paris moderne—Paul-Emile Colin—Eugène Delestre" (January 20, 1913); "Josué Gaboriaud—Van Houten—Pierre Prins—Gleizes, Léger et Metzinger" (February 1, 1913); "Cinq peintres et un ferronnier" (February 6, 1913); "Les Orientalistes" (February 7, 1913); "Simon Bussy" (February 21, 1913).

Union des Femmes peintres et sculpteurs (February 22, 1913).

Au Grand-Palais: X^e Salon de l'École française (March 14, 1913).

La Vie artistique: "Premier Salon Excelsior—Exposition M. Luce—Exposition Georges Scott" (March 15, 1913); "Peintres et sculpteurs de chevaux" (March 23, 1913); "Exposition du Cercle militaire" (March 29, 1913).

L'Art bouddhique au musée Cernuschi (April 15, 1913).

Au Pavillon de Marsan [Exhibition of Decorative Arts. Watercolors by M. A. Guérin] (April 17, 1913).

Les Intimistes (May 13, 1913).

À Bagatelle: *L'Exposition de Peinture des amateurs de jardins* (May 18, 1913).

La Vie artistique: "Au Pavillon de Marsan—L'Art des jardins" (May 25, 1913); [Palace Salon] (May 28, 1913); "Quelques petits vernissages" (October 11, 1913); "Jean Peské—Huxley de Labranche—Affiches originales" (October 30, 1913); "Mlle. Christiane Havet" (December 21, 1913).

Au Pavillon de Marsan: "Estampes japonaises" (January 11, 1914).

La Vie artistique: "L'Exposition du Cercle Volney" (January 18, 1914); "Exposant de l'Épatant" (March 5, 1914).

SOURCES

2. PARIS-JOURNAL:

Exposition Charles Lacoste (January 20, 1910).

VIIᵉ Exposition du Salon de l'École française (February 7, 1910).

Trois Expositions: "Guillaume Régamey; [. . .]; Les fleurs de Madeleine P.-F. Namur" (May 7, 1914).

Les Arts: "Exposition rétrospective d'Henri Havet" (May 9, 1914); "Le Musée historique des tissus de Lyon" (May 18, 1914); "À propos de la loi Pacca" (June 3, 1914); "Peintures de G.-L. Jaulmes" (June 5, 1914); "De Rachel à Sarah Bernhardt" (June 6, 1914); "L'art à la douane des États-Unis" (June 8, 1914); "La ronde du jour" [Marcel Lenoir] (June 11, 1914); "Marchandage" (June 15, 1914); "Icônes" (June 17, 1914); "Yvonne Serruys" (June 19, 1914); "Une série sur les fous" (June 22, 1914); "La mode et les peintres" (June 27, 1914); "Le *Cézanne* d'Ambroise Vollard" (June 30, 1914); "Architecture de verre" (July 1, 1914); "Une enquête de *Gil Blas*" (July 11, 1914); "Emblèmes hermétiques" (July 17, 1914); "Le musée du Trocadéro" (July 18, 1914); "Prenez garde à la peinture" (July 20, 1914); "Un livre de Charles Morice" (July 21, 1914); "Le pauvre peintre juif et les chameaux" (July 22, 1914); "La *Werkbundausstellung* de Cologne" (July 27, 1914); " 'Fragonards' d'exportation" (July 29, 1914).

3. LES ARTS À PARIS:

Actualités [Galerie Paul Guillaume; Sales, Theaters; *Art et Liberté*; Meetings; The Jacques Doucet Library; On African Art]. Signed "Paracelse" (No. 1, March 15, 1918).

4. JE DIS TOUT:

"Brindeau de Jarry" (October 19, 1907).

Selected Bibliography on Apollinaire

by Bernard Karpel,
Librarian, The Museum of Modern Art, New York

"Apollinaire relied above all on his sensibility,
especially on his eyes and what they gave him."

—C. M. BOWRA

"The critic must be as accurate as posterity;
he must speak in the present the words of the future."

—ERNEST HELLO (quoted by Apollinaire)

A. Major Anthologies

1. Adéma, Marcel & Décaudin, Michel. *Oeuvres poétiques*. Paris, Gallimard, Éditions de la Pléiade, 1956.

 Includes poems "inspired by paintings and painters" (Breunig). Notes; bibliography.

2. Décaudin, Michel, ed. *Oeuvres complètes de Guillaume Apollinaire*. Edition établie sous la direction de Michel Décaudin. Paris, André Balland & Jacques Lecat, 1966. 4 vols. plus 4 parts.

 Vol. 4 includes *Chroniques d'art*. Although vols. 1–4 are sparsely illustrated, each is generously supplemented by four smaller, separate boxes containing loose documentary illustrations. Edition also published in 480 de luxe copies "sur arches."

B. Archives

2a. "Album Apollinaire." Iconographie recensée et commentée par Pierre-Marcel Adéma et Michel Décaudin. Paris, Gallimard, 1971.

 524 illustrations.

3. "Documents iconographiques." *In* Pierre Cailler, ed. *Guillaume Apollinaire*. Notices établies par l'Éditeur. Geneva, Cailler, 1965. Collection Visages d'hommes célèbres.

525

The entire work consists of 138 classified plates: La famille du poète.—Les demeures du poète.—La vie de Guillaume Apollinaire par les écrits officiels.—Photographies du poète.—L'écriture—quelques dessins.—Collection Guillaume Apollinaire. For additional iconography, see Décaudin (bibl. 2).

C. Major Writings on Art

4. Apollinaire, Guillaume. *Anecdotiques.* Préface de Marcel Adéma. Paris, Gallimard, 1955.

 Reprints of chronicles that appeared in *Mercure de France* (1911–18) in the column "La Vie anecdotique."

5. Apollinaire, Guillaume. *Apollinaire on Art: Essays and Reviews 1902–1918.* Edited by L. C. Breunig. New York, The Viking Press, 1972.

 Translation by Susan Suleiman of bibl. 6. Bibliography by Bernard Karpel.

6. ———. *Chroniques d'art (1902–1918).* Textes réunis, avec préface et notes, par. L.-C. Breunig. Paris, Gallimard, 1960.

 Comprehensive documentation. Translation bibl. 5, with additional material.

7. Apollinaire, Guillaume. *Il y a.* Préface de Ramón Gómez de la Serna. Paris, Messein, 1925.

 "Peintres," pp. 127–206, written 1907–18; criticism from *Les Soireés de Paris.* Reprinted in translation in bibl. 5.

8. Apollinaire, Guillaume. *Et moi aussi je suis peintre.* Album d'idéogrammes lyriques et coloriés par Guillaume Apollinaire, accompagnés d'un portrait de l'auteur gravé sur bois par Pierre Roy d'après Georgio de Chirico. [Paris, Editions de Soirées de Paris, 1914.]

 "The album is still in proof as the war prevented its publication. The ideograms were later included in *Calligrammes*" (Adéma).

9. Apollinaire, Guillaume. *Les Peintres cubistes—Méditations esthétiques.* Paris, Figuière, 1913.

 Numerous editions include: Paris, Athéna, n.d. [1922].—

BIBLIOGRAPHY

Geneva, Cailler, 1950. Additional citations in Breunig and Chevalier, bibl. 10, p. 188.

10. ―――. *Méditations esthétiques―Les Peintres cubistes*. Texte présenté et annoté par L. C. Breunig et J.-Cl. Chevalier. Paris, Hermann, 1965.

Collection Miroir de l'Art. Notes et commentaires.―Documents.―Le cubisme et la critique, 1908–1912, pp. 97–187.― Bibliographie, pp. 188–92.

11. ―――. *The Cubist Painters―Aesthetic Meditations, 1913*. New York, Wittenborn, Schultz, 1944; rev. ed. 1949.

Documents of Modern Art, no. 1. Translation by Lionel Abel. Revised edition by Robert Motherwell issued 1949 with bibliography by Bernard Karpel. Text largely reprinted in Chipp (bibl. 28).

D. Recent Studies

12. Adéma, Marcel. *Apollinaire*. London, Heinemann, 1954; New York, Grove Press, 1955.

Outstanding biography; numerous extracts in French and English; bibliography. Translation by Denise Folliot of: *Guillaume Apollinaire le mal-aimé*. Paris, Plon, 1952. Revised edition: Paris, Editions de la Table Ronde, 1968. Text enlarged, bibliography reduced. (No English translation to date.)

13. Admussen, Richard L. *Les Petites Revues littéraires, 1914–1939*. Répertoire descriptif. St. Louis, Mo., Washington University Press; Paris, Librairie A. G. Nizet, 1970.

An annotated bibliography. Apollinaire, p. 136 (index). Necessarily complemented by Roméo Arbour: *Les Revues littéraires éphémères paraissant à Paris entre 1900 et 1914*. Répertoire descriptif. Paris, Librairie José Corti, 1956. Apollinaire, p. 71 (index).

14. Bates, Scott. *Guillaume Apollinaire*. New York, Twayne, 1967.

15. Bowra, C. M. *The Creative Experiment*. London, Macmillan, 1949; New York, Grove Press, 1958.

Chapter on "Order and Adventure in Guillaume Apollinaire"

supplemented by his introduction in *Guillaume Apollinaire—Choix de poésies*. London, Horizon, 1945.

16. Breunig, LeRoy C. *Guillaume Apollinaire*. New York & London, Columbia University Press, 1969.

 Columbia Essays on Modern Writers, no. 46. Selected bibliography, pp. 47–48.

16a. Cooper, Douglas. *The Cubist Epoch*. London, Phaidon Press Ltd in association with the Los Angeles County Museum of Art, Los Angeles, California, and the Metropolitan Museum of Art, New York, 1971.

 Distributed by Praeger Publishers, New York.

17. Davies, Margaret. *Apollinaire*. London, Oliver and Boyd, 1964; New York, St. Martin's Press, 1964.

18. *Le Flâneur des Deux Rives*. Bulletin d'études Apollinairiennes. Nos. 1–7/8 March, 1954–December 1955.

 Edited by Marcel Adéma. Complemented by annual bibliography by Michel Décaudin in special issues during 1962–69 of *La Revue des Lettres Modernes*: "Guillaume Apollinaire," nos. 1–8, covering citations from 1956 to date.

19. Lemaitre, Georges. *From Cubism to Surrealism in French Literature*. 2nd ed. Cambridge, Harvard University Press, 1947.

 Apollinaire, pp. 93–121. First edition, 1941. Bibliography.

20. Pia, Pascal. *Apollinaire par lui-même. Images et textes présentés par Pascal Pia*. Paris, Editions du Seuil, 1954.

 Detailed chronology (pp. 5–20) and classified bibliography (pp. 179–90).

21. Raymond, Marcel. *From Baudelaire to Surrealism*. New York, Wittenborn, Schultz, 1950.

 Documents of Modern Art, no. 10, edited by Robert Motherwell; bibliography by Bernard Karpel. Translation from the French (Paris, Corrêa, 1933). A study similar to Lemaitre in its concern for literary-painterly parallels.

22. Steegmuller, Francis. *Apollinaire: Poet Among the Painters*. New York, Farrar, Straus, 1963; London, Rupert Davies, 1964.

 Quotations, translations, illustrations, bibliographical notes. Also paperback edition (Noonday Press).

E. Selected Exhibitions

23. Lille. Palais des Beaux-Arts. *Apollinaire et le cubisme.* April 3–
 May 4, 1965.
24. London. Galerie Apollinaire. *Apollinaire chez lui.* December,
 1947. "Patronage of Jacqueline Apollinaire de Kostrowitzki."
 Translation of "La Jolie Rousse"; preface by André Billy. Water-
 colors and calligrams by Apollinaire. Catalogue lists 57 items
 by artists of the poet's circle; nos. 1–14 are watercolors and
 calligram manuscripts by Apollinaire.
25. London. Institute of Contemporary Arts. *Guillaume Apollinaire.*
 Fall, 1968.
 Catalogue published in form of folder of loose documents.
 Exhibition included photographs, cine-film of the poet, ideo-
 grams, paintings by the Apollinaire circle, and "works by our
 contemporaries specially created for this occasion." Commentary
 in *Arts Review* (*London*), no. 22, p. 709, illus. November 9, 1968;
 Studio International, v. 176, pp. 207–208, November, 1968.
26. Paris. Bibliothèque Nationale. *Apollinaire.* October 22–December
 31, 1969.
27. Verviers. Société Royale des Beaux-Arts. *La Peinture sous le signe
 d'Apollinaire.* October 22–November 5, 1950; Ghent, November
 11–26, 1950; Brussels, Palais des Beaux-Arts, December, 1950.
 Introduction by Jean Cassou also published September, 1950,
 in *Arts Plastiques*, which also published the catalogue (39 pp.,
 75 exhibits, 26 artists and Negro art, brief quotes).

F. Recent Art Publications

28. Chipp, Herschel B. *Theories of Modern Art.* A Source Book of
 Artists and Critics. Berkeley & Los Angeles, University of Cali-
 fornia, 1968.
 In addition to most of *The Cubist Painters* (New York, 1944),
 also includes translations of portions of "Histoire anecdotique du
 cubisme" from André Salmon's *La Jeune Peinture française*
 (Paris, 1912) and extracts from *Du Cubisme* (Paris, 1912) by
 Gleizes and Metzinger. Bibliographies.

BIBLIOGRAPHY

29. Fry, Edward F. *Cubism.* New York, McGraw-Hill, 1966.
 An anthology of 48 documents, largely from before 1914. Bibliography.

30. Golding, John. *Cubism: A History and an Analysis, 1907–1914.* London, Faber and Faber; New York, Wittenborn, 1959; 2nd rev. ed., London, Faber and Faber, 1968.
 Bibliography, pp. 188–200. Apollinaire, p. 201 (index).

31. Golding, John. Guillaume Apollinaire and the Art of the Twentieth Century. *Baltimore Museum of Art News*, v. 26, no. 4.— v. 27, no. 1. (Summer–Autumn, 1963).
 Superior essay on Apollinaire as an art critic.

32. Hamilton, George Heard. *Painting and Sculpture in Europe, 1880–1940.* Baltimore, Md., Penguin Books, 1967.
 Apollinaire, p. 423 (index). General bibliographies.

33. Jean, Marcel. *The History of Surrealist Painting.* London, Weidenfeld & Nicolson; New York, Grove Press, 1960.
 "With the collaboration of Arpad Mezei. Translated from the French by Simon Watson Taylor." Apollinaire, p. 377 (index).

34. Rubin, William S. *Dada and Surrealist Art.* New York, Abrams, 1969.
 Apollinaire, p. 513 (index).

35. Shattuck, Roger. *The Banquet Years: The Arts in France, 1885–1918.* New York, Harcourt, Brace, 1958 (c.1955).
 Bibliography, pp. 285–96. Survey on Jarry, Rousseau, Satie, Apollinaire. Also paperback, revised editions (New York, Anchor Books, 1961; Vintage Books, 1968).

G. Bibliographies

36. "Bibliographical Notes on Apollinaire and Cubism," by Bernard Karpel. *In* Apollinaire. *The Cubist Painters.* New York, 1949. See bibl. 11.
 Part I: The Man.—Part II: The Movement, pp. 54–64, mentions additional bibliographies (1924ff).

37. "Bibliographie," pp. 179–90. *In* Pascal Pia. *Apollinaire par luimême.* Paris, 1954. See bibl. 20.

Classified list of works: "ouvrages, préfaces," etc., with notes.

38. "Bibliography of the works of Guillaume Apollinaire." *In* Marcel Adéma, *Apollinaire*. London, 1954; New York, 1955. See bibl. 12.

Annotated commentary, pp. 275–89, covers I: Poetry, novels, essays, posthumous publications.—II: Pornographic works. Complemented by bibl. 18.

39. "Bibliographie des écrits d'Apollinaire consacrés aux beaux-arts," pp. 487–93. *In* Apollinaire. *Chroniques d'art*. Paris, 1960. And *Apollinaire on Art*. New York, 1972. See bibl. 5 and 6.

Supplemental references in Breunig and Chevalier (bibl. 10), pp. 188–92.

Index

533

535

INDEX

Apollinaire on Art

INDEX

INDEX

INDEX

INDEX